FRONT PAGES

NANCY CHUNN

INTERVIEW WITH THE ARTIST BY GARY INDIANA

RIZZOLI
NEW YORK

First published in the United States of America by
Rizzoli International Publications, Inc.
300 Park Avenue South, New York, NY 10010

Library of Congress Cataloging-in-Publication Data

Chunn, Nancy
Front Pages / Nancy Chunn: interview with the artist by Gary Indiana.
p. cm.
Published to coincide with an exhibition at the Corcoran Gallery of Art,
Washington, D.C., Jan. 10–Mar. 2, 1988.
ISBN 0-8478-2081-5
1. Chunn, Nancy—Interviews. 2. Artists—United States—Interviews.
3. Appropriation (Art) 4. New York times. 5. Newspapers—Selections, columns,
etc.—Front pages. I. Indiana, Gary. II. Corcoran Gallery of Art. III. Title.
N6537.C49767A35 1997
709'.2—dc21 97–34132
CIP

COVER AND BOOK DESIGN BY LISA FELDMAN DESIGN

PHOTOGRAPHY BY JOHN BACK

PRINTED AND BOUND IN ITALY

Contents

THIS BOOK IS DEDICATED TO NEWSPAPER READERS WHO TALK OUT LOUD AS THEY READ.

The deepest debt I owe is to Mark Rosen, who lovingly supported me throughout the project.

He was not only instrumental creatively but also refused to abandon me when I was acting

especially neurotic (which was most of the time).

My very special thanks go to my assistant, Jack Muccigrosso; the National Endowment for the Arts;

and to Ronald and Frayda Feldman, Marc Nochella, and the entire staff of the Feldman gallery for

their continuing support. Without their help I would never have completed this project. I would also like

to acknowledge Jon Derow, the paper conservator, and John Back, who photographed all the work.

My appreciation goes to Lenore Malen for introducing me to Barbara Einzig at Rizzoli

International Publications; to Gary Indiana, who while interviewing me created a comfortable, humorous,

and exciting atmosphere; to Peggy Jarrell Kaplan, who made sitting for my portrait a delightful

experience, and to Paul McMahon for his long-time support.

For their role in creating this book, I would like to thank Solveig Williams, Publisher, and Elizabeth White,

Associate Publisher, who saw the project through with aplomb at Rizzoli; Lisa Feldman, the designer,

whose aesthetic expertise has been invaluable; and a special thanks to Barbara Einzig, my editor, who

did absolutely everything to make this experience one of the highest points of my life.

Interview with the Artist by Gary Indiana

Gary Indiana: I know this Front Pages series came up as a kind of digression or interruption of your work about the history of China. Nancy Chunn: Yes, after I read the first part of Chinese history and realized you could spend your life just looking at China, I started doing China dynasty by dynasty. That took me about eight years: I worked for two-and-a-half years on the Ming Dynasty painting, which ended up being nineteen feet long. It was so labor-intensive, and I only had three studies and the final painting to show for two years' work. I needed a little bit of time between that painting and the beginning of the research for the Qing Dynasty, because most of my preparatory research takes six months or more to do. The painting really did look good, like a fake porcelain Ming vase, with a huge amount of varnish. But I thought, "Something's missing in it." It didn't show me, or all of me, or different facets of me.

How did you find your way into the Front Pages project—I mean just in terms of deciding how you wanted to work, the actual physical methods? First I went to Pearl Paint and spent two hundred dollars on acrylic paint. I came back and played with that, didn't like it, went back and spent two hundred dollars on pastels, which I'd never used. I wanted to do something fast, something simple, something easy. I just started to color in the newspapers. I teach a class at the School of Visual Arts called "Painting and Content." One of the ideas about art that comes into my teaching is for people to start doing work that's connected to their lives. That art is not separate from who they are, or what they do, or how they spend their time. I started listening to myself, and looking at how I spend my time, regardless if I were working or just lounging.... I'm a news freak. I'm always reading the papers, I'm always looking at the news, reading all sorts of different magazines.

In the past, I had been making very large paintings. For many of them I had to use industrial scaffolding! I had to stand four or five feet off the ground to reach the top of the painting, turning myself into a pretzel to do the work. Now I could sit like a human being for a while. I was having a great time. I just started from there, doing individual little pictures — not even the front page, just pictures in the newspaper. But I wasn't really quite satisfied with that after a while (this was over a period of weeks). Then I thought, "Well, what if I just did a page?" Then, "What if I did a month?" So I did one month, in 1995 — it was June, the choice was totally arbitrary — and I did it as if I were doing a large painting. In other words, I put a whole month on the wall, and then attended to it as an all-over piece.

How did this evolve from an experiment into a formalized, year-long project? Ronald Feldman had a drawing show for the gallery artists. My piece was the front pages of the *Times* for December 1995. Immediately after that I realized I just wanted to keep going. Doing that month was so much fun that I didn't want to stop. And I proposed to Ron, "Hey, what if I did the whole year, 1996?" It was going to be an election year. He wavered at first. He didn't know how it was going to look. So he told me to do a couple of months, and we'd see. I said, "You have no idea what it takes to do this, I'm going to need a commitment." I did the whole month of January 1996 and two weeks of February before I got the commitment that I'd have an exhibition when the project was finished. I had no idea what I was getting into, what it was going to involve, physically and mentally, to do this work.

This is a series where the raw material is coming at you every morning in the same format but with unpredictable contents. What sort of routine did you settle on to establish a working pace? First thing in the morning, I'd go down and retrieve my four copies of the *Times*. I'd begin reading the front page and the continuations of the front-page articles; I also read the Op-Ed page and Letters to the Editor. This usually took an hour to an hour-and-a-half. Later, at the end of the day, Mark Rosen (my significant other) and I would re-read the paper together. I imagined it being a little like comedy writers sitting down with the raw

material, inventing. We work very well together. I really enjoy making art by committee. I would choose whichever phrase or idea sounded best. When I went into my studio to work on the actual images, Jack Muccigrosso, my assistant, also felt free to put in his two cents: "I have a good idea about this one," or "This could be funny," and I'd say, "Let's go with it." I had created this mini-newsroom, getting input from all sources. I guess I was the executive editor.

Newspaper is a pretty fragile surface ... you must have had to think about how to preserve these things. Yes, I had to consult a professional paper conservator. His name was Jon Derow—he was great. He came to my apartment and spent the whole day here. He even brought some of the equipment I would need, which I bought from him, and set up a little shop right here to do it. Every morning before I bathed myself, I would wash the papers. It's a calcium hydroxide solution that pulls the acid out of the paper. So I would wash the pages in this bath for an hour, on a little window screen sitting in a photo tub, because when the paper's wet it's at its most vulnerable. I can't tell you how many I've ripped with my nails, trying to pull out an air hole. I'd rip it and have to start all over with another paper. After that we would air-dry the pages on the screen, until we could put them between pieces of felt, which we could not buy in New York. I had to send away for it—

How odd that you can't buy felt in New York. No, not like this. It comes in big rolls, and we cut them a little bigger than the size of the paper. We started to press them between two pieces of felt, but I noticed right away that the texture of the felt would appear on the paper. So Mark, who's a genius, said, "Why not get Plexiglas, which is totally smooth, lay the side of the paper you're going to use on the Plexiglas, and then put the felt on it? It's going to take longer to dry but you're going to get a smooth surface." Again, a low-tech solution—it takes about forty-eight hours to completely dry the paper.

So you would always be a few days behind anyway, just because of the physical process involved. I was usually running about two weeks behind, because of the wetting and drying, and also because I chose to do studies for each of the pages. In the studies I could think through the design. I'd attach little pieces of tape to the stamp images I planned to use, so I could move them around; the nature of the rubber stamps is that if you make a mistake you can't correct it—you'd destroy the paper because it's so thin. The pastels could be changed, but not very much. The show opened on January 11, 1997. I brought in the page for December 31 on January 8. That's how close it was.

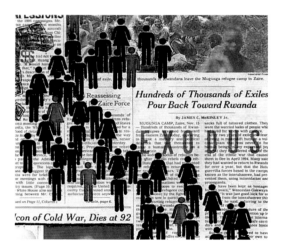

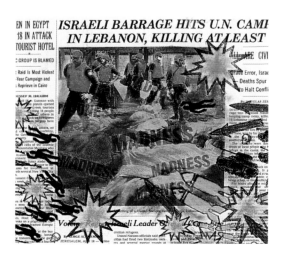

I see a real connection between this work and the China paintings—there's the idea of series, of calendrical history inside an image, of showing a historical era in iconography. Right, instead of doing the history of China, here I'm dealing with the history of New York, or the history of the United States and the world as seen by the *New York Times*, as transformed by me. I didn't really see this at first, it was more in the later months, after I started doing the whole year. But the way I dealt with images in the Front Pages was related to my working method in the China paintings, where I stacked or scattered the images—little ships, horses, marching armies—in a diagonal composition. In the Front Pages I did the same thing with these marching figures that represent the Rwandans, refugees.

I had started experimenting with this stuff in the middle of 1995. I decided not only to color the pictures in different ways, but to actually get my thoughts out. There are all these rubber stamps: the way I chose to use them reminded me of the USDA Seal of Approval, that there was some literal physical force involved in getting the word out, a primitive notion in me that if I stamped it really hard it would be like screaming. What we did—I keep using "we" because Jack and Mark were really instrumental in this entire project—we designed the stamps. Most of them we made up. The words were the kinds of words I found myself using a lot as I read the articles: "Give

me a break," "Politics as usual," "Madness," "Oops." I think I have about five hundred rubber stamps. I'm now a collector. We made little guns and various-sized coffins, bullets and explosions, it goes on and on. The stamps are like a cast of characters. They're both words and images.

I think it was the first or second day of April that we started to draw directly on the paper. This added another dimension to the pages, but it also saved a lot of money, and it went faster than just using stamps. Because this was real time. I have never in my life been so conscious of real time—conscious of every day as it passes. The paper came every day. I couldn't stop it. It was the weirdest, most bizarre feeling. It made me totally aware of my own death. It was a scary situation, I couldn't get away from it, even if I was sick I had to do it. I worked seven days a week for an entire year. And it still barely got finished for the exhibition. When I said we started to draw on the paper in April, already in April I didn't think I would last until December, that's how terrified I was. I felt like a gerbil in one of those little wheels.

When you started in January… the first three months of 1996 you were kind of restrained in what you were doing on the page. At first it was more about the *Times*, and as it goes along it becomes your commentary on the *Times*, your own way of solving visual problems—you're dealing with foreground and background, figure/ground tensions. It has almost an aspect of cell animation, taking this static gray thing and animating it, and it becomes more and more crowded—more interrelations between the stories emerge. I didn't think I was being restrained. It wasn't until I finished that I saw that the pages kept getting more and more complex. I don't know about other people's processes, but look at the first couple of the China series: they were very simple too, and as I got more involved it got more packed.

At first I didn't address all of the articles because at the beginning I really didn't have an opinion about everything. The more I did it, the more angry or involved I was getting, the more I started giving myself permission to talk back. This is what I was doing, I was talking back to power. So it was a cathartic thing, here I am screaming or at least getting my two cents in, to the power, the power represented by the *New York Times* or what's in the *New York Times*. It was a very liberating experience. It was like activism, in a way—the more you get involved, the more things mean something to you. Yes, I'm going to take issue. And that's why, toward the end, the pages look more filled, because by then I was practically rabid.

Did you come across any anomalous front pages, ones that struck you as unusual for the *Times*? As a matter of fact I did. It started out early, on January 27: I noticed that the only photographs on the front page were of women. On the same day there was also an article about Bangladesh's political system, which is headed by a woman prime minister (the opposition leader is also a woman). On June 13, there was a very curious page that had a midget or dwarf, a small person, who's an assistant to Trent Lott. Another unusual page was December 18. It showed only black men or men from Africa—Boutros-Boutros Ghali handing over the torch for the UN to Kofi Annan; Crew, the superintendent of schools; and Mobutu, who was returning to Zaire from France. Those were the three most unusual pages.

I'd be very interested to know what percentage of people who read the *Times* ever notice the bylines. Some people notice the bylines and some people don't. I became a little more aware of them with one particular series that a woman had done about female genital mutilation, because there were four different articles about it—Celia W. Dugger is the reporter's name. You know we hear about the power of the press, but until I started doing this I never sensed it so much, how these news stories can affect real change in the real world. The female genitalia mutilation articles led to the introduction of legislation that would allow Congress to pass laws to let threatened women into the United States.

*U.S. Grants Asylum to Woman
Fleeing Genital Mutilation Rite*

By CELIA W. DUGGER

If we can talk about media a little bit, the *Times* is more like the *Washington Post* in that it's about, "What do we think is important. What's the hierarchy of importance in news stories around the world." My sense of the *Times* versus network news is that the *Times* is more international in its outlook. Maybe not on the front page, but the second page— Absolutely, right next to the Tiffany ads. You always see the starving Rwandans, or Zaireans, or whatever, next to the jewels, which to me is incongruous. Or

the floods in Bangladesh, everybody's drowning, next to the Tiffany ads, as if nobody gave a damn. It's been going on that way for a long time.

The *Times* hits an international note, but it's also a local rag, it's our paper. It surprised me this year how many science articles were on the front page. I was personally very fond of them. They did have art on the front page a few times.

Weren't the art articles generally related to something besides art? One was about artifacts in a museum that had just been bombed in Afghanistan.

So that was connected to a war story. There was something about the NEA in February. And then, of course, Michael Kimmelman's article about all the new signs in Times Square, how that in itself was art. That was a big feature article.

You mentioned in a radio interview that whether a story was in the paper continuously or not, you became aware that the story was still going on in the world. This was another thing, how the stories creep in and out. The Peruvian hostages in the Japanese embassy, for instance. The *Times* was quite good about reporting that. I started putting in little people to represent them, and we started to keep track of their time in captivity with "Day One," "Day Two." All of a sudden it was Christmas day, and there was no story about them. Then they reappeared on the twenty-sixth, and then they go off again, and you wonder, and you start to see what gets bumped, what is more important...but who makes those decisions? I didn't know. I still don't know. All I did was work with what I was given, but it was fascinating how things would appear and disappear, or get buried or reversed, when something I'd noticed in the back pages would suddenly creep up to the middle of the circus ring.

The device of the front page doesn't really let us know if something that goes off the front page is still being covered on the inside pages. Did you notice any patterning—I don't want to say random patterning—but were there a lot of non-sequitur stories, things you thought would be followed up on that weren't? I wasn't aware of that, though I was aware of the reverse. For instance, the investigative reporting

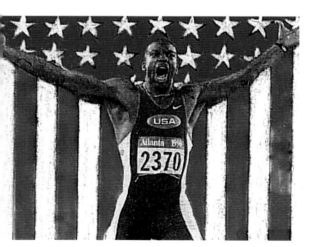

that the *Times* did on the Gulf War Syndrome, the poison gas story. I was shocked by how much attention they paid to that, and really appreciated that. Those were high-five stories for me—they occupied a large amount of space. That was a story that was played down on the TV news, a bit whitewashed, but the *Times* published about nineteen columns about the issue throughout the year.

The other two major stories in 1996 were the election and the plane crash off Long Island. One reason I chose that year was that it was an election year, and I knew that would be grist for the mill; I'd forgotten that there was also going to be the Olympics. Of course Flight 800 took over because it was a disaster of such scale, but the attention given to the Gulf War Syndrome was really quite surprising—so much attention. Another surprising thing was how often Yeltsin appeared on the front page because of the election in Russia and because of his health.

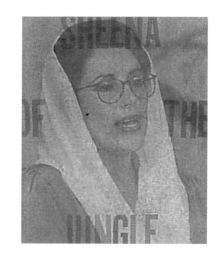

I noticed as the year progressed that you developed the coloring and altering of the photos in a more painterly way. They became more referential to various periods and styles of painting. When I started, I knew I wanted to put systems or signs on the paper. I did break from this, but for the most part, the symbols are clear and consistent. When women appeared on the front page they were colored in hot pink. And I found that road signs were quite useful. Those road signs

and caution bars are used throughout the whole year—they're signs for "Watch Out," "Look What's Ahead," "Troubled Times," or I use them to call people's attention to a particular image or text, just as they do on the road. I tend to build these systems in throughout. I found that each month, for me, had a theme, which I discovered early on—so I was able to play on it. January, "The Big Snowstorm." February, the beginning of the election campaign. So I was able to use that to make a system for the month. March had a large series on downsizing that occupied about seven days. There was also an international story about the Korean presidents on trial for their lives for corruption. Ron Brown's death and the Unabomber came in April, along with the female genital mutilation series. In May was the fake art, in June we had church burnings and the Saudi bombing. July—Flight 800 and the Olympics. August was the funniest month because of the Democratic and Republican Conventions. September, hurricanes, and riots in Israel. October—

—the lead-in to the election. No, the Yankees.

Okay, shows what I know. Then in November, the Rwandans returning home. Finally December, the Peruvian hostages and Clinton's new cabinet. I was very worried about constructing wallpaper, making every page so much the same that you wouldn't see any differences, so I kept raising the ante. I wanted to do something a little different each month, to keep my interest going, and to stretch my own art thing. I remember one of the big thrills I had was when my image spilled over and violated the single-column format. "The girl went over the line"—big deal. Then I felt liberated again.

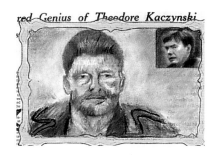

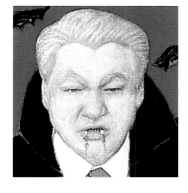

It really is a shock, in context. It was, it was. And it was a big deal for me. I really started to transform the pictures, too, actually changing Yeltsin into a vampire, or somebody into a dragon. Not just coloring them in nice colors or funny colors, but getting into the idea of transformation. Then there's the fake art—it starts with my fake Gorky on May 3. The forms in the picture just looked to me like Gorky forms. So I got a little kick, and thought, "How many pages this month will I be able to do my fake art on?" When the Valujet crashed in the swamp—when I got the paper that day the only thing I could see was a Monet. Then the Unabomber was caught, and when I looked at him he looked like a van Gogh. May for me was the month of fake art. And that's how I proceeded, every month there was something I could do to stretch myself.

You mentioned that each month seemed to have a theme. I either built it in, or the paper itself demanded it.

Would certain kinds of iconography or certain images suggest themselves when you started to see a pattern in the paper, when you realized early on that certain stories were going to stay in the news for a while? I got a brief inclination of that right off the bat with the weather. I was surprised at how many front pages had something to do with weather. When I did have the opportunity to talk to some of the people at the *Times,* I asked them, "Why weather?" And they said that because it affects so many people it really is an important news story. In some ways, I guess, you think about the weather in very immediate terms: "Should I carry my umbrella today," or "What should I wear?"

Search Called Off for Survivors of Crash in Everglac

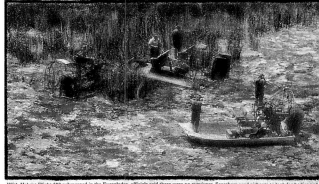

With Valujet Flight 592 submerged in the Everglades, officials said there were no survivors. Searchers used airboats to look for bodies and

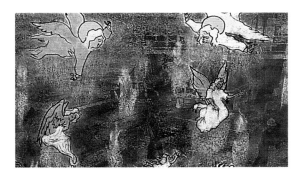

Snow, floods, hurricanes… people's livelihoods are affected, their health, sometimes they even die. The weather becomes a very important story in the larger picture.

The biggest story was Flight 800, which occupied forty front pages from July through December. I'm curious, if that had happened in another area of the country, would it have been as big a story?

I think anyone who lived in New York could imagine themselves on that plane; it really happened in our backyard, you could get in your car and go see it. For that story, I knew

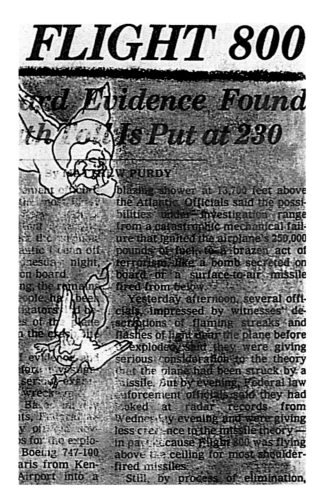

FLIGHT 800

...d Evidence Found ...h ... Is Put at 230

BY ...W PURDY

...blazing shower at 13,700 feet above the Atlantic. Officials said the possibilities under investigation range from a catastrophic mechanical failure that ignited the airplane's 250,000 pounds of fuel, to a brazen act of terrorism, like a bomb secreted on board or a surface-to-air missile fired from below.

Yesterday afternoon, several officials, impressed by witnesses' descriptions of flaming streaks and flashes of light near the plane before it exploded, said they were giving serious consideration to the theory that the plane had been struck by a missile. But by evening, Federal law enforcement officials said they had looked at radar records from Wednesday evening and were giving less credence to the missile theory — in part because Flight 800 was flying above the ceiling for most shoulder-fired missiles.

Still, by process of elimination,

what I was going to do before the paper appeared. The night of the plane crash I was teaching at the School of Visual Arts. I didn't know until I got home from school, and turned on the TV, as I always did. I knew what I was going to do — Giotto's angels — and that was a motif I elected to carry on for every article. There was a blue field, actually more than one color blue, there were choices of various angels, from Giotto or Botticelli, and there was a little flame that represented the souls of the passengers, and a black border on the top or bottom, sometimes around the whole article. Question marks appeared occasionally, sometimes the black box (which isn't black), and a few sundry other things, but always the blue field, the angels, and the flames. So when one went to the exhibition or when one looks through the book, one can see Flight 800 without reading the words: the blue field is the symbol or the sign of its appearance. July was really the most unusual month. First it was business as usual, I mean *my* usual business, making all my comments and so on, and then this disruption, where you could see a disruption that happened in the lives of so many people, that an event happens and then everything is different from then on.

I had some symbols for other things, starting right in January, all simple notions — and by the way, I think the simple notions are what made the work popular. There isn't anybody who can't read my reading of it: it is terribly accessible, you don't have to struggle, it's right there, in happy faces, stars, angels, whatever. Another simple image was the thin blue line representing police matters, which I used over and over again throughout, whether the story was about the death of a policeman, or about some particular police action. It was like cultural vernacular, very easily readable. And you can look through the whole year and pick out stories with certain themes. Another motif — anybody who died, anything about death that was in a photograph, had a black border put around it.

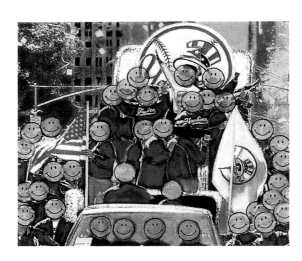

There was a significant number of sports people on the front page. I found that sports images really lent themselves to abstract design. I think it's because the athletes' arms and legs are always helter-skelter, and it was fun to divide the page that way. Winners usually got stars and losers got x'd out. One guy said, "What have you got against tennis players, you don't like them?" I said, "No, they're fine, these guys just lost, so they were x'd out."

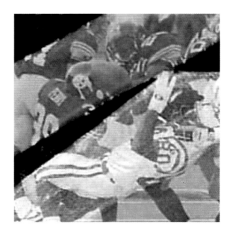

Let's talk about some of the stories you were reacting to. There were disasters, accidents, sports, and every day there was politics. And there were local issues. You had state politics, city politics ... there were quite a few water main breaks in the city, too. There were school issues, lots of budget stuff — again, money money money. And then there were things on the front page that I hadn't the foggiest idea why they were there. These were mostly photographs, sometimes innocuous local or even national stories, about I don't know what — in a sense, those were the hardest pages for me to do. The ones that I didn't have a system for, that I couldn't fit into "Politics as Usual" or the weather or a war —

But the *Times* does a lot of bewildering things like that. "A Day in the Life of the City," people sitting in Central Park. They do. For example: a picture of a woman on a balcony overlooking the Hudson River. Why? I don't know, but it was there, and it somehow needed to be commented on. Sometimes those pictures are about the weather, but often there's no apparent reason for them. You find a few articles on fashion, too. Until I did this piece, just regularly looking at the paper I never saw it in the way I do now.

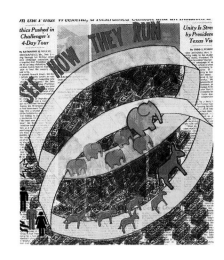

I noticed as the year progressed, politicians began to appear in costumes, like people in a masquerade ball, and also became cartoon characters. Part of that was because I began to get bored doing men in suits. I also got more humorous as the year went on, out of pure desperation to keep it interesting. It was amazing for me to do something for a whole year, with a kind of rigor, dealing with time. I started to wear watches, and I was so aware of time passing, and looking in the mirror, and aging—it affected me on a personal level.

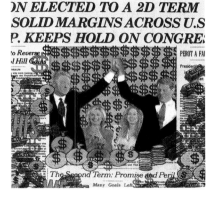

Along with that, did the world according to the *Times* start to come across as this veil of illusion, with Death behind it? I wasn't conscious of it, but I didn't have a life. Mark and I almost broke up about a hundred times. I wasn't here, I was inside the *New York Times*. I wish I could say, "Gary, you've really understood this," but I don't think I intellectualized the work that much, because I was mostly driven by absolute pure panic, that I wasn't going to finish this. As I got further on in the year, I became so panicked that I wasn't going to finish and yet, at the same time, all of the pages seemed to get more and more filled. That happened in my other series of works too; maybe it's a way of saying that if I fill it up more I'm not going to die so soon. It may have been a way to slow up time by just packing the damn things, which took longer to do, even though I had a shorter period to do them in.

After all this, are you pleased with the 366 Front Pages? People seem to like the work because someone finally said out loud, publicly, in the vernacular of the times, exactly what they really think or say in private to friends. People understand my language and images; they're simple, but also culturally funny. We're all living it. I just spoke out and just talked back. It's what we all want to do. People recognize themselves in this process, I'm pleased about that. It's how I want my art to be used and enjoyed.

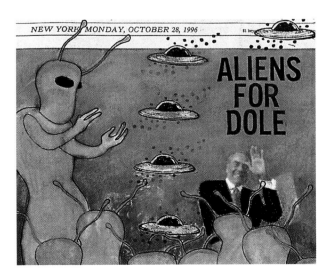

And after spending a whole year with the *Times*, how do you feel about the paper itself? The thing I love about the *Times* is the variety of stuff that appears on the front page. In some funny way, if you read the paper cover to cover, it's a daily map of the world; the front page is a map of what's important that day—or what was important the day before, actually. And that's saying a lot. It's not only economics, it's not only politics, it's not only sports. You get the world, you get the nation, you get the local, you get the extraterrestrial.

January

At first I didn't address all of the articles, because at

the beginning I really didn't have an opinion about everything.

When I started, I knew I wanted to put systems or signs on the paper.

I did break from this, but for the most part the symbols

are clear and consistent: caution bars, a black line around

anyone who died, thin blue diagonal lines in connection

with the police. When women appeared on the front page they

were colored in hot pink. I decided not only to color the pictures

in different ways, but to actually get my thoughts out. . . .

The words were the kinds of words I found myself using a lot

as I read the articles. . . . I found that each month, for me,

had a theme that I discovered early on, so I was able to play on it.

January: "The Big Snowstorm." I always outlined it in red.

And then when the floods came after the storm,

I outlined it in dark blue.

The New York Times

VOL.CXLV.... No. 50,293 Copyright © 1996 The New York Times NEW YORK, MONDAY, JANUARY 1, 1996 $1 beyond the greater New York metropolitan area. 60 CENTS

Late Edition
New York: Today, cloudy, flurries or a drizzle. High 43. Tonight, cloudy. Low 33. Tomorrow, rain, sleet or snow, breezy. High 36. Yesterday, high 43, low 34. Details are on page 28.

Tiny New York Jail Struggling To Cope With Surge in Inmates

Counties Across Nation Housing More Criminals

By MATTHEW PURDY

NORWICH, N.Y., Dec. 27 — The town square in the seat of rural Chenango County is postcard-perfect. A restored old courthouse has a old dome and stately columns. The First Baptist Church is on one side of the square, the United Church of Christ on the other.

At one corner of the square is the tiny red brick County Jail, built in 1902, where once brawlers and drunks and rustlers being led up the wooden steps for a stay in the lockup, where friendly sheriff's deputies played cards with prisoners and kept their keys on a big metal ring.

But today, the reality of the jail on the Norwich square, 45 miles north of Binghamton, is hardly quaint. Its role could be played by thousands of others like it across the country that changed significantly because the thrust this house more hardened criminals.

nals, some for longer periods, in part because there is no room for them in overcrowded state and Federal prisons.

Inside the County Jail are one youth who is accused of shooting at his family and another who is accused of beating up a teacher for $600. There are two Federal prisoners facing drug charges. A recent inmate was an escaped prisoner from New Mexico, wanted in the killing of a teen-age boy.

Frequently, inmates with mental illnesses need to be medicated and restrained, and two years ago at least eight inmates attempted suicide. Guards have found smuggled drugs, and toothbrushes and spoons sharpened into weapons. All that in a jail that holds close to 50 inmates, up from 28 two years ago.

"It's not like Andy and Mayberry," said Vincent Marsenelli, the county's Undersheriff, who has worked there for 25 years. "I kind of miss the good old days of sitting here drinking coffee and having a beer with the inmates when they get out. Those days are gone."

The population in local jails nationwide is now more than 490,000, up from 223,500 in 1983, mirroring the rise in the number of state and Federal prisoners to exceed one million. To alleviate crowding a particular challenge for jails, which traditionally held a low-level of offenders until they made bail, counties have now taken on the characteristics of prisons.

Harder-core inmates, many with drug and mental health problems, are staying in jails longer, often because crowded prisons are overloaded. And harsher penalties for crimes ranging from driving while intoxicated to failure to pay child support are crowding jails. And jails are increasingly facing security problems, from dangerous overcrowding...

Jail Population Continue to Rise

The New York Times

Continued on Page 36, Column 1

BRIDGE OVER TROUBLED WATERS

Associated Press

The main gateway for the American deployment in the peacekeeping mission in Bosnia was opened yesterday across the Sava River from Croatia as a tank from the First Armored Division crossed a pontoon bridge to Orasje. In the background is the bridge that was destroyed in fighting in 1991.

Up at Last, Bridge to Bosnia Is Swaying Gateway for G.I.'s

By IAN FISHER

ORASJE, Bosnia and Herzegovina, Dec. 31 — The first American tanks rolled into Bosnia early this afternoon on a floating ribbon of a bridge across the swift-moving Sava River, marking the end of a problem-plagued engineering project and the real start to the American role in the mission here.

The pontoon bridge, stretching more than 650 yards from Croatia to this small town in northeastern Bosnia, is the narrow, swaying passageway that will carry most of the 20,000 troops in the American contingent into the country. That parade began today in a display of military might

as about 150 tanks, artillery pieces, Humvees and trucks carrying boxes of food and latrines rumbled south across melting snow into the American sector.

The drive to build the bridge, the largest the Army has constructed since World War II, had been hampered for days by flooding, erosion and icy roads that held up supplies. But in the end, it went up quickly and with little ceremony.

The first sections were installed on both banks by 6:30 A.M. Boats steered the final pieces into place at the center of the river, and engineers latched them tight at 10:01 A.M.

Maj. Gen. William L. Nash, the commander of the American sector in Bosnia, took a half-hour celebratory stroll across the slick surface of the pontoon bridge, shaking hands with soldiers in the shadow of another bridge destroyed in fighting in 1991. Later, a Croatian woman in a fur coat offered plum brandy in plastic cups to several soldiers. They declined, though it was New Year's Eve, because this is supposed to be a dry mission.

"We had some battles with Mother Nature and the Sava River but we overcame the challenge," said Capt. Gene Snyman, commander of the 535th Combat Support Element, which helped build the bridge. "I don't think there was ever any doubt we could get over the challenge."

Capt. Robert Fancher, commander of the 502d Assault Bridge Company, whose men worked all night to lay gravel and grade roads, said:

Continued on Page 6, Column 1

2 SIDES IN SENATE DISAGREE ON PLAN TO END FURLOUGHS

NEGOTIATIONS IN RECESS

No Budget Accord or Stopgap Deal, So U.S. Government Is Limping Into 1996

By JERRY GRAY

WASHINGTON, Dec. 31 — A last-ditch effort to bring 260,000 furloughed Federal employees back to work just after New Year's Day failed today when Republicans and Democrats in the Senate rejected back-and-forth proposals from each other.

Senator Bob Dole, the Republican majority leader, and Senator Tom Daschle, leader of the Democratic minority, could not agree on a temporary plan passed by the House on Saturday that would have allowed Federal employees to work without pay until a budget agreement was reached. They said they would resume negotiations when the Senate reconvened on Tuesday.

"We need to end the impasse," Mr. Dole said from the Senate floor. "It's gotten to the point where it's a little ridiculous, as far as this Senator is concerned, so we are going to keep trying."

The Democrats continued to reject the limits the House voted to impose on Senate debate as a condition for sending Federal employees back to work, and the Republicans rejected attempts to replace their plan with a temporary spending resolution that would allow all Government functions to resume — without conditions — until a budget accord was reached.

"On Tuesday, if we can't do anything else," Mr. Dole said, "we may pass whatever it takes on the Senate side."

Mr. Dole and Mr. Daschle came to the Senate floor about an hour after they left budget talks at the White House. Republicans and Democrats, including President Clinton, have spent the last three days negotiating the terms of a plan to balance the Federal budget by 2002.

Each side left today's meeting at the White House saying progress had been made, although neither would provide any details. Senior aides have said that the last three days of talks have been taken up with the two sides laying out their positions on issues like welfare, Social Security and Medicare but that no decisions have been made.

The White House spokesman, Michael D. McCurry, said that when negotiations resumed on Tuesday the political leaders would open discussions on "the trade-offs" on those issues. "The President is ready to discuss the issues in good faith," Mr. McCurry said.

Mr. Clinton, Mr. Dole and Speaker

Continued on Page 11, Column 1

A U.S. Agency, Once Powerful, Is Dead at 108

By DAVID E. SANGER

WASHINGTON, Dec. 29 — There was a time, long forgotten in this city, when few arms of Government instilled more fear, hatred or anger than the Interstate Commerce Commission.

The robber barons of the railroad industry, James P. Morgan and James J. Hill, fumed against its interference in their affairs. Teddy Roosevelt spent much of his first term fighting to expand its once-vast authority, and Oliver Wendell Holmes Jr. and his brethren argued endlessly over the scope of the I.C.C.'s power to dictate to the states. When the lawyers who argued in front of the I.C.C. held a convention in Washington in 1930, Herbert Hoover invited them over to the White House for a picnic on the South Lawn.

For once those glory days have been just a memory. It always stood as one of Washington's halls headquarters near the arrival of the new agency. Its spacious windows to the ... history agency that almost never happens in Washington. It dies at the age of 108.

It was a slow and painful death. Deregulation in 1980 and a half ago stripped the I.C.C. of most of its powers to set transportation rates, except in a few areas when a single railroad holds a firm monopoly. It's a routine a few days ago, clerks were still wheeling tons of paper past the I.C.C.'s towering columns on Constitution Avenue and

Continued on Page 11, Column 1

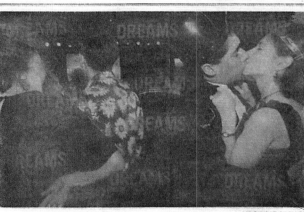

Crello/Reuter for The New York Times

Dancing (and Kissing) In the New Year

Couples hugged and kissed as ballroom dancing took over part of Grand Central Terminal last night. It was part of First Night festivities, which encourage abstaining from alcohol on New Year's Eve. Page 35.

Forbes's Silver Bullet for the Nation's Malaise

By ELIZABETH KOLBERT

COUNCIL BLUFFS, Iowa — In the ballroom of the restaurant 1892, a few dozen Iowa Republicans have gathered over identical entrees to listen to Steve Forbes. The invitation to the dinner, the event ... the cost of the broiled chicken sandwich served with potato chips and iced tea. But the campaign staff has not billed for a contribution, and almost no one in the audience, it seems, has had a no-free lunch.

Mr. Forbes, heir to the famous publishing fortune, is running for President on a platform that promises virtually every American a tax cut. By abolishing the Federal deficit and cutting services. He proposes a flat income tax which, he says, coupled with tough economic growth that will drop tax revenues will actually turn into gain.

In the three months since he announced his candidacy, Mr. Forbes has already spent tens of millions of his own money pushing his version of the flat tax and the effortless prosperity it will generate. In the process, he has confounded political observers and exasperated his opponents.

In polls, he has passed several candidates who have been campaigning for the Presidency for years, and recent surveys in Iowa

Continued on Page 10, Column 1

Fred R. Conrad/The New York Times

Steve Forbes, the Republican Candidate who is advocating a flat tax.

For More and More Job Seekers, An Aging Parent Is a Big Factor

By JUDITH H. DOBRZYNSKI

Just over a year ago, after much soul-searching, Robert W. Crispin turned down a plum job as one of the top three executives of a prestigious company on the West Coast. He decided instead to stay in his job within easy visiting distance of ailing 90-year-old mother in northwest Pennsylvania.

"We tried to live a dozen deal with this," Mr. Crispin said. "We talked about opportunities to travel back to the East. But traveling transcontinental every couple of weeks is not easy, and I was very concerned about how my wife would agonize, and how much she would have to be away from me and my 14-year-old daughter."

The company even offered to move Mr. Crispin's in-laws, but he thought that would be too disruptive.

... the corporations were getting used to a "trailing spouse" — the wife or husband whose career gets in the way of business ... new problem is cropping ... saying of America is starting to create "trailing parents," who pose even bigger relocation hurdles.

Nobody knows the exact extent of the problem. But already an estimated 10 to 12 percent of the work force is responsible for caring for an aging relative, said Andrew Scharlach, a professor at the University of California at Berkeley. By 2020, Mr. Scharlach projects, one in three people will have to provide care for an elderly parent. The Conference Board, a business research group, estimates even more people will be affected — as many as 40 percent before 2000.

With many more elderly parents to care for, more employers will face tough choices in deciding whether to

Continued on Page 44, Column 1

THE CONTENDERS

Seventh article of a series.

and New Hampshire show him in second place.

It is, to be sure, a distant second to Senator Bob Dole; still, he is the only other candidate whose support registers

Continued on Page 10, Column 1

INSIDE

Killed Trying to Save Lives

Fire Lieut. John M. Clancy went into a burning building in Queens yesterday looking for survivors, but met death. He was the fourth firefighter killed on the job in 1995. Page 27.

Questions in Colombia Crash

The Dec. 20 crash of an American Airlines Boeing 757 near Cali, Colombia, which killed 160 people, has confounded pilots and aviation experts like few other air accidents in recent years. Page 3.

Packers and Colts Win

The Green Bay Packers, with their end-zone bugs with fans, defeated the Atlanta Falcons, 37-20, yesterday in the National Football League playoffs. Indianapolis won in San Diego, 35-20. SportsMonday, page 27.

The New York Times

Tokyo's Lights Lure the Young To Forsake Rural Way of Life

DOWN ON THE FARM

FEDERAL IMPASSE SADDLING STATES WITH INDECISION

AMOUNT OF AID IN DOUBT

Not Knowing What to Expect For Medicaid and Welfare Makes Budgets Shaky

The New Year Is a New Story

Variant Gene Tied to a Love Of New Thrills

BUSINESS WORLD
Outlook '96

Pataki's Budget Plan in Brief: Amid Austerity, a Tax Break

Clinton the Conciliator Finds His Line in Sand

A Toll Road in California Offers A High-Tech Answer to Traffic

INSIDE

The New York Times

Senate G.O.P. Votes to Reopen Offices Shut in Budget Impasse

But House Leaders Insist They Will Not Give In

PESKY PUPPIES

JOB CUTS AT AT&T WILL TOTAL 40,000, 13% OF ITS STAFF

BIG LOSSES IN NEW JERSEY

Management Ranks Hit Hard as Phone Giant Gets Ready to Split Into 3 Units

Decisive Victory for Nebraska

Long, Costly Prelude Does Little To Alter Plot of Presidential Race

RECORD EARNINGS, BUT LESS SHARING

Companies Shift on Payrolls to Stockholders and Staff

Bosnian Officials Say Serbs Abducted 16 Near Sarajevo

In an About-Face, U.S. Says Alcohol Has Health Benefits

DRINK TO YOUR HEALTH

What's Yellow and Red and White All Over?

Anti-Immigrant Mood Moves Asians to Organize

Backing Natural Cures

INSIDE

The New York Times

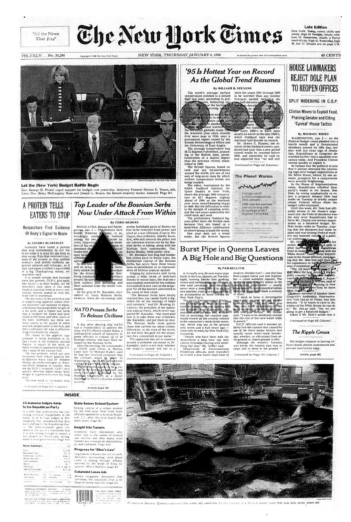

'95 Is Hottest Year on Record As the Global Trend Resumes

HOUSE LAWMAKERS REJECT DOLE PLAN TO REOPEN OFFICES

SPLIT WIDENING IN G.O.P.

Clinton Moves to Exploit Feud, Praising Senator and Citing 'Cynical' House Tactics

Let the [New York] Budget Battle Begin

A PROTEIN TELLS EATERS TO STOP

Researchers Find Evidence Of Body's Signal to Brain

Top Leader of the Bosnian Serbs Now Under Attack From Within

PLANNED OBSOLESCENCE

Burst Pipe in Queens Leaves A Big Hole and Big Questions

NATO Presses Serbs To Release Cicilians

The Planet Warms

INSIDE

The New York Times

Retailers Call Sales in December Worst Since '90-'91 Recession

Weather, Debt and an Excess of Stores Are Cited

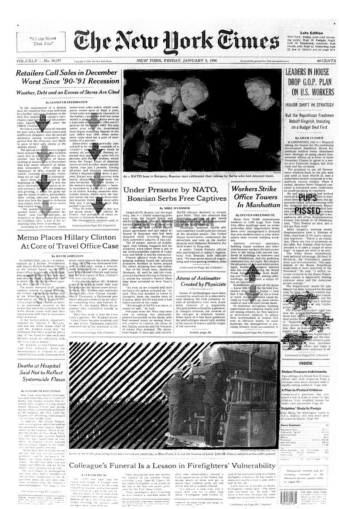

LEADERS IN HOUSE DROP G.O.P. PLAN ON U.S. WORKERS

MAJOR SHIFT IN STRATEGY

But the Republican Freshmen Rebuff Gingrich, Insisting on a Budget Deal First

Under Pressure by NATO, Bosnian Serbs Free Captives

Workers Strike Office Towers In Manhattan

PUPS PISSED

Memo Places Hillary Clinton At Core of Travel Office Case

Atoms of Antimatter Created by Physicists

Death at Hospital Said Not to Reflect Systemwide Flaws

Colleague's Funeral Is a Lesson in Firefighters' Vulnerability

Stolen-Treasure Indictments

A Plan to Protect Children

Dolphins' Shula to Resign

The New York Times

VOL.CXLV ... No. 50,298

NEW YORK, SATURDAY, JANUARY 6, 1996

60 CENTS

Late Edition

CONGRESS VOTES TO RETURN 760,000 TO FEDERAL PAYROLL AND RESUME SOME SERVICES

Republicans' Boomerang

Shutdown Tactics Fly In Faces of Everyone

By MICHAEL WINES

STEP IS TEMPORARY

Clinton Quickly Agrees to a Temporary End to the Shutdown

By ADAM CLYMER

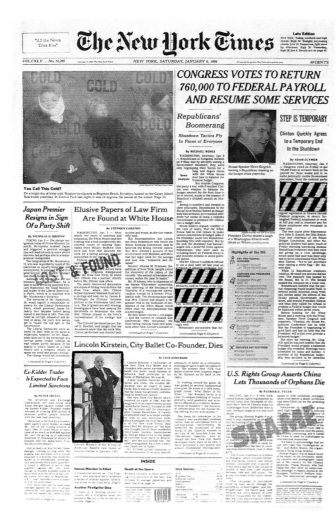

You Call This Cold?

Japan Premier Resigns in Sign Of a Party Shift

By NICHOLAS D. KRISTOF

Elusive Papers of Law Firm Are Found at White House

By STEPHEN LABATON

Ex-Kidder Trader Is Expected to Face Limited Sanctions

By PETER TRUELL

Lincoln Kirstein, City Ballet Co-Founder, Dies

By JACK ANDERSON

U.S. Rights Group Asserts China Lets Thousands of Orphans Die

By PATRICK E. TYLER

INSIDE

The New York Times

VOL.CXLV ... No. 50,299

NEW YORK, SUNDAY, JANUARY 7, 1996

$2.50

Late Edition

Record Freezing Temperatures Hobbling the Northeast Region

Emergency Services Taxed; More Cold Is Forecast

By CAREY GOLDBERG

CLINTON PRESENTS HIS OWN PROPOSAL TO HALT DEFICITS

MEETS A G.O.P. CHALLENGE

Move May Lead to Reopening of All Federal Operations Until Jan. 26 Deadline

By ADAM CLYMER

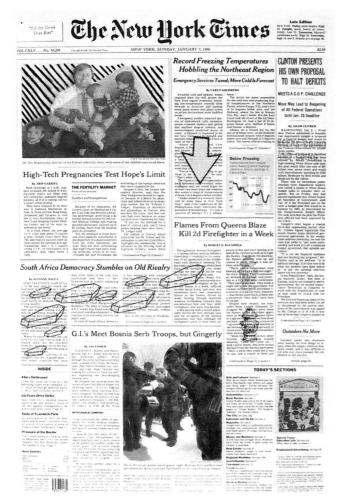

High-Tech Pregnancies Test Hope's Limit

By TRIP GABRIEL

THE FERTILITY MARKET

South Africa Democracy Stumbles on Old Rivalry

By SUZANNE DALEY

Flames From Queens Blaze Kill 2d Firefighter in a Week

By ROBERT D. McFADDEN

G.I.'s Meet Bosnia Serb Troops, but Gingerly

By JAN FISHER

Outsiders No More

TODAY'S SECTIONS

INSIDE

The New York Times

Late Edition
New York: Today, snow ending by
afternoon; strong winds, huge drifts.
High 24. Tonight, windy. Low 19. To-
morrow, clouds. High 34. Yesterday,
high 22, low 12. Details, page 14.

VOL.CXLV., No. 50,300 Copyright © 1996 The New York Times NEW YORK, MONDAY, JANUARY 8, 1996 $1 beyond the greater New York metropolitan area. 60 CENTS

A Chilly G.O.P. Response To Clinton's Budget Plan

Federal Operations, and Squabbling, Resume

By JERRY GRAY

WASHINGTON, Jan. 7 — After President Clinton yielded to Republican demands and submitted a plan late Saturday to balance the Federal budget in seven years, the Republican response today was as chilly as the weather.

The Government, meanwhile, was allowed to resume full operation after the longest shutdown in history.

President Clinton's budget was certified as balanced by the Congressional Budget Office.

That was a condition Congressional leaders had set for allowing the full Federal Government to resume operations for about three weeks, and on Saturday the President signed legislation authorizing an end to the longest Government shutdown in history.

But for the nation's capital, which bore the brunt of the 21-day shutdown of parts of the Government, the huge snowstorm stopped Federal employees from coming to work on Monday. Federal offices here will be closed.

The snowstorm began on Saturday night, as President Clinton was meeting at the White House with the leaders of the Republican majority in Congress — Speaker Newt Gingrich and Senator Bob Dole, — to try to reach an agreement on a plan to balance the Federal budget by 2002.

Mr. Clinton opened the meeting by telling the Republicans that at their urging he had prepared his own seven-year plan.

Today, Republicans said that plan did not cut or do, nearly enough.

"It shows us that Bill Clinton is the big-spending liberal Democrat we always thought he was," Representative John A. Boehner of Ohio, the chairman of the House Republican Conference, said on the CBS News program "Face the Nation." "It doesn't save the solvency of Medicare, it doesn't make the changes in it that will give Medicare recipients the choices they want. It continues welfare as we know it — there's no real welfare reform."

Treasury Secretary Robert E. Rubin said today that the Federal Government would face another fiscal problem about a month from now because of the Republicans' refusal to pass legislation to raise the debt ceiling.

"We originally thought that the early part of February would be a problem," Mr. Rubin said on the NBC News program "Meet the Press." "But because of the unex-

Continued on Page 13, Column 2

Agreement And Illusion

In Budgetary Politics, Many Battles Remain

By ADAM CLYMER

WASHINGTON, Jan. 7 — First the Republicans did what the President wanted and agreed to open some of the Government. Then the President did what the Republicans had been demanding and put a really, truly balanced budget proposal on the negotiating table.

News Analysis

With this instant political harmony, it might seem that any day now the two sides will agree on how to get it all done.

But that appears unlikely, and not just because a blizzard prevented any negotiations today and leaves Monday's talks in some doubt. The Democrats and Republicans are still hundreds of billions of dollars apart on issues like taxes and Medicare. [Page 14]

And those differences slight compared with their divergences on how to change Medicare and on whether medical should remain an entitlement guaranteed to all who are to be turned over to the states.

Beyond that, the Democrats think they have twice won the with political changes in the last year. That confidence can make it harder easier, to agree, especially when Speaker Newt Gingrich had a hard time selling his supporters on the conciliatory step the Republicans took.

The sharpest change in the political dynamics is that Republicans can no longer frame the argument — as they had been doing until Saturday night — as their having shown a commitment to balancing a budget

Continued on Page 14, Column 5

Among Economists, Little Fear on Deficit

Despite the debate in Washington over balancing the budget and eliminating the deficit, few economists at a national meeting of the American Economic Association, held in San Francisco over the weekend, expressed alarm about the deficit as a prob

It was among things about the deficit at these conventions had that remained was the less Government spending with a different rationale, one that focuses economic theory on health-care costs. That rationale is gradually becoming the economic framework for the political debate in Washington over a balanced budget.

Article, page 13.

Egg Donations Meet a Need And Raise Ethical Questions

By JAN HOFFMAN

WALTHAM, Mass — Dana G., a 23-year-old nurse with three children of her own, may be genetically related to one, two or perhaps three other children. She will probably never know.

That is because Dana donated her eggs anonymously through IVF America in Boston, a fertility clinic here, and through another clinic nearby. Each time, she was paid $1,500 for undergoing extensive screening, three weeks of hormone injections and outpatient surgery to retrieve her eggs. They were then mixed with sperm in a petri dish and implanted in the uterus of an infertile woman.

The money was the least of it, she said. Haunted by a sister's time-year

THE FERTILITY MARKET

Second of four articles

Buying Eggs

struggle with infertility, Dana realized that her eggs, which would be lost through menstruation every month, did not have to go to waste.

"I don't feel like I'm giving someone a child, but a chance at a child," she said. Then she laughed self-consciously, but blue eyes crinkling, tugs that told the recipient that I have really dry skin."

Receiving eggs from donors like Dana has become an increasingly sought-after and available option for thousands of women who cannot conceive on their own. In 1993, the last year for which the American Society for Reproductive Medicine has statistics, 135 fertility clinics were offering to retrieve eggs from donors and give them to other women, up from 26 clinics in 1988. About 80 percent of the donors were anonymous, the others were relatives or friends of the women who received the eggs.

Although the first egg donor babies were born in the mid-1980's, it was not until about five years ago, when the technique was simplified, that egg donation began to take off. Of the 2,500 babies born from donated eggs through 1993, 1,000 were conceived just in that year. Individual clinics report that their numbers have continued to climb, particularly as patients discover that the success rate of this procedure can be about 36 percent.

But more than any other area of reproductive technology, egg donation raises an array of ethical concerns: whether donors are victimized, whether clinics give recipients truthful information about the donors, whether the whole process has become too commercial. The fees paid donors are rising as desperate donor's bones critics are troubled at what they see as the crassness of the advertisements run by clinics and by

Continued on Page 17, Column 1

Coastal Blizzard Paralyzes New York and Northeast

WIPE OUT

CENTRAL PARK The snow-clad canopy of trees looked pretty, but bitter winds didn't encourage visitors to linger.

WASHINGTON The steps of the United States Capitol provided a makeshift bobsled run for an intrepid teen-ager.

UPPER WEST SIDE On her way to dinner, a woman inches across Broadway.

Wind and Snow Virtually Halt Travel

By ROBERT D. McFADDEN

A monstrous, crippling blizzard that experts said would make history attacked the New York metropolitan region and much of the East yesterday with blinding snow that was expected to become more than two feet deep before ending today. It disrupted travel, commerce and life for millions.

The classic Northeaster — from satellites a swirling comma hundreds of miles across — barreled up the Atlantic Seaboard and its energy boosted by heated coastal cities. By the dawn it was expected to leave New York, Washington, Baltimore, Philadelphia, New Haven, Boston and other areas snowbound and virtually paralyzed.

By late yesterday, thousands of travelers were stranded at airports, bus terminals and highway rest stops as most long-distance transportation came to a halt, though trains were still running. With the snow continuing this morning's commuters appeared to be a horror story. In the Northeast Corridor, Amtrak officials were suggesting mass transit as the only salvation.

The accumulating blizzard was a whiteout wherever, accumulations totaling 30 inches in Philadelphia, and earlier in the evening, Madison County, Va., had recorded 25 inches and Washington, 19 inches. In the New York region, where the snow started at 11 P.M. there were 16 inches at La Guardia Airport, 18 inches at Newark, 25 inches at Elizabeth, N.J., 21 inches in Jersey City, 13 inches in Milford Conn., as of 11 P.M. And it was still coming down.

"For the times from Washington to Boston this is going to be the greatest storm we've had since careful records began 125 years ago," said Fred Gadomski, a meteorologist at Penn State University. "There have been other storms with higher ... more snow in other areas ... focus on snow and has ... the highly populated areas."

By ... the National ... al Weather ... was calling it one of the ... storms of the cen...

With the snow on the ground in Central Park by 11 P.M. and more falling at the rate of 2 inches an hour, the service said accumulations by midday today could top the Central Park record of 28.4 inches set on Dec. 26-27, 1947. It was easily expected to top the famous blizzard of 1888, the second-largest snowstorm, which left 21 inches and caused $25 million in property damage.

While streets across the metropolitan area were all but deserted in the storm, many grocery and retail businesses were open and thousands of shoppers thronged to city and suburban stores to stock up on groceries, batteries, fuel and other necessities for what was expected to be a snowed-in day today. Supermarkets

Continued on Page 30, Column 1

With the Blizzard, A Bit of Good Luck

Last month, the Potamkin Automotive Center thought it had a great sales pitch: if it snowed more than four inches on Jan. 8, anyone who leased a car between Dec. 13 and Jan. 2 would get the vehicle for free.

With snow blanketing the city yesterday, phones started ringing at Potamkin with leaseholders questioning the offer's fine print.

Reporter's Notebook, page 24.

To accommodate production and delivery requirements in the snow emergency, The Times is printed today in two sections. SportsMonday begins on page 43, Business Day on page 33.

INSIDE

Bias in Legal Profession

An American Bar Association report found that despite surging numbers of female lawyers, bias against women in the legal profession is entrenched in the legal profession. Page 9

Vallone's Plan for Schools

Challenging Mayor Giuliani, the Council Speaker, Peter F. Vallone, has proposed a $1.4 billion plan to rebuild New York City schools to confront overcrowding. Page 29

Colts Upset Chiefs

Indianapolis upset Kansas City, the league's top team, by 10-7. Earlier, Dallas was a 30-11 winner over Philadelphia. SportsMonday, page 43.

Foreign Policy Politics

Aides to President Clinton see three issues — Bosnia, Haiti and Russian elections — that could deeply embarrass him in an election year. Page 1

Whiteout Forces Shutdown Of Schools, Harbor and U.N.

By PAM BELLUCK

Children were falling asleep atop their parents' luggage carts at La Guardia Airport last night as hundreds of snow-stranded passengers hunkered down for the night in the terminal.

Students and teachers in New York City schools knew before they went to bed that they would be staying home today, the first time since 1978 that a snow day had been declared.

By little schedules had become ... themselves, and five of the ... on the Long Island Rail Road ... closed. (Page 31.)

"I don't think there will be a morning rush hour," said Michael Charles, an L.I.R.R. spokesman. "I don't think there will be an evening rush hour, either."

As the blizzard moved across the metropolitan area, the Coast Guard closed New York Harbor to shipping, the United Nations shut for a day and frantic shoppers were blocking

grocery and hardware stores empty of meat, milk, bread, fireplace logs and toilet paper.

"It's unreal!" Tom Thousania sputtered at the ... supermarket in Leonia, N.J. ... customers waited in ... lines that wrapped around ... entire interior of the store ... and grabbed an end of ... hamburger ... cleared ... car's ...

In Great Neck ... Victoria Gee's hands clutched ... steering wheel, with her face pressed close to the windshield as she strained amid the spitting snow to see the yellow line on Northern Boulevard. "I am never afraid to drive, but today I was terrified," Ms Gee said. "I was just going through red and yellow lights because as soon as I touched the brake, the car would start swerving. It was so windy the snow was blowing, I

Continued on Page 31, Column 1

"All the News
That Fits"

The New York Times

Late Edition
New York: Today, increasing clouds, breezy. High 34. Tonight, flurries. Low 24. Tomorrow, partly cloudy, windy, colder. High 30. Yesterday, high 23, low 16. Details are on page 37.

VOL.CXLV.. No. 50,301 Copyright © 1996 The New York Times NEW YORK, TUESDAY, JANUARY 9, 1996 $1 beyond the greater New York metropolitan area. 60 CENTS

NEW YORK SHUT BY WORST STORM IN 48 YEARS; EAST IS BURIED, VIRGINIA TO MASSACHUSETTS

DOZENS ARE DEAD

Emergencies Declared in 8 States as Storm Strands Travelers

By ROBERT D. McFADDEN

The historic Blizzard of '96 broke off its ghostly assault on the citadels and hamlets of the Northeast yesterday, leaving behind a New York metropolitan region and 10 states, home to more than 63 million people, buried and paralyzed under 18 inches to three or more feet of snow.

It was not the worst snowstorm on record in New York City, where a 1947 blow left inches in Central Park, though ranked third, with 20.2 inches of It dropped 27.5 inches on Staten Island, the hardest-hit the region's rank seemed, on a... on all killed with super... its awe... over.

"It looks this storm everything... through, could very well be one of top three storms on record," said Frank Nocera, a National Weather Service forecaster.

As the storm... to oblivion in the North... and accumulations totaled ... La Guardia Airport, ... 3.7 in Brooklyn ... Shore, L.I.

In Jersey ... 27.6 inches ... Elizabeth 26.5, and ... City 29.4. In Connecticut, ... 5 inches, Danbury 21 and New ... 16. Philadelphia had 30.7, Baltimore 23, St... ah, Va., 37 and Pocahontas ... had 40 to ... ches.

Dozens ... deaths... to the ... luding a 7... old man ... suffered a heart attack while ... ing snow in Waterbury, Conn., who ... ly suffered a heart at ... ing a snow blower. ... 7-year-old man in ... a 54-year-old man in ... art attacks. Both had been cle... ing ...

In Manhattan, ... unidentified man was found dead in the snow, according to Metropolitan Hospital, though it was not clear how ... died. A 5-year-old Staten Island ... was critically injured when ... father accidentally ran over ... a snow blower.

At Jacobs Hospital in the Bronx, 19 people were treated for carbon monoxide poisoning after they sat in their cars with the engines running to keep warm, apparently with the tailpipes stuck in the snow. As of midnight, one man was in a coma.

By evening, after two days of blinding, wind-driven snowfalls that set records in many locales and brought travel, education, business, government operations and ordinary life to a standstill, the landscape from Virginia to Massachusetts was like a tintype of Whittier's snowbound America: drifted, silent, beautiful.

Continued on Page 34, Column 2

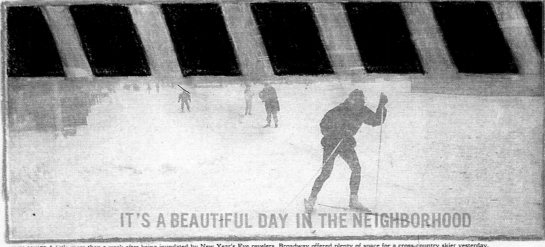

IT'S A BEAUTIFUL DAY IN THE NEIGHBORHOOD

TIMES SQUARE A little more than a week after being inundated by New Year's Eve revelers, Broadway offered plenty of space for a cross-country skier yesterday.

Infertile Couples Forge Ties Within Society of Their Own

By FELICIA R. LEE

Michael Plaut answered the telephone in his home in Scarsdale, N.Y., hungry for information that he and his wife, Stephanie, needed if they were to get on with their lives. The call confirmed his worst fear: the pregnancy test was negative.

The Plauts sobbed, held each other and then had a glass of Scotch.

"It's like we're in a period of mourning," Mrs. Plaut said. "You just get to the point where you want this to be over."

For three years, the Plauts have tried to have a baby. She is 33 and he is 34. Two years ago they learned that they fit the medical definition of infertile. They had failed to conceive after a year of trying. And, despite countless tests, no one can tell them why.

The in vitro fertilization clinic at New York University Medical Center was to be the last stop in the Plauts' quest for a biological family. In November, doctors there extracted 23 eggs from Mrs. Plaut's ovaries and mixed them with her husband's sperm in the laboratory, then transferred four embryos to her uterus.

The day the embryos were implanted, the couple glowed despite the chill in the New York air, hoping the procedure would make them parents. The dream was dashed with the telephone call.

The Plauts are among the 4.9 million couples in the United States afflicted with infertility. And just like other special interest groups that

THE FERTILITY MARKET
Support and Solace

Third of four articles.

seek rights and emotional sustenance, infertile people increasingly band together, in therapy sessions and in organizations like Resolve, a nationwide support group with local chapters. Like soldiers in combat, they forge close friendships in the charged atmosphere of infertility clinics, where procreation is the battle.

Theirs is a culture in which people speak the same language about medical techniques, insurance plans, the reputation of doctors and clinics. They know how lives are postponed because of the emotional stress of infertility and the imbalance of not knowing whether it will be just the two of them next year or a family, at long last. They discuss what to tell those longed-for children about how they were conceived.

For couples like the Plauts, the focus of their lives has become achieving pregnancy. It has strained friendships, finances and their own relationship at times. Mr. Plaut said he felt guilty because his wife was the one taking drugs and undergoing surgery. Mrs. Plaut said there was a time she felt fury at every pregnant woman she saw on the street.

Both said they envied their preg-

Continued on Page 19, Column 1

François Mitterrand Dies at 79; Champion of a Unified Europe

By CRAIG R. WHITNEY

PARIS, Jan. 8 — François Mitterrand, who revered France's socialist Party into a modern political force and whose election as President ended a decade of Gaullist rule died this morning in his official residence here of prostate cancer. He was 79.

"It is a great figure who has left us, and I salute him with emotion and with respect," said President Jacques Chirac, a conservative Gaullist and longtime political adversary of Mr. Mitterrand, who succeeded him last May.

Mr. Mitterrand will be buried at a private funeral Thursday morning in Jarnac, the southwestern French village where he was born. A public Mass will be celebrated for him at the same time at Notre Dame Cathedral in Paris. Friends said Mr. Mitterrand did not want a state funeral, but Mr. Chirac declared Thursday a day of national mourning and ordered flags to be flown at half staff.

As President, Mr. Mitterrand embraced the cause of European unity as the historical legacy he evidently sought in this crusade progression. To the political side of his youth. For most of his political career, Mr. Mit...

Mitterrand kept hidden his service in the wartime collaborationist rule of Marshal Philippe Pétain at Vichy, emphasizing instead his work with the Resistance, which he joined only at the end of 1942.

It was only in the twilight of his life, after one of his most moving...

François Mitterrand

Continued on Page 9, Column 1

OSSINING, N.Y. Headed to work, a commuter waded through two feet of snow at the railroad station.

For Commuters, It Was Not-So-Mass Transit

By RICHARD PÉREZ-PEÑA

The deepest snowfall that most commuters have ever seen crippled mass transit throughout the New York metro ... yesterday, leaving ... neighborhoods without ... ting thousands ... ed to get to work ... said they hoped ... me improve...

Metro ... Rail Road and ... ransit were barely able to muster any service in the face of the blizzard, and many of the electric trains that ran broke down — some for as long as four hours — and had to be pushed for miles by diesel engines.

Service on the elevated subway lines in southern Brooklyn and

Queens was completely knocked out, and for a time, not a bus was running on the city's streets.

Last night, Metro-North officials said they were planning to provide hourly service on the New Haven and Hudson lines. They should be hourly ... east of Jamaica ... Jefferson, ... lyn ... Montauk ... on the other line ... en Jamaica and ... Station, were expected to remain suspended.

New Jersey Transit trains were expected to be running on a Saturday schedule this morning, and bus service was expected to resume early this morning.

But Joseph R. Hofmann, the Transit Authority senior vice president

for subways, said: "I'm not making any promises about tomorrow. I've been here 27 years, and this is beyond anything we've had."

The saving grace yesterday was that most people heeded advice to stay home ... ce the snow and ... road switches, ... ns' brakes an ... and highways ... On the Long ... cials estimated ... ip at about 1,000, co ... early normal rush-hour load of nearly 196,000.

Those who insisted on making their way to work, particularly on the commuter railroads, seemed, one and all, to come away with epic horror stories about stalled trains

Continued on Page 39, Column 4

The Call of Duty Is Heard Clearly In Howl of Storm

By JANNY SCOTT

Dr. Guy Shochat spent an hour and a half yesterday morning trying to dig his car out of the snow before giving up and cross-country skiing across Prospect Park and through Flatbush to his job in the emergency room at Kings County Hospital Center in Brooklyn.

Daniel Jackson, an ambulance driver for a company based in the South Bronx, found himself filling in for an absent dispatcher — and logging 62 straight hours in sandwiches, coffee and no sleep when reinforcements failed to show up.

And John Anastasopoulos, the owner of the Forum Diner on Route 4 West in Paramus, N.J., spent a good part of his day substituting for a missing cook and washing dishes while an exhausted dish washer took a nap.

"What else can I do?" Mr. Anastasopoulos said. "I'm feeding the plowers and the police today. When they come to the door and ask, 'You open?' and I say, 'Yes, they look so happy, it's worth it."

Throughout New York City and the region, men and women trudged to work in hospitals, ambulance departments and supermarkets,

Continued on Page 39, Column 1

INSIDE

Lockheed Martin Reaches $10 Billion Deal With Loral

Lockheed Martin, still struggling to digest a merger from 1994, plans to acquire most of the Loral Corporation in a complex $10 billion deal that accelerates the consolidation of the military-contracting industry. The move is likely to lead to more layoffs. Page 47

Indecency Ban Upheld

The Supreme Court rejected a challenge to a Federal law banning indecent radio and television programming to certain hours. Page 15

China Denies Orphan Abuse

Officials conceded that about one-fifth of the children in a Shanghai orphanage died in 1989, but denied deliberate mistreatment. Page 3

Flat Tax to the Fore

The flat tax, an appealingly simple proposal for restructuring the Federal income tax system, is poised to become a prominent issue in the Presidential campaign. Page 7

To accommodate production and delivery requirements of the snow emergency, The Times is printed today in two sections. Science Times begins on page 11, Business Day on page 46, TV listings are on page 52.

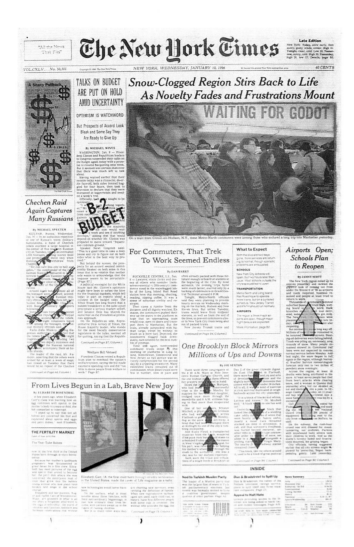

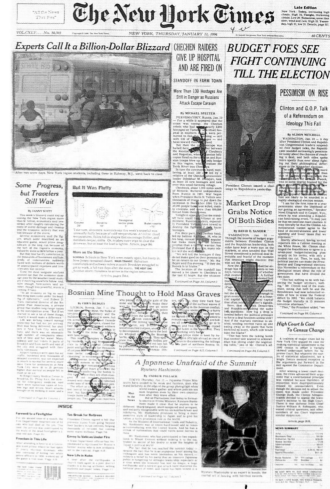

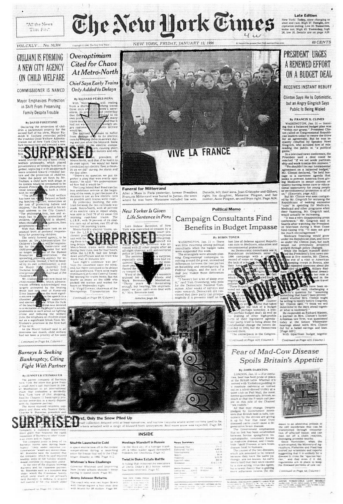

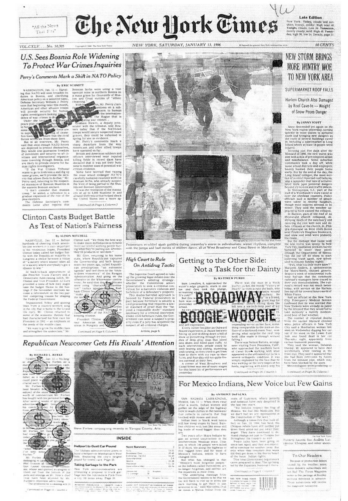

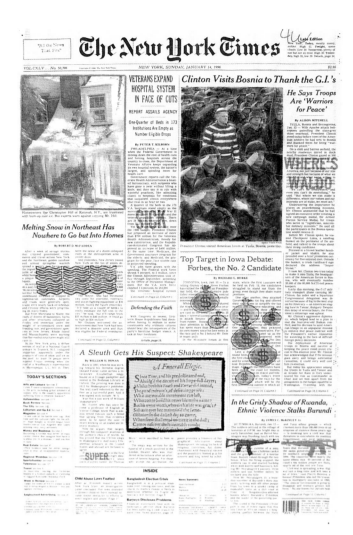
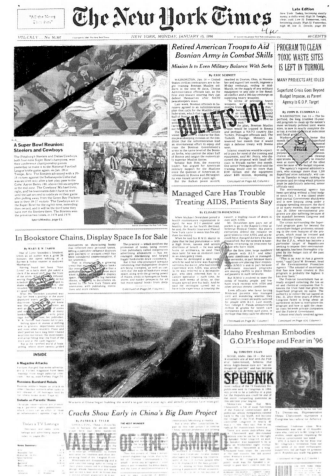
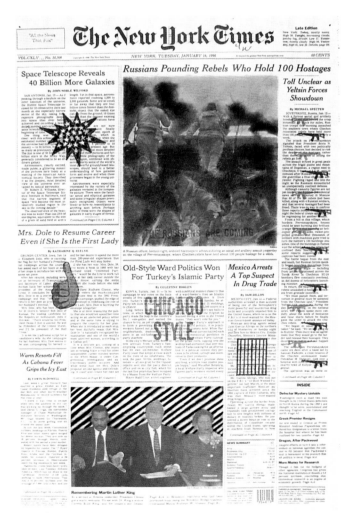
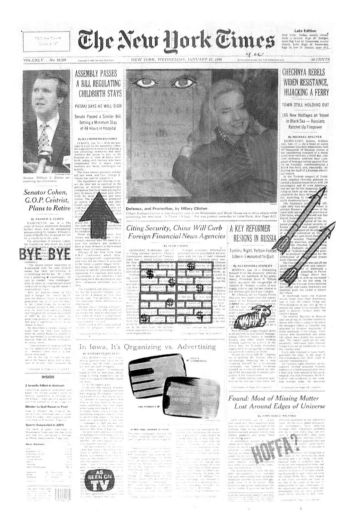

The New York Times

Late Edition

New York: Today, low clouds, dense
fog, showers. High 49. Tonight, foggy.
Low 43. Tomorrow, areas of fog, rain
arriving late. High 49. Yesterday,
high 45, low 33. Details, page D21.

VOL.CXLV... No. 50,310 Copyright © 1996 The New York Times NEW YORK, THURSDAY, JANUARY 18, 1996 $1 beyond the greater New York metropolitan area 60 CENTS

Russian troops fought for two days to free hostages held in Pervomayskoye. Yesterday they razed the village.

SHEIK SENTENCED TO LIFE IN PRISON IN BOMBING PLOT

LONG TERMS FOR OTHERS

Killer of Kahane Also Gets Life for Murder Viewed as Start of a 'War' of Terrorism

By JOSEPH P. FRIED

Despite a defiant declaration of his innocence, Sheik Omar Abdel Rahman was sentenced yesterday to life in prison for plotting a series of bombings and assassinations that prosecutors said was intended to force the United States to end its support for the Governments of Israel and Egypt.

The blind, 57-year-old cleric, who brought the fiery passions of his fundamentalist cause to America, heard his sentence imposed after he delivered an angry 100-minute speech in which he castigated the United States as an "enemy of Islam" and cast himself as a victim of an "unlawful trial."

"It is not only an attack on Muslims alone, but it is an attack on the words of God," he said of his conviction and sentence. He later added, "I have not committed any crime except telling people about Islam."

But Judge Michael B. Mukasey of Federal District Court in Manhattan, who also sentenced Mr. Abdel Rahman's nine co-defendants to prison terms ranging from 25 years to life, said his pleas could "seriously mislead the public."

"You were convicted of directing others to perform acts which, if accomplished, would have resulted in the murder of hundreds if not thousands of people," the judge said in a packed, heavily guarded courtroom.

The bombs that Mr. Abdel Rahman and the others had planned to detonate, Judge Mukasey said, would have caused destruction on a scale "not seen since the Civil War" and would have made the related 1993 bombing of the World Trade Center "seem insignificant."

In addition to the life term for Mr. Abdel Rahman, Judge Mukasey imposed a life sentence on El Sayyid A. Nosair, who was convicted of murdering Rabbi Meir Kahane at a Manhattan hotel in 1990 — a crime that prosecutors said marked the begin-

Continued on Page B4, Column 1

BUDGET STANDOFF DEEPENS AS G.O.P. CALLS OFF TALKS

CLINTON IS PRESSED

Congressional Leaders Say President Must Show Flexibility

By ALISON MITCHELL

WASHINGTON, Jan. 17 — The Republican leaders of Congress today abruptly called off budget talks that had been set to take place at the White House and said they would not resume them until President Clinton produced another proposal that moved in their direction.

Representative John Kasich, head of the Budget Committee, after a meeting on negotiations.

The move comes and the President intimated over how to balance the Federal budget yet reluctant to decide a compromise instractable.

The Republican calls after they met for two hours this morning and had a 40-minute telephone conversation with the President.

In a joint statement, the Republican leaders said they would sit down again with Mr. Clinton "once he proposed a firm budget offer that moves in the direction" of their own proposals for erasing the Federal deficit in seven years.

But Michael McCurry, the White House press secretary, said the President had already been flexible. He accused the Republicans of making escalating demands the price for negotiating.

"If they want to arrive at another compromise, we'll do no good." Mr. McCurry said in this negotiation where they're deeply into the details of an agreement, and frankly it would be a step backwards at this point if they were doing that type of an exchange," he said.

Speaker Newt Gingrich, Senator Bob Dole, the majority leader, and Dick Armey, the House majority leader, released a statement. Mr. Clinton tonight said that numbers and in some cases policy questions.

"The budget debate is an exercise in arithmetic that requires critical judgment," they wrote.

With no signs of agreement, the budget impasse now looks likely to provide a highly partisan backdrop for Mr. Clinton's State of the Union Message to the Congress on Tuesday, and it has complicated his efforts to create a budget proposal for the 1997 fiscal year, which is due on Feb. 5.

The two sides have yet to establish how they will avert a third partial Government shutdown when the temporary spending measure that is keeping many Federal agencies op-

Continued on Page B8, Column 1

Trade Organization Rules Against U.S.

The World Trade Organization ruled that a key section of the Clean Air Act discriminated against foreign oil refiners and ordered the United States to develop a plan to change its rules on imported gasoline or face trade sanctions. It was the first major ruling by the body, which acts as the international arbiter of trade. The decision involved a complaint filed by Brazil and Venezuela on the Clean Air Act's standards for "reformulated" gasoline.

The ruling's consequences were unclear, but the political significance of the ruling may overshadow its environmental impact. Republican candidates for President, led by Senator Bob Dole, have criticized the organization's power, warning that it would allow foreign judges to rule on American environmental laws. The Administration has not said if it will appeal the ruling.

Article, page D1.

INSIDE

More Signs of Slowdown; Trade Deficit Declines

Two new reports provided more indications that the economy's rate of growth is slowing. Meanwhile, the nation's trade deficit eased in October, falling to its lowest level in 19 months. Page D4.

Hearing for All-Male College

The Virginia Military Institute defended its program for men only to the Supreme Court, but the Justices seemed skeptical. Page A13.

Compensating Rail Riders

Metro-North and the L.I.R.R. will give commuters free rides to make up for service suspended or bungled in the blizzard. Page B1.

Corruption and Confusion

Indictments in a new corruption inquiry leaves Chicago politicians uncertain how to act. Page A16.

Life in Space? 2 New Planets Raise Thoughts

By JOHN NOBLE WILFORD

SAN ANTONIO, Jan. 17 — In a stunning discovery of new worlds far out in the universe, two California astronomers today announced the discovery of two planets orbiting Sun-like stars.

WHO KNEW?

producing extraterrestrial life.

The two newly discovered extra-solar planets, considerably larger than Jupiter, accompany the stars 70 Virginis, in the constellation Virgo, and 47 Ursae Majoris, in the Big Dipper, or Ursa Major. They are 35 light-years away, relatively close by cosmic standards. They are too small and dim to be seen against the glare of their parent stars, but their gravitational presence has been definitely established.

The discovery of the planets, together with another one found last October, encouraged scientists in their growing belief that the solar system is anything but unique and that other planetary systems may be fairly common. This, in turn, was seen as raising the likelihood that life exists elsewhere in the universe, perhaps even intelligent life.

The announcement, made here at a meeting of the American Astronomical Society, followed two other startling findings made public this week at the gathering — an increase

Continued on Page B7, Column 1

Saying Hostages Are Dead, Russians Level Rebel Town

By MICHAEL SPECTER

KEMSI-YURT, Russia, Jan. 17 — Conceding that they had failed in their attempt to rescue scores of hostages from the command of Chechen rebels in the village of Pervomayskoye, the Russian Army withdrew its forces from the ground and began flattening the hamlet with unrelenting missiles.

Faced with the growing embarrassment of a two-week siege here — and one that has spawned a humiliating new war over the secessionist region of Chechnya — President Boris N. Yeltsin evidently decided that after several days of a fierce battle the ground assault to rescue the sheer immensity of his military artillery power to demolish the stubborn rebels.

"The operation will end," said a spokesman for the Russian Security Service, Aleksandr Mikhailov. "We believe the hostages are dead. And now we will destroy the bandits."

[Some Chechens reported gunfire broke out before dawn at 2 A.M. Thursday and that the Russian attack on the village continued. Russian troops refused to give any numbers by name, said up to 300 Chechens had also crossed the border from Chechnya into a schoolhouse in Sovetskoye, about a mile from Pervomayskoye, the report was confirmed by a district official from Dagestan, the local republic. When Russian troops moved on Sovetskoye, scores of residents fled, and the military situation be-

came even more chaotic.]

The aerial bombardment of Pervomayskoye may prove to be the beginning in a new phase of the war in Chechnya, where the Russians have vowed any pretense of negotiating with the rebels.

Coming a day after Chechen hijackers took 200 hostages on a Turkish ferry full of Russians and demanded the release of their comrades in Pervomayskoye, the bombing made it clear that Mr. Yeltsin has decided that he is not acceding to more of their demands.

The commandos have continued on a slow course today toward Istanbul, according to news agency reports monitored here. The hijackers have given conflicting signals of their intentions, threatening at one

Continued on Page A8, Column 1

Barbara Jordan Dies at 59; Her Voice Stirred the Nation

By FRANCIS X. CLINES

WASHINGTON, Jan. 17 — Barbara Jordan, the black Congresswoman and scholar who stirred the nation with her Churchillian denunciation of the Watergate abuses of President Richard M. Nixon, died today in her home state of Texas at the age of 59.

Afflicted with multiple sclerosis, Ms. Jordan died from viral pneumonia as a complication of leukemia, according to officials of the University of Texas in Austin, where she taught.

Ms. Jordan, the first black elected to Congress from Texas after Reconstruction, retired from the House in 1979 after three terms to teach public policy ethics at the university's Lyndon B. Johnson School of Public Affairs, never losing her potent talent for public speaking even from the confines of a wheelchair.

Most recently, her rich, impassioned voice was heard once more as Congress went, as chairwoman of the Commission on Immigration Reform, she spoke out last year against a proposal to deny automatic citizenship to the children of illegal immigrants born in this country. "To deny birthright citizenship would derail this engine of American liberty," she warned with the same eloquence that mesmerized her America as an audience in July 25, 1974, when Representative Jordan argued for the impeachment of President Nixon.

Ms. Jordan, whose last statements reminded us never being without a copy of the Constitution in her purse, insisted that Watergate speech in her faith in the Constitution's promise and in her personal history as a child of the Jim Crow South.

"I felt somehow for many years

Continued on Page B11, Column 1

Barbara Jordan

Sentence: Life in Prison

Sheik Omar Abdel Rahman

An Egyptian fundamentalist leader. Convicted of conspiracy for his role in assassination and bombing plots in the United States.

El Sayyid A. Nosair

Convicted of conspiracy in the murder of Rabbi Meir Kahane, the Zionist militant, and of assault on two others at the Kahane shooting site.

Others Sentenced

Eight others received prison terms. Prosecutors said the group planned to bomb several high-profile targets, including the United Nations.

| IBRAHIM A. ELGABROWNY |
| VICTOR ALVAREZ |
| CLEMENT HAMPTON |
| AMIR ABDELGANI |
| FARES KHALLAFALLA |
| MOHAMMED SALEH |
| FADIL ABDELGANI |
| TARIG ELHASSAN |

It's Been an Uphill Battle to Sell Windows 95

By STEVE LOHR

As the editor of the newsletter Release 1.0, head of the industry conference PC Forum and chairwoman of the Electronic Frontier Foundation, a public policy group, Esther Dyson is one of computing's elite observers. But she had long resisted buying Microsoft's Windows 95 even as it went on sale last August. Ms. Dyson was no obvious choice to appear on the PBS talk show "Charlie Rose," offering her expert commentary on a new product announcement that stirred such marketing extravagance and such social phenomenon.

HTTP://WWW.OH.NO.MRBILL

Yet months later, Ms. Dyson has not yet bought the Windows 95 program. For now, she says, she is content to do her computing with the previous versions of Windows run by her personal computer.

"I don't really need Windows 95," Ms. Dyson said.

Many rank-and-file computer users have come to the same conclusion as Ms. Dyson, the diagnosis tendency. Five months after introducing Windows 95 in the biggest consumer marketing blitz ever in the computer industry, the Microsoft Corporation has found that selling information technology as a mass-market retail product remains an uphill struggle. Not only have some major retailers scaled back their software companies are complaining that the gamble that a new consumer market for various hardware add-ons and software upgrade packages, Microsoft itself has not fared little, if at all.

Retail sales of Windows 95, which depended on buyers being willing to install the software themselves and often, to consider their PC's to accommodate it, have fallen far short of last summer's earlier projections, have begun so big. In accounting terms, spurred by Microsoft's $200 million spending spree on everything

Continued on Page D9, Column 1

The New York Times

"All the News That Fits"

VOL.CXLV . . . No. 50,311 Copyright © 1996 The New York Times NEW YORK, FRIDAY, JANUARY 19, 1996 $1 beyond the greater New York metropolitan area 60 CENTS

Late Edition

New York: Today, rain developing, some heavy, fog. High 47. Tonight, rain ends, much colder. Low 30. Tomorrow, sunny, cold. High 39. Yesterday, high 52, low 33. Details, page B6.

RUSSIANS CAPTURE CAUCASUS VILLAGE; SOME FOES ESCAPE

CHECHEN REBELS OUSTED

Casualty Toll Is Still Unclear After Wild Night Battle — Many Hostages Freed

By MICHAEL SPECTER

KEMSI-YURT, Russia, Jan. 18 — After a wild battle that raged through the night and left bodies scattered from the buildings and the plains around this tiny village, a group of Chechen rebels who had been surrounded by Russian troops...

KILLING FIELDS

Russian troops stood near the bodies of Chechen fighters yesterday after the fight for Pervomayskoye ended.

In Uneasy Time, Saudi Prince Provides a Hope of Stability

By DOUGLAS JEHL

RIYADH, Saudi Arabia, Jan. 18 — Every Tuesday they come, petitioners by the hundreds — bearded sheiks, tribal elders, impoverished Saudis and some of the country's elite — to seek out the man who is poised to become the next king.

With burning incense, vast carpets and crystal chandeliers, the night-time gathering is unquestionably a royal affair. But as even the humblest visitors step forward, each is allowed a moment to make his case face to face.

At a time when living standards are falling and religious militancy is on the rise, these are uneasy days for Saudi Arabia, whose 74-year-old ruler, King Fahd, suffered a stroke in November and has transferred power to his half-brother.

But tribal traditions like the weekly councils remain an important cohesive force in the conservative kingdom. And many Saudis have come to regard the heir, Crown Prince Abdullah, as a leader whose careful attention to the rite and to public concerns may be a sign of his capacity to head off trouble.

Continued on Page A10, Column 1

No Benefit Is Found From Beta Carotene

A vitamin supplement taken by millions of Americans in hope of avoiding cancer or heart disease has fallen short under rigorous scientific examination.

Two large studies found that the substance, beta carotene, which is converted into vitamin A in the body, provided no benefits. One of the studies suggested that it might be harmful for some people. That study, which involved people at high risk of lung cancer because they smoked or worked with asbestos, was halted early, partly because of an increase in deaths from lung cancer and heart disease among those who took the supplements, compared with those who took dummy pills.

With no magic bullet available to avoid disease, health experts suggested that the best approach is a low-fat diet with plenty of fruits and vegetables, and said they hoped the study would spell the end of the beta carotene fad.

Article, page A16.

Giuliani Fights For Alternative On Arbitration

Albany Embraces Plan Advocated by Unions

By JAMES DAO

ALBANY, Jan. 18 — A bill to change the way New York City settles police and fire contract disputes, which Mayor Rudolph W. Giuliani contends would significantly increase the city's labor costs, is on a fast track to approval in the State Legislature over the end of the month.

Alerted to the rapid progress of the bill, and convinced that the legislation cannot be stopped, Mr. Giuliani and his aides have begun furiously lobbying legislative leaders to consider an alternative. They succeeded today in convincing the Assembly Speaker, Sheldon Silver, to delay passage for at least one week.

But the bill, a version of which breezed through the Legislature last year only to be vetoed by Mr. Pataki in November, is virtually certain to pass in both houses once it is released for a floor vote. The Republican-controlled State Senate has scheduled a vote on the bill for Monday. And Mr. Pataki has hinted that he would sign it into law.

Continued on Page B4, Column 1

Missing Records Were on a Table In the White House, Aide Testifies

By STEPHEN LABATON

WASHINGTON, Jan. 18 — The Clinton aide who said she had discovered copies of long-sought records of Hillary Rodham Clinton's former law firm testified today that she had found the documents in a room in the White House living quarters to which only she, the Clintons, their house guests, White House maids and butlers, and Mrs. Clinton's clothing and makeup assistant had access.

The aide, Carolyn Huber, told the Senate Whitewater committee that she found the papers in early August on a table in the room, which is near...

IMMACULATE CONCEPTION

A White House aide, Carolyn Huber, testified yesterday.

REPUBLICANS LACK CONSENSUS ON HOW TO BAR SHUTDOWN

DEADLINE IS NEXT FRIDAY

House and Senate Leadership Also Undecided on Strategy Regarding Debt Limit

By ADAM CLYMER

WASHINGTON, Jan. 18 — United in disdain for President Clinton's latest budget proposals and convinced that no deal is in sight, Congressional Republicans acknowledged today that they had not agreed on how to keep the Government open and avoid defaulting on its bonds.

The current stopgap spending authority will expire next Friday, and Senator Bob Dole of Kansas, the majority leader, pleaded ignorance of House plans at a news conference.

"I don't know precisely what they have in mind," Mr. Dole said.

Representative Robert L. Livingston, the Louisiana Republican who heads the House Appropriations Committee, said he was not prepared to bill to extend appropriations and that he favored it.

The Republicans seemed content to forget further negotiations and make the budget their chief election issue in the fall.

Continued on Page B7, Column 1

Baseball Approves Interleague Play

Major League Baseball owners, continuing their efforts to change the way the game has been played in this century, yesterday approved interleague play for the 1997 season.

Under the plan, each team would play 15 or 16 games against teams in the corresponding divisions of the other league. The Yankees and the Mets, for example, would play three games against each other.

Article, page 39.

New Premier in Greece

Greece's governing Socialist Party elected Costas Simitis, a chief critic of Andreas Papandreou, to replace him as Prime Minister. Page A11

G.O.P. Candidates Divide Religious Right

By GUSTAV NIEBUHR

With only three weeks to go before the first votes are cast in the 1996 Presidential caucuses and primaries, religious conservatives are a political force fractured by allegiances divided among several Republican candidates.

But Mr. Reed, who has not endorsed a candidate, said he saw no cause for alarm in this. While religious conservatives have spread themselves throughout the field, he said, the entire field has moved to them, not the other way around.

Continued on Page A22, Column 1

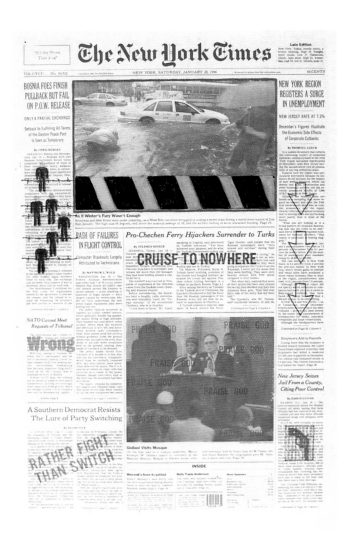

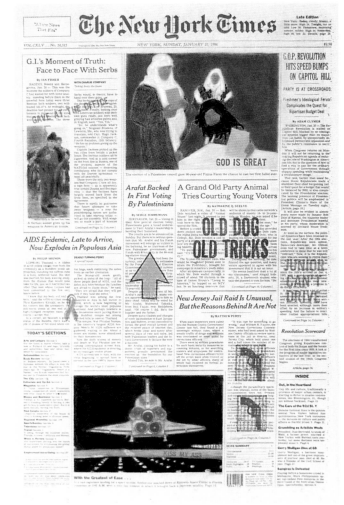

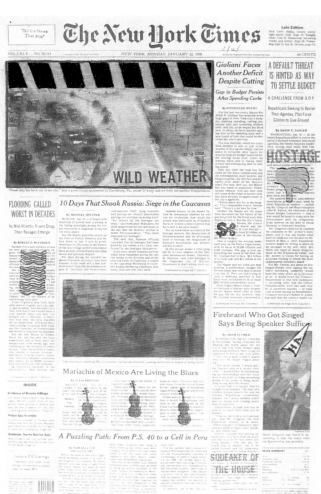

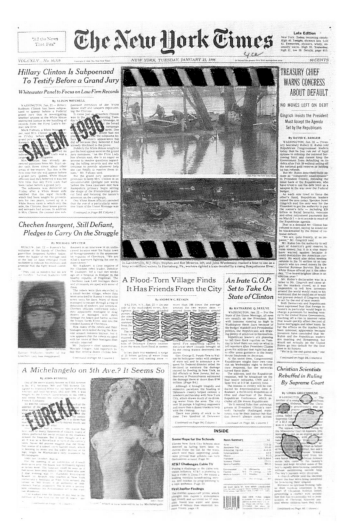

"All the News
That Fits"

The New York Times

VOL.CXLV...No. 50,316 Copyright © 1996 The New York Times NEW YORK, WEDNESDAY, JANUARY 24, 1996 $1 beyond the greater New York metropolitan area 60 CENTS

Late Edition
New York: Today, rain arriving, breezy. High 52. Tonight, rain ending, colder. Low 33. Tomorrow, becoming sunny, colder. High 39. Yesterday, high 42, low 33. Details, page C8.

On the Environment, Pataki Is Seen in All Shades of Green

He's Praised and Pilloried, but Defends Record

By ANDREW C. REVKIN

Last Wednesday morning, George E. Pataki was being praised by environmental groups, resolving a better budget bringing in the Adirondack Park. "The Governor has found the middle ground between protecting the critical resources of the park and the legitimate needs of landowners," Sarah Meyland, president of a private environmental group, said.

By afternoon, his administration was being pilloried by some of the same people for a program allowing companies four-fifths of polluting to make contributions to state environmental projects in lieu of paying fines. Critics described the plan as "green pork."

The day's many laterals — the ebb and mix of environmentalist, versa in the space of a few.

The course of Mr. Pataki's environmentalism appears to emanate from a man struggling to balance deeply felt concern for the environment with a broad agenda that includes cutting budgets and streamlining regulations to make New York friendlier to business. A similar tension is seen in his administration.

Recent staff changes, damaging leaks aimed at the Environmental Conservation Commissioner, Michael D. Zagata, and sudden changes of course on environmental issues appear to stem from a battle between a core of people close to the Governor who support strong environmental protection and a powerful anti-regulatory camp, influenced by consumer activists like Mr. Pataki's patron, Senator Alfonse M. D'Amato.

But he takes a new view of some of the Governmental issues as the growing pains of a government involved in a gutty experiment to allow him to trim a bureaucracy that he more concerned than paper-clean up the environment's untouched.

Most of the criticism, Mr. Pataki

Continued on Page B4, Column 1

At a grant announcement, Gov. Pataki doubled as a hawk perch.

Japan Trade Surplus Shrinks For the First Time in 5 Years

By ANDREW POLLACK

TOKYO, Wednesday, Jan. 24 — Japan's giant overall trade surplus shrank in 1995 for the first time in five years, led by a substantial narrowing in the politically sensitive gap with the United States.

Many analysts say the decline is likely to continue, and help ease tensions with the nation's trading partners and help keep the dollar strong.

The Government reported today that Japan's merchandise trade surplus, the difference between exports and imports, fell 11.4 percent in 1995 to $107.1 billion, from $120.9 billion in 1994, the Ministry of Finance reported early today.

Behind the decline was the rise of the Japanese yen in recent years, which encouraged imports of everything from American personal computers to Australian beef, while crimping Japan's exports of such products as cars and video-cassette recorders.

The surplus with the United States fell 11 percent to $45.1 billion, from $54.9 billion in 1994, also its first decline in five years. But in recent months the decline has been far sharper and the December data out today showed a 35 percent drop. In the next year or two, China is projected to replace Japan as the nation with which the United States has the largest trade deficit.

Already, there is some easing of tensions between Tokyo and Washington. The Clinton Administration, which has spent much of its time in office railing Japan an unfair trader, is now publicizing how fast exports of American products to Japan have been growing.

The figures released today are calculated on what is known as a customs clearance basis, which means that freight and insurance charges are included in imports. This tends to understate Japan's overall trade surplus by about $20

Continued on Page D18, Column 1

Patients Challenge Mental Health Plans

Millions of people participate in health plans that use managed care for their mental health benefits. A growing number are complaining that in the name of saving money managed care companies are denying essential mental health services, and as a result patients are suffering.

The committee affairs agencies in California and Rhode Island take such complaints seriously enough that they have begun investigations of how managed care companies handle psychological patients.

And in Massachusetts a group of patients and mental health therapists are suing the managed care company on the fact that claims tactics will be easier. I think it will really force an advantage.

The growth of managed care is widely reputed. People are driven by price and convenience.

 (partial)

Article, page C8.

FEARING ATTACK, U.S. IS TIGHTENING BOSNIA SECURITY

MUSLIM MILITANTS CITED

Washington Says It Received Reports of Plot in Revenge for Sentencing of Sheik

By CHRIS HEDGES

SARAJEVO, Bosnia and Herzegovina, Jan. 23 — American forces in Bosnia have heightened security after intelligence reports suggested that militant Muslim groups were planning attacks against American targets in Bosnia.

The reports said the attacks were intended as retaliation for the life sentence given to Sheik Omar Abdel Rahman by a Federal judge in New York this month. He was convicted of plotting terrorist acts aimed at New York City landmarks and conspiring to kill political leaders. The other reason for plots cited in intelligence reports was the American pressure on the Bosnian Government to expel the foreign volunteers from Islamic countries who have trained Bosnian troops and fought alongside them.

American military officials, who insisted on not being identified, did not make clear who the reported threat had been linked to the Sheik.

But on Sunday the Islamic Group, an Egyptian militant organization that considers the Sheik a spiritual leader, vowed in a statement that it would set its sights on the United States in retaliation for the Sheik's sentence.

Key American positions in Bosnia were put on heightened alert, and officials say they are watching the Islamic volunteers under tight surveillance. On Sunday, for example, two armored personnel carriers, each mounted with a light machine gun and a cannon, were parked in front of the NATO peacekeepers' headquarters in Sarajevo as part of the increased security.

American troops have been handed pamphlets warning them to watch out for an American citizen known as Kevin or Cleven Holt and Isa Abdullah Ali, who is said to have close links to militant Islamic groups. The Associated Press report tonight said that Mr. Holt had tried to enter a NATO compound some time in the last 24 hours, but an unidentified official did not specify the site of the compound.

Officials did not say whether the reports would have any effect on the jobs of the peacekeepers.

American intelligence reports showed a substantial increase in activity during the last few days by

Continued on Page A8, Column 1

Newark Airport Is Pressing to Surpass Kennedy

By NEIL MacFARQUHAR

NEWARK, Jan. 23 — Newark International Airport formally opens a sprawling $120 million international arrivals hall on Wednesday, a move that aviation experts say positions Newark to become the region's busiest airport.

The light-filled addition to Terminal B is designed to double the airport's capacity to take in international passengers, to 1,000 passengers an hour when it is fully operating by year's end.

That, along with a $350 million monorail to open in May connecting the main Newark terminals, could siphon off passengers from Kennedy International Airport who have long been maddened by the lengthy arrival lines at immigration and the maze that connects terminal transfers.

Kennedy is known, in the business as the airport people love to hate, said David S. Goldplate, a Washington-based airline passenger consultant. "I think Newark can capitalize on the fact that customers will be easier. I think it will really force an advantage."

The growth of Newark's relative to Kennedy has ramifications far beyond travel. Airports register most powerful economic engines for their cities and regions, and increasing passenger traffic means increased spending and jobs, both at the airport itself and at the surrounding area.

The shift toward Newark also seems to demonstrate that many travelers have finally shed the lingering impression that international travel means flying to or from Kennedy. Indeed, for travelers starting from midtown Manhattan, getting to Newark can be easier than getting to Kennedy.

When Newark 10 years ago briefly passed Kennedy in numbers of passengers, the 1986 statistics were considered an anomaly because of huge fare cuts for People Express, which later went out of business. Two years ago, Kennedy had a very slight edge, with 20.4 million passengers to 20.2 million for Newark. Figures for 1995 were still being compiled, but airport officials said Newark is one of the fastest growing airports in the nation.

And the new, more efficient international terminal sets the stage for even more growth, experts said.

Over all, people will still be driven by price and convenience.

A new arrivals hall could double Newark's capacity for foreign travelers.

Continued on Page B4, Column 1

CLINTON OFFERS CHALLENGE TO NATION, DECLARING, 'ERA OF BIG GOVERNMENT IS OVER'

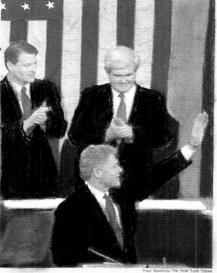

President Clinton addressed the country last night and said, "To improve the state of our union, we must all ask more of ourselves."

APPEAL TO VOTERS

Revives Theme of '92 and Tries to Pre-empt G.O.P. Messages

By ALISON MITCHELL

WASHINGTON, Jan. 23 — Offering his own idea of limited government to compete with the Republican vision, President Clinton tonight challenged the nation to provide enough educational opportunities, economic security and freedom from crime to allow Americans to make the most of an "age of possibility."

In an election-year State of the Union Message intended far more for voters than for the Republican-controlled Congress, Mr. Clinton separated himself from Democratic orthodoxy, twice pronouncing that the "era of big government is over."

But at the same time, he threw down a challenge to Republicans to resume negotiations over balancing the budget and to turn away from tactics like the threat of a Federal default or government shutdown. In Federal worker who survived the bombing of the Federal Building in Oklahoma City last April, he urged Congress to "never – ever – shut the Federal Government again."

Interrupted 79 times by applause from a visibly partisan and divided Congress, Mr. Clinton outlined seven areas of challenge to the government and several new initiatives.

Talking Like a Front-Runner

By R. W. APPLE Jr.

WASHINGTON, Jan. 23 — President Clinton gave a front-runner's speech tonight, the speech of a candidate confident that he is ahead.

In a State of the Union Message that proposed an agenda not only for this year but also for the second term that Mr. Clinton hopes to win in November, he dwelt only briefly on the protracted struggle over the budget. He sounded almost as if the fight was over, telling Congress and the nation that only one more push was needed to "make permanent deficits yesterday's legacy."

Then he hurried on to the future, setting out a series of challenges that he said the nation faced in what he termed the "Age of Possibility."

The possibilities, the President said again and again, using various metaphors and examples, could be realized by cooperation between Republicans and Democrats, between government and private initiative, and between government and himself actively discrimating against himself embracing self-reliance and teamwork and opposing virtues.

Systematically restating his nonideological, almost centrist tone, Mr. Clinton's words were an appeal to the political.

The President has spent the last year facing an increasingly hostile Congress. Twice it has closed down much of the Government as part of the tug-of-war with Mr. Clinton. It has taken aim at many of his favorite programs. It has sought, sometimes successfully, to put him on the defensive. At one point last year, he found it necessary to proclaim his own relevance.

But unlike many of his predecessors who found themselves in similar situations, notably Harry Truman, he chose not to lambaste the Republicans tonight. Instead, he took

Continued on Page A12, Column 1

government, saying responsibility, urging families to stay together, mostly over their children and domestic violence.

"The era of big government is over," Mr. Clinton said. "But we cannot go back to the time when our citizens were left to fend for themselves. We must go forward as one America, one nation working together, to meet the challenges we face together. Self-reliance and teamwork are not opposing virtues — we must have both." [Transcript, page A14.]

At one point, as he talked of the importance of families, Mr. Clinton paid tribute to his embattled wife, Hillary, who has been subpoenaed to appear on Friday before a grand jury investigating Whitewater. Looking toward her seat in the House

Continued on Page A12, Column 1

Dole Says President Defends Old Elites Seeking Largesse

By KATHARINE Q. SEELYE

WASHINGTON, Jan. 23 — Delivering the Republican response to President Clinton's State of the Union Message, Senator Bob Dole tried tonight to take from the President only a dependence in government, competing with each other for handouts, held back by outdated rules.

Mr. Dole stuck to his prepared remarks, even after hearing Mr. Clinton, which made him sound harsher than Mr. Clinton and somewhat out of sync with other Republicans, who complained that Mr. Clinton had pre-empted many of their

Continued on Page A22, Column 1

INSIDE

"All the News That Fits"

The New York Times

Late Edition
New York: Today, becoming sunny, windy, colder. High 34. Tonight, clear. Low 23. Tomorrow, clouds, light snow, drizzle late. High 39. Yesterday, high 54, low 40. Details, page C13.

VOL.CXLV...No. 50,317 Copyright © 1996 The New York Times NEW YORK, THURSDAY, JANUARY 25, 1996 $1 beyond the greater New York metropolitan area 60 CENTS

Giuliani Weighs Reducing Police Force by 1,000 Jobs

Considers Plans to Close $2 Billion Budget Gap

By STEVEN LEE MYERS

The Giuliani administration is considering reducing the size of New York City's police force by almost 1,000 officers — from almost 38,000 now, to help close a widening gap in the city's budget, senior officials said yesterday.

Through a spokesman, the Mayor declined to discuss this or any other budget proposal publicly before the preliminary budget to be unveiled next week. But when asked about the possibility of police reductions, the spokesman, Cristyne F. Roche, said only that the Mayor was considering all options in the coming negotiations.

The Police Commissioner, William J. Bratton, said last night that he hoped the city's budget woes would not require a reduction in officers. He added, however, that the city could manage the department without affecting its success in fighting crime if the force level were cut.

"I would be confident that we could deliver a high level of police service and protection," Mr. Bratton said. "We hope it would not come to that."

The reduction could save $20 million to $30 million and is among a menu of options that the Mayor's budget aides have proposed. But they said Mayor Rudolph W. Giuliani had not yet decided whether to adopt it.

The Mayor is drafting a preliminary budget plan for the upcoming fiscal year that is scheduled to be unveiled next Wednesday.

If the proposal is accepted, it would mark the first overall reduction of the city's police force since Mayor David N. Dinkins and the City Council won approval from the state in 1990 to hire more officers and pay for them by imposing taxes under the Safe Streets, Safe City program. In the last several years, crime has dropped dramatically.

Both Mayor Giuliani and Mr. Dinkins, whose leaders rank among their most significant achievements, has received at least some of the credit for the city's marked drop in crime.

The state law that created the program, however, expires in June. And so do the mandates that dictated the size of the city's police force at 38,310 officers and have so far shielded the department from budget cuts during the city's nagging financial troubles of the 1990's. The temporary tax that paid for most of the hiring, a 12.5 percent surcharge on the personal income tax, expires in December.

The reactions to a proposed reduction varied widely yesterday.

"I haven't been briefed on it," Clinton," said City Councilman, tened in Chicago. 39-year-old security guard. "But I've got to tell you, I liked what I heard about telling men to take care of their kids, and getting tough on crime and all that."

Others praised the President for not getting bogged down in what they called budget "mumbo jumbo," while many seized on his brief call to have public school students wear uniforms as an idea particularly worthy of praise.

Continued on Page B3, Column 5

New Flexibility By Iraq on Oil Worries Market

By YOUSSEF M. IBRAHIM

PARIS, Jan. 24 — After a five-year standoff, Iraq's willingness to hold talks with the United Nations about selling oil for the purchase of food has raised prospects for an accord this year that could also provoke a sustained decline in oil prices, industry executives and analysts said today.

An expected surge in the supplies of crude oil would create havoc in world markets and within the Organization of Petroleum Exporting Countries, some experts said.

But at the same time, such a deal with the intransigent Iraqi Government could alleviate severe hunger in the country, where the economy has grown desperate under years of restraints on its trade, access to money abroad and travel in and out of the country.

Last Friday, Iraq accepted a United Nations offer to negotiate a way for it to sell $2 billion worth of oil to buy food and medicine. The accord would be for a six-month period, and would be renewable.

The United Nations Secretary General, Boutros Boutros-Ghali, said today, "The fact that they have agreed to talks... we have more chance than we had before."

But pending talks have led many industry analysts to now expect an irreversible process leading in months to the end of one and a half years of economic sanctions against Iraq, and unleashing the huge export capacity of a country that sits on the world's second-largest known reserves of oil after Saudi Arabia.

"We are talking about a big drop of $1 to $2 per barrel, and maybe

Continued on Page D6, Column 1

INSIDE

Chechens Free 46 Hostages
Chechen rebels released 46 of the people they seized in a raid that set off a prolonged siege and humiliated the Russian Army. They continue to hold other hostages. Page A3.

Premier of Poland Resigns
Prime Minister Jozef Oleksy of Poland said he would resign, declaring that allegations he was once a spy for Moscow were false. Page A4.

Changing Arbitration
State lawmakers approved a bill to change the way New York City resolves contract disputes with its police and fire unions. Page B3.

Woman in Coma Is Pregnant
A woman who has been in a coma for 10 years is pregnant, the victim of a rape, and her parents have chosen to have her give birth. Page B1.

From Fiction to Fact
After years of writing novels, John Grisham is back in court, arguing for the widow of a brakeman killed in a railroad accident. Page A12.

News Summary	A2
Arts	C15-22
Business Day	D1-20
Editorial, Op-Ed	A20-21
Home Section	C1-13
International	A2-11
Metro	B1-5
National	A12-19
SportsThursday	B7-15
Media Business ... D8 TV Listings ... C21	
Obituaries ... B3-6 Weather ... C13	
Classified ... B18 Auto Exchange ... D20	

Office Seekers And Officers

Senator Bob Dole, in Cedar Rapids, Iowa, was given a tour yesterday by Officer Jim Strother. In Louisville, Ky., President Clinton was joined by a roundtable by Officer Robin Cook. Both politicians welcomed a deal on raising the debt limit.

Photographs by Associated Press

Clinton Wins Praise For Talk on Values

In kitchens, coffee shops and nursing homes across the nation, people watched as President Clinton delivered his State of the Union Message on Tuesday, and many found that they liked what they heard, especially when Mr. Clinton talked about education and cultural values.

Article, page A19.

House Democrats Buoyed, But G.O.P. Retains an Edge

By ROBIN TONER

WASHINGTON, Jan. 24 — The battle for control of the House of Representatives begins with the Democrats showing surprising strength in the polls, making their chances of regaining a majority look better than they did six months ago. But many analysts say the Republicans still have the advantage in raising money, recruiting candidates and the shape of the political map.

The stakes in this struggle, perhaps the most significant of this election year, are simple: If the Democrats pick up 20 seats, they will regain a majority in the House and end the Republicans' "revolution" of 1994.

Still, as Democrats proved with their 40-year hold on the House, majorities can be self-perpetuating. Already, some analysts say, the Republicans are reaping the benefits of their majority status in terms of fund-raising. "Money follows power," said Ellen Miller, executive director of the Center for Responsive Politics, a Washington group that tracks political contributions.

The next major filing deadline for campaign contributions is not until Jan. 31; until then, the data on Congressional fund-raising are either spotty or out of date or both. But preliminary reviews indicate that much of the money from political action committees has been redirected toward the Republicans.

A study of PAC contributions in the first six months of 1995, conducted by the Center for Responsive Politics, showed that more than 60 percent of the money went to members of the new Republican majority, reversing the pattern in the 1993-94 cycle, when the Democrats had control. A study of 400 PAC's by the National Republican Congressional Committee last year showed a similar trend.

Other factors are also in the Republicans' favor. Winning an open seat, by and large, is easier than ousting an incumbent; as a result, the wave of Democratic retirements has given the Republicans rich new opportunities, many of them in the conservatively realigning South. While 13 Republicans have announced they are leaving the House, 23 Democrats are doing so, 13 of

Continued on Page A16, Column 1

G.O.P. LAWMAKERS OFFER TO ABANDON DEBT-LIMIT THREAT

CLINTON WELCOMES MOVE

Talks Gain Urgency as Moody's Says Some U.S. Securities Could Be Downgraded

By ADAM CLYMER

WASHINGTON, Jan. 24 — Congressional Republicans said today that they would abandon the national debt as a weapon against President Clinton if he would support modest budget and tax cuts as a "down payment" on a balanced budget.

Freeing the President from their previous insistence on securing his prior approval of Mr. Clinton told Mr. Gingrich in a telephone conversation that he was "intrigued" with the suggestion, and arranged for aides from both sides to meet on Saturday. The President told Democratic leaders in Louisville, Ky., that he and Mr. Gingrich had a "good conversation."

The pressure for a deal on the debt limit was increased late this afternoon when Moody's Investors Service Inc., a leading credit-rating service, announced that it was considering lowering its rating for $387 billion in Treasury securities out of a growing fear that the stalemate could lead to a Government default. Wall Street executives said the warning was likely to drive down the price of the bonds. [Article, page A16.]

Mr. Gingrich made the proposal on the debt limit in a morning news conference and called it a response to President Clinton's appeal at his State of the Union Message that the Administration and the Republicans work together. Senator Bob Dole of Kansas, the majority leader, endorsed the idea in a letter made public later.

Senator Dole, who is seeking the Republican Presidential nomination, said in Anamosa, Iowa, where he was campaigning, "The White House might accept at least a partial tax credit of $125." That would be 25 percent of the $500-per-child credit the Republicans have sought.

Mr. Gingrich said there was already enough agreement between Republicans and the President to provide a healthy start toward balancing the budget, perhaps $55 billion of savings. But he said Republicans would probably not achieve a real balanced budget "while President Clinton is in the White House."

"We are tremendously apart on basic policy issues," like changes in Medicare, Mr. Gingrich said.

The Republicans have used the debt limit — the need for an extension of the nation's borrowing authority — as a major club as they have sought to force Mr. Clinton to agree to a budget that would be balanced by 2002. The country's debt reached the existing statutory limit of $4.9 trillion on Nov. 15, and since then Treasury Secretary Robert E. Rubin has juggled money in pension accounts to keep the Government from defaulting on bond interest and other obligations. But he has said he cannot do that beyond March 1.

Today's move was a clear Republican retreat in the long-running

Continued on Page A16, Column 3

Final Stock of the Smallpox Virus Now Nearer to Extinction in Labs

By LAWRENCE K. ALTMAN

After several stays of execution, the smallpox virus, one of the biggest killers in history, is back on death row.

The governing board of the World Health Organization recommended yesterday in Geneva that what are believed to be the last two remaining stocks of the virus, in Russia and the United States, be destroyed by June 30, 1999.

Final action requires a vote of the full membership of the health organization, and approval is expected. Yesterday's action was the most important step to date in the longstanding plans of W.H.O., an agency of the United Nations, to destroy the virus.

Destruction of the stocks, the last vestiges of the infectious agent that has killed, scarred and blinded countless millions, would be the first deliberate extinction of a species. Some scientists have recommended preserving the virus, which they believe may yield useful medical knowledge to future generations; others worry about misuse.

Smallpox is the only naturally occurring disease ever eradicated in the human population. The victory was accomplished after worldwide vaccination ended the human-to-human chain of transmission.

Fewer than 30 years ago, smallpox transmission occurred in 31 countries, killing about 2 million of the 10 million to 15 million people infected each year. Active searches have turned up no new cases since.

The governing board's 32 members, including United States, asked the organization to gain a broader consensus among scientists and political leaders before destroying the virus. Final approval to destroy the virus could come as early as May at

Continued on Page A9, Column 1

Tick Disease Advance

Researchers have been able to isolate and grow the bacterium that causes a recently identified and sometimes fatal disease in human granulocytic ehrlichiosis, or H.G.E., which is transmitted to people by the tick that carries Lyme disease.

Article, page A19.

Osamu Honda for the New York Times

Mizuko jizo, tiny monuments to aborted fetuses, are dressed and tended to at Buddhist temples in Japan.

In Japan, a Ritual of Mourning for Abortions

By SHERYL WuDUNN

KAMAKURA, Japan — Winding her way among thousands of tiny statuettes in an ancient hillside temple, Yuka Sugimoto finds the one she is seeking and lingers in contemplation of the secret, haunting act that brought her here.

Many Buddhists come to temples to pray for good health, a new husband or a pile of money, but not Miss Sugimoto. Every month she comes to this temple in the ancient Japanese capital of Kamakura to make amends with the fetus that she aborted nearly two years ago as an unmarried student.

It is not that she broods over whether she made the proper decision, given the circumstances. To her it was an act that was necessary, though evil. And like tens of thousands of women throughout the country, Miss Sugimoto regularly visits a Buddhist temple to console a tiny statuette, known as a mizuko jizo, that to her personifies her forgone baby.

"I think I've done something bad enough to be cursed," said Miss Sugimoto, in jeans and a down jacket, who traveled here from Tokyo. "I'll be scared when I have my next baby."

Japan is not sundered by the kind of debates about abortion that are common in the West. In Japan abortion is entirely legal in the first five months of pregnancy and hardly stirs a murmur within society. There are no protests at abortion clinics, no debates about banning abortions and no politicians taking stands on the issue. The last legal restrictions on abortion were removed in 1948.

Even though virtually everyone here believes that abortion is a woman's own business, it is striking how uneasy many of those women are after exercising their right.

It is not the same as the religious belief in other societies that a fetus is a human being who has a right to life. But despite the vast differences among cultures, there is an echo in Japan of that disquiet about a mother choosing to end the life of the fetus in her belly.

The signs of a pervasive but silent mourning over abortions are the tens of thousands of mizuko jizo, or guardians of aborted fetuses, miscarried and stillborn babies and those who died very early in life. In temples across the country, women

Continued on Page A8, Column 1

AMAZON.COM BOOKS - EARTH'S BIGGEST bookstore. One million titles, consistently low prices. http://www.amazon.com/ — ADVT.

THE NEW YORK TIMES is available for home or office delivery in most major U.S. cities. Please call, toll-free: 1-800-NYTIMES. Ask about the Transmedia TimesCard.ADVT.

24

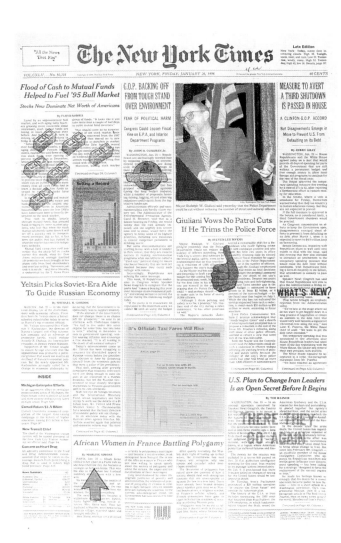
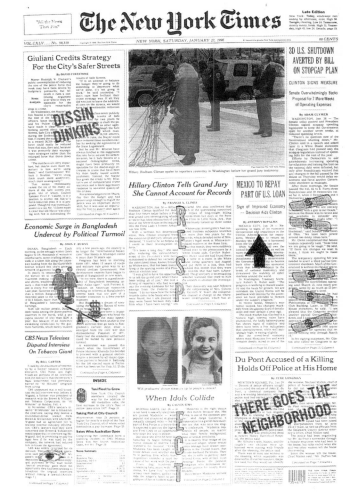
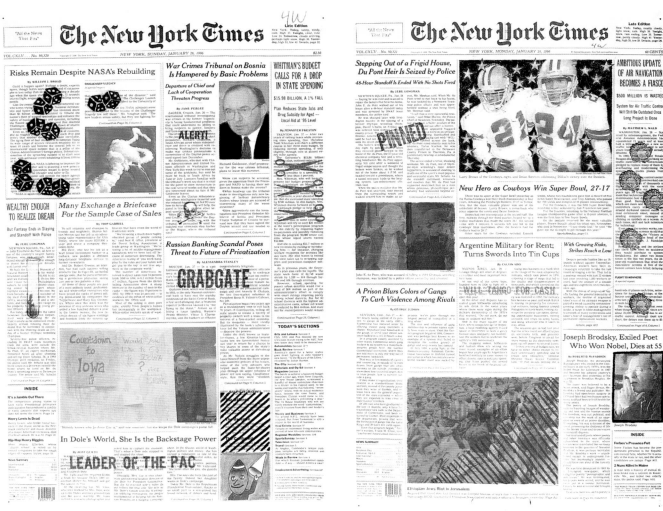

"All the News
That Fits"

The New York Times

Late Edition
New York: Today, cloudy, breezy. High 41. Tonight, clouds, very cold by morning. Low 23. Tomorrow, blustery, flurries, cold. High 25. Yesterday, high 39, low 27. Details, page B8.

VOL.CXLV .. No. 50,322 Copyright © 1996 The New York Times NEW YORK, TUESDAY, JANUARY 30, 1996 $1 beyond the greater New York metropolitan area. 60 CENTS

Johnson Returns and Will Play Tonight
Magic Johnson, who retired from the Lakers in 1991 because of his infection with H.I.V., tuned up his hook shot yesterday. Page B11.

A Secret Agency's Secret Budgets Yield Lost Billions, Officials Say

By TIM WEINER

WASHINGTON, Jan. 29 — The National Reconnaissance Office, the secret agency that builds spy satellites, lost track of more than $2 billion in classified money last year, largely because of its own internal secrecy, intelligence officials say.

Critics of the reconnaissance office said today that the money had been hidden in several tiny-day accounts that secretly solidified into a "slush fund."

The N.R.O.'s top managers themselves had no idea how much money they had spent in their classified college.[?] Senator Arlen Specter, the Pennsylvania Republican who heads the Senate intelligence committee, and Senator Bob Kerrey, the Nebraska Democrat who is the panel's vice chairman, said in a prepared statement.

The amount of money was larger than anyone had known — possibly over $2 billion, or more than the annual operating budget of the State Department, several military and intelligence officials said.

One Senate intelligence committee aide described the misplaced money as a severe accounting problem that had grown because of a lack of accountability, in turn created by

the extraordinary secrecy under which the reconnaissance office works.

A team of auditors dispatched by the Director of Central Intelligence, John M. Deutch, found the money in a series of investigations that are nearing completion. More than $1 billion was tracked down and identified last year.

Now that the money has been found, it will be used to help pay for Pentagon programs, including $820 million for the peacekeeping mission in Bosnia and hundreds of millions for the B-2 bomber project.

The National Reconnaissance Office is the agency that secretly spent

Continued on Page A11, Column 1

INSIDE

Health Costs Rise, for Some
After a dip in 1994, employees' health costs resumed their climb, rising 2.1 percent last year, surveys show. But the rise was almost entirely in traditional insurance. Page D1.

3 AIDS Drugs Found to Help
A combination of an experimental anti-AIDS drug and two licensed ones appears to be the most powerful AIDS therapy ever tested on infected patients. Page C5.

Israeli Spying Dispute
A Pentagon memo warning of Israeli attempts to spy on the United States has been withdrawn, but not before repercussions. Page A3.

Labor's New Horizon
After ignoring chicken processing plants and their workers, unions are now actively trying to bring them into labor's fold. Page A10.

DAHLIA LETS NEVER STOP HAVING FUN! Marry me! love always! Merv — ADVT.

PATAKI IS SEEKING CURBING OF RIGHTS OF CRIME SUSPECTS

APPEALS COURT ATTACKED

Rules on Search and Seizure Restrict Law Enforcement, the Governor Contends

By CLIFFORD J. LEVY

ALBANY, Jan. 29 — Gov. George E. Pataki went on the attack against the state's highest court today, announcing that he would introduce legislation to counter rulings that he contended go too far in protecting the rights of criminal defendants.

Mr. Pataki said his bill would rein in the seven-member Court of Appeals, which he and other conservatives have often accused of overstepping its bounds by imposing burdensome restrictions on the police and prosecutors. The legislation would essentially loosen the rules that the authorities must follow in searching for and seizing evidence from criminal suspects.

For months, the Governor has been grumbling about the court, which has only two Republicans among its seven members. All of them were appointed by former Gov. Mario M. Cuomo. Mr. Pataki would not get his first chance to replace one of the four Democrats until 1999, when Judge Vito J. Titone's term expires.

"In New York State," Mr. Pataki said at a news conference this evening, "a body of court interpretations has arisen that limits our police officers, that limits our prosecutors' ability to enforce the law adequately and makes it too often impossible to have a fair trial. It has got to change."

In announcing the bill, the Governor appeared to be renewing his effort to make crime a pivotal issue for the Legislature in an election year. While Republicans will undoubtedly support his proposals, Democrats may find themselves hemmed in — uncomfortable with a measure that some may feel is too tough, but also afraid of being painted as soft on criminals.

Civil liberties groups immediately criticized the bill, saying that if it passed they would mount a challenge based on the argument that it violated the State Constitution. The rules for searching and seizing evidence have long been a contentious area of the law; prosecutors and defense lawyers have fought numerous battles in state and Federal

Continued on Page B6, Column 3

Dith Pran/The New York Times
Governor Whitman called her welfare proposal "tough love at its best."

Whitman Plans Welfare Limits And Incentives to Promote Work

By JENNIFER PRESTON

TRENTON, Jan. 29 — Gov. Christine Todd Whitman proposed an overhaul of the state welfare program today that would provide more help to ease the transition to work and would, her beneficiaries earn more outside income.

Calling her proposal "tough love at its best," Governor Whitman said the state would match this generosity with sternness. Benefits would be limited to five years, recipients would have to stay current with child support payments, and teen-age recipients would have to stay in school and live with a parent or other adult.

The proposals, outlined in the Governor's annual budget message to the State Legislature, borrow from dozens of pilot programs in other states and from proposed changes in the Federal welfare rules agreed to on Capitol Hill. In drawing up her plan, Mrs. Whitman has remained on the moderate Republican course she has set for her administration in her first two years in office.

For example, she avoided many of the strictest proposals backed in other states, including a 21-month limit on beneficiaries put into effect by

Gov. John S. Rowland of Connecticut. And her plan includes not just more money for child care and job training, but a call for state-provided "pay counseling" and help negotiating conflicts between welfare beneficiaries and employers.

To push her proposals into action, Mrs. Whitman needs the approval of the State Legislature and the Federal Government. Although she made the proposal in her budget address, she put no overall dollar figure on her welfare plan. She only said that it would cost no more than the state now spends on welfare.

"President Clinton has challenged the states to come up with ways to

Continued on Page B4, Column 3

Giuliani to Propose Merging of Agencies

Redrawing the blueprint of New York City's municipal bureaucracy, Mayor Rudolph W. Giuliani plans to propose eliminating at least five city agencies — including the Department of Transportation — and consolidating their functions into other offices, senior aides said.

The proposals could save millions of dollars by consolidating administrative positions and functions. The aides said the plan would not result in any layoffs but would allow the city to cut its payroll of 200,000 through attrition.

Article, page B1.

G.O.P. MAY REVIVE A WELFARE PLAN TO SNARE CLINTON

AIM IS DEMOCRATIC SPLIT

Election-Year Maneuver Could Backfire on Republicans or Confound White House

By ROBERT PEAR

WASHINGTON, Jan. 29 — In a shift that could cause intense political difficulty for the White House, many leading House Republicans say they now want to pass the Senate version of welfare, which President Clinton vetoed four months ago.

If he signed the bill, Mr. Clinton would infuriate many liberals in his own party. If he vetoed it, he would disappoint those hoping that he would fulfill his campaign promise to "end welfare as we know it."

For members of both parties, the decision about how to proceed is complicated by election-year politics and full of peril.

The White House and Congressional Republicans both have strong views about the need for change in Federal aid to the poor. The new Republican majorities in both houses passed separate welfare bills last year. Mr. Clinton declared that the House proposal was too harsh. To the dismay of many Democrats, he said last summer that he could accept the version drawn up in the Senate, though he later voiced concerns about the possibility that it would impoverish hundreds of thousands of children.

When House and Senate Republicans compromised and passed a welfare measure late last year, President Clinton vetoed it. Republican leaders in the House say they believe they can exploit that veto in the coming election campaign by confronting Mr. Clinton. Whether the proposal be supported in the past.

Representative E. Clay Shaw Jr., a Florida Republican who is chairman of the Ways and Means subcommittee responsible for welfare legislation, said, "I favor taking the Senate bill up, passing it, sending it over to the Senate and then sending it to the President." Most Republicans on the Ways and Means Committee share that view, Mr. Shaw added.

And Representative Jimmy Hayes of Louisiana, a Democrat who switched to the Republican Party last month, said that he, too, wanted to send the Senate bill to the White House, in the hope that Mr. Clinton would sign it. He sees advantages for Republicans either way.

"If he signs the bill," Mr. Hayes said, "he will put himself at odds with many members of his own party, but it's good legislation and would make a vast improvement over the status quo. On the other hand, if he vetoes it, he will put himself at odds with his own past statements and show that he's not serious about welfare reform."

But other Republicans say they

Continued on Page B8, Column 4

Saudi Gadfly and British Embarrassment

By RICHARD W. STEVENSON

LONDON, Jan. 29 — Each Friday for nearly two years, Mohammed al-Masari has faxed a newsletter to contacts in his native Saudi Arabia, reporting on what he calls the rampant corruption, human rights abuses and errors of the ruling royal family.

Occasionally he adds a "Prince of the Month" special about a member of the royal clan whose behavior he considers particularly egregious.

A few weeks ago, Mr. Masari made clear that Saudi Arabia had made his way to London seeking asylum in 1994 after being arrested for his dissident activities, received it but himself at his office.

It was from the British Government, and it said he was being expelled to the tiny Caribbean nation of Dominica.

Prime Minister John Major's Government ignored protests from free speech and human rights groups.

contracts bestowed on British arms makers by the Saudis.

"The stability of the Saudi Arabian Government is a matter of importance throughout the Gulf and to stability more generally, and I do not believe we should give comfort to those who seek to undermine it," said Mr. Major, who was lobbied about Mr. Masari by Saudi officials and British business executives on several occasions.

Mr. Masari, who is calling for the Saudi monarchy to be replaced by a stricter Islamic government, is appealing the decision, a process that could take months, and he can remain in Britain in the meantime.

While Mr. Masari's commitment to democracy is open to question, the affair has underlined the ambivalence of Western governments, even those with the longest traditions of supporting free speech and human rights, in dealing with opponents of govern-

Continued on Page A6, Column 1

Jonathan Player for The New York Times
Britain, trying to expel Mohammed al-Masari, gave him a voice.

France Ending Nuclear Tests That Caused Broad Protests

By CRAIG R. WHITNEY

PARIS, Jan. 29 — The French Government said today that it had ended its nuclear weapons test program for good after conducting an underground blast in the South Pacific on Saturday, the last in a series of six such tests that were deplored by most of France's European allies and scores of other countries.

President Jacques Chirac announced the decision on national television this evening, calling the "halt "the definitive end of French nuclear testing."

Mr. Chirac lifted a three-year moratorium on testing last April to try out a new warhead for French nuclear submarines and to gather data for computer simulations that will make future French nuclear weapons tests unnecessary.

French officials said today that the six tests carried out since last fall, which included the last and most powerful one at Fangataufa Atoll in the South Pacific on Saturday, had yielded enough data to make an additional test unnecessary.

They said that Mr. Chirac also wanted to put his best foot forward

during a state visit to the United States this week and that he would use an address to Congress on Thursday to reaffirm France's intention to join the United States and other nuclear powers in signing a comprehensive test ban treaty this year to stop all further test explosions, no matter how small.

In Washington, the White House Press Secretary, Michael D. McCurry, said that the French decision would "provide new momentum" to efforts to reach an international test ban treaty. The United States had pressed France to abide by the global moratorium.

Mr. Chirac had said last June that the tests would end this spring but cut the number planned from eight to six after objections to the resumption of testing from 10 of his 15 European Union allies, expressions of concern from the United States and vehement protests from Australia, New Zealand, Japan and other Pacific countries.

"The possibility of rebuilding relationships with this part of the world,

Continued on Page A4, Column 1

Discipline or Abuse? Arrest Renews a Debate

By JOSEPH BERGER

JEFFERSONVILLE, N.Y., Jan. 26 — Korey Wax had behaved so badly in school that he was suspended, and when he got home, his father punished the 8-year-old further, whacking him several times across the back and chest with a three-foot rubber snake, the kind that people win in carnival booths.

The incident might have gone unremarked, a private disciplinary matter within a family, but two things have made the case the talk of this close-knit village folded into a rugged pocket of the Catskills, 10 miles west of Liberty, N.Y. The father is the Superintendent of the

local school system, and someone called the state's Child Abuse Hot Line, leading to the father's surrender to the police a week after the incident on charges of third-degree assault and endangering the welfare of a child.

The extraordinary arrest on Jan. 17 of David M. Wax, the 43-year-old Superintendent of the Jeffersonville-Youngsville School District, has touched off a sharp debate within the communities around here about the rights of parents to discipline their children, the extent to which parents can do so and the right of government to intrude. The argument is no stranger to most American communities.

Some residents think that if the charges are true, the Superintendent

went too far, and by his lack of self-control called into question his fitness to run a system that serves 925 children, one of whom is his own son, a third-grader. Others say hysteria has enveloped the case, fueled by people who watch pop-psychology television shows that equate a deserved spanking with child abuse.

"I think there's a definite debate in America as to where discipline has to come in," said Paul Griffin, president of the local Chamber of Commerce, who remembers with approval the spankings his own father administered when he misbehaved. "I think everyone has to agree that there's a need for disci-

Continued on Page B6, Column 1

354613

"All the News
That Fits"

The New York Times

Late Edition
New York: Today, snow ending around midday, then clearing. High 29. Tonight, cold. Low 16. Tomorrow, sun, high clouds. High 25. Yesterday, high 43, low 34. Details, page A14.

VOL.CXLV.... No. 50,323 Copyright © 1996 The New York Times NEW YORK, WEDNESDAY, JANUARY 31, 1996 $1 beyond the greater New York metropolitan area. 60 CENTS

Big Spending Pledges by Yeltsin Are Worrying Foreign Creditors

As Election Nears, Political Rivals Bid for Votes

By MICHAEL R. GORDON

MOSCOW, Jan. 30 — As top specialists from the International Monetary Fund complete a painstaking review of Russia's eligibility for critical foreign loans, President Boris Yeltsin has embarked on a spending spree that economists and commentators say could undermine economic discipline.

Experts are assessing if they determine Russia's access to $9 billion in new Western lending are worried that Mr. Yeltsin's campaign spending promises — if he keeps them — could undermine the country's market reforms by igniting inflation, according to economists familiar with the deliberations.

During the last two weeks, Mr. Yeltsin has announced a cascade of voter-pleasing programs to pay for funerals, pensions, back wages and student stipends. Due to resume the building of the big new temple of the religion of Chechnya.

Not to be outdone, the Communist-dominated Parliament has begun its own binge, most recently promising a 20 percent increase in the minimum wage.

Russian and Western economists say Mr. Yeltsin is now engaged in an extraordinary, and perhaps impossible, balancing act. He is trying to persuade disgruntled Russian voters that he will spend what it takes to win their support before the June presidential election even as he tries to convince skeptical Western governments and foreign lenders that he is putting Russia's economic house in order.

With billions in I.M.F. funds and

the international credibility of his economic policy at stake, Mr. Yeltsin is reluctant to displease the fund, which has been urging Russia to limit politically ambitious programs, close tax loopholes exploited by Russia's new elite, encourage privatization in the face of Communist gains in the polls, tackle such politically charged issues as land ownership and strengthen controls over Russia's boom-or-bust banking community.

Indeed, Mr. Yeltsin and his increasingly isolated Prime Minister, Viktor Chernomyrdin, have gone out of their way to assure President Clinton and foreign bankers that I.M.F.-backed reforms are alive and well.

In talks concerning Russia's deparate spending, "there of reform is completely about," Mr. Yeltsin said recently. "There will be no such departure."

But with Mr. Yeltsin trailing in the polls, the budget has become the major weapon in the campaigns of both the President and his parliamentary enemies.

"From now on, the Parliament's leftists will be competing with the President for the image of the active and most rapid defender of people's social interests," said Mikhail Zadornov, a member of the reform-minded Yabloko faction and chairman of the Parliament's Budget Committee.

Working out of sumptuous rooms in the Metropol Hotel, blocks from

Continued on Page A8, Column 1

Murdoch Joins a Cable-TV Rush Into the Crowded All-News Field

By BILL CARTER

Rupert Murdoch, the chairman of the News Corporation and Fox Inc., yesterday became the latest entrant in the business of providing 24-hour news channels, promising a new competitor to the all-news Network that already exists.

Mr. Murdoch said Roger Ailes, the former producer for CNBC, chairman of the channel, but with no name yet for the new channel, distribution of his promised channel inspired widespread doubts about its long-term survival among competitors and cable industry analysts.

Such skepticism has been growing since both NBC and ABC announced plans within the last six months to begin news channels, all of which will be chasing the same pool of news viewers. Most of that pool now supplies the audience for CNN.

The 16-year-old CNN is now a worldwide force in providing news coverage. But in an average hour the American audience numbers only about 400,000 viewers, and many television industry analysts yesterday questioned whether enough viewers would ever exist for two all-news channels, let alone four.

"Some of these new channels will fail, that's for sure," said Sharon Armbrust, a senior analyst with Paul Kagan Associates, a media consulting firm.

Mr. Murdoch said he believes the audience for news can double,

though he said he doubted that "you could have four times the audience" that CNN has.

CNN has become a highly profitable cable service, with a cash flow for 1995 that Kagan Associates estimated at $250 million. But much of its profitability is based on CNN's unique position as the only channel providing full-time news coverage. A small dip in viewing for CNN could

Continued on Page D5, Column 3

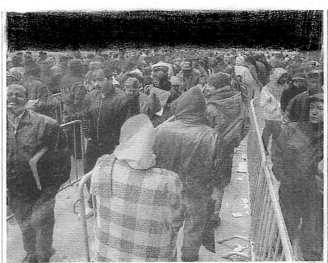

Associated Press

Hope for a green card drew hundreds yesterday, in vain, to the immigration service in lower Manhattan.

Lure of the Education Market Remains Strong for Business

By PETER APPLEBOME

Despite last week's collapse of the nation's largest experiment in private management of public schools, in Hartford, there are increasing signs, from the growth of new businesses to rising stock performance, that public education is becoming an enticing market for private businesses.

A recent study estimates that for-profit companies now take in $30 billion of the $340 billion that the United States spends each year on preschool to high school education. That figure includes for-profit companies that run schools; offer classroom instruction or tutoring; sell textbooks, software or new technology; design curriculums; provide consulting services, or fill other niches.

Thus, while Education Alternatives Inc. was losing its high-profile contract to run the schools of Hartford, Newark's school district, now

operated by the state, signed a $1.25 million contract last week with Sylvan Learning Systems of Columbia, Md., to run the remedial education program at three local high schools through June 1997. Experts say that might be a more revealing situation than Hartford's.

"When you look at the raw numbers, this is a very big industry with enormous potential for growth," said Michael R. Sandler, chief executive officer of Eduventures Inc. of Boston, which invests in companies involved in education and acts as a consultant. "Education has reached the point where the status quo is no longer acceptable."

How much growth will occur will depend, experts say, largely on the push and pull of two opposing forces. The first, coming out of a changing political climate, consists of new de-

Continued on Page A15, Column 5

A Futile Rush In Desperation For Green Card

By RACHEL L. SWARNS

Mohammed Uddin was sound asleep in his Queens apartment when he got the call. The Government was giving out green cards at the Federal Immigration and Naturalization Service offices in Manhattan, his friend told him.

In a flash, Mr. Uddin was dressing and kissing his wife goodbye. By 1:30 A.M. yesterday, he was in a taxi, racing toward downtown.

Over in Brooklyn, the phone was ringing in Kazi Hossain's apartment. The story he heard: 10,000 green cards were already gone; only 2,000 were left. By 2 A.M., he, too, was on the road, also hoping for the chance to get the permanent resident visa that would allow him to work and live legally in the United States.

But when they arrived, there were no green cards to be had, only hundreds of immigrants already in line, all with scarves and gloves and dreams in hand, all willing to endure the freezing night for the promise of legitimacy in America.

"It was like a flood coming, all the people coming, from India, Pakistan, Bangladesh," said Mr. Hossain, a 33-year-old Bangladeshi, who waited until dawn yesterday only to discover that the rumor was not true. "Everybody wants a green card. This rumor, it was like a dream."

The late-night pilgrimage of nearly 1,000 people — a mistaken response to an announcement about the annual Federal immigration lottery — offered a glimpse of the desperation that many of the city's estimated 350,000 illegal immigrants feel about getting a green card.

Those standing in the lines snaking around the Federal Building in lower Manhattan included waiters

Continued on Page B2, Column 1

FEDERAL IMPASSE A STUMBLING BLOCK TO STATE BUDGETS

PATAKI OUTLINES TURMOIL

Governors Fear a Washington Accord That Could Result in Big Spending Gaps

By JAMES DAO

ALBANY, Jan. 30 — Gov. George E. Pataki is warning that a protracted battle in Washington over the Federal budget will throw New York State's new budget into turmoil and force him to make deep new cuts in spending on top of the ones already proposed.

"I lie awake at night worried about things not happening in Washington that could have devastating impact on us," Mr. Pataki said in an interview. "Every time I hear talk, 'Let's wait and hash it out in November,' it really does threaten the whole premise of the budget."

Because New York's fiscal year starts on April 1, earlier than any other state's, Mr. Pataki has been grappling for a month with a problem that most other governors are now beginning to confront: assembling a budget without knowing how much Federal money the state will receive and how much flexibility will be given to spend it.

New York and other states find themselves in this predicament because their spending plans are so closely intertwined with the Federal budget. Between 25 and 40 percent of spending by individual states, or a total of $200 billion this year, comes from the Federal Government. Most of it comes from the Medicaid, welfare and transportation programs.

In New York State, Federal Medicaid spending alone will account for $12 billion, 19 percent of the entire state budget.

Fiscal policy experts say New York State's budgeting problems are more severe than they are in many other states because Mr. Pataki must close a $3.9 billion shortfall and had counted on almost $2 billion in savings from Federal policy changes. These proposals, which include converting Medicaid and welfare programs into block grants, are now at the heart of the fight between Congress and the White House.

Mr. Pataki's budget will effectively unravel, he said, if there is no budget agreement in Washington and current Federal spending policies continue. The Governor will still have problems, though not as great, if President Clinton's more modest proposed changes to welfare and

Continued on Page B4, Column 3

Giuliani Wary of Cuts

After sharply cutting New York City services for two years, Mayor Giuliani is now proposing to slow the reductions. In his next budget, he said, he will safeguard spending for child welfare, the elderly, health and parks, among other services.

News analysis, page B4.

Prison for Young Killers Renews Debate on Saving Society's Lost

By DON TERRY

CHICAGO, Jan. 30 — The little one is 12 years old, stands less than 5 feet tall and will be the youngest child locked up in a maximum-security facility. He was held for first-degree murder after he and a 13-year-old were convicted of dropping a 5-year-old out of a 14th-story window for refusing to steal candy for them.

The older one also a partner in the crime, at 13, will be the youngest child ever to be placed in the maximum-security prison system. At 11, his father, who taught him how to fight, was 6 or 7, is in prison for home invasion. The boy frequently ran away from home and slept in abandoned buildings. His I.Q. is 76.

The boys, whose names have been made public because of their ages, must be freed by the time they turn 21.

Ignored, neglected and failed by most of their lives by parents, teach-

ers and social workers, the two are now at the center of a national debate about how to handle the youngest of the bad. Together they have become the symbols of a future overrun by cold-hearted child criminals.

Their case raises questions now confronting communities across the country: how society can protect itself from the youngest children, should they be locked up or sent to receive treatment and intensive counseling?

In some other states, including Illinois, the answer has been harsher punishment as laws have been changed to lower the age when a child or teen-ager can be sent to a juvenile prison or waived into the much harsher world of adult courts.

Jay Hoffman, a Democratic state

Continued on Page B6, Column 1

INSIDE

Silver Lining on Wall Street
Signs of tepid economic growth were greeted by a surge in stocks. Wall Street believes such data point to lower interest rates ahead. Page D1.

Confrontation in the Aegean
President Clinton called leaders of Turkey and Greece to try to head off a NATO fight over a tiny, uninhabited island in the Aegean. Page A6.

Concerns Grow After Crash
The involvement of the F-14 pilot in a Nashville crash in an earlier crash is feeding concerns. Page A12.

An Israeli Battle of Words
In Israel, Hebrew scholars are struggling to adapt an ancient tongue to modern times. Page A4.

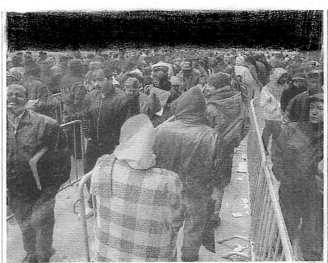

Associated Press

Disaster for a 204-Year-Old Treasure of Italian Opera
A day after a fire destroyed Venice's beloved La Fenice, opera lovers everywhere mourned and damage estimates varied wildly. The Italian Government and European Union pledged to help rebuild it. Page C11.

Replacements Lift Building Owners in Strike

By STEVEN GREENHOUSE

They work largely in the shadows as they clean bathrooms and wax floors at night, but at least 15,000 temporary replacements are being used during the building workers' strike in New York City, according to real estate executives — the biggest use of such workers in recent city history.

Not only is the use of these workers undermining New York's vaunted reputation as a union town, a town where "scabs" were once beaten and scorned, but it has given the building owners a leg up in the strike

by enabling them to keep their buildings from sliding into chaos.

The two sides said they would resume negotiations today, after having broken off talks on Jan. 20. The Secretary of Labor, Robert B. Reich, plans to meet briefly with the negotiators beforehand to urge a settlement.

On the eve of the new talks, the large-scale use of replacement workers seems to have thrown the union on the defensive in the 27-day strike, one of the most important labor contests in the city in a decade.

From across 50th Street one recent day a dozen strikers shouted

"Scab!" with stunning vehemence at two thin, dark-haired replacement workers who were sweeping the sidewalk at Rockefeller Center.

But when the two men, both immigrants from Colombia, ever so hesitantly told their stories and why they leapt at the chance to earn $9 an hour during the strike, they sounded little different from the pickets: they, too, were struggling to keep their families above water in these turbulent economic times.

With a wife and young daughter to

Continued on Page B3, Column 1

February

February, continuation of the cold spell,

back-to-back train crashes, the wounding in Sri Lanka,

and the beginning of the election campaign.

We were introduced to the Republican menu: Phil Gramm,

Lamar Alexander, Steve Forbes, Pat Buchanan, and

of course Bob Dole. The papers never stopped …

every day they came, whether I was sick, whether

I liked it or not, they came. And it just kept on going on

and on and on. My process is labor-intensive —

quilting, piecing it together, working in patterns;

it's what's traditionally considered "feminine" —

it's endurance art.

"All the News
That Fits"

The New York Times

Late Edition
New York: Today, Sun fading behind clouds, cold. High 26. Tonight, light snow late. Low 22. Tomorrow, snow, mixing with ice. High 32. Yesterday, high 39, low 19. Details, page C18.

VOL.CXLV... No. 50,324 Copyright © 1996 The New York Times NEW YORK, THURSDAY, FEBRUARY 1, 1996 $1 beyond the greater New York metropolitan area. 60 CENTS

GIULIANI'S BUDGET CUTS SPENDING 5% AND LOWERS TAXES

REDUCED TO $31 BILLION

Mayor Is Relying Heavily on Albany and Washington Aid That May Never Arrive

By STEVEN LEE MYERS

Mayor Rudolph W. Giuliani presented a preliminary $31 billion budget yesterday that would cut New York City's total spending by nearly 5 percent, continue to reduce taxes and rely heavily on help from Albany and Washington that appears unlikely to come.

As he presented the rough outline of his third budget as Mayor, Mr. Giuliani said the city needed to cut still more to reverse decades of overspending. But this time he couched his austere message in the language of compassion that has marked his oratory in recent weeks.

Even as he vowed to protect "the most vulnerable in society," the Mayor accepted the deeper cuts in welfare and Medicaid proposed by Gov. George E. Pataki, a fellow Republican. And he proposed nearly $700 million in cuts to most of the city's agencies, raising the prospect of further erosion of services used by thousands, if not millions, of New Yorkers.

"Balancing the numbers of the budget, however, is the easiest part of it," Mr. Giuliani said, presenting his proposals in the old Board of Estimate Chambers at City Hall. "The most important part of it is that it balance the needs of people, that it balance the needs of society, that it can't be devoted to one priority."

The Mayor's budget would cut spending on the city's public schools by $160 million, or 5 percent, even as the Board of Education faces deeper cuts in aid from the state and Federal governments. It would also cut emergency rent assistance for poor tenants and lunch subsidies for welfare recipients in job training.

The city's recycling program would face new cuts, as would the three library systems, which may have to close some branches an additional day — now open six days a week.

The city's major cultural institutions, like the Metropolitan Museum of Art and the Brooklyn Academy of Music, face a 16 percent cut and could be steadily declining.

"There are a lot of people who understand the role of museums better than anyone," said William H. Luers, president of the Metropolitan, noting the museum's role as a magnet for tourism. "This kind of cut can only show that this is a very bad year. It's going to be very difficult for us to make up this money."

The Mayor's preliminary proposal, the first step in a long march toward a final budget for the fiscal year that begins in July, came under immediate attack from various

Continued on Page B4, Column 4

INSIDE

Credit Safety on Internet
Mastercard and Visa have agreed on an industry-standard technology to protect credit card transactions over the Internet. Page D1.

Serbs Guard Croatian Prize
Eastern Slavonia, a sliver of land due to be returned to Croatia, is being jealously guarded by the Serbs who hold the area. Page A3.

No Budget, Less Money
With no budget accord, Congress is passing stopgap spending bills cutting agencies' money. Page A16.

Last Cubans Reach Exile
Guantánamo Bay's refugee camps closed as the last planeload of Cubans landed in Florida. Page A8.

New York Sued By Government On Foster Care

$37 Million Collected in Fraud, U.S. Says

By DON VAN NATTA Jr.

Federal prosecutors accused New York City and state officials yesterday of defrauding the Federal Government out of tens of millions of dollars by falsely reporting that services were delivered to thousands of children in foster care.

In a civil suit in Federal District Court in Manhattan, the Government said that from 1990 to 1994 the city's Child Welfare Administration routinely misled Federal officials, falsely that children had received attention from caseworkers when they did not, to obtain millions of dollars from the United States.

To qualify for Federal funds, city officials are required to monitor the care of children in foster homes and file reports on each case once every six months. But in a "substantial percentage" of cases, prosecutors said, there was no evidence that the agency completed the reports.

Instead, the agency's employees were ordered by their superiors to file false data saying that they had conducted the reviews, prosecutors said. Furthermore, the head of the child welfare agency at the time, Robert L. Little, and other agency officials in charge of foster care knew that staff members were not always conducting the reviews, as required by Federal law, the suit said.

The allegations were first brought to the Federal Government's attention by a former employee of the city agency who officials said repeatedly refused to participate in the scheme.

Prosecutors also accused New York State of receiving $37.4 million in Federal foster care funds between 1990 and 1994, even though, they say, the state officials knew the city failed to meet requirements for the money. The authorities are seeking at least $112 million in damages from the city and the state.

The lawsuit specifically accuses the city and state of depriving "needy foster children and their families" of foster services. However, the complaint does not say how widespread these failures were.

"The children of this city who are the most vulnerable and in need of attention have been deprived of critical, federally mandated foster care services," United States Attorney Mary Jo White said yesterday in announcing the lawsuit. "The false claims submitted have resulted in a loss to the United States of millions

Continued on Page B6, Column 2

A wounded Sri Lankan office worker was among those who fled a bombing attack yesterday in Colombo. *Reuters*

Albany Set to Relax Secrecy In Instances of Child Abuse

By RAYMOND HERNANDEZ

ALBANY, Jan. 31 — Spurred by the killing of 6-year-old Elisa Izquierdo, Gov. George E. Pataki and legislative leaders agreed to loosen public disclosure restrictions on child abuse cases, even after a child has died.

Barring any last-minute snags, the agreement would place New York on a growing list of states trying to revamp such laws in an effort to strike a balance between protecting children and safeguarding the privacy of families and of people who are wrongly accused of child abuse.

Six states — Illinois, Texas, Kentucky, Massachusetts, South Carolina and Maryland — have already loosened their confidentiality laws because of growing criticism that the laws have become obstacles to protecting children from neglect, abuse and even death, child welfare experts say. Child welfare officials and caseworkers are not held accountable for mistakes, critics contend, because the public never learns what went wrong.

The agreement in New York comes three months after the death of Elisa Izquierdo, who repeatedly came to the attention of child welfare workers over New York City before she died in her family's apartment on the Lower East Side. The girl's mother, Awilda Lopez, has been charged with beating her to death.

The case prompted a public outcry because numerous warnings were given by relatives, neighbors and teachers that Elisa might be in danger. The furor was heightened when child welfare officials, citing a confidentiality law, refused to discuss the details of the case.

The bill — which officials said was expected to win easy passage in the Legislature and to be signed by the Governor — drew praise from child welfare experts who said it would lift the veil of legally sanctioned secrecy that has allowed child welfare officials to conceal the way they conduct

Continued on Page B6, Column 1

Blast Kills 60 In Sri Lanka; 1,400 Injured

By The Associated Press

COLOMBO, Sri Lanka, Thursday, Feb.1 — A truck packed with explosives rammed into the Central Bank in the heart of Colombo's financial district on Wednesday, killing at least 60 people, wounding 1,400 more and crushing the hopes of many Sri Lankans that the country's long civil war was winding down.

The authorities said the explosion, which ripped through the business district at 11 A.M., was the work of the Tamil Tiger rebels, whose fight for an independent homeland has killed nearly 40,000 people over the last 12 years. But there were no immediate assertions of responsibility.

[Officials of the Sri Lankan Criminal Investigation Department said the Liberation Tigers bombing squad had arrived in the capital from the Jaffna Peninsula in the north on Jan. 27, Reuters reported from Colombo.]

In the chaos that followed the explosion, dozens of people were trapped atop burning buildings. Rescuers in helicopter gunships tried to pluck survivors from roofs, but they were repelled by the heat. Many people were evacuated by ladders; those on the streets were taken away in buses and private cars.

The director of the National Hospital's trauma unit, Hector Weerasinghe, said on Wednesday that 53 people had died. Seven more died by this morning, said Sub-Inspector Lal

Continued on Page A6, Column 1

FEDERAL RESERVE TRIMS KEY RATES TO SPUR ECONOMY

BANKS FOLLOW WITH CUT

Drop in Loan Costs Expected — Quarter-Point Decrease Is Second in Six Weeks

By CHRISTOPHER DREW

WASHINGTON, Jan. 31 — Worried that the economy has slowed and needs a modest spark, the Federal Reserve lowered short-term interest rates today by one-quarter of a point. The move amounts to tossing out a bit of stimulus at a time when housing and retail sales are flagging and consumer confidence is sinking.

It is the second central bank rate cut in less than six weeks. The move is expected to ease borrowing costs for consumers and business, and indeed banking companies, including Citicorp and BankAmerica, shaved the lending rates for their best customers today to 8.25 percent from 8.5 percent.

The Federal Reserve's most important action, trimming the rate at which banks lend money to each other overnight to 5.25 percent, could also continue to buoy the stock market, which has set records the last three days, partly in anticipation of a rate cut, and rose again today, with the Dow Jones industrial average climbing 14.06 points.

The Federal Reserve's top rate-setting committee also lowered the discount rate, which it charges on its own loans to banks, to 5 percent from 5.25 percent.

The cuts provided a significant symbol of reassurance from Washington — in contrast to the recent Government shutdowns and budget battles that have left many Americans feeling far more anxious about the future. The moves were welcomed even at the White House, concerned at strategy meetings over the effect a faltering economy could have on the President's re-election campaign.
[Page D6.]

As large banks cut their prime lending rates, similar reductions are likely to follow in mortgages, home equity loans, small-business loans and some credit card balances, and some economists said they expected the Federal Reserve and private lenders to continue trimming rates over the next few months.

The economy, analysts said, is just now beginning to show it has slowed — and whether the central bank has acted quickly and strenuously enough to keep it from stalling.

Only a handful of economists are worried about a recession now. But over the last two weeks, a steady drumbeat of statistics has made it clear that the nation's economic growth rate has fallen sharply.

Most economists estimate that economic growth fell to a rate of about 2 percent in the fourth quarter from about 4 percent in the previous three quarters. Many also fear that mounting consumer debt loads and damage from snowstorms have slowed it down to about

Continued on Page D6, Column 3

Vacuuming That Asbestos Away

Workers hired by the New York City Department of Environmental Protection vacuum asbestos-tainted mud and water left by Tuesday's water-main break at Madison Avenue and 25th Street. Page B1. *Lonnie Schlein/The New York Times*

Oregon's Mail-In Election Brings Cheer for Clinton and Democrats

By TIMOTHY EGAN

PORTLAND, Ore., Jan. 31 — While the rest of the country fussed over this state's novel election-by-mail, Oregon voters appeared more astonished today at the result of their experiment: for the first time in 34 years, they sent a Democrat to the United States Senate.

What is more, in a race that was seen as a trial run for Congressional races this fall, they elected a liberal Democrat, Representative Ron Wyden of Portland, who not only embraced President Clinton but also put him to work on a last-minute campaign mailgram.

The difference for Mr. Wyden came in Republican and independent suburban districts, where three issues that could haunt the Republican Party in fall national elections — the environment, abortion and Medicare — drove voters to the Democratic camp, according to several polls.

In eking out a victory over Gordon Smith, the conservative Republican and businessman, Mr. Wyden won in the Senate to 53-47.

He will replace Senator Bob Packwood, a Republican who resigned last fall amid complaints of ethical violations and sexual misconduct. With all but a handful of ballots still to be counted, Mr. Wyden won by about 18,000 votes out of more than a million cast, a margin of less than 2 percentage points.

Ron Wyden as he spoke yesterday at the start of an Oregon tour. *Associated Press*

Continued on Page A19, Column 1

Stalin's Music Man Is a Kremlin Star Again

By ALESSANDRA STANLEY

MOSCOW, Jan. 31 — Stalin's last surviving apparatchik has made a triumphant return to the Kremlin.

Tikhon N. Khrennikov, 82, a composer who in his 60 years at the head of the Soviet Composers Union was best known for stifling the great Russian composers Shostakovich and Prokofiev, did not fade away after Communism collapsed.

Instead, the grandiose music he

created for a new ballet, "Napoleon Bonaparte," is being performed to sellout crowds at the 6,000-seat Kremlin Palace of Congresses, under the sponsorship of York International Corporation, an American manufacturer of air-conditioning and heating equipment.

In one of the stranger twists of Russian life, some of the greatest dissident artists and writers to have survived the Soviet period, including

Aleksandr Solzhenitsyn, are ignored and even mocked in their newly democratic homeland, while some of the party faithful who struggled against art's serenely reaping the rewards of the unexamined life.

And few have defied the odds of history more than Mr. Khrennikov, who faithfully carried out the policy of artistic repression and control that were established in Stalin's time, and is now seeing his works performed thanks to the very capitalism he spent his career denounc-

Continued on Page A4, Column 3

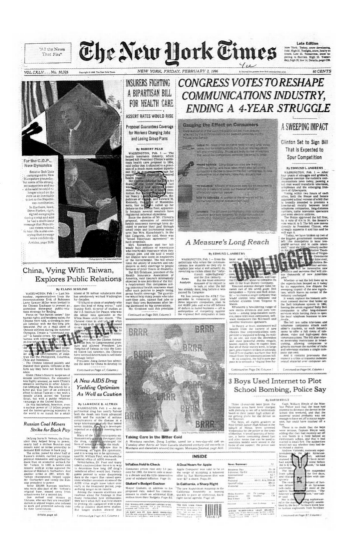

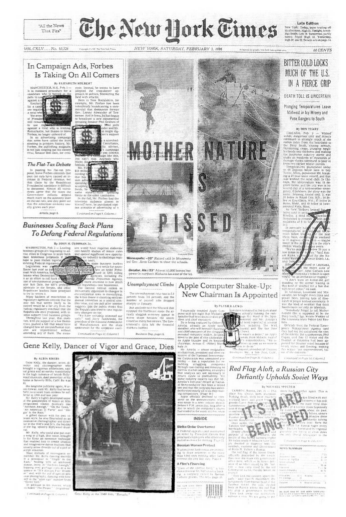

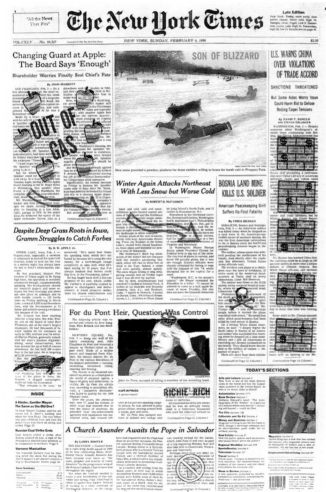

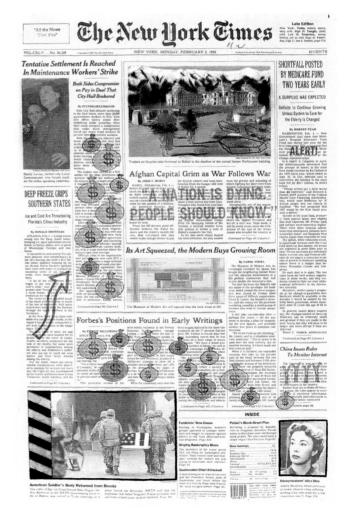

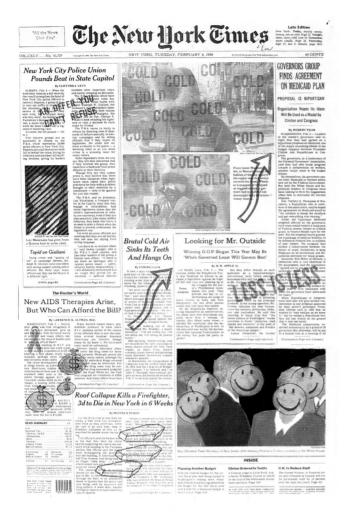

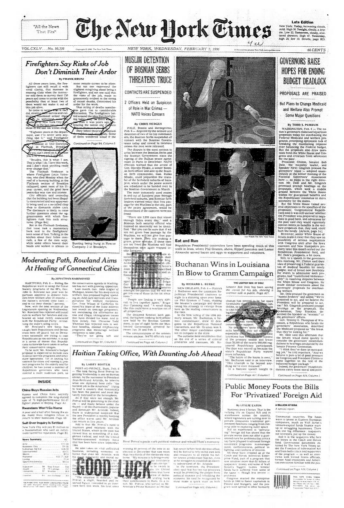

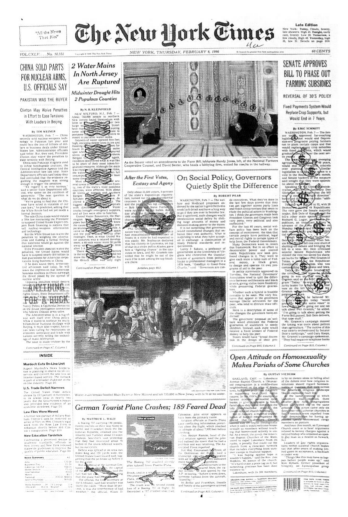

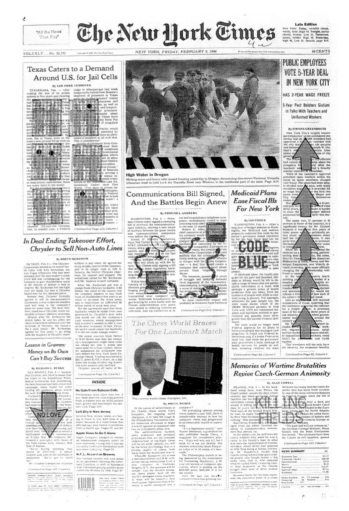

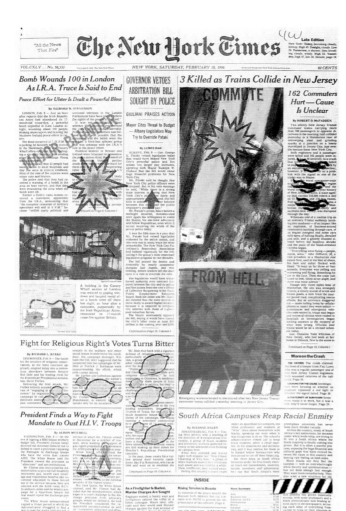

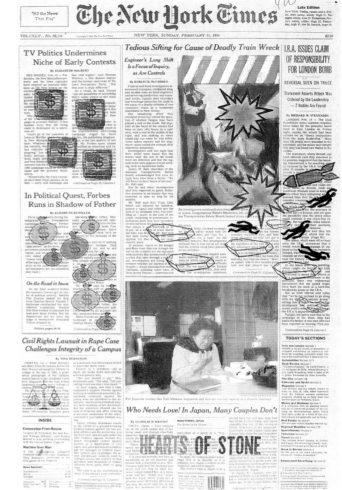

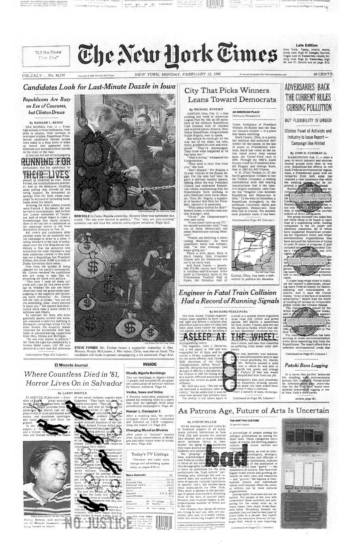

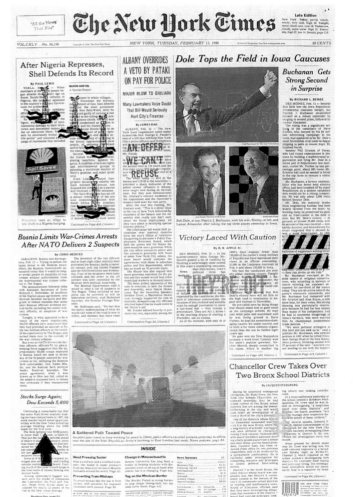

"All the News
That Fits"

The New York Times

Late Edition

New York: Today, snow early, cloudy skies. High 35. Tonight, many clouds. Low 26. Tomorrow, afternoon snow or rain possible. High 37. Yesterday, high 25, low 11. Details, page B6.

VOL. CXLV ... No. 50,337 Copyright © 1996 The New York Times NEW YORK, WEDNESDAY, FEBRUARY 14, 1996 $1 beyond the greater New York metropolitan area. 60 CENTS

Report Warns That New York Area Could Decline

Huge Transit Programs Are Recommended to Save Economy

By KIRK JOHNSON

The New York metropolitan region — the nation's pre-eminent urban center, and a worldwide symbol of opportunity — faces the threat of a long-term economic decline in the 21st century unless residents and politicians summon the will and resources for a multibillion-dollar campaign of transportation improvements, education reforms and urban revitalization, a major planning group said yesterday.

The report, based on a five-year study by the Regional Plan Association, a private research group based in Manhattan, looks ahead 25 years to the year 2020 and predicts two very different possible futures for the 31-county, three-state metropolitan area stretching from Litchfield, Conn., to central New Jersey.

One view features a bleak landscape of crumbling cities, increasingly isolated wealthy enclaves, transportation gridlock, deteriorating air and water. In the end, feeble economic growth. In the other, native fauna, residents enjoy a high-tech trains on a disconnected regional rail system patterned after the Paris Metro, the aging urban centers have been recaptured as places to live, work and play, and lifelong adult education and job banks connect the population to new opportunities in the global economy.

The report said that the first trait would emerge as the region's future if current trends continued unchanged, and that making the other one a reality would require sacrifice, ingenuity and a rejection of some of the region's most treasured tenets, from a government in every small community to the historically arrogant self-identity that holds that the area will always beat a path to New York's door.

"It may be the last opportunity we have," the association's president, H. Claude Shostal, said at a news conference in lower Manhattan. "If we don't do it, we're going to be left behind."

As a small private organization, the Regional Plan Association has no power to back the persuasiveness of its vision. But it has a history of importance of vision on the region and its past convictions. Its board of directors — which includes academics like Jerome Chang, president of Polytechnic University in Brooklyn and officials like Robert R. Kiley, former chairman of the Metropolitan Transportation Authority — move in the upper circles of the region's business and politics.

While the authors of the report acknowledge that the governors of the three states have an office with an emphasis on cutting taxes, they say that such views are too much aimed at the next election or next budget and not at the long-term risk.

The association, the oldest urban planning group in the nation, has gazed ahead twice this century, in 1929 and in 1968. Both of those studies concluded that uncontrolled growth was the New York region's gravest threat.

The new report describes a fundamentally different place: the risk now, it states, is outright decline. That thought, even the subconsciously adopted in the political and

Continued on Page B5, Column 1

■ Urban business areas
▲ Nature reserves
● New rail links

The New York Times

The 25-year plan by the Regional Plan Association is centered on proposals to establish a system of nature reserves, bolster 11 urban areas and fill critical gaps in the area's rail network.

In Nail-Biting Last Chapter, Our Heroine Gets Her Million

By JAN HOFFMAN

In a vote for verbal quantity over literary quality, a Manhattan jury said yesterday that Random House has to compensate the actress-author Joan Collins for a manuscript that its editors have already declared to be unreadable and unpublishable.

Jurors decided that Miss Collins had indeed completed a manuscript in compliance with her contract with her publishers, although they said Random House did not have to pay her for a second manuscript because it was merely a revision of the first and not a fresh work of art. The decision means that Miss Collins can keep her $1.2 million advance and collect more from Random House, though how much more remains in dispute.

The decision capped five days of testimony, during which any pretensions that Miss Collins had to literary respectability were forever shattered and the pre-editing warts of other best-selling authors were exposed by gleeful editors. The trial concluded with Miss Collins earnestly describing the creative process of writing as "a living amoeba" and with grinning jurors lugging copies of her manuscripts as souvenirs.

The case also proved a cautionary tale about the extravagant lengths to which a publisher will go to lure a high-profile name. Random House had hotly pursued Miss Collins in 1990 when she was in full celebrity bloom from her starring role in the nighttime soap opera "Dynasty." In its eagerness to sign her, the publisher jettisoned a standard protection clause, which says that if a publisher is not satisfied with a manuscript, it

can recover its advance.

Instead, Random House agreed to an unusual clause that Miss Collins's agent, the late Irving (Swifty) Lazar, sought for his luminous clients: Anticipating that their prose might be found wanting, Mr. Lazar had insisted that they be paid upon completion of their manuscripts, regardless of whether the publisher thought the writing had merit.

Publishing industry executives have watched the case closely, with some fearing that a victory for Miss Collins may inspire legions of popular writers to seek a similar clause. Random House officials said they were considering an appeal.

The central question of the volatile and voluble trial was over the interpretation of the phrase "complete manuscript." Miss Collins's lawyers argued that if she turned in the required number of words, she was in compliance.

Editors testifying on behalf of Random House, however, stiffly retorted that a complete manuscript was expected to be an author's best,

Continued on Page B3, Column 1

Top Colleges Filling More Slots With Students Who Apply Early

By KAREN W. ARENSON

For many high school seniors, applying to college used to mean filling out forms in December, getting word in April and choosing a campus in May. But now, more and more top colleges are grabbing the nation's best students using early admissions programs, and they are filling significant portions of their freshmen classes before Christmas.

That leaves thousands of applicants setting their sights on the smaller number of places that remain.

By mid-December, Harvard had accepted enough students to fill 60

percent of the spots for the class of 2000. Princeton, Brown, Notre Dame and Massachusetts Institute of Technology had all accepted close to or fill close to half, too, and many other colleges are committed close to one-third. Most colleges demand an amount of commitment from the students who return for the early word.

Early admission programs are not new, but their number has grown. The College Board reported that 471 colleges had some early-admission program last year, up from 371 in 1990.

Admissions officials say the growing emphasis on getting an early commitment is making the selection process even more frantic. Some describe families taking their elementary school children to visit an admissions officer. Others worry that seniors are committing themselves to colleges before they know where they want to go.

"It almost amounts to panic, with

Continued on Page B12, Column 1

AN ON-LINE SERVICE HALTS RESTRICTION ON SEX MATERIAL

CONTROL TO SUBSCRIBERS

Compuserve to Offer Blocking Software Championed by Censorship Opponents

By PETER H. LEWIS

Citing a desire to leave Internet censorship to individual tastes rather than government decree, the on-line company Compuserve Inc. said yesterday that it would restore worldwide access to most of the 200 sex-related computer data bases it had recently blocked under pressure from German prosecutors.

Instead of barring all of its 4.3 million subscribers from access to the controversial sites, Compuserve said it would provide subscribers with software that could be employed to selectively block any material the user finds offensive. While not foolproof, such filtering software can give people a large measure of control over what material they or their children can receive through their computer modems.

Compuserve said, however, that it was maintaining a ban on five of the computer sites suspected by German, American and other law enforcement officials of carrying child pornography.

Although Compuserve described its action as a pragmatic solution to its problems in Germany and said it had no political overtones back home, the announcement comes as a number of governments — including the United States — have moved to restrict the availability of sexually explicit or other types of potentially offensive material over computer networks.

Last week, President Clinton signed a bill into law making it a crime to make indecent material available to minors over computer networks. The new Federal law, the Communications Decency Act, has already been challenged by civil liberties groups, who argue that it is an overly broad and unconstitutional infringement of free speech.

Compuserve will adopt software similar to parental control technology already offered by two other leading on-line companies, America Online and Prodigy Services. Opponents of the Communications Decency Act assert that such technology, offered without charge, is a better way to protect the young and the sensitive, because it lets individual choice — not Government strictures — determine the content of information flowing into and out of personal computers.

The Justice Department has agreed not to prosecute anyone under the new law at least until tomor-

Continued on Page D2, Column 5

Associated Press

Gramm Bowing Out

Senator Phil Gramm is withdrawing from the Presidential race, aides said yesterday. Page B9.

Deficit Looks Tiny as Issue

By DAVID E. SANGER

For nearly two years, the Republican economic rallying cry has been loud, insistent and single-minded: The biggest problem ailing the American economy is the Federal budget deficit, and the country cannot prosper until it is wiped out. But

News Analysis

a Presidential campaign season has a way of rewriting political agendas, and Republicans have learned that what once seemed to play well in Washington does not ring many bells elsewhere.

In recent weeks, a visitor could sit through Rotary Club luncheons in Iowa or New Hampshire and barely hear mention of the deficit. And suddenly a struggle is on to redefine the party's economic priorities, to choose between the shrink-the-Government approach that House Republicans have championed since the 1994 midterm elections and the economic growth messages that Republican candidates for President seem to believe are what the voters want to hear in the 1996 race.

Indeed, the idea that Patrick J. Buchanan and Steve Forbes have in common is to treat the deficit as something akin to the dirty remnants of a big snowstorm — an eyesore that will melt away once country changes its economic climate. And now even Senator Bob Dole, jolted into new tactics by Buchanan's strong finish in the Iowa

Continued on Page B8, Column 5

DOLE OPENS DRIVE IN NEW HAMPSHIRE WITH NEW THEME

MESSAGE OF A POPULIST

Echoing Buchanan, the Senator Attacks Corporate Greed in an Appeal to Workers

By RICHARD L. BERKE

MANCHESTER, N.H., Feb. 13 — Senator Bob Dole opened the seven-day sprint to the nation's first Republican primary here today by reaching for a new economic message tailored to the populism of Patrick J. Buchanan, who finished a close second to the Senator in the Iowa caucuses.

Appropriating a theme that worked for Mr. Buchanan in Iowa on Monday and in his challenge to President George Bush here four years ago, Mr. Dole attacked corporate greed and appealed for the support of blue-collar workers. It was a departure both for Mr. Dole and for the Republican Party, which historically caters more to well-heeled voters.

"Corporate profits are setting records and so are corporate layoffs," said Mr. Dole, looking tired and subdued addressing the State Legislature in Concord. "The bond market finished a spectacular year. But the real average hourly wage is 5 percent lower than it was a decade ago. Two years ago, family earnings were hit with the largest tax increase in the history of America."

As the candidates converged on New Hampshire, there was news of the first casualty in the wake of the Iowa caucuses: aides said Senator Phil Gramm of Texas planned to announce on Wednesday that he would withdraw from the race.

Mr. Gramm had come on forcefully in last year's run-up to primary season, raising millions of dollars and building organizations in several states and early votes. He was unable to translate his efforts into votes. He placed a dismal fifth in Iowa and was upset by Mr. Buchanan the week before in the Louisiana caucuses.

By contrast, Mr. Buchanan was savoring his rise to the top of the competition, while pressing forward with his economic themes. In Manchester, he told a crowd of about 250 reporters: "New Hampshire, like every other part of America, feels that sense of economic insecurity, economic stress they are suffering, too, from wages that seem to go down as the Dow Jones hits 5600."

Until today, Mr. Dole's economic message was largely devoted to the need for a balanced Federal budget. But the unexpected strength of Mr. Buchanan in Iowa, and Mr. Dole's own less-than-decisive showing, seemed to spur the Senator to sharpen his appeal.

While the economic picture has improved dramatically in this state in the last few years — the unemployment rate is 3.2 percent in December, well below the national average — Mr. Dole is clearly banking on the idea that the economy, Mr. Buchanan, who took on Monday in Iowa, is a theme among voters for whom economic problems are a particular concern.

Mr. Buchanan, fighting a head cold and looking exhausted, accused

Continued on Page B9, Column 3

From Cold War, Afghans Inherit Brutal New Age

Reuters

In an execution in Khost last week, Shirin Khan shot to death his nephew Dur Mohammed, convicted of killing Mr. Khan's son. In the Taliban tradition, the father of the victim usually takes the executioner's role.

By JOHN F. BURNS

THE FIERCELY FAITHFUL

A special report.

HERAT, Afghanistan, Feb. 11 — When the crowds were summoned to the main stadium in Herat earlier this month, they went as Romans did to the Coliseum, to watch the ritual of death.

First, the crowd watched a harangue by a Muslim cleric of the Taliban, the Islamic fundamentalist force that emerged from the chaos of civil war in Afghanistan to take control of more than half the country in the last 18 months.

Then Taliban officials turned their attention to an Afghan man who was said to have been convicted by a Taliban court of a triple murder.

After his hands and feet were tied, and a noose put around his neck, he died slowly as the man died, the man died, totally beneath him, his limp.

From the crowd, there were shouts of "Allah be praised!" Outside the stadium, slumped against a wall and wailing, were several women, relatives of the condemned man, covered head to foot in the manner the Taliban prescribes.

The new Afghanistan is a world where murderers and "enemies" of the Taliban are hanged from cranes and the barrels of tank cannon, and the execution of others found guilty of being shot with rifles by their victims, and where convicted thieves are subjected to surgical amputations of their hands and arms.

Not since 1979, when Ayatollah Ruhollah Khomeini led an Islamic revolution in Iran, which borders on Afghanistan only 75 miles west of here, has this region been wrenched so

Continued on Page A8, Column 1

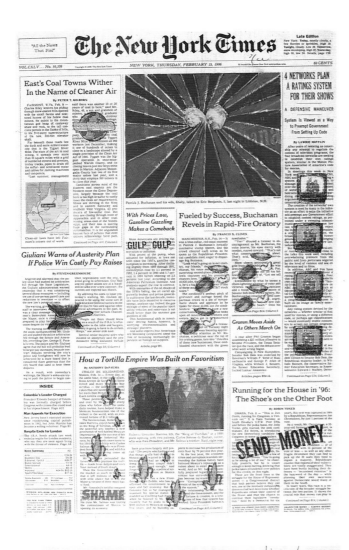
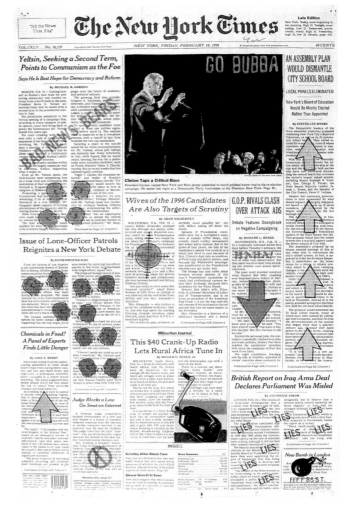
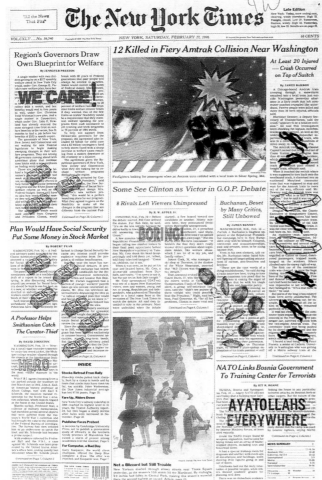
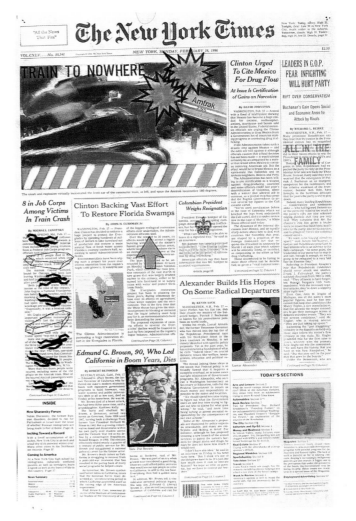

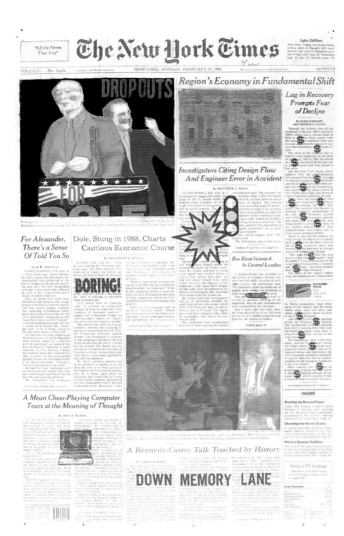
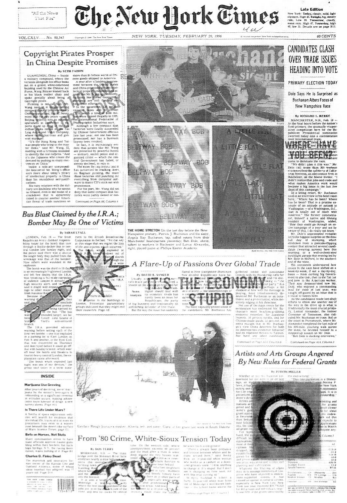
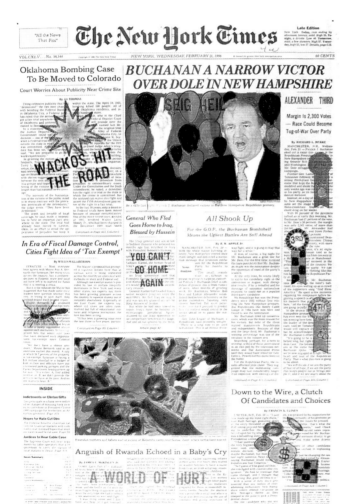
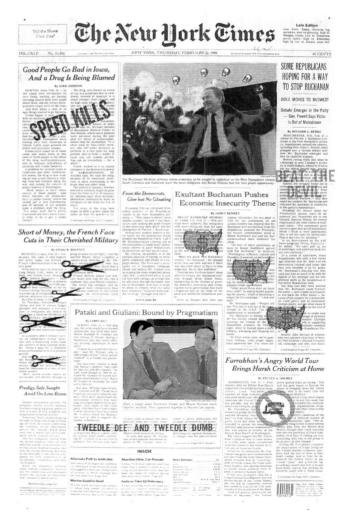

The New York Times

Late Edition
New York: Today, morning fog then some sun. High 60. Tonight, showers late. Low 50. Tomorrow, early showers then clearing. High 58. Yesterday, high 59, low 46. Details, page B14.

VOL. CXLV... No. 50,346 Copyright © 1996 The New York Times NEW YORK, FRIDAY, FEBRUARY 23, 1996 $1 beyond the greater New York metropolitan area. 60 CENTS

GOVERNMENT CUTS MAY CAUSE LOSSES IN LOAN PROGRAMS

DOWNSIZING'S DOWNSIDE

As U.S. Bureaucracy Shrinks, So Could Its Controls Over Liabilities, Audits Find

By JEFF GERTH

WASHINGTON, Feb. 22 — When President Clinton delivered his State of the Union Message last month, no part was more warmly applauded than his declaration that the "era of big government is over."

To the audience and the President, "big government" meant the huge Federal bureaucracy, with its thousands of programs and workers. But even as the number of Federal workers has begun to shrink significantly for the first time in decades, there has been another player in a largely unnoticed side of the ledger: Federal liabilities.

Each time a resident or small business takes out a Federal loan, or a homebuyer seeks a Federal guarantee, or seeks out a farmer seeks Federal insurance against crop damage, the Government's liabilities grow. And the list of Federal liabilities, including loans loan guarantees and insurance is expanding. By 1995, Federal loan guarantees alone are expected to exceed $1 trillion, up from $600 billion in 1992, according to the Office of Management and Budget. And in 1995 the Government set aside between $180 billion and $300 billion to cover costs and estimated losses on these programs.

"People want the Government to go away, to be less intrusive, less bureaucratic and more efficient," said John A. Koskinen, O.M.B.'s deputy director for management. "But they also want all the guarantees, the insurance, the promises that built the fabric of their assumptions about what their lifestyle is like."

But with this unheralded growth of the government's liabilities has come major cuts, beginning with Ronald Reagan, in the numbers of inspectors, auditors and monitors to oversee Federal loans, premises and projects. And with less oversight, experts warn, the financial health of the Federal Government's loan and insurance programs is at grave risk.

The Comptroller General, Charles A. Bowsher, said the General Accounting Office's recent audits have found that the Government now has insufficient financial accounting systems and managers to insure that those liabilities are properly moni-

Continued on Page A20, Column 1

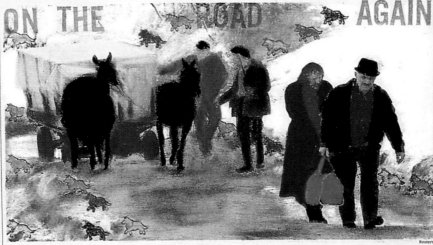

ON THE ROAD AGAIN

Bosnian Serb refugees, fearing Muslim reprisals for the long siege of Sarajevo, slogged along a snow-covered mountain road to Pale yesterday. Reuters

RUSSIA AND I.M.F. AGREE ON A LOAN FOR $10.2 BILLION

A BIG BOOST FOR YELTSIN

Agency Warns It Will Cut Off Funds if New Government Halts Economic Change

By MICHAEL R. GORDON

MOSCOW, Feb. 22 — In a major election-year boost for President Boris N. Yeltsin, the International Monetary Fund and Russia agreed today on a $10.2 billion loan to carry forward the country's free-market reforms.

The announcement followed the bailout of Mexico last year's agreement plan to proceed with a trade liberalization and other critical steps to move Russia toward a capitalist economy.

QUICK FIX

The fund's managing director, Michel Camdessus, who met with Mr. Yeltsin today, insisted the loan was not intended to help the President win re-election this June, but rather to insure that economic reforms will be "truly irreversible."

But Mr. Yeltsin himself has invested the loan with enormous political significance, telling Russian voters that only he has the reformist credentials with Western leaders to secure the loans.

And in announcing the three-year loan, Mr. Camdessus put the Russian electorate on notice that the fund would cut off the money if the Communists came to power and abandoned the reforms.

When the new Government arrives, we will, when confronted with the realities of this country, it will certainly consider this program the best possible for the country," Mr. Camdessus said. "If they don't comply with the commitments of Russia established in these documents, our support would be interrupted."

Today's announcement followed the virtual embrace of Mr. Yeltsin by Western leaders alarmed about the growing support here for the Communist presidential candidate, Gennadi Zyuganov.

President Clinton publicly endorsed the loan last month even though negotiations were still under way.

Chancellor Helmut Kohl of Germany and Prime Minister Alain Juppé of France, for their part, have made recent pilgrimages to Moscow to signal their support for the Russian President and to encourage him to stay on the reform track.

The West has few means at its disposal to influence the Russian electorate, especially since too blatant an endorsement of Mr. Yeltsin could backfire with nationalists. But the West does have money to encourage market reforms here and is willing to use it.

At $10.2 billion, the fund's loan is $1.2 billion more than had been discussed just a month ago. Significantly, more than $4 billion of the loan is to be provided during the first year. That is especially important because Mr. Yeltsin has signed a num-

Continued on Page A2, Column 3

Two New Faces Join Greenspan As Fed Choices

By ALISON MITCHELL

WASHINGTON, Feb. 22 — President Clinton today renominated Alan Greenspan as chairman of the Federal Reserve Board and filled two other vacancies with appointees considered unlikely to strongly dispute the chairman's slow growth strategy to control inflation.

The decision gives a third four-year term to Mr. Greenspan, 69, who was originally named by President Ronald Reagan in 1987 and whose priority has been to fight inflation by keeping the economy from becoming overstimulated. Mr. Clinton named his budget director, Alice M. Rivlin, as vice chairman and appointed Laurence H. Meyer, 51, an economic consultant in St. Louis, to a second vacancy on the seven-member Federal Reserve Board.

Both are Democrats, Ms. Rivlin, 64, and Mr. Meyer, 51, are considered less likely to rock the boat at the Fed than Felix G. Rohatyn, the New York investment banker whom Mr. Clinton originally hoped to name as vice chairman. Analysts said the appointments indicated that Mr. Clinton had backed away from using his appointees to press for a robust public debate on the pace of econom-

Continued on Page D6, Column 1

Dole Adopts a New Persona: Savior of the Grand Old Party

By KATHARINE Q. SEELYE

PORTLAND, Ore., Feb. 22 — Thanks to Patrick J. Buchanan, Bob Dole is starting to find his voice.

In speech after speech on the stump, he has been portraying his race for the Republican Presidential nomination as a struggle on behalf of the party itself. Fighting now for the whole party, a Senator tells reporters on his campaign plane, "not just for Bob Dole."

Until Mr. Buchanan defeated him in the New Hampshire primary on Tuesday, threatening to spoil his last bid for the Presidency and fracture the party in the process, Mr. Dole had delivered desultory campaign speeches based chiefly on the notion that his 35 years in Washington entitled him to the White House.

But in the last two days he has started to argue, with some verve, that he is the candidate who can hold the party intact and defend it against the extremism that he attributes to Mr. Buchanan.

"We're the party of Abraham Lincoln, we're the party of Ronald Reagan, we're the party that brings people together," he said at a Chamber of Commerce breakfast this morning in Englewood, Colo., a Denver suburb.

Later, on a factory tour in Colorado Springs, he said: "I want to unify. I want to bring our party together."

He said the party had "a big tent with a lot of room in it." And, sharpening his attack on Mr. Buchanan, he added, "What we must never do is play on people's fears, or we will never get anywhere."

Mr. Dole chose to press his new theme in Colorado rather than leave in time for a debate tonight at Arizona State University, where Mr. Buchanan and another rival for the nomination, Lamar Alexander, chided him for his absence. [Page A21.]

For the second day in a row, Mr. Dole today characterized the race as a struggle for the heart and soul of the Republican Party, characteriz-

Continued on Page A23, Column 4

Buchanan Drawing Extremist Support, And Problems, Too

By DOUGLAS FRANTZ and MICHAEL JANOFSKY

It was an awkward moment for Patrick J. Buchanan as his campaign car pulled up outside a rally

Mr. Buchanan and his aides huddled quickly at the curb. The candidate did not want to be photographed with Mr. Duke, an aides said, but was reluctant to skip the rally before the state, fearing the nation Republican. But after receiving assurances that Mr. Duke would keep his distance, Mr. Buchanan entered the Quality Hotel in Metairie and delivered his talk. When Mr. Duke tried to put an arm around the candidate near the conclusion, Mr. Buchanan brushed past him, and aides interceded to keep them apart, said two Buchanan supporters who were there.

Despite efforts to keep at least a minimal distance from extremists like Mr. Duke, Mr. Buchanan's campaign has attracted a number of workers and volunteers aligned in the past with Mr. Duke and other

Continued on Page A23, Column 1

Serbs on Trek: Weighed Down And Terrified

By STEPHEN KINZER

SARAJEVO, Bosnia and Herzegovina, Feb. 22 — In yet another of the heartbreaking journeys of war, numbers of Serbs fled their territory, leaving their homes near Sarajevo.

With a shortage of vehicles putting many people afoot, men strained under the weight of sacks stuffed with whatever possessions they were able to carry, women harnessed themselves to sleds, and old people herded livestock ahead of them on their way, step by wretched step, toward the Bosnian Serbs' headquarters in Pale.

The refugees were coming from suburbs of Sarajevo that have been in Serbian hands since the war began here nearly four years ago, but which are due to come under the control of the Muslim-dominated Government beginning on Friday. They fear that the new authorities will seek revenge for the long Serbian siege of Sarajevo.

One of the refugees, Dragana Vasa, fled on foot with her husband, daughter and 85-year-old father. She said she was certain that the Muslim police would arrest her husband, had served in the Bosnian Serb army and perhaps the rest of the family as well.

Asked why she did not trust United Nations pledges that the new Bosnian Government police force would protect human rights, she replied, "The U.N. has never protected the rights of Serbs in this war."

Before leaving, some smashed their windows, doors, furniture, ap-

Continued on Page A6, Column 1

Pataki Proposes Law to Let Prosecutors Appeal Sentences

By CLIFFORD J. LEVY

ALBANY, Feb. 22 — Seeking a far-reaching change in the state's criminal justice system, Gov. George E. Pataki announced today that he would propose legislation that would allow prosecutors to appeal sentences and bail amounts after judges set them.

In his latest attack on a judiciary that he maintains gives too much rights to criminals, Mr. Pataki said that if a prosecutor believes a judge has been too lenient, he or she should be able to ask a higher court to overturn the decision. Under current state law, only defendants can appeal their sentences or bail amounts.

Prosecutors in the Federal system can appeal such rulings, but criminal justice experts said that only a handful of states have similar laws in their courts.

The bill would also stiffen penalties for people who violate orders of protection issued by judges in domestic-violence and other cases, and the Governor portrayed it as a response to the killing of a woman by her former boyfriend in Queens earlier this month. That slaying has stirred a backlash against a Criminal Court judge, Lorin Duckman, who set a low bail for the former boyfriend after he was arrested for beating the woman.

The man, Benito Oliver, was a convicted rapist with a history of domestic violence.

The other criminal justice proposals the Governor has advocated in recent months, the one he announced today drew immediate criticism from civil liberties advocates and reaction from senior Democrats in the State Assembly, the Governor's main rivals in Albany.

The Democrats said they supported Mr. Pataki's plan to increase

Continued on Page B4, Column 5

Queens School Is Succeeding on a Shoestring

By MARIA NEWMAN

In what was once the boys' shower room off the gymnasium at Public School 175 in Rego Park, 21 kindergarten students sat on the floor or a few chairs and listened attentively as Christine Bregman, a science teacher, explained how a magnet could pull certain objects through and

Downstairs, in the school's auditorium, second and third graders sat in as assembly as the principal, Joseph P. Seluga, said that for the first time, they were being asked to take part in a schoolwide candy sale to help the school buy replacement cartridges for their computer printers.

And just inside the front door, Mona Rodriguez, a parent, was filling out paper work on a vision and hearing test that specially trained parent volunteers had conducted on each child. Parents have taken over the task at P.S. 175, Ms. Rodriguez said, to relieve teachers and teacher aides who are already overburdened by state and city requirements.

"They're asking more and more of teachers every year," Ms. Rodriguez said as she sat at the security desk next to a teacher aide, who was herself filling in for the security officer, who was on a lunch break.

At Public School 175 in Rego Park, everyone is pitching in to do more with less.

Six months into a school year in which the Board of Education was asked to cut more than $200 million from its budget, schools like P.S. 175 are running out of space and resources, cramming more children into each classroom and asking parents to do more to support their children's public school education. Although P.S. 175 received slightly more money for textbooks and teachers and substantially more for furniture, the increases come as en-

Continued on Page B3, Column 1

Doing more with less at P.S. 175: once a shower, now a science room.

 354613

INSIDE

Dow Jumps 92.49 Points
Stocks surged in hectic trading for a second straight day. The Dow Jones industrial average rose 92.49 points, or 1.7 percent, to 5,608.46. Page D1.

Thou Shalt Now Post
The Tennessee Senate has approved a resolution urging homes, schools and businesses to post and observe the Ten Commandments. Page A12.

Navy Grounds Jet Fighters
The third crash of an F-14 in a month has led the Navy to ground the jets for at least three days. Page A14.

Military Cuts for France
France announced that its military would shrink by about a third and become a volunteer force. Page A3.

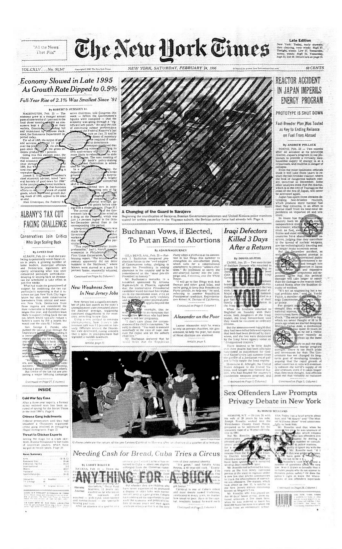

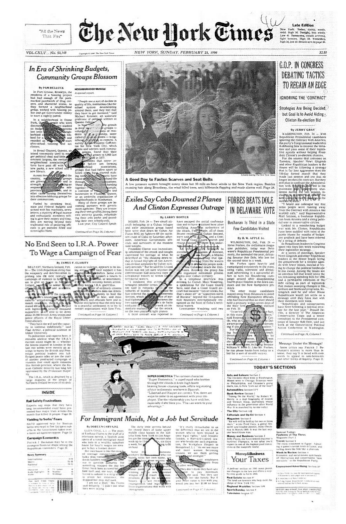

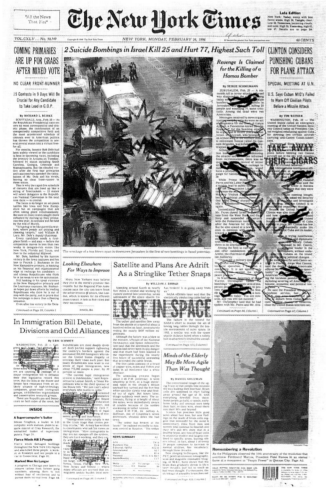

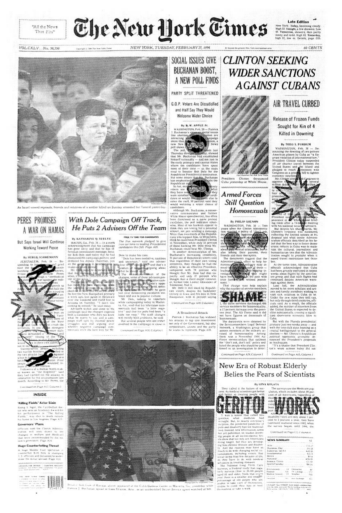

"All the News
That Fits"

The New York Times

Late Edition
New York: Today, mild, showers early, then becoming sunny. High 50.
Tonight, windy, much colder. Low 30.
Tomorrow, sunny. High 34. Yesterday, high 58, low 37. Details, page C18.

VOL.CXLV .. No. 50,351 Copyright © 1996 The New York Times NEW YORK, WEDNESDAY, FEBRUARY 28, 1996 $1 beyond the greater New York metropolitan area. 60 CENTS

Roberto Robaina, Cuban Foreign Minister, arrived at the United Nations yesterday to brief the Security Council on the downed planes.

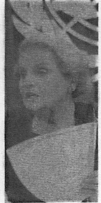

Madeleine K. Albright, United States delegate to the U.N., read from transcripts of radio communications that preceded the downings.

U.S. SAYS CUBANS KNEW THEY FIRED ON CIVILIAN PLANES

RADIO TRAFFIC RECORDED

Washington Says Pilots Were Exultant at Destruction of Aircraft Off Havana

By BARBARA CROSSETTE

UNITED NATIONS, Feb. 27 — The Clinton Administration made public today a transcript of aerial radio conversations that American diplomats say proves Cuban military pilots knew they had targeted a small civilian plane and screamed with glee when they made a direct hit.

"This one is in sight, this one is in sight," the pilot of the MiG-29 told a nearby MiG-23 as the fighters closed in on the three unarmed American civilian planes sent by the Rescue Center and other aircraft.

"Cleared to destroy," the answer from the tower.

The transcripts also asked for authorization and when exulted in the destruction of the first plane: "this one won't mess around any more."

The transcripts were released at a news conference today by Madeleine K. Albright, the American delegate to the United Nations Security Council, before a morning to a meeting which wrecked yet another target. Extracts from this are on Page A6.

Four people are presumed to have died in an incident Saturday afternoon when two of the Cuban-American craft failed to return to the site where they threw flowers into the water.

"I was struck by the joy of these pilots in committing coldblooded murder," Ms. Albright said, noting the pilots' crude references to "taking out the cojones" of their victim and bragging about their own success in similar language. "Frankly, this is not cojones, this is cowardice," she said, visibly angry.

Several air-to-air and air-to-controller conversations in the transcript released today, translated from Spanish by the American Government, seem to demonstrate that at least in the case of one Cessna, the fighter planes made no effort to warn off the civilian pilot as required by international aviation procedures.

The only caution, according to the transcript, was a radio message from air traffic controllers in Havana, as three American planes notified the tower they were crossing south over the 24th parallel, which Cuba regards as an "air defense

Continued on Page A6, Column 5

How Cuban Pilots Were 'Authorized to Destroy' Aircraft

MIG-23 *We have it in lock-on. Give us authorization.*	**GROUND CONTROL** *Fire.*
MIG-29 *It is a Cessna 337.*	**MIG-23** *Give us the [expletive] that we have!*
MIG-23 *That one, that one! Give us the [expletive]!*	**GROUND CONTROL** *Authorized to destroy.*

Source: U.S. Government transcripts

AT&T to Provide Its Customers With Free Access to the Internet

By PETER H. LEWIS

AT&T said yesterday that it would offer its telephone customers five hours of free Internet access each month for a year, bringing computer network service a step closer to becoming a utility like electricity or water.

In addition, AT&T said it would offer residential customers unlimited Internet access, including electronic mail and nationwide phone directory services, for less than $20 a month.

"The Internet is going to take one further step toward being a mass medium," said Eli M. Noam, director of the Columbia Institute for Tele-Information at Columbia University.

The Internet service will begin in March for the estimated 10 million to 20 million AT&T phone customers who have a personal computer and a modem. AT&T said it would provide

A GIANT MERGER OF PHONE AND CABLE

U S West, a regional phone company, will acquire the nation's third-largest cable operator in a multibillion-dollar deal. Business Day, page D1.

customers with free software for using the World Wide Web of the Internet and round-the-clock telephone technical support.

AT&T's rivals, MCI and Sprint, also have programs to provide Internet access to their customers, but are not as comprehensive as AT&T aimed the Internet mainstream America.

"Paul S said institute for the Internet center in Menlo Park this race of online ne to computers and other people, and to do more than voice. Now they are committed to turning the phone line into an information utility conduit."

By its aggressive move into the consumer market, AT&T made clear that it views the Internet as more than a passing fad. At least 15 million Americans are connected to the Internet and on-line information services today.

The Internet is composed of an ever-growing constellation of com-

Continued on Page D7, Column 1

INSIDE

**Habits, Not Genes,
Predict Healthy Old Age**

The way people age may not be a matter of fate or genes, but a matter of how they live. Staying active physically and socially helps successful aging, research shows. Page C3.

Aftermath of Bombings

Palestinian police rounded up scores of suspects in bombings last weekend, while in Teaneck, N.J., mourners remembered two young people killed by one blast. Pages A3 and B5.

Canada Likes the V-Chip

The V-chip, which allows parents to screen out violent television programming, is proving popular in Canada. Page A2.

Gretzky Traded to St. Louis

After weeks of skating in circles, the Los Angeles Kings sent hockey's career scoring leader, Wayne Gretzky, to the St. Louis Blues. Page B9.

Pataki Adviser Gets Subpoena Over Inaugural

By CLIFFORD J. LEVY

ALBANY, Feb. 27 — The Democratic-controlled Assembly issued subpoenas today to Gov. George E. Pataki's top economic adviser and a private lawyer, seeking information about the corporation that financed Mr. Pataki's three-day inauguration last year.

Senior Democrats in the Assembly maintained that the two men and other officials were hiding how they raised hundreds of thousands of dollars for the event.

The move touched off what is likely to be a lengthy battle between the Republican administration and Democratic legislators over the inauguration, an unusual affair whose records have been kept secret by the Governor's aides.

Both houses of the Legislature can issue subpoenas, but in recent decades they have seldom invoked this power. The subpoenas drew an immediate denunciation today from Pataki administration officials, who said they were considering asking a court to declare them void.

"I think that there is a real question as to the authority of what they may and may not do," Mr. Pataki said at a news conference this morning, declining to comment further.

But the Assembly Speaker, Sheldon Silver, said the public had a right to know the names of the people and corporations that donated money for the inauguration.

"This is an extraordinary remedy," Mr. Silver said. "But they have stonewalled every other attempt to

Continued on Page B4, Column 6

Forbes Claims Victory in Arizona Race

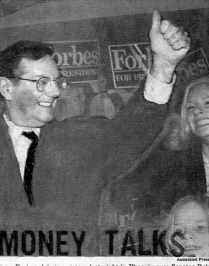

Associated Press
Steve Forbes claiming victory last night in Phoenix over Senator Bob Dole and Patrick J. Buchanan in the Arizona Republican primary. Senator Dole won primaries in North and South Dakota.

Dakotas Choose Dole — Party in Turmoil

By RICHARD L. BERKE

PHOENIX, Feb. 27 — Further complicating an already muddled Republican Presidential competition, Steve Forbes claimed victory in the Arizona primary today, while Senator Bob Dole prevailed in primaries in North Dakota and South Dakota.

The primary here was the biggest electoral prize thus far, with 39 delegates at stake, and by beating out Patrick J. Buchanan and Mr. Dole, Mr. Forbes sought to establish himself as a formidable contender for his party's nomination.

Mr. Dole's pair of victories was overshadowed by the verdict in Arizona, which is likely to rekindle criticism that he lacks the broad appeal and the organizational ability to forge for himself an easy path to the Republican nomination.

But the outcome was an important boost for Mr. Forbes, the publishing heir who pumped millions of dollars of advertising money into his candidacy. He placed something of a roll, having won the Delaware primary on Saturday.

"A week ago they wrote our obituary," Mr. Forbes said at a hotel ballroom here as hundreds of cheering supporters repeatedly interrupted him. Forbes or perhaps convention in California, "that is why Republicans are better off than they were ahead."

Both of Mr. Forbes's competitors, Senator Dole and Mr. Buchanan, conceded defeat. About 60 percent of the precincts reporting, Mr. Forbes had about 33 percent of the votes, while Mr. Dole and Mr. Buchanan were in a race for second with about 28 percent each.

Lamar Alexander, whose campaign had been bolstered by a strong showing in New Hampshire, was failing to break into double figures in any of last night's contests. In Arizona, he trailed far behind with 7 percent of the vote. And in North Dakota, he trailed Senator Phil Gramm, who had dropped out of the race but was still on the ballot.

The most significant result of the busiest day of balloting since the first votes were cast earlier this month is that the race is more scrambled than ever, with three candidates vying for the title of front-runner: Mr. Dole won the Iowa caucuses and North and South Dakota. Mr. Forbes won Arizona and Delaware. And Mr. Buchanan, the conservative columnist, won the New Hampshire primary and the Louisiana caucuses.

Asked at a press conference tonight in Atlanta who the front-runner was, Mr. Buchanan replied: "Boy, you've got a good question there. That's very hard to say."

On his way back to Washington after campaigning in Atlanta, Mr. Dole blamed the heavy advertising by Mr. Forbes for his loss in Arizona. "Forbes spent $4 million — that's what happened," Mr. Dole said. "We

Continued on Page B7, Column 1

Still Talking About Tax Cuts, Congress Goes Back to Work

By ADAM CLYMER

WASHINGTON, Feb. 27 — Congressional Republicans sought today to reclaim their party's agenda from the rhetoric of its Presidential campaign, insisting that what the economy needed was old-fashioned budget balancing and tax cutting.

Congress returned to Washington after a three-week vacation when the Presidential results from its ranks fared badly in the campaign. But one element of Capitol Hill Republican orthodoxy, tax cuts, seemed sure to survive both the upsets of the primaries and the new political buzzwords of "layoffs" and "corporate responsibility."

Arguing that the economy was suffering only from "the Clinton crunch" of tax increases adopted in 1993, Representative Dick Armey of Texas, the majority leader, scoffed at the campaign's invocations of job insecurity and foreign trade barriers as merely "all that noise."

Senator Alan K. Simpson of Wyoming, chairman of the Senate Judiciary subcommittee on immigration, denounced Patrick J. Buchanan's call for a halt to most legal immigra-

tion as "a very unfortunate play to base emotions." Mr. Simpson added, "It's racist."

Speaker Newt Gingrich of Georgia told reporters this morning that he favored attaching a tax cut to a bill to raise the statutory ceiling on the Federal debt. "The failing Clinton economy is hurting people," Mr. Gingrich said. "I think we need something to stimulate and create jobs and keep from a recession."

The Speaker later revived the idea of a deal with the Administration on balancing the budget. "It seems to me possible that there could be an Administration agreement to get a balanced budget deal in the next couple of weeks," he said. But Senate aides familiar with the budget process said they had seen no recent progress suggesting that an agreement was any more likely than it had been since talks broke down in early January.

Another member of the House Republican leadership said Mr. Gingrich had told the group that President Clinton had telephoned him to suggest that they make one more try to reach agreement. At the White House, aides would not confirm that the discussions would lead somewhere.

One central Congressional figure who held back from comment on economic policy was the Senate majority leader, the candidate leader, Bob Dole, who paid a brief visit to the Capitol before leaving to campaign in South Carolina for the Republican Presidential nomination, he said he did not know what the budget situation

Continued on Page A15, Column 1

Nonviolence of Castro's Foes Still Wears a Very Tough Face

By MIREYA NAVARRO

MIAMI, Fla., Feb. 27 — José Basulto, the leader of Brothers to the Rescue and the pilot of the plane that returned safely to Florida on Saturday after two companion aircraft were shot down, used to fight Fidel Castro the old-fashioned way.

In 1961, he took part in the ill-fated Bay of Pigs invasion. He returned to Cuba the next year to fire a cannon at a Havana hotel from a boat.

But five years ago, after a teenager died while fleeing Cuba on a raft, Mr. Basulto founded this volunteer pilots' group, which flies what it describes as humanitarian searches for seaborne refugees but also has swooped over Havana to drop anti-Castro leaflets.

The change in tactics by Mr. Basulto is part of a broader movement among some anti-Castro exiles here, from the crude military actions of the past to nonviolent but aggressive methods of protest. Invoking the legacy of Gandhi and Martin Luther King, this group, and others are reaching a new level of

Associated Press
José Basulto vowed to fly back to the scene of the shooting.

Cuba, the group has single-handedly forced a hardening of American policy.

This Saturday, Mr. Basulto was returning to the Brothers to the Rescue searches in the same waters where the planes were shot down by Cuban fighter jets, drop flowers and pray for the four members of the group who were killed. The action, he said, is consistent with his group's policy of nonviolence and "civic confrontation" with the Castro Gov-

Continued on Page A6, Column 1

Fox Offer: The Fur Flies

By LAWRIE MIFFLIN

To hear the wrath of Rupert Murdoch's competitors yesterday, one would think that the chairman of the News Corporation had devoted treachery.

tial candidates in the fall, so they could make a final campaign pitch to the public.

He even said he had got the idea in part from Vice President Al Gore.

The three traditional networks, through various voices, always off the record, chastised Mr. Murdoch for "grandstanding," accused him of "pretending" to have a news division when only they really had them, scoffed at the proposal itself and accused Mr. Murdoch of toadying to politicians.

Meanwhile, independent analysts who study the news media's role in

electoral politics — and rarely find themselves praising Mr. Murdoch — applauded his plan and said the other networks were overreacting.

Continued on Page B7, Column 1

The New York Times

Late Edition
New York: Today, mostly sunny, windy, colder. High 32. Tonight, mostly clear. Low 21. Tomorrow, sun, then some clouds. High 36. Yesterday, high 60, low 32. Details, page D17.

VOL.CXLV... No. 50,352 Copyright © 1996 The New York Times NEW YORK, THURSDAY, FEBRUARY 29, 1996 $1 beyond the greater New York metropolitan area. 60 CENTS

PRESIDENT AGREES TO TOUGH NEW SET OF CURBS ON CUBA

CHOKING OFF INVESTMENT

Supporters Say Measures May Hasten the Downfall of the Ailing Castro Regime

By JERRY GRAY

WASHINGTON, Feb. 28 — Driven largely by the downing of two civilian American planes by the Cuban military, Congressional negotiators and the White House agreed today on a package of sanctions intended to punish Fidel Castro by curbing foreign investment in Cuba.

The measure, which President Clinton had opposed until this week, would give the weight of law to the nearly 40-year-old embargo against Cuba that has been the policy of every American President since Mr. Castro came to power. That would prevent any President from lifting on his own as Mr. Clinton and others have in the past from certain sanctions without Congressional approval if Cuba's Government had not changed.

But the Administration's visible reaction to the downing of the planes last Saturday also includes more potent provisions that supporters said would deter foreign investment in Cuba and thus hasten the downfall of an ailing regime.

One provision would deny visas to anyone — corporate officer, principal, controlling shareholder — with a stake in a property confiscated in the 1959 Cuban revolution from someone who is now a United States citizen. A senior Administration official said billions of dollars' worth of property now controlled by foreign companies in Cuba could be affected.

"I don't expect our allies will be pleased with this legislation, but we believe it advances an important part of our foreign policy," the official said.

Another provision would allow American citizens whose property was confiscated by the Castro Government to file suit in the United States against any foreign company using that property. But in a concession to win the support of the Administration, it would give the President the right to waive that rule every six months to keep the courts from being choked with lawsuits.

No other nation observes the United States embargo on Cuba. Canadian, Mexican and French companies, among others, have sizable investments there. Canada, for example, imports about $225 million of Cuban goods a year and sends Cuba about $160 million worth of Canadian goods. Canada is expected to challenge the policy under the North American Free Trade Agreement.

Only last summer, Secretary of State Warren Christopher recommended that Mr. Clinton veto this bill. But Cuba's downing of the planes, which had taken off from Florida, put enormous political pressure on the President to act decisively. Mr. Clinton only narrowly lost Florida to George Bush in 1992, and the state is considered a key battle-

Continued on Page A6, Column 1

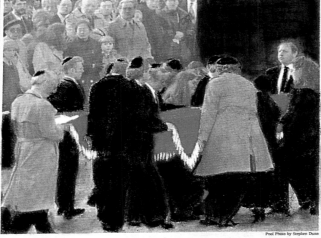

Young Bombing Victims Mourned and Buried
The coffins of Sara Duker, 22, and Matthew Eisenfeld, 25, were carried to their graves yesterday at an Avon, Conn., cemetery. They and 22 others were killed on Sunday on a Jerusalem bus. Page B6.

Pool Photo by Stephen Dunn

Talks on Ulster Set for June 10 By 2 Premiers

By SARAH LYALL

LONDON, Feb. 28 — Declaring that they had resurrected hopes of bringing peace to Northern Ireland, the leaders of Britain and Ireland said today that they had established a date before which all-party talks would begin June 10.

Prime Ministers John Major of Britain and John Bruton of Ireland said Sinn Fein, the political wing of the Irish Republican Army, would be allowed to take part in the talks, but only if the I.R.A. agreed to restore its cease-fire.

The announcement appeared to make important concessions to Sinn Fein and the I.R.A., which ended its 17-month cease-fire earlier this month with a spate of bombing attacks in London.

For the first time, the leaders set a date for inclusive negotiations, long a Sinn Fein demand, and they agreed that such talks could begin before the I.R.A. gave up any of its arsenal, an issue that derailed negotiations up to now.

But the plan also calls for quick elections in Northern Ireland to determine who will speak for the parties there, and Sinn Fein has been suspicious of that idea in the past. It remains unclear whether Sinn Fein will agree to the conditions and, most important, whether the I.R.A. will declare a new cease-fire.

There was no immediate reaction from the I.R.A.

But Gerry Adams, Sinn Fein's president, responded cautiously, welcoming the setting of a date for

Continued on Page A8, Column 4

Death Penalty Is Ruled Out By Morgenthau in 3 Slayings

By GEORGE JAMES

In his first decision in a capital case since New York State reintroduced the death penalty last year, the Manhattan District Attorney, Robert M. Morgenthau, said yesterday that he would not seek to execute two young men charged with killing three members of a Harlem family in a robbery last October.

Mr. Morgenthau, who opposes the death penalty but has said he would consider each potential capital case on its merits, refused to explain his decision. Prosecutors say that a teen-age girl enlisted the two men to rob and murder her strict father, but that instead they killed her and her mother and younger brother.

While Mr. Morgenthau would not elaborate, lawyers for the defendants said they had presented to the District Attorney's office a number of possible mitigating factors, including evidence of the men's mental limitations and psychiatric problems.

One law enforcement official also said that a committee of senior prosecutors in Mr. Morgenthau's office set up to advise him on capital cases

took into account the fact that neither defendant had a record of violent crime and that one of them was only 18. The committee also questioned whether the Harlem crime, terrible as it was, ranked with the most heinous cases, like terrorist attacks, cold-blooded mob killings or torture killings, said the official, who spoke on condition of anonymity.

Since the new death-penalty law went into effect in September, Mr. Morgenthau — the state's best known District Attorney, whose office handles many of the most publicized cases — has walked a fine legal and prosecutorial line, insisting that his personal opposition to capital punishment would not affect his judgment in whether to seek it. By contrast, District Attorney Robert T. Johnson in the Bronx has declared flatly that he will never seek execution, a stance that has provoked harsh criticism from Gov. George E. Pataki and other death-penalty proponents.

But yesterday the Governor said

Continued on Page B4, Column 4

South Carolina Is a Crossroads For the G.O.P.

Old South Confronting New on Trade Issue

By KEVIN SACK

CLINTON, S.C. — With red lipstick from farewell kisses still smeared across both cheeks, Todd E. Alexander went to work at Clinton Mills textile mill. During a midday break, the 23-year-old maintenance technician explained how his involuntary search for a job had intersected with his search for a Presidential candidate in the state's Republican primary Saturday.

"I'm looking for job security and the economy," Mr. Alexander said a few days ago. "It would sure help a lot if a President could help out the companies over here in America and make it so our products are bought." Although he had not ruled out Senator Bob Dole, Mr. Alexander said, Patrick J. Buchanan's protectionist message "is pretty good right now."

Twenty-six miles down State Route 72 in Greenwood, there is a different South Carolina. One of the largest new employers there is the Japanese film giant, Fuji, which recently announced plans to bring 200 people to its work force at a sprawling complex on the edge of town. Since opening its doors in 1989, Fuji has been an important corporate citizen, town leader and $33 million annual payroll coursing through the local economy.

That is the main reason Harry Rankin, a co-owner of the Scuttlebutt bookstore on Greenwood's Main Street that sells office supplies to Fuji, plans to vote for Mr. Dole. "The main thing is that he's not a protectionist," Mr. Rankin said, citing the Fuji plant here and its plans for expansion. "Buchanan's is just a closed-door policy."

On the verge of a crucial Presidential primary, these are the two voices of South Carolina and, by extension, of the modern South itself.

While one voice cries out for Government protection for the mature industries that have employed gen-

Continued on Page B9, Column 3

One Governor's Sway

Carroll A. Campbell Jr., the former Governor of South Carolina who helped George Bush win there in 1988, is promising to do the same for Bob Dole in Saturday's primary.

Article, page B9.

NEW YORK PRIMARY SUDDENLY EMERGES AS A CRUCIAL TEST

FORBES WILL BATTLE DOLE

Court Permits First Contested Statewide G.O.P. Fight for Convention's Delegates

By ADAM NAGOURNEY

With a nudge from Steve Forbes's resurgent campaign, the Republican Presidential primary in New York has suddenly emerged as a central contest on the election calendar, presenting a largely unrestricted race between Mr. Forbes and Senator Bob Dole for 93 delegates, being chosen by voters next Thursday.

A Federal appeals court in Manhattan, upholding an earlier decision that New York's extremely restrictive ballot-access procedures imposed an unconstitutional burden on candidates other than the party leadership's favorite, ruled unanimously yesterday that Mr. Forbes's name must be placed on the Republican ballot in all 31 of the state's Congressional districts. The result is the first contested statewide Republican Presidential primary in New York's history. [Page B8.]

Mr. Forbes's aides said yesterday that he would follow up on his victories in two other primaries — in Delaware last Saturday and in Arizona on Tuesday — with a full-scale effort in New York.

They said he viewed the New York primary as a chance at repudiation of the state's Republican leadership, which, under the guidance of Senator Alfonse M. D'Amato, a leading supporter of Mr. Dole, has been preventing other candidates from getting on the ballot with him.

"I think we have an excellent chance of winning this state," Mr. Forbes told reporters yesterday at a news conference. "What is happening here in New York is that the Republican Party has saturated the airwaves here in New York State as much as it has elsewhere."

His press secretary, Gretchen Morgenson, added: "We are 1,000 percent committed to New York. We are going to force a huge force in New York. We have been brutalized by the New York State Republican Party, and we absolutely, positively going to win New York."

If Mr. D'Amato was dishearted by the appeals court's decision, he did not much show it. "I love this life," he said in Washington. "This is part of the process. This is what we live for, I'm telling you. You live for elections. If you can't handle this, you're not up to it."

Although Mr. Forbes's campaign organization has saturated the state, it said $1 million worth of television time remaining for the week.

Further complicating matters for Mr. Dole, Patrick J. Buchanan will also appear on the ballot in at least 18 of the state's 31 districts. And a

Continued on Page B8, Column 2

Arizona Voting Puts Forbes Back in Race

Although his candidacy had been written off by his rivals, Steve Forbes found himself back in the running for the Republican Presidential nomination with a proposal for a flat tax paying off with a victory in the Arizona primary.

Mr. Forbes's rival Senator Bob Dole in Arizona. But Mr. Dole won in both North Dakota and South Dakota, giving him his first statewide victories since winning the Iowa caucuses earlier this month.

Mr. Forbes now has the largest delegates to his party's convention. Of the 996 delegates needed for nomination, he is leading with 37 delegates, followed by Patrick J. Buchanan, 31, Mr. Dole, 27, and Lamar Alexander, 5.

Article, page B8.

Woes of Modern Russia Mirrored In the Decline of Its Coal Mines

By MICHAEL R. GORDON

SHAKHTY, Russia — Faced with the slow, agonizing decline of one of its vital industries, Russia has begun an ambitious attempt to rescue its failing coal mines.

In the dank, serpentine tunnels of the Yushnaya mine here in southern Russia, where miners toil amid rickety scaffolding, it is clear that the industry is crumbling.

Decades of mismanagement and unfulfilled reforms have created a kind of permanent crisis for Russia's 800,000 beleaguered, but still politically potent, coal workers.

And the stakes go far beyond coal.

continued economic reforms in the face of stiff resistance from managers determined to maintain their control of Russia's smokestack industries.

The restructuring is being carried out under the watchful eyes of the World Bank, which has promised a $500 million loan on the condition that the reforms proceed and that an adequate social safety net be set up for the laid-off miners.

The loan, unlike the new $10.2 billion loan from the International Monetary Fund, would be specifically earmarked for creating a smaller

Continued on Page A3, Column 1

Changing Her Mind, Diana Agrees to Divorce

Diana says she will keep the title Princess of Wales, but Buckingham Palace said this and other issues, like money, were not yet settled.

By SARAH LYALL

LONDON, Feb. 28 — The Princess of Wales said today that she had reluctantly changed her mind and would agree to divorce her estranged husband, Prince Charles, the heir to the British throne.

"The Princess of Wales will retain the title and be known as Diana, Princess of Wales," said a spokeswoman for the Princess, in a statement that overshadowed the announcement of a breakthrough in the Northern Ireland peace effort.

Her announcement, issued just before the evening television news, riveted many in Britain, a country hungry for any scrap of information about the Princess. But it appeared to be a surprise to Diana's in-laws at Buckingham Palace.

"The Queen was most interested to hear that the Princess of Wales had agreed to the divorce," said a Palace spokesman who heard about Diana's announcement when reporters called for a response. While Charles and Diana met earlier today in the Prince's house at St. James's Palace, the spokesman said, "details of the divorce settlement and the Princess's future role were not discussed."

Nor, he added, is it correct to say that the Princess is sure to be allowed to retain her title — an important issue for Diana, who is said by royal-watchers to want to keep as many of the perks of royalty as possible. "All the details on these matters, including titles, remain to be discussed and settled," he said. "This will take time."

Diana's lawyer, Anthony Julius, said tonight that her decision to accede to ending her marriage had been a hard one. "It was an exceptionally difficult decision and one

Continued on Page A8, Column 1

INSIDE

Loans Delayed for China
The Export-Import bank will defer loans for trade with China while the United States weighs evidence that China sold nuclear parts. Page A4.

Daiwa Admits Fraud
Daiwa Bank agreed to pay $340 million, pleading guilty to charges it covered up a trading fraud. Page D1.

The Volatile Stock Market
The stock market has been increasingly volatile, but such swings are a return to historical norms. Page D1.

New Method for Census
The Census Bureau said it would count only 90 percent of the population in 2000 and rely on sampling methods to figure the rest. Page A16.

Grammy Award Winners
Alanis Morissette, Hootie and the Blowfish, and Seal took home the major awards last night at the 38th annual Grammy Awards. Page C13.

March

March had a large series on downsizing

that occupied about seven days.

There was also an international story about the

Korean presidents on trial for their lives for corruption....

A lot of wars...and on March 14, a really unusual photo

with Arabs and Israelis in the same picture...

I had to cover it with doves for peace.

Good science articles—on March 10,

monkey business with the Scopes trial,

and then on the 16th, a comet comes back.

March 28, cosmic debris,

followed by the rush to get out of Hong Kong.

The New York Times

VOL. CXLV No. 50,353 Copyright © 1996 The New York Times NEW YORK, FRIDAY, MARCH 1, 1996 $1 beyond the greater New York metropolitan area. 60 CENTS

Late Edition

Today, partly cloudy, chilly. High 35. Tonight, snow late. Low 27. Tomorrow, period of snow, mixing with sleet or rain near coast. High 38. Yesterday, high 33, low 25. Details, page B6.

House Approves Biggest Change In Farm Policy Since New Deal

Legislation Phases Out Subsidies Over 7 Years

By ERIC SCHMITT

WASHINGTON, Feb. 29 — The House today approved a major overhaul of American farm programs, voting to end 1930's policies that pay farmers not to plant certain crops and to replace many subsidies with fixed payments that would end after seven years.

The legislation, the most far-reaching agricultural bill since the New Deal, ends most Government controls over planting decisions for American farmers. The vote was 270 to 155, with 54 Democrats voting for the bill and 19 Republicans voting against it.

"We've now changed the farm program world," said Representative Pat Roberts, the Kansas Republican who heads the House Agriculture committee.

The Senate approved a similar, but slightly more costly bill earlier this month. Lawmakers from both chambers will likely meet next week

to hammer out a compromise version. Agriculture Secretary Dan Glickman said the bill "fell short" in financing for research, development and food for the poor. He said he would not recommend the bill to Mr. Clinton unless the conference committee altered these provisions.

The Administration and Congress both want to pass legislation soon because farmers are clamoring for action because planting season has begun or will begin soon in many [...]

Glickman also complained [...] elimination of the market-based subsidy payments would deprive farmers of a vital safety net. But with crop prices at 10-year highs, [consumer] [...] the fixed payments [...] would actually cost [...] the next few years than current subsidies, which fall [...] prices are high.

"This is a cruel hoax on the American taxpayer since the payments are clearly overloaded," said Mr. Canfield, a vice president at Public Voice for Food & Health Policy, a consumer research organization in Washington.

The conference's overall bill rests on the notion that, for the first time, would establish the link between what farmers plant and how much the Government pays them. In its place, the measure would provide fixed payments to farmers that the payments would gradually decline over seven years. [...] open market [...] the bill's sponsors argue that this approach would cut about $3.6 billion over seven [years] compared to the present system.

Midwestern farms support such support [...] have misgivings when it comes to how much is spent. But because the fixed payments are based in part on acre-

Continued on Page A25, Column 1

JUDGE'S DECISION BOLSTERS GINGRICH

An Accusation Against Gopac Is Thrown Out of Court

By ADAM CLYMER

WASHINGTON, Feb. 29 — A Federal judge today threw out a major accusation involving Speaker Newt Gingrich, ruling that the political action committee Mr. Gingrich headed did not make illegal campaign contributions to him and other Republicans, as the Federal Election Commission had charged.

That accusation was also central to one made by Representative David E. Bonior, Democrat of Michigan, to the House ethics committee. Mr. Bonior, the second-ranking House Democrat, also accuses Mr. Gingrich of improperly helping contributors to the PAC and of taking its money for personal use. The committee has not decided whether to consider the case.

Mr. Gingrich's allies hailed today's ruling as vindication both for the Speaker and for Gopac, known as Gopac. But the committee was not done with the other matters involving [...]

In the past several days, the committee has issued subpoenas to more than a dozen individuals and organizations involved in a course that Mr. Gingrich taught at Kennesaw State College and Reinhardt College, both in Georgia. The committee's special counsel, James M. Cole, is investigating whether the course was used for partisan purposes and whether tax laws were violated.

While the committee declined to

Continued on Page A14, Column 4

Food to Get Vitamin To Halt Birth Defects

For the first time, the Food and Drug Administration has ordered that foods be fortified with a vitamin to prevent birth defects. The substance, folic acid, protects against neural tube defects like spina bifida.

Starting in 1998, folic acid will have to be included in fortified foods like flours, corn meals, pasta and rice. The vitamin also occurs naturally in fruits and vegetables, and women who consume adequate amounts during the first six weeks of pregnancy reduce the risk of having babies with neural tube defects by up to 70 percent. About 2,500 babies are born in the United States each year with such defects.

Article, page A10.

Pool photo by Lou Krasky

Patrick J. Buchanan and Lamar Alexander joined two of their rivals in a Republican debate in South Carolina.

Republican Debate Reveals Rift on Abortion

By KATHARINE Q. SEELYE

COLUMBIA, S.C., Feb. 29 — For the first time since the Iowa caucuses more than two weeks ago, cultural issues, particularly abortion, were back on the table today as the Republican Presidential race moved South.

At a debate here among the four leading candidates, each was confronted with the question about abortion, including the question whether they would submit prospective Vice-Presidential running mates to a litmus test on the matter.

The debate also touched at times on matters like South Carolina's practice of flying the Confederate flag atop its Capitol and how the candidates felt about allowing women to enroll at the Citadel, the state-supported military institution that has tried to keep its cadet corps all-male. [Page A22.]

But the focus was on abortion, and the question that seemed to make some of the candidates, particularly Senator Bob Dole, the most uncomfortable was a provocative one asked by a female reporter.

"If I were raped by a vicious criminal and became pregnant," she asked, "would you oppose a first-trimester abortion, knowing that a continued pregnancy would cause me mental and emotional anguish?"

Senator Dole replied: "Yes, I would. I'm opposed to abortion, as I've indicated before. I have a strong pro-life record, a consistent record in the Congress of the United States, and I would keep it that way."

But after two of his rivals, Lamar Alexander and Steve Forbes, responded that they would permit an abortion in the case of rape, Mr. Dole revised his answer, saying he, too, would make such an exception. After the debate, both he and his press secretary offered further clarifica-

Dole's Replies in Debate in the South Leave a Muddled Stance

tion of his position.

Of the four candidates present, only Patrick J. Buchanan said without any subsequent qualification that he would urge the questioned to have the baby. "If that happened to you," Mr. Buchanan said, "it would be a horrendous atrocity, and it's happened too many times in this country. And what I believe should happen to the rapist in a case like that, if it was particularly vicious and you had a serial rapist, I would vote for his execution.

"As for you," Mr. Buchanan add-

ed, "I would try to counsel you to go to my friend, the Piedmont Women's Center, run by a friend of mine, who counsels those who have been raped and begs and urges them and pleads with them and provides support for them if they will only carry the child to term and we can put it up for adoption. I would try to counsel you to do that, because I believe the unborn child is innocent. And the only guilty party here is the rapist."

This was not the first time that Mr. Dole had found himself trying to clarify his remarks on abortion.

On the NBC News television program "Meet the Press" earlier this year, he said he had once supported a constitutional amendment to ban all abortions unconditionally but added, "I would not do it again." He

Continued on Page A22, Column 5

Buchanan's New York Drive: Low in Money, High in Zeal

By JONATHAN P. HICKS

From his home in Hempstead, L.I., Gary R. Grella frantically works the phone, distributes fliers and otherwise runs his slice of Patrick J. Buchanan's New York campaign with more fervor and passion for what he calls "counterinsurgent."

"You're talking to campaign headquarters right here on the kitchen table," said Mr. Grella, a 48-year-old engineer's aide for the Village of Hempstead.

"I've put in more money to the campaign than the Buchanan people down at headquarters," he added, pausing to calculate the telephone bills and photocopying costs that

BUCHANAN STRIKES A CHORD

Voters in Flint, Mich., are attracted to Patrick J. Buchanan, especially on the issue of trade. Page A22.

"I've put in $700."

Heading into the New York Republican Presidential primary next week, Senator Bob Dole of Kansas has a solid lock on the powerful party organization. Steve Forbes's current campaign has the money, being believable its promise to spend $1 million on television advertising across the state over the next [...] days.

Mr. Buchanan's campaign, however, clearly has the fervor. In his scattered network of haphazardly organized volunteers, Mr. Buchanan has cobbled together a campaign operated by a passionate assortment of anti-abortion activists, Conservative Party members and many blue-collar Republicans who express disenchantment with the state party, which worked so hard to keep Mr. Buchanan off the ballot.

Like Mr. Grella, many have spent hundreds of their own dollars. And they hope to turn their enthusiasm into an unexpectedly strong showing, with the aim of winning at least

represent the bulk of Mr. Buchanan's operation in Nassau County.

Continued on Page A20, Column 1

U.S. TO SHEPHERD PROTEST OFF CUBA BY AN EXILE GROUP

MOVE TO AVOID ANY CLASH

Clinton Cautions the Cubans Not to Hinder a Ceremony Honoring Dead Pilots

By STEPHEN ENGELBERG

WASHINGTON, Feb. 29 — In a move aimed at heading off another confrontation between Cuba and anti-Castro activists, President Clinton today ordered the Coast Guard to escort Cuban-American protesters who plan to take boats and small airplanes into the Caribbean on Saturday.

A White House spokesman said the escort was intended to make sure the protest, commemorating the shooting down last week of two American aircraft by the Cuban Air Force, would be confined to international airspace.

At the same time, Mr. Clinton warned the Cubans not to interfere with the ceremony, which is to honor the four Cuban-Americans who were killed when their Cessna planes were destroyed.

The steps announced today seemed intended as much to restrain the protesters as to protect them, and Administration officials said they were determined to avoid any further deterioration of relations with Cuba. There have been fears that ships or aircraft joining the protest — or operating independently of it — might try to penetrate Cuba's territorial limit.

The rescue, which was a Miami-based group, conducted last Saturday's failed flight and is organizing the new protest, has in the past flown inside Cuban airspace. One plane did so on Saturday, according to United States Government radar tracking.

Administration officials today rejected suggestions that their plan could put the Coast Guard into the middle of a potential conflict, saying they had no indication that the protesters intended to enter Cuban territorial waters.

"We do not believe there's need to defend anybody from anything," said a senior Coast Guard official who briefed reporters on the condition he not be named.

The Cuban-American groups plan to place a wreath in international waters at the spot about 17 miles off the Cuban coast where the United States says MIG's shot down the planes. That position is outside Cuba's territorial waters but inside Cuba's air defense zone.

In shaping its policy toward Cuba this week, the Administration has struck a delicate election-year balance between domestic politics and foreign policy.

Mr. Clinton has been particularly sensitive to the political repercussions of President [...] actions since a flood of Cuban refugees were housed by the Carter Administration at Fort Chaffee in Arkansas in 1980, a move that Mr. Clinton believed contributed to his defeat for re-election as Governor that year.

The White House is also concerned about the activist Cuban-American political community, not only in Florida, which is a highly competitive and important special state for Mr. Clinton's re-election, but also in places like New Jersey, which the Democrats for the first time since 1964 and would badly like to keep in his column this fall.

The attack last Saturday already has transformed American foreign

Continued on Page A6, Column 1

INSIDE

A Talk With the I.R.A.
Roman Catholic political leaders said they had met with the Irish Republican Army and believe that it might restore a cease-fire. Page A3.

Whitewater Inquiry Halted
Senate Democrats used a procedural tactic to temporarily halt the Senate's Whitewater inquiry, which they have called political. Page A25.

Dissent on Cholesterol
A large physicians' group says guidelines for cholesterol testing include too many people. Page A18.

Jets Splurge on O'Donnell
The Jets signed former Steeler quarterback Neil O'Donnell for $25 million over five years. Page B9.

Hard Times for 80's Titans
How the takeover titans of the 1980's have fallen: Michael Milken has had his probation extended, and T. Boone Pickens, once a raider, has turned to a friendly investor for help. Page D1.

BOB JOHNSON BET **MICHAEL S. OVITZ** Disney **PRESIDENT BILL CLINTON** **TED TURNER** Turner Broadcasting **VICE PRESIDENT AL GORE** **BOB WRIGHT** NBC **RUPERT MURDOCH** Fox **PETER LUND** CBS

Paul Hosefros/The New York Times

TV Executives Promise Clinton a Violence Ratings System by '97

By ALISON MITCHELL

WASHINGTON, Feb. 29 — Showcasing the persuasive powers of the Presidency, President Clinton today summoned the leaders of the entertainment industry to the White House and was rewarded with an industry pledge to produce a violence television ratings system by next January.

Presiding over a two-hour session in the state dining room, Mr. Clinton

led 30 media industry executives, including the heads of the four broadcast networks and the major cable networks, through a discussion ranging from ratings issues to the quality of children's television. And by doing so, the President positioned himself to seize the lead from the Republicans in the increasingly potent political debate over the content

of popular culture.

The election year tug-of-war the executives found themselves caught in was abundantly clear.

At the White House, Vice President Al Gore credited the President, the First Lady and his wife, Tipper Gore, for leading the way in the crusade against television violence. Hours earlier, Speaker Newt Ging-

rich, holding his own breakfast with the entertainment executives, attributed the movement to clean up television to former Vice President Dan Quayle and his 1992 assault on the television character Murphy Brown for having a child out of wedlock.

"That was then picked up frankly by Senator Dole," he said, referring to the Republican Presidential contender Bob Dole's assault on Holly-

Continued on Page B14, Column 1

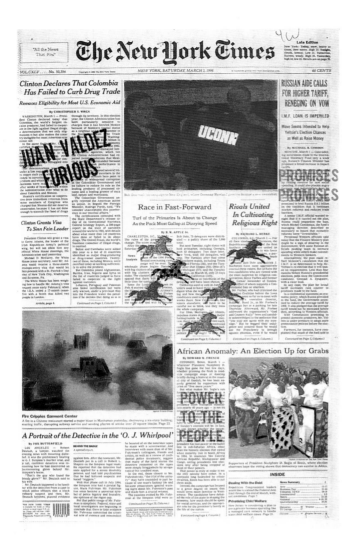

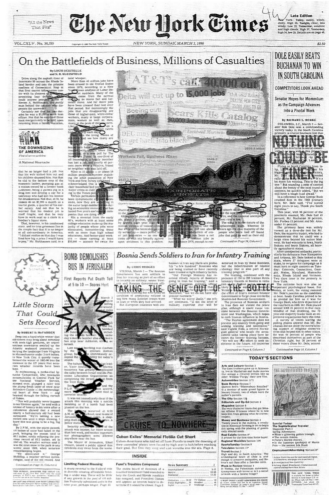

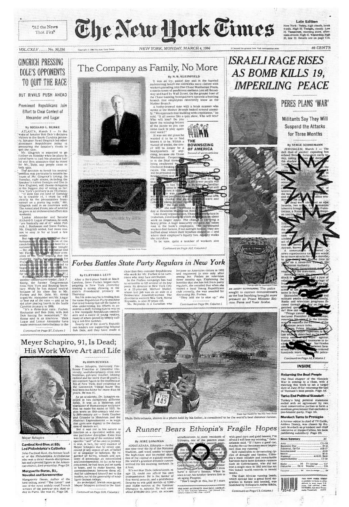

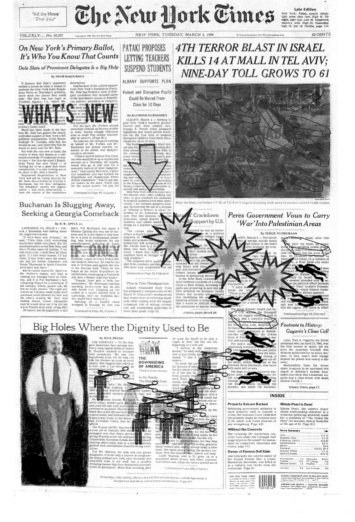

The New York Times

VOL.CXLV...No. 50,358 Copyright © 1996 The New York Times NEW YORK, WEDNESDAY, MARCH 6, 1996 $1 beyond the greater New York metropolitan area 60 CENTS

Late Edition
New York: Today, rain tapering off as showers. High 41. Tonight, a few showers. Low 34. Tomorrow, showers, maybe thunder. High 43. Yesterday, high 61, low 32. Details, page C18.

A Hometown Feels Less Like Home

By SARA RIMER

DAYTON, Ohio — To Wall Street and the world, it was the National Cash Register Company. Then, it was modernized, computerized, streamlined down to NCR. But in Dayton, the company was always just "the Cash."

The Cash got rich selling its cash registers to the world, and it rewarded its workers with good livings and unrivaled benefits, and its hometown with a synonym hand of its workers. Millions of dollars of works. They were all bound together — the company, the workers and the town. A lot of people here, Dayton was the Cash, and the Cash was Dayton.

"NCR was part of Dayton's soul," George Bayless, a 58-year-old banker said as he drove past the vacant swath of Main Street where 30 yellow-brick NCR factory buildings once stood.

As a boy, Mr. Bayless learned

THE DOWNSIZING OF AMERICA
Fourth of seven articles:

In the Community, Fraying Bonds

to swim in the big pool in the park that NCR's founding patriarch, John Patterson, built. He played French horn in the NCR high school in 1955, he walked down the aisle of an NCR auditorium, just as generations of high school graduates had before him, and would for two decades more.

Nearly all of it has vanished in the steep decline and takeover of NCR: the buildings, 20,000 jobs,

even the NCR name; the security, the middle-class aspirations, the way of life. And today, as its faraway corporate parent, AT&T, prepares to break into three pieces, the future of Dayton's hometown company is profoundly unsure.

The same could be said of the future, and the present, of the entire town. For Dayton was always much more than just the Cash. Daytonians invented and manufactured many of the staples (and a few of the quirky incidentals) of American prosperity — the cash register, of course, and the airplane, but also the automobile self-starter and pop-top top. Frigidaire, Delco, Dayton Tire, Huffy Bicycle and Esther Price Chocolates started with the company in an unwritten social contract crafted on a foundation of profits and jobs, plenty of jobs.

Now, this test marketer's vision of average America is deep in the passage between the nomination.

NCR helped give Dayton an identity, with institutions like a school and auditorium, which were razed when hard times came.

Associated Press

Continued on Page A16, Column 2

DOLE, SWEEPING 8 PRIMARIES, CALLS FOR PARTY TO UNITE; ALEXANDER READY TO QUIT

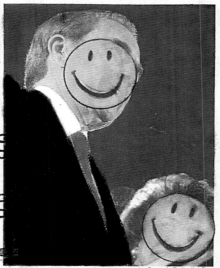

A triumphant Bob Dole with his wife, Elizabeth, in Washington.

Amy Toensing for The New York Times

KANSAN FAR AHEAD

Buchanan and Forbes Trail in Most Votes but Will Stay On

By RICHARD L. BERKE

Senator Bob Dole won a clean sweep of eight primaries spanning New England, the Rockies and as far South as Georgia yesterday, leaping far ahead of his rivals in the biggest test thus far of the Republican Presidential primary season.

In a string of triumphs in politically and geographically diverse states that he said demonstrated his ability to unite the Republican party, Mr. Dole handily won in Georgia, Massachusetts, Colorado, Connecticut, Maryland, Vermont, Maine and Rhode Island.

By late last night, the results claimed two casualties, former Gov. Lamar Alexander of Tennessee and Senator Richard G. Lugar of Indiana. Aides to both said they would announce their withdrawals from the race today.

Two of Mr. Dole's rivals who have never held elective office — Patrick J. Buchanan and Steve Forbes — vowed to press on even though they competed for a distant second or third place in most of the contests yesterday.

At a boisterous victory rally on Capitol Hill, Mr. Dole set his sights on President Clinton instead of dwell on the intramural competition. After buoyantly reciting state after state where he had won, Mr. Dole declared, "Tonight we're proving the pundits wrong," and pretty soon we're going to unite and beat Bill Clinton in 1996."

Calling on the party to rally around him only weeks after his lead seemed to be jeopardized by chaotic early primaries, the Kansas Senator, who is making his third try for the Republican nomination, added: "All my life in politics, I've been trying to bring America together. And I'll do the same as the Republican nominee. And I'll do the same as the President of the United States."

Mr. Dole claimed a majority of the 208 national convention delegates that were selected yesterday; 996 are needed for the nomination. Mr. Forbes was a distant second in the overall delegate tally.

In light of the daunting numbers, Mr. Alexander met with his top advisers tonight to consider his future course. He canceled campaign events in Florida today, and aides said he planned to travel home to Nashville and pull out of the race.

"Governor Alexander will be mak-

Continued on Page B7, Column 1

Finding the Formula

By R. W. APPLE Jr.

ATLANTA, March 5 — Through two campaigns and the start of a third, Bob Dole was the man who could hardly win a Presidential primary. Now, presto change-o, he has turned into the man who can hardly lose one.

> **News Analysis**

His clean sweep of the most closely-watched of today's primaries — in New England, the Rockies, in Borden and in the Deep South — demonstrates his national appeal. Even polished candidates with democratic opponents and appeal. The result is the him the strong, if not overwhelming, favorite to win the Republican nomination unless he stumbles in the New York primary on Thursday, which now seems much less likely.

Harold Wilson, the British Prime Minister, once observed that a week is a long time in politics. Bob Dole

knows better. In the turbocharged world in which he is competing, a couple of days can be a lifetime. Less than a week ago, the oddsmakers were writing the Kansas Senator off after a series of lackluster performances, now at least for the moment, he looks almost as inevitable as the sunrise.

Asked by reporters this afternoon whom he considered his chief opponent, the suddenly sanguine Mr. Dole replied, "Bill Clinton."

Mr. Dole's triumph in South Carolina on Saturday marked the turning point, but he ran much less powerfully in winning Georgia today. Here he had neither strong organizational support (the Democrats control the Statehouse) nor a powerful intermediary with the religious right like Gov. David Beasley of South Carolina, who filled that role there.

In the simplest terms, Mr. Dole is succeeding by taking some of Patrick J. Buchanan's natural supporters away from him, because they think he has a better chance of defeating President Clinton, because they find Mr. Buchanan too extreme, because Mr. Dole has finally started to play to his strengths, or for some other reason. The defections are substantial.

The religious right had been considered Mr. Buchanan's strongest constituency, for example, and so it proved early on, but not in South Carolina. In Georgia, Mr. Buchanan recovered a bit among such voters, but Mr. Dole did respectably, according to a survey of those leaving the polls by the television networks and The Associated Press. And in

Continued on Page B7, Column 1

At Last, New York Has Piece of Action In Republican Race

By ADAM NAGOURNEY

From Buffalo to midtown Manhattan, the three major Republican Presidential candidates raced their campaigns across New York yesterday, staging the kind of last-minute political displays that strategists.

GAG D'AMATO

Senator Bob Dole began the campaign day on a traditional note. He paid tribute to New York's politicians, its culture and concerns at a Manhattan breakfast with civic and political leaders.

It fell to Patrick J. Buchanan to end the day on a more incendiary note. On a visit upstate, he exuberantly attacked New York's most powerful Republican party leader, Senator Alfonse M. D'Amato, using the kind of venom politicians normally reserve for campaign opponents.

"I would urge my voters not only to come out and vote for Mr. Buchanan but to repudiate the corrupt politics of Al D'Amato," Mr. Buchanan said during a news conference in Buffalo. "A vote against Senator Dole will be a vote for open and clean politics in the State of New York."

Between those events, the third major candidate, Steve Forbes, took

Continued on Page B6, Column 1

Move in Senate Aims at Cutting Corporate Aid

By RICHARD W. STEVENSON

WASHINGTON, March 5 — Acknowledging that Congress does not have the political will to do the job itself, a bipartisan group of senators pushed today for the formation of an independent commission to help drastically cut the subsidies and tax breaks for business that they called "corporate welfare."

With the business society emerging as a potent issue, the Presidential primaries, the senators, ranging from conservative Republicans like John McCain to liberal Democrats like Edward M. Kennedy, argued that the time was right for a sweeping reduction in the tens of billions of dollars in special breaks.

While the benefits help particular companies and industries and do protect some jobs, they said, they also cost taxpayers money, inhibit competition and slow long-term growth.

But since Congress has proved not to have the stomach to confront the issue, the senators said, the only realistic way of doing so was to turn the problem over to a panel of appointees who would presumably be less susceptible to pressure from lobbyists, interest groups and campaign contributors.

Legislative aides said the proposal was bound to be hotly disputed because many in Congress are wary about offending powerful interests. And though the idea has won the backing of members of both parties and of policy research groups across the ideological spectrum, it is unclear whether there will be enough Congressional support to enact legis-

Continued on Page D2, Column 1

House Panel Backs Alien Farm Workers

Bowing to big farming interests, the House Agriculture Committee approved an amendment to the House immigration bill yesterday that would grant temporary work visas to up to 250,000 foreign farm workers, even though many Republicans say the move would only encourage a flood of illegal immigrants.

The overall bill that the committee is considering would impose a tough crackdown on illegal immigration, which has become a major theme in the Presidential campaign, and several Representatives condemned the

amendment yesterday.

What large farmers and ranchers fear, their lobbyists say, is that the new immigration bill might work too well, and that the additional border guards and sophisticated new systems employers would have to use to confirm an alien's legal status would dry up their labor market.

But opponents of the measure, including the Administration, say there is no farm worker shortage and that farm interests are just seeking a surplus of cheap labor.

Article, page A14.

Israeli Forces Seal Off Big Parts of West Bank

By SERGE SCHMEMANN

JERUSALEM, March 5 — Israeli troops fanned out across the West Bank today, welding shut houses and barricading Palestinians in their towns and villages in retaliation for four attacks within nine days by suicide bombers.

A new Israeli crackdown got under way and military a after elements, bombings, things, the entered divided controlled

the other side a Tel Aviv on Monday that took 14 lives, was the work of Hamas. An anonymous caller to Israel Radio's Arabic service, who purported to be calling in the name of Hamas, said the attack was carried out by Islamic Holy War, a small group based in Syria dedicated to attacks on Israel.

In any case, after four consecutive bombings in which 61 died, including the bombers, Israel was in no mood to look for twenty-five subtleties which looked increasingly to be foregone.

Prime Minister Shimon Peres, visiting the West Bank where four soldiers were killed in the beginning. "They had their say," he said. "They'll get a response."

Among the first houses sealed off at dawn, in a village north of the West Bank city of Nablus, belonged to the family of Yahya Ayyash, the bomb maker known as "the Engineer" in whose name the first three bombers blew themselves up. Mr. Ayyash was as-

Israelis were left reeling by a series of bombings. A teen-ager yesterday mourned three of her friends killed in Tel Aviv blast. Page A12

Continued on Page A12, Column 1

INSIDE

Beyond Mendel's Pea Pods

Driven by discoveries in genetics and an assortment of ethical and social issues, biology students are asking complex questions about inherited traits and disease. Page B9.

Fight Over Gay Marriage

Conservatives are campaigning across the nation to insure that the possible recognition of same-sex marriages in Hawaii in 1997 will not spread to other states. Page A13.

At Denver Airport, Success

Shaking off embarrassments caused by delays, cost overruns and devoured luggage, Denver International Airport is emerging as an efficient and profitable travel hub. Page A13.

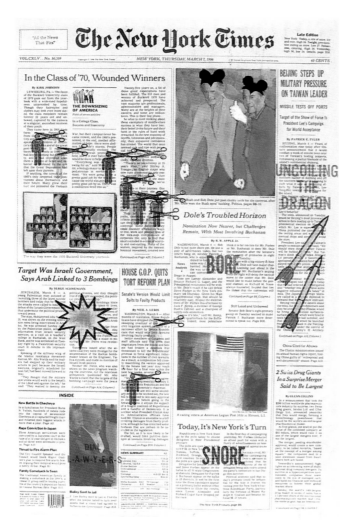

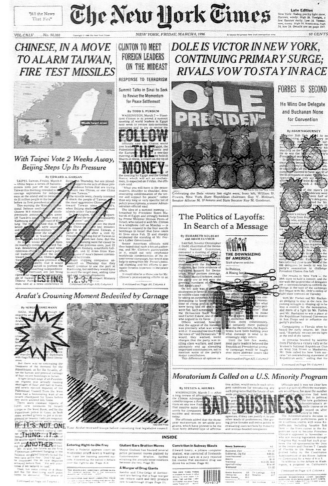

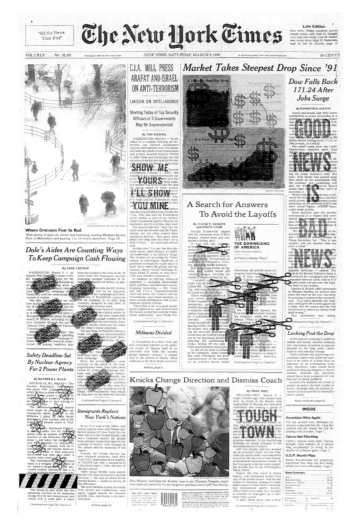

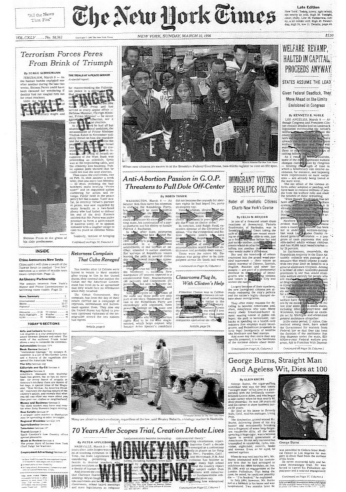

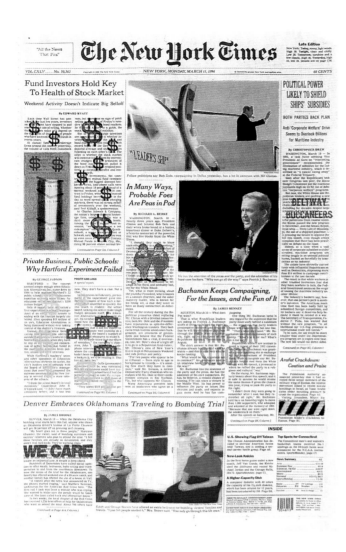

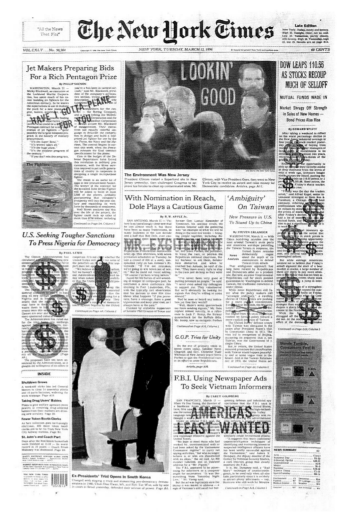

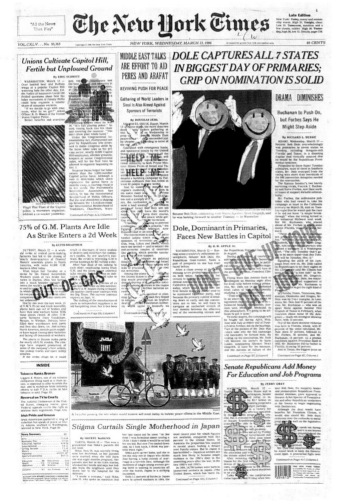

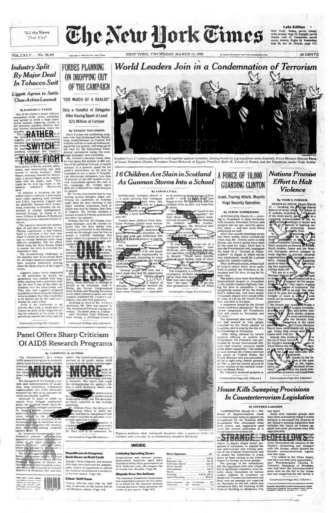

The New York Times

Late Edition
New York: Today, thickening clouds, then rain. High 59. Tonight, evening rain. Low 37. Tomorrow, becoming sunny, brisk. High 46. Yesterday, high 63, low 45. Details, page D16.

VOL.CXLV . No. 50,367

Copyright © 1996 The New York Times

NEW YORK, FRIDAY, MARCH 15, 1996

$1 beyond the greater New York metropolitan area.

60 CENTS

Pataki Warns Of Further Cuts In State Budget

Cites Failure to Obtain Promise of U.S. Help

By IAN FISHER

WASHINGTON, March 14 — At the end of a last-ditch visit to Washington in which he received no assurance of help from the Federal Government, Gov. George E. Pataki set the stage for cutting as much as $2 billion more from his already beleaguered budget.

Early this afternoon, Mr. Pataki said that unless the Clinton Administration sent him some signal by the end of today that it would agree to revamp the Medicaid and welfare programs he could be left with no choice but to begin looking at "contingencies."

By the end of today, he could actually cut up to $2 billion. His proposed budget would close a projected gap of $3.9 billion.

By early evening, after a phone conversation with Mr. Clinton's chief of staff, Mr. Pataki said he had not received the assurance he had hoped for. He had wanted the Clinton Administration to offer general support for several budget measures endorsed by the nation's governors last month and modified this week.

"We are now taking another look, working tonight as is generally the case," the Governor said in a telephone interview after he left Washington this evening. "We are considering all the options that we have."

Mr. Pataki's actions came under fire from Democrats in Washington today. They charged that the Governor was simply positioning himself to make still deeper state cuts — mostly in social programs — and then blame the President, saying his inaction on the Federal budget had left the Governor no choice.

"He's looking for someone to blame," said Representative Nita M. Lowey, a Democrat of Westchester and the Bronx. "I don't think the President is going to eliminate Medicaid so Governor Pataki can balance his budget."

Every state budget depends to a greater or lesser extent on financing from Washington. But Mr. Pataki drafted his budget earlier than most other governors, and it assumes that

Continued on Page B4, Column 6

Einstein Manuscript Is Going, Going . . .

In 1912 Albert Einstein crossed out a line in his notes and made scientific history. Tomorrow, the manuscript in which he corrected himself — his particular theory of relativity — is expected to bring between $4 million and $6 million in an auction at Sotheby's.

Article, page B1.

INSIDE

Smoking and the States

Prompted by new Federal rules requiring states to discourage teen-age smoking, antismoking forces and tobacco companies are battling over a range of state laws. Page A22.

One for the Coach

In Pete Carril's last season, Princeton upset U.C.L.A., the defending champion, 43-41, in the first round of the national tournament. Page B7.

354613

CLINTON, IN ISRAEL, STRESSES SUPPORT FOR PEACE EFFORT

ANTI-TERROR AID PLEDGED

$100 Million Package Planned — President's Visit Is Also Meant to Bolster Peres

By SERGE SCHMEMANN

JERUSALEM, March 14 — By turns politician, preacher and professor, President Clinton raced from the ancient Mount Herzl to the heart of Tel Aviv today to convince Israelis that the United States stood squarely with them and behind the peace process.

The formal centerpiece of Mr. Clinton's brief visit was a commitment of $100 million to support Israel with training and technical assistance in the fight against terror.

American officials said the aid would include advanced bomb-detection devices, X-ray systems, robotics for dealing with suspected bombs and advanced thermal and radar sensors. They said $50 million of the funds would come from the Pentagon's 1996 budget, and the rest would be in next year's budget.

American foreign aid to Israel is $3 billion a year, of which $1.2 billion is military assistance and $1.8 billion is civilian.

Mr. Clinton was less precise on the possibility of a formal military treaty with Israel, which would be troubling for both Israel and the United States. The President said only that the two sides would immediately begin negotiating a agreement to combat terrorism, and urged leaders not to "jump ahead."

The pledge of $100 million, coming on the day after world leaders gathered in Egypt to condemn terror, was part of a broad effort by Mr. Clinton to affirm Israel's and the United States faith and purpose with the Palestinians after four suicide bombings in which 62 lives were lost.

"The message of the fact to the people of Israel should be be quite clear," Mr. Clinton said at a news conference in Jerusalem. "Just as America walks with you every step of the way as you work toward peace, we stand with you now in defeating all that you are and all that has been accomplished."

The President's 22-hour visit was clearly intended to bolster Prime Minister Shimon Peres's damaged standing before the national elections on May 29. It included a meeting with the entire Israeli Cabinet; a visit to the national cemetery on Mount Herzl to lay a wreath at the tomb of Prime Minister Yitzhak Rabin, and to pay respect at the graves of 10 victims of recent attacks, and meetings with the opposition leader Benjamin Netanyahu and

Continued on Page A9, Column 1

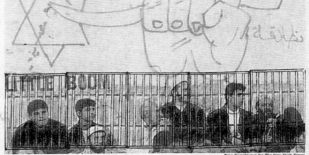

Hamas, the militant Islamic group, has emerged as the strongest opponent of peace accords between Israel and the P.L.O. Hamas supporters are shown rallying under a wall bearing anti-Israeli graffiti.

Rina Castelnuovo for The New York Times

Alms and Arms: Tactics in a Holy War

By JOHN KIFNER

JERUSALEM, March 14 — Hamas, the main force behind the suicide bombers who have thrown the shaky Middle East peace talks into crisis, is an organization with deep roots, a popular base that feeds on misery and resentment, an international support network, and a clear goal: to turn the nascent Palestine into an Islamic state.

Mosques, hospitals and schools are its weapons as well as bombs, and Yasir Arafat, as much as Israel, is its target.

As world leaders met this week in a show of resolve, even the study groups like Hamas say the nature of the organization presents a daunting quandary: Do you attempt to co-opt the religious and civilian side, thus isolating the militants, as Mr. Arafat has sought to do? Or do you seek to crush Hamas whole, as Mr. Arafat's American and Israeli partners are now pressing him to do?

ROOTS OF TERROR
A special report

No one knows as well as Israel whether the new tactic of the 1970's and 1980's was to turn the national to fight to the Islamic movement well to cells on the West Bank and the Gaza Strip the religious movement here has long been torn between more militant than Mr. Arafat's more secular and corrupt P.L.O.

But cracking down was hardly more successful. In 1992, in an attempt to decimate Hamas, Israel deported 415 of its activists to a snowy hillside in Lebanon. Many of the deported militants enrolled in guerrilla training camps, and returned to Israel with

their grievances and their skills honed to a fine edge.

Indeed, it was the assassination of Hamas's chief bomb-maker that brought the latest wave of suicide bombings, breaking a seven-month lull in terror attacks.

Hamas, the major Islamic militant organization, is linked to three of the four suicide bombings in the last two weeks that have left 62 people dead, including the bombers, and now looms as the gravest immediate threat to a Middle East peace.

Many who study the group fear opponents of peace — Israel, Mr. Arafat, and the others who joined the anti-terrorism conference Wednesday in Egypt — are again in danger of outsmarting themselves by misjudging Hamas.

Although its organization and military operations are deliberately murky, interviews with a wide range of Palestinian, Israeli and Western experts present a portrait of Hamas that is more cohesive

Continued on Page A8, Column 4

Traffic Jam Clogs AT&T's Information Highway

By MARK LANDLER

BRIDGEWATER, N.J., March 14 — If you wanted to get on the information highway today via AT&T, you first had to drive along it to a jam-packed parking lot in Central Jersey town.

More than 5,000 people gathered at an AT&T office building here on a sun-drenched morning to munch hot dogs, swap tales about cyberspace and watch as AT&T flipped the switch on its new Internet-access service, called Worldnet. Mostly, though, they lined up for the free —

but exceedingly scarce — computer software that is necessary to actually sign on to Worldnet.

Since AT&T announced its low-cost Internet service in February, more than 400,000 people have requested it so far. So to assuage at least some of the impatient, AT&T threw an old-fashioned grand opening, complete with balloons, bunting and a high school marching band.

Drive out, AT&T promised in local newspaper ads and voice-mail invitations to hundreds of New Jersey residents, and you could be among the first to get a free copy of the coveted software. (The automobile is the only technological throwback with a key role in AT&T's cyberfantasy: the voice mail was sent out via a Western Union.)

Despite the sunshine and jaunty spirits, AT&T is learning a hard lesson about the explosive, unpredictable growth of the Internet. Though it offers telephone service to 90 million customers in the United States and is one of the world's consummate corporate marketers, AT&T has been surprised and staggered by the demand for its Internet-access service.

AT&T even managed to run out of supplies today, after stocking more than 5,000 copies of the software and giving local consumers little more than a day's notice of the event. A spokesman said AT&T would mail copies of the software to the 253

Continued on Page D3, Column 3

Democrats Hone Swords in Chicago Election

By ADAM CLYMER

CHICAGO, March 14 — The 4200 block of Ridgeway Avenue is a monument to the remnants of the storied Chicago Democratic Machine. Every single house, on each side of the street, displays a jauntily angled sign proclaiming "Blagojevich for Congress '96."

At the other end of the district, closer to Lake Michigan, Rod Blagojevich's chief Democratic rival, Nancy Kaszak, boasts that she is "unbought and unbossed" and that she plays the piano badly. Her campaign reflects a new generation of political power brokers, with techniques taught and money raised by Emily's List, an organization that seeks to elect to Congress more Democratic women who support abortion rights.

But the contest in next Tuesday's primary in the Fifth Congressional District is more than a generational clash of styles in one of the few cities where politics remains a major league spectator sport. It is also spring training for one of the races the Democrats absolutely have to win if they hope to reduce, or overturn, the Republicans' 19-vote margin in the House of Representatives.

The Fifth, a Democratic stronghold where President Clinton is very popular, fell into Republican hands in 1994 after Representative Dan Rostenkowski, seeking a 19th term, was indicted on corruption charges. Michael Patrick Flanagan, a little-known Republican lawyer, upset Mr. Rostenkowski and immediately became the Democrats' No. 1 target nationally.

"This is one of our top priority races in the country," said Repre-

Regaining Dan Rostenkowski's House seat is one of the Democrats' top priorities. Rod Blagojevich is campaigning to be the nominee.

Todd Buchanan for The New York Times

sentative Martin Frost of Texas, chairman of the Democratic Congressional Campaign Committee. "We think Flanagan is vulnerable."

The Democrats message is ready being honed. As Ms. Kaszak said at a candidates' forum on

Wednesday, Mr. Flanagan "voted for all the budgets voted to cut Medicare, to cut college loans, to cut Head Start, to cut it through bilingual education." The Democrats cite a congressional votes 93 percent of the time with Newt Gingrich."

Or, in the version offered by Ray Romero, a long-shot candidate who

Continued on Page A26, Column 1

A DEAL IS REACHED ON LINE-ITEM VETO WITH DOLE'S HELP

PROSPECTS STILL UNCLEAR

Presumptive G.O.P. Candidate Helps Overcome Resistance to Aiding the President

By JERRY GRAY

WASHINGTON, March 14 — Prodded by Senator Bob Dole, Congressional Republicans ended a nearly yearlong stalemate and agreed today on a version of the line-item veto for the President.

The proposed legislation would shift control of the power of the purse from Congress to the White House. It would give the President the power to remove items from spending bills one by one, rather than vetoing or approving bills in their entirety, as is now the case.

The measure's supporters say it would allow the White House to kill pork-barrel projects and specially aimed tax breaks and to influence policy directives by denying money for them.

As has been the case several times in the last few weeks, Senator Dole, the Republican leader and now presumptive Presidential nominee, worked behind the scenes to force a compromise on an issue that House and Senate Republicans had not wrapped up, despite the fact that both houses had passed different versions of the measure.

Though the line-item veto was part of the Contract With America, the House Republicans' 1994 campaign manifesto, House and Senate were in a long-running stalemate over their differences. Senator Dole, in no hurry to give such a powerful budget weapon to a Democratic President.

House and Senate negotiators are to meet to draft the measure into a bill next week, at which time it will be decided when it would take effect.

Senator John McCain, an Arizona Republican who has been one of the leaders of a nearly decadelong fight for the line-item veto, said he expected the bill would call for the veto power to take effect this year.

Asked today to explain the sudden breakthrough on the line-item veto after months of bickering over widely differing versions in the House and the Senate, Mr. McCain replied, "Senator Dole said it had to be done."

If the line-item become accomplished the President would be able to spending vetoed by the current campaign. But the measure's prospects are uncertain.

Though President Clinton and many Democrats favor the line-item veto, there are many in Congress

Continued on Page A20, Column 1

Dole Courts Democrats

Touring in the Midwest, Senator Dole outlined his case against President Clinton and urged Democrats who strayed to Ronald Reagan in the 1980's to vote again for a Republican Presidential candidate.

Article, page A26.

Officer Killed and Another Hurt In Carjacking Battle in the Bronx

By CLIFFORD KRAUSS

Two police officers were shot last night, one fatally, in a gun battle that erupted after the officers tried to thwart a carjacking in the Fordham section of the Bronx. The wild gunfight also left four others wounded, including three bystanders.

The slain officer, Kevin Gillespie, a member of the elite Street Crime unit, died at Barnabas Hospital from a gunshot wound to the chest despite frantic efforts to save him.

The other officer, Terrance McAllister, was taken to Jacobi Medical Center, where he was in stable condition with a bullet wound to the leg.

The shootings occurred around 9 P.M. off the Grand Concourse near 183d Street when officers from Mr. Gillespie's unit, patrolling in the neighborhood to crack down on guns, began to pursue suspects in a carjacking.

"Once again the city lost a dedicated hero who died in the line of duty," said Mayor Rudolph W. Giuliani, who went to the hospitals last night after receiving word of the shooting. He said Officer Gillespie, a father of two young sons, had been on the force for four years, and had started with the elite unit only three months ago.

Mr. Giuliani said Officer Gillespie, a Long Island resident who would have turned 34 on Tuesday, had been wearing a bulletproof vest, but the bullet managed to penetrate it and course through his body, leaving him gravely wounded.

Last night, the police were out in force in the Fordham area, with helicopters overhead, in a search for the suspects. The police said that in addition to the officers and the bystanders, one other person, a 14-year-old boy who was one of the suspects, was shot and critically injured.

Investigators were able to arrest one other suspect, but at least two more were still being sought, and this morning the police began a floor-by-floor search of buildings within a six-block area of the shootings.

The incident began when officers in an unmarked police car saw a carjacking in progress, and pursued the

Continued on Page B2, Column 1

The New York Times

Late Edition

New York: Today, sunny, windy. High 52. Tonight, clear skies and chilly. Low 32. Tomorrow, increasing clouds. High 48. Yesterday, high 60, low 43. Details are on page 48.

VOL.CXLV .. No. 50,368 Copyright © 1996 The New York Times NEW YORK, SATURDAY, MARCH 16, 1996 $1 beyond the greater New York metropolitan area. 60 CENTS

Dole Is Cashing In a Chit For Supporting Gingrich

By MICHAEL WINES

WASHINGTON, March 15 — When Newt Gingrich needed him last year, Bob Dole gulped down whatever doubts he harbored about the Contract With America and dutifully signed on to the House Speaker's Republican revolution.

Now, Mr. Dole, the presumptive Republican nominee for President, has a chit to cash in. It will be interesting to see how he spends it.

Mr. Dole is edging off the stump and back to Washington, planning a burst of legislation that will define his campaign and aides hope force President Clinton into some political Hobson's choices.

"There's no doubt that there is now a legislative strategy to get things passed through the Congress and onto the President's desk," Senator John McCain, an Arizona Republican, said in an interview this week. "If the President doesn't sign them, it's not Bob Dole's fault. It's the President's."

Mr. Gingrich is not merely a key to that strategy, but a potential stumbling block as well. On one hand, he will have to be on the front lines if his chamber's rebellious right wing is to fall in line behind Mr. Dole's agenda.

On the other, Mr. Gingrich has acquired a public image, rightly or not, as a right-wing rebel himself. Polls show he is roughly as popular as President Nixon was in the summer of his impeachment hearings. His Contract With America has lost its political cachet. And Democrats

would like nothing more than to lash him to Mr. Dole as the general election campaign heats up.

Mr. Dole's challenge — and for that matter, Mr. Gingrich's — will be to use the Speaker's assets without resurrecting his liabilities.

"The most powerful message Clinton has is 'I will protect you from the radical right,'" said Eddie Mahe, the veteran Republican political consultant. "Bob Dole has to make sure he does not provide Bill Clinton any extra ammunition to make that case."

To do so, Mr. Mahe said, "he's got to demonstrate that it's a partnership between him and Newt, but that he's senior partner. And whenever he makes a decision, the junior partner accepts and executes that decision."

Perhaps belying his public image, Mr. Gingrich is plunging into that role. His spokesman, Tony Blankley, said the Speaker has already turned many of his more visible legislative duties over to the House majority leader, Dick Armey of Texas; Mr. Gingrich will spend the bulk of the year campaigning for House members and helping Mr. Dole concoct legislative strategy, he said.

Mr. Blankley said House aides were already considering some 40 pieces of legislation for action, each of them "completely part of what Dole's agenda is going to be." Ultimately, he said, the objective is a seamless national campaign, from the White House

Continued on Page 8, Column 4

3 Men Held in Killing of Officer, Bringing Calls for Death Penalty

By CLIFFORD KRAUSS

Three Bronx men, all with long records for armed robbery and other crimes and all under the supervision of parole officers, have been arrested in the killing of the New York City police officer who died in a wild shooting spree along the Grand Concourse on Thursday night.

The officer, Kevin Gillespie, 33, was the third police officer to die by gunfire in the line of duty this year. His death set off an effort to pressure the Bronx District Attorney, Robert T. Johnson, a longstanding opponent of capital punishment, into seeking the death penalty.

Gov. George Pataki said yesterday that he was willing to remove Mr. Johnson from the case if Mr. Johnson is not legally empowered to or unwilling to substitute prosecutor if the District Attorney resisted calls for the death penalty.

"I have the ability, I have the will to consider removing the District Attorney," Mr. Pataki said. "This is a case that demands the death penalty, and I'm going to monitor the case closely."

Mr. Giuliani said Mr. Johnson should voluntarily step aside from the case unless he changed his mind, adding that "when police officers are murdered, a piece of us, our decency and our

law are taken away."

"I believe it is the ultimate crime," the Mayor said.

Steven Reed, a spokesman for Mr. Johnson, said that while the District Attorney has always "had grave reservations about the death penalty, he has said he would never" seek it. After the death penalty law was signed by Governor Pataki last year, Mr. Johnson said, "It is my

Continued on Page 24, Column 1

The Killing Streets

The Bronx where Officer Kevin Gillespie was killed has known a violence like few places in the city. Page 25.

Independent Counsel Given a Wide Reach

A Federal appeals court said yesterday that the independent counsel investigating business deals involving Bill and Hillary Clinton did not exceed his authority by exploring an area that led to the indictment of Gov. Jim Guy Tucker of Arkansas.

The independent counsel had been accused of overstepping his mandate, a complaint made about other such prosecutors. But the court said a special prosecutor could look at any violation of Federal law growing out of the initial investigation.

Article, page 7.

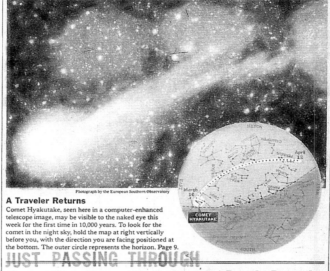

A Traveler Returns

Comet Hyakutake, seen here in a computer-enhanced telescope image, may be visible to the naked eye this week for the first time in 10,000 years. To look for the comet in the night sky, hold the map at right vertically before you, with the direction you are facing positioned at the bottom. The outer circle represents the horizon. Page 9.

Photograph by the European Southern Observatory

Court Puts Down Rebellion Over Control of Federal Land

By TIMOTHY EGAN

Dealing a major blow to dozens of counties that have passed ordinances asserting that the Federal Government does not own the public lands that make up about half of the American West, a judge in Nevada has said the measures are illegal.

The ruling by a Federal Judge, Lloyd D. George, blocks an effort by county officials to take control of lands that the Government has said it owns and uses, and is likely to have national implications.

The ruling strikes at the heart of a rural revolt, sometimes referred to as Sagebrush Rebellion II. Nearly two years ago, Nye County, Nev., a commission led by Richard Carver, a commissioner of Nye County, Nev., took a bulldozer to a Forest Service road, declaring that the county's newly passed ordinance meant the Government no longer owned the property. He was cheered on about 50 armed supporters, and he later threatened to arrest a Forest Service ranger who tried to stop him.

The Justice Department, comparing the situation to a rebellion of Southern counties against Federal civil rights laws in the late 1960's, sued Nye County one year ago. A number of rangers who work for the

Forest Service, the Bureau of Land Management and the National Park Service had asked for legal help, saying the county ordinances had made it impossible for them to do their jobs.

In 85 counties across the West and dozens of towns, residents had passed ordinances proclaiming control over Federal land.

"The United States has a multifaceted strategy for dealing with this and with these county ordinances," said Mike Coppelman, the Deputy Assistant United States Attorney General who handled the case, "and the first step was to knock out the legal basis" for such measures.

Mr. Coppelman called Judge George's ruling "a sweeping and total vindication of the rights of the United States to own and manage Federal lands for all Americans."

The Nye County case, essentially a cry for states' rights, who raised questions about the legal help to the states, drew Washington's attention. The Assistant Attorney General in the Reagan Administration, argued the case for Nye County. Mr. Marzulla said the lawsuit accomplished one goal in forcing Federal agencies to work

Continued on Page 10, Column 4

In Heavy Smoking, Grim Portent for China

By PATRICK E. TYLER

BEIJING, March 15 — Rushing down a Beijing alleyway where a north wind was kicking up dust among the vegetable stands and cigarette vendors, Huang Jinhui, 25, paused to explain to a stranger why he smoked.

"Everyone smokes," said Mr. Huang, a young barber from Sichuan Province in central China.

"I know that it smoking is not a good habit, that it is harmful to your health," he laughed, "But I have no choice. In carrying on social relationships and doing business, I have to smoke."

In a nearby alleyway restaurant, where the tables were littered with empty beer bottles and cigarette ash, the air was a gauze of smoke. Fu Li, a woman from Henan Province, self-consciously with her cigarette.

"I'm in very beginning, doing just for fun," she said of her habit. "When you play mah-jongg with friends, if someone offers you one, you cannot refuse it, and so you think about the rest."

Few Chinese, it seems, are changing.

China today has the biggest smoking habit in the world, with an estimated 300 million smokers out of 1,200 million adults, accounting for 30 percent of the world's consumption.

The per-capita consumption of

China has the biggest smoking habit in the world. This farmer said he started smoking last year, after taking a winter job in Beijing.

Mark Leong for The New York Times

Chinese smokers still lags behind some industrial countries, where as many as 22 cigarettes a day is the norm among smokers, but China is rapidly catching up. The average Chinese smoker consumed 12 cigarettes a day a decade ago, 16 today.

The crushing Communist Party, which has built its legitimacy on providing a better job for the social welfare of the 1.2 billion Chinese than all the emperors and dictators of old, will soon be confronted with an epidemic of lung cancer and respiratory and heart dis-

eases that threatens to overwhelm its health establishment.

The Government has recently begun to mobilize a national campaign against smoking. But this runs up against a powerful tide of self-interest rooted in the vast state-owned tobacco monopoly, which has become the world's largest cigarette producer and whose tax revenues are the Government's single greatest income source — $8.6 billion in 1995.

"The tobacco industry is the

Continued on Page 5, Column 1

Pataki Reveals Surprise Funds To Ease Budget

By JAMES DAO

ALBANY, March 15 — After Washington failed to provide the aid he wanted, Gov. George E. Pataki made the surprise announcement today that he had found $1.4 billion in additional money that he said would enable him to balance his 1997 budget without making painful new spending cuts.

The announcement, at a hastily called news conference this afternoon, came one day after the White House rebuffed Mr. Pataki's request for changes in welfare and Medicaid laws that could save New York State $2 billion in the coming fiscal year, which begins in just two weeks.

The Governor's plan predicts that the regional economy will improve so that the state will take in $463 million more in tax revenues than Mr. Pataki had originally projected. It also estimates that the state will spend $758 million less on an array of programs, mainly by reducing the welfare rolls or shifting health care costs to the Federal Government.

The plan calls for only $223 million in spending reductions — mostly from new programs the Governor had put in his earlier budget plan — a relatively small amount, which could make the whole plan more palatable to legislators facing re-election this fall.

But the proposal is heavy with potentially risky assumptions about declines in interests rates, drops in state health care costs and savings from refinanced state debt. As a result, legislative leaders from both parties, who have been hesitant to start budget negotiations until the

Continued on Page 26, Column 1

2 BUILDERS CHOSEN FOR SPEEDY TRAINS ON NORTHEAST RUN

BIG CUTS IN TRAVEL TIME

From Washington to New York in 2½ Hours, Amtrak Says, in Challenge to Planes

By MATTHEW L. WALD

WASHINGTON, March 15 — Taking a decisive step in its ambitious plans to upgrade train service in the Northeast and to be again a run for their money, Amtrak today chose the contractors to build a $611 million fleet of "American Flyer" that would cut the time of a run between Washington and Boston by two hours.

The top speed of the new trains, 150 miles an hour, is almost twice as fast as the trains now used between New York and Washington, and 50 miles an hour faster between New York and Boston.

Amtrak is ordering 18 "train sets," each consisting of six cars and an engine at either end. Each of the 345 seats on the trains will have an electrical outlet for a laptop computer. The trains will be built by Bombardier Inc. of Quebec, and GEC Alsthom, a French-British venture. But much of the work will be done in Plattsburgh, N.Y., in the northeast corner of New York, and in Barre, in central Vermont.

Amtrak officials said they hoped the first train would be delivered in late 1999.

The new trains, combined with track improvements already under way, will cut the running time from Capitol Hill in Washington to midtown New York from about two hours and a half hours now to two and a half hours now, he said. He said he believed many travelers would be attracted by the new speed and convenience of the train schedule, allowing the railroad to raise prices closer to airline shuttle prices.

Both Amtrak and the airlines vary their prices according to time of day and offer discounts to various groups, but the unrestricted weekday fare from New York to Washington on the Amtrak Metroliner is $106; the air shuttle is $160. No one knows now what the prices will be in 1999, when the first of the new trains is supposed to be delivered.

Like the outlets for laptops, phone connections for modems will be available, Mr. Downs said. There will also be provisions for electronic entertainment at each seat. Instead of the cafe cars on the Metroliners, which are memorable among travelers who missed the chance to stop at a takeout shop in the train station, there will be "bistro" cars with improved menus, officials say.

"We're back," Mr. Downs declared. "Rail passenger service in

Continued on Page 48, Column 5

New Rules on Air Traffic Control Would Let Pilots Choose Routes

By MATTHEW L. WALD

WASHINGTON, March 15 — The Federal Aviation Administration said today that it would adopt a radically different concept of air traffic control in which pilots would pick their routes, altitudes and speeds, and air traffic controllers would intervene only if flight plans conflicted.

Proponents argue that this concept, called free flight, would save time for passengers and money for airlines by easing delays. Over the next 10 years, it would gradually replace the 35-year-old "positive control" system in which a controller at a radar screen orders every change a pilot makes.

Under positive control, planes do not fly from one airport directly to another; they fly from one check point to the next. As a result, they are sometimes strung out in long lines, and bunching up at the checkpoints, producing delays.

New technology to allow free flight is needed to enable the nation's air traffic system to handle the 40 percent increase in flights expected in the next 20 years, said the agency's Administrator, David R. Hinson.

Mr. Hinson was backed up by representatives of the pilots, the air traffic controllers and the airlines.

"We will not be able to maintain our premier status in the world unless we take action now to provide improvements on our airspace," said Robert W. Baker, executive vice president of American Airlines.

Mr. Baker said that this year there would be 63.2 million landings and takeoffs and that by 2007 the number would reach 74.5 million. Shaving a few miles and a few minutes off each flight would add up to a major improvement for both airlines and passengers, he and others said.

A NASA study cited today by the aviation agency found that letting planes pick their own routes instead of following the airways laid out by the radio beacon routes would have saved $1.28 billion last year for the airlines. But the added cost of delays in lost time to passengers, which is difficult to quantify.

R. Michael Baiada, an aviation consultant who advocates free flight,

Continued on Page 3, Column 1

INSIDE

For AT&T, Fewer Jobs to Cut

AT&T now expects about 18,000 employees will be dismissed, down from the 30,000 it forecast in January, in part because more people than expected took buyouts. Page 37.

Plea in Assisted Suicide

In an unusual plea agreement, a Manhattan man, George Delury, will go to jail for helping his wife commit suicide by giving her a fatal cocktail of honey and drugs. Page 23.

Struggle for Sudan's Soul

The Sudan's elections reflect a debate between militants who preach holy war with the West and pragmatists who want to mend fences, but the outcome is not in doubt. Page 4.

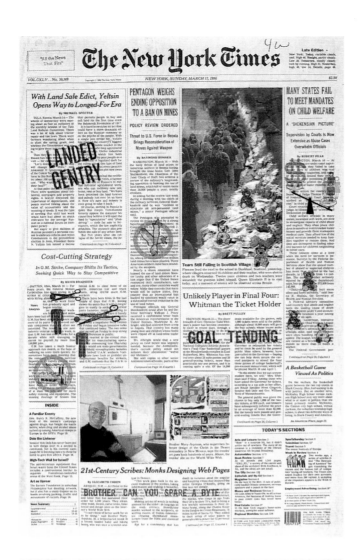

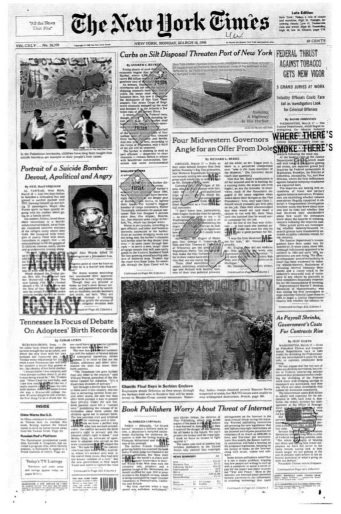

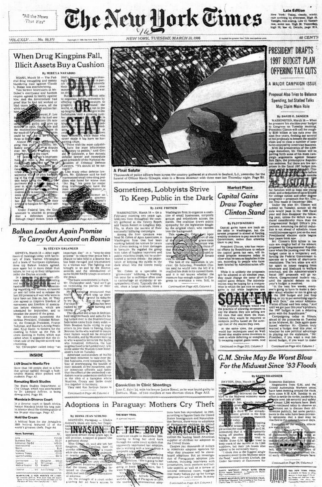

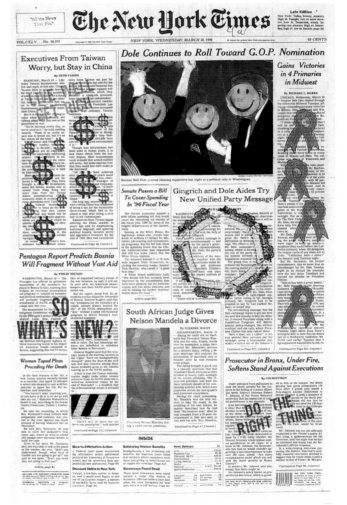

The New York Times

VOL. CXLV . . . No. 50,373 Copyright © 1996 The New York Times NEW YORK, THURSDAY, MARCH 21, 1996 $1 beyond the greater New York metropolitan area. 60 CENTS

Late Edition

New York: Today, Mostly cloudy, windy, few snow showers. High 42. Tonight, flurries. Low 33. Tomorrow, cloudy, windy. High 45. Yesterday, high 47, low 40. Details, page D22.

Money Is Channeled to Hamas By Way of a 'Shocked' Jordan

By JOHN KIFNER

AMMAN, Jordan, March 20 — "There are no Hamas offices in Jordan," Information Minister Marwan Muasher declared firmly. "Hamas simply does not exist here."

Of course, he conceded confidentially in the next breath, everyone knows that representatives of the Palestinian group operate from the political headquarters of the powerful Muslim Brotherhood, a legal organization with 17 seats in the 80-member Parliament.

"They are pro-Jordanian citizens," the Minister said with a shrug. "They make statements for Hamas. There is nothing the Government can do."

"The Government cannot censor people, particularly Jordanian citizens. We are a democracy."

While King Hussein of Jordan has basked in his new role as the key ally of Israel and the United States, striding alongside President Clinton from Air Force One last week at the Sharm el Sheik "summit of the peacemakers," there appears to be no crackdown here on the support network of the militant Islamic movement, whose rash of suicide bombings in Israel has plunged the Middle East peace effort into crisis.

Western envoys, dispatched by their governments to press Jordanian officials to close down Hamas operations, were told in effect that like Claude Rains in "Casablanca," the Jordanians

were shocked at allegations of such goings-on in the Hashemite Kingdom.

"We were, frankly, upset by these pure accusations," Mr. Muasher said.

Israeli, Palestinian and Western intelligence officials say Jordan is a major conduit for much of the Hamas budget, estimated at $70 million a year, nearly all of it for the social service network of mosques, hospitals, schools and other institutions that form the movement's political base in the West Bank and Gaza Strip.

But it is a cash flow outside Government control that appears almost impossible to trace, let alone halt, moving across the Jordan River as it has for generations — but more easily now since Israel and Jordan signed a peace treaty — through Middle Eastern money changers in tiny street booths, by electronic transfers in the half-dozen glittering new glass-and-steel bank towers here and even in the pockets of travelers crossing the three bridges over the border.

Under American pressure in the wake of suicide bombings in Israel, Jordan expelled several Hamas operatives last summer, including Mousa Mohammed Abu Marzook, the organization's key leader, now in Federal detention in New York, and his deputy and successor, Emad al-Alami, now operating from Damascus and

Continued on Page A6, Column 5

NATO Urged to Keep Force In Bosnia After Pullout Date

By CRAIG R. WHITNEY

TUZLA, Bosnia and Herzegovina, March 20 — As warnings mount that the fragile Bosnian peace could collapse without the presence of NATO peacekeepers, international civilian and military authorities here have begun to press for keeping at least a reduced NATO force in Bosnia beyond the extremely schematic departure date contained in this year's peace agreement.

While the Clinton Administration continues to insist that all 20,000 American troops will be out of Bosnia only nine months from now, key officials here say the delicate tasks of resettling refugees and rebuilding the country are likely to fail without the security of outside peacekeepers. The NATO-led international force, known as IFOR, totals about 60,000 troops.

At American insistence — and consistent with pledges President Clinton made to Congress when he sought support for the peacekeeping mission here — the NATO forces are to leave at the end of the year. Both Britain and France have said that if the Americans go, the Europeans will pull out, too.

But many international officials in Bosnia say a total withdrawal could be disastrous. "We need something after IFOR, maybe a 60,000-man force," said Carl Bildt, the international representative in charge of coordinating civilian efforts to put

the peace agreement into effect.

"Refugee return is a two-year plan," Mr. Bildt said. "Reconstruction will take much longer than one year. Almost everything depends on a feeling of overall security for which some kind of military presence will be required."

The United Nations itself, in an intelligence assessment drawn up last month, warned that without major new aid for economic and political rebuilding, Bosnia was likely to fragment and fall back into conflict after NATO forces pull out at year's end.

Mr. Bildt has already asked officials of the alliance in Brussels to begin thinking about what NATO

Continued on Page A10, Column 1

INSIDE

Prosecutor Defies Pataki
The Bronx District Attorney said he had not ruled out the death penalty in a police officer's killing, but he would not be pressured by Gov. George E. Pataki to decide. Page B1.

Warning to Russian Voters
Secretary of State Warren M. Christopher warned Russian voters that they face a choice in the June presidential elections between inclusion in the West and isolation. Page B1.

Subway Graffiti, Again
A decade after a hard-fought campaign virtually eliminated subway graffiti in New York, the plague is coming back — 'a chilling thing,' a former transit official said. Page B1.

New Ball Park for Detroit
Voters in Detroit have decided to build a new ball park for the Tigers, putting America's oldest baseball stadium in jeopardy. Page A12.

HIGH COURT RULES RESULTS ARE VALID IN CENSUS OF 1990

UNDERCOUNT WAS ISSUE

Decision Is Seen as Setback to Large Cities and Minorities; More Tests Are Likely

By LINDA GREENHOUSE

WASHINGTON, March 20 — The Supreme Court today upheld the validity of the 1990 census, ruling unanimously that the Federal Government had no constitutional obligation to adjust the results to correct an acknowledged undercount in big cities and among minorities.

While the decision, written by Chief Justice William H. Rehnquist, ends a long-running lawsuit, it almost certainly will not resolve a continuing policy debate over the best way to count the nation's population. New York City and a coalition of other big cities brought the lawsuit in 1988 to challenge the Bush Administration's refusal to use statistical sampling methods to adjust the 1990 census figures.

In the Supreme Court, the Clinton Administration supported its predecessor's position, telling the Court that the decision whether to make a statistical adjustment was within the discretion of the Secretary of Commerce. The Court accepted that argument today, with the Justice Rehnquist concluding that "the Secretary's decision not to adjust need bear only a reasonable relationship to the accomplishment of an actual enumeration of the population."

Last month the Census Bureau's Commerce Department agency, announced that as a way of saving money on the census for the year 2000, it would directly count only 90 percent of the population and rely on statistical sampling methods to calculate the remainder. At a hearing earlier this month in the House of Representatives, some members of the Government Reform and Over-

Continued on Page A22, Column 3

Vote on Lawsuits Near

The Senate voted yesterday to move ahead with a measure that would limit damages available to people who are hurt by faulty products. The measure faces a promised veto by President Clinton.

Article, page A22.

Pool photograph by Haris Gutkelechi

Menendez Brothers Found Guilty at Retrial

Lyle, top, and Erik Menendez as a jury in Los Angeles convicted them of murdering their parents in their Beverly Hills mansion in 1989. Their first trial, in 1994, ended with separate juries deadlocked. Page A12.

Universities Troubled by Decision Limiting Admission Preferences

By PETER APPLEBOME

A Federal appeals court decision that sharply limits the use of affirmative action at the University of Texas has shaken the nation's colleges and universities threatening to dismantle admissions policies that give preference to minorities.

The unanimous ruling, by a three-judge panel of the United States Court of Appeals for the Fifth Circuit, in New Orleans, forbids a factor in admissions. Even though the appeals court called "the whole some practice of correcting perceived racial imbalance in the student body."

It was a rejection of race-based affirmative action admissions policies that went far beyond the Supreme Court's landmark 1978 deci-

sion in the Bakke "reverse discrimination" case, which said that in the interest of diversity on campus, race could be a factor among many in admissions decisions.

Ecstatic conservatives hailed the ruling as a definitive statement in the continuing dismantling of affirmative action programs nationwide.

"This is clearly another nail in the coffin of racial preferences," said Clint Bolick, litigation director of the Institute for Justice, a conservative organization in Washington. "I think it would be a very costly gamble for any public university to persist in any kind of racial preference system. As an attorney, my advice to any university would be to get out of the racial classification business."

But some educators and affirmative-action supporters said the appeals court had dangerously exceeded its powers in rejecting the Supreme Court's Bakke decision. But they said that it was uncertain that the Supreme Court would hear the case, let alone uphold the opinion.

Ted Shaw, the associate director of the NAACP Legal Defense and Educational Fund Inc. said, "This is a disturbing, troubling ruling, that's part of a pattern we're seeing in which some judges who were appointed by very ideologically con-

Continued on Page D24, Column 1

PATAKI IS SEEKING TO END REGULATION OF HOSPITAL RATES

INSURERS TO GET BIG ROLE

His Plan to Reduce Financing to Train Doctors Is Called Blow to City Hospitals

By CLIFFORD J. LEVY

ALBANY, March 20 — Gov. George E. Pataki unveiled a broad plan today intended to lower health care costs by lifting most of the rules that control the fees charged by hospitals.

He also called for the state to make deep cuts in financing for medical education, a proposal that quickly ran into opposition in New York City, where hospitals train doctors and is one of the centers of care in poor neighborhoods.

Mr. Pataki's aides said that by reducing money for medical education, the state should be able to cut by 30 percent the number of slots for medical residents in New York over three years. Such a move, they said, would help slim down a health care system that is bloated with extra doctors.

The Governor said that ending the state's decades of practice of setting rates paid to hospitals by hospitals would push down costs as incentives for people to seek cheaper treatment outside hospitals.

"We are just so confident that this will lead to a stronger and healthier health care system as we move into the next century," Mr. Pataki said at a news conference this morning.

The plan is the latest jolt to hospitals in New York City, which are already facing sharp cuts in Federal and state spending for Medicaid and Medicare. The city, which has one of the largest concentrations of hospitals in the nation, educates far more doctors than any other and relies heavily on government money to care for its poor.

Mr. Pataki's plan stirred a fierce response from some city hospital executives, who contended that the cuts might force hospitals to consolidate or close, hurting medical care in some areas. The proposal could also be a new source of tensions between the Governor and Mayor Rudolph W. Giuliani, two Republicans who have often been at odds.

"This would obviously have a negative impact on the H.H.C. hospitals," said Maria Mitchell, who is Mr. Giuliani's top health adviser and is also chairwoman of the Health and Hospitals Corporation, which runs the 11 municipal hospitals.

The Democrats who control the State Assembly also criticized the plan, saying it would give too much power to insurance companies and penalize consumers. Both houses of the Legislature must pass the proposal. It is intended to replace rules that expire on June 30.

Mr. Pataki expressed confidence that the plan could be passed before the deadline. But privately, leaders of both parties said that with the

Continued on Page B2, Column 1

Surprise Discovery in Blood: Hemoglobin Has Bigger Role

By SANDRA BLAKESLEE

With almost the surprise that might greet discovery of a new bone in the human body, scientists have detected a major new task performed by hemoglobin, the blood's red pigment and transporter of gases.

Besides ferrying oxygen from lungs to tissues and carting back carbon dioxide on the return journey, hemoglobin has now been found to distribute a third gas on its rounds, according to research published today in the journal Nature.

The gas is nitric oxide, and hemoglobin seems to be able to make the blood vessels expand or contract by regulating the amount of nitric oxide to which they are exposed. The finding is likely to have significant implications for the treatment of blood pressure and the development of artificial blood.

The atom of iron cradled by each subunit of hemoglobin is known to have a strong affinity for nitric oxide after it has released its oxygen, behavior hitherto regarded as something of a curiosity. The new discov-

ery is that another part of the hemoglobin, a segment of its protein chain known as a cysteine residue, can also hold and release nitric oxide, giving the blood pigment the ability to regulate local levels of nitric oxide in the circulatory system according to need.

Nitric oxide — long known as a noxious gas in the atmosphere — is turning out to be as important as oxygen in keeping cells and tissues alive, said Dr. Jonathan Stamler of Duke University Medical Center in Durham, N. C., and senior author of the new report. The invisible, odorless gas was first discovered to have a physiological role in the body in 1987. It is now known to be a messenger that acts on many different cells, changing their shape and function. And it plays a ubiquitous role in human health, Dr. Stamler said, including the maintenance of learning and memory, blood pressure and sexual erections.

The finding that hemoglobin car-

Continued on Page A22, Column 3

Edward Keating/The New York Times

Suspend Disbelief for the Moment, It's Spring

Folk wisdom says that on the vernal equinox an egg will balance on one end. Physicists say it might happen any day. Parks Commissioner Henry J. Stern and 25 students sided with the cosmos yesterday in Manhattan.

Britain Ties Deadly Brain Disease to Cow Ailment

By JOHN DARNTON

LONDON, March 20 — The British Government said today for the first time that there might be a link between what is commonly called mad-cow disease, a deadly neurological affliction of cattle here, and a similar fatal human disease in humans.

Appearing mindful of the widening scare among Britons over the safety of British beef, the Health Secretary, Stephen Dorrell, said there was no scientific proof that the disease in cows, which is formally known as bovine spongiform encephalopathy, can be

transmitted to humans through beef.

But then he told a stunned House of Commons that a committee of scientists set up to advise the Government on the issue had linked an unusual outbreak of the human disorder, Creutzfeldt-Jakob disease, to exposure to the cattle disease.

The Health Secretary called on the public to moderate its consumption of beef, and said that "the most likely explanation" was an apparently new variant of Creutzfeldt-Jakob Disease, which was discovered in 10 people under the age of 42, including some in their teens. Normally the disease, a rare neurological degenerative illness that is

"incurable and generally strikes older people." The Creutzfeldt-Jakob Disease found through Britain, the world, but its rare, afflicting an average of about one out of every one million

Continued on Page A7, Column 1

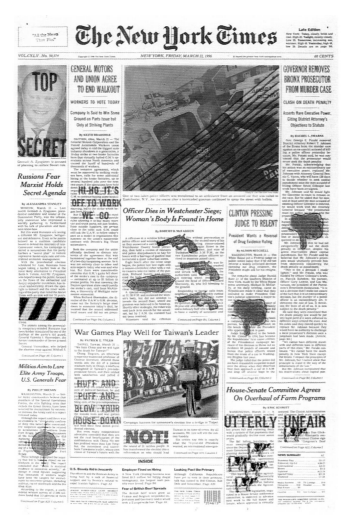
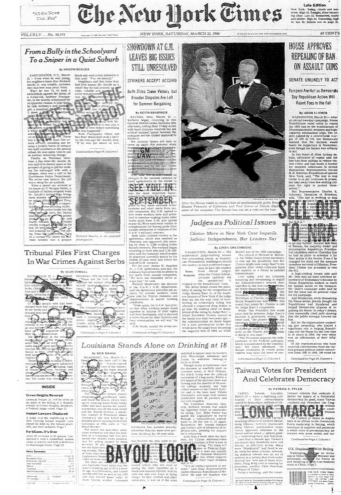
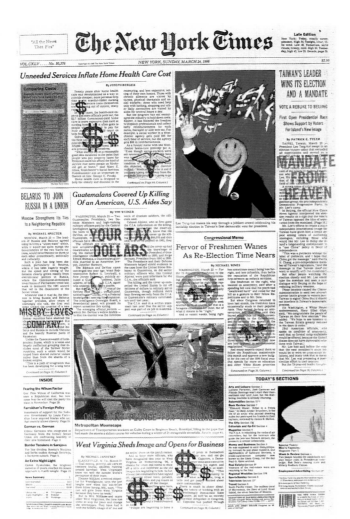
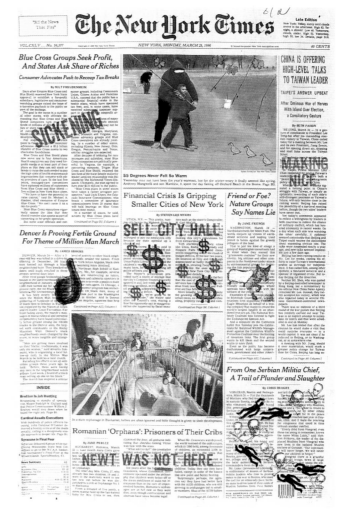

"All the News That Fits"

The New York Times

Late Edition
New York: Today, sunny, a few afternoon clouds, windy. High 54. Tonight, clear, cold. Low 33. Tomorrow, mostly sunny, cooler. High 45. Yesterday, high 60, low 43. Details, page C28.

VOL.CXLV...No. 50,378 Copyright © 1996 The New York Times NEW YORK, TUESDAY, MARCH 26, 1996 $1 beyond the greater New York metropolitan area 60 CENTS

Giuliani Officials Broke Rules On Contract Bids, Records Show

Queens Group Gets $43 Million for Welfare Job

By JOE SEXTON and ALAN FINDER

The Giuliani administration broke city bidding rules last summer to award $43 million in contracts to a politically well-connected Queens organization, according to an examination of city records and interviews with municipal participants in the contract.

The two contracts — the first New Yorkers awarded to the Neighborhood Association — even though it submitted the highest bid and did not receive the highest grade from a city evaluation committee.

The contracts represent the city's initial effort to turn over enforcement of welfare rules to private agencies, and their value makes them among the Giuliani administration's most ambitious efforts to privatize traditional government work of any kind.

In giving the Queens agency the power to aggressively monitor thousands of single, childless adults on public assistance, the city is asking the agency to make sure, for example, that welfare recipients continue their treatment for drug and alcohol abuse, and that they are moving toward financial independence.

It is not clear whether the apparent violations of city contracting rules, meant to prevent corruption and favoritism and to insure an impartial competition for city business, were deliberate or resulted from sloppy management.

But there is no doubt that they produced a windfall for the Queens agency, which had never before won a city contract of more than $3.5 million and whose board members have made sizable political contributions to both Democratic and Republican politicians in New York.

"At best, this process is bizarre and inexplicable," said Larry Comptroller, whose office is conducting a review of how the two contracts were awarded.

Investigators were unable for months to find from the administration officials why the contracts went to the Queens agency.

"If there were no rules and no statutes that govern the process, this bidding mechanism would have violated anyone's sense of fairness," said the Comptroller, a Democrat who has frequently been at odds with the Republican administration.

"More specifically, it appears to have violated the City Charter, the Procurement Policy Board rules and the regulations of the bidding process itself."

Among those rules are requirements that each bidder's final proposal be formally evaluated and that a cost analysis be conducted.

Mr. Hevesi also found that, unless city officials could come up with new documentation, it was legally impossible to determine whether he completed the contracts, that the contracts were unfinished, that the would call for an independent investigation of what happened and who's culpable.

The Comptroller could only have stopped the awarding of the contracts before they were approved

Continued on Page B7, Column 1

Tucson H.M.O.'s May Offer Model for Medicare's Future

By PETER T. KILBORN

TUCSON, Ariz. — "Partners for Seniors has expanded pharmacy benefit!" a newspaper ad proclaims to Tucson's big retirement community. "Enjoy free health club benefits," promises another of an Arizona. "Do you know," touts FHP Health Care, "how your health plan stacks up against FHP's? You tell us. $0 premium. $0 deductibles."

Tucson's health care organizations are fighting a hospital-like free annual physical exams, free X-rays, free mammograms, free laboratory tests, free eyeglasses, $3 and $10 doctors' appointments, free rides to get to them and this year's newest offering: $7 for a three-month supply of any of 300 prescription.

The juices of unfettered competition are bubbling in Tucson's medical community largely by the payments the Government gives for medical care for each Medicare patient, four private H.M.O.'s are vying for the business of the elderly and stirring a big spurt from the conventional Medicare system by offering new services, lower prices and more preventive care.

In response to the companies' appeals, 42 percent of the people 65 and older in Tucson's Pima County, or six times the national average, have fled the standard, more costly Medicare program to enroll in the programs for the elderly offered by the four competing H.M.O.'s: Partners

Health Plan, a group, FHP and Cigna Health care of Arizona. In one of a few other communities, including Riverside, Calif., San Diego and Portland, Ore., have similar organizations care more than 25 percent of the Medicare aged population. For leaders in the health organizations' success in enrolling the elderly makes Tucson a test case for the fight from the health care industry to curb the rise in Medicare spending. Both Democrats and Republicans support greater use of H.M.O.'s, they differ on how to reach that goal. Last week Republicans proposed financial incentives for the elderly to

Continued on Page B11, Column 1

Britain Defends Beef As Europe Asks Ban

The European Union moved yesterday to ban British beef as unsafe, while the British Government stepped up its own emergency meetings and said further steps were needed to protect consumers from so-called mad cow disease.

The latest developments in the worldwide consumer scare were certain to be a major effort to achieve a European Union.

Although British officials said the country might have to destroy 4.5 million cattle, the Government huddled and said that such moves imposed by other European countries were unjustified.

It was clear, though, that many, if not most British consumers did not believe the Government's assurances. British consumers were voting with their pocketbooks. Meat remained unsold in supermarkets, livestock markets were deserted, and the wholesale price of beef plummeted.

Article, page A3.

Continued on Page D26, Column 4

Bob Dole made an emotional visit yesterday to his home town, Russell, Kan. Welcoming the candidate at his old house were, from right, a niece, Karen Nelson; her son, Ryan; Mr. Dole's daughter, Robin, and, at far left, Ms. Nelson's husband, Jeff, and Mr. Dole's nephew Mike Steel (with camera).

Dole Vows Victory to Town That Has Never Failed Him

By KATHARINE Q. SEELYE

RUSSELL, Kan., March 25 — If there is a new Bob Dole, he is the man who returned to his home town today, not as a loser in a national campaign, as he had done before, but as a winner.

"By most accounts, I am a big enough delegate to be the Republican nominee for President of the United States," Mr. Dole told a cheering crowd gathered in the high school gym here the day before the California primary, which is expected to clinch the Republican Presidential nomination for him. "And tomorrow I will add enough to erase any doubt."

Mr. Dole then donned a winter coat against a frigid March wind and, in buoyant spirits, began a walking tour of Main Street shops, chatting with old friends, reminiscing about old times and indulging his wife, Elizabeth, as she picked out a wallpaper border for their bathroom back in Washington.

When a young woman asked him to autograph her T-shirt on the front, just below the shoulder, he laughed. "Ay yi yi!" he chirped, turning her to write on her back instead. He ran into his former math teacher, Alice

Mills, now 96. When she reported that as a student Mr. Dole had done all his homework, he said in a stage whisper, "I haven't turned it in yet."

To the people who know him best — the homefolks in Russell — it is the town he left in an easy-going college life and returned to after World War II in a body cast. It is the town that they elected as Senator left behind so many of his friends and family have died. And so the day is filled with triumph, but it was filled with loss as it was filled with triumph.

"At this moment, I wanted to be home, to come to this place," he said at the gym, his voice starting to quaver and tears welling in his eyes. He paused and contorted his lips. He then gave a thumbs-up sign. "And see all of my friends," he added. The crowd applauded with encouragement, and he went on.

"Some debts can never be repaid, but I have come to Russell to acknowledge mine," he said, naming friends in the crowd and those who helped him through his long rehabilitation from war injuries.

"It was here that I learned not to

Continued on Page B8, Column 1

It's Politics, But Unusual

An Election Year Puts Its Spin on Congress

By ADAM CLYMER

News Analysis

WASHINGTON, March 25 — It was hard enough for members of Congress to make laws when they had to get them through the House, the Senate and the White House.

These days they have to worry about the Electoral College, too.

With the Senate majority leader as the presumptive Republican Presidential candidate and the Speaker of the House pledging support, the Congressional part of the law-making agenda is as political as it has ever been. And the Presidential part is as political as it always is in a year divisible by four.

But the partisan imperatives lead in three directions: toward laws both sides think useful as politics and policy, toward confrontations designed to emphasize partisan differences to voters and toward stunts to please important supporters. Sometimes an issue, like the unfinished 1996 budget, is tugged between one category and another.

First, there are measures that both the President and the Republicans running Congress want to see become law, like the line-item veto, an increase in the limit on the Federal debt and very probably a requirement that health insurance be portable from job to job.

The mutual support for these measures does not rest solely on both sides' considering them to be in the national interest. Both sides are also acutely aware that if they go

Continued on Page B5, Column 4

STUDY CRITICIZES FEDERAL RESERVE AS LAX MANAGER

OVERSPENDING IS FOUND

Report in Congress Precedes Greenspan 3d-Term Action — Oversight Is Sought

By RICHARD W. STEVENSON

WASHINGTON, March 25 — In a rare independent examination of the Federal Reserve's operations, a Congressional report released today criticized the secretive central bank of its own finances, suggesting that it could spend less and return millions of dollars to the Treasury.

The report by the General Accounting Office was released by two Democratic Senators a day before the Senate Banking Committee is to take up renomination of the Federal Reserve's chairman, Alan Greenspan, to a third term. While it contains no direct criticism of Mr. Greenspan and does not address the monetary policy pursued by the Federal Reserve under his leadership, the report provides an unusually detailed look inside an institution with enormous power and, critics contend, insufficient accountability.

The report that the central bank's spending from 1988 to 1994, the documents its fastest-higher rate than the Federal Government spending. It said the Federal Reserve did not always seek fully competitive bids for services it buys.

The report also said that the Federal Reserve, which operates with no oversight of its internal finances, had accumulated, with little justification, a $3.7 billion contingency fund out of money that would otherwise have been returned to the Treasury, with $1.6 billion of the fund put aside since 1988, the year Mr. Greenspan became chairman. Each year, the Federal Reserve returns $16 billion to $24 billion in profits from its own operations.

More broadly, the report — a draft that is expected to become final within the questioned whether the central bank was being managed to prepare it for a financial world.

The report seems likely to raise eyebrows among political leaders, from President Clinton down, who have heard Mr. Greenspan lecture repeatedly on the need to make painful choices to reduce the Federal budget deficit, and among ordinary citizens, whose mortgage rates, credit card bills and savings accounts are all influenced by the central bank.

There has long been a tug-of-war between members of Congress who want greater oversight of the Federal Reserve, and the central bank, which jealously guards its independence as a bulwark against political meddling in its area of interest rates. Although the G.A.O. has made studies of the Federal Reserve's operations, this one, which took two years, was its most comprehensive.

The Federal Reserve's policymaking body, the Federal Open Market Committee, is also to meet on Tuesday. The committee is not ex-

Continued on Page D26, Column 4

Russia Drops Big Tariff Increase, Clearing Way for an I.M.F. Loan

By MICHAEL R. GORDON

MOSCOW, March 25 — Russia has dropped a plan for a sharp across-the-board increase in import tariffs, clearing the way for a $10.2 billion loan from the International Monetary Fund, Western economists said tonight.

The election-year loan had been thrown into jeopardy earlier this month after Russia's Finance Minister, Vladimir Panskov, proposed a 5 percent increase in the tariffs, contradicting previous assurances to the I.M.F.

But a senior Western economist said tonight that Russia has met almost all of the conditions the fund's staff has prepared, and his confidential analysis recommends the loan go forward.

The fund's 24-member executive board is scheduled to take up the loan on Tuesday, and formal approval is now virtually assured.

The huge loan, which the United States has strongly supported, is linked to a comprehensive plan to proceed with market reforms and is

expected to give President Boris N. Yeltsin an important election-year boost.

Mr. Yeltsin has been gaining ground in the polls against Gennadi A. Zyuganov, the Communist candidate. One of Mr. Yeltsin's selling points has been his ability to secure Western financial assistance.

Under the I.M.F. schedule, an initial disbursement of $340 million could come as early as this month and more than $1 billion would be available before the elections in June.

That will provide Mr. Yeltsin with a badly needed infusion of money at a time when he is trying to win votes by making good on his promise to see that back wages are paid and social spending is increased.

On a related economic dispute, the Clinton Administration announced tonight that Russia has finally dropped its ban on American poultry imports. But negotiations on Mos-

Continued on Page D1, Column 1

And the 1996 Oscar Winners Are ...

Best Actor
Nicolas Cage
"Leaving Las Vegas"

Best Actress
Susan Sarandon
"Dead Man Walking"

Best Picture
"Braveheart"

Best Supporting Actor
Kevin Spacey
"The Usual Suspects"

Best Supporting Actress
Mira Sorvino
"Mighty Aphrodite"

INSIDE

Whitewater Figure Gets Jail
David Hale, a central witness in the Whitewater inquiry who pleaded guilty to fraud, was sentenced to 28 months in prison and ordered to make restitution of $2.4 million. Page B11.

New Life for '54 Case
Sam Reese Sheppard, who was 7 when his mother was bludgeoned to death, says now, 42 years later, that he thinks he can prove his father is not her killer. Page A12.

Test for English-Only Laws
The Supreme Court agreed to review a constitutional amendment in Arizona that requires public employees to conduct government business only in English. Page A14.

THE NEW YORK TIMES
Published in more seasonal N.Y.
1-800-NYTIMES And about Times
news: Current and

The New York Times

VOL. CXLV.... No. 50,379 Copyright © 1996 The New York Times NEW YORK, WEDNESDAY, MARCH 27, 1996 $1 beyond the greater New York metropolitan area. 60 CENTS

Late Edition

New York: Today, sunny, breezy, cooler. High 47. Tonight, clouds arriving. Low 33. Tomorrow, thickening clouds, rain late. High 46. Yesterday, high 58, low 45. Details, page B16.

California Voting Leaves Dole Claiming G.O.P. Nomination

Nevada and Washington Also Support Senator

By RICHARD L. BERKE

LOS ANGELES, March 26 — Declaring that "we are now just one election away from restoring America's leadership," Senator today capped two dozen publican primary victor triumph in California, state of all, surveys of vo polls show.

"I am so confident that I am going to declare right now that I am the Republican nominee," Mr. Dole said flatly, repeating his now familiar ritual of a Tuesday night victory party in a Washington hotel ballroom. He proclaimed that he now had amassed enough delegate to propel him to the nomination.

The Kansas Senator crushed Patrick J. Buchanan by a 3-to-1 margin, according to voter surveys by The Associated Press and four major television networks. Keyes, radio talk-show host, fin hind Mr. Buc Dole also expected primaries in Washington.

While Mr. Dole's victory was never in doubt, the apparently wide margins today reinforced the Senator's base in the state with by far the largest delegate prize, as well as the largest cache of electoral votes: 54. It is a state White House officials say the President must carry to win re-election.

"The battle for the Republican nomination is over," Mr. Dole said.

"And the battle for America's future is beginning tonight."

apparent victory led Barbour, the Republican national chairman, to end months of ality and officially put the party far s behind him. "As of Republican National Committee will treat Senator Dole as our party's nominee," Mr. Barbour said in an interview. "We have up until the nomination is determined by millions of Republican primary voters around the country."

The Dole campaign is nearly out of money and the Republican Party plans to help the campaign endure months before the party convention in August by paying for generic advertising and other costs.

Mr. Barbour also insisted that despite President Clinton's edge in not abandon all, as did Barbour campaign party push campaign of California was inexplicable indefensible," he said. "The effect was that in 1992, we won fewer Congressional seats, fewer legislative seats and probably cost ourselves a United States Senate seat."

By prevailing in this winner-take-all state with 165 delegates — commonly called "the big enchilada" — Mr. Dole, the 72-year-old majority

Continued on Page A18, Column 1

On Russia's Campaign Trail, Communist Recasts the Past

By ALESSANDRA STANLEY

BARNAUL, Russia, March 26 — Revising Soviet history as he goes, the Communist leader Gennadi A. Zyuganov made his first presidential campaign swing today, trying out his election pledge to preserve plural ism and private property on distant Communist crowds in the distant provinces.

Mr. Zyuganov has been accused of talking like a social democrat to non-Communist audiences and like a hard-line Communist to the party rank and file. Out here on the stump in southern Siberia, he is crafting a message that justifies modest economic liberalism by rooting it in the Soviet past, mixing in familiar slogans and references to Lenin and Stalin meant to reassure the old guard.

"When Lenin came to Russia in 1917 the country was already in ruins," Mr. Zyuganov said at a news conference in a local administration building that was packed with elderly supporters. "Lenin doesn't need to be defended. When he died, there was a stable ruble, a stable economy and a New Economic Program." By

a New Economic Program, Mr. Zyuganov was referring to a brief period when the Bolsheviks allowed Russians a little of commerce and private enterprise.

Many Communists, including one of Mr. Zyuganov's top economic advisers, Igor Bratishchev, a Communist member of Parliament, have described the last five years of free market reform under President Boris N. Yeltsin as a reversion to a New Economic Program, and a return to capitalism behind in the party. But in this case and others Mr. Zyuganov, who is running a coalition candidate in the hopes of attracting non-Communist voters, is air-brushing his party's history and trying to draw on aspects of Soviet rule that mesh with his eclectic platform.

Before a large crowd of students and teachers at the Pedagogical Institute in Barnaul, trying to explain the Communist Party's new embrace of the Russian church — a bow to the nationalists whose support he seeks — Mr. Zyuganov cited Stalin. He did not refer to Stalin's ruthless persecution of priests, but to the moment when German troops were poised to take Moscow during World War II, and Stalin called on the Orthodox Patriarch to bless Red Army troops.

"Russian Orthodox church choirs sing better than the Bolshoi," Mr. Zyuganov said, "because they sing with soul. I told my party members religious rights must be guaranteed — and my party made a great step forward."

When he left Moscow on Monday, Mr. Zyuganov's campaign was bogged down in controversy over his party's authorship of a bill disavowing the 1991 treaty that dissolved the Soviet Union, as well as a top Communist official's insistence that the

Continued on Page A10, Column 1

Ability to Discover Tiny Breast Tumor Creates a Dilemma

By GINA KOLATA

In 1992, more than 23,000 American women learned that they had tiny tumors in the milk ducts of their breasts. They might, or might not, develop into invasive, life-threatening breast cancers. Almost half of them had breasts removed (mastectomies) to avoid any chance of cancer.

Some of these tumors might never become cancerous, researchers say, and yet large numbers of women received the most radical treatment for any type of breast cancer, a more conservative treatment chosen by slightly more than half the women, was removal of a small lump of tissue (lumpectomy) sometimes followed by radiation treatments. The dilemma faced by women who have such tumors and the doctors who treat them is that no one knows what treatment is appropriate. The increased use of mammography brought the number of diagnoses of these small tumors up fivefold in 1992 from the number of such diagnoses 15 years earlier.

This sort of tumor is too small to feel but is visible in a mammogram. Mammography did not cause the tumors, but merely brought them to the attention of doctors and women. Then, because it is impossible to determine which of these small tumors are dangerous and which are not, doctors proceeded with treatment.

"It's really tough," said Dr. Ann

Continued on Page C11, Column 1

NEW YORK COURT LIFTS RESTRICTIONS ON SPLIT PARENTS

WOMEN PRAISE DECISION

Parents Who Have Custody Win More Freedom to Move Children Out of State

By RAYMOND HERNANDEZ

ALBANY, March 26 — New York State's highest court issued a ruling today intended to give divorced parents who have custody of their children more freedom to move out of the state, even if it means they are leaving behind former spouses who have visitation rights.

The unanimous decision by the Court of Appeals overturns a requirement that custodial parents who want to move meet several strict standards, like proving that a move is prompted by "exceptional" circumstances.

Instead, the seven judges on the appeals panel ruled today that legal authorities judge such cases should be governed largely by one central concern interest of the child.

"Like Humpty Dumpty," the court said in the opinion, written by Judge Vito Titone, "once broken by divorce cannot be put together in precisely the same way."

He added that it is the rights and needs of the child that must be given the greatest weight, since they are innocent victims of their parents' decision to divorce, and are the least equipped to handle the stresses and strains of the changing family situation."

The ruling was consistent with a trend among New York's politicians and judges to put the well-being of the child above the desire to keep the family together. For example, Gov. George E. Pataki, Attorney General Dennis C. Vacco and Mayor Rudolph W. Giuliani have all recently called for changes in the way officials determine whether to allow a child to remain with abusive parents. They have said that instead of focusing on holding a family together, more weight should be given to the needs of the child.

The decision also comes as a growing number of states are trying to balance the rights of noncustodial parents — generally fathers who have visitation rights — with the rights of custodial parents, most of

Continued on Page B4, Column 3

David Packard, 83

The co-founder of Hewlett-Packard, one of Silicon Valley's most innovative electronics companies, died in Palo Alto, Calif. Page D20.

Edmund Muskie, 81

The Maine Democrat who was a governor, senator, Secretary of State and a vice presidential nominee, died in Washington. Page D21.

Dole Blocks Vote on Raising Minimum Wage

By ADAM CLYMER

WASHINGTON, March 26 — After hours of arcane parliamentary stratagems interspersed with political attacks, Senator Bob Dole, the majority leader, today led a Republican bloc in refusing to let the Democrats bring the minimum-wage increase issue up today to dim the luster of Mr. Dole's Presidential campaign on the day he hoped a victory in the California primary would give him the last of the delegates needed to clinch the nomination. But, Senator Edward M. Kennedy of Massachusetts acknowledged, "We haven't lost any sleep over it."

Seizing the moment, Mr. Kennedy gibed, "The day that Bob Dole locks up the Republican nomination, he locks out working families that are looking for a very modest increase in the minimum wage" — to $5.15 an

hour from $4.25 an hour, over 15 months.

Mr. Kennedy, who has been promising to offer the wage increase as an amendment to some piece of legislation for got chance the Republican on when le stum parliamentary maneuver could have kept Mr. Kennedy for even being offered. "That won't happen again."

Mr. Dole muttered to aides when he saw Mr. Kennedy exploiting his mistake.

The Kansas Republican discussed the substance of the wage issue only briefly. At one point he said that if the wage rise too high, "there are going to be young people who will lose their jobs, and a lot of them will be teenagers." He also said that anything was to be added to the bill the Senate was considering, a measure to create park areas in 24 states, it should not be the minimum wage but rather changes in welfare and Medicaid, "issues the American people are really concerned about."

In an interview this evening, Labor Secretary Robert B. Reich disputed Mr. Dole's assessment of the effect of raising the wage. He said that independent research, "not supported by any party with a stake in the outcome, showed that a modest

Continued on Page B8, Column 5

BRATTON QUITS POLICE POST; NEW YORK GAINS OVER CRIME FED A RIVALRY WITH GIULIANI

Chester Higgins Jr./The New York Times

Police Commissioner William J. Bratton and Mayor Rudolph W. Giuliani yesterday at City Hall, where Mr. Bratton announced his resignation. In his tenure, crime in New York fell to its lowest levels since the 1960's.

An Officer Who Shot a Colleague Is Convicted of Lesser of Charges

By GEORGE JAMES

In a case that raised troubling questions about police procedures and race, a white New York City police officer who mistakenly shot a black undercover transit officer in a Manhattan subway station was convicted yesterday of second-degree assault.

The jury in State Supreme Court in Manhattan deliberated for only five hours before acquitting Officer Peter Del-Debbio, 33, of the more serious charge of first-degree assault, which would have meant a minimum term of 1½ to 4½ years in prison. The second-degree conviction gives Justice Bernard J. Fried the option of sentencing Officer Del-Debbio to probation for the shooting of Officer Desmond Robinson, 32.

The case was 15 seconds of panic and confusion after a youth dropped a shotgun and it went off in

the last car of an F train in the station at 53d Street and Lexington Avenue. As the case unfolded, it forced police officials to confront the tensions between white and black officers, particularly whether white officers are too quick to assume that blacks working undercover are criminals. It also underscored the uncertainties that officers face when making almost instantaneous judgments about the use of deadly force.

Officer Del-Debbio, off duty and waiting for a train home, said he stepped into the F train, identified himself as a police officer and picked up a shotgun the youth had dropped. Officer Del-Debbio said a black man who warned out to be Officer Robinson ran toward him, revolver in hand. Officer Robinson was working undercover and not wearing a badge that would have identified him as a police officer.

Neither Officer Del-Debbio nor his wife, Denise, showed much emotion when the verdicts were read yesterday; Officer Del-Debbio stared straight ahead and closed his eyes tightly. Officer Robinson, who retired on medical disability after the

Continued on Page B3, Column 1

New Questions Arise Over City Contract

The chairman of the board of a Queens social-service organization that won city contracts to monitor welfare recipients said yesterday that the $43 million deal had been put together by an employee acting without the approval of the board.

The new questions arose after city records and interviews with participants in the process indicated that the Giuliani administration broke city bidding rules in granting the contracts to the Hellenic-American Neighborhood Action Committee. It was not the top-rated competitor and its proposal was millions of dollars more costly than others presented.

The group's chairman said an employee had improperly set up a separate corporation to run the welfare programs. And he said another employee who actually signed the city contracts had no power to do so.

Article, page B1

INSIDE

More Nixon Tapes Due

More than 3,000 hours of Nixon White House tapes will soon begin to become public, said people involved in a suit over them. Page A17.

Aftermath of Rape Case

An acquittal in a rape case leaves a woman wondering what happened in court and a town trying to resolve divided loyalties. Pages B1 and B6.

27 MONTHS IN JOB

He Will Run Subsidiary of Security Company Based in Boston

By DAVID FIRESTONE

Police Commissioner William J. Bratton announced his resignation yesterday after 27 months in office, ending a tenure that saw a precipitous drop in New York City's crime rate and a consequent rivalry for the limelight with Mayor Rudolph W. Giuliani that eventually led to the Commissioner's departure.

Mr. Bratton said he would leave on April 15 to run the New York office of First Security Services Corporation, a Boston company that provides uniformed security services to private corporations throughout the Northeast. Mr. Bratton will run a subsidiary intended to expand the company's reach into governments and public agencies.

The Mayor did not name a successor to the position. Both men sought to the departure of the administration's most important Commissioner, a nationally known crime fighter who the city succeeded official, reversal the city yesterday, and several of the Mayor's political rivals seized on the marks a turning point for the Mayor. Having run for office on a platform that made crime-fighting pre-eminent, Mr. Giuliani appointed Mr. Bratton as the architect of a plan to reorganize the Police Department, with a focus on fighting crimes that affected the quality of life.

Taking over a department that had just been wrecked by a damaging corruption scandal, Mr. Bratton, former chief of the city's Transit Police, engineered a series of management strategies that relied on a block-by-block analysis of computerized crime statistics.

Aided by a significant increase in the size of the force begun under the previous Mayor, David N. Dinkins, Mr. Bratton steered the department as crime fell to its lowest levels since the 1960's. Although many have sought credit for it, the decline in crime has become Mr. Giuliani's most significant political accomplishment.

The success of the anticrime effort in a city long notorious for its violence brought New York international attention and became a keystone of Mr. Giuliani's attempt to attract tourists and retain businesses and residents, as well as to secure his re-election in 1997.

With Mr. Bratton gone, the Mayor will now have an opportunity to demonstrate his long-held contention that it is his administration's management techniques, not any one person, that is responsible for the drop in crime.

Mr. Bratton was almost universally praised by elected officials around the city yesterday, and several of the Mayor's political rivals seized on the

Continued on Page B5, Column 1

229 EAST 44TH ST. HAS BEEN LIBERATED FROM the cable monopoly! Better building-wide service. Better prices. Call Liberty Cable 212-891-7711 — ADVT.

THE NEW YORK TIMES is available for home or office delivery in most major U.S. cities. Please call, toll free 1-800-NYTIMES. Ask about the Transmedia Triworld card ADVT.

354613

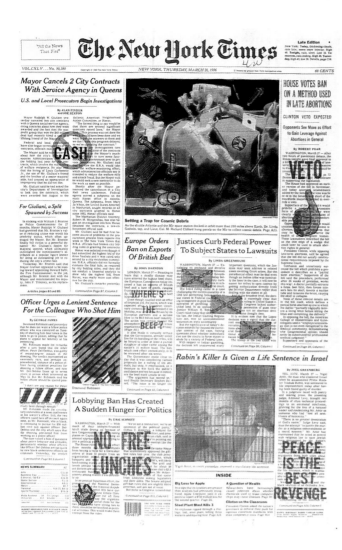

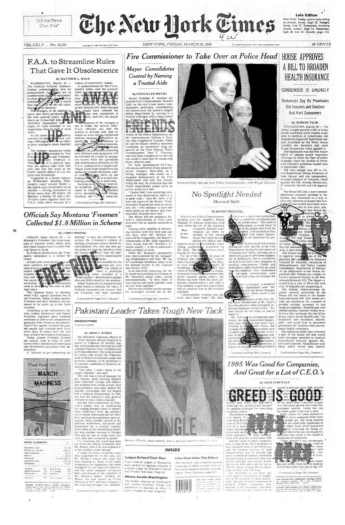

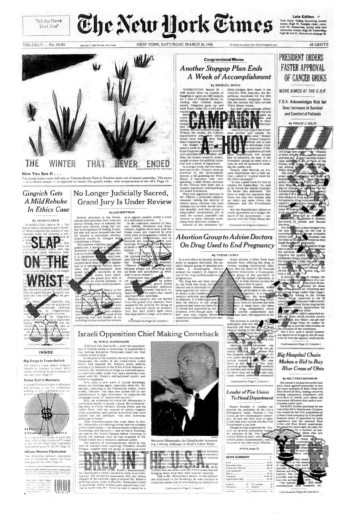

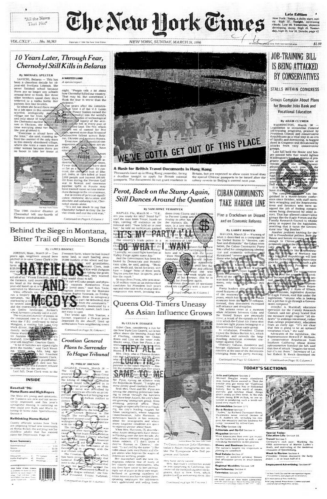

April

This was the month that I started making drawings on the papers;

on April 2, the whale eating baby fish, one big

company devouring the small fry, a theme picked up on April 29,

with the Bell-Atlantic and Nynex merger.

Ron Brown's death and the Unabomber came in April,

along with the female genital mutilation series.

I became more aware of who writes the stories in the *Times*

with that particular series — it was Celia Dugger.

Her articles led to the introduction of legislation that would

allow Congress to pass laws to let threatened women

into the United States. We hear about the power of the press,

but until I started doing this I never sensed it as much.

"All the News That Fits"

The New York Times

Late Edition
New York: Today, afternoon showers, breezy. High 49. Tonight, rainy, chilly. Low 38. Tomorrow, becoming sunny, windy. High 52. Yesterday, high 62, low 38. Details, page C14.

VOL.CXLV..No. 50,384 Copyright © 1996 The New York Times NEW YORK, MONDAY, APRIL 1, 1996 $1 beyond the greater New York metropolitan area. 60 CENTS

Tennessee Celebrates a Title

Tennessee's Chamique Holdsclaw taking a leaping shot against Georgia in the N.C.A.A. women's championship game yesterday in Charlotte, N.C. Holdsclaw had 16 points and the Lady Vols gained their fourth national title with an 83-65 victory. SportsMonday, page C1.

Breaking Ranks, Lab Offers Test To Assess Risk of Breast Cancer

By GINA KOLATA

In the small world of geneticists in the forefront of studying human disease, the researchers tend to know one another. So last year, after the discovery that as many as 1 percent of Jewish women carry a mutated form of a gene that might predispose them to breast and ovarian cancer, it was easy enough for leading scientists and two major commercial testing labs to agree informally not to offer the test to the general public.

The reasoning was that many questions remained about the risk posed by the gene, about what, if anything, could be done to lessen the risk and about whether widespread testing would do more harm than good.

Now, however, a private commercial institute that was not part of any agreement to hold off on testing is offering the test to the public, arguing that women have a right to know whether they carry the mutated gene and that it is patronizing for scientists to say otherwise.

That decision, by Dr. Joseph D. Schulman, director of the Genetics and I.V.F. Institute in Fairfax, Va., to offer the test for $295 has outraged some leading geneticists, raising the question of how, and by whom, the dissemination of new genetic tests should be controlled.

But others are rooting for Dr. Schulman. Dr. Walter Nance, who is chairman of the department of human genetics at the Medical College of Virginia in Richmond and a past president of the American Society of Human Genetics, said he thought that Dr. Schulman was "doing us a service by goading the community."

Dr. Nance added: "We have a test here that does have the potential of actually saving lives. That being true, you've got to ask the question, How long can you delay it? How long are you willing to delay it? Are you willing to go through N.I.H. grant cycles and apply for grants? Is that an appropriate way to bring it to the

Continued on Page A15, Column 1

Abortion Pill Advances

The New York group holding the American patent rights to the French abortion pill said it was seeking F.D.A. approval. Page A12.

DELAYS BY H.M.O. LEAVING PATIENTS HAUNTED BY BILLS

MANAGED-CARE LOOPHOLE

H.I.P., Biggest New York Plan, Has Some Members Facing Lawsuits From Doctors

By ESTHER B. FEIN and ELISABETH ROSENTHAL

The Health Insurance Plan of Greater New York, the state's largest and oldest health maintenance organization, routinely fails to pay millions of dollars of its members' medical bills each year, leaving subscribers either to cover the bills themselves or to fight collection agencies and lawsuits from doctors demanding overdue payments.

An analysis of records filed with the New York State Department of Insurance, as well as H.I.P.'s own financial reports, show that the H.M.O. has for years delayed paying for treatment it authorized outside of its regular network of doctors, therapists and hospitals, including emergency appendectomies and bypass surgery, specialized physical therapy and doctors' visits when patients fall ill far from home.

Complaints against H.I.P. to the Insurance Department vastly outnumber those against any other health maintenance organization in the state — even accounting for its size — and they are overwhelmingly about bills that H.I.P. ignored, often for years. "H.I.P.'s complaints are why we took the industry average," said Howard Casolino, chief of the Insurance Department's Consumer Service Bureau. "H.I.P. has systemic problems regarding payment of claims."

It is unclear whether H.I.P., a nonprofit company, fails to pay bills

PAST DUE

A special report.

because of inefficiency or by design. But there is little incentive for reform: as it sits on legitimate claims, it hangs on to millions of dollars it invests. And it pays no penalties because regulators and legislators have been lax in policing H.M.O.'s.

While H.I.P. executives acknowledge an abysmal history of paying claims, they contend that management changes and an overhaul of a disorganized claims processing system last year have rectified the situation. Complaints about H.I.P. to

Continued on Page B6, Column 1

The Speaker's Gruff No. 2 Takes Charge in the House

By JERRY GRAY

WASHINGTON, March 30 — When he arrived on Capitol Hill in 1985, the Almanac of American Politics promptly summed up the political picture rough and, and arrived at a position as someone "hardly likely to be a power in the House."

Representative Dick Armey is still politically crude, rough-edged and brooding. But 12 years after quitting a college classroom to run for Congress, he has become one of the most powerful politicians in Washington.

Several predecessors could be cited to rival Newt Gingrich for the title of most powerful Speaker of the House in the nation's history. But at almost universally accepted in Washington these days is that he has a majority leader's job in the House that Mr. Armey singularly wielded so much authority.

Unabashedly political, fiercely conservative and with tongue as sharp as barbed wire, the 55-year-old Mr. Armey has emerged as the leading Republican voice in the House as well as the majority's rhetorical stick.

"I just do what any of the boys confronting, I can't," said in an interview the other day. "But it is a tool sometimes you use it."

Since the start of the second session of the 104th Congress in January, Mr. Gingrich's low poll ratings have become a drag on the Republican majority and its agenda, which has been suffering.

In the face of that and, more important, to free himself to travel around the country raising money for Republican candidates, the Speaker has ceded more and more of the day-to-day power to his deputy. As a result, Mr. Armey has a decisive voice in determining which bill will be brought to the floor, in what form and when.

It is rare for any leader to trust his No. 2 with such power. But Mr. Armey describes himself as "a man totally without guile," and Mr. Gingrich, and even some of Mr. Armey's most ardent crit-

Continued on Page B8, Column 1

Dick Armey

An Accountability Issue

As States Gain Political Power, a Ruling Seems to Free Them of Some Legal Reins

By NINA BERNSTEIN

To some proponents of states' rights, a major Supreme Court ruling last week is a welcome reinforcement of a long-standing trend in American politics.

News Analysis

But the bitterly contested decision, in a gambling dispute in Florida, raises the specter of a system in which states can use enhanced sovereignty to avoid accountability.

Many Federal laws on the environment, business, health and safety now have provisions that allow people hurt by violations of those laws to sue in Federal court. But the new decision, in Seminole Tribe v. Florida, says states are immune from such suits unless Congress authorizes lawsuits that even as it applies from the Federal Government to the states block grants, waivers and a retreat from Federal regulation, it will be less accountable to those who believe they are the victims of government wrongdoing in matters like water pollution, health care and copyright infringement.

"This is a case about power," Associate Justice John Paul Stevens wrote in his dissent from the 5-to-4 majority decision. The importance of the Court's decision, he declared, "cannot be overstated."

Few cases could seem less relevant to the everyday life of most people than a Seminole tribe's dispute with Florida officials over casinos. But the Supreme Court's decision has turned that obscure suit and a dusty amendment into the stuff of historical watersheds.

The decision came in a case challenging a 1988 law that permits Indian tribes to sue states in Federal court for failing to negotiate in good faith over gambling operations on tribal land. In an opinion by Chief Justice William H. Rehnquist, the

Continued on Page B9, Column 4

Leadership Debate At Investors' Group

The Council of Institutional Investors, a collection of large pension funds that has been a leader in the shareholder rights' movement, faces a showdown today over how it governs itself. Corporate members are seeking representation among the group's officers, but union members are vehemently opposed.

Business Day, page D2.

As China Undercuts Democracy, Hong Kong Scuffles for Passports

By EDWARD A. GARGAN

HONG KONG, Monday, April 1 — Inexorably, the clock marched toward midnight, and the last chance to apply for a British overseas passport.

Then, a few minutes into this morning, a phalanx of blue-uniformed police pushed a tiny woman, barely visible in their midst, toward the doors of the black marble-and-glass immigration office as she clutched a white paper application.

Yau Sui-chun, who is 62 this month, was the last of the 54,178 Hong Kong residents to file on Sunday for status as British overseas citizens by the formal midnight deadline.

He had pushed her application across a certain wood table under the glare of television lights, she ended a final week of mounting clamor by more than 100,000 Hong Kong residents to register as citizens of a British Dependent Territory.

Each day, for the last week, tens of thousands of people, anxious over China's increasing intrusions into Hong Kong affairs, camped in lines and queues, stood in interminable lines and at times engaged in scuffles over line-jumping, all to sign up for this tenuous sort of British identity — an identity they hope will provide some security after China retakes this colony on July 1, 1997. Despite Beijing's assurances of autonomy, many here are deeply afraid of what will happen then, and their fears have grown with recent Chinese intrusions into Hong Kong's democracy.

"This is the best we can hope for," said Billy Lai, who joined the line for passport applications early on Sunday, as he took the application form from an immigration officer. "Much better than a Chinese passport."

The British National Overseas passport, while not conferring British citizenship, does allow residents of British and former British territories to travel without a visa to Britain and about 80 other countries.

As for the new "Special Administrative Region" passport that will be

Continued on Page A10, Column 1

FACING ELECTION, YELTSIN IS HALTING WAR ON CHECHENS

OFFERS MORE AUTONOMY

He Also Approves Talks With Rebel Chief in Pushing for Peace Before June Vote

By MICHAEL SPECTER

MOSCOW, March 31 — Struggling to end the deeply unpopular Chechen war before pivotal elections in June, President Boris N. Yeltsin said today that all major military operations in the secessionist republic in southern Russia would stop at once.

In a speech broadcast to the nation tonight and in comments to journalists after it, Mr. Yeltsin said for the first time that he would approve peace talks with the main rebel leader, Gen. Dzhokhar M. Dudayev. He also said he was ready to grant Chechnya almost any new freedom short of Mr. Dudayev's stated goal of total independence.

"We will be able to give more autonomy to Chechnya than to any other republic of Russia," Mr. Yeltsin said in an interview that was also televised nationally. "We are not afraid of doing that."

This is not the first peace plan Mr. Yeltsin has offered, nor is it likely to be any more successful than those that have come before. But the 65-year-old president, running hard for re-election, is nevertheless publicly staking his reputation that he does not find a way to end the war.

Even as Mr. Yeltsin spoke, Russian warplanes continued to strike at rebel bases in southern Chechnya, and the Russian commander in the region, Lieut. Gen. Vyacheslav Tikhomirov, said it would be "impossible" to turn war to peace so quickly.

[General Tikhomirov said on Monday that his troops had halted all operations in the region at midnight Sunday, Reuters reported, monitoring the Itar-Tass news agency.]

But a quick peace was apparently not Mr. Yeltsin's goal. In most ways the plan presented tonight is simply a political confection: While troops are to be withdrawn, they are to be taken only from areas where there is no conflict now. Mr. Yeltsin said Russian forces would remain to "protect" the Constitution and the people. And he admitted that he could not yet find a resolution to the problem that started the war: the separatists' insistence on independence and Moscow's refusal to let the region secede from the nation.

Still, by offering to begin troop

Continued on Page A8, Column 1

Program Creates Community for Foster Care

Dexter Williams and other hard-to-place foster children get "honorary grandparents" like George King.

By DIRK JOHNSON

RANTOUL, Ill. — On the grounds of a shuttered Air Force base here, an old-fashioned, close-knit Midwestern neighborhood has been created from scratch, right down to the stay-at-home moms and checkers-playing grandparents.

And for the first time in his 6-year-old life, Marc, a foster child who has cerebral palsy and a history of rejection, belongs to a family that wants him forever.

"Are you going to be my daddy?" he asked Mark Owen, 37, his new foster father, a tall, broad-shouldered man in a work shirt. "I've never had a dad before."

The answer came in a hug so tight and long it seemed that Mr. Owen would never let go.

In a pioneering two-year-old program for foster children who stand little chance of being placed in a family permanently, a University of Illinois professor of child development, Brenda Krause Eheart, has drawn upon the small-town closeness and nurturing she remembered from her childhood in the 1950's in upstate New York.

After securing the purchase of 63 duplex apartments on 22 acres, part of the former Chanute Air Force Base, Ms. Eheart's group, Hope for the Children, recruited and hired foster parents, who live rent-free.

The program pays one parent $18,000 a year to stay home with the children. The group also recruited middle-aged and elderly people who serve as "honorary grandparents." They receive subsidized rents in exchange for volunteering 8 to 10 hours a week as crossing guards, crafts instructors and tutors. But their principal value, Ms. Eheart said, comes in simply being part of the lives of the children, playing ball, lending an ear and tell-

Continued on Page B9, Column 1

"All the News That Fits"

The New York Times

Late Edition

New York: Today, becoming sunny, breezy. High 54. Tonight, thickening clouds late. Low 37. Tomorrow, clouds and sunshine. High 53. Yesterday, high 52, low 46. Details, page C16.

VOL.CXLV..No. 50,385 Copyright © 1996 The New York Times NEW YORK, TUESDAY, APRIL 2, 1996 $1 beyond the greater New York metropolitan area. 60 CENTS

Kentucky players celebrating after beating Syracuse for the the N.C.A.A. title at the Meadowlands last night.

Barton Silverman/The New York Times

Basketball Finale As Baseball Opens

The University of Kentucky captured the national collegiate basketball championship last night, defeating Syracuse, 76-67, at the New Jersey Meadowlands.

As the college basketball season ended, baseball got under way with cheering in Queens, snow in Cleveland and, in Atlanta, World Series rings for the Braves. But the traditional festiveness of opening day was overshadowed by the death of Umpire John McSherry, who collapsed just seven pitches into a game in Cincinnati. McSherry, a 26-year veteran, suffered sudden cardiac death. The 51-year-old umpire had had several health-related problems in the past.

Weather put off three games, including the Yankees' snowed-out opener in Cleveland, but the Mets thrilled the home crowd by rallying for a 7-6 victory.

SportsTuesday, page B7.

BOYS OF SUMMER

Agence France-Presse

At Jacobs Field in Cleveland, Yankees' Kenny Rogers built a snowman.

Peres Vows to Submit Final Pact With Palestinians to Israeli Vote

By JOEL GREENBERG

JERUSALEM, April 1 — In an apparent effort to win the support of wavering voters in Israel's coming elections, Prime Minister Shimon Peres said today that he would put any final peace agreement with the Palestinians to a referendum.

It was the first time an Israeli leader has proposed that a permanent accord with the Palestinians be put to such a vote, and it drew immediate criticism from the Palestinian Authority.

Under the Israeli-Palestinian accords signed in 1993, which a permanent settlement was supposed to start in May, covering such crucial issues as borders and the future of Jerusalem, Jewish settlements and Palestinian refugees.

Mr. Peres raised the subject with reporters on his way to Oman for a visit to expand ties with Persian Gulf states. He said that in forthcoming policy discussions in his Labor party, he would "ask the party for a mandate to negotiate a permanent settlement with the Palestinians, to announce that we will bring it to a referendum."

"If we get to a permanent settlement with the Palestinians," Mr. Peres added, "I'll propose making it a referendum as well, like the settlement with the Syrians."

Yitzhak Rabin, the Prime Minister who was assassinated last November, had said he would call a referendum before an agreement was signed with Syria on a pullout from the strategic Golan Heights, but Mr. Peres has said he would do the same thing in a referendum on protected regarding a final settlement with the Palestinians.

Coming less than two months before national elections set for May 29, the remarks seemed calculated to counter the opposition Likud party's contentions that if Mr. Peres is re-elected he will divide Jerusalem and allow the creation of an armed and dangerous Palestinian state on Israel's doorstep.

"What's the point in all the guesses," Mr. Peres said, referring to the shape of a future settlement. "In any event, if you're conducting such ne-

Continued on Page A8, Column 1

Court Toughens Law Prohibiting Age Bias

In a unanimous ruling, the Supreme Court strengthened the Federal law against age discrimination on the job, saying that a lawsuit for age discrimination can succeed even if a worker is replaced by someone older than 40, the age at which the law's protections begin to apply.

The law bars discrimination based on age regardless of the age of the person who actually gets the job or promotion, Justice Antonin Scalia said in the opinion for the Court.

"The claim cannot be, in the protected class, thrust out to another person of protected class is thus irrelevant, as he has lost out because of his age," Justice Scalia said.

Article, page A14.

Under Pressure, Federal Judge Reverses Decision in Drug Case

His Original Ruling 'Demeaned' Police, He Says

By DON VAN NATTA Jr.

After enduring an avalanche of criticism and calls for his ouster, a Federal judge yesterday reversed his decision suppressing evidence and a videotaped confession in a Washington Heights drug case.

The judge, Harold Baer Jr. of Federal District Court in Manhattan, made no direct reference to the political storm his ruling had whipped up from City Hall to the White House. But he expressed regret for the remarks in his original decision that prompted the greatest outrage, in which he had questioned the credibility of police officers and suggested that it was not necessarily suspicious even for innocent people in Washington Heights to run from the police.

"Unfortunately," he wrote, "the hyperbole in my initial decision not only obscured the true focus of my analysis, but regretfully may have demeaned the law-abiding men and women who make Washington Heights their home and the vast majority of the dedicated men and women in blue who patrol the streets of our great city."

The judge said he had based his reversal on new evidence presented at a second hearing on the issue, including the testimony of a second police officer, which he said buttressed the police account of the disputed search and undermined the credibility of the defendant. But several outside experts called the new ruling extraordinary, and the de-

fense lawyer in the case, while avoiding criticism of the judge, pointedly noted the heavy political pressure he had faced.

The judge's original ruling was the first of a series of judicial decisions in New York in recent months that prompted outrage from politicians, who accused some judges of protecting criminals rather than the public. Even President Clinton and Senator Bob Dole joined the chorus of criti-

Continued on Page B2, Column 1

Associated Press

Judge Harold Baer Jr.

Aetna to Buy U.S. Healthcare In Big Move to Managed Care

By LESLIE EATON

The Aetna Life and Casualty Company plans to spend $8.8 billion to buy U.S. Healthcare Inc., a leader in what is known as managed health care, creating the nation's single biggest medical benefits company.

The combined company will cover 23 million people, or one in every 12 Americans, offering everything from health and disability protection to prescriptions, mental health, vision, dental care as well as retirement services. It will be the fourth-largest company in the country operating health maintenance organizations, which try to keep down medical costs by negotiating with doctors and hospitals for lower charges and controlling patients' access to health care services.

It is expected to be the second-largest H.M.O. in New York City, trailing only the Health Insurance Plan of Greater New York — and will cover more than 650,000 people in the city.

The deal, announced yesterday, offers the strongest evidence yet that traditional health insurers like Aetna's bread and butter faces inexorable decline as H.M.O.'s and other forms of managed care have proven that they can be both less costly and more profitable in providing health

benefits. The combined company will retain the Aetna name. But its strategy will more closely resemble that followed by U.S. Healthcare, an aggressive marketer concentrated in New York, New Jersey and Pennsylvania. U.S. Healthcare specializes in a particularly low-cost but restrictive form of health care plan that relies on primary physicians as gatekeepers to limit access to specialists and other kinds of expensive treatments.

"Strong forms of managed care gained managed care is really going into its own," said Leonard Compton, the chairman of Aetna, who will become chief executive of the combined company, which will be named Aetna Inc.

U.S. Healthcare, which consumers know through its Purple Rockwell-style advertising, is within the health industry one of the strongest proponents of capitation, in which doctors are paid one low fee for each patient whether that person receives treatment or not.

U.S. Healthcare practices tough cost controls, closely monitoring the services provided by its doctors and hospitals. It penalizes those viewed

Continued on Page D8, Column 1

For Helms, His Home State Is Source of Foreign Policy

By DAVID E. SANGER

DURHAM, N.C., April 1 — As the chairman of the Senate Foreign Relations Committee, Senator Jesse Helms dictates how he feels the United States should run its foreign leadership of Vietnam.

Nine months after the Clinton Administration formally recognized the Vietnamese Government, Mr. Helms is trying to undercut the new relationship by charging that there are no obstacles felt in the search for possible American prisoners of war or the missing in action. In a speech last week he denounced Vietnam as one of Asia's "repressive governments," attack-

ing its record on human rights.

So it might seem surprising that on Sunday night Mr. Helms had a referendum, in effect, right here on the Angeles mission, the local Vietnamese elite to Washington, along with six other envoys from Southeast Asia. He was very proud of his budget surprised to find a North Vietnam dinner table. "After all, he is interested in promoting North Carolina."

In fact, Mr. Helms boasts that he intends to use his chairmanship to broaden the world's most lucrative emerging markets by North Carolina, today most notably on any May 30 when the RJ. Reynolds Tobacco company, the subsidiary of RJR-Nabisco, a longtime supporter of the Senator, which has invested $21 million in a joint-venture cigarette factory in Da Nang.

"It can be seen and will be seen by many as betting on Yeltsin or a waste of money," Mr. Camdessus said in an interview in his office, three blocks from the White

Continued on Page A18, Column 1

I.M.F. Head: He Speaks, and Money Talks

By JEFF GERTH and ELAINE SCIOLINO

WASHINGTON, March 31 — If Boris N. Yeltsin is re-elected President of Russia in June, he will owe his victory in some part to one of Washington's least-known but most powerful people: Michel Camdessus.

The 63-year-old Frenchman is head of the International Monetary Fund, the obscure global lending organization that gave a vital lift to Mr. Yeltsin's campaign when it formally approved a $10.2 billion loan to Russia last Tuesday.

Although the monetary fund is not supposed to take sides in elections, the extraordinary deal — the second-largest loan in the fund's history — was driven by the West's desire to impede the comeback of the Communist Party in Russia.

The United States and Germany urged that the loan be approved, but Mr. Camdessus had cleared the way by rewriting fund rules in 1994 to ease credit to Russia, and Mr. Camdessus went on Russian television to announce the new terms that Mr. Yeltsin's economic reforms had won.

Even Mr. Camdessus recognizes the inevitable political consequences of taking such an activist course.

David Scull/The New York Times

Michel Camdessus has reinvented a staid organization.

House. "But nothing more important could be done today for the prosperity of the entire world. So we agreed.

In the case of Russia it illustrates how Mr. Camdessus has played the role of gambler, preacher and politician in the fine years since he became head of the fund, a position he has held since 1987. In the process, he has reinvented a staid organization whose role — originally the limited one of stabilizing currency markets — has grown to the point where it can now virtually dictate broad economic policies

to a major power like Russia.

But Mr. Camdessus's greatest moments of activism — the record $18 billion plan to Mexico last week and the loan to Russia last week — have brought criticism that the end the fund failed to anticipate the Mexico financial crisis of 1995 and is now lending money to Russia. The two loans are almost half of the monetary fund's $55 billion in outstanding loans, leaving in them its greatest concentration

Continued on Page A10, Column 3

2 BELL COMPANIES AGREE TO MERGER WORTH $17 BILLION

7-STATE TELEPHONE GIANT

SBC, Based in Texas, Will Buy Pacific Telesis in First Link of Former AT&T Units

By MARK LANDLER

In the first marriage of two regional Bell telephone companies and one of the largest corporate mergers ever, SBC Communications announced yesterday that it will acquire the Pacific Telesis Group for $17 billion.

The deal would create a communications colossus, providing service to more than 30 million residential and business telephone lines in seven states west of the Mississippi, including California and Texas.

The combined company would also provide wireless service coast to coast, with cellular and other wireless franchises that reach a potential market of 53 million people from Boston to Los Angeles.

Coming just two years after Congress passed a sweeping telecommunications bill, the deal underscores how telephone and media companies are rushing to bulk up for the untrammeled competition of an open marketplace.

Nynex and Bell Atlantic, the regional phone companies serving New England, New York and the other mid-Atlantic states, have been mulling a merger for months, and several analysts said yesterday's deal could lead them to consummate their courtship.

Together, SBC and Pacific Telesis would be the nation's second-largest phone company with revenue of $21 billion in annual revenue. Only AT&T, the long-distance carrier, would be bigger. Both SBC originally Southwestern Bell and Pacific Telesis were created in the 1984 breakup of the Bell System.

AT&T, which is in the process of cutting more than 30,000 jobs, SBC and Pacific Telesis said yesterday that they plan to hire 1,000 employees to augment their combined work force of 110,000.

The new company will be named SBC Communications and will be based at SBC's headquarters in San Antonio. Telephone service to customers in California and Nevada, however, will continue to be provided by companies named Pacific Bell and Nevada Bell.

"We could have survived as an independent company," Philip J. Quigley, the chairman of Pacific Telesis, said yesterday. "But this is going to be an industry with a handful of strong global players."

By negotiating quickly and mostly in one-on-one sessions, Mr. Quigley and his counterpart, Edward E. Whitacre Jr., the chairman and chief executive of SBC, were able to keep the deal almost completely under wraps until yesterday. Mr. Whitacre will become the chief executive of the combined company, while Mr. Quigley will become vice chairman.

The deal is subject to approval from the Justice Department and the Federal Communications Commission. Despite the size and first-of-its-kind nature of the deal, legal experts predicted yesterday that the transaction would not run aground on antitrust or regulatory

Continued on Page D9, Column 1

INSIDE

Libel Suit Settled

The Knight-Ridder company settled a libel suit over a 1973 article in The Philadelphia Inquirer. Page A12.

Ansel Adams, Digitized

Bill Gates of Microsoft has acquired the electronic rights to the works of Ansel Adams. Page D6.

New Life After Westway

With the Westway project finally dead, construction is beginning on a replacement roadway. Page B1.

FORMER SECRETARY OF DEFENSE ROBERT McNamara will appear LIVE on @times, The New York Times on America Online, Thurs., April 4, 10 P.M. ET. Free software & information: 800-343-5201.—ADVT.

The New York Times

Late Edition
New York: Today, mostly cloudy, breezy. High 53. Tonight, an occasional drizzle. Low 42. Tomorrow, mostly cloudy, light rain. High 55. Yesterday, high 53, low 40. Details, page C12.

VOL.CXLV No. 50,386 — Copyright © 1996 The New York Times — NEW YORK, WEDNESDAY, APRIL 3, 1996 — $1 beyond the greater New York metropolitan area — 60 CENTS

ECONOMY SHOWING SIGNS OF REBOUND FROM SLOW WINTER

PROFITS MAY STAY STRONG

Leading Indicators Soar 1.3%, but Analysts Are Cautious — 4th-Period Gain Cut

By ROBERT D. HERSHEY Jr.

WASHINGTON, April 2 — Battered recently by storms and undermined for months by weak sales, the economy has been sluggish for most of the last year. But figures released today gave some tentative signs that business could improve this spring — and that corporations' strong profits have been relatively unaffected by 1995's weakness.

The index of leading indicators, a gauge of the economy's coming points over the next six months to a year, rose 1.3 percent in February, the Commerce Department said, while it was the largest gain in appear to have been drawn down enough to encourage companies to restart production soon.

"I still think something more is going to emerge in the economy," said Rosanne Cahn, an economist at CS First Boston in New York. And Kevin Flanagan, a vice president at Dean Witter Reynolds in New York, said that "the inventory situation should not be the drag on growth it was in 1995."

Yet analysts cautioned that it was still too early to confirm growth this Presidential election year even reaching the 2 percent pace that the Commerce Department is reporting today a downward revision for the fourth quarter, finally established for 1995.

The department cut its estimate of fourth-quarter growth in the gross domestic product to a slim annual rate of five-tenths of a percent from nine-tenths of a percent. And many analysts predicted that the first quarter of 1996 might be only a little better, with estimates ranging from under 1 percent to little more than 1.5 percent.

"An economic rebound is not yet baked in the cake," the First Union National Bank warned clients.

Analysts expressed more than the usual skepticism about the leading index and its huge advance, three-fifths of which reflected expansion of the factory workweek that drove in January because of the blizzard in the East.

But despite the doubts, many economists said that the worst might be over for now.

This combination of mild optimism and strong uncertainty have made the economy a mixed prospect as an issue in the Presidential campaign, as Clinton Administration officials search for signs of growth and Republicans deride its modest extent.

But the figures released today are likely to be reflected in another debate stirred by candidates this year — over who is benefiting from whatever growth there is. Commerce Department figures showed that the profits of American companies grew more than twice as fast as the econ-

Continued on Page D2, Column 1

A Belated but Bright Start for the Yankees

Yanks' Bernie Williams diving back to first in the season opener in Cleveland. David Cone held the Indians hitless until the sixth inning of the game, which had been delayed a day by snow. Page B11.

Associated Press

In Bosnia Field, Changes Refuel Talk of Graves

By MIKE O'CONNOR

LAZETE, Bosnia and Herzegovina, April 2 — As war crimes investigators began their first search of this area for evidence of mass killings, an independent visit today to one of the most important suspected mass graves on their itinerary showed indications of extensive tampering.

The ground, a large field that seems to have been recently dug over and re-spread with heavy equipment. This is the picture that hundreds of bodies are believed to have been buried a year after truckloads over the town of breeze.

It is not clear how deadly a ground was disturbed or whether any bodies have been removed.

In the area patrolled by American forces based on the the measurements of United States officials that had the surveillance occasionally around patrols.

The evidence considered particularly important because three Serb bosses assert that the highest Serb military commander, Gen. Ratko Mladic, personally supervised the

Continued on Page A6, Column 1

Republicans Are Up in Arms At Labor's Political Rebirth

By PETER T. KILBORN

WASHINGTON, April 2 — Stunned by organized labor's intention to spend more than ever in this year's national elections, Republican campaign committees and businesses are crying foul and turning up the heat to blunt labor's impact.

In their pronouncements Republican organizers, who backed or ignored unions in the past since the 1970's, are calling unions "big labor" again and blaming Washington union bosses away labor bosses."

They have filed suits with the Federal Election Commission calling the unions' campaign war chest illegal, and they are forming their own teams of campaigners in Congressional districts to take on labor's workers.

Labor's brethren reform in these elections came to a head in the week has 13.1 million dollars for the war chest by raising $35 million, most of it from a monthly assessment on each of the labor federa-

tion's 78 unions of 15 cents per capita.

That money, to be used to pay hundreds of full-time organizers and educate voters on issues, is a new resource to pour into the campaign. It comes on top of the more than $40 million in voluntary contributions from union members to political action committees, money that will be spread mostly among Democrats running for the Congressional seats that 73 freshman Republicans won two years ago.

For all that, the unions' spending is sure to fall far short of the money that Republican campaign committees and their allies among business associations and big business are likely to raise. "There will be no parity here," said Ellen Miller, executive director of the nonpartisan Center for Responsive Politics. She said Republican-dependent unions 7 in voter-education programs.

Labor's redoubled campaign ef-

Continued on Page D20, Column 4

For Doctors, An Anxiety Is Removed

By ESTHER B. FEIN

When Howard Grossman was a medical student and a young doctor, nobody ever talked openly about how when they were asked, doctors sometimes helped their terminally ill patients to die.

Yet, he knew, and he knew that others did too.

"Nothing was ever spoken, nothing was ever openly discussed, it was conveyed," said Dr. Grossman, one of three physicians who joined three patients in the 1994 lawsuit asking the courts to strike down a New York State law prohibiting doctors from helping dying patients commit suicide.

Yesterday's decision by the Federal Court of Appeals for the Second Circuit striking down the law, Dr. Grossman said, liberated "the vast underground of doctors" who have helped terminally ill people end their lives.

"Doctors have been doing this, but they have been isolated, alone and terrified, afraid to reveal their secret even to the person they sleep next to every night," he said.

Even with yesterday's victory, it was difficult for the doctors who had brought suit to shed the euphemisms they had used for years to cloak the efforts at assisting terminally ill patients who wanted to die.

"I am one of many doctors who have been practicing rules too, who don't want them out of the limelight," said Dr. Samuel Klagsbrun, a Manhattan psychiatrist who works in palliative care, easing the treatment of people in their pain, and in their care of their pain, and in their pain. Some have lived. Some have died."

Dr. Klagsbrun said he joined the lawsuit despite his own fears because he saw medical decisions spiraling out of the hands of doctors and into the grip of technology, and hospital lawyers practicing defensively. "As medicine has gotten so sophisticated, and our ability to keep peo-

Continued on Page B5, Column 1

SHIFT IS HISTORIC

Federal Decision Allows Doctors to Prescribe Drugs to End Life

By FRANK BRUNI

A Federal appeals court in Manhattan ruled yesterday that doctors in New York State could legally help terminally ill patients commit suicide in certain circumstances, striking down parts of a longstanding state ban on assisted suicide.

The unanimous decision by a three-judge panel of the Court of Appeals for the Second Circuit marked the second time in two months that a Federal appeals court had ruled in favor of assisted suicide. [Excerpts, page B5.]

"What interest of the state possibly have in the prolongation of a life that can but ended?" the judges said.

"And what of the state," the court added, "to require the contingency of agony when the result is imminent and inevitable?"

The ruling, following a similar one last month by the Court of Appeals for the Ninth Circuit in San Francisco, signaled what legal and medical experts said was a historic shift in the opinions of courts on issues that has become increasingly controversial in recent years.

"I have always thought that society would move toward some sort of legalization of assisted suicide, but I thought it would take the better part of a decade, not the better part of a year," Arthur Caplan, director of the Center for Bioethics at the University of Pennsylvania, said. "You're talking about a sea change — overnight — in public policy on this issue."

The State Attorney General, Dennis C. Vacco, immediately said he would appeal yesterday's ruling to the United States Supreme Court, and he joined opponents of assisted suicide in denouncing the decision as a chilling precedent. Mr. Vacco said that in allowing physicians to help patients commit suicide, the court was giving "those who swear an oath to preserve life a license to kill."

"By opening this door," Mr. Vacco said in a statement, "the court has set us on a path which will lead to abuse that is virtually undetectable until it is too late." He did not say whether he would seek a stay of the court's ruling pending review by the Supreme Court.

The ruling would make physician-assisted suicide legal in some cases in Connecticut and Vermont as well, since those states also fall within the Second Circuit.

Connecticut's Attorney General, Richard Blumenthal, said that as he understood the decision, "Whatever the court is saying has to be permitted in New York would also have to be permitted in Connecticut and Vermont." Mr. Blumenthal said he had not yet read the decision, however, nor had he determined whether he

Continued on Page B5, Column 5

INSIDE

Another Beating on Tape
A videotape of two white deputies clubbing Mexicans near Los Angeles revived accusations that law enforcement officials have a shown pattern of brutality. Page A10.

Acquittal for Lemrick Nelson
The man charged in the fatal attack on a Hasidic scholar in Crown Heights was acquitted of assaulting a police officer — charges his lawyer called police harassment. Page B2.

Britain's Daunting Prospect: Killing 15,000 Cows a Week

By SARAH LYALL

LONDON, April 2 — In the last two weeks, the British mad cow scare has humiliated the Government, agonized the $8.3 billion beef industry, and turned carnivores into vegetarians.

The latest twist, in the form of a proposed remedy, is a logistical nightmare: how to kill at least 15,000 older cows a week through the next six years and destroy their carcasses.

Britain has about 11 million cows, 4.7 million of them older than 30 months. A more stringent approach would also destroy entire herds in which has shown unusually high incidences of mad cow disease, being discussed by government leaders, consumer issues, including the export ban on British beef. [Page A8.]

As the matter stands, no one figure — Britain will slaughter the older death and destroy a vast number of government officials admit they don't know how they would go about what it would cost, or exactly how much compensation they would receive from the European Union, which has closed the export ban.

Even if has be able, for

other offal that farmers are not allowed to use for meat, said Phil Saunders, a spokesman for the Beef and Livestock Commission, which advises the cattle industry.

Government officials said they did not know how they could incinerate so many cows each week or whether Britain would be forced to put some slaughtered meat into cold storage until incinerator space is available.

"What we have now is not sufficient to deal with that large number," said a spokesman for the Ministry of Agriculture, which insisted that his name not be used. "These are proposals that are being looked at."

Under one option, Mr. Saunders said, some of the animals might be slaughtered at licensed landfill sites set up for the purpose.

Continued on Page A8, Column 5

Sharing the Meaning of Tonight's Passover

Third graders from the Roman Catholic St. Elizabeth Ann Seton Regional School in East Meadow, L.I., tasted matzoh they helped make yesterday at the Stop and Shop/Foodtown under the supervision of Rabbi Shmuel Spielman, left. In Manhattan, one synagogue is planning a "cyber seder." Page B3.

Vic DeLucia/The New York Times

In A-Plants' Backyard in Connecticut, Trust Ebbs

By GEORGE JUDSON

WATERFORD, Conn. — At the very tip of this town, where Millstone Point forms the eastern shore of Niantic Bay, three nuclear power plants owned by Northeast Utilities sit idle, under intense scrutiny by Federal regulators because of a poor record of safety-procedure violations.

In Waterford, where the reactors are largely out of sight, and next door in East Lyme, where they dominate the view from Main Street along the bay, people who have lived with atomic energy in their backyard for nearly three decades are re-

examining their comfort level, knowing now that the state's largest utility skimped on safety to cut costs.

In a corner of Connecticut where nuclear power was an economy industrial built in the early confidence stone reactor remains high. London County's 270,000 residents, 40,000 are retired from the Navy base their relationships more work at the Electric Boat shipyard, or are related to workers

there, where nuclear-powered submarines are built, or work at Millstone itself.

But increasingly, the confidence expressed personal, based on faith in the plants and neighbors who work at Millstone Point, rather than trust in Northeast Utilities or its watchdog, the Nuclear Regulatory Commission.

"People have some philosophy about this that so many people share," said Dini, the First Selectman of East Lyme. "I know people at Millstone, and I believe that the hundreds of people who work there all

Continued on Page B4, Column 1

THE NEW YORK TIMES is available for home or office delivery in most major U.S. cities. Please call toll-free: 1-800-NYTIMES. Ask about the Transmedia TimesCard ADVT.

60 SUTTON PLACE HAS BEEN LIBERATED from the cable monopoly! Better building wide service. Better prices. Call Liberty Cable 212/891-7777 — Advt.

"All the News
That Fits"

The New York Times

Late Edition
New York: Today, Thickening clouds, a late shower. High 53. Tonight, some showers. Low 42. Tomorrow, morning showers, a brighter afternoon. High 48. Yesterday, high 60, low 38. Details are on page C18.

VOL.CXLV No. 50,387 Copyright © 1996 The New York Times NEW YORK, THURSDAY, APRIL 4, 1996 $1 beyond the greater New York metropolitan area. 60 CENTS

Ex-Professor Is Seized In Montana as Suspect In the Unabom Attacks

By DAVID JOHNSTON

WASHINGTON, April 3 — Federal agents today raided a remote Montana cabin where they believe they seized a man they believe is the Unabomber, the elusive terrorist who has left a 17-year trail of mail bombs across the United States that have killed 3 people and maimed 23 others.

Law-enforcement officials said tonight that the agents had found explosive chemicals and other bomb-making material at the wilderness cabin belonging to the suspect, Theodore J. Kaczynski. They said they planned to charge Mr. Kaczynski on Thursday with the string of deadly bombings that had long baffled the authorities.

The suspect is a 53-year-old former assistant professor of mathematics at the University of California at Berkeley. He graduated from Harvard College in 1962 and received a doctorate in mathematics from the University of Michigan several years later. His is just the sort of academic-oriented background that the authorities had attributed to

the bomber, whose communications with the press had reflected an obsession with science and technology issues.

Since the early 1970's, Mr. Kaczynski has lived in a tiny, hand-built cabin 50 miles northwest of Helena, Mont., near the Continental Divide in the edge of Lolo National Forest. In an area so remote that one of the F.B.I. agents who had kept him under surveillance there is said to have watched a cougar attack and kill a deer.

The authorities confronted Mr. Kaczynski at the cabin today and, after a brief scuffle, searched it for evidence of bomb-related material. Federal investigators, who had said before the search that they did not have sufficient evidence to charge Mr. Kaczynski with the bombings, said afterward that the searchers had found what they believe is enough evidence to charge him in a complaint to be filed on Thursday.

The family members, who law-enforcement officials said included Mr. Kaczynski's brother, turned the papers over to a Washington lawyer as an intermediary. They also permitted the F.B.I. to search their house, and, officials said, further evidence against Mr. Kaczynski was found.

The filing of formal charges against Mr. Kaczynski will mean that investigators can begin taking fingerprint and blood samples to determine whether they match the evidence collected over the years like the fingerprints and the DNA, drawn from dried saliva, that the bomber left on stamps used to mail letters to his victims and to news organizations.

Mr. Kaczynski was reared in Evergreen Park, Ill., a working-class suburb of Chicago that offers a tableau of Middle American images, from the brick colonial house where the Kaczynski family once lived to the nearby park where children played soccer and touch football today. The family later moved to Lombard, another Chicago suburb, and it was at the house in that city that Mr. Kaczynski's papers were found.

The Unabomber, who came to be so called because some of his early targets were employees of universities or airlines, began his reign of mayhem in May 1978 and delivered his last package bomb in April 1995.

Continued on Page B12, Column 1

Theodore J. Kaczynski in his 1994 Montana driver's license photo, and a sketch the authorities based on a 1987 sighting of the bomber.

Recalling Dodgers' Flight, Mayor Makes His Pitch for New Stadium

By STEVEN LEE MYERS

Recalling how New York City lost the Dodgers after a previous mayor refused to help the team build a new baseball stadium in Brooklyn, Mayor Rudolph W. Giuliani has begun to offer the economic justification — and with it the political one — for building the Yankees a new home on the West Side of Manhattan.

In news conferences on Tuesday and again yesterday, Mr. Giuliani said that what would be "a political bond with New York City" was his boyhood memory of the heroes of his youth, the Yankee, and to important, he said he wanted to help move the Yankees to Manhattan anyway.

To do that, the Mayor has proposed building above the Hudson River rail yards near Jacob K. Javits Convention Center. On Tuesday, Mr. Giuliani said that revenue from a West Side stadium would be so high it "would be off the charts." Yesterday he said the city could not afford to repeat the mistakes of the past, ignoring the desires of one of the city's most valuable assets.

"It's also my responsibility to do the best that I can to make certain that the Yankees stay in New York City."

Mr. Giuliani said yesterday. "And that if, in fact, they are determined to leave the Bronx, that we not lose them to New Jersey, Tampa or someplace else."

No one has come right out and said Mr. Steinbrenner's Yankees plan to abandon their nostalgia-soaked 73-year-old stadium. But in his carefully measured remarks, the Mayor has made it clearer than ever that such a move is a distinct possibility and that the city had to have what he called "a fall-back strategy," namely

Continued on Page B10, Column 1

COMMERCE SECRETARY AMONG 33 LOST IN A CROATIA PLANE CRASH

ALL FEARED DEAD

Ronald Brown Headed a Business Mission to Rebuild Balkans

By R. W. APPLE Jr.

WASHINGTON, April 3 — A military plane carrying Commerce Secretary Ronald H. Brown and a delegation of American corporate executives slammed into a mountainside today as it approached the airport at Dubrovnik, on the Adriatic coast of Croatia. Chances that Mr. Brown had survived were "next to zero," a White House official said after more than 12 hours of rescue efforts.

Clambering over rocky, rugged terrain, working by flashlight in pelting rain, Croatian search parties found nine bodies and one survivor, described by a Dubrovnik doctor at the scene as "a woman who was bleeding profusely." She died later, Croatian officials said.

But there was no definitive word on the fate of Mr. Brown, a 54-year-old political insider who helped spark President Clinton's 1992 campaign. Glyn Davies, a State Department spokesman, said tonight that all 33 people aboard the plane were presumed dead, but later retracted his comment, saying they were considered missing. The Croatian television said all had perished.

Searchers at the scene and officials in Washington said they held out almost no hope that survivors would be found.

A United States military official in Germany said there was no indication the plane had been downed by hostile action.

One of those missing was Nathaniel C. Nash, 44, the Bonn bureau chief of The New York Times, who was accompanying Mr. Brown on a trip to Balkan nations for an article on reconstruction efforts. Commerce Department staff members were on board as well, including Charles Meissner, Assistant Secretary for International Economic Policy.

Names of the corporate executives aboard were not made public by the Government, but some companies issued statements confirming that their executives had been on board. Among them were Robert A. Whittaker, chairman of Foster Wheeler Energy International of Clifton, N.J.; Robert E. Donovan, president of Asea Brown Boveri of Norwalk, Conn.

Several prominent businessmen who had planned to make the trip did not do so. One was Alfred A. Checchi, co-chairman of Northwest Airlines, who elected instead to attend a White House state dinner on Tuesday.

A senior American official, speaking on the condition of anonymity, said the pilot of Mr. Brown's plane had flown up a valley parallel to the one he should have followed before turning for his final approach. When he turned, he hit the mountain, the official said on the basis of reports from the scene.

President Clinton went to Mr. Brown's Washington home to comfort the Commerce Secretary's wife, Alma, and then to the Commerce Department, where he spoke feelingly of the missing Cabinet member as "a magnificent life force." Mr. Clinton said Mr. Brown,

Continued on Page A8, Column 1

Tragic End to Mission in Balkans

A plane carrying Commerce Secretary Ronald H. Brown, shown above arriving in Tuzla yesterday, crashed near the Croatian city of Dubrovnik. Secretary Brown was visiting the region with executives from U.S. companies.

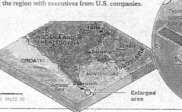

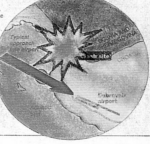

A Storm-Swept Mountain's Grim Story

By CHRIS HEDGES

VELJI DO, Croatia, April 3 — Croatian special police officers wrapped in green army ponchos, their faces averted from withering sheets of rain, labored up the steep slope of St. John Mountain tonight in a huge search for the far-flung wreckage that had been the plane carrying Secretary of Commerce Ronald H. Brown and 32 others.

Debris and bodies were scattered down a dark, wooded hillside lit by the bobbing flashlights of the search teams and occasional, startling flashes of lightning.

Blasts of thunder rolled out over the rocky, razorbacked precipice that rise and fall in confusion off the Adriatic coast. The heavy rain had turned the dirt roads that much reached, serving the wreckage into deep muck, difficult. And soldiers coming down from the remote site was difficult.

Two Croatian commanders of the

In Rain and Darkness the Searchers Locate a Disaster's Debris

operation, standing next to a stone hut, their hair matted down by the rain and their boots covered with mud, said they had found one survivor, and, to their astonishment, a surviving but unconscious woman. But the woman died as rescuers tried to get her to a hospital in Dubrovnik.

None of the passengers had yet been identified by late tonight, and except for the woman, all who had left he recovered in the morning.

The heavy rain, fog and continuing made the use of helicopters impossible, or until daybreak made the move along the mountainous, as it was too far into the area," one said. "We will do the best we can, but the terrain is very difficult.

The rain makes it hard for us to maneuver. We have 100 men now, another 100 are on the way. Others that some survived."

As he spoke, in the center a convoy of six military trucks an army jeep with its headlights made its way up.

The officers at the wreckage of the plane were strewn over a hill collected about 20 items by road side of the ancient walled city of Dubrovnik. They said that the bodies they had recovered, along with the woman, came from the fuselage of the plane, which had broken into two sections.

"This is a terrible, terrible tragedy," said one soldier as he came down from the mountain.

The gray steep over the steeply wooded region where the plane went down near Cilipi

Continued on Page A8, Column 1

Jet Crash Casts a Sudden Shadow Over Official Washington

By TODD S. PURDUM

WASHINGTON, April 3 — At 10:30 this morning, President Clinton's national security adviser, Anthony Lake, arrived in the Oval Office to find the President, the President's wife, Hillary Rodham Clinton, had arrived grim-faced. Mrs. Brown's house in Northwest Washington for a visit.

In that moment, the crowd of that day turned out the deputies and secretaries, Alexis Herman and Mack Ellen Glynn, crept into the office of their boss, Michael D. McCurry, with news service bulletins and spirited him off to the top-secret Situation Room in the basement.

By 11 A.M., Mr. McCurry was on the phone to Mr. Brown's wife, Alma, to tell her all he knew. She was home sick with the flu, not listening to radio or television, friends said, and the President's call came out of the blue.

"I want you to hear it from me." said the President told her the President was, and of the West Wing, young aides who were Mr. Brown's friends, and by midafternoon he and his wife Hillary Rod ham Clinton had arrived grim-faced. Mrs. Brown's house in Northwest Washington for a visit.

From there, the President went to the Commerce Department auditorium, and President brought to their feet by

repeating what he said Mrs. Brown had told him: that her husband had fought for the department and its workers, and that she hoped the President would too. Then Mr. Clinton brought a hush over the crowded room by reading from Scripture, Isaiah's sweep of how the faithful "shall mount up with wings as eagles" and "run and not be weary."

"Ron Brown walked and ran and flew through life," Mr. Clinton said. "And he was a magnificent life

force. And those of us who loved him will always be grateful for his friendship and his warmth.

So it went throughout the top echelons of the White House and Government, where almost everyone knew the affable Mr. Brown, one of the principal architects of the Democrats' 1992 victory.

Many had worked for him in his four-year tenure as chairman of the Democratic National Committee. Mr. McCurry was his press secretary for a time; later, so was Ms. Terzano.

The deputy White House chief of staff, Harold M. Ickes, worked with Mr. Brown on the Rev. Jesse Jackson's presidential campaign in 1988, and on Mr. Clinton's in 1992. Together with Paul Tully, the political director of the Democratic National Committee who died of a heart attack at the height of the 1992 campaign, Mr. Brown was the main institutional author of Mr. Clinton's victory, and he remained the odds-on

Continued on Page A9, Column 1

INSIDE

'Move to Stamp Out Pushers'
Using several new weapons, the Police Department will begin its biggest assault ever against drug dealers next week in several New York City neighborhoods. Page B1.

Carl Stokes Dies
Carl B. Stokes, a slave's great-grandson who became the first black Mayor of a major American city when he was elected to lead Cleveland in 1967, died at 68. Page D22.

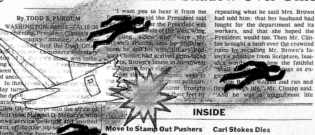

"All the News That Fits"

The New York Times

Late Edition
New York: Today, early shower then brightening skies. High 48. Tonight, partly cloudy. Low 35. Tomorrow, partly sunny. High 47. Yesterday, high 57, low 40. Details, page D16.

VOL.CXLV . . . No. 50,388 Copyright © 1996 The New York Times NEW YORK, FRIDAY, APRIL 5, 1996 $1 beyond the greater New York metropolitan area. 60 CENTS

A NATO helicopter hovers over the wreckage of the military jet that carried the Secretary of Commerce and American business executives.

Plane Crash in Croatia Silenced A Big Player in Capital Debates

By DAVID E. SANGER

WASHINGTON, April 4 — When Ronald H. Brown died on a hillside near Dubrovnik, Croatia, on Wednesday, he was in the thick of three battles, each concerned the diversion of his energies in Washington.

The first was the continuing struggle within the Administration — sometimes quiet, but flared three years after it began — over the degree to which the nation's commercial interests should drive its foreign policy agenda.

As Commerce Secretary, Mr. Brown often argued forcefully for what he called "commercial diplomacy," the use of America's clout abroad to create jobs at home, a

stark counterpoint to the "high diplomacy" of the cold war. But there was always resistance, and many wonder whether, without Mr. Brown's high-profile circuiting of the globe, that approach will prove a permanent legacy of the Clinton Administration, or whether it could slowly dissolve.

The second battle was to save the Commerce Department from a Republican-dominated Congress that has set its target for disassembly and abolition. With patience, Mr. Brown called this "ill-later's disarmament" in the face of Japanese and European competition, and was winning the argument. But without him, many in the Administration said today, the issue is bound to arise again.

And the third battle centered on Mr. Brown's true passion in life: politics. His death deprives the Clinton Administration of its most visible black Cabinet member and its bridge to black voters, even though some prominent blacks were concerned that Mr. Brown was a bit too much of an insider, too interested in compromise. Mr. Brown was just beginning to try again to work the

Continued on Page A13, Column 5

Bad Equipment Tied to Crash, Perry Suggests

By R. W. APPLE Jr.

WASHINGTON, April 4 — Defense Secretary William J. Perry suggested today that malfunctioning instruments may have caused the crash of an Air Force jet that took the life of Commerce Secretary Ronald H. Brown and at least 32 others in Croatia on Wednesday.

Returning from a trip to Egypt, Mr. Perry, who was on his plane, suggested that kind of accident that good instrumentation should be able to prevent."

He said when the plane was referred to assumed to be on the ground or in the plane. Mr. Brown's plane, a military version of the Boeing 737, slammed into a mountain near Dubrovnik's airport on the Adriatic Sea.

More than 30 hours after the crash, it was not clear how many passengers were aboard, though it was evident there were no survivors. After rescue teams searched through the night and all day in heavy fog and rain, Miomir Zuzul, the Croatian Ambassador to the United States, said they had discovered 33 bodies. The Pentagon used the same figure.

But the plane's manifest, issued by the State Department, listed 35 people: Mr. Brown and 11 Commerce Department aides, including Charles F. Meissner, Assistant Secretary for International Trade, whose wife, Doris, heads the Immigration and

Continued on Page A12, Column 3

COMMUNISTS LOOK TO THE SOVIET ERA IN THEIR PLATFORM

A DRAFT LAW IS PREPARED

Moscow Party Would Curtail Free-Market Reforms if It Wins Back Power

By MICHAEL R. GORDON

MOSCOW, April 4 — In a stark expression of what they hope to achieve if they take back power, Communist members of Parliament have prepared a draft law that calls for heavy state intervention in the economy.

The proposed law would curtail pro-market reforms and rejects some key measures Russia has adopted at the insistence of the International Monetary Fund, which recently granted Russia a $10.1 billion loan.

Some aspects of the bill, which has not yet been made public, read like an evocation of the worker's paradise proposed by the Bolsheviks 79 years ago: guaranteed employment, cheap apartments and controls on the price of consumer goods.

It would even restore a State Planning Committee, an echo of the Gosplan agency that controlled virtually every facet of economic life in the old Soviet Union.

Prepared by a leading Communist policy team, the plan may yet be modified as the election team of Gennadi A. Zyuganov tries to mold it into a platform that can be sold to non-Communists as well as the party's rank and file.

Trying to strike a pragmatic note, Yuri V. Maslyukov, the Communist chairman of the Parliament's Committee for Economic Policy, said the draft law was just one possible proposal.

"I won't criticize it in this particular case," he said in an interview. "I think this proposal is premature."

But ardent Communists, who constitute much of Mr. Zyuganov's constituency, said the plan was needed to restore social protections and pull Russian industry out of a state of "crisis."

Oleg V. Malyarov, one of the advisers who worked on the draft law, said it could serve as "the specific embodiment" of Mr. Zyuganov's promises.

And though the Communisis are debating among themselves how far and how fast to push, much of the draft law appears to reflect a broad consensus within the party about how to overhaul Russia's economy.

The draft law comes at a time of rising political expectations among the Communists. A copy of the draft law — "Urgent Measures to Take Russia

Continued on Page A10, Column 4

Suspect Arraigned on One Bomb Count

Search of Cabin Yields Lethal Ingredients

By TIMOTHY EGAN

HELENA, Mont., April 4 — Theodore J. Kaczynski, the onetime university professor taken into custody on Wednesday as a suspect in the Unabom case, was arraigned here today on a single felony charge of possessing bomb components and was held without bail.

The Government followed a search for Federal authorities said, they found evidence that Mr. Kaczynski abandoned his one-room mountain cabin 50 miles the northwest near the town of Lincoln, into a virtual bomb laboratory.

When the 53-year-old suspect was brought into the Lewis and Clark County jail here on Wednesday night, his hair was matted and his blue jeans were badly torn, as if the scuffle that he had had with the Federal agents who had arrested him at the cabin earlier in the day. Today at his arraignment he was dressed in orange jail overalls, and he seemed confident, with a slight smile on his face as he glanced around the room.

Just before being taken as Mr. Kaczynski was taken to the courthouse here, he ignored shouts from reporters asking whether he was the Unabomber, the mail-bomb terrorist who has killed 3 people and injured 23 others from coast to coast over 18 years.

The Government did not charge Mr. Kaczynski today with any crimes specifically relating to the Unabom case, and Federal officials would not publicly say that they consider him to be the serial bomber.

But it is not unusual for a suspect regarded as dangerous to be held on a relatively modest charge while Federal prosecutors build a larger case against him, and investigators privately said they were certain that Mr. Kaczynski was the Unabomber, a conviction apparently bolstered by the results of the intensive search at his 10-by-12-foot cabin.

The F.B.I. affidavit that was the basis of the charge brought today against Mr. Kaczynski pronounced it an extensive

bomb-making materials that Federal agents said had been found at the cabin. And law-enforcement officials said interviews tonight that the bomb materials matched fragments from Unabomber devices almost precisely, including chemicals and techniques.

Government sources said tonight that the agents had discovered at the cabin the kind of typewriter believed to have been used to type the Unabomber's 35,000-word manifesto.

Continued on Page A24, Column 1

Associated Press

Theodore J. Kaczynski ignored shouted questions as he was escorted into the Federal courthouse in Helena, Mont.

Long and Twisting Trail Led To Unabom Suspect's Arrest

By DAVID JOHNSTON

WASHINGTON, April 4 — The tip came the way the F.B.I. had long expected, from a family member with misgivings. But the search for the man investigators believe is the Unabomber still had months to go before the suspect was arrested on Wednesday, as his deeply torn family struggled with its loyalties and then as an elite team of agents stood vigil for days in a frozen Montana snowscape.

And even now, the case is far from finished. Federal inspectors and other law-enforcement officials worked today. With the arrest of Theodore J. Kaczynski in Montana, hundreds of agents, held back in recent weeks for fear of somehow tipping their hand to a fugitive who had eluded them for nearly 18 years, are now fanning out

to airports, bus stations, homeless shelters and universities nationwide. They are trying to fill the many blanks in the life of Mr. Kaczynski, a Harvard-educated recluse.

The tip that led to the arrest rived in startlingly mysterious fashion: a Federal official today said it was David, one of Mr. Kaczynski's brother, David, of Schenectady, N.Y., first approached the Federal Bureau of Investigation early this year, his initial wariness giving way through an intermediary described by Federal officials suppressing the investigation, David Kaczynski, who had also attended Harvard and who in 1971 helped his brother buy the Montana property, grew suspicious late last year that his brother might be the author of the Unabomber's published 35,000-word manifesto.

David Kaczynski combed old family papers, finding what he feared might exist, copies of some letters dating to the 1970's that were written by his brother to newspapers protesting the abuses of technology. The sentiments were disturbingly reminiscent of what he thought he had read in the Unabomber manuscript.

But it was not until January that a lawyer for the family telephoned the F.B.I. in Washington.

"The lawyer was nervous," one official recalled. The lawyer described the situation without reveal-

Continued on Page A25, Column 6

City Official Helped Group Win Contract

Last April, when a Queens social-services organization was trying to gain a multimillion-dollar contract with the city, it sent an unusual salesman to the city agency that was evaluating competing bids.

The salesman, it turned out, was a city official himself, and he had already been offered a job with the private group seeking the contract.

The presentation by the official, Albert J. Farina, on behalf of the Hellenic American Neighborhood Action Committee appears to have violated city conflict-of-interest rules, which generally prohibit city workers from lobbying city agencies on matters in which they have a financial interest. And the disclosure of his role is the latest problem to arise from the city's dealings with the Queens group, whose $43 million contracts to monitor welfare recipients were canceled last week by Mayor Rudolph W. Giuliani.

Article, page B1.

Burst Main Points to a Wider Pipe Problem

By PAM BELLUCK

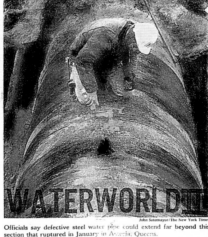

that the problem extends far beyond ...

WATERWORLD III

John Sotomayor/The New York Times

Officials say defective steel water pipe could extend far beyond this section that ruptured in January in Astoria, Queens.

Continued on Page B6, Column 1

Study Recommends The Yankees Move To a West Side Site

By RICHARD SANDOMIR

A consulting firm's recommendation that the Yankees move from the Bronx to the West Side of Manhattan was based on the conclusion that a new ball park along the Hudson River would produce a significant increase in attendance, higher prices for luxury boxes and an enhanced image for the city.

The report was commissioned by the city to help the Yankees, studied options, including renovating the current Yankee Stadium, but came down solidly in favor of a West Side stadium with a retractable domed roof that could be used for baseball, football, concerts and conventions. The cost for such a stadium would be $1.06 billion, it said.

Although he has insisted that he wants the team to remain in the South Bronx, Mayor Rudolph W. Giuliani has pushed the West Side site as the most attractive way to keep the Yankees from relocating to New Jersey, and the best way to avoid a repetition of the Dodgers' move from Brooklyn to Los Angeles in 1958.

The Yankees' lease in the Bronx expires in 2002, and the team's principal owner, George M. Steinbrenner 3d, has made it clear that he is dissatisfied with the team's 73-year-old home in the South Bronx, complaining about security, parking,

Continued on Page B4, Column 1

NEWS SUMMARY

INSIDE

Pact on Drug Prices Blocked
A judge has thrown out a $408.9 million settlement of a price-fixing lawsuit brought by pharmacies against big drug makers. Page D1.

Uphill Campaign for Rao
Prime Minister P. V. Narasimha Rao has opened his re-election campaign in India, by apologizing for not being somebody else. Page A3.

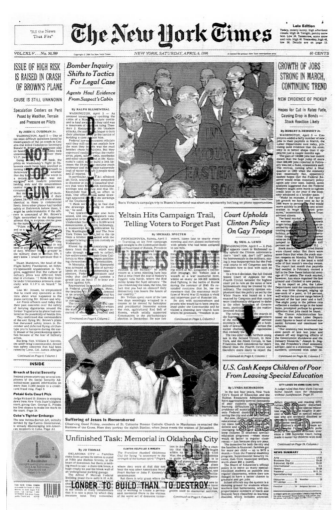

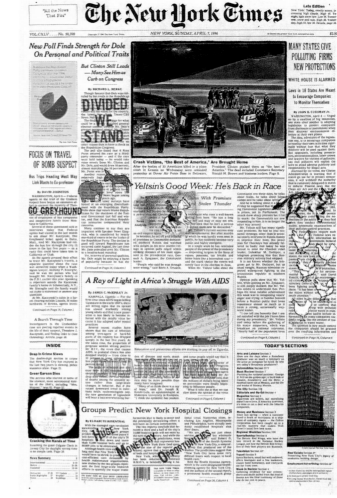

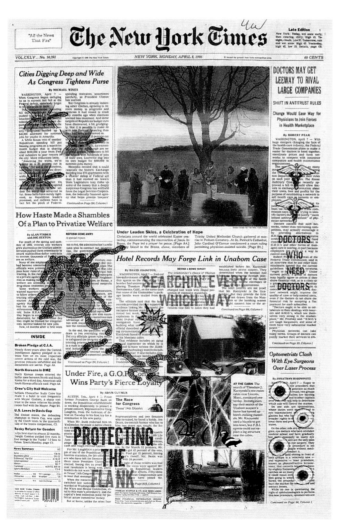

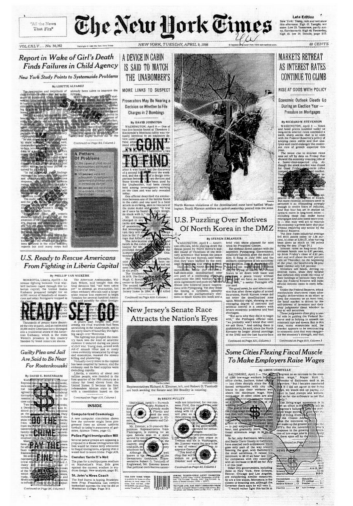

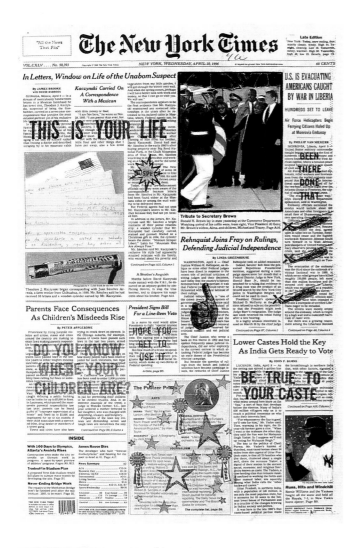
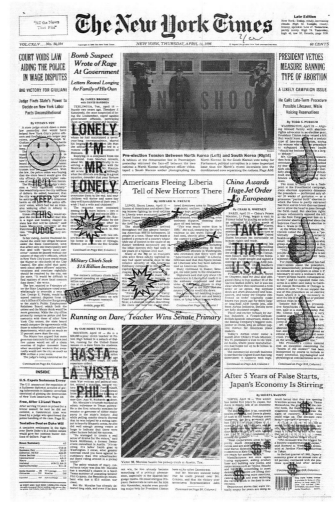
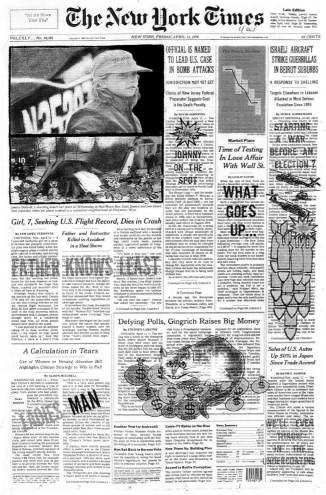
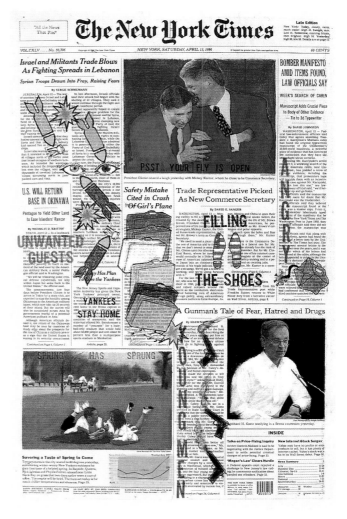

The New York Times

VOL. CXLV No. 50,397 Copyright © 1996 The New York Times NEW YORK, SUNDAY, APRIL 14, 1996 $1 beyond the greater New York metropolitan area. $2.50

Late Edition

New York: Today, rainy early, then brightening skies. High 57. Tonight, patchy fog. Low 44. Tomorrow, becoming cloudy. High 59. Yesterday, high 55, low 45. Details are on page 40.

As Revenues Drop, Hospitals Talk of Forsaking Charity Care

Threats to Turn Away Many of the Uninsured

By JENNIFER PRESTON

With managed care driving down their revenues, many hospitals around the country say they can no longer afford to provide the medical care to the growing number of uninsured who have come through their doors seeking treatment for everything from the flu to heart disease.

More than a dozen states have stepped in to reimburse hospitals for a portion of the hundreds of millions of dollars they spend on free medical treatment, mostly to the working poor. But some states have yet to address what health care experts say is a looming crisis particularly for hospitals in urban areas.

Until the last few years, hospitals were able to pass much of the cost of treating the uninsured onto paying patients. Now, many hospitals say that without more public financing they will be forced to stop uninsured patients seeking all but emergency care, which is required under Federal law.

New Jersey, one of the few states committed to reimbursing hospitals for treatment of the uninsured, paid $388 million to 84 hospitals last year. But state officials have been unable to agree on how to pay for hospital treatments this year, illustrating how difficult it is for states to help cover the cost of free medical care when taxpayers are pressuring politicians to reduce government spending.

With Gov. Christine Todd Whitman and the State Legislature at an impasse over a new financing plan, hospitals will go without their third state payment this year, which should have been due tomorrow. Since they have not been reimbursed for more than $100 million in free medical care, some hospitals have stopped payments to suppliers and are drawing up plans to close wards and lay off employees.

"Providing health care for those in need is not a hospital problem," Mr. McLaughlin said. "It is a statewide social problem, and therefore the state's responsibility. Because of our inability to cost-shift, we can no

Continued on Page 36, Column 1

War Wounds Still Mold Life, And Some Politics, for Dole

By KATHARINE Q. SEELYE

WEST DES MOINES, Iowa, April 13 — When Bob Dole was to give a speech on affirmative action last month in California, he ended up delivering just one sentence on the subject ...

... that transformed his life — Mr. Dole sustained in World War II, Mr. Dole could not hold his ... and the microphone at the ... decided to ad-lib ... to his main topic ...

The incident is but one small example of how Mr. Dole's war wounds — sustained 51 years ago on Sunday — still shape his life, which most days includes negotiating complex legislative deals, but the most mundane tasks of living, just like the 40 million other disabled Americans.

Because Mr. Dole has learned to cope with so many potential impediments, people who work with him on Capitol Hill say they barely notice his limp right arm or useless right hand and are not aware that his left hand is partly numb. "None of us thinks about it because he works so well in this atmosphere," a top Democratic aide said.

It is easy to forget, for example, that the majority leader of the Senate cannot tie his shoes (he wears loafers). He cannot cut his food with a knife (he and his wife, Elizabeth, prefer to eat at home). As a young father, he could not lift up his daughter (she had to stand on a chair so he could hug her).

What most people see is Mr. Dole on television or in photographs clutching a pen in his right hand to keep his fingers from splaying and to

ward off people who might try to shake that hand. But when he sleeps, he clutches the sawed-off top of a wooden crutch, wrapped in gauze. "It relaxes my hand," he said. "Oh ..."

... been away, the day ... a college athlete ... a doctor. But in ... artillery shell to ... soldier was permanently crippled. He feared that, if he lived at all, he would only peddle pencils on the street.

Now 72, Mr. Dole is one election

Continued on Page 22, Column 3

Asian Childhoods Sacrificed to Prosperity's Lust

By NICHOLAS D. KRISTOF

SVAY PAK, Cambodia — She giggled for a moment, a 13-year-old girl, all sparkling eyes and white teeth, her laughter washing over the grunts from a pornographic video playing a few feet away. Then the brothel owner strutted over.

The owner, a hearty, friendly woman in her late 20's who paid good money to buy the girl, named Sriy, cheerfully and explicitly recommended her anatomical features and said the $10 fee was not so great because "she only just lost her virginity."

In fact, that is a lie. Sriy was sold into prostitution two years ago.

As if to prove her point, the owner of the brothel, in this town 50 miles northwest of the capital, reached out and tugged down on the girl's dress to display her left breast, or rather the nipple of what will become a breast if Sriy survives to maturity. "You like?" the owner asked in broken English. "You take girl?"

Sriy endures these indignities, along with up to 10 customers a night, because she is considered the brothel owner's property. Sold by her step-father to another brothel, which then sold her to this one, the girl must work until the debt is deemed to be repaid. Or until she gets AIDS.

If she tries to escape, she will be caught, severely beaten, perhaps starved, and locked inside her room, while still being forced to have sex with many customers a night. A neighboring brothel burned down in mid-March, and the bodies of two girls were found in the wreckage. They had been locked inside, forced to have sex with customers in their rooms, and never allowed out because they showed signs of wanting to escape.

Sriy is one of tens of thousands of children who are slaves working in the plantations of the 1990's: the brothels of Cambodia, India, China, Thailand, the

Continued on Page 8, Column 1

CHILDREN FOR SALE
A special report.

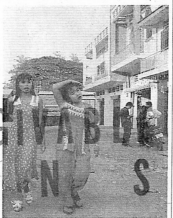

Nicholas D. Kristof/The New York Times
Two young prostitutes on a street outside Phnom Penh.

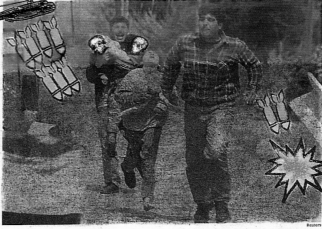

Reuters
Lebanese civilians, including a man with the bodies of his two children, run from the scene of a rocket attack.

The New York Times Magazine
A CELEBRATION OF
100
ONE HUNDRED YEARS

In the first of three centennial issues this year, The New York Times Magazine regards the world as it has looked over the last 5,000 Sundays since the magazine's establishment by Adolph S. Ochs. This special retrospective number encompasses homages to the Hamptons (1673) and a family's paradise (1735), the fall of Broadway and the fall of Communism, civil rights and women's rights.

There are special moments of memorable writing from public figures like Churchill, Einstein and King; authors like Mann, Auden and Mailer; and a host of noted journalists. The editors reviewed 2,500 articles and selected excerpts from 150 that convey the special gleam in the light of historical hindsight.

Magazine, section 6.

Boston Braces for a Colossal 100th Marathon

By JERE LONGMAN

BOSTON, April 11 — The 100th running of the Boston Marathon on Monday will stretch like a pair of Spandex tights to four times its normal size. The last of the runners may not reach the starting line for an hour. By then, Cosmas Ndeti, the three-time men's champion from Kenya, should be approaching the midway point.

An insular race that began in 1897 with 15 runners starting from a line drawn in the dirt, and which official-

ly closed its doors to women until 1972, has thrown itself open to the world for this celebration. The golden anniversary marathon will now be the largest in the world, largest, with 38,500 registered runners and another estimated 32,000 unregistered participants, or "bandits," also expected to challenge the insidious 26-mile-385-yard course.

A field of 50,000 participants would dwarf even the bloated field of 32,000 runners who started the 25th New York City Marathon in 1994.

"That's more people than they put in Central Park for opening day,"

said Vic Navarra, the official starter of the New York City Marathon, who has been spending three or four days a week in Boston since January to aid Boston organizers. "I said we had 32,000 people who wanted to run turned away."

Boston and New York, the country's two premier marathons, have always differed in temperament way. New York is a glitzy event, a 26-mile block party. Entry is by random lottery. Boston has always been a serious race, with strict qualifying

Continued on Page 24, Column 1

ISRAELIS BLOCKADE PORTS IN LEBANON AND SHELL SOUTH

PRESS WAR ON GUERRILLAS

Residents Flee on Both Sides of Border but Arab Rocket Attacks Drop Sharply

By SERGE SCHMEMANN

JERUSALEM, April 13 — Israeli gunboats blockaded Beirut and other Lebanese ports today and Israeli warplanes shelled southern Lebanon as Israel raised the heat against northern Islamic guerrillas.

Israeli commanders noted that the guerrillas of the Party of God, the Iran-backed organization also known as Hezbollah, fired only a few Katyusha rockets into northern Israel today, a sign that they had been driven from positions from which to launch these kinds of earlier days. ...

Continued on Page 10, Column ...

Liberian Truce Fails to Hold; Anarchy Rules

By HOWARD W. FRENCH

MONROVIA, Liberia, April 13 — Hopes that a renegotiated cease-fire would help this embattled city were dashed by early morning, when gunfire rang out anew and sporadic shelling resumed near a diplomatic enclave where thousands of Liberian refugees had sought shelter.

With the flight of relief agency personnel, most of the American and European employees remaining here joined people in neighboring Sierra Leone. Some 400 Americans, whom officials hoped to evacuate by Monday, are thought to be scattered about the city.

The fighting brought renewed vigor to rampaging bands of warring militias. By midmorning the streets of the Liberian capital had become as dangerous as ever since the renewal of seven-year civil war here Saturday.

Heavily armed militia members — young men and boys enjoying impromptu stolen toys — zoomed around Monrovia aboard hot-wired vehicles and worker teams taken the previously busy international relief agencies.

The wholesale looting of relief agencies, carried out in broad daylight on Friday, sealed the decision to reduce staff in Liberia.

The United States Embassy, too, decided today to reduce its staff to a dozen or so essential members, and American Special Forces units flown in from Europe last week will be relieved by Marines who are en route to points offshore here by midweek.

With the departure of internation-

Continued on Page 12, Column 1

INSIDE

An Insurer to Benefit
A health insurance company with ties to Republican leaders stands to benefit from a proposed addition to a bill the Senate will consider. Page 16.

A Tax Vote on Tax Day
House Republicans will celebrate April 15 by voting on a constitutional amendment that would make it tougher to increase taxes. Page 16.

Seeking Unity, and Survival
In Queens, churches struggle to incorporate immigrants who share a faith but bring their own religious and cultural notions to it. Page 33.

Bosnia Aid Pledged
At an international meeting, pledges of $1.23 billion were made to help Bosnia rebuild, but a share for the Serbs remained uncertain. Page 9.

Devils Are Done In
New Jersey becomes only the eighth team in history to miss the playoffs a season after winning the Stanley Cup. SportsSunday, Section 8.

TODAY'S SECTIONS

HOME DESIGN

201 EAST 67TH ST. HAS BEEN LIBERATED from the cable monopoly! Better building-wide service. Better prices. Call Liberty 212-991-7777 — Advt.

MOVE EASIER & SAVE THOUSANDS the MovePlanner/1-888-668-Plan/free call — Advt.

THE NEW YORK TIMES is available for home or office delivery in most major U.S. cities. Call free: 1-800-NYTIMES. Ask about Trans-months TimesCard. ADVT.

354713

"All the News
That Fits"

The New York Times

VOL.CXLV...No. 50,398 Copyright © 1996 The New York Times NEW YORK, MONDAY, APRIL 15, 1996 $1 beyond the greater New York metropolitan area. 60 CENTS

Late Edition

New York: Today, sunny, then increasing clouds. High 59. Tonight, showers late. Low 47. Tomorrow, rain, heavy at times. High 53. Yesterday, high 54, low 41. Details, page C14.

Woman's Plea for Asylum Puts Tribal Ritual on Trial

FLIGHT INTO DETENTION
A special report.

By CELIA W. DUGGER

YORK, Pa., April 12 — Fauziya Kasinga says she fled her homeland of Togo at age 17 to avoid the tribal rite of female genital mutilation and an arranged marriage as the fourth wife of a man nearly three times her age. When she arrived at Newark International Airport, she felt sure that she would find sanctuary in a country that "believed in justice."

Instead she has passed her 18th and 19th birthdays behind bars. First, immigration officials took her to the Esmor detention center in Elizabeth, N.J., where she describes being shackled in chains at times, denied sanitary napkins and put in an isolation cell.

Last June, she said, she was tear-gassed and beaten during a melee at Esmor, where immigration authorities later concluded that guards had abused detainees.

After the Esmor disturbance, she and many other asylum seekers who entered this country illegally in the New York area were sent to prisons in Pennsylvania, where she has been strip-searched and locked in a maximum security cell with an American convict — an account confirmed by the York County Prison warden, Thomas H. Hogan.

"I feel empty, mute," Ms. Kasinga said today in a barely audible whisper, as she sat in her prison blues at the York prison. "I keep asking myself, 'What did I do to deserve such punishment? What did I do?'"

Ms. Kasinga's two-year ordeal will reach a critical juncture on May 2, when the Board of Immigration Appeals, the highest administrative tribunal in the nation's immigration system, is to consider her asylum request.

Immigration officials and advocates for refugees say her case is likely to set an important

Fauziya Kasinga says she fled Togo to avoid mutilation and an arranged marriage; she has been held in detention since.

Steven M. Falk for The New York Times

Continued on Page B4, Column 1

Fear of a Communist Comeback Has Many in Russia Packing Bags

By MICHAEL SPECTER

MOSCOW, April 14 — At the age of 22, Galina Mardoyan has seen enough turmoil to last a lifetime. By the time she was done with high school, the Soviet Union had collapsed. As an Armenian living in Georgia, she felt despised, so she moved to a resort on the Black Sea where she hoped to live quietly with her grandmother.

She got there in 1992, just in time to watch thousands of her new neighbors in the once glorious vacation town of Sukhumi butcher one another in a savage civil war. She fled again, this time to Moscow, where she is a college student.

Now, for the first time, convinced that the Communist Party will win parliamentary elections in June and set the country reeling backward to a time when the freedoms she has come to rely on were prohibited, Ms. Mardoyan is packing her bags again.

"People here talk about a Communist comeback as if it will be nothing much," she said in an interview, her black eyes filled with anger and anxiety. "They think it's changing a bus or changing the name of a color. But those who remember what it was like before don't want them if there. They want it. But I know what happened here and it's not going to happen to me."

Her fear of a Communist future may seem extreme, but it is not unusual, particularly in big cities like Moscow, where Communists who dominate the polls in rural areas are still deeply unpopular. From young artists who cannot conceive of living in a Russia without the right to express themselves, to retired people — even those who say

Continued on Page A8, Column 1

they are going to vote for the Communists — apprehension has settled like a thick blanket over the country.

People here have learned through the hardest of experiences to be cynical. The century has taught Russians to expect the worst, so it is hard to know how serious people are when they give voice to their rising anxiety and try to tell what they are really worried about. But those worried the most, it is not reasonable to suppose, could return to their jobs as intellectuals, those with a foreign education, entrepreneurs and members of minorities — suddenly seem to have

NEWS SUMMARY A2

THE NEW YORK TIMES is available for home or office delivery in most major U.S. cities. Call toll-free 1-800-NYTIMES. Ask about Times-media TimesCard. ADVT.

354613

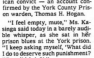

Faldo Overtakes Norman to Win Masters

Nick Faldo embracing Greg Norman after his victory yesterday at the Masters in Augusta, Ga. Norman began the day leading by six strokes; Faldo won the golf tournament by five shots. SportsMonday, page C1.

Associated Press

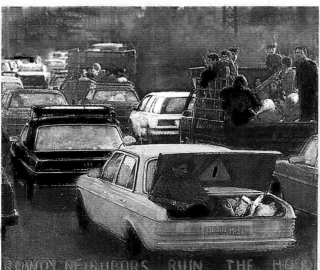

Thousands of residents of southern Lebanon packed their things and fled north as Israeli attacks continued.

Agence France-Presse

Tight Security Gets Tighter As a Sad Anniversary Nears

By SAM HOWE VERHOVEK

HOUSTON, April 14 — Across Ohio recently, police chiefs and sheriffs received a letter from Ted A. Almay, superintendent of the state's Bureau of Criminal Identification and Investigation. The Branch Davidian compound near Waco, Tex., went up in flames on April 19, 1993. Mr. Almay reminded them, and the Federal Building in Oklahoma City was blown up on the same date two years later.

Anti-Government groups place great deal of emphasis" on that date because of what happened at Waco, the letter went on. "It is for that reason that we recommend an internal alert for any possible violence April 19, 1996," it said. "We urge to exercise all due caution."

In Chicago, the authorities plan to take a more specific step on April 19, which is Friday. The Cook County Sheriff's office intends to search the criminal and civil court buildings with its canine unit on that day. And in Nebraska, extra officers are being stationed in state government buildings. "We are very aware of the date," a spokesman for the State Patrol said.

With the approach of the one-year anniversary of the homemade truck bomb that led to 168 deaths and injured more than 400 in Oklahoma, law-enforcement officials around the country are openly acknowledging that they are on an unusual alert for any signs of terrorist activity that day. For the public at large,

they offer a discordant mix of recommendations: do not worry, treat the day like any other working day but do be aware of the date, keep an eye out and report any suspicious activity immediately.

The tightest security will be at Federal buildings, though many of the measures that will be in effect there — more security officers, metal detectors, surveillance by closed-circuit cameras, protection of water supplies, mandatory identification concrete barriers to keep cars away from buildings, and

Continued on Page B8, Column 1

As Clinton Visits Changing Asia, Military Concerns Gain Urgency

By STEVEN ERLANGER

WASHINGTON, April 14 — After his last trip to Japan three years ago, one dominated by vicious disputes over trade, President Clinton returns on Tuesday to a changed strategic landscape, with Japan seeming a reduced economic threat, and China seeming a larger military one.

With Beijing struggling for respect as a great power, in displays of military power toward Taiwan, and North Korea, whose 1953 armistice between the dead, Asia appears to be raising new questions about American "commitment" to power, to enforce this quarrel for good of China.

So President Clinton's planned drop-by visit to Japan then two full days in Tokyo are intended to highlight security reassurances rather than trade squabbles, to try to convince the region that America will remain Asia's closest ally and the most efficient restraint on China's ambitions and North Korea's desperation.

Mr. Clinton's new emphasis is an acknowledgment that diplomacy is something larger than trade, and that even in the post-Soviet world

America's interests require demonstrations of military strength and political will.

As such, Mr. Clinton's trip to South Korea, Japan and Russia is another step in his revised self-definition of his presidency. These days Mr. Clinton represents himself not only as passionate, consoling it in times, but also as the kind of religion, policy steward that centrists like his presidential rival Senator Bob Dole, has represented.

In private he visits, old being questioned, his task will be to certain if his own plans are vague. Across the north is deteriorating relationship with the United States and 43 years of stalemate there it appears to be crumbling and dangerous. In Russia, the whole thrust of American policy is at stake in June's elections. Mr. Clinton, with other leaders like Chancellor Helmut Kohl of Germany, will try to help an ill, weakened and more nationalist-sounding Boris N. Yeltsin beat back the Communist leader,

Continued on Page A8, Column 4

The I.R.S. Scrambles To Meet a Deadline

While millions of taxpayers rush to meet the filing deadline, the Internal Revenue Service is scrambling to meet demand that it reduce its paperwork and modernize its computers — a multi-billion dollar project.

Unless Congress can be convinced that the I.R.S. can complete project, it could lose next year's proposed $850 million allocation.

The chairman of the House subcommittee that oversees the I.R.S. refers to money already spent for the program as "a $4 billion fiasco."

An I.R.S. official says there has been progress at modernization and cites a program that permits some taxpayers to file by telephone.

Article, page B8.

INSIDE

No Shadows in Silicon Alley

Software, multimedia and Internet companies now employ more workers in the New York area than television, book publishing or newspapers do, a study has found. Page D1.

Pakistan Hospital Bombed

A bomb killed at least six people in a Pakistan cancer hospital founded by an athlete who has said he is considering starting a movement to try to oust the Prime Minister. Page A7.

Dissent on Growth Hormone

A new study tries to debunk claims that human growth hormone is a fountain of youth, calling it ineffective and expensive. Page A13.

Thomas Hartwell for The New York Times

Live From Cairo, It's . . .

The Arab world got an early glimpse of satellite television during the gulf war. Now three Saudi-backed satellite broadcasters are vying for an audience of millions. Page D1.

NYU MEDICAL CENTER HAS BEEN LIBERATED. For better business television, Call Edward Foy, Liberty Cable 212-891-7700 — ADVT.

PANIC IN LEBANON SPREADS AS ISRAEL KEEPS UP ATTACKS

GUERRILLAS STRIKE BACK

Flood of Refugees Doubles as Offensive Against Militants Continues for 4th Day

By SERGE SCHMEMANN

JERUSALEM, April 14 — Hundreds of thousands of Lebanese refugees fled north today after Israel warned them to leave southern Lebanon and continue to leave their homes.

Israeli planes and gunboats continued to bombard southern villages and other targets in the fourth day of Israel's operation against Lebanese Shiite Muslim guerrillas of the Party of God.

The operation began with the largest Israeli air bombardment since the 1982 war. The rockets broke, Israeli officials said, rockets struck northern Israel as well as fell in the two days. The Israeli Army and the guerrillas resumed the shelling Monday morning, but no one was hurt, Reuters reported.

For the third day in a row, Israeli helicopter gunships struck Beirut, hitting what the army described as offices of the guerrillas in the southern suburbs. Lebanese reports said the rockets struck shops adjacent to the office.

The Israelis also hit an electrical transformer station in the Bekaa region, blacking out parts of the city. Others said the strike on retaliation for similar damage to the northern city of Qiryat Shemona.

The actions followed Israel's two-pronged strategy of battering guerrilla bases and of using pressure to get them to rein in the militant group, known as Hezbollah, which has been waging a struggle for 11 years. Israeli Army from the south maintains that things today to air bombings in the city of Tyre, and two western Bekaa region and the towns of Nabatiye and Zaharani, doubled the estimated number of refugees above 400,000, confronting Jerusalem. Syria, which also troops and officers in Lebanon, control over Lebanon.

The Israelis charge the offensive on Thursday, saying that two rocket attacks against northern Israel this month were the latest in what it described as a campaign orchestrated by Iran with support from the Party of God to topple the current peace negotiations.

On northern Israel today, a rocket were fired which wounded a woman in a school in western Galilee, causing extensive damage but no injuries.

Continued on Page A8, Column 1

Metro Police Leader Wants to Improve Ties to Minorities

By CLIFFORD KRAUSS

On the eve of ceremonies that will give him command of the nation's largest police force, Howard Safir, the incoming New York City Police Commissioner, said yesterday that one of his first goals would be to improve police relations with the city's black and Hispanic residents.

Mr. Safir said he was troubled by the perception, particularly among minorities, that the Police Department is abusive. While the department has seen an increase of more than 50 percent in abuse complaints over the last two years, Mr. Safir said he was not sure that the impressions left by such reports accurately reflected reality. "I'm not in a position to say that yet," he said in an interview as he unpacked in his new office. "It's something I'm going to take a close look at."

He said he had no reason to disbelieve the assertions of his predecessor as Commissioner, William J. Bratton, that police brutality had decreased in recent years and that there were no remaining pockets of corruption that compared with the scandals in recent years in the 30th Precinct in Harlem or the 48th Precinct in the Bronx, where more than 50 police officers were arrested on charges ranging from perjury to drug dealing.

Nevertheless, he said, "perception

Continued on Page B6, Column 1

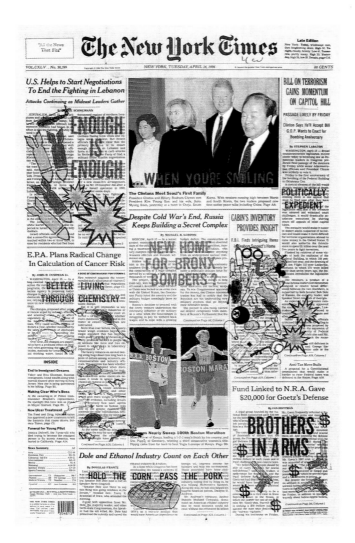

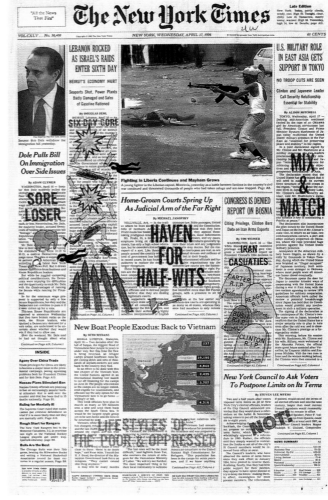

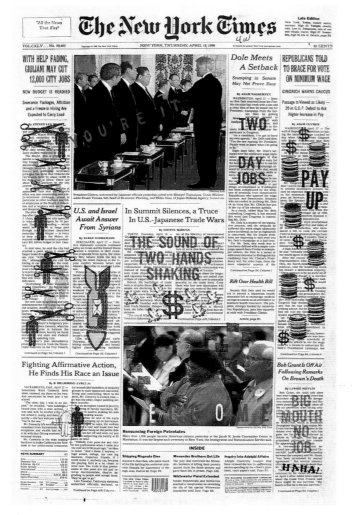

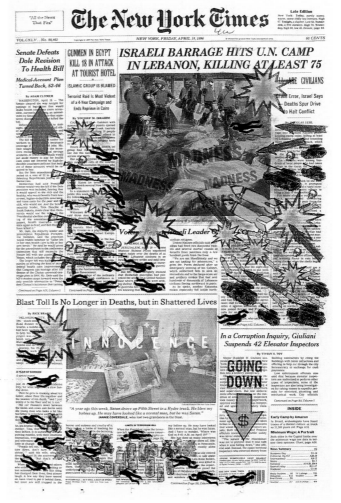

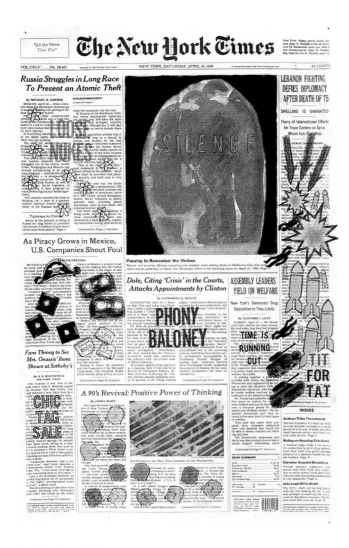

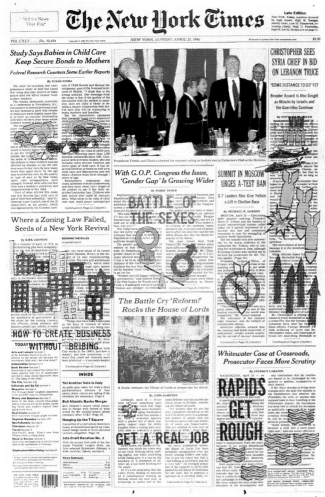

"All the News
That Fits"

The New York Times

Late Edition

New York: Today, increasing clouds, a shower late. High 75. Tonight, showers, mild, breezy. Low 62. Tomorrow, more showers. High 74. Yesterday, high 81, low 52. Details, page C9.

VOL.CXLV No. 50,405 Copyright © 1996 The New York Times NEW YORK, MONDAY, APRIL 22, 1996 $1 beyond the greater New York metropolitan area. 60 CENTS

A Day to Send the Clothes Dancing

It was a brilliant Sunday to hold the West Side Spring Festival, on Broadway between 96th and 110th Streets. There was sun, shopping and eating: the breeze blew out of the doldrums and off the rack.

Barbara Alper for The New York Times

Clinton and Yeltsin Accentuate The Positive at Summit Meeting

By ALISON MITCHELL

MOSCOW, April 21 — President Clinton and President Boris N. Yeltsin emerged from a meeting in the Kremlin today effusively celebrating the American-Russian partnership even as they glossed over a host of policy differences.

They announced some progress on disputes over treaties on conventional forces and anti-missile defenses. And both men put a premium on keeping the relationship between the United States and Russia on a solid footing despite growing anti-Western sentiment in Russia and a coming presidential election here that could well return a resurgent Communist Party to power.

The five-hour meeting between the two Presidents capped a weekend of glittering international summitry in which Mr. Yeltsin and the leaders of seven major industrial democracies, meeting for the first time in Moscow, called for speedy enactment of a nuclear test ban.

Those visitors also provided a warm embrace for Mr. Yeltsin, giving him the opportunity to demonstrate his prestige as a world leader as he heads into the election running behind Gennadi A. Zyuganov, the Communist candidate, in opinion surveys.

Mr. Clinton, sitting by Mr. Yeltsin's side at a news conference, lavishly praised his Russian counterpart. "Thanks to President Yeltsin's leadership, 60 percent of Russia's economy is now in the hands of its people, not the state," he said. "Inflation has been cut. Democracy is taking hold. Since 1993, trade be-

SYRIA AND ISRAEL ARE STILL BALKING OVER A CEASE-FIRE

MIDEAST TALKS CONTINUE

Christopher Is Shuttling From Jerusalem to Damascus — Long-Term Pact Elusive

DAMASCUS, Syria, April 21 — Hopes for a cease-fire in southern Lebanon between Israel dwindled today as both Syria and Israel insisted on a broader memorandum of understanding that would stop the fighting for longer than a few weeks.

tween the United States and Russia is up 65 percent."

For his part, Mr. Yeltsin asserted that the elections in his country "do not interfere with the long-term cooperation between our two countries." When both men were asked how a Communist victory would affect ties, Mr. Yeltsin answered brusquely: "There's nothing to think about, because I am sure that I will be victorious."

Mr. Clinton, laughing, said, "That makes my answer irrelevant, doesn't it?"

At the news conference, Mr. Yeltsin chastised reporters for suggest-

NYNEX AND BELL ATLANTIC REACH ACCORD ON MERGER; LINKS 36 MILLION CUSTOMERS

Connecting the Northeast

The proposed merger would create the nation's largest local telephone company.

NYNEX
Headquarters: New York City
17.1 million lines in service
65,800 employees
937,000 stockholders
$13.4 billion revenue in 1995

Bell Atlantic
Headquarters: Philadelphia
19.8 million lines in service
61,800 employees
991,000 stockholders
$13.4 billion revenue in 1995

Deal Produces Divided View Of Effects on Phone Service

By BARRY MEIER

Consumer advocates and regulators were sharply divided on the likely effects of a Nynex-Bell Atlantic merger on communications customers in the New York metropolitan area, but the two companies have carved out far different reputations when it comes to service.

Some consumer watchdogs expressed concern that pairing the two regional Bell operating companies would create a telecommunications giant that would dominate local telephone, long distance, wireless, Internet and even video service in a region stretching from Maine to Virginia.

In this view, likely competitors might be deterred from entering that marketplace, giving the new company freer rein to dictate rates and service at a minimum, the prospect of natural competition between Nynex and Bell Atlantic has been eliminated.

"We are concerned that this merger may throw a monkey wrench in bringing alternative sources to consumers," said an executive director of the Citizens Utility Board, an advocacy group in Albany.

But others said that the merger of the two companies

JOB CUTS EXPECTED

Union Says It Will Fight 'With Every Resource Available to Us'

By MARK LANDLER

Ending a prolonged public courtship, the Bell Atlantic and Nynex Corporations agreed yesterday to one of the largest corporate mergers in American history, people involved in the negotiations said.

The two regional telephone companies will consummate the deal today after the boards unanimously approved it, bringing a weekend of deliberations that followed two years of on-again, off-again talks.

The merger is breathtaking in size and scope. Together, Bell Atlantic and Nynex would be the second-largest phone company in the United States after AT&T, with a stock market value of $53 billion, annual sales of close to $27 billion, 127,600 employees and 36 million customers in 12 Eastern states.

The new company, which Bell Atlantic and Nynex said was unnamed, would dominate telecommunications up and down the Eastern Seaboard, offering phone service in an almost unbroken swath from the rocky Maine coastline to the tidewater country of Virginia.

The dominion would include the nation's financial and political centers, New York City and Washington, as well as major population centers like Boston, Philadelphia, Newark, and Richmond. One analyst estimated that 40 percent of the nation's long-distance calls originate in the Bell Atlantic-Nynex region.

The deal continues a grand reassembling of the Bell System that was foreshadowed by the overhaul of the nation's telecommunications laws in February and began in earnest earlier this month when SBC Communications and Pacific Telesis announced they would become the first of the seven Bell companies to join forces.

For consumers, the merger will have an immediate impact because the companies do not compete in each other's territory. But for some 22,000 employees in the network area, the merger could have significant implications.

"Executives close to the companies said that it could result in the loss of 1,000 to 3,000 jobs in the cuts would fall mainly on executives and administrative operations, these people said.

Continued on Page D5, Column 2

Dole Concedes Wage Increase Will Win Vote

By KATHARINE Q. SEELYE

WASHINGTON, April 21 — Bowing to political reality, Bob Dole, who has strongly opposed increasing the minimum wage, acknowledged today that an increase would probably be expected the measure to pass.

While he argued repeatedly on the NBC News program "Face the Nation" whether he would support raising the minimum wage to $5.15 an hour from $4.25 an hour, Mr. Dole acknowledged for the first time that the increase appeared inevitable. "Will there be an increase? I assume there will. The House has already indicated they're going to pass the minimum wage."

His concession came after he repeatedly sidestepped the question of whether he would support a raise. Subsequently, he said: "What we'll try to do, if there is an increase, is to package it with some other things," mentioning other measures that the Democrats oppose, like tax cuts, or as part of a budget agreement, thereby dooming any increase.

Other measures he would link the wage with, he said, include proposals allowing for new rules for employees who work part-time, or for compensatory time off in lieu of being paid overtime. He acknowledged that unions "aren't crazy about" these ideas. Speaker Newt Gingrich, appearing later on CNN's "Late Edition," endorsed Mr. Dole's concept of packaging the wage bill with other measures.

For the last several weeks, Mr. Dole has battled the Democratic ini-

Continued on Page B6, Column 1

Continued on Page A7, Column 1 *Continued on Page ?, Column ?*

Murmur of Gore's Ambition Becomes Louder

By RICHARD ...

WASHINGTON — President ... advisers ... pact that ... about the delicate ... Presidential aspirations for 2000.

Accordingly, one of Mr. Gore's closest confidants was circumspect when the two had lunch recently at the White House ... in the present Presidential politics ... was startled when ... said, 'If you ...' "He ... with great ..."

Both ... campaigns are gearing up behind the black gates of the White House; one is in full view, and the other is a subject of quiet conversation. But in Mr. Gore's inner circle, and among leading Democrats, the notion of the Vice President running for President has moved beyond the stage of mere assumption. With characteristic discretion, Mr. Gore is laying the groundwork for the ... closest ingly, as Mr. Gore sees to it that the favors he does for Mr. Clinton in 1996 will be repaid to Al Gore in 2000.

The closest the Vice President came in an interview last week to acknowledging his designs on the office 18 steps from his own: "I'm not actively discouraging the idea. But neither am I obsessed with it."

Insisting that "it's early" in the present ... Mr. Gore declined ... was the re-e... ton.

He said Mr. ... as Mr. Clinton's ... paigning against what he called the dangers of the "Gingrich-Dole Congress."

Mr. Gore's political advisers may

Continued on Page B6, Column 5

Al Gore is a Vice President who, discreetly, is seeking a promotion.

Paul Hosefros/The New York Times

Pooh's Playmate Dies

Christopher Robin Milne, immortalized as the young friend of Winnie-the-Pooh in the children's stories of his father, A. A. Milne, died on Saturday at 75. Page B12.

E. P. Dutton & Company, 1926

Students Still Sweat, They Just Don't Shower

By DIRK JOHNSON

WEST DUNDEE, Ill. — They might wear nose rings, headsets or sport ... knows where. ... among American high school ... days, one thing ... strange: showering with classmates after gym period.

"Standing around together naked?" said Andre Hennig, an 18-year-old senior at McHenry High School in the northwest suburbs of Chicago. "Oh, no, man — people would feel really uncomfortable about that."

In a striking measure of changed sensibilities in school and society, showering after physical education class, once an almost universal daily ritual ... seem as ... but body image ... awareness ...

"You just cake on the deodorant," said C. J. Glawe, a 16-year-old sophomore in a Crystal Lake South letter jacket, "and hope you're not going to smell too bad."

Students across the United States have abandoned school showers, and their attitudes seem to be much the same whether they live in inner-city high-rises, on suburban cul-de-sacs or in far-flung little towns in country.

To be sure, Ms. Young said, avoiding showers is not entirely new. Many people well into middle age can remember the trumped-up excuses or notes from home or the routine than we did."

Continued on Page B10, Column 1

INSIDE

Price of Crime Calculated
A comprehensive survey for the Justice Department determined that crime costs Americans at least $450 billion a year. Page A8.

Center-Left Leads in Italy
Partial returns from Italian elections pointed to a historic victory by the center-left. Page A3.

Baseball All the Way?
Mayor Giuliani says he is open to a baseball-only stadium in Manhattan for the Yankees. Page B1.

Today's TV Listings
Television and radio news, listings and advertising appear today on pages B10-11.

354613

The New York Times

Late Edition
New York: Today, becoming cloudy, showers late. High 77. Tonight, showers, then cooler, drier. Low 45. Tomorrow, sunny, cool. High 62. Yesterday, high 73, low 58. Details, page C10.

VOL.CXLV...No. 50,406 Copyright © 1996 The New York Times NEW YORK, TUESDAY, APRIL 23, 1996 $1 beyond the greater New York metropolitan area 60 CENTS

New Medicare Trust Fund Data Show an Unexpected Shortfall

Program Is Solvent, but Gap Shows a Weakne[ss]

By ROBERT PEAR

WASHINGTON, April 22 — Medicare's Hospital Insurance Trust Fund lost $4.2 billion in the first half of the current fiscal year, according to new Government data, which suggest that the financial condition of the program is worse than projected by Administration officials last year.

The trust fund, which pays hospital bills for the elderly and disabled, lost money last year for the first time since 1972. But the loss for all of last year was only $35.7 million.

The new data show that the losses are growing. In the first half of the current fiscal year, from October 1995 through March of this year, the trust funds sent $60.5 billion and took in $56.3 billion, a shortfall of $4.2 billion, the Treasury said.

There is little chance that the trust fund will actually run out of money. It still contains more than $120 billion. Congress would almost surely act to rescue the program before it ran out of money. But the new data provide fresh evidence that, after months of acrimonious debate between the White House and Congress, Medicare remains a budget problem of immense and growing proportions.

Chris Jennings, a special assistant to President Clinton for health policy, said today that the new numbers were not surprising. "They indicate the need to move forward, balance the budget and enact some changes in Medicare that will strengthen the trust fund," he said. "Republicans and Democrats should work together to address the problem."

In a letter to Congress last week, Treasury Secretary Robert E. Rubin told Congress and the Administration resume discussions to reach an agreement on Medicare and the budget.

Republicans proposed many changes in Medicare last year to help control costs. But President Clinton said the changes would hurt beneficiaries. Republicans may hesitate to put forward new proposals after they were bloodied in that battle. Representative Bill Archer, the Texas Republican who is chairman of the Ways and Means Committee, said, "The President preferred to scare seniors and play politics instead of saving Medicare."

It is not entirely clear why the

Continued on Page A17, Column 1

Lapsed Airline Taxes Leave Hole in Budget

As Republicans and Democrats have fought this spring over cutting the Federal deficit, they have neglected to renew a handful of excise taxes that expired last December. So far, the lapse, principally involving levies on the aviation industry, has added $1.7 billion back to the same deficit the parties are trying to cut.

Officials say the taxes should be reinstated when it is politically palatable. But nobody seems to know when that might be.

Article, page A20.

Bill Seeks to Protect Inmates From Guards Who Seek Sex

By MONTE WILLIAMS

BEDFORD HILLS, N.Y. — What woke her in the predawn of Aug. 8, 1995, was the urgent tapping on her shoulder. Felita Dobbins, a prisoner at the Bedford Hills Correctional Facility, said she opened her eyes to find a [...] ping out of the pants of his uniform.

He [...] the prosectors [...] left her [...] head and [...] issued several times before. "You tell any[...] do."

Ms. [...] stood [...] Reid, who later pleaded guilty to sexual abuse, had promised to kill members of her family, including her 2-year-old daughter, if the other times he had forced her to have sex.

Women's rights advocates say such incidents are all too common in New York prisons, adding that no law bars sex between guards and prisoners. They are backing a bill in the State Assembly that would classify all sex between prison employees and inmates as coercive or nonconsensual — a crime. Proponents say the imbalance of power between inmates and officers negates the possibility of true consent, as much as it does for children [...].

"These relationships represent the ultimate abuse of power," said Jeanine F. Pirro, the Westchester County District Attorney. "Prisoners are reliant on correction officers

for everything from food and safety to sanitary napkins."

Fourteen other states, including New Jersey and Connecticut, have laws banning sex between prison employees and inmates.

[...] prisoners [...] mail [...] D[...] of Bedford [...] M. [...] New York City's [...] of Correction [...] sexual contact [...] the inmate could [...] is that sort of [...] an [...] curred. The bill has the unanimous support of the State Department of Correctional Services and the quali-

Continued on Page B4, Column 1

INSIDE

Judge Faces Formal Charges
A state panel plans to file charges against Lorin Duckman, the judge accused of mishandling domestic violence cases. The charges could lead to his censure or removal. Page B1.

Evaluating the Job Market
In a report that could fuel the debate over corporate downsizing, White House economists emphasize the pace of job creation. Page D1.

Nets Dismiss Coach
After consecutive 30-52 seasons and a failure to gain the playoffs, the Nets did the expected and dismissed Coach Butch Beard. Page B11.

Celebrating a Telecommunications Marriage
Raymond W. Smith, left, Bell Atlantic's chairman, and Ivan G. Seidenberg, Nynex's chairman, who announced yesterday that their companies would merge in a deal valued at $22.1 billion. Page D1.
Associated Press

Palestinians Meet to Rethink Calls for Israel's Destruction

By SERGE SCHMEMANN

GAZA, April 22 — The Palestine National Council, the Palestinian parliament-in-exile whose roster of members reads like a who's who of Israel's enemies, convened today in Gaza for what Yasir Arafat says that the time had come to formally take Israel's destruction off the Palestinian agenda.

Participants here said Mr. Arafat faces some hard bargaining over the next three days. His mission is to convince the members, many of them hard-core radicals, to make a conciliatory gesture toward Israel at a time when Israeli attacks have killed scores of civilians in Lebanon and while Gaza is in its seventh week of harsh Israeli restrictions imposed after a series of suicide bombings in Israel.

Some of the biggest names of the Palestinian resistance — like George Habash of the Popular Front for the Liberation of Palestine, and Nayef Hawatmeh of the Democratic Front for the Liberation of Palestine — declined to come to the meeting, which has been planned for several weeks. Still, those members who did accept Israel's offer of safe passage included several Palestinians whose names continue to inspire rage among Israelis.

Among the estimated 500 dele-

gates gathered in Gaza's modern Cultural Center was Mohammed Abbas, a.k.a. Abu Abbas, who is wanted in the United States for leading the group that hijacked the Achille Lauro in 1985 and killed a disabled American passenger. There was also Mohammed Daoud Odeh, who as Abu Daoud is held accountable by Israel for the massacre of Olympic athletes in Munich in 1972, though he has denied any role.

These men and all other members of the Palestine National Council granted permission by Prime Minister Shimon Peres to enter Israel to attend the meeting. Mr. Peres's offer was intended to insure that the Palestinians would formally abandon the calls for Israel's destruction enshrined in the Covenant adopted by the Palestine Liberation Organization at its inception in 1964.

Under the Israeli-Palestinian accord signed in September 1994, Mr. Arafat pledged by early May to purge the document of articles like No. 15, which declares it a duty "to repulse the Zionist, imperialist invasion from the great Arab homeland and to purge the Zionist presence from Palestine."

In his impassioned opening

Continued on Page A12, Column 1

Ethiopia Tries Former Rulers In 70's Deaths

By JAMES C. McKINLEY Jr.

ADDIS ABABA, Ethiopia, April 19 — As the leaders of the Marxist Government that once held this nation in an iron grip filed quietly into court, Hiwet Teklu could barely stand to look at them from her seat in the back of the cavernous room.

They were once the most powerful men in Ethiopia. They were also, she says, her son's killers.

Mrs. Teklu's son, Samson Allem, was a 22-year-old student in 1978 when the Red Terror, as the wave of political killings was known here, was under way. Like thousands of other students involved in a pro-democracy movement, he was imprisoned by Communist militiamen, tortured for 15 days and then shot to death in the dead of night, Mrs. Teklu said.

The next morning, his body was dumped near his mother's front door. A hand-lettered sign pinned to his chest said "Red Terror."

"These people are lackeys of their sons and daughters," the 54-year-old merchant said, wringing her hands, in an interview outside court. "They are getting a fair trial."

Almost 20 years after those days, the remnants of the Derg are finally being put on trial. As witnesses this month in the trial of the Derg, the leftist military junta that overthrew Emperor Selassie in 1974 and ruled with Marxist tactics until 1991, when it was driven from power by rebels from northern province [...]

The trial, [...] several [...], marks the start of what promises to

Continued on Page A10, Column 1

ITALIAN LEFT WINS BIG BREAKTHROUGH IN NATIONAL VOTE

EX-COMMUNISTS IN POWER

New Olive Tree Party to Rely on Marxists for Support of Economist as Premier

By CELESTINE BOHLEN

ROME, April 22 — By taking a step to the center, Italy's former Communists broke through a last barrier to national politics on Sunday, helping to lead their partners to a victory in both houses of Parliament and winning for the first time a chance to form an Italian government.

Jubilant and feeling a little surprised at their triumph, leaders of the center-left coalition known as the Olive Tree celebrated today that they had humbled the mighty Italian Communist Party and in recent elections, its political heir, the Democratic Party of the Left.

"The Olive Tree has the numbers to govern," said Romano Prodi, the 56-year-old economist who for the last year has been the moderate face of Italy's new left and now stands to become its next Prime Minister. "Governing is a tremendously difficult thing in Italy, but now it is not impossible."

The election in Italy, third in four years, was a humiliating setback to Silvio Berlusconi, the media mogul and former Prime Minister, just two years ago. The center-right coalition was seen for a year as the answer to Italy's political woes.

But the election, as we learned, was two different things in Italy, and many analysts today were predicting that the new Prodi Government will face in due course many of the same difficulties and contradictions that brought Mr. Berlusconi's coalition to an early end.

Final election results showed that the Olive Tree won control of the 315-seat Senate, and won 284 seats in the 630-member Chamber of Deputies. The numbers are enough to insure that Mr. Prodi, a newcomer whose only other government experience was stewardship of Italy's largest state-owned company, will be given the chance to form Italy's 55th government since the end of World War II.

But for an absolute majority in the lower house, Mr. Prodi and the Olive tree will probably have to turn for support to the 35 deputies from the Communist Refounding party, a splinter group of hard-core Marxists who, unlike Italy's mainstream leftists, have renounced none of the symbols, slogans or policies of their past.

They stand on a platform of strong social services, no pension reductions and a system of automatic pay raises based on increases in the cost of living. They oppose the European Union's plans for a single, unified currency.

While Communist Refounding has

Continued on Page A6, Column 1

Chechnya War as Fierce as Ever Despite Yeltsin's Pledge of Peace

By MICHAEL SPECTER

SHALI, Russia, April 18 — The people of the Chechen flatlands have developed a routine in the weeks since President Boris N. Yeltsin announced his initiative to end the war in this secessionist region in southern Russia.

They get up at dawn to watch the Russian bombers drop their deadly payloads on the rebels. But for the heavy artillery and the misty valleys that surround the militia, the Chechen separatists have increasingly turned their [...] [...] "Then [...] Yeltsin's [...] has ever been [...] question for any [...] across Chechnya. From one end of this broken republic to the other, soldiers are fighting [...] any time it suits [...], where more than 30,000 Russian troops poured into the mutinous region before the presidential election in June, Mr.

Yeltsin has said that if the fighting continues he will surely lose. Last month he announced an immediate end to all offensive military activities in the republic.

The next day at dawn his bombers struck the villages strung across the southern mountains — where most Chechen rebels are based. They have attacked almost without stop since Mr. Yeltsin made his speech. Hundreds of civilians have died. But the bombs rarely reach the fighters, who are well entrenched in the fortifications.

Every day now Mr. Yeltsin vows loudly that the air war in Chechnya is over. Every night Russian television shows devastating pictures of the air war in Chechnya. There are times, standing 20 miles away from the worst bombing, when the assault from the sky becomes so relentless that it looks as if somebody has taken a giant torch to the snowcapped mountains.

[...] called a change after Yel-

Continued on Page A11, Column 1

Residents of Jordan, Mont., and ranchers in the area are struggling to save their way of life.

Siege Is Subplot in Town's Survival Drama

By TIMOTHY EGAN

JORDAN, Mont., April 20 — For a town that has barely a tumbleweed's toehold in the high plains of Eastern Montana, life has new plot twists and drama around here — even before the anti-government fugitives known as the Freemen.

In the four weeks that Federal authorities have been locked in a sort of velvet-gloved standoff with the Freemen, not a shot has been fired on either side. F.B.I. agents complain about getting fat on farm suppers and bored with a watch-and-wait routine as predictable as prairie winds.

But all around the island of the siege, people are engaged in a daily struggle to keep their little hold on fast-fading American life from disappearing from the map altogether.

Real drama, says rancher Bev Murnion, is her face turned out of the lacerating wind, is getting $300 for the same size cow that brought $500 two years ago, or watching a newborn calf die after a sudden

cold snap. A real siege is when a chinook wind melts a foot of snow, and then the standing water freezes at night, and Ruth Coulter still has to drive 30 miles to deliver the mail to three patrons — down from more than 100 — a route she started on the job 47 years ago.

"We take care of everything from womb to tomb," said Mr. [...] whose friends sometimes call him Dr. Muniak, though only in jest. Medicine, such as it is, is one of the fragile pillars on which civilization in Garfield County rests. Mr. Muniak, 50, is the part-time ambulance driver, the part-time X-ray technician, the part-time secretary and the full-time guy who gets

Continued on Page B6, Column 1

229 PARK AVE. HAS BEEN LIBERATED FROM the cable monopoly! Butter building web service. Better prices. Call Liberty Cable 212-891-7777. ADVT

THE NEW YORK TIMES is available for home or office delivery in most major U.S. cities. Call toll-free 1-800-NYTIMES. Ask about Times mark TimesCard. ADVT

354613

"All the News
That Fits"

The New York Times

Late Edition
New York: Today, windy, cool, brilliant sunshine. High 62. Tonight, some clouds. Low 49. Tomorrow, partly sunny, warmer. High 72. Yesterday, high 85, low 58. Details, page C18.

VOL.CXLV...No. 50,407 Copyright © 1996 The New York Times NEW YORK, WEDNESDAY, APRIL 24, 1996 $1 beyond the greater New York metropolitan area. 60 CENTS

Bronx Jury Orders Goetz to Pay Man He Paralyzed $43 Million

Subway Shooting Victim Likely to Collect Little

By ADAM NOSSITER

Nine years after a criminal jury acquitted Bernhard H. Goetz, the man he paralyzed with his own gun and ordered him to pay $43 million.

Bernhard H. Goetz in the courthouse before the verdict.
Associated Press

Passing of Regents' Exams To Be Required for Diploma

By JAMES DAO

ALBANY, April 23 — The New York State Board of Regents is to approve a plan on Wednesday that will require every public-school student in the state to pass rigorous Regents examinations to earn a high school diploma, a plan widely considered to be the most significant change in state education policy in more than a decade.

The new policy will be phased in starting this fall and will have the greatest impact on New York City schools, where only about 21 percent of the students successfully complete the battery of tests needed to earn a Regents diploma last year.

Continued on Page B8, Column 3

INSIDE

Court Rules on Patent Trials
In a decision that could limit the role of juries in patent infringement cases, the Supreme Court ruled that it was up to judges to resolve what a patent means. Page D1.

Cleaning Up in Liberia
After weeks of violence in Liberia's capital, people came out of hiding to find a nightmarish scene. Page A3.

College Standards and Race
A mandate for equality in college admission standards in Mississippi threatens to reduce the number of black students there. Page A14.

Trial of Tokyo Cult Chief
A sect leader's trial for Tokyo nerve gas attacks opened with strong security and public interest. Page A12.

Giuliani to Keep Fireboxes
Ending a two-year fight, the Giuliani administration will keep two-thirds of the city's fireboxes. Page B1.

Rangers Tie Series
Adam Graves scored two goals as the Rangers beat the Montreal Canadiens, 4-3, to tie their playoff series at two games each. Page B11.

CHRISTOPHER GETS SNUB FROM ASSAD IN MIDEAST TALKS

AN ABRUPT CANCELLATION

Syrian Says Secretary Arrived Too Late for Their Meeting — Can Try Again Today

By STEVEN ERLANGER

JERUSALEM, April 23 — President Hafez al-Assad of Syria abruptly canceled a meeting this afternoon with Secretary of State Warren M. Christopher.

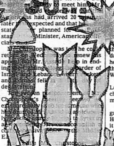

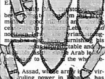

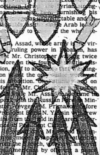

Last for U.S. on Rights
Outmaneuvering Washington, China blocked an effort to subject it to scrutiny by the United Nations Human Rights Commission. Page A12.

Continued on Page A6, Column 1

SENATE PASSES HEALTH BILL WITH JOB-TO-JOB COVERAGE

Dole Prods Clinton to Meet on Budget

PRESIDENT ACCEPTS

Fast White House Reply Seems a Surprise to the Senate Leader

By JERRY GRAY

WASHINGTON, April 23 — Adding the fight over a balanced budget to the forefront of this fall's presidential race, Senator Bob Dole, the presumptive Republican candidate casually suggested today that he and President Clinton negotiate the issue one on one, a proposal the White House quickly accepted.

"The President accepts," said Leon E. Panetta, the White House chief of staff. "We are prepared to meet tomorrow."

Mr. Dole, seemingly caught off guard by the nearly instant White House response, said, "We'll see how it looks."

Continued on Page B7, Column 2

Senator Bob Dole at a news conference yesterday.
Agence France-Presse

Disputed Issue In Senate Bill: Mental Care

By ROBERT PEAR

WASHINGTON, April 23 — The health insurance bill passed by the Senate today would make an immense change in national health policy by requiring insurers to provide coverage for mental illnesses that is equivalent to the coverage provided "for other conditions" like heart disease, diabetes and cancer.

Continued on Page B6, Column 1

VOTE IS UNANIMOUS

Measure Would Also Aid People With Chronic Medical Problems

By ADAM CLYMER

WASHINGTON, April 23 — The Senate today passed legislation to make health insurance coverage portable from one job to another.

Continued on Page B6, Column 1

Grandeur and Modernity in New Library

The lobby of the new Science, Industry and Business Library, at Madison Avenue and 34th Street.
Jack Manning/The New York Times

By PAUL GOLDBERGER

An Appraisal

There are no Corinthian columns, no ornate coffered ceilings, and the grand staircase is of stainless steel and marble. No library door.

The new $100 million library, which occupies roughly 160,000 square feet in the former B. Altman building, is the largest single mark main building was completed in 1911. It unites all of the library's various collections of scientific, technological, mathematical and business material, which had been divided between 42d Street and the library's West Side annex, and places them in a new environment that is itself a showpiece of technology.

The Science, Industry and Business Library will be open to intended for use by the general public and business people, with special attention to the needs of smaller businesses that do not have their own research facilities. But it also has a wider goal, which is to serve as a prototype for a whole new level of computerized access at the library. There are about 250 computers on the premises, as well as 500 work stations equipped

Megastore in Times Square
Times Square's redevelopment took a concrete step forward with the opening of a Virgin megastore on Broadway. Page B2.

Continued on Page B2, Column 5

The Camelot Auction Begins, With the Prices Fit for Kings

By JAMES BARRON

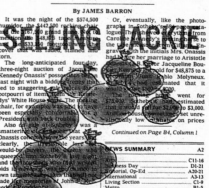

It was the night of the $574,500 humidor, the $442,500 rocking chair and the $167,300 grand and the $68,600 tape measure and cover that was nicked, stained and torn.

The long-anticipated four-day, three-night auction of Jacqueline Kennedy Onassis's possessions began last night with a bidding frenzy that led to staggering sales prices for a potpourri of items from the Kennedys' White House years. The rocking chair, for example, was said to have been especially comfortable for President, with back troubles.

Continued on Page B4, Column 1

The New York Times

VOL.CXLV... No. 50,408

Copyright © 1996 The New York Times

NEW YORK, THURSDAY, APRIL 25, 1996

$1 beyond the greater New York metropolitan area

60 CENTS

P.L.O. ENDS CALL FOR DESTRUCTION OF JEWISH STATE

BIG VICTORY FOR ARAFAT

Palestinian Assembly Presses to Keep Peace Effort Alive Despite Mideast Strife

By SERGE SCHMEMANN

GAZA, April 24 — Bowing to the insistent demands of Yasir Arafat, the main assembly of the Palestine Liberation Organization voted today to revoke the clauses in its 32-year-old charter that called for armed struggle to destroy the Jewish state.

The vote came behind closed doors after two days of impassioned speeches at the annual meeting of the Palestine National Council, the old Palestinian parliament-in-exile, inside Palestinian lands since Mr. Arafat began peace talks with Israel and gained control over portions of the West Bank and Gaza.

The vote was 504 in favor of amending the document and 54 against. Fourteen members abstained, and 97 of the 669 members of the council were absent, including members of radical movements who refused to attend any discussions on changing the charter.

The vote was well over the two-thirds required to amend the charter.

The meaning when Israeli-Palestinian talks are severely strained by suicide bombings and subsequent Israeli restrictions, and by the strife in Lebanon, testified to the central importance that Mr. Arafat and most Palestinian leaders place on continuing peace.

Younger delegates who raised great hopes on a peace that viewed the vote as a victory over older, more militant exiles.

"It's a dream for us to be here and say it is enough of the old style, it's time to replace the new era," said Mufid Abed Rabbo, 39, a member of the new Palestinian legislature from Tulkarm, who spent many years in Israeli prisons.

Israel and the United States, which were both involved behind the scenes, hailed the vote.

"Ideologically it is the most important change in the last 100 years," Prime Minister Shimon Peres said on Israel Radio. Secretary of State Warren Christopher, arriving in Tel Aviv on the fifth day of shuttle diplomacy to stop the latest round of fighting in Lebanon, said it was "a historic milestone on the road to reconciliation and peace between the people of Israel and the Palestinians."

The vote was a major personal victory for Mr. Arafat, who had to convince a hall full of grizzled veterans of the armed struggle in a gesture demanded by Israel just when Gaza is in the eighth day of crippling restrictions imposed after four suicide bombings, and when continuing Israeli raids into Lebanon are causing deep resentment among Arabs.

In impassioned speeches on Monday and today, Mr. Arafat argued that for the Palestinians to live up to their commitments would

Continued on Page A10, Column 3

INSIDE

Whitewater Respite Seen

President Clinton's advisers revealed a sense that the problems related to the Whitewater affair are dissipating. Page B12.

An Advance in Genetics

In a step that may aid understanding of human disease, scientists have determined the complete genetic blueprint of yeast. Page B10.

School Officials Indicted

Officials of a Bronx school district were accused of rigging school board elections in order to help keep their jobs. Page B1.

The High Cost of History

Buyers seeking a "piece of history" continued to pay huge sums at the auction of items from Jacqueline Kennedy Onassis' estate. Page B1.

'Mary Poppins' Author Dies

P. L. Travers, who said she had never meant to write for children when she wrote the magical Mary Poppins leaped from her pen, was 96. Page B14.

Yasir Arafat voting yesterday to change the Palestinian charter.

Agence France-Presse

Bosnia Hunting Enemies Down, Diplomats Say

By CHRIS HEDGES

ZAGREB, Croatia, April 24 — The Muslim-led Bosnian Government has dispatched small Iranian-trained commando units to capture enemies, including war criminals, senior Croatian officials and Western diplomats say.

The existence of the teams came to light this month when two Bosnian Muslims, along with an Iranian, were arrested and accused of trying to assassinate a renegade Muslim leader, Fikret Abdic, who is in exile in Croatia.

The Muslims, four men and a woman, one of whom are formally employed by the Bosnian police in Bihac, in northwestern Bosnia and Herzegovina, were captured on April 8 near Rijeka, Croatia. The team had grenades, automatic assault rifles, rocket-propelled grenades and plastic explosives in its possession, the police said.

The five Bosnians who are being interrogated are members of the Muslim Government's intelligence, the Bosnian Agency for Investigation and Documentation, officials who have read the transcripts of the interrogations said.

Western diplomats and Croatian officials said the five Muslims' activities were so secretive that they seemed to operate outside the Bosnian Government and give them a green light for attacks against their opponents. They did not give the names,

Continued on Page A6, Column 1

Mitsubishi Overture In Harassment Case

Mitsubishi Motor Manufacturing of America struck back at what could be the largest Federal sexual harassment lawsuit, the company's chairman said, indicating that Mitsubishi was softening its hard line in the case.

Business Day, page D1.

U.S. Frees African Fleeing Ritual Mutilation

By CELIA W. DUGGER

Fauziya Kasinga, who sought sanctuary in the United States in 1994, saying she was escaping her African tribe's custom of mutilating the genitals of young women, was released by Federal immigration authorities yesterday after more than a year of sometimes harsh confinement in a detention center in New Jersey and prisons in Pennsylvania.

Immigration officials said they decided to free Ms. Kasinga, 19, of Togo, because she has developed strong ties in recent months to religious and human rights groups who have promised to support her and insure she shows up for legal hearings. The officials phoned her lawyers yesterday with the decision and then told Ms. Kasinga.

"They called me in," she said. "I couldn't believe I was leaving the prison today. I was screaming!"

Her case, scheduled to be heard on May 2 by the highest administrative tribunal in the immigration system, is expected to set a precedent that will influence the treatment of other women who stay they are fleeing genital mutilation, a common rite in 26 African nations. Officials said the case might not be resolved for a year, and the limited detention space could be better used.

But Ms. Kasinga's lawyer, Karen Musalo, said she believes the Immigration and Naturalization Service let her client go only after an April 15 article in The New York Times detailing the case and the conditions of her detention led to a public outcry, a barrage of news accounts and the promise of continuing protests by an array of advocacy groups.

"When their decision to detain her

saw the light of day, there was an outpouring of concern and shock from the public," said Ms. Musalo, acting director of the International Human Rights Clinic at American University, Washington College of Law. "I don't want to sound like a curmudgeon — we're extremely pleased — but we hope it doesn't take

this kind of outcry for justice to be done for other asylum seekers who are being detained."

Immigration officials said publicity did not influence the decision to release Ms. Kasinga. David Martin, general counsel for the Immigration Service, said her lawyer had within the last week informed the agency that a Bahai family had agreed to take her in during the appeals pro-

Continued on Page B7, Column 1

Fauziya Kasinga of Togo was released from a Federal prison in York, Pa., yesterday after spending more than a year in confinement.

Greg Mahany for The New York Times

ELECTRIC UTILITIES TO PROVIDE ACCESS FOR COMPETITORS

REGULATOR ORDERS MOVE

Opening Up of Power Lines Is Expected to Lead to Lower Rates for Consumers

By AGIS SALPUKAS

WASHINGTON, April 24 — In a move that could eventually save American consumers billions of dollars a year in electricity bills, the Federal Energy Regulatory Commission ordered electric utilities today to open up their transmission systems to outside energy providers.

The ruling applied only to the distribution of wholesale power and thus did not break the monopoly hold that utilities have over residential customers.

But by enabling low-cost energy producers, like utilities in the Midwest, to use a national network to deliver electricity to high-cost areas, like the Northeast, the decision will probably put downward pressure on both wholesale and, ultimately, retail prices.

Utilities in the Northeast, including Consolidated Edison of New York, will be able to buy cheaper power from outside sources and resell it to their customers. For example, Con Edison could find it easier to buy energy from, say, Cinergy in Cincinnati.

"This opens up the market nationwide," said Bruce Levy, president of the Electric Generation Association, which represents independent power producers. "This should eventually lead to lower rates for consumers."

Elizabeth A. Moler, chairman of the commission, estimated that the rule change would save industry and consumers "tens of dollars every year." Her staff put the figure at $3.8 billion to $5.4 billion.

"The utilities will continue to be financially sound but they will be challenged in ways they have never been challenged before," Ms. Moler said. "New competitors will emerge and mature, and new services will be invented."

The decision is also expected to speed up efforts by states like Cali-

Continued on Page D4, Column 3

CONGRESS AND WHITE HOUSE FINALLY AGREE ON BUDGET, 7 MONTHS INTO FISCAL YEAR

NO DETAILS ON DEAL

Environment and Policy on AIDS at Pentagon Were Last Hurdles

By JERRY GRAY

WASHINGTON, April 24 — After two days of intense negotiations — and seven months of living with stop-gap spending measures and partial Government shutdowns — negotiators for Congress and the White House agreed late this afternoon on a permanent budget for the fiscal year that began on Oct 1.

Neither side would give details of the deal until they had shared the information with their leaders and colleagues. But the negotiators said the $160 billion spending plan included $23 billion in cuts demanded by the Republicans as well as increased spending on health, education, environmental and other programs favored by the Clinton Administration.

Yielding to the House demands, Republicans apparently stripped from the bill environmental provisions that had drawn a veto threat from President Clinton. They also agreed to revive a requirement that the military expel any person who tests positive for the virus that causes AIDS. That move had also drawn a veto threat from the White House.

"We believe the President will find it acceptable," the White House chief of staff, Leon E. Panetta, said. Earlier in the day, Congress had signaled that they negotiations were moving ahead when it voted for only a 24-hour extension of another temporary spending bill.

Mr. Panetta met with reporters just after Representative David R. Obey, the ranking Democrat on the House Appropriations Committee, and Senator Mark O. Hatfield of Oregon and Representative Robert L. Livingston of Louisiana, the Republican chairmen of the Senate and House Appropriations Committees.

Even though the leaders were optimistic that the bill would be passed, none said it would be easy to sell, especially among House Republican freshmen, who have appeared to resist a budget fight with Mr. Clinton.

Mr. Obey and Mr. Livingston said they would bring the legislation to the floor on Thursday for a vote. Mr. Obey said they expected it to be individual differences in the House, but I think what you see is the consensus that most members in the House will ultimately vote for the package," Mr. Livingston said.

Before today, only eight of the 13 bills necessary to finance the Government had been approved. To the

Continued on Page B13, Column 1

Terrorism Bill Is Signed Into Law
With families of terrorism victims watching and Senator Bob Dole at his side, President Clinton signed an anti-terrorist bill yesterday. Page A18.

Associated Press

Clinton-Dole Fight on Health Bill Is Preview of Campaign to Come

By ADAM CLYMER

WASHINGTON, April 24 — President Clinton and Senator Bob Dole started scrapping today over health insurance and it was clear that they saw a major theme for the campaign confront in the making.

The nature of the two contenders' clash over campaign relief is a provision of a bill whose central purpose is to make health insurance more accessible and to protect workers who change jobs from losing their benefits.

Both houses of Congress have passed the bill, but the House version contains a provision that Mr. Dole strongly supports and Mr. Clinton as strongly opposes. It would allow people to set up tax-deductible medical savings accounts, which they would tap to pay basic medical costs, whose high deductibles would not cover the first few thousand dollars of annual health costs.

Despite Mr. Dole, the Senate re-

jected medical savings accounts last week. Today he took an indirect approach — relying on arcane Senate procedures. He moved to choose Senate conferees who could be expected to surrender to the House and approve the accounts.

Senate Democrats stalled his effort, at least temporarily. But the White House weighed in with a warning that the conference could end the provision — the entire bill would be vetoed.

George Stephanopoulos, senior adviser to President Clinton, said unanimously if Senate Democrats the bill more partisan with medical savings accounts, the President will veto it.

Republican supporters of the accounts contend they would help reduce inflation in health care costs by giving the insured a reason to keep costs down. Mr. Clinton and other Democrats contend they would help only the healthy and the rich.

Some Senate Republicans say they did not believe Mr. Clinton would kill the bill because of a single provision. Others argue that it

Continued on Page B12, Column 1

On Daughters-at-Work Day, Some Are Including the Sons

By TAMAR LEWIN

On the fourth annual Take Our Daughters to Work Day today there is a lot less talk about discrimination against girls and a lot more about the evils of excluding boys.

Indeed, the Ms. Foundation for Women, which started the event in 1993, estimates that 90 percent of participating employers are marking this year by inviting both boys and girls to Take Our Daughters to Work or even, adding insult to injury, Take Our Sons and Daughters to Work.

The foundation started Take Our Daughters to Work Day after a wave of highly publicized research about how girls are shortchanged in school and lose self-confidence as they approach adolescence. The response was so overwhelming that what was planned as a program in New York City became a nationwide event involving millions of girls at thousands of workplaces.

"What created this day," said Marie Wilson, president of the Ms. Foundation, "is women, men, teachers, parents, everybody, saying, 'Right, this is true. I see what happened to

my 11-year-old girl, how she used to be sure of herself and now she's not; she used to be interested in math and science, and now she just talks about her hair.'"

But as the program grew — some five million took part last year — it aroused controversy about sending girls and not boys to work. At some schools, exciting work programs for girls but not their brothers were left in the classroom.

Now, in a spirit of the times changed as programs favoring one sex or race came under sharp attack from opponents of affirmative ac-

Continued on Page B11, Column 1

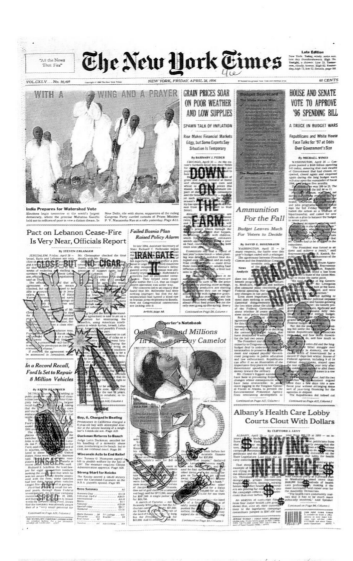
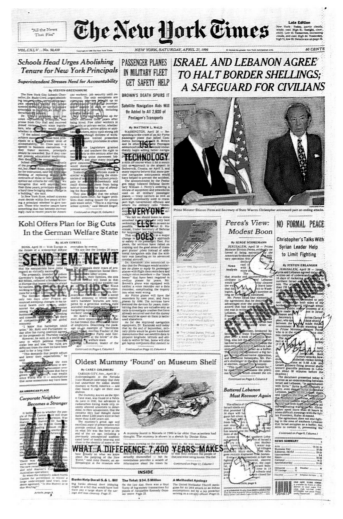
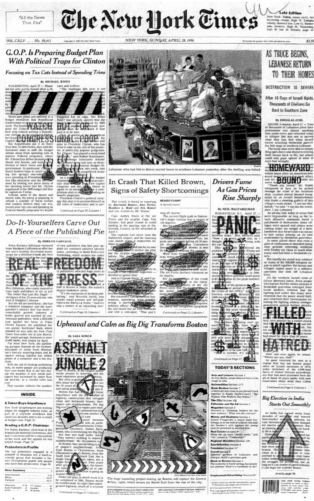
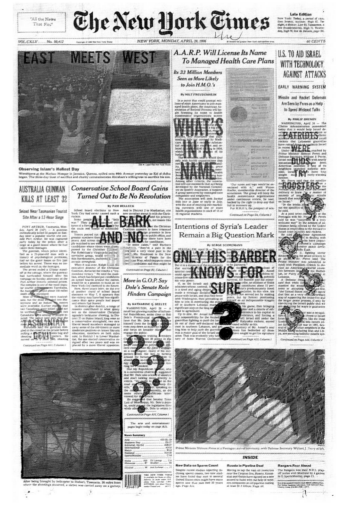

The New York Times

Late Edition
New York: Today, windy, showers, thunderstorms by afternoon. High 67. Tonight, rain ending. Low 50. Tomorrow, partly cloudy. High 65. Yesterday, high 60, low 51. Details, page C18.

VOL.CXLV... No. 50,413 Copyright © 1996 The New York Times NEW YORK, TUESDAY, APRIL 30, 1996 $1 beyond the greater New York metropolitan area. **60 CENTS**

Two Child Welfare Employees Are Suspended in Abuse Death

City Hall Says They Failed to Shield 6-Year-Old

By DAVID FIRESTONE

Five months after Elisa Izquierdo's beating death created a flurry of finger-pointing, the Giuliani administration yesterday accused the caseworker and supervisor in charge of the 6-year-old girl's case, the first such disciplinary action ever against city child welfare employees.

Both employees were suspended without pay for 30 days yesterday after being charged with a variety of failures to protect Elisa from her mother, been accused of beating the

Nicholas Scoppetta, the city's new Administration for Children's Services, said three other departmental charges are proved at administrative hearings, the charges may lead to their dismissals. But the union that represents the two has vowed a hard fight to defend them.

Elisa's battered body was discovered in her apartment in a lower Manhattan project on Nov. 22. Subsequent investigations found that the city's child welfare system had been repeatedly notified of the dangers the girl was facing but

did little to stop the abuse.

Yesterday's actions were the latest in a series of moves and directions from the Izquierdo case and already destroyed who a reorganization earlier this year of the city's child welfare system, which had announced direct control of Mr. Scoppetta's Giuliani. The administration's decision to single out the two employees for responsibility in a child welfare case was clearly intended to send a message to other caseworkers and supervisors in the chronically overburdened system.

"It's about time that someone be held accountable for their actions, their negligence and possibly even worse than that," said the Mayor, standing next to Mr. Scoppetta at a news conference at City Hall. "It's the only way in which you're going to build accountability into this system."

But the decision drew accusations that City Hall was unfairly blaming two low-level workers for a systemic failure. Charles Ensley, president of Social Service Employees Union Local 371, said the union would fiercely fight the charges against its two employees. He said the city was ignoring the real problems in the agency.

"We will not permit them to scapegoat workers to cover up their own mismanagement," Mr. Ensley said. "They can make a series of allegations if they want, but fortunately these workers have due process and are supported by a mighty, mighty union."

Mr. Ensley said the employees had years of service to the city and spotless records.

That, however, was part of the administration's point. After years of excusing poor performance by low-paid, overworked caseworkers, the city was no longer going to accept

Continued on Page B5, Column 1

Company Hid Data In City Contract Bid

A company in line for a $31 million city contract to maintain firehouses complained the city's official investigators, preventing workers from obtaining the major subcontractor for the job, barred from operating in the state records below. Either problem could have disqualified the company.

are the latest facing the city's moves to give work to private companies.

Article, page B1.

Two Rivals Negotiating Slate In an Effort to Defeat Yeltsin

By MICHAEL R. GORDON

MOSCOW, April 29 — In a bid to compete with the rebounding re-election campaign of President Boris N. Yeltsin, two major rival candidates, a Harvard-trained economist and a nationalist general, said today that they were negotiating an improbable political alliance.

Grigory A. Yavlinsky, a popular reform-minded economist, and Aleksandr I. Lebed, a former general with a strong nationalist constituency, confirmed that the unlikely new order, said in separate interviews today that they were involved in intensive negotiations to merge their political fortunes.

The aim, the men said, is to fashion an alternative in the neck-and-neck two-way race that appears to be taking shape between Mr. Yeltsin and Gennadi A. Zyuganov, the Communist candidate.

They must still resolve outstanding differences, including which of the two ambitious men would be at the top of the ticket.

On the face of it, an alliance that could mobilize supporters of economic reform and conservatives who crave the restoration of national order and pride would seem formidable. Mr. Yavlinsky has been eagerly courted by Mr. Yeltsin's supporters, while Mr. Lebed was for a time discussed as a possible vote-getting front man for the Communists.

But opponents of the alliance say it cannot win and insist that only Mr. Yeltsin can prevent a Communist

victory. Still, they fear that Mr. Yavlinsky and General Lebed may act as spoilers, drawing vital support away from Mr. Yeltsin in a tight race with Mr. Zyuganov.

"All votes cast in favor of Yavlinsky are really working for Gennadi Andreyevich Zyuganov, the Communists," said Anatoly B. Chubais, a free-market economist who was ousted as Mr. Yeltsin's Deputy Prime Minister in January but has since joined his election team. "It is absolutely obvious that Yavlinsky will never be Russia's President in 1996." But Mr. Yavlinsky dismissed that criticism as partisan and said his polls showed he could win a victory over Mr. Zyuganov, if possible.

And General Lebed argued that Russia was so politically polarized

Continued on Page A10, Column 1

INSIDE

Sperm Protein Dispute

Each of three labs claims to have found an elusive sperm protein that could be the basis for a contraceptive vaccine. Only one can be right. Science Times, page C1.

New Tack on Securities Law

Lawyers are trying to use a California initiative to avoid a Federal law that limits their ability to sue when share prices drop. Page A13.

'Rent' on Broadway

After a Pulitzer and much attention, the rock opera that started small opened big on Broadway. A review by Ben Brantley, page C13.

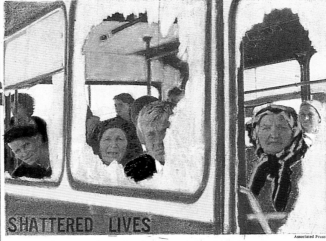

SHATTERED LIVES

Associated Press

A Bitter Homecoming Near Sarajevo

Three Muslim refugees trying to get home were killed yesterday in confrontations with Serbs. In a bus battered by stones, Muslims staged a protest near the office of Carl Bildt, a peacekeeping official. Page A10.

Much Bluster Over 90 Cents

Minimum-Wage Issue Dominated by Dogma

By DAVID E. ROSENBAUM

WASHINGTON, April 29 — As a political matter, the issue of raising the minimum wage is relatively straightforward, like mathematics. As an economic question, it is much more subjective, like, say, religion.

News Analysis — Take the politics first. The issue has proved to be a bonanza for President Clinton and Democrats in Congress. For the first time since Republicans won control of Congress, a significant number of backbenchers have defected from the position of their leaders.

The only reason the Democrats have not yet succeeded in passing a bill that would raise the minimum wage, now $4.25 an hour, by 90 cents or even more, is that the Republican leadership has gone to great lengths to prevent a vote.

The Democrats seem to have held the issue in reserve until the election year.

In the 1992 election campaign, Mr. Clinton advocated raising the minimum. But during his first years in a central position, in his first two years in office, when Democrats controlled Congress, he did not mention the issue. He was too busy or otherwise committed for those days the President was too busy dealing with health care, as if Bill Clinton can handle only one issue at a time.

Then, this year, Democrats began trying to attach an increase to the

Continued on Page A17, Column 3

California's Governor Joins G.O.P. Abortion-Plank Foes

By ADAM NAGOURNEY

WASHINGTON, April 29 — In a new threat to party unity, Gov. Pete Wilson of California today joined his counterparts from New York and New Jersey in vowing to work to remove an anti-abortion plank in the party's platform at the Republican convention this summer.

The statement caught Senator Bob Dole by surprise, particularly Mr. Wilson was in Washington to discuss the California campaign effort with Mr. Dole the presumptive Republican candidate.

"We should not put the plank to one side and simply go on with our business," Mr. Wilson — whose state will host the Republican convention in August — told a group of reporters here before meeting with Mr. Dole. "I don't think it should be in the platform."

Mr. Wilson said that efforts to pass a constitutional amendment outlawing abortion — which has, in some form, been part of the Republican platform for 20 years and is supported by Mr. Dole — was a political mistake that could hurt the party. "It's unrealistic to tell people, in fact, it's going to happen when it never will," Mr. Wilson said.

The remarks by the California

Continued on Page A18, Column 1

POINTED EXCHANGE IN HIGH COURT

In refusing to hear a case from South Dakota, the Supreme Court demonstrated how highly charged the issue of abortion remains. Page A19.

Governor add to a growing resentment among Republican governors — including George E. Pataki of New York, Christine Todd Whitman of New Jersey and William F. Weld of Massachusetts — questioning what they see the Republican position on the issue virtually since the Supreme Court ruled in the Roe v. Wade decision of 1973 that women had a constitutional right to have an abortion.

Mr. Wilson said he had no intention of supporting a change in the language of the platform dealing with abortion rights. It seemed to all but guarantee that the Republican Party — already roiled by complaints from some conservatives unhappy with Mr. Dole's candidacy — will have to endure a public fight over an issue that Mr. Dole would rather avoid.

Foes of abortion, some of whom have privately questioned Mr. Dole's commitment to their cause, expressed alarm at Mr. Wilson's state-

Continued on Page A18, Column 1

PRESIDENT DECIDES U.S. WILL SOON SELL OIL FROM RESERVES

EYE ON VOTERS' GAS COSTS

Republicans in Congress Had Endorsed Making a Move to Reduce the Deficit

By ALISON MITCHELL

WASHINGTON, April 29 — In an effort to stem an election-year surge in gasoline prices, President Clinton announced today that the Government would seek to bring them down.

President Clinton directed the Energy Secretary, Hazel R. O'Leary, to report to him in 45 days on the effects that the recent run-up in gasoline prices have had. Prices have risen an average of $1.24 for a gallon of regular, up about 10 percent from a year ago.

Mr. Clinton also has been authorized by Congress in a budget agreement reached last week and it had envisioned the action more as a deficit-reduction measure to raise $227 million from the sale of oil. The sale would amount to two-thirds of a day's consumption of crude oil.

But the President attributed his decision most immediately to his concern about the surge in gasoline prices which have emerged as a political issue in the Presidential race.

The Senate majority leader, Bob Dole, cited the higher prices when he wrote Mr. Clinton last week calling for repeal of the 4.3-cents-a-gallon gasoline tax that was passed by the Democratic Congress in 1993 as a part of the President's budget-reduction package.

Several industry analysts said Mr. Clinton's move might have more utility as a political gesture than as a way to bring down prices. "This is an election-year statement," said Frederick P. Leuffer, an oil analyst at the brokerage firm of Bear Stearns & Company. "This alone will have no impact on gasoline prices."

But hours after Mr. Clinton announced the oil sale, he was already

Continued on Page A17, Column 1

U.S. Loses Trade Case

The United States has lost a case brought before the World Trade Organization in a decision that is expected to fuel a political debate.

Business Day, page D1.

Ex-Director of C.I.A. Disappears While Canoeing on Choppy River

By TIM WEINER

WASHINGTON, April 29 — William E. Colby, the spymaster who led the Central Intelligence Agency through its worst days in the mid-1970's, was missing and presumed dead today after disappearing while on a solo canoe trip in rough waters, the authorities said.

His canoe was found on a sandbar on Sunday, 400 yards from his weekend home in Rock Point, Md., a settlement about 40 miles south of Washington at the confluence of the Wicomico and Potomac Rivers.

Fred Davis, the sheriff of Charles County, Md., said Mr. Colby, who was 76, had taken his canoe out on the Wicomico (pronounced wic-o-MICK-o) on Saturday evening.

A chilly wind from the southeast was gusting up to 25 miles an hour on Saturday, whipping up whitecaps on the river. There was running ice pelted by rain, waxing moon. The water was high and from recent rains.

According to an account on Saturday, Mr. Colby and his wife, Sally Shelton, who was at a conference in Houston over the weekend, that he was feeling under the weather, friends said.

Mr. Colby's neighbors in Rock

Continued on Page B7, Column 1

George Tames for The New York Times, 1992
William E. Colby

Eritrea: African Success Story Being Written

By JAMES C. McKINLEY Jr.

ASMARA, Eritrea, April 28 — On the outskirts of this lovely Italianate capital, the Government recently built an iron foundry where there is no iron. Instead, former rebel soldiers are melting down the Ethiopian tanks once used to crush them and are constructing farm tools.

The plant, named for what is the namesake of a military base run by the Eritrean People's Liberation Front where, with international help, rebels made bullets and spare weapons from scrap during the 30-year war and are now string out machine parts from old battle debris, beating battle debris, if not into plowshares, into badly needed construction material.

"It's a pleasure to be making something for peace," said the former officer, Tekeste Ghebre-Egzihbher. "It was only a matter of time."

Five years after winning the war that led to independence, former Eritrean rebels are rebuilding their shattered country with the same tenacity and self-sacrifice that served them well in the longest civil war in recent African history.

When the Ethiopian Government of Lieut. Col. Mengistu Haile Mariam finally fell and the Eritrean front's soldiers marched victorious into Asmara in May 1991, they found a faded and crumbling capital.

Nothing had been painted or fixed since the 1960's. Few people dared go out at night for fear of crime. The palm-lined main boulevard was crowded with beggars and prosti-

Continued on Page A8, Column 1

James C. McKinley Jr./The New York Times

After winning independence from Ethiopia, Eritreans are rebuilding. Two workers, called out of retirement, repaired a 1930's-vintage train.

May

May was the month of fake art—it starts with my

fake Gorky on May 3. The forms in the picture just looked

to me like Gorky forms. So I got a little kick and thought,

"How many pages this month will I be able to do my fake art on?"

I saw Cy Twombly on the eighth; then when I got the paper

on the day that the Valujet crashed in the swamp

(May 13) the only thing I could see was a Monet.

On May 17 I was inspired by *The Umbrellas of Cherbourg*,

that opening sequence with umbrellas, but somebody

at the exhibition later saw it as a John Baldessari, and I thought,

"Great, this fits in perfectly." Then the Unabomber

was caught, and when I looked at him he looked like

a van Gogh. And that's how I proceeded, every month there

was something I could do to stretch myself.

The New York Times

VOL.CXLV .. No. 50,414 Copyright © 1996 The New York Times NEW YORK, WEDNESDAY, MAY 1, 1996 $1 beyond the greater New York metropolitan area. 60 CENTS

Late Edition

New York: Today, sunny, breezy. High 65. Tonight, a few showers late. Low 51. Tomorrow, partly cloudy, a few showers. High 68. Yesterday, high 61, low 48. Details, page C13.

SUNY Chancellor Resigns Post After Battling Pataki's Trustees

Board's Rebuff Over Provost Had Caused a Rift

By JAMES BARRON

After months of tension and disagreement over the direction of the State University of New York and Gov. George E. Pataki's plans to streamline it, the Chancellor of the 64-campus institution resigned in his resignation yesterday.

The Chancellor, Thomas A. Bartlett, was appointed in October 1994 while Mario M. Cuomo, a Democrat, was Governor. The 65-year-old educator had been at odds with the seven trustees named by Governor Pataki, a Republican who has proposed a major overhaul of the financial aid that would reduce amounts available to individual students.

The Pataki-appointed increasingly involved themselves in policy issues and personnel matters, pressing to de-emphasize SUNY's historical centralized approach to managing its far-flung operations. They favored giving each campus autonomy over crucial matters like tuition and academic standards.

They also pressed for a "realistic" budget for the entire SUNY system to take into account the state's fiscal troubles. That put Mr. Bartlett, who serves at the mercy of the trustees, in a bit of a bind earlier in the year. Unlike W. Ann Reynolds, his counterpart at the City University of New York, he did not ask legislators to restore money. Mr. Pataki proposed taking away. Instead, he said SUNY would have to raise tuition by at least $250 a year to deal with the cuts.

A highly placed member of the SUNY administrative staff, speaking on condition of anonymity, said the final straw that led to Mr. Bartlett's

departure was the failure of the SUNY board to approve his choice for provost on Monday. The provost would have been SUNY's top academic officer. He had administered Daniel Hatton, a college administrator who is the chief academic officer at the University of Maryland and a former high school professor at the State University at Binghamton.

Mr. Bartlett said nothing beyond a short prepared statement, which urged SUNY not to lose sight of its strengths as it evolves in a time of financial and philosophical change.

"As it repositions itself to fit very new circumstances," he said in the statement, "it is vital to protect the founding vision of the State University of New York: broad access for students and narrow all its of educational quality. As well, it is incumbent upon the future of trustees to pick a chancellor that is full support with authority and commitment."

Mr. Bartlett said he had concluded that he was not that person.

"I have spent a great deal of time over the last several weeks thinking about what is best for the State University and how its interests are best served," he said. "I have decided that while I still feel very much committed to SUNY's best at this time that I step down as chancellor."

Mr. Pataki issued a statement that praised Mr. Bartlett for serving "with distinction and professionalism." The Governor said Mr. Bartlett, a former chancellor of the Oregon university system who came out

Continued on Page B5, Column 5

Taking Control of an Inquiry, F.B.I. Looks at Giuliani Aides

By DON VAN NATTA Jr. and ALAN FINDER

The F.B.I. is taking control of the investigation into how Giuliani administration officials awarded $4 million in welfare contracts, and cutting out the city's Investigation Commissioner, senior law enforcement officials said yesterday.

The officials said the action was taken because the Investigation Commissioner, Howard Wilson, routinely briefing the Mayor's boss, on the progress of the inquiry.

Mayor Rudolph W. Giuliani's spokeswoman said that Federal prosecutors had begun the briefings that Mr. Wilson was giving Mr. Giuliani. Senior law enforcement officials said that the briefings became alarming to Federal officials because investigators are now trying to determine what role, if any, some of the Mayor's top aides played in awarding the contracts to a politically connected Queens group and whether the aides did anything improper.

Until now, the United States Attorney in Manhattan was working closely with Mr. Wilson's office, sharing information and often jointly conducting interviews of witnesses, including city officials, executives of the Queens group and others involved in the contracts.

Mr. Giuliani canceled the contracts March 27 after The New York Times reported that the city had

violated several rules in awarding the contracts to a Queens group.

When we referenced the officials, who assured that they not participated, and reached consensus at ... whether any year's mayor did acted improperly.

Federal investigation was the decision to investigation was concerns that the appear to be independently because of Mr.

Continued on Page B4, Column 6

INSIDE

Giuliani Seeks Industry

Mayor Rudolph W. Giuliani announced a plan to encourage new industry like the manufacturing of computer software. Page B1.

The Longest Game

The Yankees and Orioles played the longest nine-inning game in history: 4 hours, 21 minutes. Page B9.

New From Louisa May Alcott

The manuscript of Louisa May Alcott's first novel, previously unknown to scholars, was found misfiled in a Harvard library. Page C15.

Associated Press

Lebanon Buries Victims of Israeli Shelling

Coffins were passed from hand to hand yesterday at a funeral near the United Nations camp where an attack on April 18 killed about 90 people who had taken refuge from an offensive against Islamic militants. Page A6.

Wages in U.S. Rose 1% in First Quarter

Wages and salaries advanced 1 percent in the first three months of the year — the fastest pace since 1991.

After years of concern about stagnant wages, the increase is the first sign that many workers are beginning to enjoy increases in pay that outpace the rising cost of living.

The government report, combined with a separate private survey showing that consumer confidence improved in April, points to an economy gradually picking up speed.

But that pace has some analysts worried that inflation could accelerate. Indeed, an increase in wages, coming at a time when crude oil and grain prices have jumped sharply, could threaten to rekindle inflation, these analysts say, and prompt the Federal Reserve to keep a tight rein on credit by raising interest rates.

Business Day, page D1.

Democrats Outflank G.O.P. In First Campaign Skirmishes

By ADAM NAGOURNEY

WASHINGTON, April 30 — Senator Bob Dole fired the first shot last Friday afternoon: a single-page press release and letter to President Clinton demanding repeal of the 4.3-cent gasoline tax increase enacted as part of Mr. Clinton's 1993 deficit reduction program. Mr. Dole, his aides said, would ride the issue through the coming week.

President Clinton responded to Mr. Dole's bullet with a cannon blast. Leon E. Panetta, the White House chief of staff, appeared at states urging Mr. Dole to stop talks on balancing the budget. Mr. Clinton's campaign headquarters faxed out a stream of documents containing a 14-year history of gasoline tax increases and Mr. Dole's earlier advocacy of such increases.

By Monday, Mr. Clinton had

moved to trump Mr. Dole by invoking the full power of the White House, announcing in time for the evening news broadcasts, as his aides boastfully recounted today, that the Government would sell oil from the Strategic Petroleum Reserve in an effort to stem the price rises at the pump.

The recent skirmishes over the gasoline tax point to a growing disparity that Mr. Dole's aides and Republicans outside his organization are agreeing with evident and increased concern: While Mr. Dole is still hoping to lay the basic foundations of a Presidential challenge, the Clinton campaign is emerging as a formidable machine, able to draw at once on the power of the Presidency and an experienced and well-financed campaign apparatus.

With the primary season behind it, Mr. Dole's campaign is confronted with difficulties raised by a relative lack of experience among its staff (Mr. Dole has almost logged more time on the Presidential circuit than his senior staff) compounded by a bifurcated political structure that pulls

Continued on Page A16, Column 1

Politics of Gasoline

Republicans pushed for repeal of a 1993 gasoline tax, blaming the Administration for higher pump prices. And in response to the President's move to tap Federal oil reserves, oil prices fell in futures markets.

Articles, page A16.

LAWMAKERS AGREE ON TESTING BABIES FOR THE AIDS VIRUS

A MANDATORY PROVISION

Privacy Fears Are Raised, but States That Resisted Would Lose Some Federal Aid

By IAN FISHER

WASHINGTON, April 30 — House and Senate negotiators tentatively agreed today on a measure that would eventually require states to begin mandatory testing of newborns for H.I.V., the virus that causes AIDS. Health officials cannot reduce the number of infected infants, people involved in the talks said tonight.

States that did not comply would risk losing Federal money under the Ryan White Act, which provides hundreds of millions of dollars each year for treatment of people with AIDS. The testing provision has been agreed to by House and Senate conferees ironing out differences in companion versions of the overall Ryan White reauthorization bill, Congressional aides and others said.

The provision would establish a complicated series of measures states would have to take, and it was not immediately clear if all of the details had been decided. Several people involved in the bill would take cautious but certain steps toward national testing of newborns. But that would happen only after a period of trying to reduce the number of infected babies by requiring doctors or other health professionals to counsel pregnant women to be tested for AIDS.

The provision would apply only to women whose H.I.V. status is not known.

The question of mandatory testing has long been one of the most contentious AIDS issues, especially among people who say the practice not only would violate the privacy rights of pregnant women but also could ultimately lead to testing of other groups at risk of contracting the disease.

The issue is particularly thorny when it comes to newborns. Studies show that steps taken before or at birth can substantially reduce the rate of AIDS transmission from mother to infant. On the other hand, because infected infants can be born only to infected mothers, an infant's test results could reveal the mother's medical condition, whether she wished to be tested or not.

New York is the only state that has addressed the issue by regulation. Like most other states, New York has routinely conducted anonymous AIDS tests on newborns as a way of tracking the spread of the disease. For the first time, in regulations that go into effect on Wednesday, mothers will be able to learn their infants' test results — and, by proxy, their own.

The agreement ironed out today in the Ryan White Comprehensive AIDS Resource Emergency Act would require doctors and other health care workers to advise pregnant women to be tested for H.I.V., a measure that advocates for people with AIDS have long pushed as an

Continued on Page D22, Column 3

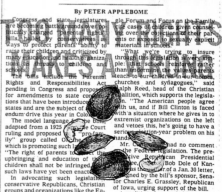

Associated Press

Unbridled's Song's groom, Martin Perales, left, sprucing his charge up yesterday before the horse tested a new shoe meant to help his ailing foot. Above, a farrier, Steve Norman, swabbing the foot.

Doug Pensinger/Allsport

Kentucky Derby Favorite May Miss the Race

By JOSEPH DURSO

LOUISVILLE, Ky., April 30 — Ernie Paragallo, a husky, ruddy man with bushy hair and a knack for picking horse talent, is no ordinary aristocrat. He is a "pinhooker" from Brooklyn, a man who buys horses low and sells them high.

Not so long ago, a dream investment seemed to have him at the top of the horse racing business as the owner of Unbridled's Song, the favorite for Saturday's 122d Kentucky Derby and a son of Unbridled, winner of the 1990 Derby. But today, a sore left forefoot has compromised his colt's chances and left Paragallo and

his trainer with the difficult decision of whether to run at all.

It is a crossroads that underlines all the financial risks and emotional pressures of trying to win America's most treasured horse race.

Will the question be to go away — to these very horses — to run, let alone win? Should he risk damaging Unbridled's Song bloodstock value with a poor performance? Did his trainer make any mistake in treating the sore foot after the last race, the Wood Memorial at Aqueduct, three weeks ago? And,

since a horse has just one chance, how important is it to win the Derby at any cost?

The stakes are high, especially for Paragallo, who normally deals with horses of far less quality. With a $1 million stake, the Derby will pay $770,000 to the winner and provide greater rewards in the breeding shed when a horse's racing career is over.

"If things go our way," said Jim Ryerson, who trains the colt, "I think we have enough days left to heal the injury, and he'll do fine. Maybe they won't, but at this point we are thinking optimistically."

They have no other choice. A final

Continued on Page B11, Column 4

An Array of Opponents Do Battle Over 'Parental Rights' Legislation

By PETER APPLEBOME

Congress and state legislatures are becoming battlegrounds over politically charged "parental rights" bills, billed by conservatives as ways to protect parents' ability to raise their children and criticized by many education and health organizations as threats to children and schools.

The bills include the Parental Rights and Responsibilities Act pending in Congress and proposals for amendments to state constitutions that have been introduced in states and are the subject of a referendum drive this year in Colorado.

The model language, first adapted from a 1925 Supreme Court ruling and proposed by a "pro-family" group called Of Heritage, which is promoting such legislation, "The right of parents to direct the upbringing and education of their children shall not be infringed." But such laws have yet been enacted.

In advocating such legislation, conservative Republicans, Christian groups and organizations like the Ea-

gle Forum and Focus on the Family cite cases of children given counseling over the objections of their parents or exposed to sexually explicit materials in schools.

"What we're trying to insure through this legislation is very simple: that schools reinforce rather than undermine the values parents teach to our children in our homes, churches and synagogues," said Ralph Reed, who supports the legislation. "The American people agree with us, and if Bill Clinton is faced with a situation where he gives in to extremist organizations on the left and vetoes this, he's going to have a serious election-year problem on his hands."

Mr. Clinton had no comment and the Federal legislation. The prospective Republican Presidential candidate, Bob Dole of Kansas, has the author of a Jan. 30 letter, signed by the bill's sponsor, Senator Charles E. Grassley, Republican of Iowa, urging support of the bill.

A coalition of more than 40 education, health, women's, child advocacy

Continued on Page B7, Column 1

"All the News That Fits"

The New York Times

Late Edition

New York: Today, sunny, mild. High 72. Tonight, increasing clouds, late shower possible. Low 53. Tomorrow, cloudy, showers. High 67. Yesterday, high 66, low 46. Details, page B10.

VOL.CXLV.. No. 50,415 Copyright © 1996 The New York Times NEW YORK, THURSDAY, MAY 2, 1996 $1 beyond the greater New York metropolitan area. 60 CENTS

Mexico's Leader Quietly Adopts A Warmer Approach to the U.S.

Zedillo Praised in Washington, Chided at Home

By SAM DILLON

MEXICO CITY, May 1 — In a series of quiet policy changes, President Ernesto Zedillo has recently reversed long dearly held tenets of Mexico's historically prickly relationship with the United States.

For the first time Mexico has approved American extradition of two drug traffickers to the United States.

Mexico also recently abandoned a long-held position rejecting international discussion of its human rights record, and in a separate shift allowed Washington to begin airlifting illegal immigrants back to their hometowns deep inside Mexico.

Last week the Defense Minister approved a military agreement providing for the training of Mexican soldiers at American bases and the provision of U.S. military equipment. It is the first pact of its type since the 19th century — a period that convinced Mexicans that the United States was its principal enemy.

The Clinton Administration officials who have negotiated these policy changes, and who will discuss further cooperation when a senior delegation headed by Secretary of State Warren Christopher visits Mexico on Monday for annual meetings, have praised Mexico's more accommodating policies.

But in Mexico the changes have aroused debate about whether the country is slowly surrendering its sovereignty, continuing a trend that critics trace back to the North American Free Trade Agreement in 1994, and that accelerated last year when Washington and Mexico worked closely in the effort to rescue the Mexican economy.

Mr. Zedillo's Government has seemed to avoid publicity for the recent shifts. But in an interview today, a senior Government official said Mexico's increasingly intimate relationship with the United States showed the tremendous degree to which both Governments rely on each other and were seeking intelligent management of our bilateral relations.

On the other hand, some Mexican opposition politicians see the changes as a symptom of their country's financial and political vulnerability.

"These shifts are tremendous symbolic meat," said Lorenzo Meyer, the author of standard history of United States-Mexico relations. "In the present chain of events means we are losing the relative independence Mexico achieved for 50 years. The Government is weak, and the United States, sensing a power vacuum, is injecting itself in our affairs."

Since the 1930's, successive Mexican presidents have overseen a policy characterized by guarded, distant relations with Washington and routine opposition to American interests in forums like the United Nations.

"For decades Mexico sought to defend itself by saying no," said Humberto Garza, a prominent professor at the Colegio de Mexico, "even sometimes to United States initiatives with which it now very often was not really in disagreement."

The tectonic plate shift in policy first shifted during the previous

Continued on Page A14, Column 1

Muse of Anti-Yeltsin Forces: He Is Feared, Never Ignored

By MICHAEL SPECTER

MOSCOW, May 1 — Aleksandr Prokhanov seems too bourgeois to be seditious. He speaks with the ironic detachment of a French intellectual. His hair is straggly and graying. His clothes are elegantly faded.

As he muses about the depth and beauty of the Russian soul, it can be easy to forget that Mr. Prokhanov is often seen as one of Russia's most dangerous men — a fire-breathing anti-Semite whose opposition newspaper, Zaftra, or Tomorrow, has practically called for the violent overthrow of President Boris Yeltsin.

Perhaps more than anyone in Russia, Mr. Prokhanov, 58, — and then helped forge — the powerful alliance of Communists and nationalist groups that has made Gennadi A. Zyuganov, the Communist Party leader, the main challenger for the presidency only five years after his party was banished from Russian life.

As a theorist, Mr. Prokhanov stands squarely behind the man most capable of defeating Mr. Yeltsin. It is, in fact, impossible to imagine Mr. Zyuganov's current popularity without the program Mr. Prokhanov helped craft for him.

Unlike the theatrical extremist Vladimir V. Zhirinovsky, with whom he shares some basic values, Mr. Prokhanov may soon see much of his vision of Russia turn into reality.

"You can detest his racism and his politics, as I do," said Vitaly Tretyakov, the editor of a liberal daily, Nezavisimaya Gazeta. "But you can never ignore him. And you have to give him credit. He saw how bitterly would bring the forces of opposition together in Russia before anyone else did."

Predicting what kind of Communist Mr. Zyuganov would be if elected President has become an obsession for many people here and in the West.

They say he will be a social democrat as he tried to suggest this week meeting with Russia's leading bankers; others are sure he is still basically an old-school hardliner who believes it was reform, not Communism, that killed the Soviet Union.

"Boris Yeltsin has always been judged by the company he keeps," said Sergei Filatov, a liberal senior adviser to the President who has been nudged out of the inner circle as Mr. Yeltsin becomes motivated less

Continued on Page A10, Column 2

Subway Explosions Panic Passengers

Hundreds of subway riders scrambled for the exits, hundreds more were trapped in stalled trains and service was disrupted on the city's busiest subway line for hours last night after a series of electrical explosions along a southbound train on the Lexington line at around 7 P.M. Several people were treated for minor injuries.

Officials said the blasts were caused by a beam falling from the underside of the train and possibly striking the electric third rail.

When the first blast occurred, some riders bolted for the exits and others reacted calmly. But a rising cloud of smoke and a second blast a few seconds later made people think that bombs were going off.

"Everybody thought the worst," said one rider, comparing the scene to a Bruce Willis movie.

Officials promised normal service by morning.

Article, page B1.

ALONE AT LAST

At a meeting of moment, if not substance, Yasir Arafat yesterday had his first one-on-one Oval Office chat.

Paul Hosefros/The New York Times

Clinton Makes Arafat's Day In Oval Office

By STEVEN ERLANGER

WASHINGTON, May 1 — A natty, neatly barbered Yasir Arafat, having traveled from a life as a guerrilla leader to one as a statesman, had his turn on the White House stage today, hearing himself praised by the American President for his courage and his commitment to peace.

The meeting with President Clinton lasted only an hour, but it was Mr. Arafat's first one-on-one meeting with any American President, and he clearly relished it.

The Israeli Prime Minister, Shimon Peres, in a pre-election meeting with Mr. Clinton on Sunday and Tuesday; today it was Mr. Arafat's turn to pose in the Oval Office, an extraordinary symbolic transformation for a man who once led a pistol to the United Nations and led a guerrilla movement responsible for deaths of hundreds in bombings and hijackings all over the world of Israeli civilians.

It was Mr. Clinton, acknowledging that Mr. Arafat had met his promise to renounce violence to armed struggle and the destruction of Israel from the charter of the Palestine Liberation Organization. And it was another way for the United States with those seeking to associate the power of the White House with accepting risks for peace," as one White House official said today.

Continued on Page A3, Column 4

Wider Mental Care Insurance Is Now Feasible, Experts Say

By ROBERT PEAR

WASHINGTON, May 1 — With new ways of controlling the cost of mental health care, some experts say, it may now be feasible for Congress to require insurance coverage for mental illness on a par with coverage for other illnesses.

The Senate recently voted to require equivalent coverage for mental and physical illnesses, and radical changes in the health care industry have made such plans now set lower limits on hospital days and doctors' visits, require patients to pay a larger share of the bill, for treating mental illness.

The House measure, which is not included in a comparable House bill, has encountered fierce resistance from employers, insurers and health maintenance organizations, which say it would drive up the cost of health insurance.

But a new industry of specialized managed care companies has sprung up to provide mental health services at predictable costs. These companies monitor the work of psychiatrists and psychologists, often second-guessing their judgments about the best treatments for people with depression, schizophrenia and other mental ailments.

Mary E. Clark, a health care consultant at Hewitt Associates, which advises large corporations on employee benefits, said these techniques had slashed the cost of mental health care. "In an unmanaged environment," she said, "mental health care can represent 15 percent to 20 percent of total employee health care costs. In a managed program, you can bring that down to 8 percent or 10 percent."

The experience of the BellSouth Corporation illustrates her point. Mental health services, which once accounted for 8 percent of employee health costs, were cut to 5 percent of the total after the company adopted a managed care program, emphasizing alternatives to hospitalization.

The Senate and the House have passed legislation to make health insurance more readily available to millions of Americans changing jobs. The Senate requirement for "parity for mental health services" will be a major issue when a Congressional conference committee meets to iron out differences between the two versions.

The mental health provision, adopted by the Senate at the sugges-

Continued on Page B10, Column 1

PANEL URGES SHIFT IN HOW NEW YORK PAYS HEALTH BILLS

INSURANCE SUBSIDY PLAN

Mayoral Study Calls for a Tax of 2% on Medical Fees to Pay for Care of the Poor

By ESTHER B. FEIN

A mayoral advisory panel has recommended that New York City fundamentally change the way it pays for health care for the indigent, proposing that the government subsidize insurance for the uninsured rather than maintain the current system of subsidizing hospitals that treat the poor.

The seven-member panel, whose report is scheduled for release today, said its proposals were intended to "promote and encourage the use of primary and preventive care and minimize overreliance on an expensive hospital system."

Rather than subsidizing insurance, the city would spend $1.5 billion annually, with much of the money coming from a 2 percent tax on the fees of doctors, hospitals and insurers, a cost bound to be passed to private customers through higher premiums. Although the report does not use the word "tax," the assessment it describes is just that. The word is apparently avoided to deflect criticism from insurers and providers who have been opposed to paying such new fees and are likely to lobby against it if the Mayor embraces the panel's recommendations.

In a further effort to blunt opposition, the panel said the 2 percent tax, which would raise $900 million a year, would be levied against "the two private sector industries that will benefit most from the proposal: insurers and providers."

Still, the report notes, if New York's expanded market of insured eligible residents, while providing a larger and more direct reimbursement for care, the program could help the bottom line of the institutions when cries across the country are grappling with ways to pay for care for the uninsured as hospitals are buffeted on one side by falling care company demands, and on the other by cuts in government reimbursement for Medicaid, the program for the poor, and Medicare, the program for the

Continued on Page B4, Column 4

The Long Unabom Manhunt Becomes a Paperback Sprint

By DOREEN CARVAJAL

With the shipment of its first load of books, a publishing boom in the 100-yard dash made fierce by its tantalizing size: quickly down to bare shelf.

Waiting for the overtake publishing brother, Pocket Books, for the pleasure of quick publishing lawyers and top executives were left to ponder whether to defy an F.B.I. bureaucracy that has effectively stalled their finished book.

"The whole thing is just kind of annoying," said an irritated Mark Olshaker, the co-author of the Pocket Books project, which was completed days after the capture of the Unabomber suspect, Theodore J. Kaczynski. "The only way the book was threatened was a standard review by the F.B.I. Bureau of Investigation because the co-author, John Douglas, is a retired agent. "This is the F.B.I.'s idea of expediting — then I can see why it took so many years to catch the Unabomber." Mr. Olshaker said.

In the furious world of literature, where books get bigger, longer than the basic size, since publishers finish first is critical — and often extremely profitable — because demand slackens for second- or third-place finishers by as much as 25 percent, according to Barnes & Noble, the nation's largest bookstore chain.

Written and sold in less than four weeks, instant books may have fleeting life spans, but they do have a long, cherished history in the publishing industry. They have flourished in more primitive forms since Pocket Books published its first quickie, a 1945 memorial that appeared six days after Franklin D. Roosevelt died. These books, in turn, spawned a class of slower-moving cousins, "crash books," which are

Continued on Page D5, Column 1

Copies of the first Unabom book being inspected before shipment.

Michael J. Okoniewski for The New York Times

NEWS SUMMARY A2

Sunny Straw Poll Supports a Beautiful Central Park
The Frederick Law Olmsted luncheon, which has been called the American Ascot and is Central Park's largest fund-raising event, drew more than 1,000 guests yesterday, as well as $2.5 million for the park.

Carrie Boretz for The New York Times

INSIDE

Giuliani Defers to F.B.I.
The Mayor said the F.B.I. was correct in taking over an investigation of contracting practices to avoid an appearance of conflict. Page B1.

Oregon Lawmaker's Woes
Representative Wes Cooley and his wife, Rosemary, face scrutiny over whether they fraudulently received her survivor's benefits. Page A16.

Next for Knicks: the Bulls
The Knicks completed a sweep of the Cavaliers to set up a second-round playoff matchup with the Bulls. It starts Sunday in Chicago. Page B11.

"All the News That Fits"

The New York Times

Late Edition
New York: Today, windy, showers developing. High 67. Tonight, showers ending. Low 54. Tomorrow, mostly cloudy, a shower. High 71. Yesterday, high 70, low 51. Details, page A28.

VOL.CXLV No. 50,416 Copyright © 1996 The New York Times NEW YORK, FRIDAY, MAY 3, 1996 $1 beyond the greater New York metropolitan area. 60 CENTS

BUSINESS AS USUAL

Greg Marinovich/SouthLight, for The New York Times

New Government, Old Solutions
South Africa's ambitious program to solve its desperate housing shortage has produced only 11,000 of the one million houses it has promised to build by 1999. The Government has resorted to opening camps like this one, which it says are temporary, that harken back to apartheid-era practices. Page A10.

PRESIDENT VETOES LIMITS ON LIABILITY

Political Debate Continues on Manufacturers' Protection

By NEIL A. LEWIS

WASHINGTON, May 2 — In a move likely to reverberate throughout the coming campaign, President Clinton today vetoed a bill that would restrict the amount that people injured by faulty products would win in lawsuits.

The measure set limits on both state and federal courts on punitive damages, money juries may give beyond awards compensating victims for their losses. It involves products as diverse as school buses, heart valves, cigarettes and microwave ovens.

Supporters of the measure contend that it would put an end to multimillion-dollar jury awards that they say inhibit the ability of businesses to add to consumer goods. Opponents say that limiting such awards, which are given to punish reckless, outrageously willful actions, give companies less incentive to make products safe.

The issue is a clear example of how different public positions become wrapped in politics in the shadow of a Presidential race. Both Mr. Clinton and the presumptive Republican opponent in November, Senator Bob Dole of Kansas, have used it to define their differences.

When Mr. Dole and Speaker Newt Gingrich sent the measure to the White House earlier this week, they held a news conference that included the unusual move to be decried the veto as a political device because it went against its maker.

Today, in the Oval Office, Mr.

Continued on Page [...]

INSIDE

Muslims Held in War Crimes
Bosnia has detained two Muslims for war crimes, the first time any party to the Balkan war has honored an arrest warrant from the international tribunal at The Hague.

Inside the Drug Case
In announcing dozens of arrests around the country, officials provided rich details on the workings of a Mexican drug syndicate. Page A24.

Ruling Rejects CUNY Cuts
A judge ruled that City University of New York misused a special financial-emergency status to lay off professors and cut costs. Page B1.

JEWISH WOMEN-GIRLS LIGHT SHABBAT candles today 18 min. before sunset. In NYC 7:37 PM. Info. 718 774-3000. Outside NYC 118 774-3990. In merit of Raizel Gutnick, OBM — ADVT.

Giuliani to Propose New Agency To Get Around Borrowing Limits

By STEVEN LEE MYERS

Mayor Rudolph W. Giuliani will propose the creation of a new authority that would allow New York City to sidestep the constitutional limit on the city's debt, increasing the amount of money the city could borrow to finance expensive capital projects from schools to city jails, officials said.

The move is certain to provoke a fight with the City Council, and add to contentious discussions of the city's budget. By proposing the new authority, however, the Mayor is raising an issue that could ultimately provide an enormous infusion of money to repair the city's crumbling schools and build new ones, city officials said, and would give the city and negotiating leverage over the City Council, whose Democratic leaders have vowed to increase spending for school construction.

Continued on Page B2, Column 5

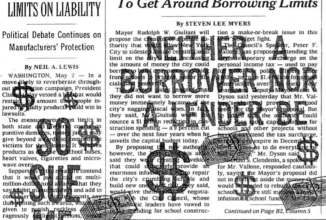

Dith Pran/The New York Times

Swingin' on a Stalk
Children from Taft Elementary School in Washingtonville, N.Y., enjoyed Tim Watkins's "Sunbabies" at Liberty State Park in Jersey City yesterday. The 70-degree weather should cool today, with rain.

Can Nashville Say No to N.F.L. Team? Maybe

By KEVIN SACK

NASHVILLE, April [...] now, the boom that began in the South with membership in the major leagues of professional sports teams. And in city after city, governments have raided state treasuries to build expensive new stadiums, although largely a peep of protest from taxpayers.

Now it's Nashville's turn. But when it comes to the N.F.L.'s Oilers and the N.B.A.'s Hornets and Jacksonville (N.F.L.'s Jaguars)...

and Orlando (N.B.A.'s Magic) and St. Petersburg (where baseball's Devil Rays will play in 1998), a surprising degree of resistance has risen here to a May 7 referendum on building a publicly financed football stadium that would bring the Houston Oilers to middle Tennessee in 1998.

The antistadium movement that has stoked, indeed, on both sides of the debate say the underlying sentiment that Nashville is growing too quickly. Although studies suggest that professional football would have negligible direct impact on the city's economy, many here see it as a symbol for progress that is not universally embraced.

After being repeatedly thwarted in efforts to get Houston to build a stadium to replace the aging Astrodome, the Oilers last year began making overtures to Nashville, the second-largest city in a state without a professional sports team. No city without an N.F.L. franchise has rejected a team's offer to locate there.

But the Nashville referendum, said Mayor Philip Bredesen, has become almost a cultural vote, unlike a 1967 referendum that proved the sale of liquor.

"On one side are [...]"

Continued on Page A8, Column 1

ECONOMY REVIVED AT PACE OF 2.8% IN FIRST QUARTER

STRENGTH HELPS CLINTON

But Investors Are Shaken as Dow Falls 76.95 Points and Bond Yields Pass 7%

By DAVID E. SANGER

WASHINGTON, May 2 — The economy, swinging back to life in the first quarter of the year, the Commerce Department said its growth in an annual rate of 2.8 percent after nearly coming to a halt at the end of [...]. The Clinton administration quickly took credit for reviving economic expansion that one [...] above [...]. The economic growth, even [...] of most economists, was strong enough that it immediately complicated the [...] of Senator Bob Dole. As presumptive Republican nominee and his supporters, citing the anemic growth rate of five [...] percent [...] last year, have been talking about the arrival of "the Clinton crunch," blaming higher taxes and government regulation for extinguishing economic growth.

And the gain — which would have been even greater, economists said, had it not been for the General Motors strike in March — raised fears that further advances were on the way. The good news to the economy was something referring to investors was the quickening of the economy, posed a threat of higher inflation, rising interest rates and a tighter monetary [...]. Federal Reserve. In the bond market, traders dumped their bonds, pushing interest rates higher. On Treasury securities, interest rates jumped 7 percent for the first time in [...] On Wall Street, where investors fear that higher rates might make stocks less attractive, the Dow Jones industrial average fell nearly 77 points, closing at 5,575.22. [Page D1.]

The 2.8 percent estimate issued today is a [...] advance" figure that is subject to revision up or down in coming months, was fueled by a 12 percent surge in the rate of investment by businesses, including a jump of nearly 50 percent in the pace of computer purchases. Consumer spending also soared at a slow Christmas, increasing at an annual [...]

Continued on Page D2, Column 1

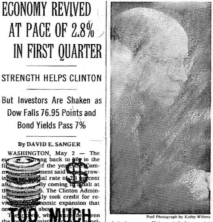

Pool Photograph by Kathy Willens
A judge gave Edward J. Leary 94 years and said it wasn't enough.

94-Year Term In Firebombing In the Subway

By GARRY PIERRE-PIERRE

Edward J. Leary, a computer analyst who lost his job and took his anger into New York City's subway system, was sentenced yesterday to 94 years for the firebombing of two trains in 1994. But not before a State Supreme Court justice, Rena K. Uviller, expressed her contempt for him.

"Evil exists in this world," Justice Uviller said. "No reason for it. It's just there. And we are looking at it in the person of Edward Leary."

She also expressed frustration over maximum sentences that limited the length of the penalty she could impose, calling them inappropriately low considering "the horror Edward Leary inflicted on so many people."

Mr. Leary, 50, who sat stoically throughout the hourlong proceeding, must serve at least 31½ years in prison before he will be eligible for parole. In his first public remarks since the incident, he showed no remorse and betrayed no emotion at times.

"I'm [...]" said Mr. Leary, who [...] trial was that he [...] incompatible [...] treat depression [...] understand how I [...] any people. I've [...] trying to think really why I did it."

Mr. Leary showed no emotion as he read his words in a low monotone from a sheet of paper. He continued to insist that prescription drugs were responsible for his actions.

"I'd give my right arm, give my life, to change that," he said. "I would do anything in my power to [...]"

Continued on Page B4, Column 2

SENATE VOTES BILL TO REDUCE INFLUX OF ILLEGAL ALIENS

CRACKDOWN GAINS, 97-3

Measure Faces Reconciliation With a House Version, and Perhaps a Clinton Veto

By ERIC SCHMITT

WASHINGTON, May 2 — Riding a wave of public anger against illegal immigrants, the Senate overwhelmingly approved a bill today that would tighten America's borders against immigrants living and working here.

The bill, approved by a 97-to-3 vote, would nearly double the size of the Border Patrol, now about 5,175 agents. It would stiffen penalties against document fraud, speed deportation [...] of illegal immigrants convicted of crimes and [...] benefits to legal and illegal immigrants.

The Senate also authorized Federal pilot programs that would require employers [...] to an automated national database to verify the legal status of workers they want to hire, an approach that critics contend could eventually [...] into a national [...].

"We brought forward significant elements of the illegal immigration [...] that are rather sweeping," said Senator [...] of Wyoming, the bill's main author and the Senate's leading authority on immigration.

But the Senate rejected an important legal immigration provision when [...] offered by Mr. Simpson [...] permit lives that the immigration [...].

Both President Clinton and Senator Bob Dole, the presumptive Republican [...] president, stand to benefit politically from tough positions against illegal immigrants. More than 70 percent of the nation's legal and illegal immigrants live in six voter-rich states — California, [...] as [...] Florida — [...] as [...] many [...] are worried that immigrants unduly burden schools and other [...].

The two bills were reconciled with the Senate version approved in March. The two bills are largely similar, except for provisions in the House bill that include restrictions on asylum-seekers and a measure to allow states to bar public schooling for illegal immigrants.

Mr. Clinton, who has threatened to veto any bill that includes the education provision, urged Congress to resolve other provisions the White House opposes. He said, "While this bill strongly supports our enforcement efforts, it still goes too far in denying legal immigrants access to vital safety-net programs which could jeopardize public health and safety."

Today's vote capped nearly 52 hours of often emotional debate

Continued on Page A22, Column 4

Political Pact With Ex-Film Star May Bring Down India's Premier

By JOHN F. BURNS

MADRAS, India, May 2 — Since Indira Gandhi was assassinated more than a decade ago, no woman has had a deeper impact on the politics [...] power in New Delhi.

As voting concluded today for a new state government, part of the second phase of the general election [...] newspaper [...] [...] resident [...] in ca [...] [...] [...] tremendous [...] [...] has been called the most corrupt of any government since India gained [...] in 1947. [...] opponents who seem likely to [...] Ms. Jayaram's regional [...] landslide when results are [...] next week have said they may prosecute her for graft and that they have said runs into billions of dollars.

Few Indian politicians have evoked the frenzy that accompanied her tours of the southern state of Tamil Nadu in the early period after she was elected Chief Minister in 1991. Men and women would press presence and crawled across public platforms to touch her feet.

As Ms. Jayaram, 47, seems to have fallen in popularity almost as fast as she rose, and she may not be going down alone. Because Indian [...] have made [...] the most bizarre personalities in Indian politics — P. V. Narasimha Rao chose Ms. Jayaram last month as his political ally in the national elections being held concurrently with elections in Tamil Nadu [...] experts say the [...] seats that Mr. Rao's Congress Party may lose in Tamil Nadu could be enough to doom the party in its struggle to retain

Referring to Mr. Rao's move to ally himself with Ms. Jayaram, Sathiya Moorthy, editor of Aside, a political magazine published here, said, "It only goes to prove the wisdom of the old Sanskrit axiom, 'In bad times, you make only bad decisions.'"

Along with many who follow politics here, Mr. Moorthy said he believed that Mr. Rao, who at 74 is the archetypal Indian politician, steeped

Continued on Page A8, Column 1

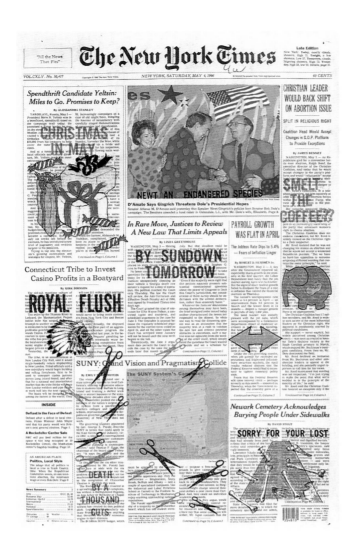

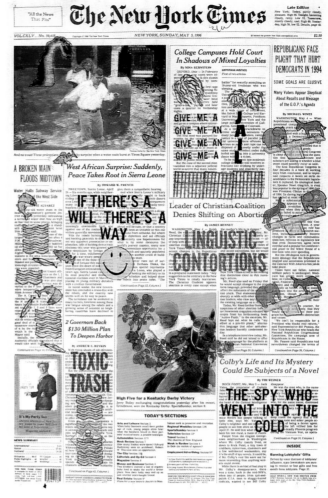

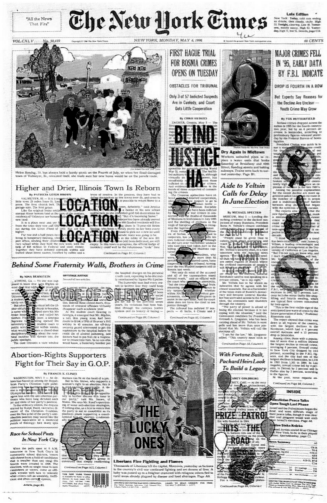

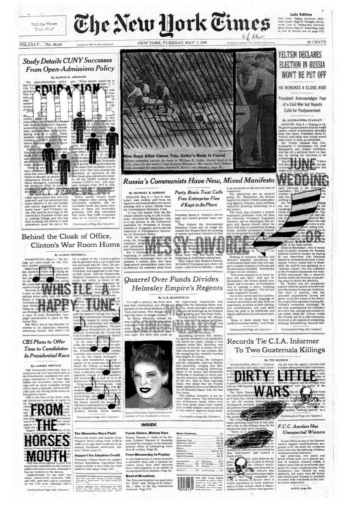

"All the News That Fits"

The New York Times

Late Edition

New York: Today, a drizzle early, then mostly cloudy, cool. High 56. Tonight, showers. Low 53. Tomorrow, showers, cloudy. High 64. Yesterday, high 64, low 42. Details, page C9.

VOL.CXLV No. 50,421 Copyright © 1996 The New York Times *NEW YORK, WEDNESDAY, MAY 8, 1996* $1 beyond the greater New York metropolitan area. 60 CENTS

House Approves Bill to Require Notification on Sex Offenders

Legislation Is Modeled After New Jersey Statute

By JERRY GRAY

WASHINGTON, May 7 — The House voted unanimously tonight to require states to notify localities when convicted sex offenders who might still pose a danger to children settle in their area.

On another crime-related measure, the lawmakers voted to increase drastically the penalties for crimes against the young, the elderly, women, and the mentally and physically handicapped.

For example, the measure sponsored by Representative Louise M. Slaughter, Democrat of upstate New York, which passed on a vote of 411 to 4, would make a second conviction on a serious sexual crime against anyone — whether in state or Federal court — a Federal offense punishable by life in prison without parole.

And by a voice vote this evening, the House adopted an amendment sponsored by Representative Martin Frost, a Texas Democrat, to broaden Federal jurisdiction over sex crimes against children.

defendant convicted in Federal court of a second sex crime against a child.

The measure requiring community notification on convicted sex offenders, including those who move across state lines, was modeled after a New Jersey statute known as Megan's Law. It was approved in mid-afternoon by a voice vote and after about seven hours of debate on the other crime measures, it sailed through the House, receiving all 418 votes cast in a recorded vote requested by the bill's sponsor.

Some versions of Megan's law, already enacted by a number of states, have been blocked by a series of Federal court challenges.

Representative Dick Zimmer, Republican of New Jersey, sponsored the Federal legislation and brushed aside criticisms that the law may be flawed, declaring that the approval of the bill was "a great day for children and a great day for their parents."

"With the passage of this bill we ...

Continued on Page B6, Column 1

Giuliani Is Said to Be Ready To Postpone Some Tax Cuts

By STEVEN LEE MYERS

Mayor Rudolph W. Giuliani plans to scale back significantly his proposed package of tax cuts, postponing a reduction in New York City's property taxes for co-op and condominium owners and calling for an extension of a temporary surcharge on the personal income tax due to expire in December, officials said yesterday.

The Mayor's decision to delay some tax cuts and to extend the surcharge, a move his senior aides derided earlier this year as the "equivalent of a tax increase, came as he moved to close a budget gap for the next fiscal year now projected to exceed $2.5 billion.

In his preliminary budget proposal only three months ago, Mr. Giuliani proposed a total of $428 million in new tax cuts, by far the most ambitious reductions he had offered thus far. In his first two years in office, the Mayor cut taxes only modestly, with the intention of stimulating business rather than providing broad relief for taxpayers.

As he prepares to submit his final budget to the City Council tomorrow, the Mayor has decided to propose only $107 million in new cuts, all of them in sales and business taxes, according to a draft copy of the proposals. Administration aides and other officials, who spoke on condition of anonymity, concurred that was the plan.

By far the largest tax cut that Mr. Giuliani wants to scrap involves the 12.5 percent surcharge on the personal income tax, paid by most working New Yorkers. The surcharge was concocted four years ago to pay for 7,000 police officers. An average taxpayer making $26,000 pays an additional $78 a year.

Eliminating that tax would have cost the city $171 million in lost revenues in the coming year and $447 million when the cut in property taxes on co-ops and condominiums will save $70 million.

But as with any changes in the city's taxes, extending the income-tax surcharge will require the approval of the State Legislature and Gov. George E. Pataki, which is by no means assured.

At a news conference at City Hall, Mr. Giuliani declined Tuesday to discuss the status of his tax cuts, but he did acknowledge that budget pressures had forced him to consider all his options.

Continued on Page B4, Column 2

For School Boards, The Counting Begins

Yesterday was school board election day in New York City, and the president of one board, ousted three times on corruption and patronage charges, was making the rounds. At one polling place, he angrily told poll workers to be sure not to lose the votes cast by himself, his relatives and his friends. At another polling site, one of the few voters who turned out pronounced himself baffled by the whole process. "It's weird," Stephen Schiller said. "It's squirrelly. It's surreal."

The often cited failings of decentralization were on display in the selection of the city's 32 community school boards yesterday. But despite low voter turnout and confusion over an antiquated process in which voters fill out paper ballots, ranking their candidates in order of preference, and then deposit them into cardboard boxes. It will take city election officials weeks to count the votes.

Article, page B1.

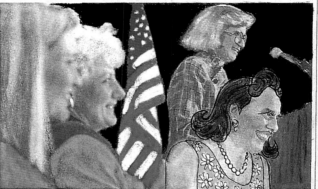

Senator Bob Dole attended a meeting of Republican women in Washington yesterday. He attacked the credibility of President Clinton, who appeared at Woodbridge High School in New Jersey.

Dole Says He Has Plan to Win Votes of Women

By KATHARINE Q. SEELYE

WASHINGTON, May 7 — Bob Dole tonight directly confronted for the first time one of his greatest weaknesses in his campaign for the White House — his lack of support among women.

"I've seen some poll numbers, and you've seen the poll numbers that say, well, there's a gender gap," he said to a group of Republican women tonight. "Does this bother me? You bet it does. I don't believe there should be a gender gap; I think that gap will close. Do I have a plan to eliminate it? Yes I do."

His plan, Mr. Dole said, was to start discussing his support of certain pieces of legislation of particular interest to women. He noted first that he had sponsored a measure to make it easier to convict people of sex crimes. However, that measure was part of the 1994 anti-crime bill, which Mr. Dole ultimately voted against because it contained a ban on assault weapons. The bill passed anyway.

More Time for Candidates

Like CBS and Fox before them, NBC and CNN announced they would offer free television time to major Presidential candidates. Page B11.

The second item for which he took credit was "leading the Senate" to fund the Violence Against Women Act. That, too, was part of the anti-crime legislation that he opposed.

The Senate majority leader, who is the presumptive Republican nominee, then turned to other issues that Republicans hope to use as part of their appeal to women. He said his record also included "fighting for a balanced budget, for lower taxes, for better schools, for a strong national defense and for a brighter future for all America."

The second element of his strategy to woo women voters is to point out the "credibility gap" between President Clinton's words and his actions, related to Mr. Clinton's promises to balance the budget and restructure welfare, only to veto Republican measures that Mr. Dole would have done so.

In Woodbridge, N.J., today, President Clinton focused on an issue the Democrats have identified as a family concern: teen-age smoking. [Page B4.]

Mr. Dole did not even make passing reference in his remarks to the

Continued on Page B10, Column 1

SOFTWARE PIRATES GROWING IN NUMBER IN CHINA, U.S. SAYS

SANCTIONS THREATENED

Ties to Beijing, Already Mired in Disputes, Could Be Hurt by Any Curbs on Trade

SOFTWARE PIRATES GROWING IN NUMBER IN CHINA, U.S. SAYS

SANCTIONS THREATENED

Ties to Beijing, Already Mired in Disputes, Could Be Hurt by Any Curbs on Trade

By DAVID E. SANGER

WASHINGTON, May 7 — Clinton Administration officials said today that ever-growing, largely undiminished evidence of illegally producing pirated music, computer software, videos and compact disks, and they are preparing to take retaliatory action next week against more than $2 billion in Chinese imports to the United States.

The threat comes amid hardening positions, escalating tensions in a relationship still mired in disputes over China's reported shipments of nuclear weapons material, its continued repression of dissidents and its efforts to intimidate Taiwan.

Several of Mr. Clinton's top advisers have said in recent days that they are worried about the steady deterioration of the relationship with Beijing. The Administration had no choice but to dig in in the piracy dispute because China had repeatedly ignored warnings that it must fulfill its commitments under a major accord signed in March 1995.

White House officials say that by retaliating against China in a dispute that is costing American companies billions of dollars in lost sales, the Administration hopes to defuse a broader movement in Congress to terminate China's preferential trading status, which is up for renewal next month. Ending those trading privileges, a senior Administration official argued today, "would essentially terminate our economic relationship" with China and wipe out whatever leverage Washington has over Beijing.

The Administration reiterated its support for China's broad trading rights — which President Clinton "delinked" from Beijing's human rights record in 1993 — during a meeting today between Vice President Al Gore and the British Governor of Hong Kong, Christopher Patten. Mr. Patten is visiting Washington to warn that terminating China's most-favored-nation trading status in the United States would devastate Hong Kong, the transit point for most of the goods made in China. He told Patten that a renewal of M.F.N. was important to our national interest. He also told Patten that he would revoke China's M.F.N. status, declaring that the Administration had failed to charge China's treatment of dissidents or its trading practices.

Caught in the middle is Senator

Continued on Page A9, Column 1

Wide Epidemic of Meningitis Fatal to 10,000 in West Africa

By HOWARD W. FRENCH

ABIDJAN, Ivory Coast, May 6 — In one of Africa's worst outbreaks of disease, meningitis has infected more than 100,000 people in the last three months, killing more than 10,000, relief workers said.

The epidemic, which has been most virulent in the region just south of the Sahara, as the Sahel, has been striking women, laden and cold-ridden by colds and other respiratory infections.

The disease causes inflammation of the lining of the brain and spinal cord. Airborne bacterial germ, medical meningitis is easily spread through close contact. Early symptoms include high fever, seizures and...

... the disease is contracted, it can be treated in its early stages

with antibiotics, but once it takes hold and invades the bloodstream, preventive vaccines available is now being administered on an emergency basis in the region.

In northern Nigeria, where the disease has hit hardest, about 10 percent of 50,000 or so cases official reported so far have ended in death. The aged and women are most vulnerable.

Continued on Page A10, Column 1

INSIDE

Penmanship: Fine Art to Lost Art

By MARY B. W. TABOR

Continued on Page B12, Column 1

Zaner Bloser style 1970's

D'Nealian method 1970's

Palmer method 1940's

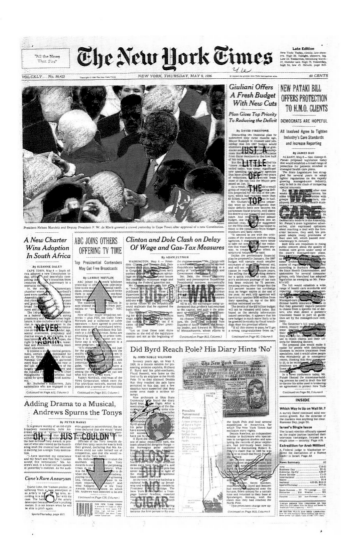

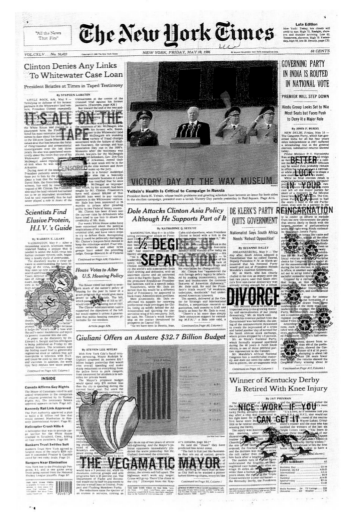

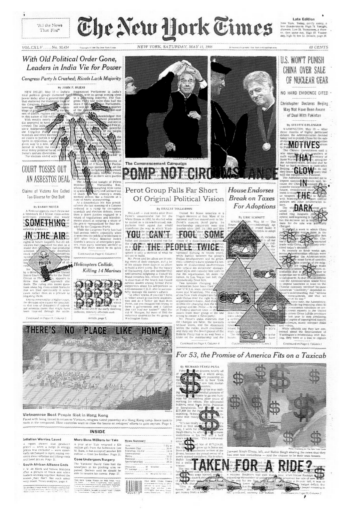

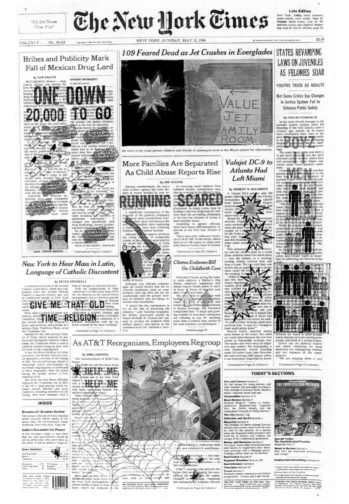

The New York Times

Late Edition

New York: Today, sunny, a few puffy clouds, breezy, cool. High 60. Tonight, chilly. Low 44. Tomorrow, mostly sunny, a bit warmer. High 66. Yesterday, high 63, low 45. Details, page B8.

VOL.CXLV.. No. 50,426 Copyright © 1996 The New York Times NEW YORK, MONDAY, MAY 13, 1996 $1 beyond the greater New York metropolitan area 60 CENTS

Students Lag in Districts Where Patronage Thrives

By MATTHEW PURDY and MARIA NEWMAN

LESSONS UNLEARNED
First of two articles.

Michael DiBisceglie was a teacher and drug-program coordinator when the local school board in Brooklyn's Bushwick section made him principal of Public School 106 in 1980. A board member who thought Mr. DiBisceglie was not qualified for the job, remembers the lobbying from his biggest supporter on the board: "Why can't you vote for him? He's my son-in-law."

The appointment was just another bit of favoritism that went without notice in the New York City school system.

But the decision reverberated far beyond Mr. DiBisceglie and his patrons on the board. Over the next 15 years, Mr. DiBisceglie was responsible for the education of thousands of Brooklyn children — and according to education officials and parents he made a poor job of it. Board members criticized him as a weak leader who demanded little from teachers. Parents said he played them off one another, dividing the school. And one former board member, Michael D. Nieves, said that "a good number of times" when he visited the school the principal was...

State inspectors... school lab...ratory... the extent... after year... report, t... ity of thir... below th... books were so... dren could not bring... to study. There were no art, music or gym teachers. Classroom fights were common.

The inspectors could hardly fail to notice the chaos. During their visit, students came into the room where they had been working and poured coffee into their briefcases, and one inspector reported money missing from her pocketbook. The school, the inspectors concluded, suffered from poor leadership and was in a state of "educational dysfunction." Only after the report did the board decide to remove the principal.

The case of P.S. 106 hardly matches the outrageous tales of corruption that emerge periodically from some New York City's local school districts — cash bribes for principalships, a cabal of educators accused of conspiring to steal a school board election.

But a close look at several troubled districts around the city shows clearly the debilitating toll that pervasive political infighting, patronage and favoritism can take on children in classrooms. When a superintendent...

Continued on Page B4, Column 1

With Campaign Staff in Disarray, Yeltsin Depends on Perks of Office

By ALESSANDRA STANLEY

MOSCOW, May 12 — Boris N. Yeltsin took a running headstart last week on the election law that prohibits presidential candidates from advertising on radio, television or billboards before May 15. Beginning Thursday and throughout the long Victory Day holiday, his campaign flooded the airwaves with gauzy television commercials featuring World War II veterans reminiscing about their past, hinting darkly about the future.

In one of them, a sad-eyed veteran looks straight into the camera and says wistfully, "I just want my children and grandchildren to finally savor the fruits of the victory we fought for and that they didn't let us enjoy."

They... subliminal reference...

In his... re-election... priv... includ... oly... bend... elec... rules... in contrast... so far have... advertising time on the... old-style rallies... and canvassing, the Yeltsin campaign has commandeered all the best focus-group research, direct mailings, polling data, political consulting and advertising expertise money can buy. The President's advisers even solicited the advice of Sir Tim Bell, the British public relations wizard who reshaped Margaret Thatcher's image in her first term as Prime Minister.

But all the money, artistry and technology in the world may not be able to pull Mr. Yeltsin's reputation together again — and there are other obstacles to victory besides the public's deep disenchantment with his presidency.

Decision-making at the top of the campaign is balkanized into multiple, and often rival, power centers.

The internal power struggles were acutely illustrated last week, when Mr. Yeltsin's powerful chief of security, Maj. Gen. Aleksandr V. Korzhakov, set off a political firestorm by recommending that the election be postponed to prevent a Communist takeover. Mr. Yeltsin quickly insisted he would go ahead with the election, scheduled for June 16, but the debate over whether the vote should take place continues to rage within party headquarters.

The campaign slid around the advertising ban by painting the veterans ads as public service messages pegged to the May 9 Victory Day holiday, which Russia celebrates as V-E Day. But the ads were crafted by

Continued on Page A8, Column 1

G.O.P. to Press Missile Defense As Clinton Test

By PHILIP SHENON

WASHINGTON, May 12 — Congressional Republicans, eager to turn defense policy into a major issue in the Presidential campaign, are preparing to press President Clinton with legislation that they will portray as a test of his commitment to national military readiness.

The first test is to come in the next few weeks as the full House and Senate debate legislation sponsored by Senator Bob Dole, the presumptive Republican Presidential nominee, that would force the United States to spend billions of dollars on the national missile defense...

...technol...ors, in... bo... for it... Calle... the bill... Speaker... come up... this week... military a... billion

Mr. Clinton... veto th... authorization bill if... gains provisions requiring the... ...to spend $13 billion more than requested. Votes in the Senate on the missile defense bill and its version of the authoriza-

Continued on Page A13, Column 1

INSIDE

Child-Support Bill Stymied
Legislation intended to crack down on parents who do not pay child support is popular in Congress, but it is stalled nonetheless. Page A13.

Fighting Flares in Lebanon
Israel suffered its first casualties since the United States brokered a truce two weeks ago. Page A3.

Knicks Fall Short
The Chicago Bulls held off the Knicks, 94-91, to take a 3-1 lead in the playoff. SportsMonday, page C1.

Search Called Off for Survivors of Crash in Everglades

With Valujet Flight 592 submerged in the Everglades, officials said there were no survivors. Searchers used airboats to look for bodies and debris.

Loved Ones Lost, Perhaps Never to Be Found

By RICK BRAGG

ATLANTA, May 12 — Rescue workers found no bodies. They found no bodies. When Valujet Flight 592 dropped out of the sky and into the Florida Everglades on Saturday afternoon, it was as if 109 people aboard the DC-9 were just erased.

It left a wedding on Tybee Island, Ga., without a bride, and a cheerleading squad in Ypsilanti, Mich., incomplete. It left a lover way in Dublin, Ga., and, and a 55-year-old woman an... ...N.C., more alone than she had ever thought possible.

But... anything, said one... George... whose son... died... ...Florida, is the... of tho... who... under... ...for... "We can't even... out... thinking about them being under-

Inaccessibility of Bodies Is Adding to the Pain of Grieving Families

ground, said Linda Hinley, whose son, Ben, was engaged to Teresa Wilson.

The 24-year-old Ms. Wilson and her mother, Betty McLendon, were on their way home from a Caribbean cruise when Flight 592 crashed.

"How can you have a funeral?" said Mrs. Hinley, who answered questions about her future daughter-in-law graciously and patiently, until the notion of the burial and how it would be arranged brought her to... ...the crash destroyed whole families... killed 14-year-old Laura Faveto and her parents, Betsy and

Franco, whose life together had begun in almost storybook fashion years before when a... then Miss Stewart, took a... break cruise and fell in lo... ...ship's officer.

It took Roy Ren...na, and their daughter, Kelly... na, and checked in at Eastern... can University... Ypsilanti... him with... ...ty house in Plymouth.

Down South in Raleigh, N.C., Barbara A. Nevill mourned her son, Andrew D. Nevil, 27, who had lived with her in the house he grew up in. When she learned about the crash, she dialed a succession of relatives, searching for someone to talk to, lean on.

"I got all answering machines," she said.

Oddly, few people who had

Continued on Page B7, Column

Hope of Rescue Is Swallowed by Swamp

By MIREYA NAVARRO

MIAMI, May 12 — With... hope of finding survivors at which officials called the most chaotic... crash site they have ever encountered, investigators... day grew... of the task... ...the grieving... remains and the wreckage... ...under that... ...into the...

...for... which descended on... valu-jet... ...ng for... 592... ...after takeoff from Miami... before 11 A.M. But recovery of remains and wreckage will take at least a week, officials said.

...faced a daunting task... the site about 20 miles northwest of Miami, including 3 to... ...water with almost n... ...of muck that can be 5 to 8 feet deep, as well as alligators and poisonous snakes... so sticky that rescuers could not walk through it, officials said.

The Federal Aviation Administration said today that it would take a closer look at the operations of Valujet and other carriers that maintain its aircraft at a discount carrier that operates less than three years old is subject to an F.A.A. review every year after several months. [Page B7.]

At a news... near the crash today... ...Transportation Secretary Federico F. Pena said the airline is safe. "I think if we have found... issues... ...about Valujet... ...responsive they have been... ...in some cases... ...they have up-to-date standards that we have..."

Rescue... ...had found no evidence... ...most of the wreckage buried...

"The wreckage... ...down in that... relative... Patrick... Metro-Dade Police Department, who flew over the site.

Robert Francis, vice chairman of the National Transportation Safety Board, which is investigating the crash, said experts have been to the site "the majority of... ...difficult... ...that they have not encountered... ...for the recovery of... ...craft."

At a briefing, Mr. Francis confirmed that the crew had reported... smoke in the cabin... ...both the crew and... ...asked to return...

...engine jet, bo... ...at... about 100 miles... ...international... Saturday afternoon, the F.A.A. said, and was heading back to the airport when it crashed. Greg Feith, the

Continued on Page B7, Column 1

So, How Did Gasoline Prices Get This High?

By ALLEN R. MYERSON

HOUSTON, May 10 — As president of Suncoast Resources here, Kathy Lehne trucks gasoline around Texas and surrounding states. She buys from the region's refineries, pumps the fuel into storage at gas stations, other business and schools.

But this spring, instead of fuel, some stations were giving her excuses. "The supply was tight; they were hoarding," she said. But the pipelines...

By shopping around, Ms. Lehne was able to find supplies. "Somebody always has it," she said. But, especially as her suppliers prepared to change over to summer gasoline for-

mulas, some let their stocks of winter fuels run nearly dry.

In many cases, prices have risen by 20 cents a gallon, more steeply than crude oil prices. Yet most motorists seem to base where they gas up on habit and convenience rather than on price, so for all their complaining, most Americans do little to change the way they shop for fuel. And that, in turn, puts little pressure on the oil companies to hold down gasoline prices. [Page B6.]

Still, motorists and their elected officials have let prices get so high that something... ...extra cash...

Pushing... gas... ...er are some abrupt changes in how the industry does business, particularly a sharp reduction in the inventories held at refineries and distribution

terminals and the increased number of specially refined gasolines.

"The impact of the change in strategy should not be underestimated," Philip K. Verleger Jr., vice president of Charles River Associates, a Washington consulting firm, told distributors and gas station owners in a speech two weeks ago.

"Up until late 1994 or early 1995, the cardinal rule for terminal managers was never run out," Mr. Verleger said. "The situation today is different. One major keeps a sign in the office... ...competition... 'KILL.'... ...Low and...

The other strong pressure on prices comes from a new wave of

Continued on Page B6, Column 1

90's Mom, From Start to Finish

Joyce Talley of Washington began Mother's Day with the Advil Mini Marathon Tune-Up, a 5-kilometer run in Central Park yesterday, winning a hug and flowers from her daughters Terry, left, and Anne, who also ran.

Barbara Alper for The New York Times

"All the News That Fits"

The New York Times

Late Edition
New York: Today, sunshine, scattered clouds. High 65. Tonight, clouds. Low 55. Tomorrow, mostly cloudy, a few thundershowers. High 68. Yesterday, high 58, low 43. Details, page C18.

VOL.CXLV.... No. 50,427 Copyright © 1996 The New York Times *NEW YORK, TUESDAY, MAY 14, 1996* $1 and the greater New York metropolitan area. 60 CENTS

Web of Patronage in Schools Grips Those Who Can Undo It

By MATTHEW PURDY

LESSONS UNLEARNED
Second of two articles.

The revelations began bubbling out of New York City's community school board system more than a decade ago.

Principals and teachers in the Bronx told a grand jury that they had to work for political clubs to enhance their careers. A school board member in Queens was secretly recorded trafficking in jobs for the politically connected, telling supporters that "I'm a politician before I'm here." There was evidence of widespread fraud in the 1993 school board elections, and there was pressure on teachers and others to serve not just pupils but politicians.

In each case, outrage followed. But in Albany, where legislators created the dysfunctional school boards and have the power to change them — the response has always been the same: little action, if any.

Far from trying to change the system, many state legislators from New York City are bonded to their local school boards through political clubs and patronage jobs that provide every incentive to maintain the status quo. Past efforts at changing the system have usually ended in a deadlock with opposing Assembly and Senate bills, which some officials have said fit the purposes of those legislators who wanted the boards to remain untouched.

The Assembly took a step toward altering the school system yesterday, when it passed legislation that would eliminate local school boards, expand the central Board of Education and establish governing councils at each school. But the most widely supported proposal in the Republican-controlled Senate is so different that legislators concede reconciliation is unlikely. The Senate bill would keep local boards and put City Hall in charge of the schools. [Page B5.]

The chief sponsors of the opposing bills are the two most powerful New Yorkers in Albany — the Assembly Speaker, Sheldon Silver, a Manhattan Democrat, and State Senator Guy J. Velella, a Bronx Republican. And they typify the relationship between legislators and the local boards.

Even as Mr. Silver proposes dismantling the local boards, he remains connected to the board in his Lower East Side district, which for years was dominated by his allies. Mr. Silver and his club endorsed a slate of candidates fighting to regain control of the board last Tuesday's volunteer campaign coordinator.

Mr. Silver arranged for the lawyer who challenged a Manhattan Democratic organization in court over the process of getting candidates through the petition to the ballot. Earlier this year, the current superintendent of his local board who was ousted by the new slate of board members, to be an education adviser in Albany.

Mr. Velella, one of the leaders of the Senate's Republican majority, is a former school board president. He said he feels it his duty to continue his involvement in the boards in his

Continued on Page B4, Column 1

Librado Romero/The New York Times
Despite calls for change in school boards, Albany has done little.

BLACK BOX FOUND AT SITE OF CRASH IN THE EVERGLADES

HUMAN REMAINS LOCATED

Data Recorder Clues Sought as Search Goes On for Other Monitor and Victims

By MATTHEW L. WALD

MIAMI, May 13 — Investigators got their first break this afternoon in the crash of a Valujet DC-9 in the Everglades on Saturday, with two American climbers and five others missing as a police officer combing the scene of body parts stepped on a 30-pound metal box that turned out to be the flight data recorder, one of the plane's two "black boxes."

The box, which is actually yellow, had been partly covered by mud under several feet of water. Investigators packed it in an igloo cooler borrowed from a firefighter and rushed it by police car to Miami International Airport, where it was put on a plane to Washington for engineers at the National Transportation Safety Board.

"We were extraordinarily fortunate today to find the flight data recorder," Robert Francis, the vice chairman of the safety board, said in a briefing this evening. Its recovery, he added, "is as important as anything we can have in the investigation of the accident."

At the crash scene, which killed 110 people, workers pulled several hundred body parts from the water. The search area is about 100 yards by 300 yards of mud, sometimes under a few inches to a few feet deep. It is several miles inland from the edge of Miami's urban sprawl.

Continued on Page B7, Column 1

Associated Press
A blizzard killed eight climbers on Mount Everest; among survivors rescued by helicopter was Seaborne Weathers of Dallas, who said he owed his life to a Nepalese pilot who landed on broken ice at 20,000 feet.

Everest Takes Worst Toll, Refusing to Become Stylish

By JOHN F. BURNS

NEW DELHI, May 13 — Around dusk on Saturday, with two American climbers and five others missing and probably dead on the slopes of Mount Everest, a team of New Zealander and Japanese climbers put a call to his snowhole just below the summit of the world's highest mountain.

His voice filtered through the climber, Rob Hall, to say what may have been his last words before he died. "Hey look, don't worry about me," he said.

As news filtered through today of the worst single loss of life that has ever occurred on the 29,028-foot mountain, the last hours of Mr. Hall, a professional mountaineer who had reached the summit of Mount Everest a record five times, captured the drama that no amount of high technology has been able to strip from the challenge of ascending the world's highest peaks.

The eight climbers who died in a fierce blizzard that blew up on Friday, shortly after they and at least a dozen others reached the mountain's summit, were doing something that has become almost routine in recent years.

Since the first successful ascent of Everest on May 29, 1953, more than 4,000 climbers have tried to reach the top. On these Friday, 615, who died, or scores of Americans, had made it to the top. In 1993, 40 climbers achieved the feat in a single day.

But mountains like Everest some how beckon to challengers. There are those who love the mountains, for the fashion able image taken in recent years, when high technology, clothing and equipment have made it far easier to climb the highest mountains, but also easier to get into situations that can be suddenly fatal.

The dead from this latest disaster

Continued on Page A3, Column 1

The Foreboding Sky, The Rumbling Earth

Sometimes it's hard to know what to worry about — killer asteroids or giant volcanoes. The Federal Government has recently put money on the asteroid financing the first government effort to map space for objects that could devastate Earth in the distant future.

A giant volcano has no immediate concern. It has a 5,000-year-history of enormous eruptions and it has been rumbling ominously recently. Volcanologists are using new technology to monitor it.

Articles, Science Times, page C1.

HIGH COURT SAYS LIQUOR PRICE ADS CAN'T BE BANNED

FREE-SPEECH ISSUE CITED

Rhode Island Case May Affect Federal Efforts to Restrict Cigarette Promotions

By LINDA GREENHOUSE

WASHINGTON, May 13 — In a ruling that strengthens free-speech protection for advertisers and casts doubt on the Clinton Administration's cigarette advertising, the Court struck down today a Rhode Island ban on advertising liquor prices.

All nine Justices agreed that the ban violated the First Amendment's guarantee of free speech. The ban, part of a 40-year-old state law, was similar to many liquor-price advertising bans in other states.

There was, however, no majority opinion on a rationale, indicating that the Court's approach to commercial speech remains in flux 20 years after the Court first extended First Amendment protection to truthful, nonmisleading advertising of lawful products. But for the most part, the four separate opinions expressed nuances of difference rather than the deep fissures that characterize other areas of constitutional doctrine in which the Justices have yet to find common ground.

"When the day is done, and you add up all these crazy fragments, you come away with a strengthened test" for First Amendment protection of commercial speech, one specialist in this area, P. Cameron DeVore of the Seattle law firm Davis Wright Tremaine, said today in an interview.

In invalidating the Rhode Island law, the Court overturned a 1994 ruling by the United States Court of Appeals for the First Circuit, in Boston, which found "inherent merit" in the state's judgment that the advertising of discounts on liquor prices thus setting the stage for discourage liquor consumption.

Continued on Page D11, Column 1

U.N. Says North Korea Will Face Famine as Early as This Summer

By NICHOLAS D. KRISTOF

TOKYO, May 13 — "Hunger in North Korea is growing more intense as the country's economy continues to deteriorate, so that malnutrition could become widespread in the coming months, some experts said.

The latest sign of the crisis, the World Food Program, the Food and Agriculture Organization of the United Nations warned today that "the food supply is becoming increasingly desperate" in North Korea, and that without emergency food imports, the country is likely to be devastated by segments of the population.

"There is no campaign fervor," said Nikolai Kazmin, 67, a retired industrial designer, as he carefully weeded his brother's grave at the Borino cemetery in the town of Ivanovo, the administrative capital of the region. Yeltsin has a huge apparatus. But the presidential structure in the provinces is not working.

for the World Food Program, said by telephone from the organization's office in Pyongyang, the North Korean capital. "However, with levels of rations that are being distributed, malnutrition will develop and become widespread in the coming months unless there are substantial food shipments."

North Korea, with the world's last Stalinist government, remains virtually sealed off from the rest of the world, and few foreigners are allowed to visit. But many Western diplomats, business executives, academics and other visitors to the country say that the growing signs of hunger are deteriorating.

Even in Pyongyang, which has by far the best standard of living in the country, visitors say that power outages are now routine and that water is often cut off for much of the day. Some Western diplomats and oth-

Continued on Page A10, Column 4

Clinton Thriving in Gentle Glow of TV Lights

By RICHARD L. BERKE

WASHINGTON, May 13 — Lou Young, a reporter for Channel 2 in New York, stood in his trench coat, "live" at Liberty State Park in New Jersey last week, informing viewers at the start of the 5 o'clock news each tilt and whirl of the President's helicopter as it prepared to touch down.

"Marine One should be coming into this area any minute, as far as we understand," Mr. Young reported. As the camera panned to the waiting entourage, he added, "You can see that Marine One has the security you would expect for a limousine."

He was no different than every event for viewers at 5:30. Janet on Channel 10 had her story at 5:30. In New Jersey took an appropriately people not to fall prey to cigarette advertisers."

And, like most of her colleagues at the local stations, Pat Battle, a reporter for Channel 4 in New York, took on an appropriately Presiden-

tial tone in much of her three-minute report of the visit. While Ms. Battle told viewers that the President was in town "to raise his already favorable standing in the public opinion polls," she did not give equal treatment to his Republican opponent.

From the newspaper campaign, it was better than paid advertising: uncritical coverage of the President broadcast into every living room and home. Yet the battleground states of Pennsylvania and New Jersey, the viewing audience, it was President Clinton who was put on display that evening, not candidate Clinton.

It has long been a rule that the

farther a President ventures from the Oval Office (and from the hard-to-impress national press corps), the better the coverage. Thanks to good political fortune, and careful orchestration by his aides, Mr. Clinton is rivaling Ronald Reagan's success in using incumbency to produce those flattering images on television. That, combined with Mr. Clinton encourage the portrayal of himself as above the political fray — more specifically, the intramural party combat — of Mr. Dole and the Republicans.

A political truism accounts for much of the respectful treatment:

Continued on Page A17, Column 1

James Hill for the New York Times
In Ivanovo, Communists long ago rushed in where President Boris Yeltsin is to tread on the campaign trail.

Selling of Yeltsin Hits Obstacles in Heartland

By MICHAEL R. GORDON

LEZHNEVO, Russia, May 9 — The re-election of Boris N. Yeltsin promises to be a hard sell in this downtrodden factory town 200 miles northeast of Moscow.

The two textile plants in Lezhnevo are idle. The recent voting trend here in the Ivanovo region is strongly anti-Yeltsin. Workers and retirees, dispirited and cynical, are more preoccupied with getting by than with politics.

In an election in which voters show no enthusiasm for any of the candidates, mobilizing the electorate for

the June 16 vote is vital to Mr. Yeltsin's re-election prospects.

But while the President has embarked on a highly publicized tour of 16 Russian towns and cities and begun an ambitious program of television advertising, his campaign in some of the provinces is barely off the ground.

A region of storybook onion-domed churches, carefully tilled garden plots and aging textile factories, Ivanovo, in the heart of old Russia, is a microcosm of the problems that Mr. Yeltsin's campaign is confronting in the field.

And the campaign is further complicated by the only lukewarm support of the Governor, inattention, Yeltsin campaign officials in cow and the entrenched network of Communist Party cells.

Vladislav N. Tikhomirov, the Governor appointed by Mr. Yeltsin here,

Continued on Page A12, Column 1

INSIDE

Taking Aim at Clothes Rack
To compel enforcement by Beijing of laws against pirated software and videos, the United States plans to aim sanctions at China's lucrative clothing industry. Page D1.

The D'Amato Tightrope
In assailing Newt Gingrich, Senator D'Amato may be playing to voters at home and trying to reverse recent setbacks. But he may lose some powerful friends nationally. Page B1.

Serenity on Wall Street
The 150th anniversary of Trinity Church is a reminder that the sanctuary not only survived Wall Street's growth, but fostered it. Page B1.

WEIZMANN INSTITUTE OF SCIENCE. SEE op-ed page for "Thinking All Science." — ADVT.

The New York Times

Late Edition
New York: Today, thickening clouds. High 65. Tonight, becoming damp and cool. Low 51. Tomorrow, mostly cloudy, light rain. high 62. Yesterday, high 63, low 43. Details, page B6.

VOL.CXLV... No. 50,428 Copyright © 1996 The New York Times NEW YORK, WEDNESDAY, MAY 15, 1996 $1 beyond the greater New York metropolitan area. 60 CENTS

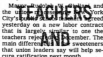

Jim Estrin/The New York Times
Sandra Feldman, head of the union, predicted ratification.

Inquiry Turns To Chemicals In Jet's Cargo

By MATTHEW L. WALD

MIAMI, May 14 — The Valujet DC-9 that crashed in the Everglades on Saturday was carrying as cargo in its forward hold 50 or 60 bottles of chemicals used to make oxygen for emergency masks, the National Transportation Safety Board said tonight, raising the possibility that they caused a fire or explosion. When the bottles make oxygen, by mixing two chemicals, the reaction also produces heat.

The board also said that the flight-data recorder, recovered on Monday and deciphered overnight by its technicians, recorded the plane's instruments as indicating a very sudden drop in altitude and speed, while the plane did not actually slow or drop. Experts said the instruments could have been thrown off in that fashion by an explosion inside the plane.

The plane also carried in the cargo hold aircraft tires, said the vice chairman of the board, Robert Francis, in a briefing this evening. Mr. Francis pointedly said he would not speculate about the cause of the crash, which killed the 104 passengers and crew or about expeffects, noted that the tires not been the crew radio and cabin.

crash beam or that with soot, was not yet sis progressed the crash the transportation Washington about low-cost airlines. [Page A16.]

The presence of the chemical bottles, oxygen generators, was discov-

Continued on Page A16, Column 2

INSIDE

Of Horses and Tax Codes
A Kentucky Congressman, using an obscure tax provision, partly succeeded in securing a tax break potentially worth millions of dollars to owners of race horses. Page A19.

Ritalin and Performance
With surging use of Ritalin, ethicists are pondering whether it is being overused, not just for symptoms of attention deficit disorder but to enhance mental performance. Page C8.

Knicks' Season Ends
Michael Jordan scored 35 points to lead the Bulls to a 94-81 victory over New York as the Bulls won the series 4 games to 1 and advanced to the Eastern Conference final. Page B9.

TEACHERS' UNION AND MAYOR AGREE ON NEW CONTRACT

PACT IS LIKE ONE REJECTED

Labor Chief Says the Members Are More Realistic on What New York Can Afford

By STEVEN GREENHOUSE

Mayor Rudolph W. Giuliani and the union leaders for New York City's public schools agreed yesterday on a new labor contract that is largely similar to one the teachers rejected in December. The main difference is sweeteners that union leaders say will help secure ratification next month.

Mr. Giuliani repeatedly said that City Hall made major concessions in renegotiating the contract.

"What they have got is exactly what they had rejected time," the Mayor said. "They haven't gotten any more and they haven't gotten any less."

Mr. Giuliani's aides asserted that all the changes in the new record were in by minor concessions made by the union. "The contract is the same contract in that it's within the pattern," said First Deputy Mayor Peter Powers. "Anything extra they got, they paid for."

The revised agreement, like the rejected one, would raise the salary for beginning teachers to $31,911, from $28,749, and would increase the maximum teachers' salary to $70,000, from $60,000.

Like the old contract, the new one calls for no layoffs for three years, a two-year pay freeze, and a 13 percent raise over the following three years. The changes include an incentive package intended to persuade 2,000 to 2,500 teachers to take early retirement, a reduction in the number of years it takes for teachers to earn the $70,000 maximum, and the elimination of a plan to defer part of a beginning teacher's salary.

In addition, the contract offers a $3,500 supplement each semester to teachers who volunteer to teach an additional period each day. Officials said that this would increase productivity and help fill the gap left by teachers who take the early retirement package.

Sandra Feldman, president of the United Federation of Teachers, predicted that teachers would approve the agreement because of these new benefits and because they increasingly see that the city's fiscal woes

Continued on Page B4, Column 2

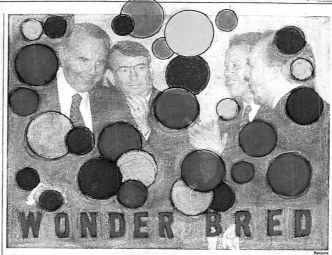

Senator Bob Dole, beside Gov. Tommy G. Thompson of Wisconsin, shook hands yesterday with Gov. John Engler of Michigan at a G.O.P. luncheon. Both Governors are considered possible Dole running mates.
Reuters

$2.3 Billion Deal Creates Giant In Managing of Doctors' Offices

By MILT FREUDENHEIM

For more than a decade, doctors have complained, to little avail, as employers, managed-care companies and, later, hospitals came together in competing organizations dedicated to squeezing down health care costs — and, in the process, limiting physicians' incomes and independence.

Besides handling negotiations with purchasers, physician-practice management companies typically develop computerized systems that help doctors weigh the economic trade-offs of providing medical care to groups at a fixed price per head. The management companies also take control of the doctors' office expenses and other administrative functions.

Both Medpartners, which has been a recent favorite of investors, and Caremark have been buying doctor groups at a rapid rate. Together their doctor groups will have contracts covering 1.5 million patients.

They will be especially strong in five Southern California counties, where their contracts will cover 6 percent of the population and 15 percent of the doctors.

"We want to be the supreconsoli-

Continued on Page D7, Column 1

The creation of by far the biggest such company was announced yesterday. Medpartners/Mullikin Inc., a physician-practice management company, said it would buy Caremark International Inc., which has a similar business, in a stock-swap transaction valued at $2.34 billion.

The new company, Medpartners Inc., would have contracts with 7,250 physicians, mainly in Southern California and across the South and Southwest. And its top executives say this is just the beginning: they plan to buy many more physician groups and the companies that manage them.

U.S.-CHINA TALKS OVER PIRACY FAIL

A Trade War Is Growing Closer as 2 Sides Threaten Curbs

By SETH FAISON

SHANGHAI, May 14 — Two days of last-ditch talks ended today without resolving the differences that remain between China and the United States over Chinese pirating of software, music, movies, and the discord brings the two nations ever closer to a trade war.

The United States still accuses China of failing to carry out broad sections of an agreement reached last year on the issue, while China maintains that it is proud of its record of protecting intellectual property rights.

Their inability to resolve matters in motion a series of punitive actions by the United States, the first step is expected to be the publication of a list of Chinese exports to the United States worth about $3 billion a year that could be subject to 100 percent tariffs.

By mid-June, when the sanctions are to be imposed, the list is likely to be slimmed down to about $2 billion worth or less. Chinese trade officials have said they plan to retaliate with their own sanctions.

In the last four years, negotiations between American trade officials have come to posturing and public threats that melted away as an agreement was reached moments before a deadline. But the strained political climate between Beijing and Washington — and the unpredictability of election-year politics — may make this year's outcome harder to foretell.

Lee Sands, an assistant United States trade representative, led the American side in two days of meet-

Continued on Page A12, Column 1

DOLE WILL REDUCE DUTIES IN SENATE, HIS AIDES PREDICT

BOWS TO G.O.P. CONCERNS

He Is Now Expected to Wait to Name Running Mate Until the August Convention

By ADAM NAGOURNEY

WASHINGTON, May 14 — Senator Bob Dole has decided to remove himself from his day-to-day duties as Senate majority leader, bowing to a growing concern of prominent Republicans that his legislative obligations are undermining his presidential bid, his aides said today.

And in another critical effort to shape his general election strategy, Mr. Dole has decided to wait until the Republican National Convention in August to announce his running mate. His aides said that decision is expected to end weeks of discussion within his campaign over whether an earlier announcement would give the Senator a political lift before the convention. Mr. Dole's aides said they would prefer a more traditional timetable for an announcement, either at or just before the convention.

In keeping with what Mr. Dole is doing at a news conference for Wednesday in a Senate Office Building, where Mr. Dole has said he might transfer authority to three senior Republican Senators: Trent Lott of Mississippi, the majority whip; Thad Cochran of Mississippi, and Don Nickles of Oklahoma. But one aide said tonight that there was an outside possibility that Mr. Dole, looking to make a dramatic gesture, might decide to relinquish his post as majority leader.

A decision to give up his daily responsibilities in the Senate would be a strategic about-face for Mr. Dole. He has resisted earlier calls for him to leave the post, arguing that the prestige and platform it affords would advance his cash-short campaign. Mr. Dole has been the Senate Republican leader since November 1984.

But his own advisers, as well as Republican governors, senators and party leaders, have concluded that Mr. Dole's original plan to try to run for President from the well of the Senate is unworkable.

Mr. Dole's expected decision comes after what has proved to be a tumultuous five weeks since the Senate came back from its spring break. He had originally hoped to use the Senate floor to display his legislative skills and to force President Clinton to sign or veto a parade of Republican-initiated legislation that could frame the campaign.

Instead, Mr. Dole has found himself mired in legislative battles with Senate Democrats over issues like raising the minimum wage, and he has been linked with unpopular Republican positions in the House. Both those circumstances have, in the view of his aides, contributed to his low standing against Mr. Clinton in early polls.

The sentiment among his aides has been almost unanimous that he

Continued on Page A18, Column 4

Sports of The Times

Struggles Give Way to Gooden No-Hitter

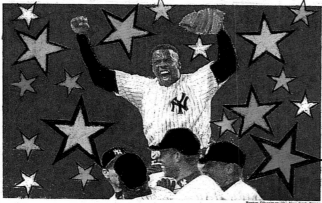

Barton Silverman/The New York Times
Dwight Gooden being carried off the field at Yankee Stadium after pitching his first no-hitter last night.

By DAVE ANDERSON

As Paul Sorrento slugged the pop-up soared into the sky above Yankee Stadium and on into history, and Dwight Gooden soared into the sky with it.

At age 31, after having been suspended throughout the 1995 season for having repeatedly violated his substance-abuse treatment program, after having struggled through spring training after having been on the brink of being released by the team two years ago until David Cone missed a because of what turned out to be a shoulder aneurysm that required surgery, Gooden pitched a no-hitter last night in the Yankees' 2-0 victory over the Seattle Mariners.

"One day at a time," he has often said recently of his struggle with alcohol and drugs for the last decade.

"One day at a time."

And before 31,025 rooters on a cool Bronx evening, it was one out at a time, one batter at a time, one out at a time, one inning at a time. When he watched Sorrento's pop-up settle into shortstop Derek Jeter's glove, he jumped into the air and pumped his right fist.

"I'm dedicating this to my father," he said early later.

"He's having open-heart surgery tomorrow."

His father, Dan Gooden, will undergo surgery in Tampa, Fla., where Gooden was raised.

"Hopefully, he made all day; hopefully, he knows about this," Gooden said, alluding to his father. "This is sweeter than my first victory here. I think this is a great feeling, especially since it happened in New York."

New York was once his, especially in 1985 when he had a 24-4 record with a 1.53 earned run average with the Mets before he began struggling

Continued on Page B13, Column 3

Russian Polls: Mostly Wrong, But the Only Game in Town

By MICHAEL SPECTER

MOSCOW, May 14 — With one month left before this anguished nation chooses its next President, public opinion polls — which have never come close to predicting Russian voting patterns — are now among the country's principal obsessions.

The polls have become so popular and influential, in fact, that they threaten seriously to distort the voting behavior they are supposed to predict.

This week one major poll reported that the Communist Party leader, Gennadi A. Zyuganov, had essentially maintained a 2-to-1 lead over President Boris N. Yeltsin. The same day another equally successful firm reported that Mr. Yeltsin had, for the first time, moved into first place.

"In another country it wouldn't even matter," said Vsevolod Vilchek, director of sociological research for Russian State Television. "But people in Russia trust these polls more than they trust themselves. Everyone is afraid of tomorrow. Everyone is trying to figure out who is the person who will bring the least pain. And I think that these polls are making people's minds up for them."

Even that would not be so bad, Mr. Vilchek and others say, if the polls accurately reflected the moods and desires of voters before what will be only the second presidential election in Russian history.

But they do not, most independent experts agree.

Public opinion is always hard to gauge, and here the results of such questionnaires are often particularly distorted. Even polling professionals admit that the general level of fear, distrust and confusion among voters in Russia today makes it almost impossible to take an accurate snapshot of the electorate.

"You are talking about sampling 30,000 villages and more than 1,000 cities," said Igor Klyamkin, head of the analytical-center at the Public Opinion Foundation. "You must go to places that have for decades despised authority and then ask people their most personal fears about the future. And they are supposed to tell

Continued on Page A6, Column 1

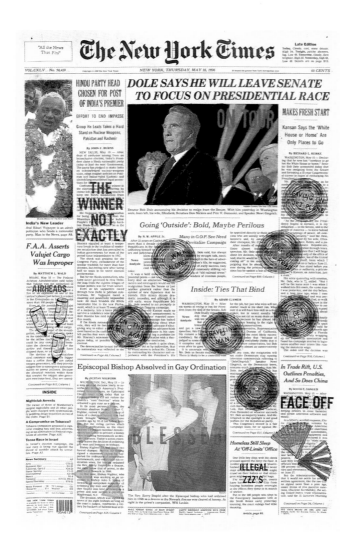

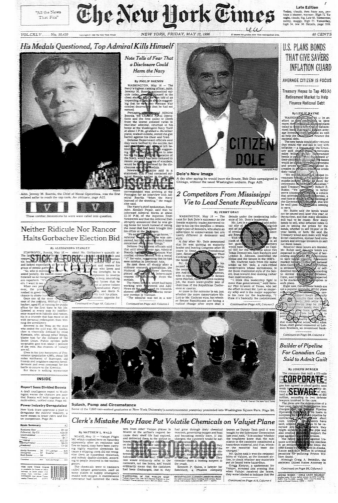

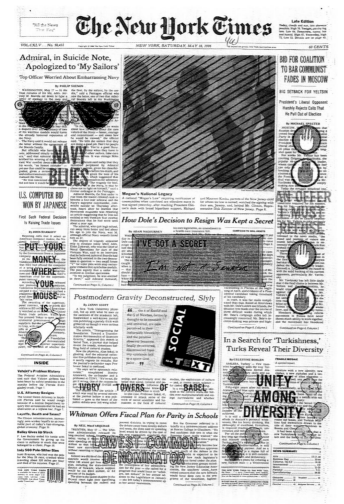

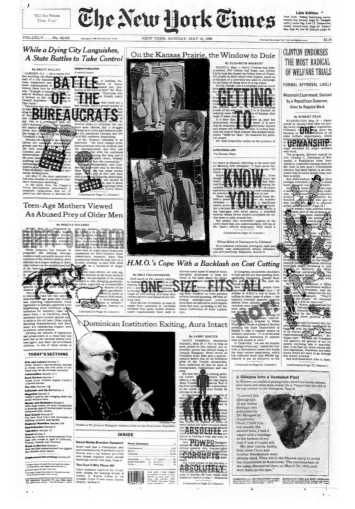

The New York Times

Late Edition
Today, hazy sun, record heat, windy. High 94. Tonight, clear, sultry. Low 75. Tomorrow, hot, humid, perhaps late thunder. High 91. Yesterday, High 89, Low 55. Details, page D10.

VOL.CXLV.... No. 50,433 Copyright © 1996 The New York Times NEW YORK, MONDAY, MAY 20, 1996 $1 beyond the greater New York metropolitan area. 60 CENTS

Hindu Die-Hards Seizing Their Day in the India Sun

By JOHN F. BURNS

NEW DELHI, May 19 — The sun was barely over the smoggy horizon today when a group of men and boys in khaki shorts, brown belts and white shirts lined up in rows of schoolchildren outside turned to face the dawn.

In a ritual repeated in cities and towns across India every morning, the devotees of the group lined up one by one in front of a saffron-colored flag embodying everything sacred to India's 800 million Hindus, and much that is threatening to its 120 million Muslims. Then each man and boy snapped his right arm in a horizontal arc across his chest and bowed stiffly from the waist.

"Long live Mother India!" they shouted.

Among the weather-stained apartment blocks of Noida, a middle-class suburb where the morning drills have become common-

place, the Sanskrit chants, physical exercises and military drills that followed attracted little notice. But among the men and boys on the scrub grass, part of an organization that claims a million members nationwide, there was a sense that on this Sunday morning, at least, their turn had come. On Wednesday, they learned that for the first time in nearly 50 years of independence that it was to have a Hindu nationalist Government. For the nationalist organization that runs the drills, the Rashtriya Swayamsevak Sangh, the summons to the new Prime Minister, Atal Bihari Vajpayee, was a clarion call signifying that a long and often bitter struggle for power had triumphed, if not in quite the decisive way that nationalists had dreamed. With the

Continued on Page A8, Column 5

Hindu nationalist youths on the outskirts of New Delhi, in a morning ritual before carrying out their exercises.

Question at Olestra's Debut: Is the 'Fake Fat' Truly Safe?

By MARIAN BURROS

CEDAR RAPIDS, Iowa, May 17 — For the fourth time in the last month, Kathy Mazzocca, who works as a restaurant hostess here, was buying three large bags of Max potato chips at Randall's, one of the city's better supermarkets. She loves the new chips, she said, because they have no fat, relatively few calories and taste like the real thing.

The chips are made with olestra, the controversial new fat substitute approved in January by the Food and Drug Administration and promoted by its supporters as a near miracle. And indeed, it might help an ever-plumper population enjoy its snack foods without guilt and without fear — except perhaps of some gastrointestinal distress, as the package warns.

Olestra is the first new nutrient to enter the food supply since aspartame was approved more than 20 years ago. And just as that artificial sweetener caused a tidal wave of diet soda sales, olestra could do the same for the country's favorite foods.

Six kinds of Frito-Lay potato and tortilla chips are the first consumer products to be made with olestra. They are being tested marketed in Cedar Rapids, in Eau Claire, Wis., and in Grand Junction, Colo. They are such curiosities that some people are sending them to friends in other parts of the country. And there's a rumor, said Gary McClure, the manager of a Hy-Vee supermarket here, that one store (not his, of course) is selling the snacks in another region. A black market in Max snacks?

Only a sensitive palate could tell the difference between traditional potato chips, which have 150 calories an ounce and 10 grams of fat, and Max brand olestra chips, with 75 calories an ounce and no fat at all.

Still, Procter & Gamble, the maker

Continued on Page A12, Column 1

INSIDE

An Admiral's Albatross
Though Adm. Jeremy M. Boorda was not involved in the Tailhook scandal, at his funeral yesterday there was a sense that the admiral, who committed suicide, was another of its victims. Page B6.

Bid From Taiwan to Beijing
Lee Teng-hui became Taiwan's first elected president and declared in his inaugural address that he was willing to travel to Beijing to talk with China's leaders. Page A3.

Economic Zone Fight
New York City and state officials escalated their public feuding over a stalemate that threatens an urban renewal plan for Harlem and the South Bronx. Page B1.

Dahmer's Macabre Estate
Plans to auction off some of the murderous tools of Jeffrey L. Dahmer, the Milwaukee serial killer, have spawned one of the strangest fund-raising drives ever. Page A10.

KENNEDY AIRPORT IN BIG REVAMPING AFTER LONG DELAY

UPGRADE COSTS $3 BILLION

New Terminals, Rebuilt Roads and a Manhattan Rail Link in 5 Years Are Planned

By JOHN SULLIVAN

In the confident 1950's, New Yorkers would travel to the airport, not to fly but to dine in a glass-enclosed restaurant as airliners lifted into the twilight. The urbane airline traveler didn't now, as harried travelers flee Kennedy International Airport by the quickest means to fight their way home through the endless traffic on the Van Wyck Expressway.

But after 20 years with almost no improvement, New York's primary airport is undergoing a profound transformation. In the next five years, the airport managers and private developers are expected to spend more than $3 billion to replace two aging terminals, rebuild airport roads and parking lots and build a rail line that will ease travel between Kennedy's terminals as well as connect the airport to Manhattan.

In part, the plan is notable simply for its scale: $3 billion is triple what it cost to build the World Trade Center. But also remarkable is that it is a front runner moving forward after more than a decade of inaction.

Plans for major construction at the airport in 25 years, and the plan to build a rail connection has been under study for three decades.

Why now? The money is available, both from fees tacked onto airline tickets and from private developers. And the political climate here, with both city and state agreeing that the revamping of the airport, which was ranked among the worst in the world in a recent survey of passengers, was an embarrassment to New York. The vaguely galling of many New York politicians has been that the Port Authority recent investments is the airport.

Continued on Page A12, Column 1

A Fire-Scarred Tire, An F.A.A. History

Investigators say a partly burned tire from the cargo hold of the ValuJet DC-9 that crashed in the Florida Everglades has been sent to a laboratory for testing to determine whether it played a role in the crash: that one or more of the tires may have been overheated, causing it to being carried as cargo in the unlimited the tire.

As a result, some questions, don't consider the Federal Aviation Administration to have failed to ensure that training are .

Articles, pages B10.

Worst Drought Since 30's Grips Plains

Lewis Mayer surveys his parched land in Oklahoma's panhandle. He fears the drought can only get worse.

Jim Wilson/The New York Times

Phony Polls That Sling Mud Raise Questions Over Ethics

By ADAM CLYMER

SALT LAKE CITY, May 19 — In the 1940's, "twilight fliers" would appear on the eve of an Election Day, anonymously accusing candidates of such sins as having Communist friends, dating Nazis, or conspiring with the Pope.

Politics matches an updated technique for anonymously spreading accusations is a fake public opinion survey, intended not to elicit information from voters but to push them away from supporting a particular candidate.

In these "push polls," pollsters paid by a political candidate give the impression that they are conducting a real poll, when they are actually posing questions that spread doubts about the opponent.

Though these push polls are more typically employed in House races, Senator Bob Dole's Presidential campaign used them in Iowa before the caucuses there, attracting rare public attention to a device that is a descendant of the midnight fliers.

The American Association for Public Opinion Research, an organization of commercial, political and academic pollsters, which is holding its 51st annual conference here, denounced the technique as an "unethical campaign practice" and appealed to its members to report any campaign using the polls.

"We think they hurt our profession," said Diane L. Colasanto, president of the organization. "We think they hurt the political process."

While push polls designed to help Republicans have drawn more attention recently, both parties' candidates use them widely. Publicly, the Congressional Democrats deny that the polls are part of their strategy, while their Republican counterparts will not discuss the subject.

"It's a thoroughly bipartisan form of corruption," said Larry J. Sabato, a

professor of government at the University of Virginia and an expert on the process.

Bill McInturff, a Republican pollster, said at the conference here on Friday that reputable pollsters do not do push polls.

But he acknowledged that when he was polling for Mr. Dole last winter, material that his polls found would damage opponents was then used by telemarketers, also working for the candidate, in push polls. "I didn't want to know," he said.

There seems little likelihood that either professional or public pressure will curb the practice. And despite public disgust with political attack advertisements, the similarly

Continued on Page B7, Column 1

Russians Place Bets On Vote's Future(s)

Mixing politics and financial speculation, Russia's fledgling futures market is wheeling and dealing over next month's presidential election.

The bets are not on who will win, but on the percentage of the vote that the candidates will receive. With a crowded field of contenders and ever-shifting electoral alliances, betting opportunities abound.

But more than stake money. The "president" futures have become influential. Specialists and supporting clients are investing and converting. With a slim but significant challenger in the future, President Yeltsin seems to be the beneficiary of the betting so far.

Article, page A4.

Wheat Farmers and Ranchers Are Ruined

By SAM HOWE VERHOVEK

HARDESTY, Okla., May 16 — Since last October, an average of 2.32 inches of rain has fallen on the wheat fields and cattle ranches that dominate the landscape here in the Oklahoma panhandle — the second driest stretch since the Oklahoma Climate Survey started keeping records 106 years ago.

For 44-year-old Lewis Mayer, that means that his winter wheat crop, which normally would be waist-high and turning from green to gold with the approach of next month's harvest, is about to be plowed under and declared a total loss.

"There's just no rain at all, it's hotter than blazes, all the grass has thinned out, said Mr. Mayer, rumbling some dirt into dust as he knelt to wheat stalks that came up ankle-high weeds at best. "I was a 10-year-old boy in 1935, and I remember it just similar. Very similar."

From Kansas south to Texas, one of the worst droughts on record has pushed thousands of farmers on the Great Plains to the edge of financial ruin and spurred panic selling of cattle in some areas.

Coming after two years of low rainfall and a number of other weather problems, the ferocity of this drought has slowly begun to bring back memories for some here of the Depression-era Dust Bowl.

The Oklahoma Agriculture Commissioner, Dennis Howard, predicted last week that 5,000 to 10,000 of the state's 70,000 farming families would go bankrupt this year because of the drought and record low cattle prices brought on by mass liquidation of some ranchers' herds. Mr. Howard said half the farm families in the state were in "critical or endangered shape," meaning that many in danger of failing to make mortgage or lease payments due the farmer.

In Texas, where the $6 billion cattle industry is the largest of any state, 130 counties have applied for emergency Federal subsidies for ranchers to buy feed, after certifying that at least 40 percent of all pasture land is too arid for grazing. That is the highest number of applications ever in the state, according to the Federal Department of Agriculture.

The starkest reminder of the Dust Bowl's huge dust line soil blowing across the plains, turning day into dusk and making crops suddenly worthless is unlikely to come to pass. That is because of government-mandated conservation measures that started at the end of the New Deal, including year-round, drought-

Continued on Page B8, Column 1

NEWS SUMMARY A2

Watching the Shuttle Soar
The space shuttle Endeavour lifted off early yesterday from Kennedy Space Center in Florida for a 10-day mission. A lone surfer paused south of the space center to catch the view and a wave. Page A11.

Reuters

THE NEW YORK TIMES is available for home or office delivery in most major U.S. cities. Call, toll-free: 1-800-NYTIMES. Ask about Times-media TimesCard.

354613

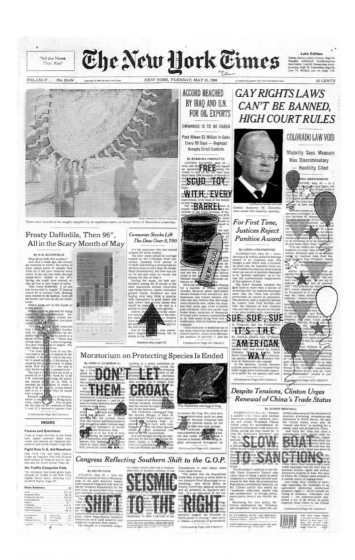

The New York Times

NEW YORK, TUESDAY, MAY 21, 1996

ACCORD REACHED BY IRAQ AND U.N. FOR OIL EXPORTS — EMBARGO IS TO BE EASED

GAY RIGHTS LAWS CAN'T BE BANNED, HIGH COURT RULES — COLORADO LAW VOID — Majority Says Measure Was Discriminatory — Hostility Cited

FREE SCUD TOY WITH EVERY BARREL

For First Time, Justices Reject Punitive Award

Frosty Daffodils, Then 96°, All in the Scary Month of May

Consumer Stocks Lift The Dow Over 5,700

SUE SUE SUE IT'S THE AMERICAN WAY

Despite Tensions, Clinton Urges Renewal of China's Trade Status

Moratorium on Protecting Species Is Ended

DON'T LET THEM CROAK

SLOW BOAT TO SANCTIONS

Congress Reflecting Southern Shift to the G.O.P.

SEISMIC SHIFT TO THE RIGHT

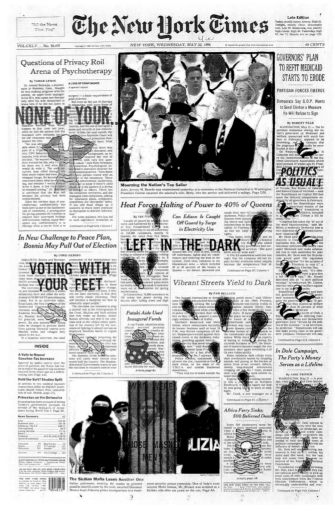

The New York Times

NEW YORK, WEDNESDAY, MAY 22, 1996

Questions of Privacy Roil Arena of Psychotherapy

NONE OF YOUR...

GOVERNORS' PLAN TO REFIT MEDICAID STARTS TO ERODE — PARTISAN FORCES EMERGE

POLITICS AS USUAL

Mourning the Nation's Top Sailor

Heat Forces Halting of Power to 40% of Queens — Con Edison Is Caught Off Guard by Surge in Electricity Use

LEFT IN THE DARK

In New Challenge to Peace Plan, Bosnia May Pull Out of Election

VOTING WITH YOUR FEET

Vibrant Streets Yield to Dark

The Sicilian Mafia Loses Another One

Africa Ferry Sinks; 500 Believed Dead

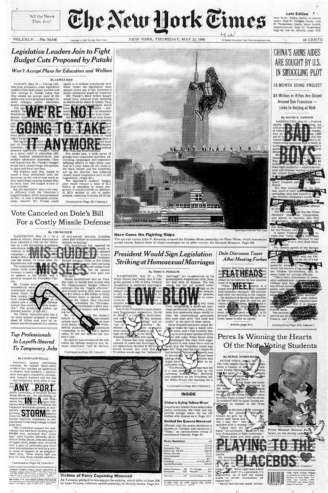

The New York Times

NEW YORK, THURSDAY, MAY 23, 1996

Legislative Leaders Join to Fight Budget Cuts Proposed by Pataki — Won't Accept Plans for Education and Welfare

WE'RE NOT GOING TO TAKE IT ANYMORE

CHINA'S ARMS AIDES ARE SOUGHT BY U.S. IN SMUGGLING PLOT

BAD BOYS

Vote Canceled on Dole's Bill For a Costly Missile Defense

MIS-GUIDED MISSILES

Here Come the Fighting Ships

President Would Sign Legislation Striking at Homosexual Marriages

LOW BLOW

Dole Discusses Taxes After Meeting Forbes

FLAT HEADS

Top Professionals In Layoffs Steered To Temporary Jobs

ANY PORT IN A STORM

Peres Is Winning the Hearts Of the Non-Voting Students

PLAYING TO THE PLACEBOS

Victims of Ferry Capsizing Mourned

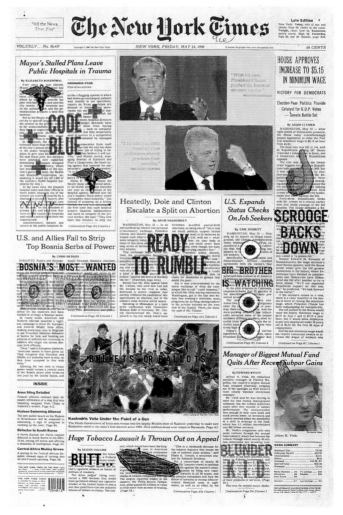

The New York Times

NEW YORK, FRIDAY, MAY 24, 1996

Mayor's Stalled Plans Leave Public Hospitals in Trauma

HOUSE APPROVES INCREASE TO $5.15 IN MINIMUM WAGE — VICTORY FOR DEMOCRATS

CODE BLUE

Heatedly, Dole and Clinton Escalate a Split on Abortion

U.S. Expands Status Checks On Job Seekers

SCROOGE BACKS DOWN

BIG BROTHER IS WATCHING

U.S. and Allies Fail to Strip Top Bosnia Serbs of Power

READY TO RUMBLE

BOSNIA'S MOST WANTED

BULLETS OR BALLOTS

Huge Tobacco Lawsuit Is Thrown Out on Appeal

BUTT

Manager of Biggest Mutual Fund Quits After Recent Subpar Gains

BLUNDER KID

The New York Times

Late Edition
New York: Today, mostly sunny.
High 69. Tonight, clear. Low 51. To-
morrow, becoming cloudy, perhaps a
period of rain, chilly. High 60. Yester-
day, high 76, low 66. Details, page 45.

VOL.CXLV.... No. 50,438 Copyright © 1996 The New York Times NEW YORK, SATURDAY, MAY 25, 1996 $1 beyond the greater New York metropolitan area. 60 CENTS

In Post-Cold-War Washington, Development Is a Hot Business

Foreign Lending Agencies Attract Deal Makers

By JEFF GERTH

WASHINGTON, May 24 — While foreign-policy makers have trouble even defining the post-cold-war era, Washington deal makers have already figured out how to make millions in it.

A cottage industry of consultants, business executives and lobbyists are tapping into one of Washington's least-known pools of money — international development banks. Foreign aid budgets are shrinking, but these banks are growing. Each year the generate some billion in contracts.

And in the Washington tradition of revolving doors, former officials of these banks are taking advantage of the many business opportunities. The institutions themselves are financed in part by American tax dollars, but former officials need not disclose how much they must disclose about their activities.

Those deals often reflect the other new trend of the post-cold-war era: the worldwide embrace of privatization. Big public sector projects that were once undertaken by governments — from airports to water treatment plants — are now often being done by private investors.

"The cold war's demise gave the philosophical underpinning to the earlier support for private intervention," said a former official of the World Bank. The development banks act as "catalysts" for business, he said.

Consider the Inter-American Development Bank, which is owned by 46 nations and aims to reduce Latin American poverty. It recently made available some of its billions of dollars in annual loans to private businesses, following the trend at other international lending organizations.

Last fall the bank entered into a first-of-its-kind alliance with a private group of investors whose advisers include several prominent formers, from Mr. Bentsen, who served as Secretary of the Treasury and was a governor of the inter-American bank.

Now a businessman, Mr. Bentsen and his billion-dollar private investment giant corporation has benefited. They hope to realize profits of as much as 25 percent a year by investing in Latin American power projects, telecommunications systems and toll roads, according to Mr. Bentsen.

In this regard, Mr. Bentsen went last March to attend the inter-American bank's annual meeting. Though he was too busy for sessions when he was in office as Secretary. This year he met with executives of the potential investors who were attending. However, Mr. Bentsen said, he has not been involved in actual negotiations with the bank.

When raising money for its fund, Mr. Bentsen's group makes no announcement.

Continued on Page 6, Column 1

A Few Miles Apart, 2 Russias Contend for Nation's Future

By MICHAEL SPECTER

ST. PETERSBURG, Russia, May 24 — Andrei Valenko decided to buy some art this week. First he thought about a painting but they all looked too abstract to him. Then he settled on a pretty famous print.

"I loved that Lenin the moment I saw it," said the 24-year-old banker after he had paid $300 to a local antique dealer for a deep-red vintage poster of Lenin. It showed him exhorting the masses to fight for the final victory of Communism. "It'll look great in my office."

About 40 miles away in the village of Vosolovo, in the headquarters of a rundown state farm that is struggling simply to feed the families of its workers, there is also a portrait of Lenin. This one is strictly standard issue, the type you could buy for about three cents in Soviet times. The man sitting in front of it, Aleksandr V. Yegorov, proudly calls himself a "red director," and even though he runs this farm, he has

never earned enough money in any year to buy a vintage print of anything.

"You know what this region is called?" he asked, referring to the province surrounding St. Petersburg. "It is called Leningrad. That place [St. Petersburg] for the liberals and the foreigners is called St. Petersburg now. They never change the name. But the peasants here never did change the name. And we never will. Because there is really no reason to be like them."

It is hard to imagine how such fundamentally different ways of life as Communism and capitalism can exist side by side. As the country stands before an epochal presidential election, it is sometimes hard to believe that people from such radically different worlds can all call themselves Russian.

But on a visit to the country's glittering cosmopolitan soul — St. Petersburg — and to the stolid peasant towns that surround it, schizophrenia seems almost understandable. In last October's parliamentary elections, the city voted more heavily for reform and democrats than any place in Russia. The region that surrounded it, however, was overwhelmingly Communist.

St. Petersburg has always been the great European capital of this nation, the place for which Stravinsky, like so many other artists and intel-

Continued on Page 6, Column 3

Ariel Sharon Keeps Talons Very Sharp

Not one for chasing after the "floating vote" with dovish posturing, Ariel Sharon has published a hard-line article in the Israeli press just as the conservative Likud Party candidate, Benjamin Netanyahu, is trying to soften his image before elections next week.

Mr. Sharon, a long-time veteran of wars both political and metaphorical, declared that it was time to dispel the confusion of the Likud's nationalist camp's position in simple language, specifically concerning the Oslo accords, the 1993 agreement to the pact with the Palestinians. Instead, Israeli security forces should operate as they ever should. Keep the Golan Heights and not make peace with Syria.

The whole article, on whether the article was approved by the Likud Party, but it is unlikely Mr. Sharon would have felt bound to seek anyone's approval.

Article, page 3.

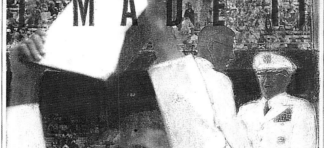

At Annapolis, a Time for Celebration and Remembrance
Kirsten Elstner for The New York Times
Gen. John Shalikashvili, right, Chairman of the Joint Chiefs of Staff, presented diplomas to graduates of the Naval Academy in Annapolis yesterday after paying tribute to the late Adm. Jeremy Boorda. Page 9.

An American Place
Unions Gear Up For Political Fight

National labor leaders have vowed unions will play a historic role in this year's Presidential and Congressional races, and indeed, there is evidence in northeast Ohio that a sizable grass-roots push has begun.

For the United Steelworkers in Canton, and across the country, that means a fax in every union hall as part of their new Rapid Response political action program.

The goal is to have 4 percent of the rank and file ready to mobilize as soon as word comes from international headquarters by fax, whether it's hopping on a bus to send a blizzard of letters to an elected official.

And six months before elections there are already union staff members from Washington working full time in the field on the Republican incumbent. Congress considered until it passed.

Article, page 10.

Sighs Sum Up D'Amato's Verdict As Whitewater Panel Nears End

By FRANCIS X. CLINES

WASHINGTON, May 24 — After 53 public hearings, 264 depositions and $1.3 million in costs and an intense review of Whitewater, if anyone is wearing an air of ambivalent ease with Senator Alfonse M. D'Amato, it is Mr. D'Amato himself.

"No one had much fun working on this, and his surrogate not really on the rise.

"Ah, it was very good, it was successful at this," Mr. D'Amato said of the Democrats' defense of President Clinton, whose own poll standing has resurged despite the inquiry.

"I don't remember, I don't remember, I don't remember," the Senator intoned crankily, offering a contra-like summary of White House witnesses who have frustrated him.

This amounts to high tribute from one of politics' most combative professionals: grudging respect for the White House in managing if not muffling the tangled issue as the November elections approach.

In the dying moments of the laborious process, it is Mr. D'Amato himself who says he has based on his business nature more in the talk of long on smoking-gun certitude.

"It was very good," chant of 'This is nothing more than politics; the hearings have no merit.' They're creating very substantial doubt as to the work and credibility of the committee's efforts.

As the hearing process quietly fades toward a June 17 deadline to produce a report of findings, the final curs have been flaring with Democrats on the rebound. They accuse Mr. D'Amato of presiding over a political witch hunt that proved rank with partisan and little decisive evidence accessible to the average voter.

"The public thinks it's over with this thing," said Christopher J. Dodd of Connecticut, general chairman of the Democratic National Committee and a member of the Whitewater panel. Mr. Dodd has sat across from Mr. D'Amato in counterpoise, a rival Presidential strategist who parses each nuance of testimony as Mr. D'Amato serves as a principal in Senator Bob Dole's campaign.

"The public thinks it's a huge waste of money and time," Mr. Dodd said of the inquiry, citing Democratic polls that he said showed that fewer than 1 in 5 voters were interested.

He said he planned to cite Whitewater in the Presidential campaign as a symptom of "Gingrich-Dole" priorities.

"It's boomeranged on the Republicans," Mr. Dodd said. "The fact that we've spent so much on this and Ruby Ridge and Waco, with virtually no hearings on Medicare, education, the environment, has become a huge

Continued on Page 11, Column 1

Managed Care for Needy: Giuliani's Unrealized Plan

By ESTHER B. FEIN

PROGNOSIS: POOR
Second of two articles.

Mayor Rudolph W. Giuliani's ambitious quest to save the city hundreds of millions of dollars by shepherding most of New York's 1.2 million Medicaid recipients into managed-care plans has not met the administration's forecasts.

The Mayor and his aides took over City Hall in 1994 with bold predictions. By May 1, 1996, they said, more than half the city's Medicaid recipients would be transferred to managed care, a move that would also improve medical care for people who too often depended on emergency rooms for basic medical attention.

But as of this month, less than a third of the city's Medicaid recipients have made the move, and in recent months the trend has been in the other direction, away from managed care.

Health care administrators, industry analysts and government officials — even some members of the administration — are saying that the Mayor's plan was badly planned and too far-reaching.

The city moved management of Medicaid care too quickly to private marketing and to assure that they had enough doctors to handle the patients they were enrolling, and told critics, among them government regulators.

Maria K. Mitchell, the Mayor's chief health policy adviser and the official responsible for the managed-care initiative, strongly defended the program, saying the city moved quickly when abuses

Continued on Page 24, Column 1

NEW ADS TO INJECT ISSUE OF INTEGRITY INTO THE CAMPAIGN

HARSH TONE EARLY IN RACE

Dole's Departure From Senate And Clinton's Military Past Come Under Attack

By JAMES BENNET

WASHINGTON, May 24 — In the kind of broadside attacks usually reserved for the waning days of summer, the Clinton campaign and the Republican Party are preparing to broadcast commercials sharply assaulting the character of the opposition.

With the election more than five months away, the contest increasingly is being waged hourly — between the candidates and between their surrogates.

As recently as Thursday, for instance, the two men engaged in an extraordinarily intense cross-country exchange challenging each other's values and personal integrity, focusing on the issue of late-term abortion.

The new commercials, which essentially trade accusations that two legendary candidates are shirking their duties, continue to raise the living standards already declared themes of the barrage now stretching during the campaign.

In ads that matched finances that more than Mr. Clinton's, Republicans supposed to be broadcast covering half the country, beginning Saturday. By contrast, the Republican National Committee is planning a far more limited but still national run on the Cable networks, beginning Monday.

In announcing its plan to buy time the Republicans are in a bid to step up pressure. journalists have been Democrats scrambling to think that the commercials are nothing more than advertising.

The attacks are the latest in an era of attack ads and expensive air wars waged by both parties, the candidates, and labor unions.

"Is this unprecedented?" Haley Barbour, the chairman of the Republican National Committee, said to-

Continued on Page 10, Column 1

Associated Press
A New Kansas Senator
Lieut. Gov. Sheila Frahm of Kansas was named to fill Bob Dole's Senate seat. Page 9.

Sensing a Shift by Constituents, Legislature Stands Up to Pataki

By RAYMOND HERNANDEZ

ALBANY, May 24 — Martin H. Luster, a four-term Democratic Assemblyman from Ithaca, had a sudden political conversion more than a year ago when his constituents voted overwhelmingly for Gov. George E. Pataki to take over the Governor's mansion.

Days after the election, Mr. Luster telephoned the state's most powerful Democrat, Speaker Sheldon Silver of the Assembly, and urged him not to "obstruct" the new Governor's policies. Then, several months later, Mr. Luster voted for an income tax cut supported by Mr. Pataki — a proposal similar to one that Mr. Luster and other Democratic legislators had blocked for the last five years.

"There was a clear message" in the 1994 elections, Mr. Luster recalled. "We had to take it to heart."

But this year, as the Republican revolution began running into trouble across New York and the rest of the nation, Mr. Luster and many

other Assembly Democrats who had seemed vulnerable if they did not show sympathy toward Republican goals are no longer looking over their shoulders.

Now they are turning against him, showing a new willingness to take a hard line against Mr. Pataki. Even in this year's confrontation over the state budget, some of the more conservative Democratic Assembly members, like William Magee of Oneida and William L. Parment of Jamestown — who were among a group of Democrats who just a year ago appeared poised to bolt from the party to support the Governor's budget — are speaking out against his policies.

The turnabout among these Democrats, as well as many moderate Republicans in the State Senate, helped provide the impetus for the

Continued on Page 25, Column 2

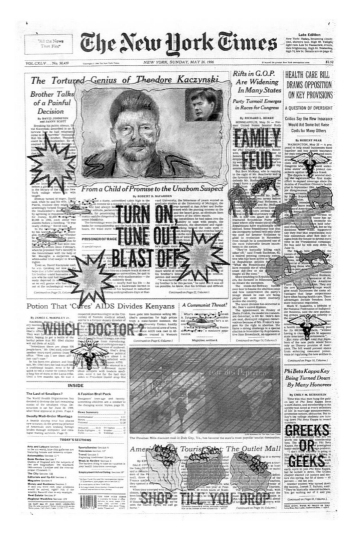

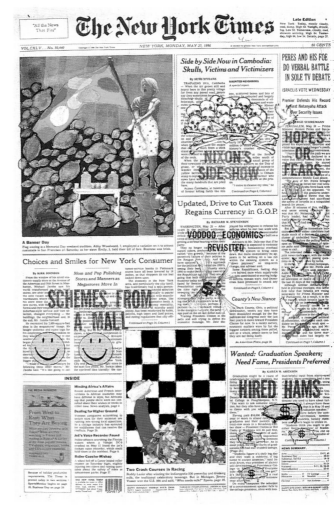

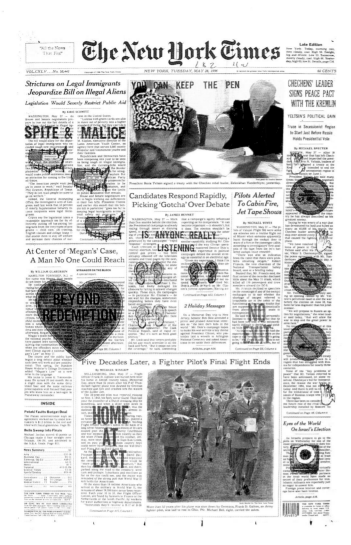
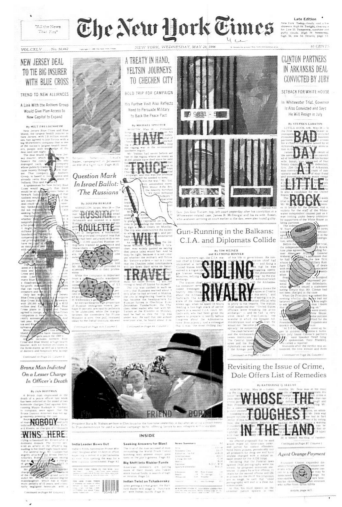
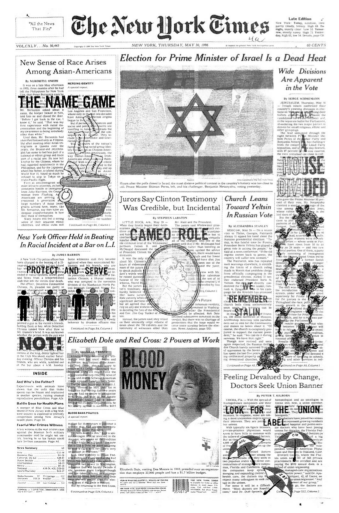
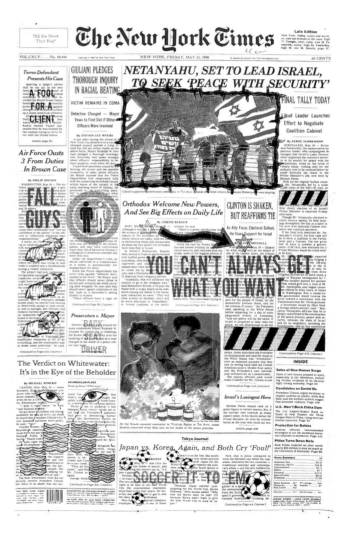

June

The month began with Timothy Leary's death.

From then on we've got everything from nuts to nuts:

the Freemen in Montana, the church burnings,

the Central Park attacker, the Zodiac killer, mad cow disease,

the Dallas cop who tried to kill the Cowboys' Michael Irvin,

and the microbes that invaded the food supply.

Bringing us back to earth was the Gulf War Syndrome

and the Saudi bombing.

"All the News
That Fits"

The New York Times

Late Edition
New York: Today, sunny, warm and dry. High 80. Tonight, clear and cool. Low 61. Tomorrow, mostly sunny, continued warm. High 80. Yesterday, high 77, low 52. Details are on page 44.

VOL.CXLV... No. 50,445 Copyright © 1996 The New York Times NEW YORK, SATURDAY, JUNE 1, 1996 $1 beyond the greater New York metropolitan area. 60 CENTS

Muslims in Sarajevo Take Over Homes of Serbs Who Fled War

A Form of 'Ethnic Cleansing,' Rights Groups Say

By CHRIS HEDGES

SARAJEVO, Bosnia and Herzegovina, M... polit
international... tantamount... expansio... violate... ment, the Muslim-led Bosnian Government has expropriated tens of thousands of homes... who fled during the war... an... driving the Muslims rocketed...

Most of those who fled and are los... their homes are ethnic Serbs or Croats though some are Muslims. But the overwhelming effect of... people have not Serbian or Croatians coming back, help... making... largely Muslim city as... to the melting pot it once...

As families return after fleeing the besieged capital, or after leaving temporarily at the wrong time this year, they find their homes have been taken over by Muslims who were displaced from other parts of Bosnia or by soldiers in the Muslim-led army. Other refugees may never return to Sarajevo when they learn their homes have been taken over.

M... city official in charge of housing the 70,000 or so apartments directly controlled by the government, has little sympathy for the distraught families who clog his waiting room.

"We have 30,000 people in this city who were forced from their homes in areas of Bosnia now controlled by the Serbs and the Croats. These displaced people have no place to live," he said, seated at a small desk covered with papers. "These are the people who we must help, not the people who fled Sarajevo during the war. No one expelled people from

Sarajevo. Those who left abandoned their homes of their own free will, so they have little right...

International monitors have suggested that the actions violate the Dayton accords as well as basic rights.

Frank Raguz, the Organization for Security and Cooperation in Europe, said, "The Government has pushed through a series of laws that are designed to carry out a silent, unseen campaign of ethnic cleansing." Mrs. Raguz, whose office monitors human rights violations, said, "It was mostly Croats and Serbs who fled Sarajevo during the war. And as they return, they find they have no place... This is a direct violation of... gives... the right to go home." Mr. Radanovic, a 41-year-old Bosnian Serb, haunts his old apartment...

Continued on Page 4, Column 1

Serbs Expel Muslims From Part of Bosnia

In what the United Nations call the first case of "ethnic cleansing" since the fighting ended, it was violence by Serbs has forced at least 30 Muslims to flee a town in northern Bosnia over the last few days. The attacks have exposed the inability of international forces to protect Muslim residents and a basic weakness of the peace plan.

Article, page 4.

His Stricken Neighbors Pray For Victim of Beating on L.I.

By LIZETTE ALVAREZ

RIVERHEAD, L.I., May 31 — For the past week, the white two-story house where Shane Daniels lives has been awash with bouquets. Bundt cakes and flowered cards. Every half-hour, the doorbell buzzes, offering up another well-wisher, plate in hand. Former teachers, longtime friends, even the school bus driver who once shuttled the young man to middle school, have called to say, "I'm so sorry. What can I do?"

On Sunday, Mr. Daniels, 21, was beaten so badly outside a nightclub that he was left a whisper away from death in a racially charged attack involving a New York City police detective. His parents, Laura and Curtis, were visiting relatives in Virginia. When the phone call came, they rushed home not knowing what to expect.

Since then, they have spent long days at their son's bedside and at home, responding to the outpouring of affection and sorrow. Curtis Dan-

iels has insisted on going to his construction job every day. So yesterday, he missed the family's visit from Mayor Rudolph W. Giuliani, who flew by helicopter to University Hospital in Stony Brook to offer his sympathy amid criticism of his lax response to the arrest of one of the detectives in the attack. Late last night, a lawyer for a second man arrested in the attack, a 27-year-old college student, said the man would surrender to the authorities today.

Mr. Daniels, the youngest of six children, the one who called his brothers from work just to tell them he loved them, remains in critical though his condition was slightly today.

"We have a feeling that prayer, understanding, love and faith that he will some way or another pull through," said his uncle...

At the Daniels home... careful reminders that... coming home; it's just... when. His compact disc and the Geto Boys — neatly on his entertainment... His Eddie Bauer shirt... folded in a row.

"Mom, did your brother Shell ask..." "He loves that shirt..." And although Mr. Daniels is said to have motivated, his family... avoid turning race... They say they have a... lives keeping racism out of their door, and they want to let it in now. "We don't want... incident was racial..." Daniels said. "But...

Continued on Page 24

Jury in New Jersey Finds Ex-Prosecutor Guilty on 30 Counts

By ROBERT HANLEY

NEWARK, May 31 — A former New Jersey County Prosecutor who fashioned himself as a tough crime fighter with a staunch law-and-order stance was convicted on several charges of fraud and abuse of power and immediately sent to jail.

M... after a... trial... ac... fo... Nicholas L. Bissell of Somerset...

After deliberating about seven hours over two days, a jury of nine women and three men also convicted Mr. Bissell's 42-year-old wife, Barbara, of all 13 fraud charges filed against her in a Federal indictment last September. She was freed on her own recognizance pending sentenc-

Continued on Page 25, Column 4

Unabom Manifesto Echoes 60's Tumult

A look at the famous turmoil in the late 1960's offers intriguing clues to why Theodore J. Kaczynski rejected society and... themes later elaborated in the Unabom manifesto. Ultimately, experts draw links between the 60's and... once a promising mathematician at the University of Michigan and now suspected of being the Unabomber, weathered campus disputes over the Vietnam War, nuclear arms without necessarily...

Article, page 7...

THE NEW YORK TIMES ON THE WEB. "ALL the News..." ... nquee: CyberTimes, news updates, interactive crosswords & forums, searchable classifieds. Now on the Internet at www.nytimes.com — ADVT.

135 EAST 71st ST. HAS BEEN LIBERATED from the cable monopoly! Better building-wide service. Better prices. Call Liberty Cable 212/891-7777—Advt.

THE NEW YORK TIMES is available for home or office delivery in most major U.S. cities. Call, toll free 1-800-NYTIMES. Ask about Transmedia TimesCard. ADVT 354613

WORKFARE RULES CAUSE ENROLLMENT TO FALL, CUNY SAYS

THOUSANDS DROP OUT

Students Are Forced to Choose Assigned Jobs Over School, Or Lose Their Benefits

By KAREN W. ARENSON

New rules introduced by the Giuliani administration that require all welfare recipients to work have led thousands of students and would-be students to drop out of college or not enroll, according to officials at the City University of New York.

The decline in enrollment is significant, CUNY officials say, because studies show that college gives people on welfare a good chance to get better jobs at higher pay. City officials say the job experience is more important.

At CUNY, which has more students on welfare than any other college or university in the state, the number of those students has already dropped 17 percent from 27,000 a year ago. About 22,000 of CUNY's 206,500 students — more than 11 percent — are on welfare.

Although the officials acknowledge that students might be dropping out for other reasons, like rising tuition and shrinking financial aid, they say the vast majority have left because of the welfare restrictions and point out that total enrollment has fallen only 3 percent in the last year.

In addition, CUNY officials say they are seeing sharp declines in the number of students on welfare registering for the fall semester.

Sergio Hernandez, president of the Bronx Community College student government, is one of those who is dropping out. Mr. Hernandez, who has been studying to be a nuclear medicine technician, said he tried to mesh workfare with education but said the workfare assignments conflicted with many of his classes.

"Now I'm dropping out of school and looking for employment," he said. "I'm hurting because I feel the education and the chance to get into this field would have given me a chance to survive in the real world."

W. Ann Reynolds, the CUNY Chancellor, voiced similar concerns this week. "A college education is the surest way of welfare and to a successful life," she said.

But New York City officials say that holding any job — like the street-sweeping and park-cleaning positions —

Continued on Page 25, Column 1

Timothy Leary, Pied Piper Of Psychedelic 60's, Dies at 75

By LAURA MANSNERUS

Timothy Leary, who effectively introduced a generation of Americans to the psychedelic 1960's with the admonition, "turn on, tune in, drop out," died yesterday at his house in Beverly Hills, Calif. He was 75.

He was... his generation with another era, Mr. Leary was very much a man of the moment, and made his dying an act of performance art by having video cameras record it for possible broadcast on the Internet. He had planned a celebration, a listing of his books and lectures, tributes from friends, a listing of his daily drug intake, legal and illegal — from the time he was told last year that he had cancer.

A friend who was at his bedside, said his last thought? Why not?

Zachary Leary said, "He... the quality." A friend who was around him... said: "Yeah. Buy public..." Mr. Leary... em-

Most of all, as... of publicist for psychedelic experience, a career that blossomed in the heady days of the 1960's after he was dismissed from Harvard for his experiments. The phrase "turn on, tune in, drop out" came to him shortly afterward, in the shower, after

Continued on Page 12, Column 1

Timothy Leary

NEWS SUMMARY 2

Arts 13-17,20,47
Business Day 31-44
Editorial; Op-Ed 18-19
International 2-7
Metro 21-25
National 8-11
SportsSaturday 26-30
Obituaries 12 Weather 44
TV Listings 48
Classified 45 Religious Services 11

NETANYAHU NARROW VICTOR; SETS OUT TO FORM A CABINET AND ASSURE ARAB NEIGHBORS

NO. 1 BARELY

Benjamin Netanyahu greeting followers outside his home in Jerusalem. Associated Press

The 'American' Premier
Benjamin Netanyahu

By SERGE SCHMEMANN

JERUSALEM, May 31 — In a conversation with Israelis about Benjamin Netanyahu inevitably turned around to how "American"...

Some say it with admiration, with disdain... of his American... his American... his Kennedy-... the American name once tried — Ben Nitay.

Man in the News

Above all they talk about his mastery of "American-style" politics, by which people here mean his mastery of pungent sound bites and packaged issues. That Mr. Netanyahu's image was massaged by an American, Arthur Finkelstein, came as a surprise to no one.

But behind Mr. Netanyahu's made in U.S.A. facade is a very Israeli core, a native "sabra" reared on militant Zionism, honed in an elite commando unit, and chary of ever giving an inch to enemies, whether political or Arabs.

His heritage: his father, the historian Benzion Netanyahu, an ardent follower of the right-wing school of Zionism as early as 1925 that the Jewish claim to the entire Land of Israel was unassailable and nonnegotiable, and his brother, Yonatan Netanyahu, who died leading the commando rescue of Jewish hostages at Entebbe, turned him into an hero.

The question from now that the 46-year... he is universally... been chosen by Israelis to lead them through the end of the century, is whether his comforting talk of continuing his predecessor's pursuit of peace, albeit with more concern for security, is only an "American"

Continued on Page 6, Column 1

TALKS TO MUBARAK

Israeli's Associates Say Top Ministers Will Be Likud Moderates

By SERGE SCHMEMANN

JERUSALEM, May 31 — Confirmed as the winner in Israel's leadership race by the narrowest of margins, Benjamin Netanyahu turned today to the task of reassuring anxious neighbors and sifting candidates for his new Cabinet.

After counting absentee ballots through... of the day, the Israeli Election Commission finally declared Mr. Netanyahu the winner over Prime Minister Shimon Peres by 29,457 votes, 1,501,023 to 1,471,566.

Mr. Netanyahu made a victory statement, and his victory address is not expected until Sunday evening. But his associates reported that he had talked by telephone with President Clinton, who invited him to Washington, and that Mr. Netanyahu had telephoned the leaders of Jordan and Egypt.

His associates said the Prime Minister-elect candidates for the key ministries of Foreign Affairs and Defense would be men from the moderate wing of the conservative Likud party.

Given the closeness of the vote, the last-minute endorsement of several ultra-Orthodox rabbis probably gave Mr. Netanyahu... a gesture... over the Orthodox... Mr. Netanyahu... a black yarmulke on his head, made a stop today to pray at the Western Wall.

The tightness of the race was underscored by the fact... 3,000 voters had cast blank... Prime Minister, indicating... enchantment with both candidates.

About 12,000 of those were cast by Arabs, many presumably to register their anger over the Israeli military operation in Lebanon last month.

Election Commission also confirmed a new Parliament in which small parties will hold almost half the seats and religious parties will have an unprecedented representation, with more than a third of the votes.

The official count cleared Mr. Netanyahu, who at 46 will be Israel's youngest Prime Minister, to start shaping a coalition in Parliament and forming a Cabinet. Only when a Government is accepted by Parliament will he be formally sworn in, the eighth person to serve as Prime Minister since the founding of the state in 1948.

Mr. Peres also... for Mr. Netanyahu to congratulate... Mr. Peres gave no indication of his own plans, but speaking briefly to reporters outside his office, he vowed to remain true to the peace effort with the Palestinians that he and his predecessor...

Continued on Page 6, Column 1

Secretary Brown Insisted on Flight Despite Storm Risk, a Friend Says

By PHILIP SHENON

WASHINGTON, May 31 — Only hours before his death in a plane crash on a storm-shrouded mountaintop last month, Commerce Secretary Ronald H. Brown, a former businessman who had overruled staff members who were worried about his plans to fly into Croatia because of treacherous weather, the former business partner said today.

Nolanda S. Hill, whose business partnership with Mr. Brown, said he had realized the risks and could not wait, because of the importance of the trip... to... American investment in the...

Ms. H... suggested... despite... that ended with... death and that of the 34 other passengers on the military version of the Boeing 737.

"I begged him not to go, but he said, 'No,'" Ms. Hill said of her final conversation with Mr. Brown, which she said had taken place over a satellite telephone while he was in Tuzla,

Bosnia, on April 3 and was only minutes away from boarding the plane in... "He never let anybody... his work... He would never let anybody... stop him."

Ms. Hill's assertion that Mr. Brown was speaking out in defiance of three Air Force officers who were disciplined because they failed to order safety inspections before the crash.

"It was their decision," said Ms. Hill, who... her long...

Continued on Page 11, Column 1

INSIDE

Emotional Appeal by Yeltsin
Saying he felt their "pain," President Boris N. Yeltsin made an emotional appeal to Russian voters in his campaign platform. Page 3.

Uneasy Co-Hosts for Soccer
The World Cup for 2002 was jointly awarded to traditional enemies, Japan and South Korea. Page 27.

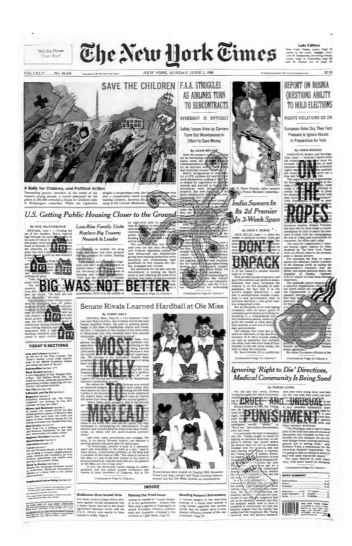
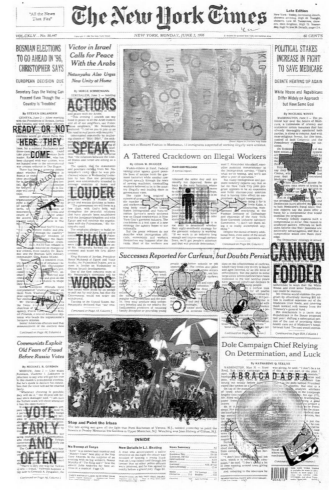
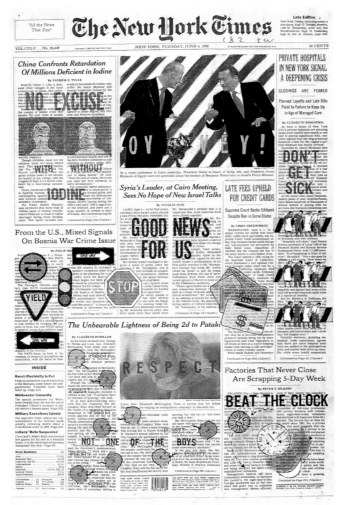
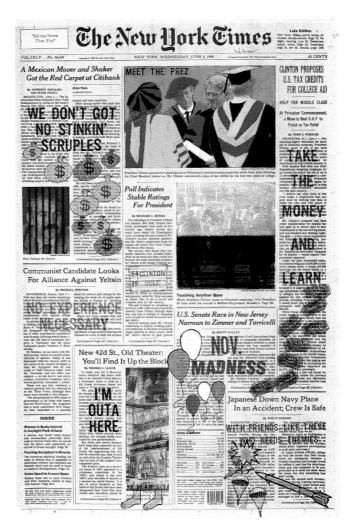

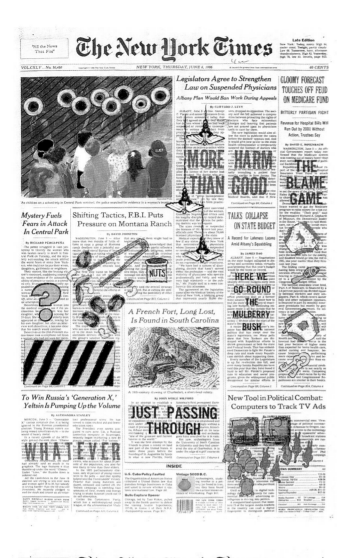

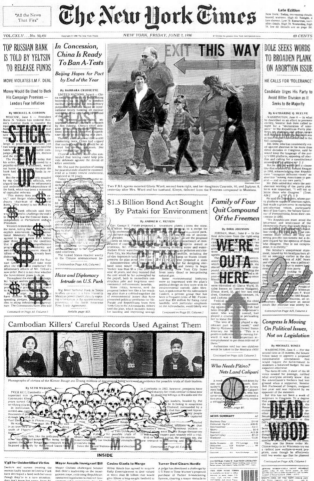

The New York Times

"All the News That Fits"

VOL.CXLV .. No. 50,452 Copyright © 1996 The New York Times *NEW YORK, SATURDAY, JUNE 8, 1996* $1 beyond the greater New York metropolitan area. **60 CENTS**

Late Edition
New York: Today, hazy sun, humid, coastal fog. High 80. Tonight, foggy, warm. Low 70. Tomorrow, chance of thunderstorms. High 82. Yesterday, high 76, low 63. Details on page 44.

Police Identify Comatose Victim In Brutal Attack in Central Park

A Quiet Life Built Around Music and Writing

By ROBERT D. McFADDEN

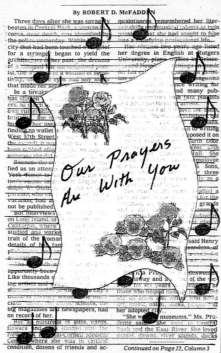

Our Prayers Are With You

HEALTH CARE BILL FAILS OVER DISPUTE BETWEEN PARTIES

REPUBLICANS ALSO SPLIT

Dole Enters Talks on Measure to Make It Easier to Keep Insurance in New Job

By ADAM CLYMER

WASHINGTON, June 7 — Health insurance legislation, hailed six weeks ago by Senator Bob Dole as proof that Congress could overcome election-year partisanship, died today on sharp disputes among Republicans and between Republicans and Democrats.

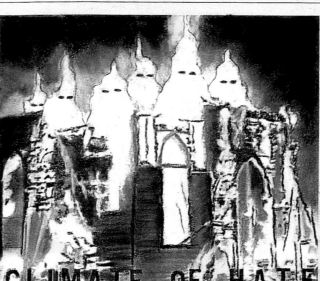

CLIMATE OF HATE

Another Fire at a Southern Black Church
Arson destroyed a 93-year-old sanctuary at the Matthews-Murkland Presbyterian Church in Charlotte, N.C., on Thursday. It was the 30th such burning in a year and a half at black churches in the South. Page 6.
NBC News via Associated Press

A Surge in Jobs Shows Strength In the Economy

By ROBERT D. HERSHEY Jr.

'G.O.P. Peace' Candidate

Dole, in Urging Civility, Is Seeking to Avoid Damage of a Divisive National Convention

By R. W. APPLE Jr.

DON'T TELL WALL STREET

Russia Vote Is a Testing Time For a Key Friend of Clinton's

By STEVEN ERLANGER

GROUND CONTROL TO STROBE

Deputy Secretary of State Strobe Talbott at a meeting this week.
Associated Press

Tree That Grew in Brooklyn Is Dying All Over New York

LOST SYMBOL

A drawing of leaves from Ailanthus altissima, the tree of heaven.
From "North American Trees" (M.I.T. Press)

Ex-Governor of Colorado Hints at Perot Party Bid

By ERNEST TOLLERSON

INSIDE

Monitor Resists Deadline For Election in Bosnia

Pentagon Reports on Crash
Air Force operations were ruled a factor in the crash that killed a Cabinet member and 34 others. Page 10.

Bulls Lead Finals, 2-0
Michael Jordan scored 29 points to lift Chicago over the Seattle SuperSonics 92-88. Page 27.

92

The New York Times

VOL.CXLV...No. 50,453 Copyright © 1996 The New York Times NEW YORK, SUNDAY, JUNE 9, 1996 $3 beyond the greater New York metropolitan area. $2.50

Late Edition

New York: Today, hazy, very humid, isolated thundershowers. High 86. Tonight, muggy. Low 72. Tomorrow, humid, a few storms. High 84. Yesterday, high 84, low 69. Details, page 48.

A striped bass caught near 125th Street in Manhattan is but one of many signs that efforts to clean up the Hudson are finally bearing fruit.

Suzanne DeChillo/The New York Times

Shaking Off Man's Taint, Hudson Pulses With Life

By WILLIAM K. STEVENS

A RIVER RECLAIMED
First of two articles.

Reversing Pollution's Toll

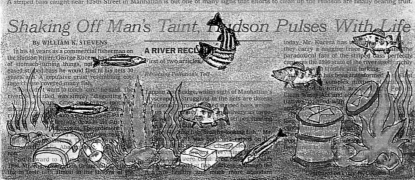

In his 40 years as a commercial fisherman on the Hudson River, George Kucera eased striped bass he would find in his nets 30 years ago. "A repulsive crust resembling cottage cheese covered many fish.

"I didn't want to touch 'em," he said. The fish, which died, was simply "disgusting."

Fast forward to 1996. Mr. Kucera, now almost in the shadow of the...

Dole and Clinton Refocus On Tax Cuts as an Option

Proposals Differ but Share Political Appeal — Many Economists Have Doubts

By ALISON MITCHELL and DAVID E. ROSENBAUM

WASHINGTON, June 8 — When President George Bush broke his "Read my lips, no new taxes" pledge in the spring of 1990, many Republicans lamented that he had handed away the Reagan legacy.

Two years later, Mr. Bush was defeated by Bill Clinton, a Democrat who ran on a platform that promised tax breaks — a middle-class tax cut he called — but Mr. Clinton, too, turned around once in office, and put into place a deficit-reduction plan that included large tax increases.

Now, as the 1996 Presidential campaign moves into its final five months, both parties are once again homing in on tax cutting as a far more appealing economic theme than deficit reduction. President Clinton hopes to avoid the label that Republicans like to pin on Democrats. And Republicans want to return to the theme that proved so successful for them under Ronald Reagan.

Aiming to unveil an economic plan around the time of the Republican convention, advisers to Senator Bob Dole are drafting a tax plan they hope will be as bold and popular as Mr. Reagan's call in 1980 for an across-the-board tax cut. The problem is to do so without making a mockery of Mr. Dole's long record of fighting doggedly for deficit reduction.

Meanwhile, launching a series of pre-emptive strikes, Mr. Clinton has thrown his support behind Republican proposals for a repeal of the gasoline tax increase he sponsored in 1993 and for a tax credit to help offset adoption expenses. He has also called for small businesses to receive a 10 percent income tax credit for employee education and training.

Last week, after a struggle inside his Administration, Mr. Clinton came out with a tax credit proposal designed to make two years of community college virtually free for those who maintain good grades.

Although neither side in the Presidential campaign has tipped its hand completely on tax policy, a clear policy choice seems to be emerging.

Mr. Clinton advocates limited tax breaks designed to assist the middle class and the working poor with special attention to child rearing, job training and education.

Mr. Dole has already proposed a $500-a-taxpayer tax break for contributions to charities that help poor people. But, seeking to draw a sharp distinction with Mr. Clinton, he is also planning far more sweeping proposals, everything from an across-the-board income tax cut to some kind of tax system with fewer brackets and lower rates. He has said that the country should "scrap the current tax code and start again from scratch."

While candidate Dole defies raise doubts among many mainstream economists. In Mr. Clinton's case, the analysts say that tax breaks are an inefficient way to accomplish social goals like better education. In Mr. Dole's case, they worry that politically acceptable spending cuts could never be found to offset large tax cuts and that the consequence would be the reversal of progress that has been made in deficit reduction.

Ross Perot, the Texas billionaire, this week upbraided both men for their tax cut fever. "Take a poll, find out what you want to hear and tell you got elected and don't do it," he said.

But the political appeal of tax cutting is apparent.

"I hear from polling that if you have a candidate who for some kind of tax cut against a candidate who opposes any tax cut in the name of deficit reduction, the candidate who opposes the tax cut loses," said one Democratic consultant. "At a strategic level, it's very important not to fall into the trap."

From the Republican perspective, Senator Spencer Abraham of Michigan, a close associate of Senator Dole's, said: "I want to have a tax debate. I think it will help focus the

Continued on Page 28, Column 1

NEW FILES PROVE VIETNAM COVER-UP

U.S. Military Lied to Families on Deaths of Secret Agents

By TIM WEINER

WASHINGTON, June 7 — Newly declassified Government documents prove that the United States, after sending hundreds of Vietnamese commandos into North Vietnam during the 1960's, deliberately declared them dead to cover up the history under a shroud of secrecy.

Nearly all of these secret agents survived capture, many in prison and are alive in the United States. They are asking the Government for back pay — $2,000 a year, without interest, for their prison time — and help in settling fellow commandos out of Vietnam.

The documents, stamped "secret" or "top secret," were declassified on Wednesday after 14 months of news reports, diplomatic cables and legal documents supporting the commandos' claims. They show how the United States, after training the commandos and sending them into North Vietnam on sabotage missions, literally wrote them one off, scratching their names one by one from a classified pay list.

Other documents greatly exaggerated reports of the deaths of a commando team code-named Scorpion. Radio intelligence — and the C.I.A. recorded — that Scorpion's members were captured alive in June. Nonetheless, the State Department, falsely, paid their wives or families a death gratuity of about $4,000 and tried to...

MISSING AND PRESUMED EXPENDIBLE

Continued on Page 16, Column 3

INSIDE

Clinton Orders Actions Against Black Church Fires
President Clinton ordered Federal initiatives to investigate and combat a wave of suspicious fires at black churches in the South in recent months, including a 24-hour toll-free telephone number for the public to report tips. Page 27.

China Conducts Atomic Test
Two days after China announced it was softening its stance on nuclear tests, it conducted one and said it would stage another before joining an international ban. Page 14.

Graf Wins French Open
Steffi Graf defeated Arantxa Sánchez Vicario, 6-3, 6-7 (4-7), 10-8, yesterday in the French Open final even though the Spaniard twice served for the match. SportsSunday, Section 8.

Warning Israel, Arab Chiefs Set Summit Session

By DOUGLAS JEHL

DAMASCUS, Syria, June 8 — In a firm message directed at Israel's new conservative Government, leaders of Egypt, Syria and Saudi Arabia announced plans today to convene the first Arab summit meeting in six years and to recommit themselves to a peace with Israel.

In a joint communiqué, the leaders declared peace in the Middle East would be achieved only if Israel's new leaders would "put Israel in confrontation with the international community," representing a genuine threat to relaxing the region to the cycle of violence and instability.

The large-scale meeting of Arab leaders, to be held in Cairo from June 21 to 23, would be the first since shortly after Iraq invaded Kuwait in August 1990. The support voiced for it here underscored the depth of Arab apprehensions about Israel's new course.

Arab diplomats have made plain their hope for a show of renewed Arab unity as a counterweight to Prime Minister-elect Benjamin Netanyahu of Israel and his apparent intention to slow the pace of peace between Israel and its Arab neighbors.

The announcement of the meeting came at the end of a one-day meeting here among President Hafez al-Assad of Syria, President Hosni Mubarak of Egypt and Crown Prince Abdullah of Saudi Arabia. After the meeting one of the Syrian officers in the aftermath of the negotiations.

In elaborating on the decision, Foreign Minister Amr Moussa of Egypt pointed to what he called disturbing...

ALL TOGETHER NOW

Continued on Page 12, Column 1

In Russia's Science City, Voting for Past Glory

By MICHAEL SPECTER

AKADEMGORODOK, Russia, June 7 — It has been four decades since they carved this gentle haven for scientists from the deep stands of birch and poplar that sweep across the Siberian plain. It was to be a city like no other in the workers' paradise, a place where the unfettered ideals of socialism would fuel the quest for perfect truth.

For a while, it seemed to work. Nikita S. Khrushchev, who created this science city, spared nothing to make certain that the finest Soviet minds were freed from the worries of the common man. He let researchers drive about in 3,000 miles of Moscow's ability to ask for equipment. Ex any every train. As institutes sprouted among the blooming lilacs, thousands of idealistic men and women rushed to fill them.

"It was the most beautiful time of our lives," said Masha Pivtich, an engineer who retired in 1962, when she to the job known as the new institute of Hydrodynamics. "It was like a religion to us then. We believed so very deeply in everything we did."

"Beliti" is a word that does not come with in Akademgorodok these days. As a center of science the city is still a lovely contrast to grim Novosibirsk, 25 miles away. But only half of the scientists here can afford the past few years, many people who can afford liberal wash-room who drive cars with wood-frame windows. With federal resources less than a tenth of what they were a decade ago, the staff of each institute have tried to integrate some of the 15,000 scientists who...

"We need something back," said Mrs. Pritvich, who, like many of her colleagues, says she will vote with reluctance for the Communist leader, Gennadi A. Zyuganov, in the presidential election on June 16. "I am not a fool who thinks things will be better than the future. But Mr. Yeltsin has let them sell our country and I would like it to stop."

Strange as it may seem, this quintessential fortress of intellectual rigor, where the liberal economic policies of perestroika were born, will

Continued on Page 16, Column 3

TODAY'S SECTIONS

The New York Times Magazine

PICTURES

Magazine/Section 6
In the second of three centennial issues this year, The New York Times Magazine today looks back on the array of pictures it has published since 1896. Adolph Ochs created the magazine then as a place to present writing and photography. The issue presents 68 pictures, chosen from about 100,000, reflecting documentary photojournalism, portraits, wit, style and social commentary.

There have been many technological changes in photography since the magazine began, but as these pictures demonstrate, the more important transformation has taken place behind the camera. Photographers once said, in effect, "This is what it looked like." Increasingly, photographers like Sebastião Salgado, Susan Meiselas, James Nachtwey and others among the 54 represented have said, "This is how I saw it."

Arts and Leisure/Section 2
How do you make a museum blockbuster? The Winslow Homer exhibition that will arrive at the Metropolitan this month is a result of a five-year adventure: part treasure hunt, part research project and part diplomatic exercise.

Automobiles/Section 11†
Book Review/Section 7
The City/Section 13§
Editorials and Op-Ed/Section 4
Money and Business/Section 3
What is the right way to approach China? Boeing and Microsoft illustrate opposite strategies.

Real Estate/Section 9
Development dreams of the 80's change to reflect realities of the 90's.

Regional Weeklies/Section 13¶
SportsSunday/Section 8
Television/Section 12*
Travel/Section 5
Getting away for a weekend to Cape May, N.J., to watch birds or just amble around; Puget Sound, Wash., to explore the San Juan Islands, and Newport, to recall the age of the grand cottage.

Week in Review/Section 4
Why don't travelers see ads for "America's safest airline"? Because there is no "safest," and one of the few chance accidents could happen to any of them.

Employment Advertising/Section 10*

In New York City and the metropolitan region.
(† Elsewhere, autos/pages are in section 3.)
§ In most parts of New York City.
¶ In Long Island, Westchester, Connecticut and central and northern New Jersey.

HOPE SPRINGS ETERNAL

Paul Hosefros/The New York Times

Stopping Short of 'No'

At a fund raiser for Senator John W. Warner yesterday, Gen. Colin L. Powell left a question mark in the air by not repeating his usual answer when asked about running for Vice President with Bob Dole. Page 30.

DAILY INTRIGUE, INFO, HOROSCOPES and more at http://www.nytsplustics.com — ADVT.

THE NEW YORK TIMES is available for home or office delivery in most major U.S. cities. Call, toll-free, 1-800-NYTIMES. Ask about TimesCard.

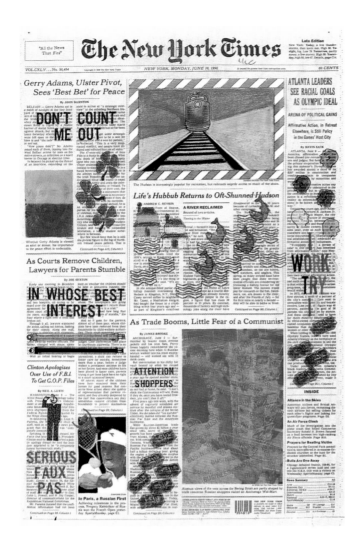

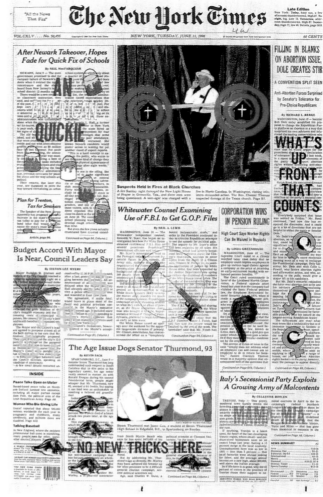

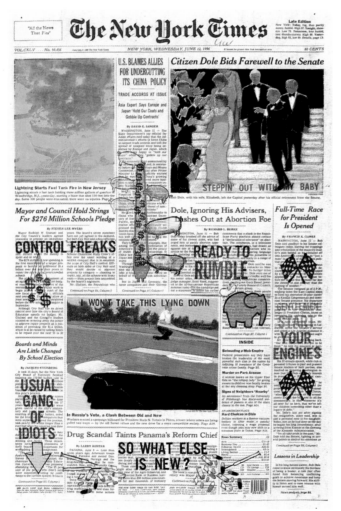

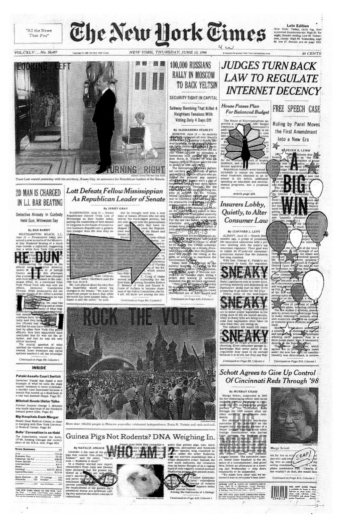

The New York Times

Late Edition
New York: Today, morning clouds, humid, then sunny, hot. Thunder. High 90. Tonight, clear. Low 68. Tomorrow, sunny. High 86. Yesterday, high 80, low 68. Details appear on page D18.

VOL.CXLV.... No. 50,458 Copyright © 1996 The New York Times **NEW YORK, FRIDAY, JUNE 14, 1996** $1 beyond the greater New York metropolitan area. **60 CENTS**

Man Said to Admit a Week of Attacks

Tied to Killing and to Central Park Crime

By RICHARD PÉREZ-PEÑA

A rootless 22-year-old man whose only criminal record was for jumping a subway turnstile confessed investigators to the killing of a dry cleaner and to the beating of a woman in Central Park and brutal assaults on two other women, law-enforcement officials said yesterday.

The reported admissions by John J. Royster, whom detectives described as mentally disturbed, turned what had seemed to be four similar but unrelated attacks on women into an apparent eight-day spree of savagery, a set of events that caught even hardened investigators by surprise.

At a City Hall news conference last night, Mayor Rudolph W. Giuliani said that all four attacks had been solved with the arrest of Mr. Royster.

District Attorney Robert M. Morgenthau of Manhattan, speaking at the same news conference, said that Mr. Royster would be charged with first-degree murder in the killing of Evelyn Alvarez on Tuesday, raising the possibility that he could face the death penalty.

Mr. Morgenthau and Jeanine F. Pirro, the Westchester County District Attorney, said Mr. Royster would face additional charges in the attack on Mrs. Alvarez and in a Central Park case that included sexual assault of a jogger and in the attacks on June 7 and 11 of a woman at 63d Street and Park Avenue in Manhattan.

Mr. Morgenthau said police officials said that fingerprints found at the scene of the slaying of Mrs. Alvarez, 65, on Park Avenue near 88th Street, led them to Mr. Royster. The prints matched those taken from Mr. Royster after a far-reaching arrest in March, the officials said, and detectives found him last Wednesday night at a row house in the Bronx.

One detective said, on condition of anonymity, that after Mr. Royster was taken to a police station and questioned about the death of Mrs. Alvarez, "he asked to pray," so his interrogators left the room. "He prayed and meditated," the detective said. "We came back in and he said, 'O.K., I'm ready.'" He confessed to them all.

Mr. Royster gave details of all four crimes, but the assailant would know, investigators said, but they would not give examples. A detective said that Mr. Royster had confessed to many other crimes, as well, and that those claims were still being investigated.

Mr. Giuliani and law enforcement officials at the news conference would not confirm or deny that Mr. Royster had confessed.

The Mayor used the news conference to heap praise on the Police Department. "Tonight, we really announce a stunning achievement of the very best in investigatory work," he said.

Police Commissioner Howard Safir

Continued on Page B5, Column 1

Chang W. Lee/The New York Times
John J. Royster of the Bronx, the suspect in a slaying on Park Avenue and beatings in Central Park and Yonkers, in police custody yesterday.

For Suspect, a Nether Life Spent on Fringes of the City

By N. R. KLEINFIELD

He lived around and tattered life of need on the fringes of the city, but mostly he seemed to occupy some other world accessible only to himself.

Jobless, he never moved through the universe of home business and food stamps and city refuges in a solemn and circumscribed nether life. He is a man who appeared to avoid hitching much to anyone, who up to yesterday had never been accused of a serious criminal act beyond vaulting a subway turnstile.

But the police said yesterday he has confessed to a string of four brutal crimes accomplished over eight days, including the beating and attempted rape of a piano teacher in Central Park and the slaying of a Park Avenue dry cleaner.

Mr. Royster, a lanky 22-year-old who is 6-foot 10 and weighs 140 pounds, gravitated among residences in Manhattan, Brooklyn and the Bronx, and apparently the unmapped addresses of homelessness.

"I could best way to describe him as a transient, is as a transient," said Police Commissioner Howard Safir. "He moved around a lot."

What remains elusive is the trigger point for this compressed crime spree. While Mr. Royster's recent life had demonstrated few glimmers of promise or satisfaction, no one was able to readily point to any convulsive moment that might have abruptly transformed him.

Lucy Ortiz, an elderly woman who lives in the apartment home in the University Heights section of the Bronx, said he used to take and sell prescription medication, possibly an antidepressant, on the street. She once asked him where he got it from, and she said he answered, "From a doctor."

His arrest interrupted an effort to begin canvassing for the Sierra Club. The club uses a vendor called the

Continued on Page B4, Column 1

U.S. Grants Asylum to Woman Fleeing Genital Mutilation Rite

By CELIA W. DUGGER

The highest administrative tribunal in the United States immigration system granted political asylum yesterday to a 19-year-old woman from Togo who said she had fled her homeland to escape having her genitals cut off.

The decision of the Board of Immigration Appeals in the case of the woman, Fauziya Kasinga, is its first recognition of genital mutilation as a form of persecution and a basis for asylum. The rite has been practiced on millions of women in 28 African countries.

The ruling is a precedent that is binding on the 179 immigration judges across the country. The few who have heard such cases have been divided in their decisions.

The board, part of the Justice Department, reversed the decision of the Immigration and Naturalization Service, also part of the department. It had argued that although genital mutilation should not be a reason for granting asylum in carefully defined circumstances, Ms. Kasinga's case should be sent back to an immigration judge to consider what the service said were inconsistencies in her story and new testimony from an expert on Togo.

Immigration law calls for asylum to be granted to people who can show

Continued on Page B2, Column 6

Associated Press
Fauziya Kasinga

LAST OF FREEMEN SURRENDER TO F.B.I. AT MONTANA SITE

81-DAY 'SOFT SIEGE' ENDS

Government's New Tack After Branch Davidian Disaster Proves to Be Success

By CAREY GOLDBERG

JORDAN, Mont., June 13 — The last 16 members of the anti-government Freemen turned themselves over to Federal agents tonight, ending one of the longest sieges in law enforcement experience enforcement so peacefully that the surrender did not even disturb the cattle grazing as the group's remote Montana ranch.

After 81 days of resistance, the members of the law-flying group simply drove into Government vans that were to take them to Billings, Mont., to face the very legal system they had declared they did not apply on their land.

Fourteen of the 16 will face charges by the Federal and United States Attorney John P. Matteucci. Members of the group are accused of threatening Federal officials and of defrauding banks and businesses of as early as Friday.

Top Federal officials said the resolution of the standoff without bloodshed was a vindication of their reduced 1993 assault on the Branch Davidian compound in Waco, Tex., by emphasizing patience and accepting help from an array of private citizens.

"The power of patience at the Federal Bureau of Investigation," said the Director of the Federal Bureau of Investigation to reporters. "It was a model of patient, honest and persistent attempts at negotiation ultimately prevailed."

The demise of the small republic the Freemen had christened Justus Township also delighted the group's long-suffering neighbors, many of whom saw the anti-tax protesters with their white supremacist beliefs as parasites and threats.

"My God, it's finally over!" exclaimed Ruth Coulter, a postal carrier and rancher. "And nobody got killed! Wonderful. Wonderful!"

The surrender took the form of a

Continued on Page A22, Column 1

HIGH COURT VOIDS RACE-BASED PLANS FOR REDISTRICTING

Justices Uphold Patient Privacy With Therapist

By LINDA GREENHOUSE

WASHINGTON, June 13 — Finding that the confidentiality of psychotherapy serves important public as well as private interests, the Supreme Court ruled today that Federal courts must allow psychotherapists and other mental health professionals to refuse to disclose patient records in judicial proceedings.

By a vote of 7 to 2, the Court created a new evidentiary privilege, in both civil and criminal cases, similar to the lawyer-client and marital privileges the Federal courts have recognized for years.

The decision, written by Justice John Paul Stevens, brings the Federal courts into line with the 50 states, all of which recognize some type of therapist-patient privilege.

The Court's new rule, which now becomes part of Rule 501 of the Federal Rules of Evidence, is more inclusive than some of the state privileges in extending the rule to cover clinical social workers.

The decision upheld a ruling by the United States Court of Appeals for the Seventh Circuit, which last year applied a psychotherapist-patient privilege in the Federal courts of Illinois, Indiana, and Wisconsin. The Federal appellate circuits have been divided on the question. The Second Circuit, which covers New York, Connecticut and Vermont, recognized the privilege in 1992.

The case before the Court today grew out of an effort by a licensed clinical social worker and her patient, a police officer who received counseling after killing a man in the line of duty, to protect records of the therapy sessions from being disclosed in a Federal civil rights suit brought against the officer by the man's family.

"This case amply demonstrates the importance of allowing individuals to receive confidential counseling," Justice Stevens said. "If the privilege were rejected, confidential conversations between psychotherapists and their patients would surely

Continued on Page A25, Column 3

QUESTIONS REMAIN

Approach Seems to Lead to Intensive Review of Individual Cases

By LINDA GREENHOUSE

WASHINGTON, June 13 — Invoking the recent precedent in North Carolina and three in Texas as the product of unconstitutional racial gerrymandering, the Supreme Court had been drawn too deliberately to give minority voters a decisive influence.

The twin 5-to-4 rulings took a big, although still inconclusive, step toward answering the question raised by two earlier rulings: whether any districts drawn with a racial factor, as least as a significant factor, is unconstitutional. Those rulings, in 1993 and last year, made majority-black districts open to legal challenge by disaffected white voters and subject to searching scrutiny under the 14th Amendment's guarantee of equal protection.

Lawyers representing black voters said today that more and more, it appears that no districts would pass muster. "The noose is tightening," Elaine Jones, director-counsel of the NAACP Legal Defense and Educational Fund Inc., said in an interview. Theodore M. Shaw, director of the southern regional office of the American Civil Liberties Union, predicted the result would be the "bleaching" of Congress, as well as state and local legislative bodies, as new districts drawn across the South to increase minority representation fall under legal attack.

The approach the Court took in the decisions today appears to commit it to intensive, case-by-case review of individual districts. The decisions entailed 189 pages and, in the Texas case, included a detailed analysis of three challenged districts, in a majority opinion by Justice Sandra Day O'Connor.

Predicting pleas from the four dissenters to reverse course or pull back on applying the strictest constitutional scrutiny to minority-black districts, Justice O'Connor said: "We see no need to revisit our prior debates." The Court's dissenters "acknowledge voters are more than mere racial statistics," she said.

The rulings produced widespread confusion in both North Carolina and

Continued on Page A24, Column 1

INSIDE

Abortion Still Roiling G.O.P.
Despite Bob Dole's efforts to calm the Republican furor over abortion, the issue continues to explode through the party, portending a troubled convention. Page A18.

Easing Ballot Access Rules
Governor Pataki proposed legislation to eliminate the complex web of rules that have made it difficult to get on the New York ballot. Page B1.

New Jersey Judge Leaving
Robert N. Wilentz, chief justice of the New Jersey Supreme Court, is stepping down from a court regarded as innovative. Page B1.

Big Trading Loss Seen
Sumitomo of Japan says it has discovered a loss of $1.8 billion stemming from unauthorized trades in copper. Page D1.

Advance in Heart Surgery
A Brazilian surgeon has developed a heart operation that may let many people resume daily activities and avoid transplants. Page A16.

Arizona Governor Is Indicted
Fife Symington was indicted on Federal charges of fraud and extortion involving his real estate projects in Phoenix. Page A14.

Indictment on Gifts to Espy
An agricultural cooperative was indicted on charges of giving illegal gifts to Mike Espy when he was Secretary of Agriculture. Page A21.

Zhirinovsky Savors Russian Kingmaker Role

By MICHAEL SPECTER

MOSCOW, June 13 — The old woman on the poster is dressed entirely in black. She is wrapped in the arms of the only person she feels certain can guide Russia safely from the abyss, and a prayer for deliverance brightens her dark eyes.

"You are our last hope," the campaign ad says, referring to the mournful, empathetic, troubled man to whom she clings. "Our last hope and savior."

Vladimir V. Zhirinovsky, the theatrical 50-year-old extremist who is seeking the Russian presidency again this year, loves that campaign poster. "This woman is Russia," he said recently, standing before one of the ads, which appear all across Moscow. "And I am Russia. And the people know it."

Mr. Zhirinovsky has been written off as a harsh joke in every election since 1991, when he ran for President and came in third. He stunned the world in 1993 when his Liberal Democratic Party (not liberal, not democratic, hardly a party) drew more votes in a parliamentary election than any other.

Mining the anger of voters who feel cheated by President Boris N. Yeltsin's reforms and bitter about the grim legacy of Communism, he again did better than anyone expected in parliamentary elections last December.

And in the presidential election on Sunday, despite the broad belief that he has finally yielded his niche as the poster boy for Russia's most disenfranchised and anguished voter, he nevertheless expects to have turned his

Continued on Page A8, Column 1

Agence France-Presse
This Zhirinovsky billboard in Moscow shows the extremist consoling a woman with the legend, "You are our last hope and support." The author of the swastika evidently disagreed.

354613

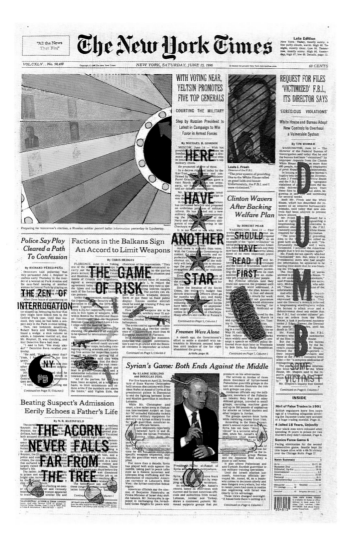
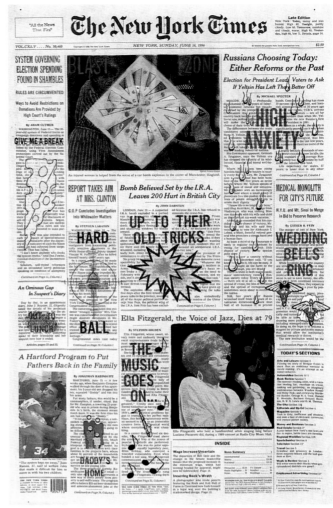
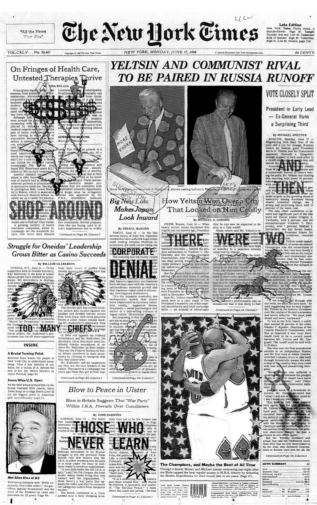
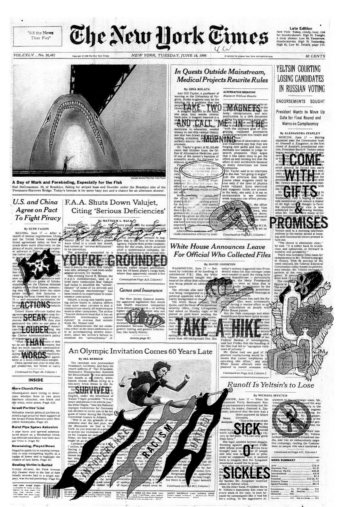

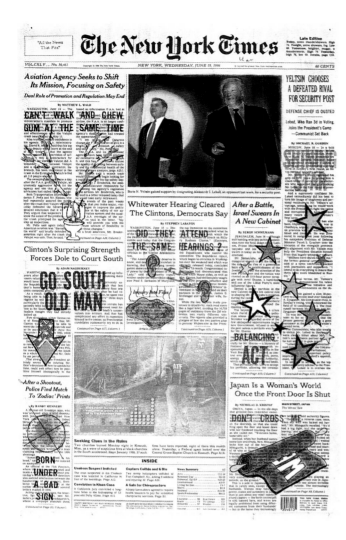

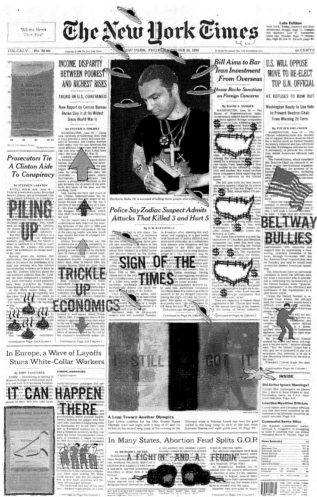

"All the News That Fits"

The New York Times

Late Edition
New York: Today, AM clouds, then hazy sun, sticky. High 85. Tonight, some clouds. Low 70. Tomorrow, some sun, thunder. High 85. Yesterday, high 67, low 62. Details, page B6.

VOL.CXLV.... No. 50,465 Copyright © 1996 The New York Times NEW YORK, FRIDAY, JUNE 21, 1996 $1 beyond the greater New York metropolitan area. 60 CENTS

Bigger Than Ever

The proposed purchase of Infinity Broadcasting by Westinghouse would merge the two biggest station owners, both of which had been buying stations aggressively in recent months.

WESTINGHOUSE/CBS
- 39 stations (18 AM, 21 FM) in 13 cities; radio network serving 550 stations
- $549 million in radio station revenue in 1996 (est.)
- Radio personalities include Charles Osgood

INFINITY BROADCASTING
- 44 stations (15 AM, 29 FM) in 13 cities; shows simulcast on more than 110 stations
- $501 million in radio station revenue in 1996 (est.)
- Radio personalities include Howard Stern, Don Imus

Sources: Westinghouse; Infinity; Duncan's Radio Market Guide

The New York Times

TWO RADIO GIANTS TO MERGE, FORMING BIGGEST NETWORK

$3.7 BILLION ACQUISITION

Westinghouse Will Buy Infinity in Deal Tied to New Law — F.C.C. Approval Needed

By GERALDINE FABRIKANT

The Westinghouse Electric Corporation announced today that it would acquire the Infinity Broadcasting Corporation for $3.7 billion, merging the nation's two largest radio broadcasters in a deal made possible by changes in Federal regulations last year limiting radio station ownership.

The merger of Westinghouse, the large industrial company that also owns the CBS radio and television networks, and Infinity, the nation's largest independent radio broadcaster, would create a radio giant with 83 stations.

The consolidation will be particularly potent in the nation's largest markets, including New York, where Westinghouse will own three AM stations and four FM stations ranging on the dial from sports talk and all-news stations to two classic rock stations. Such power has raised concerns among some regulators that diversity of radio is threatened.

While Westinghouse surely did expect that there would be antitrust problems, the deal requires approval of the Federal Communications Commission and any deal of this size is certain to attract the attention of the Justice Department. Congress's revision of telecommunications regulations in February added luster to traditional media like radio at a time when there is intense fascination with new alternatives like the Internet.

The appeal of such consolidation is evident for Westinghouse, in a highly fragmented business, the merger will increase Westinghouse's reach in numerous local markets so that it can offer advertisers audiences far larger than rivals provide. And radio advertising revenues have been growing faster than those of other media recently, in part because radio's heaviest listening periods are those hours when commuters are in their cars, where there is no competition from other media.

Westinghouse's willingness to make such a large bet on radio is part of a push by the company's chief executive since 1993, Michael H. Jordan, to transform an industrial company into a media and entertainment concern. That effort was crowned in November when he completed the $5.4 billion purchase of CBS Inc.

Executives in yesterday's deal say that Infinity's founder, Mel Karmazin, who has been aggressively

Continued on Page D5, Column 4

Justices Grant U.S. Employers Tool to Bargain

By LINDA GREENHOUSE

WASHINGTON, June 20 — The Supreme Court ruled today that it is not an antitrust violation for companies within an industry to get together and impose new contract terms on their unionized employees after labor negotiations have broken down.

The 8-to-1 decision, clarifying the relationship between Federal labor and antitrust law, was a victory for National Football League team owners in a seven-year-old dispute over salary caps for rookie players.

But it has implications as well for all industries that conduct bargaining on a multi-employer basis, accounting for some 40 percent of all major collective-bargaining agreements, according to statistics in Justice Stephen G. Breyer's majority opinion.

Under antitrust principles, competitors — whether football's professional sports teams, in other fields, or trucking companies, or Hollywood studios — cannot agree to restraint of trade, making antitrust a potentially powerful weapon for labor at the bargaining table. The 235 players who sued the N.F.L. after the team owners unilaterally imposed a salary cap won a $30 million antitrust judgment, later overturned in an appellate decision that the Court upheld in its ruling today.

Supreme Court opinions going back to the 1940's have held modern antitrust and labor law implied an accommodation between laws for collective action during negotiations leading to a labor con-

Continued on Page A24, Column 4

For Dole, Nixon Was a Mirror and a Mentor

By ELIZABETH KOLBERT

It was a political gesture that to many seemed out of place.

On the evening of March, when he was virtually on the verge of a visit to the candidate in Los Angeles when Mr. Dole made a half-wistful, half-triumphal visit, Mr. Dole spoke admiringly of what Mr. Nixon had accomplished. He also expressed affection for the man who, had his achievements, plunged the country into crisis and left the White House in disgrace.

"I got along very well with President Nixon," Mr. Dole said to reporters. "We were friends in the good times and bad."

Mr. Dole's ties to former President Nixon, almost 30 years back, 1988, when Mr. Dole won his Senate and Mr. Nixon finally captured the House. As a freshman Mr. Dole was much like the President, in his time. As he quickly made a name for himself the President impressed and become even suggested he seemingly was rewarded with chairmanship of the Republican connection long outlasted Mr. Nixon's retreat from political life. Despite his own aversion to advisers, Mr. Dole regarded the former President as a mentor, turning to him privately for counsel, and he helped smooth the way for Mr. Nixon's public rehabilitation.

In a poignant tribute, Mr. Dole has said Mr. Nixon was the only man in Washington who consistently remembered, in greeting, to reach out for his healthy left hand. Speaking at the former President's funeral two years ago, Mr. Dole tried, unsuccessfully, to choke back the tears.

According to Mr. Dole's supporters, his attachment to Mr. Nixon reflects deep wells of feeling that lie hidden beneath the Senator's detached manner and mordant wit. It is a matter, they also suggest, of mutual identification. "In Dole, Nixon saw himself," one associate of both men said. "And in Nixon, Dole saw himself."

But Mr. Nixon is a curious choice of attachment and not merely because of his ambiguous place in American history. Mr. Dole's kinship with the former President

President Richard M. Nixon and Bob Dole on Jan. 25, 1971, outlining the Republicans' campaign plans.
Associated Press

Continued on Page A22, Column 1

ELECTION LOOMING, YELTSIN DISMISSES 3 TOP HARD-LINERS

FRENZY IN THE KREMLIN

Advisers 'Assuming Too Much Authority,' Leader Says — Centrists Seem to Win

By ALESSANDRA STANLEY

MOSCOW, June 20 — Seeking to end a bitter power struggle within his campaign and cleanse his tarnished administration before the presidential runoff election 13 days away, President Boris N. Yeltsin today dismissed three of his most powerful and hawkish advisers, including his closest confidant and widely feared security chief.

The extraordinary reversal of Kremlin fortunes was played out in a frenzied atmosphere of arrests, midnight phone calls, coup rumors and palace intrigue.

When the smoke cleared, the dismissals left a new balance of power and the Kremlin. Gen. Aleksandr I. Lebed, a retired general who is Mr. Yeltsin's new national security czar, sits squarely at the President's right hand.

The three advisers who were ousted were Maj. Gen. Aleksandr V. Korzhakov, Mr. Yeltsin's longtime bodyguard, sidekick and chief of presidential security; Gen. Mikhail Barsukov, head of the agency that replaced the K.G.B., and Oleg Soskovets, a hard-line Deputy Prime Minister who oversaw Russia's vast military-industrial complex.

The President's prospects for re-election in the runoff, now set for July 3, may have been substantially enhanced by the arrests. His household, briefly threatened by a leaderless and increasingly mainly by the anti-reform camp, had breathed easier when he awkwardly tried to explain his decision.

"One of them has fresh faces," he said, referring to Korzhakov, Mr. Lebed. "Because Korzhakov, why is there so much work to him? Why have been on the case that I worked under Korzhakov is prompting. Korzhakov looks too much for it. To make it short, the power structure and the much under it, and producing too few results."

Mr. Yeltsin's top campaign aide, Anatoly B. Chubais, put a more sinister spin on General Korzhakov's behind-the-scenes maneuvering.

Today, at a crowded and emotionally charged news conference, Mr. Chubais said the three aides were willing to use force to derail the election because they were fearful of losing their access and power in a second-term Cabinet stripped of their ally, Defense Minister Pavel S. Grachev, and featuring Mr. Lebed, an anti-corruption crusader. Mr. Lebed finished a strong third in the first round of the election on Sunday and was then brought into the Government by Mr. Yeltsin.

"When Boris Yeltsin decided to dismiss them," Mr. Chubais said, "he drove the last nail in the coffin called the illusion of a military coup in the Russian state."

But even some of Mr. Chubais's allies in the embattled and balkanized Yeltsin election team dismissed

Continued on Page A8, Column 1

CALIFORNIA JUDGES EASE 3-STRIKE LAW

Lower Courts Receive Right to Ignore Earlier Convictions

By CAREY GOLDBERG

SAN FRANCISCO, June 20 — Substantially watering down California's tough "three-strikes" sentencing law, the California Supreme Court ruled today that judges have the right to disregard earlier convictions for conviction if they decide a mandatory prison sentence would be too cruel.

The decision by the State Supreme Court is sweeping in meaning that most of the more than 1,100 people who were sentenced under prison terms under the state three-strikes law because they had multiple felony convictions can now appeal. The ruling allows them to argue that the judges who imposed the sentences were barred from discretionary role afforded judges under the State Constitution.

The unanimous ruling also appeared to indicate that the national trend toward harsher sentencing — the three-strikes type of offender, often imprisoned for 25 years to life in prison — may have reached high tide, some experts said.

They cautioned, however, that the California Supreme Court decision did not by any means herald the end of the 1994 three-strikes law here, nor was it particularly meant to lighten sentences. Rather, it was a fine-tuning that returned to judges their customary power over sentencing, authority that the three-strikes law had shifted largely to prosecutors who tended to be tougher.

"The ferocious and inexorable demand for a life sentence for minor offenses becomes a bit more mindful," said Vincent Schiraldi, executive director of the Center on Juvenile and Criminal Justice in Washington, a key critic of the law's effects.

The court's decision stemmed from a San Diego case in which a repeat offender, Jesus Romero, was charged with possessing a tiny quantity of cocaine base. He had previously

Continued on Page A24, Column 6

Perot Party to Open Convention In California, on Eve of G.O.P.'s

By ERNEST TOLLERSON

Seizing a chance to upstage the Republicans, officials of the Ross Perot-led Reform Party announced yesterday that its convention would open on Aug. 11 in Long Beach, Calif., the day before the Republicans begin meeting in San Diego.

Reform Party officials also said that after one day of nominating speeches, its supporters will spend some part of the convention in Long Beach before the Republican convention opens, about 100 miles away, to also cover the Reform Party.

The Republican convention will not diminish our development of a great nominating convention for Bob Dole."

Mr. Verney and party organizers settled on a three-day convention schedule for submitting names of candidates in Virginia and in California and Kansas, or his party on the Aug. 29, also shaped the Reform Party's decision to open the convention on Aug. 11, said Mr. Verney said the Reform Party selected Long Beach for its Aug. 11

Continued on Page A23, Column 1

INSIDE

Newark Police Official Charged With Corruption

A Federal grand jury has charged William R. Celester, right, Newark's top police official, with spending department money on gifts for his wife and girlfriend, trips to Bermuda and Mexico and campaign contributions to the Mayor. Page B5.

Third Term for Greenspan

The Senate overwhelmingly confirmed Alan Greenspan for a third term as chairman of the Federal Reserve, brushing aside opposition from a few Democrats. Page D2.

New Account on F.B.I. Files

A Secret Service official contradicted the White House's explanation of how confidential F.B.I. files on former Government employees were obtained. Page A24.

Rising Math Scores

For the second year in a row, elementary school students in New York City raised their scores in a standardized math test. But they did not fare as well in reading. Page B1.

Indonesia Grows Restless

Thousands of opposition supporters protested in Jakarta, signaling rising tensions as Indonesia begins preparing for elections after 30 years of virtually uncontested rule. Page A3.

U.N. Chief Fights Back

Defying American opposition, the United Nations Secretary General began campaigning in Europe for support for a second term. Page A12.

54-16 0311

Inti Pran/The New York Times

News Summary A2

THE NEW YORK TIMES is available for home or office delivery in most major U.S. cities. Call, toll-free, 1-800-NYTIMES. Ask about TimesCard. ADVT.

JEWISH WOMEN/GIRLS LIGHT SHABBAT CANDLES today 15 min. before sunset. In NYC 8:13P.M. INFO 718-774-3060, outside NYC 718-774-3000. In merit of Raizel Gutnick, OBM — ADVT.

THE NEW YORK TIMES ON THE WEB. "ALL the News ..." • more: CyberTimes, news update, interactive crosswords & forums, searchable classifieds. Now on the Internet at www.nytimes.com — ADVT.

354613

Man Seized in Wave of Killings and Robberies

By JOSEPH BERGER

GREENBURGH, June 20 — A Staten Island man was charged today with murdering a 92-year-old homeowner in a case the authorities linked him to another murder on Long Island and a wave of vicious robberies against elderly people throughout the New York City suburbs.

The police said all the crimes involved the same technique. The 31-year-old suspect would slyly insinuate himself inside an elderly person's house by offering to do repair work and asking for a drink of water. Once inside, the police said, the suspect would push his victims down stairs or bludgeon them with bottles from their homes.

The Greenburgh Police Chief, John Kapica, identified the suspect as Larry R. Stevens, a round-faced, slightly built man with a thin mustache, but he said Mr. Stevens used so many different aliases and birth dates that they could not be sure of his real name. They said he had no steady job, lived with his 68-year-old mother, Doris Bimbo, in a cramped apartment in a Staten Island house

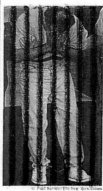

Larry R. Stevens covered his face yesterday after his arrest.
P. Saul Sommer/The New York Times

PARK BEATING VICTIM IMPROVES

A woman savagely beaten in Central Park two weeks ago regained consciousness and began to communicate. Page B1.

and was part of a clan of Romanian Gypsies that calls itself the Royster clan.

Mr. Stevens's capture today was the third time in a week that stray fingerprints helped solve a series of crimes in the New York City area. Fingerprints also helped track down John J. Royster, who confessed to killing a Park Avenue dry cleaner and severely beating three other women, and Heriberto Seda, who admitted killing three people and wounding five others in a spree known as the Zodiac shootings.

But the Stevens arrest for second-degree murder raises questions about how well suburban police departments coordinated their efforts

Continued on Page B2, Column 4

98

The New York Times

VOL.CXLV No. 50,466 Copyright © 1996 The New York Times NEW YORK, SATURDAY, JUNE 22, 1996 $1 beyond the greater New York metropolitan area. 60 CENTS

New York: **Today,** mostly sunny, a few thunderstorms late. High 87. **Tonight,** clearing. Low 69. **Tomorrow,** sunny, less humid. High 86. Yesterday, high 83, low 65. Details, page 14.

New York State's Budget Delay Puts Services on Shaky Ground

School Debts Rise and Hospitals Are Threatened

By JAMES DAO

ALBANY, June 19 — With New York State's record-breaking budget deadlock approaching the end of its third month, the budget is now so late that its effects are being felt far beyond the Capitol walls, causing serious financial strains on schools and local governments and threatening disruption of services in the state's hospitals.

The cuts, on the verge of causing the loss of thousands of jobs in a little more than a week, the Legislature has become a major political liability for all the state leaders this state, leading officials cope with the effects. More than 20 schools have been forced to borrow millions of dollars to keep them afloat. And state agencies have had to resort to emergency measures to get state aid to local towns and to meet up those loans. And local property taxes. Some school officials also contend that they will be unable to borrow the money to meet payrolls next month if the budget delay lasts into July.

As a result of all this, said Louis Grumet, executive director of the New York State School Boards Association and the Legislature will eventually end up approving will go to the cost of the loans, "for teachers."

The budget delay is also jeopardizing several laws that directly affect thousands of people or businesses because the laws are to expire at the end of the month, and their fate is linked to the budget negotiations. One of those laws sets rental reimbursement rates for the administration and causes local hospitals and nursing homes with other services, with a few weeks left. Mr. Pataki has vowed that the law does not expire budget in place by June. Negotiations are proceeding but Mr. Pataki has said that he would not sign a final agreement until the tax cuts enacted.

"The entire health care system is being brought to the point," said Daniel Sisto, president of the Healthcare Association of New York State, which represents 45 hospitals and nursing homes.

A second law due to expire June 30 protects nearly 10.9 million people living in commercial lofts. Most of them in lower Manhattan. The law allows people to live in commercial buildings and requires their landlords to upgrade them to residential standards. Without an extension, some Republicans fear that hundreds of thousands of tenants could be forced to commercial or move out and begin eviction proceedings against their tenants.

Michael McKee, of the development for the New York State Tenants and Neighbors Coalition, said he thought that the landlords could agree to extend the law before the deadline but that it did not seem that would happen. "Loft tenants are

Continued on Page 24, Column 2

TEACHERS RATIFY 5-YEAR CONTRACT

New York's Worsening Deficit Is a Factor in Union's Vote

By STEVEN GREENHOUSE

New York City's public-school teachers overwhelmingly approved a five-year contract yesterday, an agreement similar to one they rejected in December. The vote was a victory for the labor leadership and Mayor Rudolph Giuliani's labor strategy.

Sandra Feldman, president of the United Federation of Teachers, said teachers ratified the contract, by and large, because of lessons from the rejected negotiation, she said teachers saw that the agreement, even with its two-year pay freeze, was not as bad in light of the city's financial problems.

"The first time, teachers did not believe there wasn't enough money to provide them with a wage increase in the first two years," Ms. Feldman commented by union, they were aware of the reality of the city's economic situation and approved a contract reflecting it, important to Ms. Feldman, who was embarrassed by the bitterness rejection of the contract in December, the first time in years that a union rejected a contract leadership had negotiated.

The contract approved yesterday greatly improved on the rejected one. Both included three years of job security, a two-year freeze and a 13 percent raise over the last three years. The revised contract, like the rejected one, increases teachers' maximum pay to $70,000, from $60,000, and raises starting salary to

Continued on Page 22, Column 1

Unabom Case Headed to California

A Federal judge in Montana yesterday cleared the way for the suspect in the Unabom case, Theodore J. Kaczynski, to be transferred to Sacramento, Calif., to face charges related to bombing deaths and injuries. The judge did not say when Mr. Kaczynski, who was escorted by Federal agents, would be moved. Page 6.

Associated Press

Silicon Valley Reduces Donations To Clinton Campaign as a Penalty

By JANE FRITSCH

WASHINGTON, June 21 — Four years ago, Bill Clinton set out to win Silicon Valley by holding private meetings to solicit their advice and by promising to make high-technology businesses more competitive in world markets. High technology became a frequent theme of Mr. Clinton's campaign to "get America growing again."

The strategy worked. Public endorsements of Mr. Clinton by executives of computer and software companies came an early and important boost to his campaign against President George Bush. And donations from the executives helped to shore up Mr. Clinton's campaign fund.

But Silicon Valley's ardor for President Clinton has cooled, largely because of his handling of a bill that became too politicized and he could not hold, they said, after Mr. Clinton's committee to endorse a computer technology issue. Among the companies accused of conspiring to deny brand-name discounts to independent pharmacists.

Article, page 33.

Accord in Drug Case Set at $351 Million

A Federal judge approved a $351.3 million settlement of a lawsuit against drug companies accused of conspiring to deny brand-name discounts to independent pharmacists.

Article, page 33.

fallen by as much as half, Clinton fund-raisers say. The campaign has had no trouble raising money in other parts of the country. But in Silicon Valley, we're really getting hammered.

As the recent state works to ban software in Silicon Valley, the executives are concerned about a tax issue and a test of Mr. Clinton's commitment to the high-technology industries.

The move at the White House in recent months will demands that the major companies that their software be given the same favorable tax treatment that is given to the master recordings of records, tapes and movies that are exported for reproduction in other countries.

So far, Mr. Clinton and the Treasury Department have refused the requests to hand down an administration decision, saying, "Collectively, say we ever, the Treasury Department is somewhat worried, said Harris Miller, president of the

Continued on Page 7, Column 5

EUROPE MAY EASE BRITISH-BEEF BAN

Plan Vague, but Britain Ends
- Tactic of Noncooperation

By CRAIG R. WHITNEY

FLORENCE, June 21 — Leaders of the European Union's 15 member countries agreed today to a plan that would allow the British to resume selling beef. In response, Britain ended its policy of obstruction, which had begun only after the European Commission's decision to ban exports of all beef products from the countries certified free of mad-cow disease, a brain disease that was transmitted to consumers who ate meat from infected animals has been tentatively linked to a fatal brain disease.

Prime Minister and his ministers had agreed to give Europeans to give in on British beef exports, and set down no dates for when the ban would be lifted, and it left key decisions in the hands of those Eurocrats who are the nemesis of the anti-European Tory Majority Conservative Party.

Mr. Major will thus have some convincing to do in Parliament when he presents the plan on Monday.

Foreign Minister Malcolm Rifkind said the Prime Minister would try to give Parliament an idea of when exports of grass-fed veal and other beef products though at least risky might resume.

Mr. Rifkind also said the European leaders had agreed to let Britain sell beef to non-European countries if anybody wanted to buy it before the

Continued on Page 4, Column 5

GULF WAR ILLNESS MAY BE RELATED TO GAS EXPOSURE

MEDICAL REVIEW TO BEGIN

Iraqi Arms Depot Destroyed by Americans Stored Chemical Agents, Pentagon Says

By PHILIP SHENON

WASHINGTON, June 21 — The Pentagon disclosed today that American troops may have been exposed to nerve gas in the war in the Persian Gulf when their unit blew up an Iraqi ammunition depot that was loaded with chemical agents. The announcement may help explain the mysterious illnesses reported by some troops who served there.

Defense Department officials say that when American soldiers destroyed the depot in southern Iraq in March, they were carrying out war orders to destroy it, monitoring equipment offered no warning that it contained chemical weapons.

But the equipment may have been faulty, and Pentagon officials said today that it had been used by United Nations investigators last month showed that sarin stored in a chemical agent in the depot, a possibly mustard gas and sarin, a deadly nerve agent — and that they may have here is that the United Nations workers probably knew about agents inside it," said Kenneth Bacon, the Defense Department's chief spokesman.

The Pentagon consistently said the beginning of a dramatic policy reversal for the Pentagon, which has insisted in the past that it knew of no reason for the array of medical and psychological ailments reported by soldiers who served in the gulf.

More than 70,000 veterans have filed disability claims for ailments that they believe are related to the war, ranging from chronic fatigue to hair loss to memory loss, and collectively the ailments have become known as gulf war syndrome.

The Pentagon said today that 300 to 400 American soldiers assigned to the Army's 37th Engineer Battalion were directly involved in the demolition of the Kamisiyah ammunition depot at Talil al-Jihan, in southern Iraq, between March 4 and March 7, 1991.

Dr. Stephen Joseph, the assistant secretary of defense for health affairs, said today that the Pentagon's initial review of its records showed that no unusual frequency of illness among the soldiers who were closest to the explosion at the depot. "There are no reports that we have located

Continued on Page 20, Column 1

Noted Finding of Science Fraud Is Overturned by a Federal Panel

In the conclusion to one of the most celebrated investigations of alleged scientific misconduct in the United States, a Federal appeals panel yesterday rejected findings that a scientist had faked data in a decade-old report signed by a leading Nobel laureate.

The appeals panel was highly critical of the Government's Office of Research Integrity, which had found that the scientist, Dr. Thereza Imanishi-Kari, now of Tufts University, was guilty of misconduct.

The case was wending its way through the halls and byways of science because the report, published in 1986 in the journal Cell, was signed by Dr. David Baltimore, a Nobel laureate.

Dr. Baltimore was never accused of wrongdoing but the paper, which dealt with the genetics of immunology, which he adamantly defended, led to accusations of fraud that was first brought by a postdoctoral student, Margaret O'Toole, who worked in

Dr. Imanishi-Kari's laboratory.

The appeals panel, reluctantly backed off from the tendency of the Government in December 1991, 18 months after he had been named yesterday, by the Research Adjudications Panel in the Department of Health and Human Services, was another setback for the Office of Research Integrity, which has at several other cases been badly bruised by criticism of the office's work in the earlier case against Dr. Mikulas Popovic, a colleague of Dr. Robert Gallo, the co-discoverer of the AIDS virus.

Campbell Gardett, a spokesman for the Department of Health and Human Services, would say only that yesterday's decision "speaks for itself" and that for all practical purposes the 10-year-long matter was at an end.

Continued on Page 20, Column 4

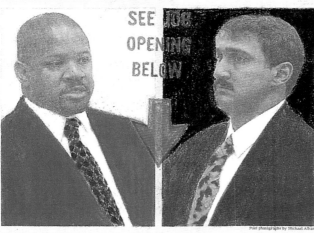

No Jail Time in Shooting of Transit Policeman

Desmond Robinson, left, the former transit police officer shot by Peter Del-Debbio, right, when he was a police officer, went to court yesterday to ask that Mr. Del-Debbio not be sent to jail. Page 21.

Pool photographs by Michael Albans

Serb Gangs Rule in Last-Chance Fief of U.N.

By CHRIS HEDGES

VUKOVAR, Croatia, June 19 — Chez Daddy's nightclub changed owners a few days ago in a business transaction that, as so often happens in the Balkans, dispensed with impediments like money and the law.

A group of armed men came in with guns, beat up a waiter who did not surrender his name, took the keys and funds out and beat the owner unconscious. All those who were sitting there, with the pistols in their belts, are the new staff.

"We have Romanian girls and Bulgarian beer," the waiter said as he poured a cup of coffee. "It costs $100 for a bottle of whisky. Now, I have a transaction that was more profitable in the last days.

He described how armed gangs that has been ruled by armed gangs that are plundering and extorting, stripping factories at machinery, carting off farming equipment and trafficking in stolen cars. In an agreement backed by both Serbia and Croatia, this last Serbian-con-

trolled enclave in Croatia — the under United Nations administration in February as the first step in returning it back to Croatia within two years.

Eastern Slavonia may be the final opportunity for the allies to achieve a more peaceful transfer of power in at least one small pocket of the former Yugoslavia. United Nations officials, who were the main brokers of the agreement here, have expressed hope that once the region is returned to Croatia, many Serbs will remain to live with

Continued on Page 5, Column 1

354613

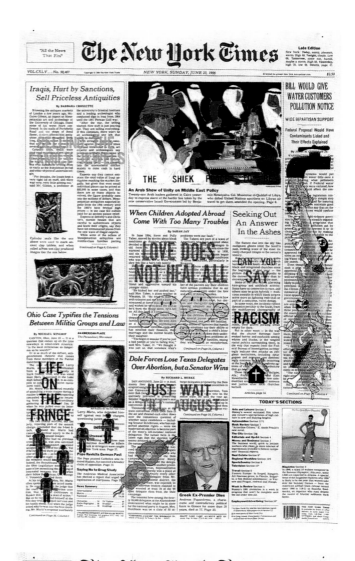

The New York Times

"All the News That Fits" — VOL.CXLV...No.50,467 — NEW YORK, SUNDAY, JUNE 23, 1996 — $3.50 — Late Edition

Iraqis, Hurt by Sanctions, Sell Priceless Antiquities
By Barbara Crossette

BILL WOULD GIVE WATER CUSTOMERS POLLUTION NOTICE
WIDE BIPARTISAN SUPPORT
Federal Proposal Would Have Contaminants Listed and Their Effects Explained

THE SHIEK

An Arab Show of Unity on Middle East Policy

When Children Adopted Abroad Come With Too Many Troubles
By Sarah Jay

LOVE DOES NOT HEAL ALL

Seeking Out An Answer In the Ashes

CAN YOU SAY RACISM

Ohio Case Typifies the Tensions Between Militia Groups and Law
By Michael Winerip

LIFE ON THE FRINGE

Pope Revisits German Past

Saying No to Drug Study

Dole Forces Lose Texas Delegates Over Abortion, but a Senator Wins
By Richard L. Berke

JUST WAIT TILL AUGUST

Greek Ex-Premier Dies

TODAY'S SECTIONS

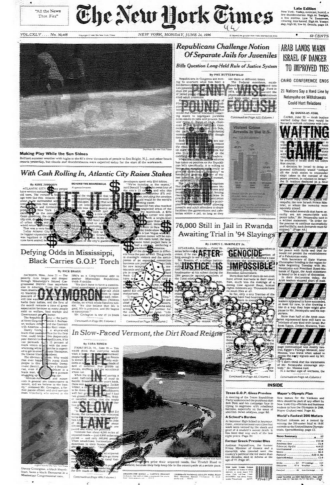

The New York Times

"All the News That Fits" — VOL.CXLV...No.50,468 — NEW YORK, MONDAY, JUNE 24, 1996 — 60 CENTS — Late Edition

Republicans Challenge Notion Of Separate Jails for Juveniles
Bills Question Long-Held Rule of Justice System
By Fox Butterfield

PENNY WISE POUND FOOLISH

ARAB LANDS WARN ISRAEL OF DANGER TO IMPROVED TIES
CAIRO CONFERENCE ENDS
21 Nations Say a Hard Line by Netanyahu on Withdrawals Could Hurt Relations
By Douglas Jehl

WAITING GAME

Making Play While the Sun Shines

Violent Crime Arrests in the U.S.

With Cash Rolling In, Atlantic City Raises Stakes
By Kirk Johnson
BEYOND THE BOARDWALK

LET IT RIDE

76,000 Still in Jail in Rwanda Awaiting Trial in '94 Slayings
By James C. McKinley Jr.

AFTER JUSTICE IS

GENOCIDE IMPOSSIBLE

Defying Odds in Mississippi, Black Carries G.O.P. Torch
By Rick Bragg

OXYMORON

In Slow-Paced Vermont, the Dirt Road Reigns
By Sara Rimer

LIFE IN THE SLOW LANE

INSIDE

Texas G.O.P. Gives Preview

Mayor's Olympic Plan

World's Fastest 200 Meters

Former Greek Premier Dies

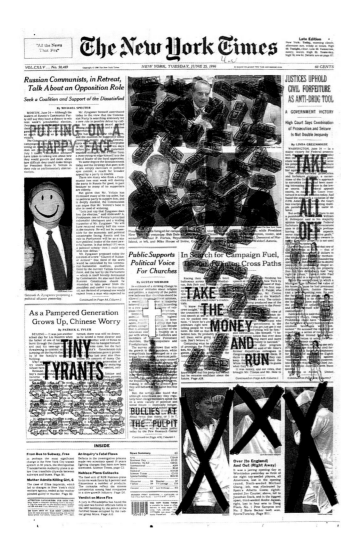

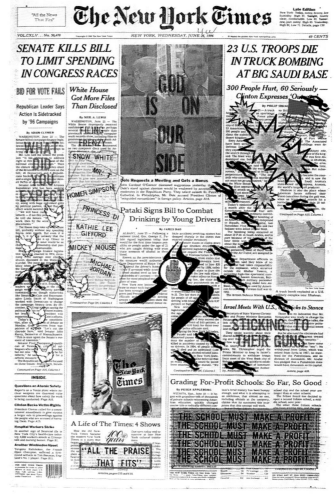

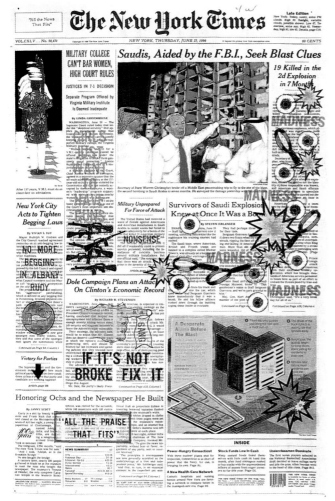

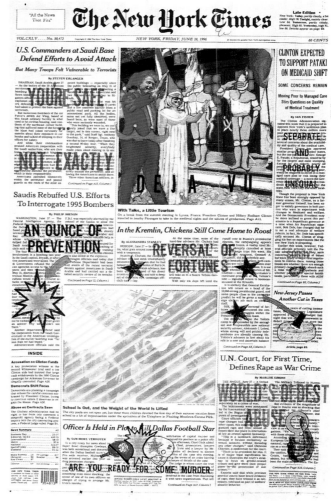

The New York Times

"All the News That Fits"

Late Edition
New York: Today, sunshine, high clouds. High 83. Tonight, some clouds, perhaps a shower. Low 72. Tomorrow, hazy, hot and humid. High 94. Yesterday, high 78, low 64. Details, page 25.

VOL.CXLV No. 50,473 Copyright © 1996 The New York Times NEW YORK, SATURDAY, JUNE 29, 1996 $1 beyond the greater New York metropolitan area. 60 CENTS

Fund Plans to Lend $50 Million For Jobs, Not Profit, in New York

Financiers Form Private Development Authority

BY KIRK JOHNSON

A group of 50 major New York City corporations and business executives, that has been talking and building up in this town for so long opment authority for the city.

Although plans are not final, the organizers say they are creating a large, privately run economic development fund.

Mr. Kravis, the man behind many of the biggest corporate takeovers and buyouts of the last decade — the second K of Kohlberg, Kravis, Roberts & Company — thought up the idea, raised much of the money over...

Continued on Page 22, Column 1

CHICAGOANS SPLIT ON HOUSING PLAN

High-Rises for Poor Are to Be Torn Down and Replaced

BY DON TERRY

CHICAGO, June 28 — Dreamers and schemers have been talking and building this town for as long as the city's poor...

In the next few years, Mr. Daley hopes to raze the infamous Cabrini Green housing development on the city's near North Side into a national model for the wonders of public and private partnerships...

Continued on Page 25, Column 1

C.I.A.'s Unsavory Ties

The Central Intelligence Agency knowingly used as informers a number of Guatemalan military officers suspected of political assassinations, kidnappings and a Presidential murder, it said today. It also found that several Guatemalan officers and officials covered up the military's role in the 1990 killing of an American here.

Article, page 2.

Key Witness Asserts His Right to Silence In Inquiry on Files

BY FRANCIS X. CLINES

WASHINGTON, June 28 — The inquiry into the Clinton Administration's improper gathering of F.B.I. background files intensified today as a key witness invoked his constitutional right of silence and officials disclosed that the independent counsel's office had sealed a White House file vault...

Continued on Page 7, Column 1

Sharing Consolation After the Shock in Saudi Arabia

At a memorial service in Dhahran yesterday, American military personnel comforted one another while mourning comrades killed by a truck bomb on Tuesday. Investigators continued to examine the site. Page 5.

Justice Dept. Report Details Ruse by Immigration Aides

By ERIC SCHMITT

WASHINGTON, June 28 — Forty-eight hours before a group of influential House members visited the Immigration and Naturalization Service's Miami headquarters last year, top officials staged an elaborate ruse to cover up serious overcrowding and other problems at a local detention center.

The center, in downtown Miami, designed to hold 226 immigrants, was bursting with 407, threatening serious health and security hazards. More than 50 women had to sleep on cots in the lobby of the center's medical clinic. Criminal detainees mixed with other immigrants, including children as young as 10 years old.

It was these conditions that touched off an elaborate deception and cover-up, detailed in a Government report, a copy of which was obtained by The New York Times today. The report was prepared by the inspector general of the Justice Department, the immigration service's parent.

It was essential, the Miami immigration officials thought, to impress the seven-member delegation from Washington. With the blessing of two regional supervisors, Valerie Blake, the Miami deputy district director, ordered an additional dozen inspectors temporarily and sent them to the airport to keep the immigration inspection lines flowing quickly. She told inspectors not to "whine" about staffing shortages and to lie if asked whether the airport's holding cells were occupied by aliens other than criminals.

Ms. Blake also directed that 58 detainees, several criminals among them, be released without screening. At a cost of $13,867, she ordered 50 immigrants be sent on packed lunches, to a center in northwestern Florida or another center in New Orleans and that they be kept there until the...

Continued on Page 10, Column 1

In a Milestone, Islamic Leader Is Turk Premier

By STEPHEN KINZER

Breaking a chain in secular leadership that has held since the founding of the republic in 1923, the leader of an Islamic party became Prime Minister yesterday.

Necmettin Erbakan, the new Prime Minister and leader of the Welfare Party, formed a coalition Government. A former Prime Minister, Tansu Ciller, who will serve as Deputy Prime Minister and Foreign Minister.

President Suleyman Demirel approved the new Government after meeting with Mr. Erbakan late yesterday. Emerging from his meeting with the President, Mr. Erbakan said: "I have very good news for you. A new Government has been formed."

Although Mr. Erbakan automatically assumed the mantle of Prime Minister, Turkey's Parliament must give the new Government a vote of confidence before Mr. Erbakan's Welfare Party and Ms. Ciller's True Path Party take office. In the 550-seat Parliament, some True Path deputies, however, have hinted that they might vote against the coalition...

Continued on Page 5, Column 1

HIGH COURT SPLITS ON INDECENCY LAW COVERING CABLE TV

RULINGS PUZZLE EXPERTS

Community-Access Channels Are Freed of Restrictions for Protecting Children

By LINDA GREENHOUSE

WASHINGTON, June 28 — In a splintered decision indicating deep fissures and great uncertainty over how to approach free speech in media, the Supreme Court said today that operators of cable television systems may ban indecent programming from certain commercial channels but not from the community-access channels operated by local governments.

"Everything is up for grabs," said I. Michael Greenberger, who argued the Supreme Court challenge to the law on behalf of a coalition of community cable programmers.

Continued on Page 8, Column 1

Justices Uphold Newly Set Limit On Federal Appeals by Inmates

By LINDA GREENHOUSE

WASHINGTON, June 28 — Ruling unanimously and with unusual speed, the Supreme Court today held a rarely used strict limit on Federal appeals by state prisoners, on the understanding that the Supreme Court itself retains jurisdiction to hear these appeals.

Central to the Justices' view that Congress left intact a route by which inmates can bring their appeals directly to the Supreme Court, bypassing obstacles to review in the Federal district and appellate courts that were imposed by the new Federal law.

Continued on Page 9, Column 1

Appeal Is Mandatory

New Jersey's Supreme Court rejected a request by a convicted murderer to be executed instead of ordered a new trial or review of his case. Exercising an option under New Jersey court rules, the inmate chose last fall not to continue to challenge his death sentence.

Article, page 9.

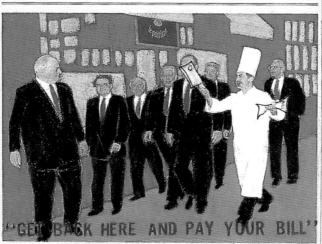

A Summit Meeting Marches on Its Stomach

After endorsing a 40-point program to increase cooperation in fighting crime, leaders of the Group of Seven countries resumed their culinary tour of Lyons last night under the eye of Chef Jean-Paul Lacombe. Page 4.

INSIDE

Communists in India Cabinet
India's President inducted the first Communist party ministers to serve in the Government since independence nearly fifty years ago. Page 3.

Germany Cuts Job Benefits
Germany has approved measures to reduce workers' sick pay and job security in an effort to make its industry more competitive. Page 33.

The Citadel to Admit Women
After a Supreme Court ruling on another military college, The Citadel said it would admit women. Page 6.

'What Do I Hear for Jordan?'
The N.B.A. and the union reached an agreement, which would open the richest free-agent market. Page 27.

News Summary	2
Arts	11-17
Business Day	32-45
Editorial, Op-Ed	18-19
International	2-5
Metro	21-24
National	6-10, 25
SportsSaturday	27-31
Obituaries	26
Weather	25
TV Listings	48
Classified	46
Religious Services	10

THE NEW YORK TIMES is available for home or office delivery in most major U.S. cities. Call toll-free: 1-800-NYTIMES. Ask about Times-media TimesCard.

354613

[Graffiti-style overlaid text across the page:]

WHERE BANKERS FEAR TO TREAD

MOVIN ON UP OR DOWN

SORROW

ALIENS LIES & E-MAIL

GUNS DRUGS & GOLD

"GET BACK HERE AND PAY YOUR BILL"

WIN SOME LOOSE SOME

GIVE ME THAT OLD TIME RELIGION

NOT A KIND WORLD

The New York Times

Late Edition
New York: Today, partly cloudy, humid. Some thunder. High 85. Tonight, early shower. Low 72. Tomorrow, mostly sunny. High 90. Yesterday, high 77, low 64. Details are on page 34.

VOL.CXLV.... No. 50,474 Copyright © 1996 The New York Times *NEW YORK, SUNDAY, JUNE 30, 1996* $1 beyond the greater New York metropolitan area. **$2.50**

REPUBLICANS SEEK TO KEEP BUCHANAN OUT OF SPOTLIGHT

EMPHASIS IS ON HARMONY

Dole and Aides Say They Want to Avoid Tumult That Hurt the Party 4 Years Ago

By RICHARD L. BERKE

WASHINGTON, June 29 — Fearful of a replay of the tumult that Patrick J. Buchanan caused at the Republican convention four years ago, several convention organizers say he will not be offered a prominent role at the party's gathering in August, nor may he be allowed to speak in prime time.

While final decisions have not been made, there is wide agreement that a featured role for Mr. Buchanan would conflict with the image of the party and the almost certain nominee, Bob Dole, according to people familiar with the deliberation, which involve officials from the Dole campaign and the Republican Party. They said Mr. Dole had made it clear he did not want Mr. Buchanan as a high-profile speaker and had said that Mr. Buchanan's outspoken statements against abortion and on other issues and his attacks on Mr. Dole during the primaries are at odds with the party's effort to present a unified front.

Mr. Buchanan, who is weighing a run for President as an independent, the Dole campaign maintains, is the last thing any particular delegate to a recent convention wants.

Asked if Mr. Buchanan would have as significant a role as he had in Houston in 1992, Haley Barbour, the Republican national chairman, said only that the four-night show would be much faster-paced this year. "There will be hardly any long speeches," he said, adding that "there will be more control over the program."

Several people involved in the liberations said that Mr. Buchanan might not be offered a speaking position at all, even though one said Mr. Dole in the New Hampshire primary and amassed the second-largest number of convention delegates.

At best, they said, he would be given a brief, early evening speaking slot. "The likelihood that Pat Buchanan is going to have anything that resembles a prominent position is remote at best," said one person close to the convention deliberations, speaking on the condition of anonymity.

Gen. Colin L. Powell is at the top of the list of possible speakers at the convention in prime time. Mr. Dole himself told General Powell at a meeting three weeks ago that he would like to see him attend the convention, which opens on Aug. 12 in San Diego. While Mr. Dole did not specifically ask General Powell to speak, the candidate's aides said they hoped Mr. Dole would follow

Continued on Page 20, Column 3

TODAY'S SECTIONS

* *In New York City and the metropolitan area.*
† *Elsewhere, auto pages are in Section 11.*
§ *In most parts of New York City*
¶ *In Long Island, Westchester, Connecticut and central and northern New Jersey.*

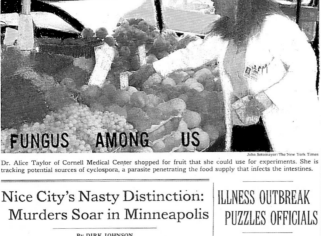

FUNGUS AMONG US

John Sotomayor/The New York Times

Dr. Alice Taylor of Cornell Medical Center shopped for fruit that she could use for experiments. She is tracking potential sources of cyclospora, a parasite penetrating the food supply that infects the intestines.

Nice City's Nasty Distinction: Murders Soar in Minneapolis

By DIRK JOHNSON

MINNEAPOLIS, June 27 — This was a city that had all the right answers.

Fortune magazine ranked it an atmosphere of cultural vitality, social liberalism and civility give woodsy neighborhoods a fairy tale look. Even the brutal Upper Midwest winters are made manageable, with elaborate passageways to protect downtown workers.

It is a way of life that the Star Tribune of Minneapolis can regard smugly as "Minnesota nice," a phrase used in these places to describe a kind of unfailing courtesy.

But lately, this idyllic image has been shattered by violence, with carjackings and drive-by shootings, where children play.

Finding similarities between Minneapolis and New York murder, of all things — would seem quite a stretch.

To be sure, Minneapolis has never been Lake Wobegon, the mythical small town of Garrison Keillor, who broadcasts his radio show, "A Prairie Home Companion,"

GOOD CITY GONE BAD

WE'RE GOING TO GET YOU

11-year-old boy was killed after being shot in the abdomen from a drive-by shooting earlier this month. A 22-year-old man on the block was shot dead a few days later. "This was a place where people cared about each other, where you left the doors unlocked and let the kids run outside."

Now there are T-shirts declaring "Murderapolis" — terrible gallows humor aimed at visitors from New York or Detroit.

So much for civic homilies belying the denizens' new image. "There's been an erosion of your basic values. Stoicism is a virtue in Minnesota, home of the fabled old Swedish farmer who loved his wife so much he nearly told her.

"What is happening to my Minneapolis?" asked Barbara Atlas, 42, who lives on Newton Street, where an

Continued on Page 31, Column 1

The New (Yorker's) Voice In the Back Seat of the Taxi

By LISA W. FODERARO

It seemed like a simple enough improvement: Remind passengers as they leave taxis to take all their stuff, in an attempt to reduce the thousands of lost-and-found complaints that pour in each month. Fuhgeddaboutit.

This is New York City. Here the question of what kind of voice should issue from the city's 12,000 yellow cabs, possibly a way to the future, has engendered the kind of discussions usually reserved for debates over where to find the best pastrami sandwich or who should be the next mayor.

Should the recorded announcement be crisp and clear and devoid of regional accent? Or should it be done in the spirit of New York lore — make that Noo Yawk law — the aggressive voice that goes with the mythic image of a cigar-wielding, cantankerous cabbie?

When the Taxi and Limousine Commission introduced on June 1, the Taxi and Limousine Commission left it up to the major taxi-meter shops, which service cabs, to produce and install the recorded announcement. The commission stipulated what to say: "Please remember, when leaving this taxi and please get a receipt from the driver" — but not how it should be said.

Some taxi shops left it to their employees to record the greetings. The result was a new version, to be which some use typical New Yorkers (one slightly Greek, the other unmistakably Brooklyn) with two that didn't have much accent.

After getting many replies, the Taxi and Limousine Commission has decided to pursue a new recording with a single voice. It will choose from among a few who volunteered their services at a lower volume, should be toned down by the end of July. But the decision has not muffled a

IT'S UP TO YOU NEW YORK NOO YAWK

Chang W. Lee/The New York Times

A taped reminder is aimed at easing traffic at the lost-and-found.

Continued on Page 31, Column 1

INSIDE

Turkey's Islamic Premier
Turkey's new Prime Minister is a pragmatic reformer or a Muslim fundamentalist who has grown too close to the West. Man in the News, page 6.

Scrubbing Ivory Tower
A university is trying to spruce up its public profile, hiring a P.R. specialist and grooming its scientists for reporters. Page 25.

Saudi Kingdom Shows Cracks, U.S. Aides Fear

But Washington Feels Need to Tread Softly

The following article is based on reporting by Elaine Sciolino, Jeff Gerth and Douglas Jehl and was written by Ms. Sciolino.

WASHINGTON, June 29 — When a bomb struck Saudi Arabia's National Guard headquarters last November, killing five people, King Fahd was thunderstruck. "Catastrophes are coming around after the other," he confided to a close associate.

Two weeks later, the King experienced a catastrophe of his own: he suffered a debilitating stroke, forcing the royal family to grapple with the issue of who will rule the country.

Until recently, the United States took for granted the stability of its most strategic Arab ally. But a decade of overspending, the rise of a militant domestic opposition and uncertainty about the royal succession have deepened new cracks in the House of Saud.

This year's catastrophe — the truck bombing that killed 19 American military personnel in Dhahran — deepened the worries in Washington about the future of the world's largest oil producer and raised hard questions about how the United States can best protect its enormous stake in Saudi Arabia.

"There has been an unwillingness to confront the Saudis," one senior Administration official said. "We all know they're in transition, but no one wants to go to them and say that there is a danger in the kingdom and ask, 'Who's in charge?' An episode like the bombing forces you to think hard about doing these things."

There are limits to what the United States feels it can do to effect change in the country.

Given the vast size of political and religious voices in America, a goal elsewhere is not for work, to open the door to more of that. This dispatch of many American troops, either to impose security at a site that can lead to more strength, the Government may have to compromise productivity in a society that thrives with one-sixth as many workers.

For many months, the Clinton Administration's official policy is to refrain from putting pressure on the royal family.

In an interview shortly before he left for Saudi Arabia, Defense Secretary William J. Perry said he did not plan to press the Saudis on the issues of succession or internal opposition. "I certainly don't ask them on either of those issues," he said. "This, as far as I'm concerned, is an internal Saudi problem."

The American-Saudi relationship

Continued on Page 8, Column 1

ILLNESS OUTBREAK PUZZLES OFFICIALS

Microbe Elusive as It Navigates the Nation's Food Supply

By LAWRENCE K. ALTMAN

Federal officials are developing a crash program to detect and other items for a microbe that made more than 1,000 people sick in 11 states. Investigators are also shifting the focus on the implications from strawberries to raspberries as the source of contamination.

The microbe, known as cyclospora, is a parasite that infects the intestine and can cause intense diarrhea, weight loss and fatigue. It has caused three previous outbreaks of disease in the United States involving one last year in Charleston County, but the ones that spring are by far the largest.

The epidemic offers the latest long line of new diseases and conditions like legionnaire's disease and AIDS that have struck industrialized countries in recent years.

Despite warnings, it appears that raspberries are the borne illness in the nation. This is the first most outbreak in recent years. The microbe infected 400,000 people in Milwaukee in 1993.

This country is considered very safe, M. Osterholm, an epidemiologist. Contamination from cyclospora highlights the potential vulnerability of the food supply when it appears in the safety warnings.

Even with a careful tracking the route the microbe is penetrating into the food is proving difficult. Several factors make it a week for a particular attack. Several more

Continued on Page 20, Column 1

Western Allies Press To Oust Bosnia Serb

The leaders of the Group of Seven industrialized democracies threatened Serbia yesterday with the reimposition of United Nations economic sanctions if it did not use its influence to press Radovan Karadzic, the Bosnian Serb leader indicted on charges of war crimes, to resign from political office.

The leaders set no deadline, but they made it clear that Dr. Karadzic had to resign well before the nationwide elections in Bosnia on Sept. 14.

Carl Bildt, the international civilian coordinator for Bosnia, had asked the group's leaders to set a Monday deadline for Dr. Karadzic's resignation, which is called for under the peace agreement reached in Dayton, Ohio. A German diplomat said the expectation was that Dr. Karadzic would step down over the next few days and Perry said that day he would sometime refrain from Mr. Karadzic; otherwise swift action will follow afterwards."

Article, page 6.

F.B.I. FINDS CLUES TO THE TRUCK USED IN SAUDI BOMBING

MORE SECURITY PLANNED

U.S. Defense Chief, at the Site, Assures Skeptical Survivors of Safety Commitment

By PHILIP SHENON

DHAHRAN, Saudi Arabia, June 29 — F.B.I. agents were reported today to have uncovered the first leads in the investigation of the bombing that killed 19 Americans, the Defense Department announced that it would make changes in security at American military installations in Saudi Arabia.

American officials said that agents of the Federal Bureau of Investigation, searching the wreckage of the apartment complex bombed here Tuesday, had found a serial number on the truck that they say may help track it down quickly.

The truck, which was stolen. But officials say that the vehicle was an American-made truck that exploded last November outside of an American military training center in Riyadh, the Saudi capital, had been valuable in identifying the Muslim militants responsible for that blast.

"We may be able to see if we can find the owner of this," one Defense Department official said. "Virtually everybody believes the two explosions are linked somehow, that it was the same group of terrorists."

Officials said today that the truck was a Mercedes-Benz truck. They got away, but witnesses say one of the terrorists was driving a small white Chevrolet Caprice, another common vehicle here.

Defense Secretary William J. Perry, who arrived in Saudi Arabia today to meet with Saudi leaders and American military commanders, announced that defense perimeters around the military housing complex that was attacked on Tuesday would be expanded, creating a safety zone 400 yards and with 80 feet at the time of the explosion.

The sprawling complex, the Khobar Towers, is home to nearly half of the 5,000-member American military force in Saudi Arabia. The Defense Department said a 400-foot safety zone should provide adequate protection.

The American Air Force commander in Dhahran, Brig. Gen. Terry Schwalier, said today that Saudi

Continued on Page 8, Column 1

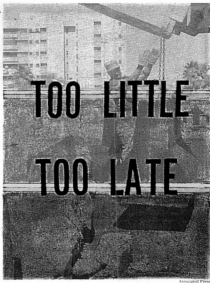

TOO LITTLE

TOO LATE

Associated Press

Concrete barriers were moved at the American military compound in Dhahran to extend the safety zone in the wake of Tuesday's blast.

THE NEW YORK TIMES is available for home or office delivery in most major U.S. cities. Call, toll-free 1-800-NYTIMES. Ask about Times-media TimesCard. ADVT.

354713

Graffiti-style overlay text: BEWARE OF HIS BARK AND BITE WE'LL HELP A BITE OUT OF YA YOU CAN RUN BUT YOU CAN'T HIDE LEAVE OR WE'LL POUT

July

July was really the most unusual month.

First it was business as usual, I mean *my* usual business,

making all my comments and so on, and then the news of Flight 800.

I knew exactly what I was going to do before the paper appeared—

Giotto's or Botticelli's angels, a blue field bordered in black,

and little flames that represented the souls of the passengers.

So when someone went to the exhibition or

when you look through the book, you can immediately see

the disruption that happened in the lives of so many people,

that an event happens and then everything

is different from then on.

The New York Times

Late Edition
New York: Today, becoming mostly sunny. High 89. Tonight, moonlit skies. Low 70. Tomorrow, ample sun, less humid. High 87. Yesterday, high 67, low 61. Details appear on page B5.

VOL.CXLV No. 50,475 · Copyright © 1996 The New York Times · NEW YORK, MONDAY, JULY 1, 1996 · $1 beyond the greater New York metropolitan area. · 60 CENTS

Quirk in Medicare Law Yields Bigger Bills for Outpatient Care

Officials Say Burden on the Elderly Is Increasing

By ROBERT PEAR

WASHINGTON, June 30 — Because of a quirk in the Federal Medicare law, elderly people are being required to pay more than their normal share of the bill for hospital outpatient services. It is far more than Congress originally intended and the burden is rising rapidly, shifting costs to them for a larger portion of all health care in the United States.

Beneficiaries are ordinarily supposed to pay 20 percent of the cost of services under Part B of the Medicare program. But because of the law, they are now responsible, on average, for 37 percent of the total payments to hospitals for outpatient services, one of the most important benefits under Part B, according to a recent report to Congress by a Federal advisory panel.

For many such services, the patients' share is even larger. Donna E. Shalala, the Secretary of Health and Human Services, said beneficiaries were paying more than 49 percent of the total Medicare payment to hospitals for outpatient surgery, radiology and other diagnostic services.

And Dr. Shalala said, "We expect that the beneficiary share of total hospital payments for these services will continue to increase rapidly," to 68 percent in 2000.

Since 1983, the Government has paid a flat amount for each Medicare patient admitted to a hospital, depending on the diagnosis. There are no such limits on outpatient care. A hospital can therefore increase its Medicare revenue simply by increasing its charges" or by seeing the Department of Health and Human Services.

Within the hospital regards its charges, the beneficiary pays more.

The Clinton Administration acknowledges that costs are already causing hardship for many Medicare beneficiaries. But Administration officials say they lack the authority to limit what hospitals charge for outpatient services under Medicare, and they are fighting a lawsuit by Medicare patients who insist the Government is supposed to set such limits.

The new Medicare law, in fact, says that you pay 20 percent of the charges approved by Medicare. This is called the Part B "annual deductible." After the deductible is met, you pay 20 percent of the approved amount for most services. You are responsible for the first $100 each year of the charges approved by Medicare. This is called the Part B "annual deductible." After the deductible is met, you pay 20 percent of the approved amount for most services. You are responsible for the first $100 each year of the charges approved by Medicare.

But, it states, a big exception: "If your hospital services at a hospital, you are responsible for paying 20 percent of whatever the hospital charges, not 20 percent of a Medicare-approved amount."

The costs to beneficiaries are rising because of a peculiar feature of the Medicare law: whereas the bene-

Continued on Page A10, Column 1

U.S. AGENCY WANTS THE PILL REDEFINED

Plan by F.D.A. Would Promote Use on the 'Morning After'

By TAMAR LEWIN

In an unusual move tantamount to approving a new drug, the Food and Drug Administration plans to publish in the Federal Register a notice that says ordinary oral contraceptives can be safely and effectively used as "morning after" pills, according to a top agency official.

At a hearing on Friday, the reproductive health advisory committee of the Federal agency unanimously declared that birth-control pills could be used to prevent pregnancy up to 72 hours after unprotected intercourse.

But because of concerns about not only liability litigation but also anti-abortion protests, no manufacturer has been willing to market the pills specifically as such postcoital, or "emergency" use, and without an application from a manufacturer, the Food and Drug Administration cannot formally approve the new use, said the official, Mary Pendergast, the Deputy Commissioner.

"We're trying to pave the way for greater access to emergency contraception, and this is as far as we can go without a new drug application," Ms. Pendergast said in an interview yesterday. "We hope the notice in the Federal Register will calm people's anxieties about using oral contraceptives as morning-after pills. And we're still hopeful that someone will come forward to market them."

She added, "Once we've declared that they're safe and effective, the approval process for a manufacturer would be very simple, just a matter of making sure that what they're selling is the bio-equivalent of what we've approved."

Birth-control pills have been used

Continued on Page B6, Column 1

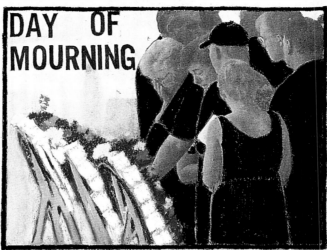

DAY OF MOURNING

Families of men killed in Saudi Arabia viewed wreaths honoring the dead at Eglin Air Force Base in Florida.

Hong Kong, Takeover Near, In Wary Dance With Destiny

By EDWARD A. GARGAN

HONG KONG, June 30 — Tucked among the coffin makers that sell hankie-sized pieces of fertile land to play Chinese chess, a fading photograph shows a waterfront site, Possession Point — the spot where the British flag was first planted, by Capt. Edward Belcher and his men on Jan. 26, 1841.

Today Possession Point — now Hollywood Road Park — is well inland from Hong Kong's shrinking harbor. The coffin makers lounge on low stools, smoke from their loosely fingered cigarettes drifting in the pudding-thick humidity, as they wait for their next customers and watch the faint moment of British rule.

Next year from today, at midnight's stroke on June 30, 1997, the territory's last colonial governor will leave Hong Kong, relinquishing Britain's final Asian outpost and its 6 million people to one of the world's last remaining Communist governments. It is a moment that is riveted in people's minds and emotions, a date with a destiny many fear and others exult in.

In Beijing, where an immense digital clock ticks glowing red seconds inexorably toward zero hour, Hong Kong's return to China has become decisive rhetoric — the return of territory once taken — the religion of a generation of mainland-bred Chinese, and it forced China to try to bury the "century of colonial humiliation."

Under this yoke, however, Hong Kong has become Asia's pre-eminent financial center, a city feverishly at work on the globe's largest civil engineering project — involving a new airport, town, railroads, two immense bridges and two tunnels — to keep Hong Kong's harbor. Hong Kong the place where money is made.

Continued on Page A6, Column 1

Economic Summit Subplot: Do French Walls Have Ears?

By DAVID E. SANGER

LYONS, France, June 29 — As Air Force One landed on the edge of this ancient city, at the edge of this summit of the world's leaders, security agents from the smallest of the nations accompanying President Clinton delivered a clear warning.

Enjoy the two- and three-star restaurants, he said, and the local Beaujolais. But bring all your documents with you — not only printed material, but anything that might shed light on Washington's economic strategies.

"He just wanted to warn us about this," one senior American official said. Mr. Clinton's aides were warned during an economic summit that it could cost economic competitors of the United States dearly to get a leg up on American negotiators.

As it turns out, Charlene Barshefsky, the acting United States trade representative, and other top Clinton aides toted briefing books that stayed close at hand — but so did their laptop computers, whose hard drives are filled with the old-fashioned American secrets.

The economic summit meetings, of course, are mostly about staged photographs of the seven leaders and lengthy communiqués that aides negotiate in the weeks leading up over differences and jockeying for future advantage.

But the real action takes place in the negotiations that vie for advantage, where the topic is closest to the interests of the United States, or essentially rules that govern monetary union before, wherever.

Continued on Page D2, Column 4

SAUDIS OFFER U.S. FULL COOPERATION IN BOMBING INQUIRY

U.S. OFFICIAL MEETS KING

Defense Secretary Confirms Some Help Was Withheld After Earlier Attack

By PHILIP SHENON

ABOARD U.S.S. GEORGE WASHINGTON in the Persian Gulf, June 30 — The Defense Department said today that Saudi Arabia's rulers had pledged complete cooperation in the investigation of the bomb attack that killed 19 American servicemen last week, even as it became clear that the Saudis did not cooperate fully with the United States after a bombing last year that killed five Americans.

After receiving the pledge from the ailing King and his senior advisers during a meeting in the western Saudi city of Jidda, Defense Secretary William J. Perry confirmed that the Saudi Government had refused earlier this year to allow the Pentagon to expand the security perimeter around the Khobar Towers apartment complex in Dhahran, site of the bombing on Tuesday.

The Pentagon has announced that the perimeter will be enlarged to 400 feet, the distance that was previously rejected by the Saudis, apparently because Saudi officials did not want to shut a public park and parking lot adjoining the apartments.

The bomb exploded about 80 feet from the nearest building in the sprawling apartment complex, which houses about half of the 5,000 American troops deployed in Saudi Arabia.

The disclosure that the United States had pressed for a larger perimeter months earlier suggests that Clinton Administration officials understood the danger, but were fearful of offending the Saudi Government by pressing for more stringent security.

"If the perimeter had been pushed back 400 feet and if the bomb had gone off at the same place, there would have been far fewer damages, without question," Mr. Perry told reporters aboard this aircraft carrier, which he visited after leaving Saudi Arabia today.

In a reflection of the delicacy with which the United States treats its relations with the oil-rich kingdom, Mr. Perry declined again to criticize Saudi officials. He insisted that they had been generally cooperative in expanding security precautions since the explosion last November, at an American-run military training center in Riyadh, the Saudi capital.

"There is not a full, cooperative relationship with the Saudis," he said. "We want to point out that both had been done, both by the Americans and by the Saudis, to improve security in the

Continued on Page A7, Column 3

Clinton Leads Rites for Dead In Saudi Blast

By DAVID E. SANGER

PATRICK AIR FORCE BASE, Fla., June 30 — President Clinton led mourning today for the 19 American airmen killed last week in Saudi Arabia, telling their grieving families, "America stands with you. We will not rest until the killers are apprehended."

The President and his top colleagues vowed this morning at an Air Force Base to track down the killers.

"Isaiah answers: 'Here I am, Lord. Send me,'" Mr. Clinton continued. "These men we honor today, America, 'Send me.'"

"We're blessed to have men and women like these who stand in times of danger," Mr. Clinton, who paid a visit to France at the start of his annual summit meeting that ended in Lyons, France, earlier Sunday. Mr. Clinton vowed that those who killed the airmen would be hunted down.

As he spoke about the summit meeting, the president repeated in

Continued on Page A7, Column 1

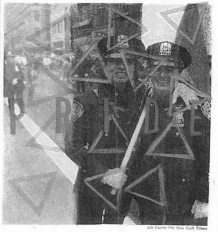

INSIDE

Two Cubans Leave Team
Two members of Cuba's Olympic boxing team crossed into the United States from Mexico yesterday in an apparent attempt to defect. Sports, Monday, page C1.

Mixed Signals in Bosnia
The chief diplomat overseeing the Balkan accord said that the Bosnian Serb leader, Radovan Karadzic, had resigned, but the Bosnian Serbs later denied the statement. Page A6.

Yeltsin's Biggest Backer
Gazprom, Russia's huge natural gas company, openly backs President Yeltsin, and its officials are working hard to make sure he wins. Page A5.

Wanted: Esquire Men
Once the quintessential men's magazine, Esquire is now struggling to get today's men, and today's advertisers, to accept it. Page D1.

A Damp Farewell to a Church Leader

Choirboys and others marched toward the Central Park Band Shell yesterday to pay tribute to Archbishop Iakovos, the departing leader of the Greek Orthodox Church in the Western Hemisphere. The often controversial clergyman is stepping down this month after a 37-year tenure. Page B8.

A First at Gay Pride March
Emma Llarado, left, and Fran Debenedictis of the Gay Officers' Action League took part in the Fifth Avenue parade yesterday. It was the first time officers were allowed to wear their uniforms at the march. Page B3.

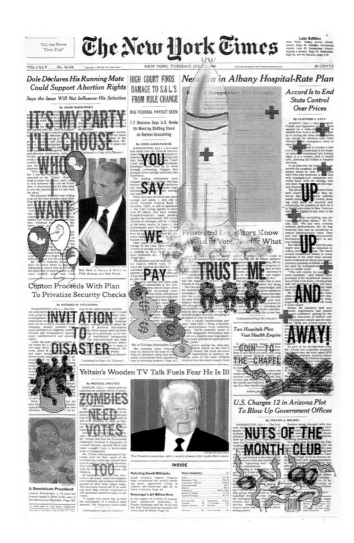

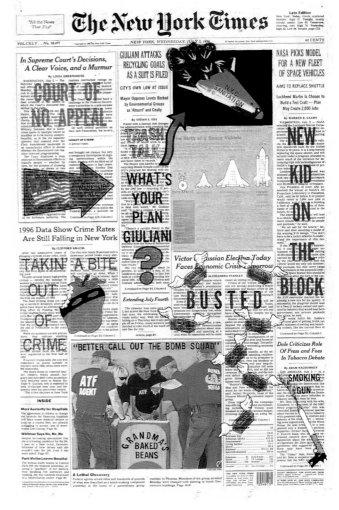

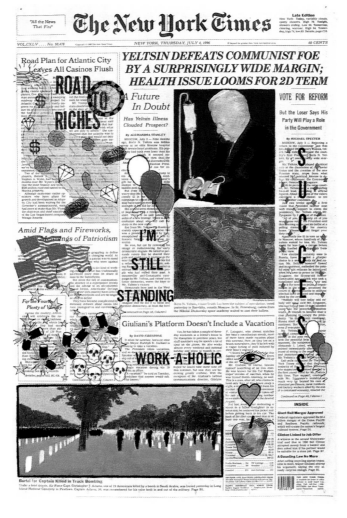

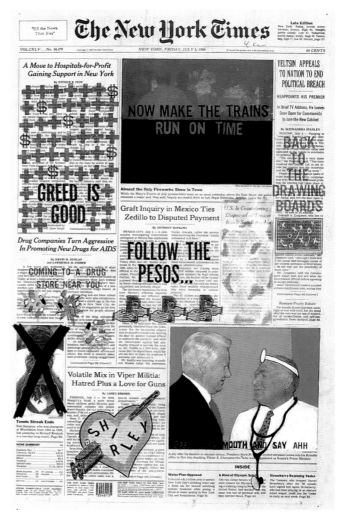

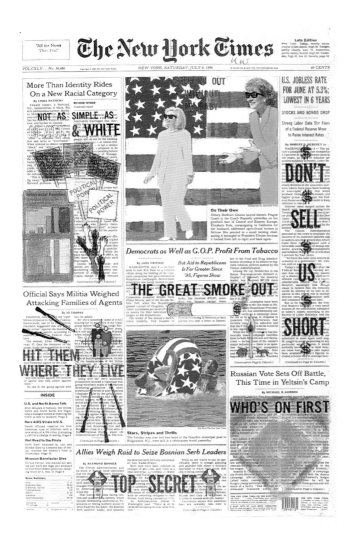
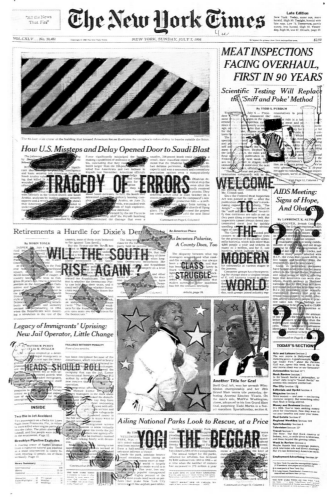
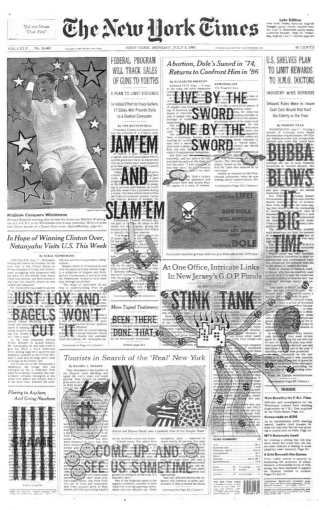
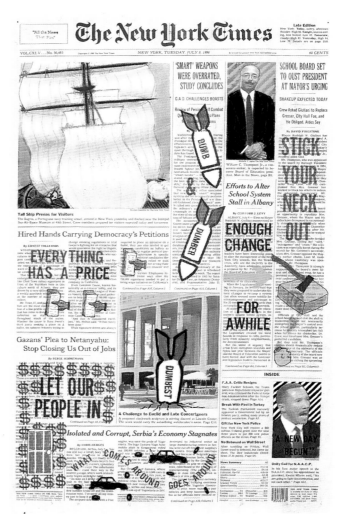

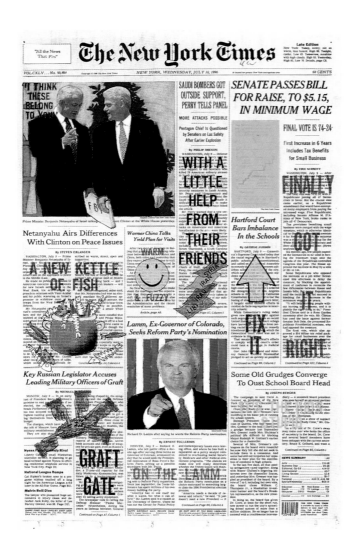

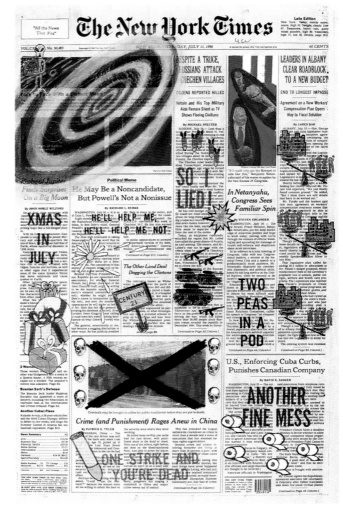

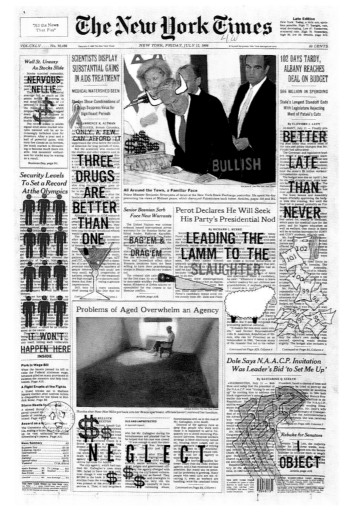

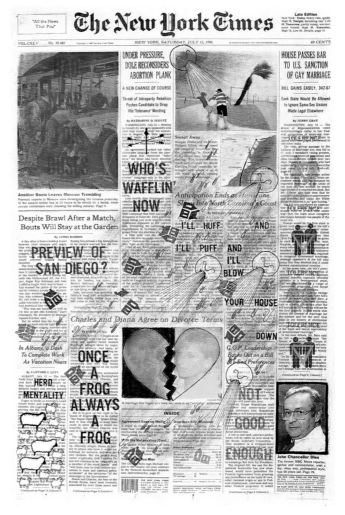

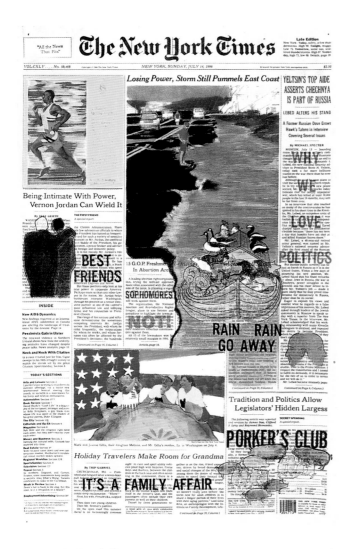
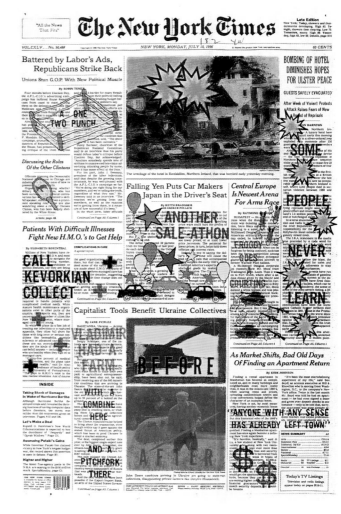
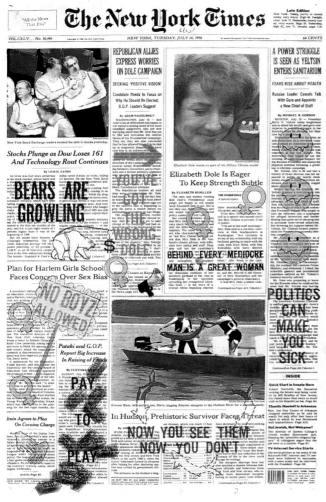
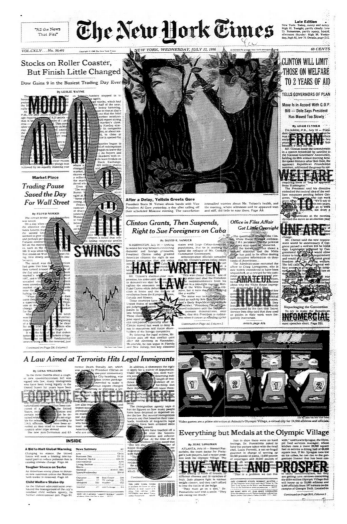

The New York Times

Late Edition
New York: Today, increasing clouds, afternoon thunder. High 86. Tonight, scattered thunderstorms. Low 73. Tomorrow, showers. High 82. Yesterday, high 87, low 74. Details, page C18.

VOL.CXLV . No. 50,492 Copyright © 1996 The New York Times NEW YORK, THURSDAY, JULY 18, 1996 $1 beyond the greater New York metropolitan area. 60 CENTS

T.W.A. JETLINER LEAVING NEW YORK FOR PARIS CRASHES IN ATLANTIC; MORE THAN 220 ABOARD

U.S. Force in Saudi Arabia: Isolation as a Key to Safety

By PHILIP SHENON

WASHINGTON, July 17 — Defense Secretary William J. Perry announced today a series of measures to protect American troops in the Middle East from chemical and biological weapons, and from terrorist bombs five or more times as large as the one the American airmen.

As many as 4,000 troops, or about two-thirds of the American garrison, will be moved to more remote bases in the desert, where they are less likely to be targeted, he said.

Officials said that details about the moving of the troops.

"We have to rethink the way we configure and deploy our forces," said Mr. Perry, who has been criticized in Congress over the inadequate security in Saudi Arabia before the bombing last month.

"We can't deal with those attacks adequately just by moving fences."

The Defense Department said last week that it had received intelligence reports suggesting that terrorists in Saudi Arabia may be planning to use an even larger, far deadlier bomb than the one detonated last month at the Khobar Towers complex outside Dhahran. The device last month was estimated at 3,000 to 5,000 pounds.

After that attack, the Air Force weapon attack, bombs even larger than 3,000 pounds, bombs in the 10,000 to 20,000-pound category, mortar attacks."

His blunt public comments were the first from a senior Pentagon official to quantify the new bomb threat, or to make mention of the possibility that terrorists operating in Saudi Arabia might have access to chemical or biological weapons.

Mr. Perry told Congress last week that he assumed the bombers who struck last month had support from a well-organized, well-financed international network and possibly from a foreign government.

Both Iraq and Iran have called for the overthrow of the Saudi Government, and both have sought to develop chemical and biological weapons.

"This is an initiative to provide adequate protection for our forces in the face of what I consider to be a threat of weapons of mass destruction in the hands of terrorists," Mr. Perry said in a brief news conference.

While the Defense Department has warned that terrorists in Saudi Arabia may be able to build far larger bombs, Pentagon officials do not appear to have any specific information to support the 10,000 to 20,000-pound range Mr. Perry suggested today.

He appeared to acknowledge that when he said the new security precautions were "worst-case planning," but said, "I believe we have to be prepared."

Another senior Pentagon official, speaking on condition of anonymity, said that the Defense Department also had no specific information that terrorists might be contemplating using chemical or biological weap-

Continued on Page A6, Column 1

Time Warner Near Approval In Turner Deal

By GERALDINE FABRIKANT

The Federal Trade Commission effectively cleared the way for the merger of Time Warner Inc. and Turner Broadcasting System Inc. yesterday but will require the new companies cable television system to carry channels as a rival to its own network.

The requirement for the second channel is intended to increase competition in programming. According to agency lawyers, it is the first time that the Government has mandated that a cable company carry a particular type of programming on a national scale. Previously, cable companies have only been required to carry broadcast stations that customers wanted. Cable television programming has historically been free.

The requirement is one of a series of concessions the agency seeks before it will approve the $6.3 billion merger, which would create the world's largest media company. Its holdings would include the nation's largest cable programmer, with Cable News Network, Home Box Office and Turner Network Television, to be distributed over Time Warner's extensive cable system, the second largest in the nation. Time Warner's businesses also include the Warner Brothers studios, Warner Music and magazines including Time, People, Sports Illustrated, Fortune and Entertainment Weekly.

F.T.C. staff members approved

Continued on Page D7, Column 1

INSIDE

A Change on Pesticides
Long-divided factions on the House Commerce Committee voted unanimously for a compromise measure that would basically alter the regulation of pesticides in food. Page A20.

600 Suspected of Tax Fraud
At least 600 New York City employees, some of whom claim they are not subjects of the United States, are suspected of evading Federal and state income taxes. Page B4.

A Planet Within a Planet
Scientists have reported strong evidence that Earth's inner core is spinning freely and slightly faster than the rest of the planet. Page A20.

Kremlin Intrigue by Design
President Yeltsin appears to be building a new Government with an eye toward insuring maximum rivalry. News analysis, page A3.

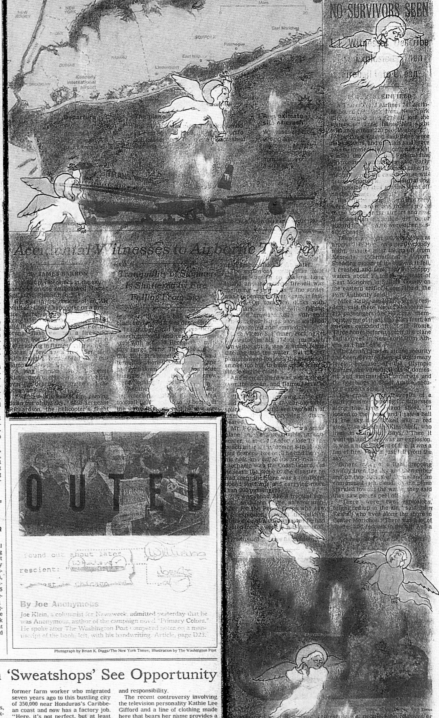

NO SURVIVORS SEEN

Accidental Witnesses to Airborne Tragedy

By JAMES BARRON

Tranquility of Summer Is Shattered by Fire Trailing From Sky

OUTED

found out about later

rescient:

By Joe Anonymous

Joe Klein, a columnist for Newsweek, admitted yesterday that he was Anonymous, author of the campaign novel "Primary Colors." He spoke after The Washington Post compared notes on a manuscript of the book, left, with his handwriting. Article, page D23.

Photograph by Brian K. Diggs/The New York Times, Illustration by The Washington Post

Wall Street Is Calmer As Stocks Rise Again

Shoulders dropped a little on Wall Street yesterday, as a reassuring day ended with all the major market benchmarks higher in extremely heavy trading. The Dow Jones industrial average closed up 18.12 points, and the composite Nasdaq index rose 10.3 points, or 1.5 percent. At some stock indicators.

The tension-easing session suggested that investors had not fled the market in disgust after a two-week downturn. Corporate earnings that were better than expected helped spur the market.

Business Day, page D1.

Hondurans in 'Sweatshops' See Opportunity

By LARRY ROHTER

SAN PEDRO SULA, Honduras, July 13 — Each morning, the workers spill off the buses and cross the guards at the gates of the industrial park before the 7:30 start of their workday.

Outside, anxious onlookers are always waiting, hoping to be the next least to find jobs in the factories that throng here.

With wages that start at less than 40 cents an hour, the apparel plants here offer little by American standards. But many of the people who work in them, having come from jobs that pay even less and offer no benefits or security, see employment here as the surest road to a better life.

"In the countryside, a peon is a peon for all of his life," said Yensy Meléndez, 29, a father of two and former farm worker who migrated seven years ago to this bustling city of 350,000 near Honduras's Caribbean coast and now has a factory job. "Here, it's not perfect, but at least an improvement."

tion can seem a rare opportunity to gain, and perceptions have become increasingly common as the global economy grows more intertwined, and have set off a heated debate about international norms of conduct and responsibility.

The recent controversy involving the television personality Kathie Lee Gifford and a line of clothing made here that bears her name provides a widely publicized focal point.

To critics in the United States, the apparel factories here, known as maquilas, are merely "monstrous sweatshops" of the third world. Clothing the Gifford group that originally accused Honduras of turning a blind eye to Honduras working for "slave wages."

The National Labor Committee, a nonprofit group, is largely financed by foundations but also receives money from labor unions in the United States.

After the attacks on her, Mrs. Gifford has now endorsed efforts to

Continued on Page A14, Column 1

MORE ON THE CRASH

HAPPY B-DAY HUNTER S. THOMPSON FROM
Earth's biggest bookstore — Amazon.com Books!
http://www.amazon.com/ — ADVT.

28 EAST 86TH ST. HAS BEEN LIBERATED
from the cable monopoly! Better bundling with service.
Better prices! Call Liberty Cable 212/891-7777 - Advt.

"All the News That Fits"

The New York Times

Late Edition
New York: Today, humid, some thunder, windy at times. High 86. **Tonight,** some thunder. Low 75. **Tomorrow,** sunny, less humid. High 86. Yesterday, high 89, low 73. Details, page A21.

VOL.CXLV...No. 50,493 Copyright © 1996 The New York Times *NEW YORK, FRIDAY, JULY 19, 1996* $1 beyond the greater New York metropolitan area. **60 CENTS**

INVESTIGATORS SUSPECT EXPLOSIVE DEVICE AS LIKELIEST CAUSE FOR CRASH OF FLIGHT 800

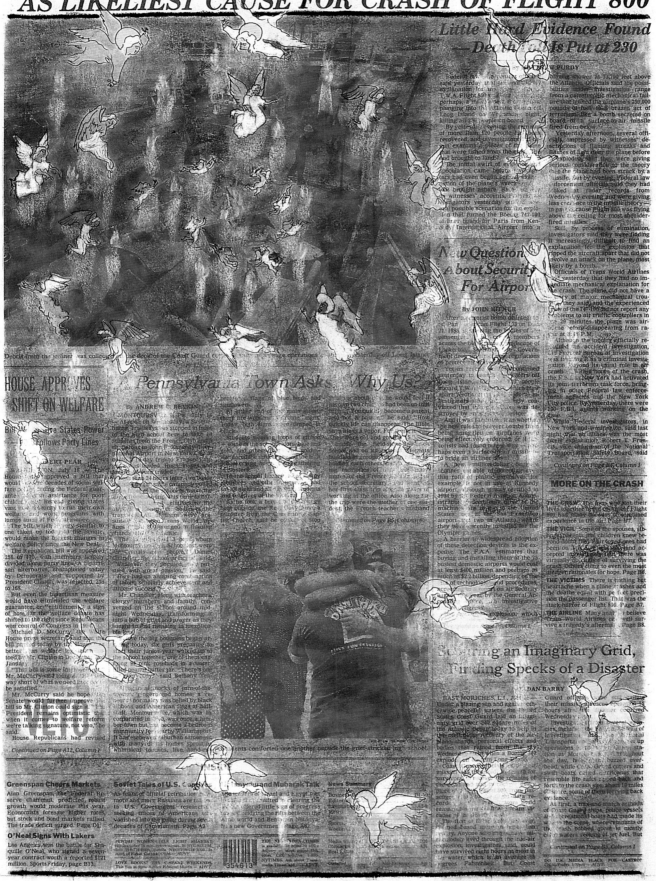

Little Hard Evidence Found — Death Toll Is Put at 230

By ANDREW PURDY

New Questions About Security For Airports

By JOHN MINER

MORE ON THE CRASH

THE CREW ...

THE VIGIL ...

THE VICTIMS ...

THE AIRLINE ...

HOUSE APPROVES SHIFT ON WELFARE

Bill ... the States' Power ... Party Lines

By ROBERT PEAR

Continued on Page A12, Column 1

Pennsylvania Town Asks, "Why Us?"

By ANDREW REVKIN

MONTOURSVILLE ...

Continued on Page B5, Column 1

Residents comforted one another outside the grief-stricken ... school.

Searching an Imaginary Grid, Finding Specks of a Disaster

By DAN BARRY

EAST MORICHES, L.I. ...

Continued on Page B5, Column 1

Greenspan Cheers Markets

Alan Greenspan, the Federal Reserve chairman, predicted robust growth would moderate this year. Economists foresee higher rates, but stock and bond markets rallied. The trade deficit surged. Page D1.

O'Neal Signs With Lakers

Los Angeles won the battle for Shaquille O'Neal, who signed a seven-year contract worth a reported $121 million. SportsFriday, page B13.

Soviet Tales of U.S. ...

... and Mubarak Talk

News Summary

"All the News That Fits"

The New York Times

Late Edition
New York: Today, mostly sunny, windy, less humid. High 80. Tonight, clear, not as windy, cool. Low 63. Tomorrow, sunny. High 81. Yesterday, high 85, low 72. Details, page 52.

VOL.CXLV... No. 50,494 Copyright © 1996 The New York Times NEW YORK, SATURDAY, JULY 20, 1996 $1 beyond the greater New York metropolitan area. 60 CENTS

Panel Advises F.D.A. To Allow Abortion Pill

Agency Foresees Final Action in September

By GINA KOLATA

GAITHERSBURG, Md., July 19 — Meeting in a windowless building here amid unusual security precautions, a committee of advisers to the Food and Drug Administration recommended today that the agency approve for marketing the abortion-inducing drug mifepristone.

The recommendation allows more than 20 years of American abortion protest has kept the drug, easily available in France, Britain and Sweden, out of the United States.

In deciding that mifepristone (mih-feh-PRISS-tone) should be considered safe and effective, the advisory committee may well have ordained a dramatic change in abortion procedure, and abortion politics throughout the country.

Although the F.D.A. is not bound by its advisory committees' recommendations, in practice it almost always adopts them. Dr. David A. Kessler, the Commissioner of Food and Drugs, said today that the agency's goal in this case was to make a final decision by mid-September.

The reaction of abortion combatants who attended the hearing where the committee voted was predictable.

Eleanor Smeal, president of the Feminist Majority Foundation, said: "I'm thrilled. It's a medical breakthrough."

Olivia Gans, director of American Victims of Abortion, a national group of women who have had abortions and now regret them, said: "The Government has this very much on a fast track, and that's what we were afraid of. It's not a good signal."

Still, some abortion-rights supporters expressed concern about this administration to get this drug approved before the election," in the event that President Clinton, an abortion-rights supporter, should be defeated this November by Bob Dole, an abortion opponent. The Commissioner of Food and Drugs is a Presidential appointee.

The committee today acted today had eight members, most of them physicians specializing in obstetrics and gynecology. Its chairman was Dr. Ezra C. Davidson Jr., a professor of obstetrics and gynecology at the Charles R. Drew University of Medicine and Science in Los Angeles.

Some members of the committee expressed concern at the cost and inconvenience entailed in the several visits to doctors' offices that would be required of women who partook in the drug regimen.

Some noted too that mifepristone had failed to induce abortion among a small percentage of women, leaving them with the choice of proceeding with surgical abortions or facing the prospect that the drug had caused a defect in the fetuses.

The panel nonetheless recommended approval, in a series of three votes: By 6 to 0, with 2 abstentions, it decided that the drug's benefits outweighed its risks; by 7 to 0, with 1 abstention, it decided that the drug was safe, and by 6 to 2 it decided that data from a French study were sufficient to support American use of the drug. The committee reserved the right to look at the research again if

Continued on Page 9, Column 1

TOP BOSNIAN SERB AGREES TO RESIGN

Karadzic Yields Political Role but He Will Not Be Exiled

By JANE PERLEZ

BELGRADE, Serbia, July 19 — Radovan Karadzic, the Bosnian Serb political leader who led his people in a brutal war of ethnic separation, has agreed to give up political power immediately, the special United States envoy, Richard C. Holbrooke, said here today.

The agreement removes an obstacle to September's national elections in Bosnia and it could aid the flagging peace effort by removing from visible public life a man indicted for genocide and other war crimes.

But Mr. Holbrooke acknowledged that it fell short of the goal of removing Dr. Karadzic from Bosnia and putting him on trial at the war crimes tribunal in The Hague, something Western nations have long demanded.

"This is a minimal acceptable package," Mr. Holbrooke said. Only a few days ago Mr. Holbrooke told Western and Bosnian officials that if Dr. Karadzic did not agree to leave Bosnia, the West would reimpose economic sanctions on Serbia. For now, Dr. Karadzic remains in his mountain hideaway of Pale, near Sarajevo, and the threat of sanctions has been withdrawn.

The agreement was negotiated with President Slobodan Milosevic of Serbia.

Continued on Page 4, Column 4

INSIDE

Growing Divisions in Mexico
An economic crisis is exaggerating an already wide income gap between rich and poor and giving rise to startling contrasts and clashes. Page 3.

Teachers for Newark
New Jersey plans to hire additional teachers for the embattled Newark schools by trimming more than 600 other employees. Page 21.

A New Look for Colorado
In Colorado, land where cattle once roamed is giving way to bulldozers clearing sites for shopping malls, offices and golf courses. Page 6.

Rough Seas Hamper Search for Clues in Plane Crash

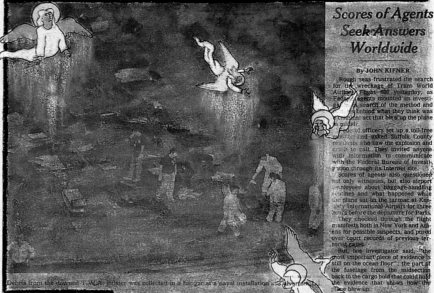

Debris from the downed T.W.A. jetliner was collected in a hangar at a naval installation in Shinnecock.

Scores of Agents Seek Answers Worldwide

By JOHN KIFNER

Rough seas frustrated the search for the wreckage of Trans World Airlines Flight 800 yesterday, as Federal agents mounted an investigation in search of the method and motive behind what they think was a criminal act that blew up the plane in midair.

A team of officers set up a toll-free number and asked Suffolk County residents who saw the explosion and crash to call. They invited anyone with information to communicate with the Federal Bureau of Investigation through its Internet site.

Scores of agents also questioned not only witnesses, but also airport employees about baggage-handling routines and what happened while the plane sat on the tarmac at Kennedy International Airport for three hours before the departure for Paris.

They checked through the flight manifests both in New York and Athens for possible suspects, and pored over court records of previous terrorist cases.

But, one investigator said, "the most important piece of evidence is still on the ocean floor": the part of the fuselage from the midsection back to the cargo hold that could hold the evidence that shows how the plane blew up.

The bodies of at least 130 of the plane's passengers also presumably remain with the wreckage. Only 100 have been recovered so far; a list of the victims is on page ...

The search that was postponed yesterday was critical, another investigator said, because the searchers have recovered less than 1 percent of the wreckage, parts of a wing and a tail, but nothing thus far that indicated where an explosion might have begun.

"If there was an explosion, the places that count are the ones that were near the explosion," this official said.

Investigators said they hope they can resume recovery operations today, adding that chemical residues and related evidence from an explosion would probably be lost if the wreckage stayed in the water as long as a week.

The possibility that an equipment failure was to blame seemed to ebb yesterday. Even the normally understated vice chairman of the National Transportation Safety Board, Robert Francis, said, "The possibility of a criminal act is a distinct one."

At a news briefing later, James Kallstrom, the head of the F.B.I. office in New York City, said, "We're looking at this as a criminal investigation."

Mr. Kallstrom, wearing an F.B.I. windbreaker field jacket, seemed determined to appear restrained as he opened his part of the news conference by saying, "We're not here to take over the investigation yet. We're not here to declare that this is a terrorist event" as has been speculated in the media.

"... If it was a terrorist event, we have the determination to go to the end and bring the people who did it to justice ... something ..."

Continued on Page 27, Column 2

Investors Pull Money Out of Stock Funds

Investors were clearly rattled by wild swings in the stock market, withdrawing money from stock mutual funds in the largest weekly withdrawal in years.

While the data, released yesterday, do not reflect investor activity on Thursday and Friday, when the stock market recovered, they continue to ...

Yesterday provided more fodder for skittish investors. After disappointing earnings reports from several technology companies, the Dow Jones industrial average declined 37.36 points, while the Nasdaq Composite index fell 12.14 points.

Continued on Page 9, Column 1
Business Day, page 39.

For Families, Few Answers Except the Ones They Fear

By JAMES BARRON

Their days are now bracketed by ... [defaced] ... And they try to adjust, to absorb the things they did not want to know. On Thursday, they did not want to know that there were no survivors among the 230 people who had barely settled in for the long flight to Paris when the airliner went down. Yesterday, they did not want to know that rescuers might never find all of the bodies.

"I just wanted to see her," said Kyle Tennant of Sunset Park, whose neighbor, Donna, was aboard the Boeing. "Don't know if she's in the water. If she blew up. If she drowned."

So the questions of this tragedy when relatives ... at the Ramada Inn ...

Some relatives are staying at the hotel, mostly people who, like the loved ones on the doomed flight, had made the journey to Kennedy from out of town. Some New York-area relatives have checked in, others stop by for the briefings at home and come back later. Some drift out to the parking lot and chat with reporters in the long hours when there seems to be no news. Some order room-service meals after rooms ...

Continued on Page 25, Column 1

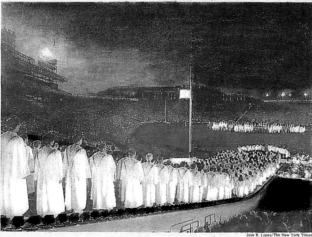

The Olympics Open Amid Pageantry, and Anxiety

The Centennial Choir took part in the opening ceremony last night for the Olympic Games in Atlanta.

Joie R. Lopez/The New York Times

By JERE LONGMAN

ATLANTA, July 19 — After six years of preparation, Atlanta welcomed the world tonight for the opening of the Centennial Summer Olympics, which began with idealistic hopes for a strong nation, moderated by a society about terrorism in the wake of the explosion aboard Trans World Airlines Flight 800.

An estimated 7,000 athletes from 197 nations marched into the Olympic Stadium, filled with 83,100 spectators who paid up to $636 for a ticket, and witnessed a captivating and vibrant, if ear-splitting, celebration meant to honor 100 years of the modern Games and evoke the hospitable spirit of the modern American South. Competition will begin Saturday and continue through Aug. 4.

After speaking to the American contingent of 654 athletes in the Olympic Village, President Clinton attended the opening ceremony.

But while the President came to celebrate the brotherhood of nations, united in the name of sport, the deaths of those aboard T.W.A. Flight 800 on Wednesday made the occasion "somewhat sadder by the tragedy that's now been suffered," the White House press secretary, Mike McCurry, said.

Security has been tight at the Olympics since the deaths of 11 Israeli athletes and coaches at the hands of Palestinian gunmen at the 1972 Games in Munich, Germany. The fear of terrorism here will be renewed after the explosion of T.W.A. Flight 800, and the Games will be marked by an eight-foot-high fences for a block on either side, and is being restricted, with concrete-filled bollards ... blimps can from a ... German ...

Continued on Page ..., Column ...

Multiracial Americans Ready To Claim Their Own Identity

By MICHEL MARRIOTT

For Alison Perry, being multiracial has meant going through life as if a question mark was drawn on her forehead. Strangers frequently approach her in a vexing guessing game. "Are you Israeli?" "Are you Italian?" "Where are you from?"

Yet for this light-colored woman with wavy hair and drawn from both her black-American father and her Italian mother, race is not what ...

"I definitely say that I'm special," Ms. Perry said. "I do not identify myself as a black woman. I definitely don't identify myself as a white woman, either."

The very existence of multiracial people like Ms. Perry challenges this nation's traditionally rigid notions of race.

Their struggles of pride, loyalty and, occasionally, shame raise profound questions about the meaning of race and the promise and pitfalls of racial identity. Multiracial Americans often find themselves claimed by many groups and belonging wholly to none, in a society that often forces them to choose one identity or imposes that identity on them.

Today, thousands of mixed-race Americans are expected to gather on the Mall in Washington in a display of pride, power and unity. Organized under the banner of the Multiracial Solidarity March, the afternoon demonstration is intended to celebrate multiracial identity and to pressure the Federal Government to add a multiracial category to the next census.

No one knows exactly how many Americans consider themselves multiracial, though the 1990 census ... their children younger ... parents are of different races.

"People of mixed race in this country haven't belonged anywhere," ...

Continued on Page 7, Column 1

The New York Times

Late Edition
New York: Today, sunny, breezy.
High 83. Tonight, clear, pleasant, less
windy. Low 65. Tomorrow, mostly
sunny, high clouds. High 86. Yester-
day, high 76, low 65. Details, page 35.

VOL.CXLV.... No. 50,495 Copyright © 1996 The New York Times *NEW YORK, SUNDAY, JULY 21, 1996* $1 beyond the greater New York metropolitan area. **$2.50**

Added Game for Atlanta: Define (Find) a Redneck

BY RICK BRAGG

ATLANTA, July 20 — If you believe what you hear on the radio, this city is acrawl with lumber-stealing, beer-swigging rednecks who think there ought to be a pig spinning slowly over the Olympic flame and water.

Olympic Diary

As the games begin, the excitement in Atlanta is... at all, but... the comedy routines... who... up com... show has... rednecked... previous job...

... uncer who op... h: "Greet-ing... L, and welc... reigners fro... Lord, be w... are them ... that they

... Summer Olympics, discus thr... Ford hub-cap... rdle the ... four re-... cursion to a ... to steal lumber. ... e sidewalks of At-... covered with Bui-... e racers, muti-eth-nic synch... ized swimmers and Japanese... reporters, indige-nous red... k people are not part of the Oly... pic experience, so far.

"Oh n... you will not see them here in... lanta," said Matthias Baum... Olympic visitor from G... are deep, deep in... woods. Other-wise... real redneck. I hav... you get off the main... into the stony road... a few of them sitt... cking chairs in fro... ile homes, play-ing the...

Asked to define a redneck, he replied: "Someone who does not take part in business."

An Indonesian woman, snapping photographs of her husband as he posed with three Atlanta police officers, said she was not sure what a redneck was, "but I read in the newspaper that they do not bother you."

That is true. The Russian women's gymnastics team has yet to be chased down Marietta Street by anyone remotely resembling the hillbilly Ernest T. Bass. In Atlanta, people read The Wall Street Journal in the crowd at

Continued on Page 19, Column 1

FIRST GOLD Renanta Maeur of Poland won air rifle event.
Associated Press

FIRST RECORD Belgium's Fred Deburghgraeve set mark in 100-meter breast-stroke.
Associated Press

FIRST BRUISE Leslie Lyness of the United States team beating Eleonoor Holsboer of the Netherlands to the ball in field hockey.
Jose R. Lopez/The New York Times

Search for Clues of Flight 800 Focuses on Ocean Floor

Debris Is Tested for Traces of Explosives

BY MATTHEW PURDY

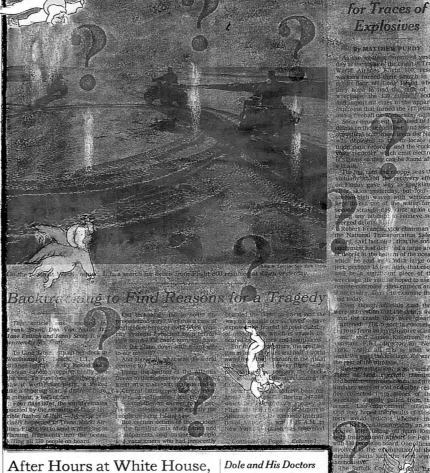

As the weather improved yesterday at the site of the crash of Trans World Airlines Flight 800, rescue workers turned their search to the ocean floor off Long Island, where they hope to find the bulk of the wreckage, the 120 missing bodies and important clues to the apparent explosion that turned the 747 jetliner into a fireball on Wednesday night.

Sonar equipment was used to find debris on the ocean floor, and special oceanographic ships in the Navy was deployed... to... to locate the flight data recorder and the cockpit voice recorder, which emit electronic signals so they can be found after a crash.

The seas remained choppy, seas that virtually halted the recovery effort on Friday gave way to sparklingly clear skies yesterday, but four- to six-foot-high waves with whitecaps kept divers out of the water for a second straight day, once again delaying any attempt to retrieve submerged debris.

Robert Francis, vice chairman of the National Transportation Safety Board, said last night that the sonar equipment had detected a large area of debris at the bottom of the ocean, which he said included a large object, perhaps 15 feet high, that could well be a significant piece of the wreckage. He said he hoped to use a remote-controlled video camera and, if necessary, divers to examine that find today.

Even though officials said they were not certain that the debris was from the crash, they were clearly heartened. His report is consistent with reports from investigators stationed here. James Kallstrom, the assistant F.B.I. director for New York, said of all this is what we want. We want the fuselage. We want the rest of the airplane.

The investigators also checked plane models to find further elements and other objects. Preliminary tests on soot and other residue collected from pieces of the wreckage already pulled from the ocean. Law enforcement officials said they hoped the results of those would indicate whether the explosion... Whether the taking off from Kennedy International Airport for Paris with 230 people on board. One official involved in the examination of the airplane parts said the crews were...

The Suffolk County Pathologist Dr. Charles... said that they... what physical evidence collected clues to the Federal investigation, but he...

Seventy-two hours after the crash, shock and grief were still sustaining an all fronts. Family members flashed out at Government officials in a private briefing and said... to have to wait...

Continued on Page 1, Column 1

Backtracking to Find Reasons for a Tragedy

This article was reported by Frank Bruni, Don Van Natta Jr., Jane Fritsch and Jenny Scott. It was written by Ms. Scott.

To Gina Goror, napping at her deck in Westhampton Beach, L.I., a strange flare in the sky looked like a Roman-candle stopping gently on the sea. To Joan Fernandez, who saw it Wednesday night, it looked like a shooting star, a distress flare, a meteor, a ball of fire.

Four days later, the world remains puzzled by the meaning of those terrible flashes of light — and what precisely happened to Trans World Airlines Flight 800 to send it plunging in flaming fragments into the ocean, killing all 230 people on board.

Did technology fail in some unexpected way? Was this a case of negligence, error or evil? Was security system breached by a terrorist's bomb? Or could someone have shot the plane down with a sort of today missing... And just what was the world coming to?

From the bottom of the Atlantic Ocean to the highest reaches of government, in a make-shift morgue and a Central Intelligence Agency room investigators and ordinary citizens, the mysteries of what exactly the people on Long Island saw.

But certain details of the accident — the familiar mix of children and grandparents and business people and vacationers who had innocently boarded the flight to Paris and the way not a single one survived — have exposed the fearful unpredictability of modern life, which is usually obscured by routines and institutions.

For the investigators, the real work of their job ahead, in the recovery of every flight passenger's remains, in the check...

... would have been notified... of the general Boeing 747-100, which went out to Paris. Flight 800 left the departure gate at... Athens, to arrive at Kennedy International... plane, as scheduled...

Continued on Page ... Column 1

After Hours at White House, Brain Trust Turns to Politics

By RICHARD L. BERKE

WASHINGTON, July 20 — They are like Gipsy meetings in the Clinton White House, at night a week... when the only President and a... ers gathered... advis-ers gather... if following... superpower sci... take regular se... one gets distracted... food is forbid...

Some of the two dozen or so who attend are intimate friends; others are political enemies. Often the sessions are tense. But, when they assemble in the ornate Yellow Oval Room, the participants try to put aside their rivalries as they pursue the goal of making sure that Bill Clinton...

Some of the two dozen or so who... most of them are from the Cabinet and... Roosevelt... something be-... Clinton holds... bor, are the center of gravity for Mr. Clinton's campaign... and for his Administration... to improve the working... integration of Government and politics. Unlike...

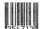

President George Bush, who enforced a sharper division between his Presidential campaign and his Administration, Mr. Clinton makes no such distinctions, though he tries to keep the meetings under wraps.

No confidential meetings has been known. But this first time the details of the sessions — including a list of attendees — have been... made. In... one participant... who said, "This is... has been unpenetrable... added before hanging up... er even spoke to me."

In the Clinton White House, political decisions are intertwined with affairs of state. In this sometimes bewildering... but these political meetings are so intertwined... that the sessions with this table on... the turmoil... of T.W.A. Flight... night.

... Mr. Clinton can pore over poll ... week before and ... w television com-... Also, on a broader level, they exchange ideas about the President's message of the week — and how best to counter Bob Dole, the presumed Republican nominee.

What emanates from the gilded armchairs and yellow damask sofas on the second floor of the White House is not a...

Continued on...

Dole and His Doctors Address Health Issue

Bob Dole, who would be the oldest man ever to assume the Presidency should he win in November, says his health is excellent and two doctors who have treated him agree.

In extensive interviews, the three detailed the medical care the candidate uses, the operation he had to remove a cancerous prostate gland, a heart problem he had years ago, and other medical matters. The doctors said they knew of no medical obstacle to Mr. Dole's serving a full term, and Mr. Dole said he would disclose any serious problems that he developed while in office.

Article, page 16.

INSIDE

Market's Big Scare, Wall Street's Big Fear
Is this the big one? That's the question that many investors were asking after the stock market took a free-fall last week, only to bounce back and then retreat. In the end, the market managed to avoid landing in Wall Street's disaster pantheon. Money & Business, section 3.

Testing the New South
A fire at a black church in South Carolina points to a clash of the Old South of segregation and the New South of racial cooperation. Page 12.

Gretzky Headed to Rangers
Wayne Gretzky, hockey's leading career scorer, is expected to sign with the Rangers today. Section 8.

In Brazil, Indians Call on Spirits to Save Land

By DIANA JEAN SCHEMO

MALOCA BANANAL, Brazil — It is at night when the mountains spills its secrets. The Macuxi sha... pre-pares for the moment with devotion, darkening the room, washing his mouth with tobacco juice and... ing. He blows leaves on the ground... mountain spirits in him, as if through a forest.

They have names and personalities, taken from people he has known: Aronio, Pedro, Paraiba — this last the spirit of the shaman's slain son. The shaman's report that they

HAUNTED TREASURE
A special report.

are withholding their gold and diamonds, so that the miners who invaded the area, devouring river banks with their machines, will kill off the Indians with... linda tem,"... spirits whis...

The shaman, Contato Francisco Silva, says the mountains contain secret doors, behind which live the Macuxi's heroes, villains and the endless dramas that drive them to one another's throats. Mr. Silva, a

wiry 60-year-old, surrenders himself to the mountain, whose spirits speak to the Macuxi Indians through him, as they await a moment of Government decision on the legal future of the Indians' land.

A recent trek through these vast mountains and savannah, where Brazil's flat-top mountains, hard by the borders with Guyana and Venezuela, reveals a landscape almost unchanged since European explorers came to South America more than 400 years ago searching for the mythical city of gold, El Dorado.

The mountains are muddy underfoot with the heaviest rainfall in 73 years. Clouds hang low over their peaks, making travel on the chartered single-engine planes that ply the area's dirt runways a question of

Continued on Page 6, Column 1

TODAY'S SECTIONS

Arts and Leisure/Section 2
The early-music movement is alive and well, but its primary home isn't New York or London. It's Cologne, Germany.

Automobiles/Section 11*†

Book Review/Section 7
In "The Spirit Level," his first book of poems since his Nobel Prize, Seamus Heaney enters the arenas of psychology, ethics and religion, and has much to say about equilibrium and karma.

The City/Section 13§

Editorials and Op-Ed/Section 4

Magazine/Section 6
A growing coalition of conservatives and liberals, believers and agnostics, share the conviction that to legalize assisted suicide is to sanction murder.

Money and Business/Section 3
Downsizing has taken its toll on well-paid workers, but the percentage of new jobs that pay above-average salaries

has increased, as one large city shows.

Real Estate/Section 9*‡
Balancing community interests and property rights: If a government action reduces land value, is it a "taking"?

Regional Weeklies/Section 13¶

SportsSunday/Section 8

Television/Section 12*

Travel/Section 5
Outdoors in Europe.

Week in Review/Section 4
Once Americans learn the cause of the T.W.A. crash, will they have the determination to pay to make flying safer?

Employment Advertising/Section 10*

*In New York City and the metropolitan region.
(† Elsewhere, auto pages are in section 3.)
‡ In most parts of New York City.
¶ In Long Island, Westchester, Connecticut and central and northern New Jersey.*

NEWS SUMMARY

International	3-10
Metro	21-26
National	12-20

Obituaries	27	TV Update	34
Radio Highlights	34	Weather	35
Styles	29	Weddings	32

KNIGHTS OF THE WHITE HOUSE

HEAVEN HELP THEM

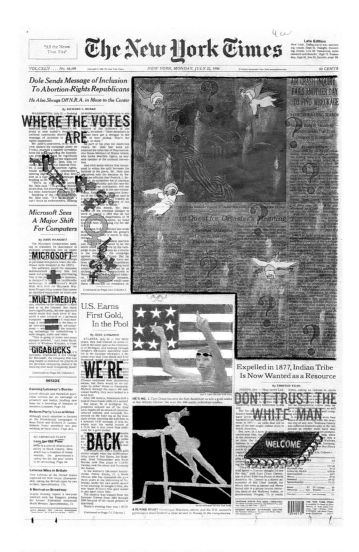
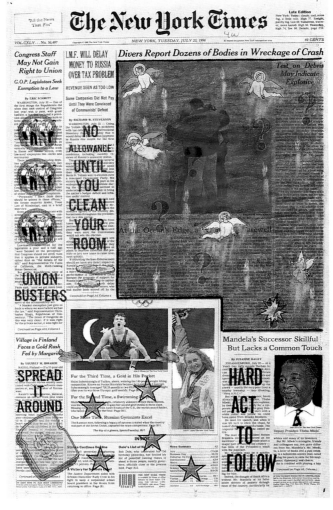

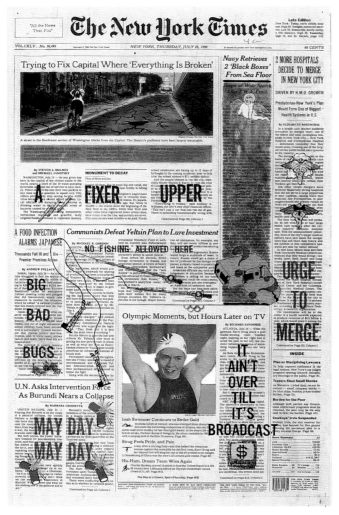

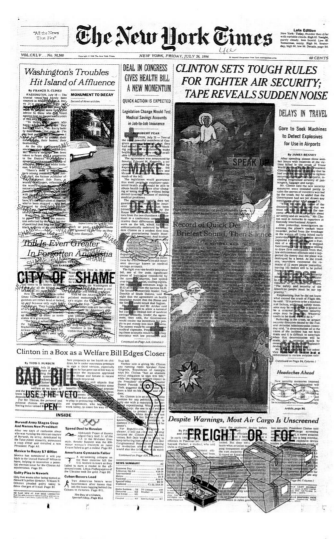

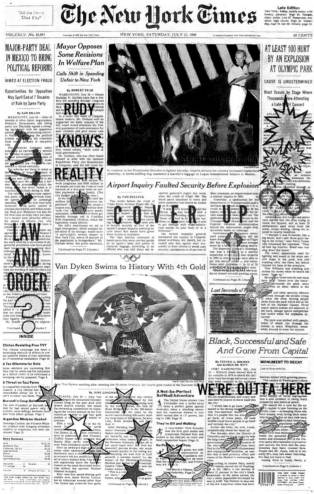

"All the News That Fits"

The New York Times

Late Edition
New York: Today, plenty of sun, pleasant. High 82. Tonight, increasing clouds. Low 68. Tomorrow, some showers. High 78. Yesterday, high 78, low 66. Details are on page 39.

VOL.CXLV...No. 50,502 Copyright © 1996 The New York Times NEW YORK, SUNDAY, JULY 28, 1996 $3 beyond the greater New York metropolitan area. $2.50

Despite His Reversals, Clinton Stays Centered

By ALISON MITCHELL

WASHINGTON — His hands in restless motion, Bill Clinton sat in the Oval Office earlier this month assessing the Presidency he calls "this great adventure."

At times fiery, his language as he disputes intermittently manipulative at others, as he disputes term. "At other term. "At others, he was thinking, he was defending our economic house in order, restore growth and create opportunity," Mr. Clinton said. "We have succeeded in reducing the deficit, expanding trade, and we have over 10 million new jobs."

"Now, what's missing in this picture?" he asked during an interview earlier this month, adding. "What's missing in this picture is that not every American has the capacity to take advantage of the opportunities."

Mr. Clinton ticked off a half-dozen ideas to help. Tax credits for community college tuition. Guarantees that pensions can be taken from job to job. Vouchers for job training. Ways to give more people access to health insurance.

What was striking about the proposals was their modesty. They sounded so humble from a President who had once fought for a $30 billion jobs program and who had made such a bold stand to give all Americans "health care that can never be taken

away, health care that is always there."

What a contrast from the grand visions of 1993, when Mr. Clinton strode into Washington...

THE CLINTON RECORD

The Overview

First of seven articles.

deserted his Democrats in droves or stayed home in the 1994 midterm elections, giving the Republicans control of Congress for the first time in half a century.

This election sent shudders through the White House and virtually split Mr. Clinton's Presidency into periods so distinct that his own advisers acknowledge that they could almost be viewed as two separate terms.

The first two years were marked by Government activism, culminating in Mr. Clin-

Continued on Page 28, Column 1

Stephen Crowley/The New York Times

'Every day I think about what was the vision I had for this country when I came here: Is it still valid? Is our strategy working? What do we still need? Where have we failed?'

PRESIDENT CLINTON
Excerpts from interview at the White House.

While Cause of Crash Is Sought, Parallel Criminal Inquiry Goes On

By JOE SEXTON

While Federal officials have yet to conclude that an act of sabotage destroyed Trans World Airlines Flight 800, an elaborate criminal investigation has been under way from the first moments after the 747 smashed into the sea on July 17.

Agents from the Federal Bureau of Investigation have interviewed close to 1,500 people, from witnesses who saw the plane's descent to officials at the Baltimore-area plant that shipped a box of corn seed aboard the aircraft for transplant, according to investigators.

Knots of terrorist groups...

slowly to interview people who had been aboard the jetliner.

That quest for clues that might yield a lead is centered in the part of the ocean floor nine miles off Atlantic City, where investigators are testing theories...

[Page 19A.]

Investigators and prosecutors have already assembled a long list of theories about who someone might have attacked the plane. According to senior investigators, they range from an attack by a Middle Eastern group to an act of arbitrary violence. Domestic militia organizations are also being considered...

Continued on Page 19A, Column 4

OLYMPICS PARK BLAST KILLS ONE, HURTS 111; ATLANTA GAMES GO ON

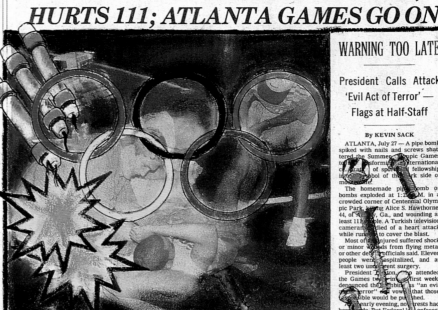

A man wounded in a bombing at Centennial Olympic Park in Atlanta was aided as he awaited an ambulance. Reuters

From Fun Under the Summer Stars to Terror

By RICK BRAGG

ATLANTA, July 27 — The city's downtown was alive in a way it had never been before the Olympics. The streets were still loud and vibrant even at 1 A.M. came and went, and at the heart of it all was the Centennial Olympic Park. Thousands of people sat on the lawns under the spotlights and the stars, danced barefoot to the throb of live electric guitars, or rambled the brick walkways with plastic cups of beer, pleasantly numb.

Then, in an instant, the celebration was lost in a chorus of screams and the smell of gunpowder, and the character of Atlanta's Olympics was forever changed.

At 1:25 on a Saturday morning, on the ground in front of the park's main music stage was strewn with wounded people. The bomb's blast drilled bits of metal into the crowd, missing some people, nicking others, boring deep into some. One man tried to reach around to the small of his back, where blood was leaking. A woman sat still as a statue, in shock, staring blankly at a neat round hole in her shoulder.

"We were listening to the band and trying to dance in the grass," said Meg Deckers, an assistant to an Atlanta real estate lawyer. Then, she was surrounded by chaos.

"There was a guy who was grabbing his stomach," she said. "He was bleeding from the lower stomach. He was in a lot of pain. We laid him on a bench."

She and her husband, Ed, used a bench as a stretcher to carry one man to the ambulances. Amid the strange, flickering lights set a city block aglow, Mr. Deckers said, "We just talked to him and held his hand and told him O.K."

The bomb is believed to have come from a bomb left beside a sound-and-light tower near the stage, came just as the band, Jack Mack and the Heart Attack, finished a set. The police had received a 911 call warning them of the bomb and where it was, but the call came too late to evacuate the tightly packed park. The authorities only had time to move people back, but the ...

Continued on Page 20, Column 1

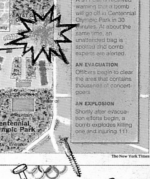

The Details

A WARNING
A 911 caller received warning that a bomb will go off in Centennial Olympic Park in 30 minutes. At about the same time, an unattended bag is spotted and bomb experts are alerted.

AN EVACUATION
Officers begin to clear the area that contains thousands of concert-goers.

AN EXPLOSION
Shortly after evacuation efforts begin, a bomb explodes killing one and injuring 111.

Centennial Olympic Park
Location of explosion

The New York Times

THE GAMES Competition has resumed, but the games are not the same. And they never will be again. Dave Anderson, Sports of The Times.

OFFICIAL DECISION The International Olympic Committee chose to continue the Games, just as it did in 1972 when 11 Israeli athletes and officials were killed in Munich.

FRAGILE AND FLAWED The Olympic Movement teetered onward yesterday — fragile and flawed, compli-

cated just like the human race. George Vecsey, Sports of The Times.

JOYNER-KERSEE WITHDRAWS After a moment of silence to remember the dead, the track and field competition resumed. Jackie Joyner-Kersee of the U.S., twice a gold medalist in the heptathlon, withdrew from the event with an injured right thigh.

TV COVERAGE Minutes after the bomb went off, television networks scrambled to provide coverage.

WARNING TOO LATE

President Calls Attack 'Evil Act of Terror' — Flags at Half-Staff

By KEVIN SACK

ATLANTA, July 27 — A pipe bomb spiked with nails and screws shattered the Summer Olympic Games today, transforming an international celebration of sport and fellowship into a symbol of the dark side of modern life.

The homemade pipe bomb or bombs exploded at 1:25 A.M. in a crowded corner of Centennial Olympic Park, killing Alice S. Hawthorne, 44, of Albany, Ga., and wounding at least 111 people. A Turkish television cameraman died of a heart attack while running to cover the blast.

Most of the injured suffered shock or minor wounds from flying metal or other debris, officials said. Eleven people were hospitalized, and at least two underwent surgery.

President Clinton, who attended the Games two days earlier this week, denounced the bombing as "an evil act of terror" and vowed that those responsible would be punished.

By early evening, no arrests had been made. But Federal law-enforcement officials said they were beginning to theorize that the bombing was a work of domestic terrorism, based on recordings of a 911 telephone warning about 30 minutes before the bomb exploded and other unspecified evidence.

At a news conference this morning, Woody Johnson, the special agent in charge of the Atlanta office of the Federal Bureau of Investigation, said, "We will not consider it an act of terrorism until information should arrive to the contrary."

Olympic officials said at 5:15 A.M. that the 17-day competition would continue, just as the Games did in 1972 when Palestinian terrorists killed 11 Israelis at the Munich Games. Olympic flags flew at half-staff at the Games sites as jittery athletes and subdued fans observed a moment of silence. [Page 21.]

During the blast in the park, at about the same time as the 911 call was made, a Georgia Bureau of Investigation agent spotted an unattended bag that contained the bomb and called a team of explosives experts to the scene.

Officers began to clear the area, but the bomb detonated before they could move thousands of concertgoers out of the park, a new, 21-acre plaza that became the physical and spiritual center of the Games.

The G.B.I. agent, Tom Davis, said

Continued on Page 21, Column 1

Associated Press

A pipe bomb that killed a woman during a rock concert at the Olympics in Centennial Olympic Park in Atlanta early yesterday left visitors to the Games in shock.

Associated Press
Alice S. Hawthorne, 44, of Albany, Ga., the bombing victim. Page 20.

The New York Times

Late Edition
New York: Today, increasing clouds, possible afternoon shower. High 78. Tonight, showers. Low 68. Tomorrow, scattered thunder. High 76. Yesterday, high 81, low 65. Details, page A16.

VOL.CXLV.... No. 50,503 Copyright © 1996 The New York Times NEW YORK, MONDAY, JULY 29, 1996 $1 beyond the greater New York metropolitan area. 60 CENTS

A Day Of Surprise

Fatuma Roba, right, became the first African woman to win an Olympic marathon, while favorites like Butch Reynolds and Javier Sotomayor lost and Carl Lewis nearly missed the long-jump final.

Kiraly Returns To the Stand

Karch Kiraly teamed with Kent Steffes to take his third volleyball gold medal, and his first in the beach version of the sport.

A Rivalry's Latest Chapter

The United States women's soccer team defeats its archrival, Norway, in overtime to advance to the gold medal game.

The day at a glance, SportsMonday, C10.

Associated Press

If Immigrants Lose U.S. Aid, Local Budgets May Feel Pain

By TIM GOLDEN

OAKLAND, Calif., July 27 — The elaborate tattoos that adorn Bech Chuom's chest are meant to protect him from wayward bullets, and he trusts the precepts he follows as a strict Buddhist to safeguard his soul.

But a decade after Mr. Chuom, 72, arrived here as a refugee from Cambodia, he depends entirely for food and shelter on the welfare checks he must forgo if that aid from legal immigrants until he plans to end welfare now moving through Congress, he says, is a mystery.

"I am old," he said, speaking in Khmer through a translator. "My mind is not so clear. Without the help, I will starve and die."

With growing alarm, many local officials around the country are predicting another result if welfare restrictions are enacted: that thousands of immigrants like Mr. Chuom will be turning to nursing homes, welfare agencies and finally, to public hospitals.

In these scenarios, local officials say, the cost of local welfare and medical costs could climb to nearly $400 million a year, forcing drastic cuts in programs.

Of the people, by estimates of people who would lose benefits for the elderly, blind or cut off, reducing the amount of aid flowing into the city by more than $290 million a year.

"The impact on states with high

populations of legal immigrants will be profound," said Christine C. Burch, the executive director of the National Association of Public Hospitals. "The immigrants will still get health care. But it will be the responsibility of local government or, in the case of private hospitals, it will come out of their charity.

For months, advocates have been paying attention to the energy of the new immigration bill that would end benefits to noncitizens of $5.4 billion over six years. The magnitude of the proposed cuts in the revised welfare legislation has left them stunned.

Under the House version passed July 18, most legal immigrants ineligible for Medicaid, food stamps and Supplemental Security Income, or S.S.I., the Fed-

Continued on Page A12, Column 1

INSIDE

Indonesia Tense After Riots
A day after Indonesia's worst rioting in decades, soldiers with automatic weapons guarded potential trouble spots throughout Jakarta. Page A4.

Congress Gets Going
Congress has shaken off months of gridlocked lethargy and is passing bills its members can go home and campaign on. Page A10.

AN AMERICAN PLACE
A Time for Volunteers
In Stark County, Ohio, a spirit of volunteerism contradicts Americans' supposed decline in civic involvement. Page A8.

Plane Split in Sky, Officials Say, Suggesting Bomb

By DON VAN NATTA Jr.

Continued on Page A12, Column 1

Limited Checks on Workers Who Have Access to Planes

By JOHN KIFNER

Despite the visible reassurance offered by crisply uniformed guards tending metal detectors and airline safety rules that have been tightened since the explosion of Trans World Airlines Flight 800, security experts say one of the weakest links may be the very people who work in the nation's airports.

Dozens of workers — hired with only the most cursory of background checks — have access to planes waiting on airport tarmacs and, federal experts say, could easily plant a bomb aboard an airliner.

"This is the major hole in the system," said Henry I. DeGeneste, who for six years was superintendent of the Port Authority police, which patrols the three New York area airports and other Port Authority locations. "I would be less concerned with the luggage screening. I would be concerned with what goes on on the tarmac.

"For a terrorist," Mr. DeGeneste

said, "the best would probably be a job in the catering company, secondly the baggage handlers, the cleaners, too. Anybody that's carrying things on the plane."

The airline industry in 1992 fended off Federal efforts to require fingerprinting and full background investigations on such employees. The rules were proposed as part of tougher security measures after Pan American Flight 103 was blown up by a bomb over Lockerbie, Scotland, but the industry asserted they were too costly and cumbersome.

While investigators have not concluded what caused Flight 800 to break apart, Federal officials said yesterday that a bomb appeared to be more likely than a mechanical malfunction or a missile fired at the aircraft below.

In December, the spectacular theft of a diamond necklace and matching bracelet from the checked bag of Sarah, the Duchess of York, by a 19-year-old baggage handler at Kennedy International Airport highlighted the longstanding problem of pilferage by workers on the tarmac and in hangars.

"If they can steal luggage, if they can take things out, they can also get into it to put things in," said Mr. DeGeneste, who recalls a constant

Continued on Page B5, Column 3

On World Stage, Many Lessons for Clinton

By STEVEN ERLANGER and DAVID E. SANGER

WASHINGTON, July 28 — Every evening, President Clinton, the baby boomer who came to office vowing to be consumed by problems here on America's shores, receives a brief personal note from Warren Christopher, his cautious, 71-year-old Secretary of State and veteran of four Democratic administrations.

At first the notes were tutorial, guiding a President who had accused George Bush of paying too much attention to foreign affairs. Candidate Clinton argued that human rights in China were more important than trade, that the fratricide in Bosnia was Europe's problem, that the United States could not and should not play the role of world policeman.

Today, Mr. Christopher's notes are more like an effort to provide guidance to a President who now regards his foreign policy performance as a highlight of the last two years. With clear if

President Clinton, with Anthony Lake, his national security adviser, has gradually become his own foreign policy spokesman.

Stephen Crowley/The New York Times

THE CLINTON RECORD
Foreign Policy

Second of seven articles.

forcing modest change in the trade policies of Japan and China — Mr. Clinton is becoming more comfortable as dealmaker and statesman.

The shift from the 1992 campaign is as pronounced as it is unlikely. He ran as a President more concerned with the last Democratic campaign, but it has been an era of a chaotic beginning and extraordinary lows. Mr. Clinton's first year was symbolized by searing images of weak-

ness: an American soldier's corpse being dragged through the streets of Mogadishu, Somalia, and a United States military transport

world events. President was not ready to calculate the structure of foreign policy of his record, a con-

There

docks of Port-au-Prince. At the end of 1994, Mr. Christopher, tired and dispirited, offered to resign.

Mr. Clinton seemed to be floundering, reacting rather than imposing American leadership on

was the points of national security came into play, and the lawyer Christopher, who managed rather than led. The

Continued on Page A14, Column 1

CLINTON PROPOSES HARSHER MEASURES AGAINST TERRORISM

CALLS FOR G.O.P. SUPPORT

In a Reversal, Gingrich Agrees to Take Up Measures That Were Rejected Earlier

By TODD S. PURDUM

NEW ORLEANS, July 28 — Spurred by the bombing at the Atlanta Olympics

Federal Bureau of Investigation, Louis J. Freeh, at the White House on Monday to discuss what the Government might do to combat terrorism.

Speaker Newt Gingrich expressed willingness to consider the provisions Mr. Clinton addressed today. Speaking on NBC's "Meet the Press," the Speaker, who helped weaken the bill in May, said he believed some agreement could be worked out, given the bombing in Atlanta and the suspicions that a bomb may have brought down Trans World Airlines Flight 800 off Long Island on July 17. One person was killed by the bomb in Atlanta and all 230 aboard the plane were killed.

Here in New Orleans, Mr. Clinton said at a meeting of the Disabled American Veterans, "As Americans, we can and must join together to defeat terrorism wherever it strikes

smokeless powder, to create chemical "fingerprints" that make the source of explosives easier to trace after a blast.

Mr. Clinton originally proposed such markers and the expanded authority to let the F.B.I. use wiretaps against suspected terrorists who are moving from place to place, after the bombing of a Federal building in Oklahoma City in April 1995 took the lives of 168 people, but the measures were among those that fell out of the final bill. In an unusual alliance, civil liberties groups and advocates of gun rights joined forces to argue that

Continued on Page B7, Column 1

With Scores of Tips, and Photos, Bomber's Description Is Emerging

By RONALD SMOTHERS

ATLANTA, July 28 — Federal investigators said today that they had begun assembling composite sketches of a possible suspect in the bombing that Saturday but did not stop, the Olympic Games.

The investigators said they were examining videotapes and scores of photographs turned in by people who were at the scene of the blast early Saturday in Centennial Olympic Park, as well as tapes from surveillance cameras in the area.

Olympic organizers said the park, a free-of-charge and free-form gathering place that had captured the spirit of the Games, would reopen on Tuesday with twice as many security personnel, more surveillance cameras and observation posts, and random searches of peoples' bags.

A member of the relief squad officers at the Atlanta organizing committee said that a "resounding positive" will let the park be reopened in the same fashion originally envisioned.

The blast, which occurred during a late-night concert, killed a 44-year-old Georgia woman and wounded 111 others, some of whom were still hospitalized. A television cameraman died of a heart attack while covering the incident.

The Games continued today with a full schedule of events, highlighted this morning by the women's marathon, which snaked through streets jammed with spectators and ended in the 85,000-seat Olympic Stadium, packed to near capacity. Security, which had been increased after the bombing, continued at a high level in some areas today, but appeared more relaxed than Saturday at some. At the rowing site at Lake Lanier, 60 miles north of Atlanta, there were occasional barriers to slow cars approaching the site. Spectators entering the Olympic Stadium downtown, however, faced less scrutiny. Many gathered at the barricades

Continued on Page B6, Column 5

Murdoch Places Bets On a Global Vision

Rupert Murdoch, the chairman of the News Corporation, is willing to act quickly and spend heavily to enhance his strategy of having a finger in every corner of every media program in every corner of the world.

A group of companies this summer has helped improve this slimmer has helped every rapidly changing technologies and business alliances.

Business Day, page D1.

"All the News That Fits"

The New York Times

Late Edition
New York: Today, mostly cloudy, a few showers. High 76. Tonight, light rain. Low 69. Tomorrow, humid, showers, some thunder. High 79. Yesterday, high 77, low 68. Details, page C16.

VOL.CXLV... No. 50,504 Copyright © 1996 The New York Times NEW YORK, TUESDAY, JULY 30, 1996 $1 beyond the greater New York metropolitan area. 60 CENTS

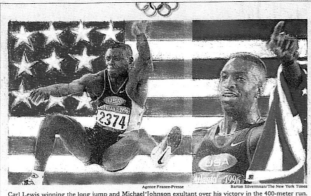

Carl Lewis winning the long jump and Michael Johnson exultant over his victory in the 400-meter run.
Agence France-Presse

The Greatest? Lewis Not Ready to Step Aside

By JERE LONGMAN

ATLANTA, July 29 — Michael Johnson won a medal tonight to master his own fate, but he will win the title as the premier track and field athlete and upstaged Johnson at the Summer Olympics with his fourth consecutive victory in the long jump and his record-tying ninth gold medal in his Olympic career. He is 35 now, but conceding nothing in these golden years.

In one of the country's momentous nights in track and field, Allen Johnson provided a third gold medal, winning the 110-meter hurdles in 12.95 seconds, a record. But while Johnson won in 19.49 seconds, the fastest of the modern era, Lewis sailed 27 feet 10¾ inches, his longest jump in two years, the grandness of the evening was compromised by the continuation of an edgy rivalry between the two stars.

Neither athlete appears to be able to look in the mirror without seeing the other's reflection. Both are also 200-meter runners, so they are forever enshrined.

But they are not friends, and not likely ever to be. That the apparent after neither accept victory tonight with...

Continued on Page B13, Column 1

The day at a glance, SportsTuesday, page B16.

WHAT TORCH?

President Finds Benefits In Defeat on Health Care

By MICHAEL WINES and ROBERT PEAR

THE CLINTON RECORD
Third of seven articles:

Health Care

WASHINGTON, July 29 — It has been three years since President Clinton and his wife, Hillary, set out to transform American medicine with a plan universal, affordable health care today, signs of the revolution are everywhere.

Health maintenance organizations are booming, more than 58 million Americans are enrolled in prepaid health plans. Care to her doctors have cut the cost of their private plans. H.M.O.'s are the new rage, their secret is the merger of patients and expensive treatments. Patricia Underial establishments — like Massachusetts General Hospital in Boston and New York Hospital-Cornell Medical Center in Manhattan — that once seemed impervious to commercial pressures are racing into mergers to guarantee their survival.

In some respects, it is what the Clintons' army of health-care cognoscenti envisioned: medicine made more affordable by a long-overdue dose of competition.

But it is not the President's revolution. Mr. and Mrs. Clinton's proposed overhaul foundered in Congress two years ago, a spectacular defeat that overshadowed their other domestic goals. As the President has passed up opportunities to attack Republicans in Congress for blocking what was, by any measure, a revolutionary change in domestic policy.

Looking back, it is difficult to believe that Clinton's health plan was his most urgent priority, as he told Congress in a grand unveiling of the plan in September 1993.

Then, the health care system was not just in trouble; it was an imminent threat to the basic security of America's everybody.

"Millions of Americans are just a pink slip away from losing their health insurance, and one serious illness away from losing all their savings," Mr. Clinton told Congress. "And on any given day, 37 million Americans, most of them working people and their little children, have no health insurance at all."

Three years later, 40 million people have no health insurance. And one Administration's principle goal—to make health-care policy has been to get out of the way while states and big corporations swiftly remake the system.

They are transforming it with stunning speed. It is a process that some experts in health policy credit the White House for accelerating, that others say has kept health care prohibitively expensive for the uninsured and subordinated the quality of the drive for profits.

"By putting the health-care reform on the table, President Clinton catalyzed a lot of action in the private sector, the private marketplace," said Ronald M. Hollander, president of the Massachusetts Hospital Association. "It drove everybody to develop strategies for dealing with that change."

Other experts say Clinton's failure and assessment that permanently set back efforts to expand

Continued on Page B8, Column 2

LOSE THE BATTLE **WIN THE WAR**

Under the ambitious plan outlined in 1993, this "health security identification card" would have allowed every American's right to medical coverage.

AGREEMENT STRUCK ON MOST ELEMENTS FOR WELFARE BILL

VOTES SET FOR THIS WEEK

With Clinton Stand Uncertain, Groups on Opposing Sides Lobby the White House

By ROBERT PEAR

WASHINGTON, July 29 — House and Senate negotiators have agreed on several issues, it appears, they have disregarded appeals for changes in the legislation.

The bill, scheduled for floor votes in both chambers this week, would end the Federal guarantee of cash assistance for the nation's poorest children and families and turn many programs over to the states.

After meeting with Mr. Clinton at the White House today, Speaker Newt Gingrich said, "We have every reason to believe the President will sign this."

But Mr. Gingrich did not say why he had reached that conclusion, and White House officials said little. One Democrat on Capitol Hill said, "They don't seem to want to tell anybody what the President will do."

As the Congressional negotiators moved to resolve differences between the two chambers, they moderated the most stringent provisions of the House bill. But contrary to what Mr. Clinton had said he hoped for, they did not grant benefits beyond those offered in the Senate bill.

For example, the conferees agreed that legal immigrants who have not become citizens should generally be denied benefits and that families dropped from welfare should not be eligible for vouchers that applies for their children.

In a joint news conference today, religious, civil rights and children's groups joined representatives of labor unions in saying the bill goes beyond repair and should be vetoed. Among the groups were the National Urban League, the Children's Defense Fund, the National Conference of Catholic Bishops and the Union of American Hebrew Congregations.

Their news conference kicked off a weeklong lobbying effort by critics of the bill and its supporters. The Republican leadership would like Clinton today to send the city...

Continued on Column 1

CONGRESS TO CHILDREN: **VETO**

ISRAEL MAPS ROADS ACROSS WEST BANK

Plan for 2 Golan Bridges Also Signals Hard Line on Land

By JOEL GREENBERG

JERUSALEM, July 29 — Signaling its intention to establish roads to trade new Jewish settlers and consolidate control, and to revive the long-delayed building throughout the West Bank.

It also revived linked to Israel's right-wing leader, Ariel Sharon, the new national infrastructure minister, that the roads had been discussed for labor Prime Minister Benjamin Netanyahu's project...

In a meeting today with leaders of the 140,000 Jewish settlers living in the West Bank and Gaza Strip, Mr. Netanyahu said he favored developing Jewish settlements in the territories as much as he favored developing Jewish communities inside Israel, breaking a commitment by the previous government.

Pinhas Wallerstein, head of the settlers' umbrella group, said he understood that Mr. Netanyahu would...

Mr. Netanyahu, leader of the Likud Party, has rejected the exchange of land for peace as a basis for Arab-Israeli negotiations, asserting that talks should be held without precondition.

Continued on Page A4, Column 5

PEACE STRIKES OUT

Airliner Bombings Are Reviewed For Similarities to T.W.A. Crash

By MATTHEW PURDY

Federal officials investigating the crash of Trans World Airlines Flight 800 are making detailed comparisons to other airline crashes caused by bombs, searching for clues that could help them determine whether the officials said they were not could have been an act that would be comparable to those they examined from similar crashes caused by bombs, including the one of the Pan Am jetliner over Lockerbie, Scotland, the take down of an Air India jet over the Atlantic.

Sketch Is Compiled In Atlanta Attack

The Federal officials said they were examining material from comparison crashes as a way of determining whether the crash of T.W.A. Flight 800 was similar.

And one of the possibilities that has could have been an act that would be comparable to those they examined from similar crashes. Robert Francis, the vice chairman of the National Transportation Safety Board, who is head of the investigation, "And we're doing what we would do in investigation and that is to look at all the things that have similarities."

Officials also said the catastrophic failure that it was raised the possibility of mechanical failure also occurred near the front of the airplane.

In response to the bombing, President Clinton and Republican leaders in Congress agreed to try to enact new anti-terrorism measures. But after an hourlong meeting, both sides were divided over specifics.

Articles, page B7.

Officials have said that the front part from the rest of the plane and plunged into Atlantic Ocean near the rest of the aircraft. Investigators have said the recovery of several have pieced...

Continued on Page B7, Column 1

DETAILS

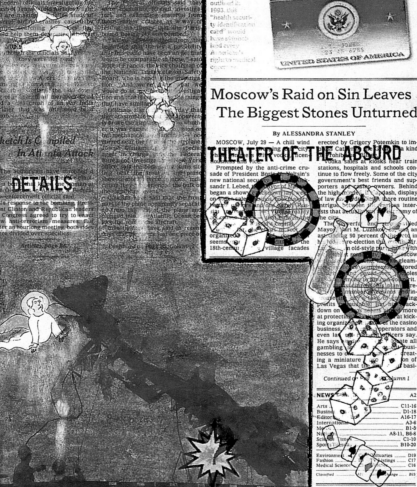

Workers hoist wreckage from T.W.A. Flight 800, which was apparently split in two by an explosion, onto a truck at the Shinnecock Coast Guard station in the effort to determine if it was brought down by a bomb.

Moscow's Raid on Sin Leaves The Biggest Stones Unturned

By ALESSANDRA STANLEY

MOSCOW, July 29 — A chill wind erected by Grigory Potemkin to impress the Empress Catherine II is a kind of prohibited. Prompted by the anti-crime crusade of President Boris N. Yeltsin's new national security chief, Aleksandr I. Lebed, began a show or from last week on entertainment and all the territories that special interest groups prohibited. And one that has similar train stations, hospitals and schools continue to flow freely. Some of the city government's best friends and supporters are casino owners. Behind the high-minded crackdown, display of law and order, more routine intrigues between rival interests that actually benefit many of the city.

The powerful and popular Mayor Yuri M. Luzhkov, an astounding 90 percent of the vote in his bid for re-election this year. Mr. Luzhkov, an old-style party boss, has presided over Moscow's transformation into a gleaming and restored capital...

He says that all gambling and businesses to shut down, creating a miniature version of Las Vegas that the basi...

Continued on Column 1

THEATER OF THE ABSURD

Roger Peterson, 87, The Nation's Guide To the Birds, Is Dead

By RICHARD SEVERO

Roger Tory Peterson, the ornithologist whose "Field Guide to the Birds" sold several million copies around the world over, died on Sunday at his home in Old Lyme, Conn., where he had lived for many years.

He was, with the exception of the last six months or so, when he was in failing health, had been active in the Roger Tory Peterson Institute of Natural History of Jamestown, N.Y., whose goal is to inform society of the natural world through the teaching of natural history.

He was thought of as a writer and third as a naturalist. But he was no less a lecturer and teacher and was renowned as a photographer and world traveler. In the heyday of his mature vigor, which stretched over half a century, he frequently seemed to be doing all those things at once.

He either wrote or edited nearly 50 books about animals, plants or nature and he contributed prefaces or introductions to many of his colleagues. His many articles about birds won numerous prizes...

Cont... Column 1

FAREWELL OUR FINE FEATHERED FRIEND

INSIDE

Sign From China on Test Ban
China conducted a nuclear test, saying it would be its last, and seemed to time its announcement to the resumption of talks on the international nuclear test ban treaty. Page A3.

Pact on Children's TV
Negotiators for the broadcast industry agreed to a compromise that would require stations to show three hours of children's educational programming a week. Page A8.

Albany's Accomplishments
For all the squabbling and delays over a budget, the New York State Legislature had several major accomplishments this year. Page B4.

An Ancient Poisoning Case
A great upwelling of carbon dioxide from the oceans may have caused the greatest dying-off of species the world has ever seen. Page C1.

MR. JENKINS SCENE ON THE WEB. www.tanqueray.com/ ADVT

TIME WARNER REDUCED THEIR CABLE RATE
1%. With Liberty you can reduce your cost by another 33%. Call Liberty Cable 212/891-7777 — ADVT

HAPPY BIRTHDAY WILLIAM GASS FROM Earth's Biggest bookstore - Amazon.com Books! http://www.amazon.com/ — ADVT

NEW YORK TIMES
home or office delivery. Call toll-free: 1-800-NYTIMES. Ask about Times-media TimesCard. ADVT

354613

The New York Times

Late Edition
New York: Today, cloudy, some thundershowers. High 79. Tonight, early showers. Low 69. Tomorrow, brighter, possible shower. High 83. Yesterday, high 73, low 67. Details are on page C6.

VOL.CXLV... No. 50,505 Copyright © 1996 The New York Times NEW YORK, WEDNESDAY, JULY 31, 1996 $1 beyond the greater New York metropolitan area. 60 CENTS

Battles on Conservation Are Reaping Dividends

By JOHN H. CUSHMAN Jr. and TIMOTHY EGAN

KELLOGG, Idaho — A rust-colored river runs through the valley where Barbara Miller is trying to raise her four children, a town of turn-of-boned holes...

THE CLINTON RECORD
Fourth of a series

Lawsuit Says Christian Coalition Gave Illegal Help to Candidates

By RICHARD L. BERKE

WASHINGTON, July 30 — The bipartisan Federal Election Commission...

those contributions should have been reported as independent expenditures or as in-kind contributions to those campaigns.

In a suit charging the Christian Coalition with illegally aiding Pat Robertson's Presidential bid...

"totally baseless" and "frivolous."

"We are absolutely and totally confident that we will be fully vindicated," said Ralph Reed, the group's executive director, "and the courts will affirm that people of faith have every right to be involved as citizens and..."

90°? Only in May. But Summer Brings The Missing Spring.

By N. R. KLEINFIELD

Some summer.
It's been cloudy. It's been cool. It's been windy. It's been rainy.
But where's the heat?

Continued on Page B4, Column 1

As Atlanta Olympic committee members watched from a rooftop, thousands gathered to reopen the...

After the Terror, Preaching, Praying and Singing

By RICK BRAGG

ATLANTA, July 30 — In a city that likes to call itself international, a time when the world...

GUARD QUESTIONED
A man praised as a hero after the bombing was taken into custody by F.B.I. and identified as a possible suspect, setting off intensive TV coverage. Page B6.

Continued on Page B11, Column 5

Netanyahu Infuriates Unions By Assault on Welfare State

By DOUGLAS JEHL

TEL AVIV, July 30 — Like every parent in Israel, Ram Wexler, 39, a Government...

Continued on Page A6, Column 4

U.S. Wins Softball

Americans took the gold in softball, 3-1, in a game of controversy.
At a glance, Wednesday, page B11.

INSIDE

New Steps to Halt Terrorism
Most of the world's major powers, meeting in Paris, agreed on tough anti-terrorist measures, but an unpopular American proposal for sanctions on countries that support terrorists was not discussed. Page B6.

Judge Points to Clinton Aide
A judge ruled that deputy White House counsel Bruce Lindsey likely took part in a conspiracy to illegally conceal the cash withdrawals by Jim Smith's 1990 campaign for Arkansas Governor. Page A10.

Behind the Welfare Cuts
When Congress considers changes in welfare, condemning a culture of dependency, it is aiming at people like Marian Seefield, a 26-year-old welfare recipient in Illinois. Page A10.

Black College Rises to Elite
Spelman College in Atlanta, a historically black women's college, recently raised $114 million, lifting it into the fund-raising ranks of elite liberal arts colleges. Page D19.

New Yorkers Can Use Mace
Governor Pataki signed a law that allows New Yorkers, for the first time in nearly three decades, to possess and use self-defense sprays like Chemical Mace. Page B1.

Life of an Esthetic Heresy
An appraisal of 2 Columbus Circle, a small white elephant of a building in Manhattan that will most likely be reduced to rubble. Page B1.

Claudette Colbert, 92, Dies; A Screwball Star With Legs
Claudette Colbert, the star of "It Happened One Night" whose flair for light comedy cheered audiences to the Depression and for decades afterward, is dead at 92. Page D21.

GET CURRENT STOCK MARKET QUOTES — all the business news from each day's Times in The New York Times on the Web's new Business section. Now on the Internet at www.nytimes.com. — ADVT.

TIME WARNER REDUCED THEIR CABLE RATE. 1% off... — ADVT.

JET'S LANDING GEAR IS SAID TO PROVIDE EVIDENCE OF BOMB

EXTENSIVE DAMAGE SEEN

Russia's Purveyor of 'Truth', Pravda, Dies After 84 Years

By MICHAEL SPECTER

MOSCOW, July 30 — When its devoted readers reached into their mailboxes this morning for Russia's oldest and most famous Communist newspaper, they came up with a big surprise: nothing.

Pravda, the ponderous Communist thought founded by Lenin and his Bolshevik comrades in 1912, one of the enduring symbols of Soviet era and probably history's most inaccurately named publication (Pravda means truth in Russian), has ceased publication.

Continued on Page A3, Column 1

THE PAPER IS BACK

Overlaid graffiti text: "1 THOU SHALL NOT COMMIT ELECTION FRAUD"

Overlaid graffiti text: "MR. GINGRICH COMES TO ISRAEL"

Overlaid graffiti text: "PRAVDA NEVER TOLD THE TRUTH"

August

August was the funniest month because of the

Democratic and Republican conventions, and Ross Perot.

I began to get bored doing men in suits. Hillary Clinton was

the one political figure that I really didn't parody.

Although I turned her into Raggedy Ann on August 29,

I kept the family intact. I really respect strong women.

I got more humorous as the year went on,

out of pure desperation to keep it interesting.

I became so aware of time passing. . . . As I got further on

in the year, I became so panicked that

I wasn't going to finish, and yet at the same time all

the pages seem to get more and more filled.

The New York Times

VOL.CXLV...No. 50,506 Copyright © 1996 The New York Times NEW YORK, THURSDAY, AUGUST 1, 1996 $1 beyond the greater New York metropolitan area. 60 CENTS

Late Edition
New York: Today, hazy sun, thunder-shower possible. High 78. Tonight, foggy. Low 69. Tomorrow, partly sunny, isolated thunder. High 82. Yesterday, high 72, low 66. Details, page D20.

CLINTON TO SIGN WELFARE BILL THAT ENDS U.S. AID GUARANTEE AND GIVES STATES BROAD POWER

New York Costs For Its Program Seen as Surging

By DAVID FIRESTONE

President Clinton's decision yesterday to transform the nation's welfare system struck both local officials and welfare administrators grasping at the enormous new costs of public assistance they say will have to be borne by city and state taxpayers.

Mayor Rudolph W. Giuliani and his staff unsuccessfully lobbied the White House for weeks and all day yesterday against the welfare bill that the President decided to sign, said that by itself the bill could add as much as $200 million in new costs to the city's social-service budget. State officials also predicted hundreds of millions in new welfare costs, although they could not firm an estimate because New York State would receive $1.1 billion less because of the bill.

The chief reason for the new costs, state and city officials say, is a provision unusual to the New York State Constitution that requires the state to provide "for the aid, care and support of the needy," as determined by the state Legislature. Because the new welfare bill would deny some benefits to legal immigrants and impose a five-year lifetime limit on assistance, to adults, New York and the cities would have to replace the lost assistance in many cases, the officials said.

"This is going to hit the city of New York a great deal," Mr. Giuliani, a Republican, union at a news conference on welfare and immigration issues, said at a City Hall news conference.

Continued on Page A4, Column 1

MILLIONS AFFECTED

After the President Acts, More in Party Back Measure in House

By ROBERT PEAR

WASHINGTON, July 31 — After hours of suspense and searching, President Clinton said today that he would sign a bill that reverses six decades of social welfare policy and touches the lives of millions of people.

The bill emerges from Congress would affect most of the 23.6 million people who receive food stamps and along the benefits paid to more than a third of the families in America with children. And it is expected to save $55 billion over six years as it dismantles a welfare program created by Democrats in the New Deal.

After President Clinton endorse the bill, the House promptly approved it by a vote of 328 to 101.

Democrats had waited for days for the President to announce his decision...

Continued on Page A22, Column 2

INSIDE

A Fading Vigil
Divers recovered 13 more victims from T.W.A. Flight 800, but officials said it was unlikely that the remains of all 230 would be found. Page B5.

New Whooping Cough Drug
The Government approved a whooping cough vaccine for infants that is less likely than the current vaccine to cause side effects. Page A12.

Yankees Get Cecil Fielder
Looking to shore up their right-handed hitting, the Yankees acquired slugger Cecil Fielder from Detroit for Ruben Sierra. Page B7.

Devers Misses 2d Medal
Gail Devers, the 100-meter dash winner, finished fourth in the 100-meter hurdles. Sergei Bubka had to pull out of the pole vault with an inflamed Achilles tendon.
The day at a glance, SportsThursday, page B11.

Delving Further Into Security Guard's Life
Agents investigating the pipe bomb that killed a woman in Atlanta spent much of yesterday searching the apartment where a security guard lives, including using a dog trained to sniff explosives. Page A12.

Ethical Furor Erupts in Britain: Should Embryos Be Destroyed?

By YOUSSEF M. IBRAHIM

LONDON, Thursday, Aug. 1 — Britain plans to destroy more than 3,000 unclaimed human embryos from fertility clinics today, in keeping with a law that has stirred horror and religious outrage among some segments of society and ethical and practical questions as well.

The microscopic eggs were fertilized or frozen. The frozen embryos, consisting of four cells each, would not develop further unless they were implanted into a woman's uterus. Unless their donors ask to have the embryos saved, any that have been stored for five years will be destroyed.

The embryos are being stored in 33 clinics, which were scheduled to begin to remove them from freezing containers after midnight. Wednesday and finishing the them and destroying them a few hours of alcohol to destroy them, officials of the Fertilization and Embryo Authority said. The embryos then be incinerated.

Although embryos have been destroyed before, this is the first time

such a procedure has been required by law and carried out on such a large scale. The newness of it all, combined with the delicate issues involved, have inspired suggestions ranging from the "adoption" of the embryos to a demand that they be given "a proper funeral."

The action is ordered under the Human Fertilization and Embryology Act, which became effective on Aug. 1, 1991, and stipulated the five-year time limit. As the deadline crept up, the once-quiet debate quickly became public and dramatic.

Some officials in the Catholic Church have referred to the event as "a prenatal massacre."

Italian doctors have offered to pay to "adopt" the embryos, with the Government of Italy banning such abortion groups urging the the Prime Minister John Major for a six-month delay.

A spokesman Wednesday, John Major's spokesman

Continued on Page A4, Column 1

Seizing the Crime Issue, Clinton Blurs Party Lines

By DAVID JOHNSTON and TIM WEINER

WASHINGTON, July 31 — After nearly three decades of Republican dominance of the issue, President Clinton has scrapped his party's traditional approach to crime and criminal justice, embracing a series of punitive measures that have given him conservative credentials and threatened the Republicans' lock on law and order.

Mr. Clinton's anti-crime efforts have sprung from his willingness to set aside decades of Democratic orthodoxy that emphasized the rights of criminal defendants and to adopt attitudes more sympathetic to the rights of crime victims.

That has led him to endorse expanding the Federal death penalty, limiting death-row appeals and spending billions for crime prevention. In what had advocates the edge was stroke, he campaign program to hire 100,000 the $8

THE CLINTON RECORD
Fifth of seven articles:
Criminal Justice

Although some solid legislative accomplishments in his first two years, Mr. Clinton warmed to the issue. And then, he has signed a broad anti-terrorism bill that expands the Government's power to investigate terrorist suspects. And in the wake of the destruction of T.W.A. Flight 800 and the bombing at the Atlanta Olympics, he is seeking even broader Federal authority against terrorism.

He has issued a "one strike, you're out" rule for people who commit a violent crime or drug offense while living in public housing. He has praised community curfews, supported mandatory uniforms for public school students and lectured the entertain-

acted in the 1994 anti-crime bill.

Some of the President's critics and even some supporters say programs like COPS, which scatters officers through departments around the country, are politically appealing but unlikely to have much lasting impact on crime. But the COPS program has allowed Mr. Clinton to campaign on crime as a central pillar of his Presidency.

Continued on Page A20, Column 1

Lawmakers Advance On Health Insurance

Two years after comprehensive national health insurance died in Congress, House and Senate leaders legislation that make health insurance more available from job to job when Senator Edward M. Kennedy who co-sponsored the bill with Senator Nancy Landon Kassebaum, said, "this would help is now on the way to 25 million Americans." he said, it would end "the worst abuses of the private health-insurance industry."

Article, page D22.

Clinton Receives Promise, Weighs His Own Decision

By TODD S. PURDUM

WASHINGTON, July 31 — When shape the top...

That was the official word at the White House today, aides sooner had Mr. Clinton finished talking than the most forceful opponents of the bill in the meeting, Secretary of Health and Human Services Donna E. Shalala, and its most articulate defender, the domestic policy adviser Bruce Reed, hurried to repeat it to reporters.

But Ms. Shalala was unmistakably flustered. At one point she rebutted criticism from a fellow Democrat, Representative Charles B. Rangel of New York, by referring to him as "my good friend Charlie Brown." Unofficially, emotions ran high, and were complex.

"Oh, I don't know," one Presidential aide mused a bit wistfully when...

Continued on Page A22, Column 1

A Cloudburst Swamps a City
A youngster walked yesterday through the flooded intersection at 222d Street and 146th Avenue in Laurelton, Queens, after a sudden storm that left streets, subways and commuter railroads under water. Page B1.

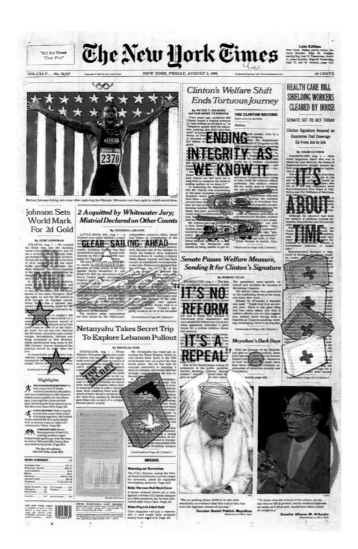

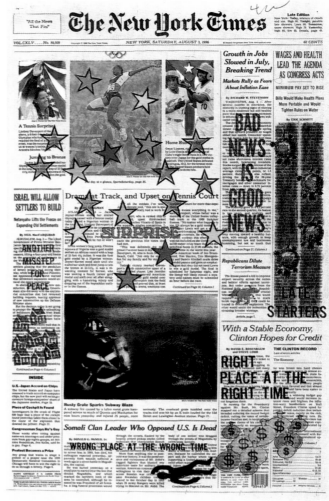

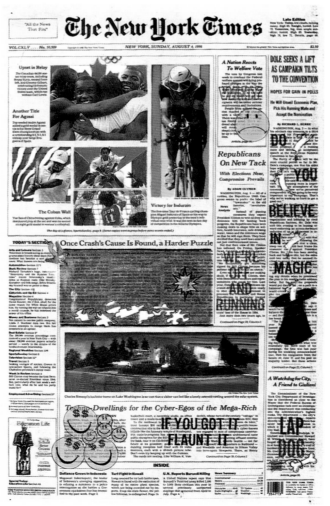

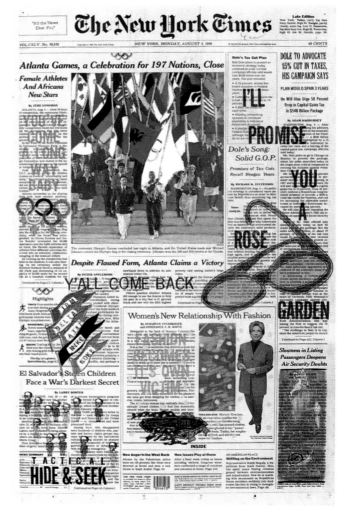

"All the News
That Fits"

The New York Times

Late Edition
New York: Today: early fog then hazy sun, humid. High 86. Tonight, patchy fog. Low 72. Tomorrow, patchy fog then hazy sun. High 86. Yesterday, high 85, low 70. Details, page C11.

VOL. CXLV No. 50,511 Copyright © 1996 The New York Times NEW YORK, TUESDAY, AUGUST 6, 1996 $1 beyond the greater New York metropolitan area. 60 CENTS

Rising Health Costs Threaten Generous Benefits in Europe

By CRAIG R. WHITNEY

PARIS, Aug. 5 — Dr. Philippe Perez, a general practitioner in the Paris suburb of Thiais, used to think nothing of prescribing $500 worth of medicated salve a month for patients with painful herpes infection, because they would be almost completely reimbursed by the French national health insurance system.

But the state-run insurance fund, under Government orders to cut its huge deficit, is now threatening to take high drug costs out of the fees it pays to doctors if they write too many prescriptions. So Dr. Perez explains the problem to his patients, and some of them now pay for the medicine out of their own pockets instead of putting in claims.

Peter König, a retired post office employee in Bonn, has found that German doctors, too, are becoming more reluctant to prescribe remedies like cough medicine that used to be on the insurance bill. Television in Bonn, he says, is now full of advertising pitches to get people to buy over-

THE HEALTH SQUEEZE
A special report.

the-counter remedies that used to be reimbursable by insurance.

In Britain, more than half of the general practitioners in the National Health Service now have budgets they cannot overspend for patients' medicines and hospital care, forcing them to think twice or bargain hard with hospitals and surgeons about the costs.

The high level of health care offered to the welfare states of Western Europe was long the envy of much of the rest of the world, but they can no longer afford the vast amounts required to pay for unlimited benefits.

So in country after country, administrators are turning to the same kinds of market-oriented cost-control measures used by managed care companies and health maintenance organizations in the United States, and

Continued on Page A4, Column 1

The Rising Cost Of Health Care

Total spending on health care as a percentage of gross domestic product. By comparison, the United States spent 14 percent in 1992.

Fashion Relearns Its Darwin: Be Adaptable or Be Extinct

By CONSTANCE C. R. WHITE and JENNIFER STEINHAUER

Perhaps only a woman like Ivana Trump — then wife of the Donald — would have applauded when the Italian fashion house Gruppo GFT rolled out its first Emanuel collection five years ago. There were jackets and dresses in flamboyant French color mixes worthy of a Plaza Hotel couch, combinations of printed fabrics, brilliant gold buttons, and bodaciously feminine side-draped skirts.

And only on the set of "Melrose Place" would a company executive slink around in the sexy short suits introduced in 1994 by the fashion house Anne Klein in its top collection, a complied by advertisements depicting the Anne Klein woman as a sort of strong-jawed all girl.

Both collections bombed. "It was a complete turnoff," said Alan G. Millstein, president of the Fashion Network Report and a former executive at Anne Klein. "That perception of the Anne Klein woman was one of a mean and hungry woman, whereas I always thought she should look like Murphy Brown."

Such fiascos are vivid evidence that the fashion business has been slow to recognize the changes in many American women's attitudes toward clothes. Women, particularly aging baby boomers, have recently wanted something less extreme — clothes that were stylish yet practical, enough to wear at the office, a business dinner and a P.T.A. meeting. And if they don't find what they

OUT OF FASHION
Second of two articles.

want, they are happy to spend their money on things that now seem far from frivolous, from vacations to furniture to plastic surgery.

Indeed, sales of women's apparel fell 4 percent to the record $84 billion set in 1995. $73 billion last year, according to Tactical Retail Solutions, a research firm.

The core line like Anne Klein, only now adjusting to this jilt of women. After switching designers and radically altering its advertising three times, Anne Klein finally closed its top line last April and is concentrating on its lower priced, more casual collection.

Other businesses, like Emanuel,

Continued on Page D5, Column 1

CLINTON SIGNS BILL AGAINST INVESTING IN IRAN AND LIBYA

ANTI-TERRORISM MEASURE

Germany and France Condemn Law Since Their Companies Could Face Sanctions

By ALISON MITCHELL

WASHINGTON, Aug. 5 — Over the objections of America's trading partners, President Clinton signed a law today that would impose sanctions on foreign companies that invest heavily in Iran and Libya, which he described as "two of the most dangerous supporters of terrorism in the world."

In a speech in the Oval Office signing of the bill, Mr. Clinton went on to call terrorism "the enemy of our generation" and vowed that the United States would combat it alone, without allies if necessary.

"Where we don't agree, the United States cannot and will not refuse to do what we think is right," he told students at George Washington University.

In a pointed message to America's allies, who have opposed the business of American companies doing commerce with you by day while funding or protecting the terrorists who kill and maim innocent civilians by night.

"That is wrong," Mr. Clinton said. "I hope and expect that before long our allies will come around to accepting this fundamental truth."

Germany and France immediately condemned the measure, with France warning that the European Union would retaliate and the Administration carried out the sanctions law. The European Union also is expected to challenge the law as well as another American law penalizing companies doing business with Cuba. Iran predicted the law was "doomed to failure."

France has been progressive in investment legislation, firstly commissioned by Senator Alfonse M. D'Amato, Republican of New York, who has been a driving force in Congress. A French official responded with a complaint today that, among two large oil companies, Conoco Inc. to give up a contract to impose American investments on allies joined the allies.

Mr. Clinton came after weeks in the buildup of an American oil company complex in Saudi Arabia at the crash of Trans World Airlines Flight 800 off Long Island. The explosion at Centennial Olympic Park in Atlanta have left a gap in national

Continued on Page A7, Column 3

DOLE OFFERS ECONOMIC PLAN CALLING FOR BROAD TAX CUT AIMED AT SPURRING GROWTH

VOWS DEFICIT CUT

Candidate Hopes to Woo the Middle Class and Revive Campaign

By KATHARINE Q. SEELYE

CHICAGO, Aug. 5 — Promising to "finish the job Ronald Reagan started so brilliantly," Bob Dole today proposed a wide-ranging plan to spur the economy with $548 billion in tax cuts and a $500-per-child tax credit, all the while balancing the budget within five years.

"We are going to balance the budget, cut taxes and remove the dead weight of Government to unleash the full potential of the American people," Mr. Dole told an enthusiastic Chamber of Commerce audience here as he unveiled the long-awaited plan he hopes will breathe new life into his Presidential campaign.

Neither advance reports had prepared for the dramatic, the candidate was enthusiastic. Somebody said, "I bet the farm — I'd like to bet the country."

Those skeptic of the supply-side economics championed by President Reagan said Mr. Dole today adopted the Reagan formula as he tried to appeal to what he described as the "forgotten middle class." He pledged to cut taxes 15 percent across the board and would still balance the budget by the year 2001.

Sketchy on what Government programs he would cut to make up the forgone tax revenue, Mr. Dole, a former chairman of the Senate Finance Committee, nonetheless contended there was "no danger" to the economy now.

A pro-growth Republican candidate asserted in his acceptance speech, cutting taxes and balancing are just a matter.

"If you have it, you can do it. I think it will come through.

Mr. Dole said his plan would cut the Federal income tax bill of a family of four making $30,000 a year by 56 percent, saving of $1,371 over what it is now. Most of that would come from a proposed $500 tax credit for each child.

President Clinton said Mr. Dole's plan would wreck the economy and hurt the American people. "I unalterably opposed to going back to the historic deficit decade before that you heard here said, most of that...

Continued on Page A12, Column 1

"Growth... Mr. Dole said. "Fiscal conservatives... budget, I say they're both right."

In a Studied Calm, Democrats ... Feverishly ...

WASHINGTON, ... morning, Department ... up at the ... paign if ... released ... been ... not ...

American public, Democrats... anything but nonchalant as they drive today to undermine their opponent's centerpiece proposal.

That is because even Democrats concede that the notion of a tax cut appeal... an appeal that... these words, and Don's... press secretary, ... the Fairmont Hotel... the ballroom... of the day... led out for broadcast ... a new television commercial deriding the Dole plan as "...minute scheme that... the deficit..."

Continued on Page A12, Column 3

Luggage Spotted in Debris Trail Suggests an Explosion to Experts

By DON VAN NATTA Jr.

Investigators located a new trail of debris from Trans World Airlines Flight 800 several miles closer to Kennedy International Airport than first found before, and said yesterday, clustered on the ocean bottom, were large chunks and pieces of luggage...

The new debris area strongly suggests to investigators that chunks of fuselage, presumably from the Boeing 747's underbelly, may have been the first parts of the plane to hit the water after a catastrophic explosion on board.

Although investigators said yes... they would begin picking those pieces...

Continued on Page A14, Column 1

Associated Press

In Atlanta, Some Whimsy for the Weary
On the morning after in a tired city, workers were cleaning up, vendors were marking down and Harold Buchholz of Germany, a tourist, indulged an Olympian fantasy with a leap into the long-jump pit. SportsTuesday, page B12.

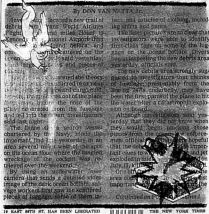

INSIDE

Big California Health Merger
Two California managed-care companies plan to merge in a $2.1 billion deal that reflects a growing interest in Medicare patients. Page D1.

British Abortion Furor
A woman and her doctor agreed to abort one of two healthy twin fetuses because she says she is too poor to support twins. Page A3.

Klaas Jury Chooses Death
A jury in San Jose recommended the death penalty for the man who murdered 12-year-old Polly Klaas nearly three years ago. Page A8.

In Africa, a Sense of Pride
Throughout Africa, people were rejoicing over the stunning success of their athletes. Nowhere was the joy greater than in Nigeria, where the gold medal in men's soccer led to declaration of a national holiday. Page B7.

In Sydney, 2000 Is Not Far Away
Organizers of the 2000 Summer Games are already saying theirs will be different from Atlanta's. They said the weather would be cooler, the transportation less complicated and the commercialism more subdued. Page B12.

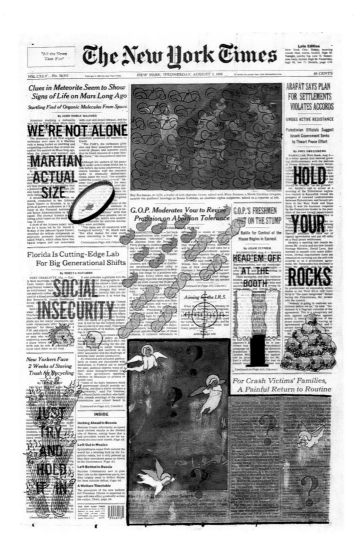

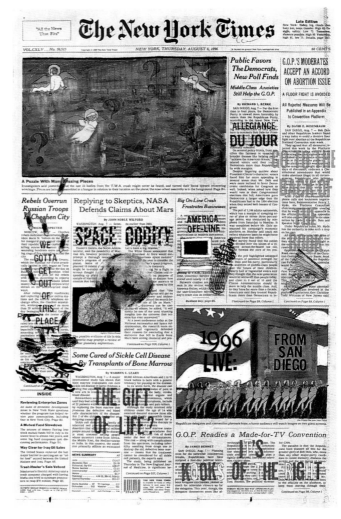

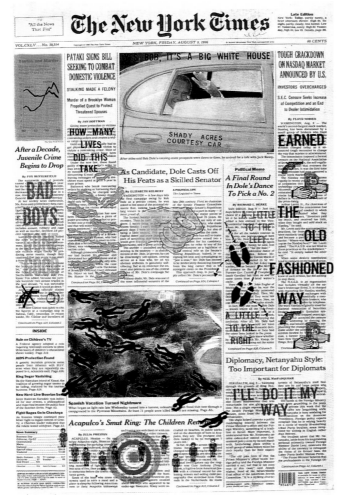

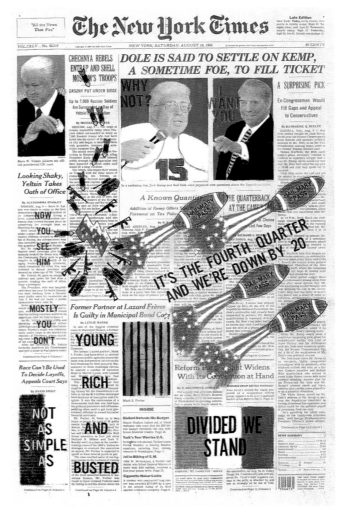

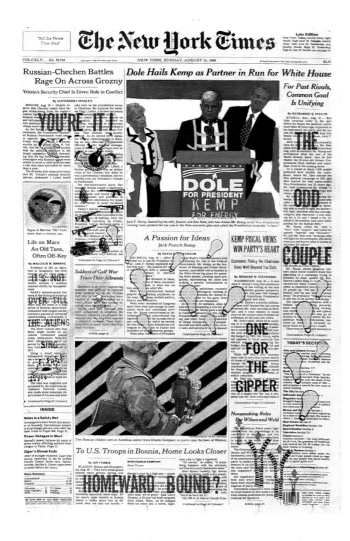

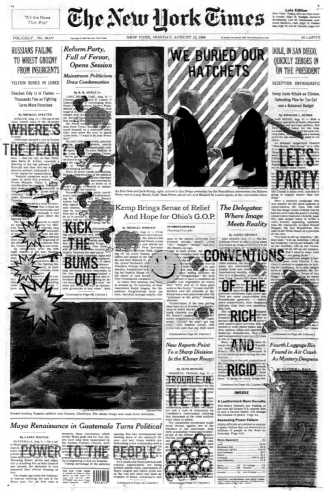

The New York Times

"All the News That Fits"

Late Edition
New York: Today: cool, damp. High 70. Tonight, lingering fog, drizzle, Low 64. Tomorrow, damp early, brighter afternoon. High 76. Yesterday, high 72, low 63. Details, page C10.

VOL.CXLV...No. 50,518 Copyright © 1996 The New York Times NEW YORK, TUESDAY, AUGUST 13, 1996 $1 beyond the greater New York metropolitan area. 60 CENTS

In Bid for Airline Security, Echoes of Unmet Promises

This article is based on reporting by Adam Bryant, John H. Cushman Jr., Matthew L. Wald and Andrew Pollack. It was written by Mr. Drew.

SAFETY STALLED

A special report.

WASHINGTON, Aug. 12 — On April 3, 1989, the 103d day after a bomb destroyed Pan Am Flight 103 over Lockerbie, Scotland, President George Bush and families of the victims pledged that the Government would take all measures to keep such a tragedy from happening again.

Later that day, Mr. Bush's Transportation Secretary, Samuel K. Skinner, announced sweeping proposals to combat terrorists and seal airport security system filled with weaknesses. Airports would be reshaped by "the most effective security measures we can devise," he said.

William H. Webster

Continued on Page B4, Column 1

Yeltsin Security Aide Denounces Russian War Effort in Chechnya

By ALESSANDRA STANLEY

MOSCOW, Aug. 12 — Russia's new national security adviser, Aleksandr I. Lebed, returned appalled and angry today from secret talks with rebel commanders in Chechnya, his rage was not directed at the enemy. At a news conference, Mr. Lebed, a former general and Afghan war hero, expressed horror at the condition of Russian troops and disgust over the conduct of bureaucrats leading the war effort.

INSIDE

Assessing Festival '96
The returns were still being counted, but officials of Lincoln Center Festival '96 declared it a success. An intriguing question was who made up the audience. The Arts, page C11.

Clinton Acts to Block Mine
President Clinton called a halt to development of a Montana gold mine that environmentalists said would damage wildlife. Page A10.

News Summary

Arts	C11-16
Business Day	D1-17
Editorial, Op-Ed	A16-17
International	A3-7
Metro	B1-5
National	A9-15
Science Times	C1-9
SportsTuesday	C17-

Environment	C4	Obituaries B8
Fashion	B7	TV Listing C15
Medical Science	C3	Weather B14
Classified	B14	Auto Exchange

Republican Convention Opens With a Show of Unity

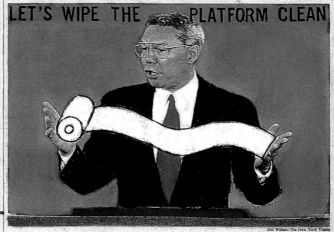

LET'S WIPE THE PLATFORM CLEAN

Gen. Colin L. Powell assured Republicans that the party was big enough "to disagree on individual issues."

Fleeing the Ghost of 1992

By R. W. Apple Jr.

SAN DIEGO, Aug. 12 — This is a convention run by revisionists determined to soften, if not rewrite, recent history.

Powell Outlines Vision of Party For All Views

By B. DRUMMOND AYRES Jr.

SAN DIEGO, Aug. 12 — Retired Gen. Colin L. Powell presented himself tonight to the Republican National Convention.

Applause for Powell As He Delivers Call for Inclusiveness

By RICHARD L. BERKE

SAN DIEGO, Aug. 12 — Republicans opened their annual national convention here today with a meticulously choreographed pageant.

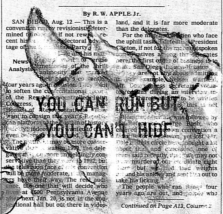

LARGER THAN LIFE

Nancy Reagan brought delegates to tears as she talked about her ailing husband, whose Presidency was featured in a taped program.

At Cornell Medical, Stay Away a Year And Get One Free

By JAMES BARRON

New York Girding for Surge in Welfare Jobs

By DAVID FIRESTONE

Former President George Bush harshly criticized the Clinton presidency last night in his remarks at the Republican convention.

The New York Times

"All the News That Fits"

Late Edition

New York: Today, becoming sunny, warmer. High 83. Tonight, clear, some fog. Low 68. Tomorrow, partly cloudy, chance of rain. Highs 82. Yesterday, high 68, low 61. Details, page B10.

VOL.CXLV . . . No. 50,519 Copyright © 1996 The New York Times NEW YORK, WEDNESDAY, AUGUST 14, 1996 $1 beyond the greater New York metropolitan area. 60 CENTS

Risky Walk in Rebel-Held Chechen Capital

By MICHAEL SPECTER

GROZNY, Russia, Aug. 13 — There is only one open road left into this city. It is a long series of bomb craters, partly mixed with dirt, sand and occasionally starts in the southwest of and runs toward the city's age-old heart.

The road has no name, but it does not need one, because everybody knows what it is there for. It is the last harrowing route to safety each day for thousands of anguished refugees who have been driven from their homes here in the capital of Chechnya by war and death and is the best entry route for the secessionist rebels who now reign over most of the city.

Winding through twisted trees, past ruined houses and down the middle of one of Russia's largest — but long unused — oil refineries, always waving white flags ripped from sheets.

The left lane is for the separatists, often walking in groups of less than 10 or driving in flatbed trucks like those used by many refugees to flee the burning city.

Today, a walk from the nearest village, Alkhan-Yurt, into Grozny was a treacherous journey, with

helicopter gunships hovering in the distance, Russian planes screeching across the steel-gray skies and a column of tanks to the west firing rounds at random. But the rebels seemed unfazed.

"It is unsafe," said one rebel, carrying a gun and knapsack, as he made his way along the muddy path toward Chernorechye, the southwest part of Grozny. "The Russians have tanks at every other entrance to the city, but they really can't stop us here."

It is now clear that the Russians are losing badly in their second battle for Grozny in the last two years. What began as a rebel hit-and-run intended to humiliate President Boris N. Yeltsin for his failed promises of peace has turned into something like a conquest.

Chechen commanders here say they originally planned to teach Mr. Yeltsin a lesson by showing the vulnerability of a city that has been a trouble-spot since early last year, and then withdraw after they made their point.

But now, they say, having captured Grozny and other Chechen cities so easily in the last week, they have no intention of pulling out, and plan to hold on until the Russians withdraw from the republic.

"This is our city," said Akhmed Zakayev, the national security adviser to the separatist government and one of its top commanders. "Why should we leave it again?"

Although the two sides announced a cease-fire to begin on Wednesday — the latest in a series of such announcements that are honored for long — today the fighting

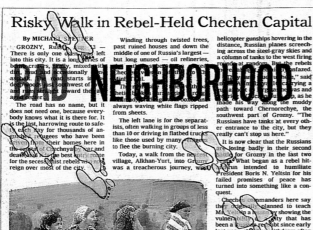
A group of Chechen women, pushing their belongings, flee Grozny. *Agence France*

Continued on Page A8, Column 1

Funds for Terrorists Traced To Persian Gulf Businessmen

By JEFF GERTH and JUDITH MILLER

WASHINGTON, Aug. 13 — Much of terrorists' financial support cells and the West individuals from Saudi Arabia and other Persian Gulf countries States, former American officials said.

Over the last anti-terrorism efforts on state sponsors of terrorism, forbidding trade with countries like Libya and Iran. But officials said the emergence of sophisticated, privately funded networks of terrorists poses a set of diplomatic and legal challenges for Western governments.

American officials businessmen in Saudi Arabia and the United Arab Emirates helped finance the Ramzi Ahmed Yousef, who has been charged as the mastermind of World Trade Center bombing in February 1993 and a plot to blow up 11 American airliners.

And American intelligence agencies are closely examining the activities of Osama bin Laden, the scion of a wealthy Saudi family stripped of his Saudi citizenship in 1994 who finances most of hard-line groups from Egypt to Algeria.

Officials in several countries, including the United States, say Mr. Bin Laden's money, as well as money he has raised, paid for terrorist

acts in Europe, Africa and the Middle East among Americans and others overseas.

The State Department, in a detailed document made public this month, described Osama bin Laden as "one of the most significant financial sponsors of Islamic extremist activities in the world." It linked him to terrorist training camps in Afghanistan and the Sudan and said he supported a group that tried to bomb American servicemen in Yemen in 1992.

In the three years before he was charged in the World Trade Center bombing, Yousef used a Pakistan guest house paid for by Mr. Bin Laden, according to the document. And the Saudi militants who killed five Americans last November in Riyadh said in their confessions that they had been influenced by Mr. Bin Laden's thinking.

Mr. Bin Laden, in interviews with

TERROR MONEY
A special report.

Continued on Page A8, Column 1

Inquiry Into Crash Proceeds on Cours

One day it was the hold, an obvious place to bomb. Another day it was the pit, where an explosive device have been hidden in a there still the possibility that engine parts unhinged, touch catastrophic mechanical

From far one thing is before certain and one by one have taken as investigators continue to pull pieces of Trans World Airlines Flight 800 from the waters off eastern Long Island.

Among the ways the shifting of the day's leading coaster, is the tortuous investigation in which the evidence wreckage is strewn across miles of ocean.

The gathering of evidence has been, at most times, as it has seemed.

Investigators say they are following a deliberate course that has made confident progress. Although the evidence they have recovered from the jet's front has explained what caused the plane to break apart, the increasing descriptions they have yet offered a long way toward explaining what did not happen.

Article, page B1.

G.O.P. OPENS FIERCE ATTACK ON CLINTON OVER CHARACTER AND HANDLING OF ECONOMY

SCATHING SPEECHES

Molinari Provides Soft Image but Throws a Political Hardball

By RICHARD L. BERKE

SAN DIEGO, Aug. 13 — Republicans melded homespun family images with hardball politics at their national convention tonight, as a lineup of speakers exploited what party leaders believe are President Clinton's two biggest vulnerabilities: his character and the economic anxieties of the middle class.

In putting Representative Susan Molinari of Staten Island before the television cameras as the keynote speaker, Republicans made a play for female voters who have turned away from the party. A day earlier, the party sought to broaden its appeal to moderates, swing voters and perhaps even minorities by advancing a message of inclusion from Gen. Colin L. Powell.

As the camera panned to her husband, Representative Bill Paxon of Buffalo, who held their 3-month-old daughter, Susan Ruby, on his knee, Ms. Molinari referred to herself as "a mom." Mr. Paxon sat beside Elizabeth Dole and Jack Kemp, Bob Dole's running mate, as his wife sought to put a softer, more youthful and maternal face on the Republican Party four years after Senator Phil Gramm of Texas delivered a widely judged flat note of an address.

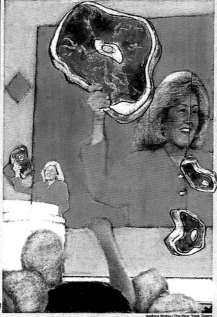
"Don't you think it's time to elect a President who will keep Bill Clinton's promises? And that man is Bob Dole."
Senator Kay Bailey Hutchison flourishing Clinton campaign literature from 1992.
Andrea Mohin/The New York Times

Party Seeking to Transform Harsh Image of Its Congress

By DAVID E. ROSENBAUM

SAN DIEGO, Aug. 13 — When Speaker Newt Gingrich made his first appearance before the Republican National Convention tonight, the first words out of his mouth were about beach volleyball, an example of what the convention was all about.

From there he quoted the Rev. Dr. Martin Luther King Jr. and called "the greatest leader of the century."

Most of the rest of his speech was about compassion and charity. He talked about how he had worked here last weekend with Habitat for Humanity, the charity that builds houses for the poor.

He made no mention of revolution

or the Contract With America. He did not talk about dismantling a corrupt government or describe his political opponents, as he often does, as traitors to American values. He did not

Mr. Gingrich and the Republicans are trying to present here this week a strikingly different face from the one that Mr. Gingrich led to power.

It is a Congress where Republicans never swear a swear word and lawmakers were so rigid that they allowed the Government to shut down twice last winter.

But now they are trying to adopt a mien of moderation and accomplishment. The theme of the convention Wednesday night will be "The Common-Sense Republican Congress."

No one is taking credit for coining this phrase, which has become ubiquitous in San Diego the last two weeks. But its intent is clear. Democrats

Continued on Page A19, Column 2

Powell Seeks Distance

A day after a rousing speech to Republican delegates, Colin L. Powell tried to stake out independent ground, while Dole aides tried to pull him into their camp. Page A17.

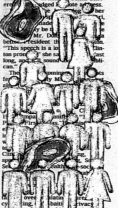

Networks vs. the Organizers: Early Rounds Go to G.O.P.

By JAMES BENNET

SAN DIEGO, Aug. 13 — When Colin L. Powell spoke about Republican diversity at convention last night, at least a broadcast networks focused on were black, though only 3 percent of the delegates are.

Two networks broadcast a six-minute about Bob nominated three cable broadcast cans the the planned images ing to muss it, a quadrennial struggle that is more intense than ever this year.

Some network executives said convention planners had misled them about the content of the Reagan video, had not given them advance copies soon enough to allow them to screen it thoroughly for news value,

had similarly delayed releasing the texts of speeches and had shifted the schedule at the last minute, forcing them to jungle off balance. Others said they had had plenty of time and information to do their coverage.

With major prime-time storms, at least one program

Continued on Page A16, Column 2

At Holloman Air Force Base, German airmen and their families are promised a "hearty welcome." *Bruce Berman for The New York Times*

Germans Back on U.S. Base, Now as Tenants

By JAMES BROOKE

ALAMOGORDO, N.M., Aug. 6 — the 300 German prisoners of war interned here half a century ago could have attended a military ceremony held here last May, they have stared as if looking at a mirage.

"This is a great day for the Luftwaffe, for Alamogordo, and for our two countries," Germany's Defense Minister, Volker Rühe, proclaimed as honor guards marched German and American flags poured waves of tornado around each marked with the Germany's Air Force. With that, the German Air Force Tactical Training Center opened for business at Holloman Air Force Base.

To look at it is simply "the German for investing $42 million in air shops, Germany has moved here with 12 Tornado jets, 300 German Air Force men

etly being etched in this dry, baking-hot expanse of cactus and sagebrush in south-central New Mexico: the training center is the first military facility in the United States leased to a foreign power.

Continued on Page B6, Column 3

INSIDE

Girls' School to Proceed
Despite civil rights issues, New York City's first single-sex public school in a decade will open. Page B1.

Suffolk Opts for English
The Suffolk County Legislature approved a resolution making English the official language. Page B5.

Inflation Fears Roil Markets
Unexpected price rises in July unnerved the bond and stock markets, the Dow falling 57.70 points. Page D1.

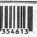

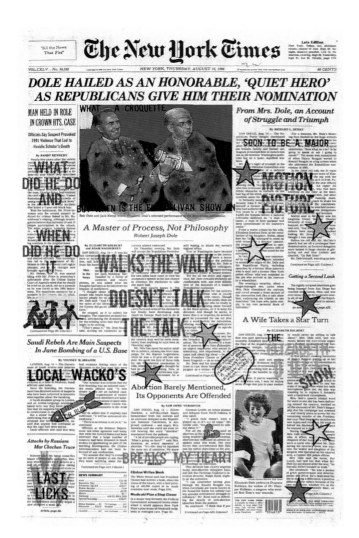

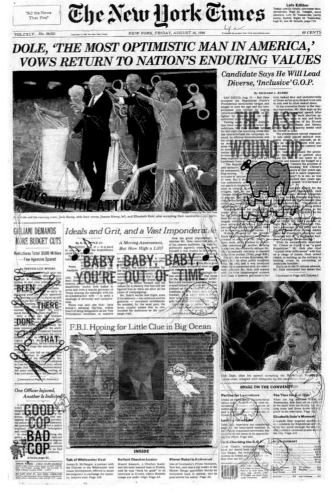

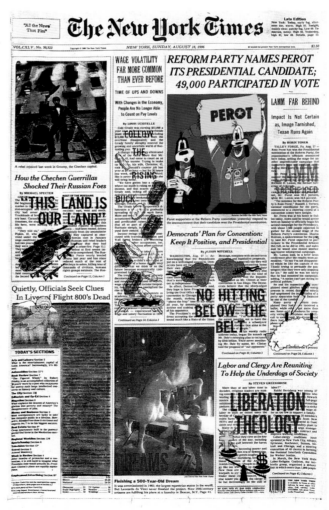

The New York Times

Late Edition
New York: Today, becoming sunny. High 85. Tonight, mainly clear, some fog later. Low 67. Tomorrow, mostly sunny, cooler. High 82. Yesterday, high 83, low 68. Details, page B11.

VOL.CXLV....No. 50,524 Copyright © 1996 The New York Times NEW YORK, MONDAY, AUGUST 19, 1996 *$1 beyond the greater New York metropolitan area. 60 CENTS

Split Puts Khmer Rouge Faction In Mood to Deal With Old Foes

But Bid for Role in Politics Has Cambodia Astir

By SETH MYDANS

NIMITH, Cambodia, Aug. 18 — It was not until the day's session of peace talks was finally over that Col. San Santha of the Royal Cambodian Armed Forces finally coaxed a smile out of his Khmer Rouge counterpart Mit Phon.

With the gift of a field telephone, an envelope of walking-around money, a hug and a whispered joke, the colonel recorded the guerrilla officer onto a Government helicopter for a 10-minute flight that would take him back into the jungle, where, it appeared, he would clearly be more comfortable.

Just two days earlier, on Thursday, Mr. Phon's breakaway faction of the Communist insurgency had reached an accommodation with the Cambodian military that would allow the Khmer Rouge dissidents to keep their weapons and their mostly jungle territory while coming into the command of the Government forces they had been fighting for years.

It was a major turning point in the three-decade-old Khmer Rouge movement, the result of a split in the ranks of the guerrillas that has reached the peak each side has termed the other the enemy and made the guerrillas' one-time enemies the friend. The Khmer Rouge in the field and in

Cambodian society, where the stated desire of the dissident faction to re-enter politics has aroused a storm of controversy.

All discussions continue over details of the breakaway faction's relationship with the Cambodian Government, the guerrilla envoys are getting a taste of the unpleasant shocks that await them in the outside world. At Saturday's meeting in a Government army camp here, they came face to face for the first time with three Western reporters representing a culture they still demonize.

Dressed in the unadorned green uniform, soft cap and sandals of the Khmer Rouge, Mr. Phon remained silent throughout the interview, leaving the talking to his superior officer, Mit Muong, who had broken with tradition to dress in a pale-blue version of the same outfit. Mit is the guerrillas' honorific, meaning comrade.

The Khmer Rouge visitors in their rubber sandals, carrying plastic bags in place of briefcases, were clearly uncomfortable in their new subordinate role, surrounded by solicitous Government colonels and generals in smart uniforms who listened to their words as sharply as the reporters did.

The guerrillas walked with their heads lowered as if wishing not to see

Continued on Page A6, Column 1

Col. San Santha, left, and Mit Phon, of a breakaway Khmer Rouge faction, celebrated an accord between the Government and guerrillas. *Seth Mydans/The New York Times*

BARROOMS' DECLINE UNDERLIES A DROP IN ADULT KILLINGS

A VIEW FROM THE STREET

Detectives Credit Changes in Everyday Life and Gains in Emergency-Room Care

By FOX BUTTERFIELD

CLEVELAND — Back when Sgt. John Kaminski started out in homicide in the 1960's, the most common murder cases were barroom brawls. "There was a bar on every street corner in Cleveland those days, and the men who worked in this city's steel and automobile plants took the trolley to their jobs, stopped off for a shot and a beer on the way home. In some bars, it was like clock work," Sergeant Kaminski remembers. After a few drinks a patron would insult the man on the next stool, usually a friend, and pretty soon a knife or a gun would be pulled out and one of the customers would be dead.

No more. The factories, the bars, the way of life are largely gone. "I can still remember the last bar fight," said Sergeant Kaminski, who is 65 years old and has been a homicide detective for 34 years.

The virtual disappearance of barroom killings is part of a profound change in American crime and society. Murders committed by adults have dropped almost in half over the last 16 years.

In fact, the last year in which figures are available, there were only 4.7 homicides per 100,000 adults 25 years or older, compared with 8.1 in 1980, according to an analysis of F.B.I. data by James Alan Fox, the dean of the College of Criminal Justice at Northeastern University.

The drop in adult homicides is perhaps the sharpest of the nation's historic and perennially pronounced crime indicators. It has helped drive declining murder rates reported by many cities over the last three years, experts say. But until recently, because it has been overshadowed by a sharp increase in juvenile murders, the downward trend has been largely overlooked by police chiefs, politicians and academic criminologists. Now, is the drop-off in juvenile

Continued on Page A11, Column 1

PEROT BEGINS HIS CAMPAIGN; VOWS TO END 2-PARTY SYSTEM AS HE RECALLS HIS '92 THEMES

A VIGOROUS SPEECH

Reform Party Candidate Wins Over the Crowd but Not His Rival

By R. W. APPLE Jr.

VALLEY FORGE, Pa., Aug. 18 — Ross Perot, who four years ago won more votes than any independent-Presidential candidate in 80 years, launched his campaign as the 1996 nominee of the Reform Party tonight with a denunciation of the two-party system and the promise to "kill that little snake this time."

The 66-year-old Texas billionaire told a crowd of 1,500 cheering party members, gathered in the convention center in this town east of Philadelphia for the second and final stage of a bicoastal convention, that he was honored and humbled to be their candidate. He promised, "I will be your servant."

But he conspicuously failed to win the endorsement of the man he defeated for the nomination, former Gov. Richard D. Lamm of Colorado.

Lacing his speech with inspirational anecdotes from American history and his own life, preaching self-reliance and ridiculing big government, Mr. Perot lambasted budget deficits and trade agreements like Nafta, which he said exported jobs. He broke no new ground and proposed few specific solutions.

A less formidable figure so far in 1996 than four years ago, partly because he is no longer a fresh face in national politics, Mr. Perot is expected to emphasize campaign finance reform in coming weeks. With Republicans and Democrats both wary of an issue that could, the Reform Party have a potent weapon.

Mr. Perot said later tonight that he had decided to accept $30 million in Federal money that he qualified for because of his strong showing in 1992. By accepting that money, Mr. Perot agreed that he would spend no more than $50,000 of his own money on his campaign, concentrating instead on raising money and fund-raising to current campaign finance laws.

Although he did not win the endorsement of Mr. Lamm this evening, Mr. Perot complained of the series of birthday parties the President raised millions in Mr. Clinton's

"I will be your servant," Ross Perot told the Reform [Party]. *Suzanne ...*

Billion-Dollar Enigma
Henry Ross Perot

By STEVEN A. HOLMES

Outside the private office of H. Ross Perot in Dallas sits a bust of Theodore Roosevelt inscribed with these words, uttered by the 26th President in 1910:

"It is not the critic who counts, not the man who points out how the strong man stumbled, or where the doer of deeds could have done them better.

	The credit belongs to the man who is actually in the arena, whose face is marred by dust and sweat and blood."
Man in the News	

Now, as Mr. Perot enters the stage again as the Presidential candidate of a third party that he created and has financed, the question that has dogged him in the past will no doubt be raised anew: is it the arena he seeks, or the limelight?

In the nearly 30 years since H. Ross Perot burst onto the national scene, the diminutive Texan has always seemed to be in the fight, pushing, scrapping, exhorting, arguing. Sometimes he has forced his way to the front on the strength of his ideas and his personal profile. At other times he has bought his way onto the

stage, something he seems to do without reluctance: since he began his run for the Presidency in 1992, Mr. Perot spent perhaps $80 million of his own money in pursuit of the office. One number dizzying even by the standards of the Kennedys and Rockefellers. Should he spend this year the way he did in 1992, the total could hit $140 million.

In his various forays, Mr. Perot, who just won an estimated seat at least $3 billion and sometimes won dramatically and sometimes stumbled badly. The antagonists ranged from small Wall Street to General Motors, the Government of Iran — and the defeats, at times, have been resounding. But even after Mr. Perot has suffered losses that would have left many others destroyed financially or politically, his grit and his money have allowed him to turn up again, like a gallant phoenix or a recurring nightmare.

"I am honored and I am humbled that you have chosen me as your candidate to be President," Mr. Pe-

Continued on Page B9, Column 1

Continued on Page ... , Co...

Clinton Has $10 Million Wish for Birthday Bash

By ALISON MITCHELL

Bill Clinton, the youngest President since John F. Kennedy, led his generation into its sixth decade last night with the ultimate in boomer birthday bashes: a Radio City fundraising extravaganza of self-celebration and reflection drenched with more Top-40 nostalgia than "The Big Chill."

There are some who might usher in the Big Five-0 milestone quietly, even pensively. Mr. Clinton, characteristically, celebrated publicly. The night's event, along with satellite parties across the country, expected to net $10 million by Democrats to wage the coming campaign.

Baby pictures of teenage Bill, first Buick and political moments from Mr. Clinton's life flew past on a giant video screen erected above Radio City's stage. Celebrity crooners — from Tony Bennett in dinner jacket to Aretha Franklin in pink and glitter, from Kenny Rogers with gray beard to Shania Twain in her youthful stage in very proper in dec and ...

Their star times illuminated with surprise appearances of Mr. Clinton's college roommates and his second-grade teacher, who arrived using a walker and proclaimed, "I'm the one who gave little Bill a C in conduct."

Whoopi Goldberg, the emcee, proclaimed the evening a time to preach to the converted. And it often sounded like the entertainment industry's revenge on the Republicans. The actor Nathan Lane told Mr. Clinton that his birthday was "so much more glamorous than, say Bob Dole's 50th. If it's a party, of course it's a humdinger. You know, you ... Rocke ... at in his honor.

The actor Lou Diamond Phillips,

Continued on Page B7, Column 5

Fifty candles proved a few too many for the First Lungs at a birthday reception yesterday; before it was all over, Chelsea Clinton had to help. *Tyler Muhammad/The New York Times*

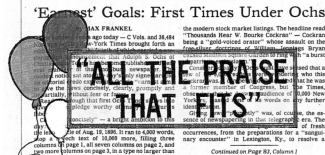

The New-York Times.

| Two Parts 12 Pages | | Part One Pages 1-8 |

Front page of the first issue of The New York Times published under Adolph S. Ochs's ownership.

'Earnest' Goals: First Times Under Ochs

By MAX FRANKEL

A hundred years ago today — C Vols. and 36,484 days — New-York Times brought forth an ... movement that Adolph S. Ochs of Chattanooga ... publisher ... eroded notice ... but newspaper ... an editorial credo express ... to give the news concisely, clearly, promptly and impartially, without fear or favor ... Read ... ough that first Oct ... a pledge worthy of ... "C ... oncisely" — a bright ambition to this day ... the lead ... le of Aug. 19, 1896. It ran to 4,000 words, top a speech text of 10,000 more, filling three columns on page 1, all seven columns on page 2, and two more columns on page 3, in a type no larger than

the modern stock market listings. The headline read "Thousands Hear W. Bourke Cockran" — Cockran being a "gold-voiced orator" whose assault on the free-silver doctrines of William Jennings Bryan packed Madison Square Garden to the rafters.

Consulting a first Ochs paper sensed that a crew of copy editors considering who this Cockran was ... "earnest" item. He was a former member of Congress, but the Times, observing that it had "100,000 New York ... of its words on any further ...

Giving news "promptly" was, of course, the essence of newspapering in that telegraphic era. The front page was chock full of fresh occurrences, from the preparations for a "sanguinary encounter" in Lexington, Ky., to resolve a

Continued on Page B3, Column 1

"ALL THE PRAISE THAT FITS"

INSIDE

Curbing Nursing Costs
As New York hospitals frantically cut costs to cope with managed care, they have taken aim at their biggest single expense: nurses. Page B1.

Israel's New Alien Poor
After sharply curbing the number of Palestinian workers, Israel is facing the alternative — laborers flooding in from all over the world. Page A7.

Military Plane Crashes
A military cargo plane carrying equipment for President Clinton slammed into a mountain in Wyoming, killing nine aboard. Page A10.

Problems in Power Grid
A lack of coordination between utilities in two recent power failures in the West has exposed the vulnerability of a huge power grid. Page A14.

354613

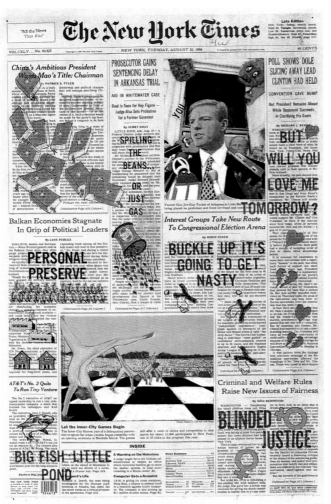

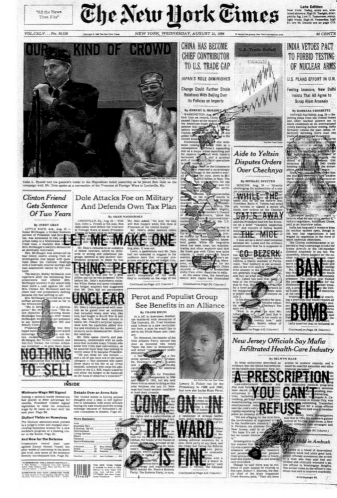

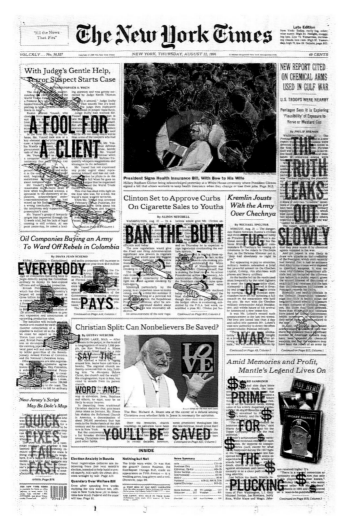

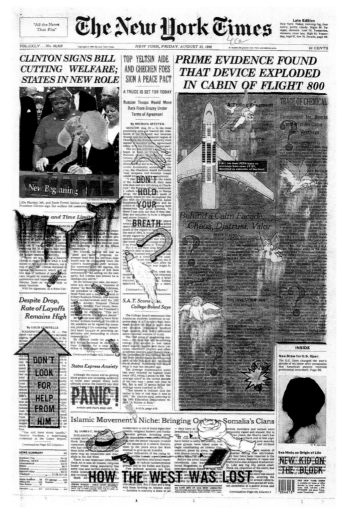

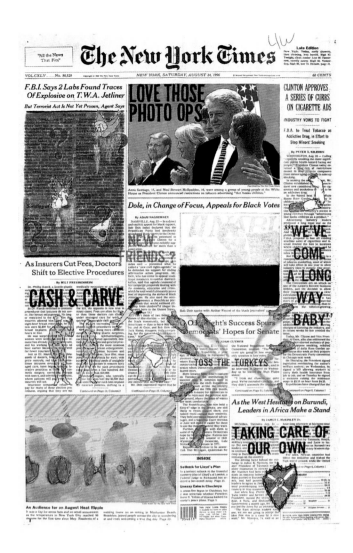

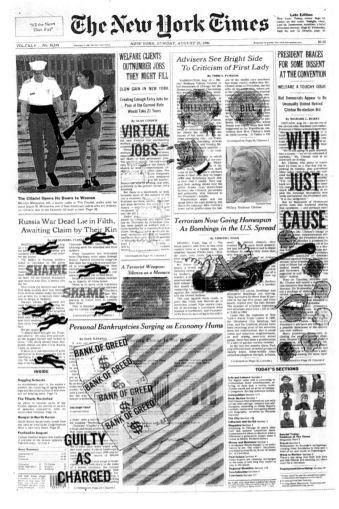

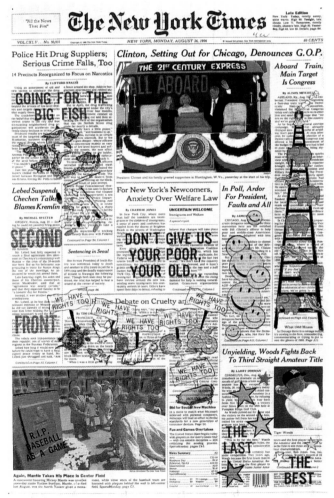

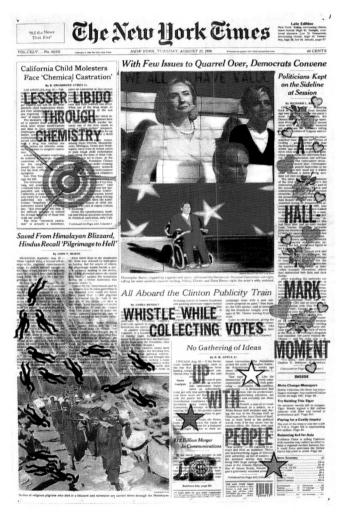

The New York Times

"All the News That Fits"

Late Edition
New York: Today, morning clouds, some showers. High 80. Tonight, some clouds. Low 69. Tomorrow, mostly sunny. High 84. Yesterday, high 83, low 67. Weather map is on page B16.

VOL.CXLV... No. 50,533 Copyright © 1996 The New York Times NEW YORK, WEDNESDAY, AUGUST 28, 1996 $1 beyond the greater New York metropolitan area. 60 CENTS

California Governor Acts to End State Aid for Illegal Immigrants

Moves Quickly Under New Federal Welfare Law

By TIM GOLDEN

[27] — Moving aggress [...] the new Federal welfare law [...] ices to illegal immigrant [...] Pete Wilson today signed [...] der [...] those immi [...] to be [...] ranging from [...] ing [...] tal care and [...] preven [...] programs.

Sta [...] said the [...] legisla [...] President Cli [...] signed [...] last Thursday, won them [...] rtial [...] importa [...] triumph in [...] [...] to enforce the provisions [...] 187. That ballot init [...] ying state services to peo [...] enter [...] United States ille [...] as approved overwhelmingly [...] lifornia voter [...] in 1994 but ha [...] en enjoined in court order sin [...] en.

Neither the [...] Federal welfare act nor the Governor's order, the first of its kind in the nation to result from the law, bars illegal immigrants from public primary or secondary schools, as the ballot initiative [...] Nor does it keep them from e [...] [...] care.

But officials said [...] tions would cover h [...] dred [...] state services and programs, including many [...] [...] censes, tha [...] [...] under the [...] contem [...]

"Today's [...] order, [...] is a vindication, [...] act itself," Mr. Wilson said in a signing ceremo—

[...] at the State Capitol in Sacramento. Both steps, he said, answer Californians' demand "that the Federal Government end the magnetic lure of public ser [...] d benefits that hav [...] ned our na [...] tion [...] migration."

But like P [...] 187, the Governor's order was immediately [...] r the threat of challenges in the [...]

[...] ts advocates argued [...] had jumped [...] for regul [...] [...] w Federal statute [...] partment must issue wit [...] months on how the imm [...] tus of people apply [...] should be verified [...] oppo [...] nen [...] usurped Federal [...] he co [...] try's immigration [...] authorizing almost a [...] mploye to begin askin [...] eople they serve whether the [...] ntered the United States legally.

"If they try to implement any part of [...] we will be in court [...] ark Rosenbaum, the [...] American Civil [...] of Southern California, one of the lawyers who won a [...] al injur [...] against Proposi [...] ned [...] r's order promote [...]

Continued on Page B7, Column 4

Profit Motive Clouding Effort To Buy Up A-Bomb Material

By PETER PASSELL

The American G [...] ment-owned corporation that is [...] ged with acquiring much of [...] s military stockpile of [...] ranium [...] resale as civilian [...] g reactor fuel turned down [...] Russian offers this year [...] tons [...] material sufficient to build 400 bombs comparable to the one that destro [...]

The incident [...] whether the co [...] State [...] urichm [...] its ov [...] profits ahead of national security [...]

Th [...] eement to buy [...] nium was a centerpiece of [...] American effort to get [...] ingredients of powerful weapons in the form [...] Soviet Union before [...] material [...] [...] terrorists [...]

"I am [...] is acting directly [...] ry to the national-security interests of the United States," Senator Pete V. Domenici, the New Mexico Republican who is an important [...] ngressional figure in the swords-to- [...] shares program, wrote to Charle [...] Curtis, Deputy Secretary of E [...] h a letter dated July 31.

The decision to buy only the 12 tons

of material earlier agreed upon, rather than the 18 tons that the Russians offered, was reversed after pressure from Senator Domenici. But some experts concerned about the spread of such material say their fears of a potentially dangerous conflict of interest at the Enrichment [...] en realized. And [...] e next time that the [...] corporation is [...] to private investors as early as this winter. And pri [...] ownership might tip the balance [...] ven further toward raising pro [...] and away from stopping nuclear proliferation.

The private investors might well [...] rrently running [...] creasing the [...] , those ex [...] [...] a better candidate for a public stock offering that leaves them in control, and with a more valuable stake besides.

"The people who now run the United States Enrichment Corporation stand to benefit enormously if they do what their future stockholders want — maximize profits," said

Continued on Page D3, Column 3

REPORT SHOWS U.S. WAS TOLD IN 1991 OF CHEMICAL ARMS

DATA ON IRAQI MUNITIONS

Files Were Hidden in Pentagon Even as It Said That G.I.'s Had Not Been Exposed

By PHILIP SHENON

WASHINGTON, Aug. 27 — A long-classified intelligence report shows that the Pentagon, the White House, the Central Intelligence Agency and the State Department were alerted in November 1991 that chemical weapons had been stored in an Iraqi ammunition depot that was blown up earlier that year by a group of American troops.

The report was relayed by the Joint Chiefs of Staff to American military commanders around the world and then remained hidden in files at the Pentagon and other Government agencies even as the Defense Department issued statement after statement suggesting that it had no evidence that large numbers of American troops might have been exposed to chemical weapons.

The November 1991 report, which was marked "priority," [...] never shared with the troops themselves. The estimated 150 American soldiers who participated in the demolition mission in March 1991 in the southern Iraqi desert were informed only this spring that they may have been exposed to a cloud of mustard gas and sarin, a nerve agent.

Many of the soldiers who destroyed the arms depot have since developed debilitating medical problems that they say may be linked to their exposure to chemical weapons, and nearly 60,000 other veterans of the gulf war have asked for special [...] eenings to determine if they are suffering from ailments related to their service in the gulf.

The 1991 intelligence report was distributed to the White House Situation Room, the C.I.A., the Defense Intelligence Agency and the offices of the Secretary of State.

Pentagon officials said much of the material in the report had been obtained from United Nations arms inspectors who traveled to Iraq after the war ended on Feb. 27, 1991, and who had found evidence of chemical

Continued on Page B8, Column 1

Some Bosnia Voting Delayed Over Abuses

The Western officials [...] harge of the September elections [...] Bosnia postponed municipal voting, citing abuses. The delay raises fears about whether the [...] lling out peacekeepers could be maintained.

Article, page A6.

Democrats Lay Claim to Family Values

GO GIRL

Associated Press

Hillary Rodham Clinton took a soft-edged, family-oriented approach in her speech to the Democratic National Convention.

'Four (12?) More Years'

Albert Arnold Gore Jr.

By DAVID E. ROSENBAUM

CHICAGO, Aug. 27 — "This two-headed monster of Dole-Gingrich," Vice President Al Gore declared on Sunday [...] sparkle in his eyes [...] ter tone in his voice [...]

[...] he motion [...] launched an all-out assault on decades of progress on be [...] half of working men and women.

Mr. Gore had struck a chord. His friendly audience of labor delegates to the Democratic National Convention rose, and [...] hooed the Republican der [...] ns.

The Vice President stood [...] n the podium with th [...] natural grin that comes [...] y to most other politicians. [...] the crowd began to chant, "Four more years."

People who have [...] ched Mr. Gore throughout his care [...] it [...] never seen him so animate [...] w [...] so good beginning to a crusade, [...] for him. For four more years is enough for Mr. Gore, he dreams, or 12 more.

But to fulfill his dream of being elected President in the year 2000, the 48-year-old Mr. Gore may have to dispel the rap, against him that his style is too flat and wooden to generate enthusiasm among voters.

Continued on Page B8, Column 1

Hillary Clinton Leads Tribute to Children

By RICHARD L. BERKE

CHICAGO, Aug. 27 — The Democratic Party [...] Americans its own version of family values tonight, led by Hillary Rodham Clinton, one of the party's [...] polarizing figures, who reached out to a constituency hotly contested by both parties with a talk about family issues and about her own family: her daughter, Chelsea, and her husband, the President.

Five days after President Clinton signed a welfare bill that many of his own supporters fear will hurt millions of children [...] mocrats [...] the night's [...] spoke of chil [...]

Each [...] ared welcome from Mrs. Clinton [...] foster children, to Mar [...] reat-ened by the very programs that Mr. Clinton made law, to the Rev. Jesse Jackson's anguished minority children facing an end to the programs that allowed their parents a chance at the American dream.

It [...] ymb [...] caring and hea [...] concerns to Democrats tried to project [...] r prime-time address [...] ational conventi [...] harder-edged pol [...] g the day and earlier evening sessions.

Greeted by a four-minute standing ovation from the delegates and a sea of "Welcome Home Hillary" signs, Mrs. Clinton delivered an address that knocked Gov. Evan Bayh of Indiana out of the prime-time speaking slot originally scheduled for him as the keynote spe [...]

In her address, Mrs. Clinton tried to relate her everyday concerns to those of other Americans with a policy-laden discussion of her husband's record, but only on issues dealing with children and family. For the first time, she thrust her 16-year-old daughter, Chelsea, onto the political [...]

Continued on Page A14, Column 2

Teacher, Not a Celebrity

Hillary Clinton Puts Emphasis on Family But Keeps a Political Spin on Her Theme

By R. W. APPLE Jr.

CHICAGO, Aug. 27 — Stern and focused, planted behind the lectern, eschewing any attempt to top Elizabeth Dole in the charm sweepstakes, Hillary Rodham Clinton stuck to guns tonight at the Democratic convention [...] ing the teacher [...] the television personality [...] ty in her debut appearance before the [...] gathered to renominate her husband. She told a joke or two [...] crowd at the United Center [...] a four-minute ovation [...] t [...] joshed, had suggested that [...] her hair short, dye it orange [...] change her name to Hillary Rodham Clinton, after the exotic defensive specialist of the Chicago Bulls arena's main tenants.

But that was the last note of levity. Mrs. Clinton said, she wished she could sit at a kitchen table [...] us" — and talk to the nation around it, but she sounded more like [...] were teaching a class or perhaps making a speech, a pointedly political speech, to the national [...]

"Right now," she said, eyes leveled at the prime-time television audience beyond the cameras, unsmiling, "in our biggest cities and our

smallest towns, there are boys and girls being tucked gently into bed, and there are boys and girls who have no one to call mom or dad, and no place to call home."

She never mentioned the Republicans by their nominee, Bob Dole. She did not even allude to Mrs. Dole, who [...] a minor sensation at the Republican convention in San Diego by [...] ng, Oprah-like, among the delegates [...] She picked up several of [...] eral spectacles Mr. Dole and others lobbed in her direction [...] o throw them back, with equal [...]

[...] United States, Mrs. Clinton said, must become "a nation that does not talk about family values but acts in ways that value families."

And she insisted, Mr. Dole to the contrary notwithstanding, that it does "take a village" — the phrase comes from the title of her latest book — to raise a child. Mr. Dole had suggested that a family was enough, and he had attacked the teachers' unions, but Mrs. Clinton said teachers, clergy, friends and others helped [...]

Continued on Page A15, Column 1

A Day of Fresh Starts, and Mourning What Might Have Been
School reopened yesterday in Montoursville, Pa., the town that lost 16 students and 5 adults in the crash of T.W.A. Flight 800 six weeks ago. Jackie Hettler visited the place where her 18-year-old son, Rance, and most of the group from Montoursville were buried together. Page B1.

INSIDE

The New York Times

Late Edition
Today, Patchy early fog then mostly sunny. High 84. Tonight, mainly clear, cooler. Low 64. Tomorrow, sunny then afternoon clouds. High 77. Yesterday, high 75, low 68. Details, page C12.

VOL.CXLV...No. 50,534 Copyright © 1996 The New York Times NEW YORK, THURSDAY, AUGUST 29, 1996 $1 beyond the greater New York metropolitan area. 60 CENTS

Democrats Send Clinton Into Battle for a 2d Term

ENROLLMENT SURGE IN NEW YORK CITY STRAINED SCHOOLS

With 91,000 More Pupils, System Improvises, Using Ex-Factories and Stores

By JACQUES STEINBERG

New York City's public schools are so crowded this year that thousands of their 196 million students report to class next week in unlikely spaces: a converted World War II torpedo factory in Brooklyn, a renovated department store in Queens, the upper floors of the Town Hall theater in midtown Manhattan and dozens of temporary aluminum trailers scattered in schoolyards across the city.

School officials said yesterday that the system was more crowded than at any time since the height of the Baby Boom four decades ago, forcing them to beg, borrow and lease classroom space anywhere they could find, especially in underused commercial buildings across the city.

Schools Chancellor Rudy Crew and other officials said there were 91,000 students more than the system's 1,100 schools were built to house — enough students to fill every school building in Washington or Denver.

"This system is going to explode with kids," said Lewis D. Spence, the Deputy Chancellor for operations. "We need to come to this issue with a strategy for dealing with it."

Fed in part by a return of young immigrants from Mexico, the Dominican Republic and Asia — and by an increasing number of students who spend more than four years in high school — enrollment in the city's schools has climbed by an astonishing 200,000 students in each of the last six years to its highest point since 1976. But to find a period when the schools were over capacity as they are now, school officials said, one has to go back to the 1950's and 1960's.

They added that a decade from now the system was expected to have almost 1.3 million students. That, the Board of Education would require the construction of enough space for 300,000 students by 2004, dozens of new schools. But at now the head of Education's five year capital plan has enough money to build space for only 30,000 students.

Most of the $2.9 billion plan, which ends in 1999, is devoted to paying for repairs, like new roofs or replacements for old coal-fired boilers still

Continued on Page B3, Column 1

Traveling Clinton Finishes Speech

After a month of drafting and re-drafting, the scramble to add the last flourishes to President Clinton's speech at the Democratic convention took place on his campaign train, where speech writers competed for Mr. Clinton's time with crowds at the back platform of his Pullman car.

The President's aides say he plans to look forward and describe a second-term agenda in a speech intended to combine the weightiness of a State of the Union Message with legislative proposals and executive actions.

They also say he will speak about the unfinished agenda in health care coverage and an urban policy to increase jobs for the welfare recipients who will now face strict benefit limits under legislation he signed last week.

Article, page B9.

The Incumbent as a Riddle
William Jefferson Clinton

By TODD S. PURDUM

CHICAGO, Aug. 28 — On Thursday night, when he accepts the nomination of a Democratic convention that he has already captivated, Some to now use and William Jefferson Clinton will be at once the best-known and least-knowable politician in the land.

He is a moderate who has pressed his liberal instincts and tendencies in the last few years. He confounds those who think he has an agenda only to find he has none. He comforts his enemies, who think they can work with him, only to find they cannot.

He is a tender man whose eyes well with tears at the drop of a hat, and a relentless man, littered with hard feelings, or in jail. He is the man with an abiding sense of the sweep of history, and a careless man, with a troubling disregard for the inconve-

nient details of his own life.

Four years ago, Mr. Clinton's lieutenants paid him a backhanded tribute the most unhinged day. He exhibited a bit of everything. Some to now use his less flattering side. He "Boy," with strong qualities him drag a meeting past its time, keep a roomful of visitors waiting or tear up a speech at the last minute sometimes without explanation or decision or explanation.

To listen to Mr. Clinton for any time at the expense of hyperarticulation without apparent limit. He can muster the same enthusiasm for a discussion of post-cold war politics and the training working class can suddenly shattered good by a college basketball game. Playing the British Prime are bigger.

"Fundamentally, he is a good person who is very altruistic in nature," said Betsey Wright, his longtime chief of staff as Governor of Arkansas who knows him as well as anyone. "Now, on top of that, he complicates it. He has this restless intellectual curiosity. We haven't had many Presidents who read as much as he does. He complicates it. There's an openness I don't think he gets credit for; he gets denigrated for it."

There may be a risk in these contradictions of the man in the ritual he follows at almost every rally and reception he attends: He thanks the band. From the humblest high school ensemble to the resplendent, red-jacketed Marines known as "The President's Own," few players escape his appreciative eye.

He asks about the make of their instruments, as he did a boy in a school gym in New Hampshire this winter. He marvels at their harmony and their heart. And he knows, instinctively, how often they can be overlooked, underestimated and misunderstood.

For Mr. Clinton is, by the social-and class-conventions of the world he grew up in, a band guy — the inside kid who did not score the touchdown but played the horn at halftime; neither jock nor nerd, geek nor cool kid nor outcast, but chameleon, moving ebulliently and effortlessly among worlds.

That quicksilver quality helped him present himself in 1992 as a New Democrat with old Democratic values, and it is that same quality

Continued on Page B10, Column 1

VOTE IS RESOUNDING

Strongly Critical Gore Delivers Brisk Attack on Dole Positions

By RICHARD L. BERKE

CHICAGO, Aug. 28 — The Democratic Party tonight once again nominated Bill Clinton for President of the United States and triumphant climaxing the four years earlier as a beginning of dire predictions that might happen if the Republicans won the White House.

Though Mr. Clinton's nomination was only a formality for a President who faced no opposition in the primaries, there was a show of solidarity among Democrats who just a year ago were at the polls and blamed them for their own party for the collapse of his health-care proposal and for delivering Congress to the Republicans in the mid-term elections.

As the convention went on through the ritual renomination of Clinton went on with enthusiasm. With the new vigor reflected the change after the pivotal primary votes. The hall rocked with cheers as Mr. Clinton's smiling face appeared on the huge screens in hall, and he threw his fists in the air.

But before the Democratic convention ended tonight and unabashedly praised Vice President Al Gore and the line-up of speakers who sought to contrast Mr. Clinton with Bob Dole and to remind voters about the party's favorite adversary, Speaker Newt Gingrich.

"Make no mistake," Mr. Gore said in one of the most aggressively partisan speeches all week. "There is a profound difference in outlook between the President and the man who seeks his office. In his speech from San Diego, Senator Dole offered himself as a bridge to the past. Tonight, Bill Clinton and I offer ourselves as a bridge to the future."

In a well-received address that seems certain to raise his profile as he gears up for an expected run for President himself in the year 2000, Mr. Gore's remarks were salted with stern warnings about what might happen if Mr. Dole reaches the White House. He also criticized Mr. Gingrich and the Republicans for government's shutdown last year — and for attacks on the First Lady, Hillary Rodham Clinton.

Linking the Republicans associated with Mr. Clinton, he said: "They all know the true measure of this man. He never flinched or wavered. He stooped to their level. And,

Continued on Page B11, Column 2

As Vice President Gore prepared to make a moving address at the convention hall, the President's wife and daughter welcomed him to Chicago. *Associated Press*

Angry at Netanyahu, Arafat Calls General Strike

By SERGE SCHMEMANN

[text partially obscured] he called for a general strike on Thursday morning.

At Mr. Arafat's suggestion, the Palestinian Legislative Council also called on all Palestinians who could to gather at the Al Aksa Mosque in Jerusalem for Friday prayers and for Palestinians everywhere to hold Prayers to protest the new settlement activity.

Though the strike is to last only four hours and should not directly affect Israel, the measure carries considerable symbolic impact as the first public protest against Israel called by Mr. Arafat in the two years since he took charge of the autonomous Palestinian areas. For Israelis it carried the clear reminder that general strikes marked the opening of the civil strife that preceded the

signing of the Israeli-Palestinian peace.

would be Jerusalem as the Palestinian capital. Prime Minister Benjamin Netanyahu

session of the Palestinian Legislative Council in Ramallah, was his strongest challenge to the right-wing Israeli Government since its election. Mr. Arafat has waged a widening campaign to mobilize internal and foreign support against the policies of the new Israeli Government.

"What is happening are continuing violations and crimes by this new Israeli leadership, which means a declaration of war on the Palestinian people, starting with settlement activity," Mr. Arafat said.

He said the strike should serve as a warning "that the situation is dangerous," and said its rallying cry

Continued on Page A4, Column 1

Rules to Ease Forming of Doctor Networks

Continued on Page A22.

Trade Commission and the Justice Department issued new rules yesterday making it easier for doctors to join together in networks to compete with insurance companies for the business of organizations.

Such collaborations often have been found to violate Federal antitrust laws because the doctors frequently want to agree on prices. The Supreme Court has long held that

price-fixing agreements should be automatically condemned as illegal. But the new guidelines will permit many arrangements in which doctors agree on prices and doctors can show that collaborations bring new competition benefits con-

Both medical groups and H.M.O.'s expressed satisfaction with the new rules.

Article, page A22.

INSIDE

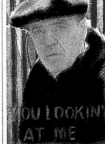

A Mafia Trial Can Begin
Vincent Gigante, the reputed Mafia boss who was known to appear in public in a robe, was declared mentally fit to stand trial. Page B1. *John Sotomayor/The New York Times*

After a Fair, Vaccinations
Officials have begun the largest rabies vaccination effort in New York State history since a goat at a county fair had to be killed after it was determined to have rabies. Page B6.

Giuliani Names His No. 2
Mayor Giuliani promoted his chief of staff, Randy M. Mastro, to Deputy Mayor for Operations, effectively making him the second-in-command at City Hall. Page B1.

More Seek War Reparations
Latin Americans of Japanese descent who were interned in the United States during World War II filed a class-action lawsuit in Los Angeles seeking reparations. Page A18.

Racing's Fuel May Dry Up
Restrictions on tobacco marketing announced last week by President Clinton could wipe out sponsorship money that has been a huge factor in the growth of auto racing. Page B15.

Convention Goal: Displaying Advantage With Women

By ADAM NAGOURNEY

CHICAGO, Aug. 28 — When the Republicans met in San Diego two weeks ago, they presented a procession of more than 40 women in four days, including the keynote speaker, and most memorably, Elizabeth Dole. As the Democrats closed out the third night of their convention this evening, they had already marched nearly 50 women across the stage and screen, including both Hillary Rodham Clinton and Tipper Gore.

From the podium to the nation's televisions screens, the Democrats at their convention have set out to more than match the Republicans woman for woman. President Clinton's party has presented women discussing everything from assault weapons to tobacco, family leave to Federal crime legislation — all issues on which Mr. Clinton and his opponent, Bob Dole, have disagreed.

Indeed, whatever public rehabilitation Mrs. Clinton sought from her speech here on Tuesday night, the broader purpose for this convention effort is unmistakable: the campaign to convince women that Mr. Clinton's policies have been better for them than the Republicans', and in particular if not obvious, advantage with women.

From the earliest days of Presidential campaign, Mr. Clinton often large leads in opinion polls have been helped by his disproportionate support among women, a fallout, in the view of analysts, of strong unhappiness among women with policies pursued by Speaker Newt Gingrich. In the latest New York Times/CBS News Poll, taken after the Republican convention, men supported Mr. Dole over Mr. Clinton by a margin of six percentage points.

Women, by contrast, supported Mr. Clinton by a margin of 16 points.

To a small degree, the aggressive effort to focus on the women's vote here this week reflected a tinge of concern among Mr. Clinton's advisers over evidence that Mr. Dole's convention might have won back some of the Republican women who had drifted to Mr. Clinton's camp.

But more important, Mr. Clinton's advisers are convinced that he cannot win without an overwhelming edge among women. Both camps believe that the election will ultimately be decided by the women's vote, and what is being attempted here now, said Celinda Lake, a Democratic pollster, is to transform the gender gap "into a gender canyon — and put the votes in our range."

So it is that tonight's proceedings were highlighted by five female sen-

Continued on Page B13, Column 2

"All the News
That Fits"

The New York Times

Late Edition
New York: Today, sunny, low humidity, light winds. High 77. Tonight, clear and cool. Low 62. Tomorrow, sunny, dry, pleasant. High 77. Yesterday, high 82, low 67. Details, page D17.

VOL.CXLV... No. 50,535 Copyright © 1996 The New York Times NEW YORK, FRIDAY, AUGUST 30, 1996 $1 beyond the greater New York metropolitan area. 60 CENTS

CLINTON, DECLARING 'HOPE IS BACK,' DEFENDS HIS FIRST TERM AND LISTS PLANS FOR SECOND

CRASH SIMULATION SETS T.W.A. BLAST IN ONE SMALL AREA

Holes in Seat Backs of Row 23 Also Offer Hints of Bomb, The Investigators Say

By ANDREW C. REVKIN

SMITHTOWN, L.I., Aug. 29 — Federal investigators have created a sophisticated computer simulation of the blast aboard Trans World Airlines Flight 800, showing that a single spray of metal fragments from a powerful explosion burst from one central area ahead of the wing.

In addition to helping investigators visualize the explosion, experts said, the result is an idea reinforced by new evidence found in the wreckage. Investigators examined the debris from that section of the Boeing 747 say they have found several faint hints that a bomb may have exploded there, causing the airplane to crash on July 17, killing all 230 people aboard.

Nonetheless, senior law enforcement officials insisted that the new evidence did not push them appreciably closer to the point where they could officially say that the crash was the result of a criminal act.

An aviation expert and a law enforcement official who is an explosives specialist both said they saw several distinctive holes that were punched through the backs of two seats on the far right side of row 23. That is in the center of the area penetrated by the computer as the site of the initial blast. Both men spoke on condition of anonymity.

The holes in the sheet metal on the seat backs are pushed through from the rear, indicating that the enormous force that created them came from behind, the explosives expert said, and row 24, the seats just behind them, is missing, he added.

No similar holes have been found in other seats, the aviation expert said.

The explosives expert said that a lot of wreckage from rows 26 to 27 was still unaccounted for, but added that many of the pieces investigators do have hold "very suggestive damage."

"That's where the violent event happened," he said.

The microscopic traces of the plastic explosive PETN, discovered during testing at the Federal Bureau of Investigation's laboratory in Washington, were also found in this general

Continued on Page B6, Column 1

Rebels Strike in 4 Mexico States, Leaving 13 Dead

By SAM DILLON

TLAXIACO, Mexico, Aug. 29 — Armed members of a newly emerged guerrilla organization attacked police and military posts in four Mexican states Wednesday, leaving 13 dead and wounded. The nearly simultaneous strikes were the deadliest outbreak of insurgent violence in Mexico in nearly three years.

The frontal assaults on police stations and army posts appeared to have been coordinated, came in towns stretching across a broad swath of southern Mexico in the states of Mexico, Guerrero, Oaxaca and Chiapas.

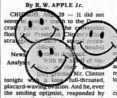

Government forces offered little more than token resistance and were limited to the defensive.

However, the group deployed hundreds of troops, perhaps hundreds, in the day and took few casualties. Army intelligence attacks were in the mountainous southern state of Guerrero.

The attacks came four days before President Ernesto Zedillo's state of the union address on Sept. 1, the Government's most important annual political ritual. They seemed to upstage Mr. Zedillo's speech and give an impression of a widespread guerrilla presence in Mexico.

The Popular Revolutionary Army, as it has no direct ties with the known rebels, who first appeared in the southern state of Chiapas in 1994, in a flow en-day attack protracted negotiations. Some armed guerrillas slipped

Continued on Page B6, Column 1

Rebels attacked in Tlaxiaco and in other towns in four Mexican states.

MASKED MEN ON THE MOVE

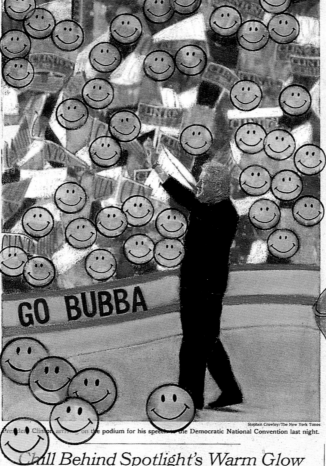

GO BUBBA

President Clinton arriving on the podium for his speech to the Democratic National Convention last night.
Stephen Crowley/The New York Times

Chill Behind Spotlight's Warm Glow

By R. W. APPLE Jr.

News Analysis

CHICAGO, Aug. 29 — It did not seem to matter much to the Democratic party as the convention floor that President Clinton's acceptance speech was a studied peccadillo.

With the smell of victory in the air, they greeted Mr. Clinton tonight with a long, full-throated, placard-waving ovation. And he, ever the smiling optimist, responded by assuring them that "we are on the right track to the 21st century."

As they cheered and he spoke, in a polished piece of political oratory

An Old Issue Intrudes At a Time of Triumph

tailored to the age of the small screen and the strictures of fiscal stringency, in a 67-minute acceptance speech far more fluent than his main rival's if not as eloquent, he looked like a man without cares.

But in truth he was not. Trouble could not possibly have come at a worse time, just a few hours before Mr. Clinton delivered his appeal to the nation that he hopes will elect him, nine weeks hence, to a second

term — trouble not so much with panel consultants as with those closest to him.

From a Democrat's point of view, at least it could not have been a worse kind of trouble. It would have been better if Dick Morris, midwife of a vastly different party, its old favorite sons, John Dillinger.

But Mr. Morris, the ambidextrous strategist who nudged Mr. Clinton back into the center after the Democrats' disastrous losses in 1994, was accused by Star of consorting with a call girl while across town the President's own White House connections prepared to testify against the nation's daughter Newt Gingrich, link to Mr. Clinton as Mr. Morris did. In any event, control of

Continued on Page A23, Column 1

INSIDE

Faster Economic Pace Seen
The economy grew faster than previously estimated, data showed, reviving the financial markets' fears of higher interest rates. Page D1.

Palestinians on Strike
A strike by Arabs in Gaza and the West Bank to protest Israeli Government policies closed most businesses and rattled Israelis. Page A4.

News Summary	A2
Business Day	D1-17
Editorial, Op-Ed	A26-27
International	A2-10
Metro	B1-6
National	A12-23
SportsFriday	B8-15
Weekend	C1-26
Media Business	D5
Obituaries	B7
Real Estate	D16

TV Listings ... D18
Weather ... D17

Classified ... B15 Auto Exchange ... B15

Pledges to Protect Programs for Youth and the Elderly

By TODD S. PURDUM

CHICAGO, Aug. 29 — Declaring that "hope is back in America," President Clinton accepted his party's nomination for a second term tonight by vowing to protect Government programs for children, the elderly and the environment in a "strong, united American community."

In a speech that blended outsized optimism with small-scale proposals, Mr. Clinton sketched out his plans for the future, claiming credit for a kind of politics mixing ideas without regard to their partisan origin.

"On issues that once tore us apart, we have changed the old politics of Washington," Mr. Clinton said in a veiled dig at the Republican tone of the Republican Convention in San Diego, his visit to which four days of campaigning by rail. "For too long, folks in Washington have asked who's to blame. But we ask, 'What are we going to do?'" [Transcript of speech, page A24.]

The President answered himself by repeating his vigorous defense of existing Government programs like Medicare and Medicaid — a stand that has scored among in public opinion polls in recent months — and by another pledge credits for education and families with children to tax breaks for homeowners. Again and again he pledged to "build a bridge to the 21st century."

But he said, setting one hour and his family as not so much the definition of either the American himself as the overarching vision of a State of all the things done, tried greater the welfare and on the just signed to the challenging every American something body out there and reaffirmed and declaring.

"There is no longer the blame on welfare, now the only question is what we're going to do who have ability — to give every people a chance to grow and support their families."

Mr. Clinton set an ebullient tone for the campaign he hopes will make him the first Democratic President elected to a second full term since Franklin D. Roosevelt 60 years ago — and only the third in this century. But for all the flags and cheering in the hall, his speech tonight made plainer than ever that he presides over a vastly different party, its old coalitions splintered, its majority status shaky and its ambitions limited by the President's own repeated pronouncements that "the era of Big Government is over."

And what was once defined as a moment of dominant party triumph was marred by a dramatic sideshow: the sudden resignation of Dick Morris, the political strategist responsible for many of the themes

Continued on Page A22, Column 1

Call-Girl Story Costs President A Key Strategist

By RICHARD L. BERKE

CHICAGO, Aug. 29 — Dick Morris, President Clinton's chief campaign adviser and the central force behind the emphasis on family values that had its apex at this week's Democratic convention, resigned today after a tabloid reported that he had had a relationship with a call girl.

More than a strategist, Mr. Morris had come to be known as a confidant and alter ego of Mr. Clinton, and his departure marred Mr. Clinton's appearance tonight, the big moment of a convention scripted to be his star vehicle.

Beyond his role in helping shape Mr. Clinton's address, Mr. Morris is widely credited with orchestrating the President's move to the political center. Mr. Morris, whose consulting fees were paid by the campaign and not the Government liked to say that he was going to have Mr. Clinton run more as "Pope than President," by acting as a mediator for the nation, especially its centers. The culmination of that effort was to be unveiled tonight, today was a jubilant convention that had gone largely according to script.

In a remarkable sequence after the and his wife, Eileen McCann, left Chicago for their home in Connecticut, Mr. Morris did not rebut the accusations to address them specifically. "What I loved I sought to avoid the limelight because I did not want to become a message," he said, "So it will not become a part me to any subject this yellow journalism. I will not subject myself to this kind of yellow journalism. I never will."

Mr. Morris had created

Continued on Page A22, Column 1

GET OFF

PARTY POOPER

GETS BOOT

A Rousing Address Revives Throng of Stunned Delegates

By FRANCIS X. CLINES

CHICAGO, Aug. 29 — Democratic delegates leapt up cheering at the sight and sound of President Clinton tonight after a long day of political anxiety over the sensational news that his main election strategist had resigned in the face of sex accusations.

"That was a sad sideshow," said one delegate, Miles Rapoport, the Secretary of State of Connecticut, speaking of the forced departure of Dick Morris, one of the President's closest advisers.

"But this is the main event," Mr. Rapoport added as he joined in a roaring cheer midway through Mr. Clinton's rousing, highly detailed acceptance speech.

The performance of assurance the President offered a warm welcome to the delegates as the speech's content.

On the floor, the crowd seemed to sense Mr. Clinton moving steadily, confidently into his speaking style, before he finally drew the delegates up with a plea for clean campaigning all around. "We don't have to diminish our adversaries," he declared, and the Democrats cheered.

From there, Mr. Clinton seemed to draw strength, in turn, from his audience, and the Democrats — President and delegates — embraced the chance to get the campaign back on track through the hourlong burst of oratory and celebration.

"Look at him — he's as confident as I was hoping he'd be," said Greg Bedan, watching amid the Indiana section. "I was anxious earlier about the Morris thing, but here he is talking about the future, about inclusiveness, and it's working for me."

The partisan throng was softened up considerably for the President's arrival by another well-crafted video self-tribute by the President and his family and friends, with delegates cheering at the testimony to Mr. Clinton's virtue by his mother-in-law.

"See, he's not flustered at all,"

Continued on Page A19, Column 1

THE NEW YORK TIMES
(ISSN 0362-4331) is published daily. Mail subscriptions, delivery in most major U.S. cities. Call, toll-free 1-800-NYTIMES. Ask about TransMedia TimesCard. ADVT

The New York Times

VOL.CXLV... No. 50,536 Copyright © 1996 The New York Times NEW YORK, SATURDAY, AUGUST 31, 1996 $1 beyond the greater New York metropolitan area. 60 CENTS

Late Edition
New York: Today, sunny, warm. High 84. Tonight, some clouds. Low 68. Tomorrow, increasing clouds, more humid and breezy. High 78. Yesterday, high 81, low 64. Details on page 19.

No Rest For Vacationers

Undaunted by bad weather in many parts of the country, national park officials said vacation areas and beaches in America took vacations this year. Here are the number of trips taken in the United States this summer that were at least 100 miles from home. Survey of travelers.

Business Day, page 31
The New York Times

Pentagon Sees A New Threat By Iraq Forces

By STEVEN LEE MYERS

WASHINGTON, Aug. 30 — After detecting threatening movements by Iraqi troops against the Kurdish districts in the north, the United States has increased its military activity in the region and moved its forces "to be prepared" if needed, Administration officials said today.

The officials said Iraq had amassed 30,000 to 40,000 troops this week a few miles south of Erbil, a village in the Kurdish zone in northern Iraq which is under United Nations protection. The troops appear to be supported by artillery, surface-to-air missiles and tanks and other armored vehicles, they said.

An Administration official said that Iraq might try to exploit the renewed fighting among Kurdish factions to impose its authority and rule over the region. "We are dealing with a situation we haven't seen for some time," the official said.

The exact number of Iraqi troops and whether Saddam Hussein received the movements in a statement today. The Pentagon indicated that the troops were ready "to undertake offensive actions."

And the Administration officials said the movements had caused enough concern to warrant the heightened state of readiness. The White House said President Clinton had ordered that "steps be taken to insure the United States is prepared for any contingency." It also said the United States had warned Iraq and notified other nations of the troop movements.

"We will consider any aggression by Iraq to be a matter of very grave concern," said Michael D. McCurry, the press secretary to Mr. Clinton, who was campaigning today in Illinois.

Continued on Page 2, Column 3

In Fort Lee, Police Are the Ones Told, 'Move On, Please'

By MELODY PETERSEN

FORT LEE, N.J., Aug. 30 — Without a permanent headquarters for nearly a quarter of a century, Police Chief J. move guns, computer evidence and all the other elements of a station in a hurry.

For the officers who are moving to temporary space, this is the most of it in 18 years of starting out.

Where police have been under the department's roof since the end of 1993 made officers stay sick, the force has been moved overnight, leaving them stranded behind.

But the home, a main office building, too little bit of a judge evicted its 92-officer apartment this month after the landlord complained that the building does not meet the set of one of the building code potential.

chief reciting that has become the force's motto as he sat in yet another building last month when the garbage collectors and construction workers.

Continued on Page 2, Column 1

STUNG BY ATTACKS, MEXICO INTENSIFIES SEARCH FOR REBELS

GOVERNMENT BARS TALKS

President Says Guerrillas Have Little Popular Support and Brands Them Terrorists

By JULIA PRESTON

MEXICO CITY, Aug. 30 — The Mexican Government, stung by widespread attacks this week by a new leftist guerrilla organization, condemned the rebels as terrorists and stepped up the hunt for them today in seven states.

The Government of President Ernesto Zedillo was caught off guard by the coordinated assaults on military and police posts across southern Mexico Wednesday night by the shadowy new organization, the Popular Revolutionary Army.

Struggling to recover, Mr. Zedillo said late Thursday that he had concluded that the group does not enjoy any widespread popular following and ordered the army and police to pursue the rebels as criminals.

Officials ruled out any possibility of political discussions with the group, whose surprise assaults in faraway villages and sleepy army barracks left 13 people dead.

The new insurgency battered the image Mr. Zedillo has worked hard to build of a country climbing out of a painful recession, moving toward a more open political system and reaching a peace with the Zapatista rebels, a different guerrilla group that rose up in the southern state of Chiapas three years ago.

The Popular Revolutionary Army appears to address much more formidable challenge to the Government. The Zapatistas when they began in Chiapas and made their political abuses suffered by the Indians.

But the new rebels' hard-core revolutionary discourse seems unlikely to attract wide appeal, like the following the Zapatistas enjoy. The Mexican public have shown time and again its distaste for instability and radical change.

"In this country at this time, the method of armed struggle is inappropriate and it only encourages the most repressive and violent elements in the Government," said Pablo Gómez, a leading member of the leftist Party of the Democratic Revolution. "There is no possibility of a generalized rebellion."

But Mr. Zedillo's economic strategy has kept wages at rock bottom and has left hundreds of thousands of Mexicans in debt and out of work. The rebels' message of despair with the Government could begin to resonate.

Continued on Page 5, Column 1

Conventions Over, the Candidates Take to the Road

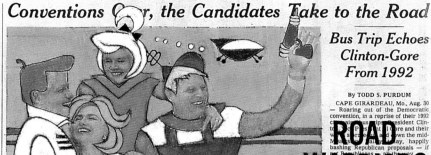

Associated Press

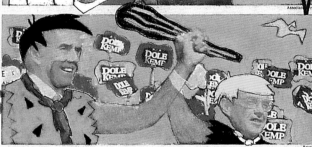

Reuters
The Clintons and Gores began the sprint toward November; Bob Dole and Jack Kemp stumped in California.

Pataki Panel Says Casinos Could Bring In $2.6 Billion

By RAYMOND HERNANDEZ

ALBANY, Aug. — A commission created by Gov. George E. Pataki issued a report that said casino gambling could generate as much as $2.6 billion in revenue for New York and create 38,000 jobs.

The findings will probably be the focus of debate early next year as the State Legislature takes up a measure to legalize casino gambling. The Legislature already passed a bill once last year, but state constitution requires the change before casinos would be permitted.

Casinos in Niagara Falls would give New York an advantage, the commission said, in competing with other states, including neighboring states, as well as Atlantic City and the Indian casinos of Connecticut. The report projects that New York could attract as many as 19 million visitors a year from outside New York.

The report makes no recommendation on whether to expand casinos, and it warns that casinos could reduce lottery sales as well as attendance at horse tracks.

Mr. Pataki would not comment on the report because he had not reviewed its findings. But it clearly took no position that the casino gambling would help the state.

The report notes the most important thing to avoid is to stop losing billions of dollars to surrounding states and communities. Mr. Pataki has been reluctant to come out in favor of casino gambling.

The report also provides powerful ammunition to hotel owners, resort operators and an intense lobbying campaign by opponents.

Continued on Page 26, Column 1

More Traces Of Explosive In Flight 800

By DON VAN NATTA Jr.

Federal investigators announced yesterday that they had found additional traces of an explosive on pieces of Trans World Airlines Flight 800, but that the new evidence was not enough for them to say that the plane was brought down by a bomb.

In a statement, investigators did not identify the explosive that was found in the wreckage, but earlier senior investigators said it was RDX.

Federal investigators said exclusively that the traces had become part of the focal point of the explosion that destroyed the plane on July 17, killing all 230 people aboard.

A week ago, a member of the Bureau of Alcohol, Tobacco and Firearms had detected a trace of explosive material that chemical experts retrieved from a piece of the plane found near the same general area where the RDX was

Continued on Page 24, Column 3

Bus Trip Echoes Clinton-Gore From 1992

By TODD S. PURDUM

CAPE GIRARDEAU, Mo., Aug. 30 — Roaring out of the Democratic convention, in a reprise of their 1992 campaign, President Clinton, Vice President Al Gore and their wives climbed aboard their own buses today, happily bashing Republican proposals — if any of them — in the midst of a bus trip.

this morning to board red, white and blue buses emblazoned with banners proclaiming that they were "on the road to the 21st century," an echo of Mr. Clinton's acceptance speech the night before.

From small town to smaller town, the foursome carried their favorite themes, snapping each others' picture, shaking hands, holding children, clapping to the macarena and pledging, over and over again, in carefully poll-tested terms, to fight for families and keep their eyes on the future.

"I want to do every single solitary thing I talked about last night," a hoarse and sweaty Mr. Clinton shouted to thousands gathered in the morning sun this morning, his voice blaring into a microphone at the riverfront town square referring to his acceptance speech nominating him the night before.

He continued, "To create more opportunity, to inspire more responsibility in our country and to build a stronger sense of community."

With the bound to stay, the First- and Second-family foursome was seeking to recapture the spirit of the successful campaign four years ago, after coming out of the convention in New York and embarking on a six-day, nine-state bus trip, which covered some 1,000 miles.

This trip — through the swing states of Missouri, Illinois, Kentucky and Tennessee — will last two days, ending in Memphis on Saturday, and the Clintons and Gores did their best to recapture the old feeling.

In New Mexico, Bob Dole, the Republican challenger, appealed to the road. In Albuquerque, he told voters today that despite his call to abolish the Energy Department, he would preserve the national defense laboratories in the state. Page 7.

As they boarded their custom caravan here — driven by specially

Continued on Page 9, Column 1

A Scandalous Story Rates High and Low

The allegation of a relationship between President Clinton's top political strategist and a prostitute was first published in a national newspaper but was eventually carried on the national news. Some thought it deserved any attention, but because he had been so close, it was a story that belonged in his Administration and the subsequent resignation of the strategist, Dick Morris, just fine.

Article, page 8.

Bilingual Parents Dismayed By English's Pull on Children

By MIREYA NAVARRO

MIAMI, Aug. 30 — In Marcel A. Apple's bedroom, the book "The Three Little Pigs" rests on a shelf next to "El primer libro de palabras en español" ("My first Book of Spanish Words"). The 3-year-old can sing along to "La Bamba," or have as much fun watching "Barney," a purple, English-speaking dinosaur, as he does "Tito," a blue, Spanish-speaking shark.

But when Marcel tired of sitting on a piano one recent afternoon, he sat on the lap of his Nicaraguan nanny, it was English that he spoke.

"Están descansando, resting?" Josefina Avendaño asked him, pointing at a picture of the countryside in a children's book.

"No, they're easy," he answered. "I try to put him in an environment where there's as much Spanish spoken as possible because it seems more enough," said Marcel's mother, Maria Pérez-Apple, a Cuban-American who herself is trying to recapture the Spanish she heard while growing up in her native New York. "He knows he can speak in English and people could understand him."

Last month Congress entered into a heated debate over English-only legislation, with proponents insisting that the very survival of American culture was at stake and opponents contending that the language was so entrenched that it was down-to-earth level of English-only drive has also been fueled by resentment against bilingual rules and other accommodation of minorities, both old and young, who have not learned English.

But new immigrant families across the nation are learning, as their predecessors did before them, that the power of American culture, particularly, the lure of English is so strong that it is a struggle to raise a child who can speak two languages fluently.

Parents send their children to foreign countries for summer vacations, hire bilingual nannies and read bedtime stories in a cacophony of tongues, all in an effort to pass on the family's language, give the children

Continued on Page 7, Column 2

Hurricane? What Hurricane?

Associated Press
It could hardly have been a better day for the beach yesterday on the Long Island and New Jersey shores. But in many places, including Ocean City, N.J., lifeguards put up "no swimming" warnings and allowed bathers only to wade in the rough surf churned by Hurricane Edouard. Page 24.

INSIDE

Chechnya Peace Seems Near
Russia's national security adviser announced that he and Chechen negotiators had agreed to seek peace and put off a decision on the status of the rebel republic. Page 4.

Palestinian Protest Fizzles
A protest called by Yasir Arafat against Israeli policies drew fewer Palestinians than expected. Page 3.

Custody Ruling Upheld
A Florida Appeals court upheld a ruling that transferred custody of a child to her father, a convicted murderer, from her mother, a lesbian. The court said conduct, not sexual orientation, was the reason. Page 7.

September

September, hurricanes, local school issues, the Gulf War Syndrome,

and riots in Israel. The papers are very active by now, with drawings

and rubber stamps. You know, originally we designed all of the

stamps and had them made. I was spending a fortune,

and at the store they felt so sorry for me that finally they said,

"We have alphabets, lady, you can buy an alphabet and

make your own stamp." You could get letters in various sizes

and various fonts, and like the old way of typesetting,

you could stick them in. This is so low-tech, but to me

it was the highest tech because it liberated me so that I could write

anything. As the project got more involved and

I found these new forms, it just opened up everything.

And in this month I suddenly started to use images that didn't refer

to the articles or photographs, such as on September 2,

when I have a love affair with the orange cone,

and I use them a lot from then on—the color, the form....

The New Dork Times

"All the News That Fits"

The New York Times

VOL.CXLV....No. 50,537 Copyright © 1996 The New York Times NEW YORK, SUNDAY, SEPTEMBER 1, 1996 $3 beyond the greater New York metropolitan area. $2.50

Late Edition

New York: Today, cloudy, breezy, humid. High 81. Tonight, windy, showers. Low 69. Tomorrow, heavy rain, high winds. High 74. Yesterday, high 84, low 67. Details are on page 54.

Welfare-to-Work Plans Show Success Is Difficult to Achieve

By JON NORDHEIMER

BEYOND DEPENDENCY
A special report

KANSAS CITY, Mo. — Deborah G. Washam shook her head with an emotion that appeared to be equal parts sorrow and exasperation.

Of the more than 80 women she has hired over the last 17 months as part of a generous welfare-to-work program sponsored in part by this city's corporate community, fewer than 25 remain on the job. Many of the others quit in a huff over perceived slights to their dignity — Mrs. Washam calls it their refusal to follow directions.

"I don't think they've had much exposure to structure in their lives," said Mrs. Washam, president and chief executive of Community Home Health Care, a licensed agency that dispatches homemakers to elderly and disabled residents in Kansas City's urban core with housework and shopping.

"As single mothers, they are on their own and think of themselves

President Clinton, in accepting the Democratic nomination on Thursday, declared "a moral obligation" under the Welfare Reform Act he signed two weeks ago to move Americans off welfare and into jobs. But the magnitude of this task seems best appreciated by those already

authority figures," Mrs. Washam said. "They would take routine supervision at work."

These concerns resonate nationally with business leaders, who are only beginning to figure out employers' roles as the states begin a trek this fall into uncharted territory under mandates that those on welfare must find work or face the loss of

News analysis, page 15. *Continued on Page 18, Column 1*

Russia and Chechens Face Unsure Peace

After 20 months of a war that has ravaged Chechnya and profoundly scarred the battered Russian psyche, the leading military officials from both sides have now announced that the bloodshed is over.

"Now we must think about the peace," says Aleksandr I. Lebed, the Russian national security adviser. But many vexing issues — including the republic's future status — have yet to be resolved.

NEW DUKE OF HAZARD?

Some residents of West Viola, Ky., waved yesterday as President Clinton's bus tour rolled down Highway 45. For his part, Bob Dole, the Republican challenger, limited his campaign activity to delivering a radio address.

Associated Press

CLINTON AND DOLE SHARPEN MESSAGES IN RACE'S FINAL LEG

CRUCIAL STRETCH AHEAD

Rivals' Standings Have Varied Little Despite Conventions, so G.O.P. Faces Hurdle

By RICHARD L. BERKE

CHICAGO, Aug. 31 — The Presidential candidates embarked this weekend on a new frenzy of charge and countercharges, sound bites and debates. President Clinton is offering himself as a youthful leader for the next century and Bob Dole is eager to ride to the White House on the promise of a 15 percent tax cut.

SAME OLD SAME OLD

The distance was established by surveys and by focus groups, and by Americans themselves. The run-up at least to most of television commercials — and set out on the most hectic, and politically perilous, stretch of the campaign.

Despite the prophecy, many Democratic and Republican analysts agree that going to the major party nominations little in the polls, at least more likely, conventions do not apparently fundamental changes in the dynamics of the campaign.

After his party's convention ended here on Thursday, Mr. Clinton's challenge still, is to hang on to his momentum. dominance in polls, while Mr. Dole hopes to engineer a comeback runaround by Election Day.

"This is where the it hasn't moved since the second week of March," Douglas S., the White House political director and message, referred to as clinching this nomination.

But Mr. Clinton's campaign and Mr. Dole's newly tuned message had begun to sink in. "We have defined the message of this campaign. It will be economic and the of the American voters," he

Mr. Clinton had avoided overt politicking and train reading to the Democratic nomination, was on the campaign trail today, as he will be roughly 20 of the next 30 days, he said. While Mr. Dole has an aggressive pace on the trail, his today were limited to a radio address in which he criticized the President's core policies. [Article 3.]

Dole's profile will rise because his cash-poor campaign was replenished with millions of dollars in Federal money after the Republican con

Continued on Page 30, Column 1

U.S. Calls Alert As Iraqis Strike A Kurd Enclave

HE'S BACK!

By ST...
WASHINGTON, Aug 31 — Ignoring strong international warnings, armored Iraqi divisions drove into northern Iraq today and an important Kurdish enclave. President Clinton ordered American forces in the region to high alert and ordered reinforcements.

Iraq's attack on the region frontal attack this time — and I... other Western nations that set up the enclave for the Kurds after the Persian Gulf war in 1991.

President Clinton said today that the situation in northern Iraq caused "grav...

"I have placed our forces in the region on high alert and they are now being..." said Mr. Clinton, who was traveling in Tennessee. "... this time — and I... it is entirely premature to speculate on any response we might... But we are prepared to... these developments."

The United States began intense consultations with its allies and however a senior official said Mr. ... probably speak to the...on Sunday.

On Friday, the President stepped up air patrols and ordered the 23,000 Americans already in the Persian Gulf region be "prepared for

Continued on Page 8, Column 1

Blue Ribbon Goes to Clinton At This Year's County Fair

By MICHAEL WINERIP

AN AMERICAN PLACE
The Judges

CANTON, Ohio, Aug. 31 — This is county fair week here, a testament to America's ability to turn most anything into a competition, whether it is the quest for Stark County's heaviest pumpkin squash (a 183.5 pounder, grown by Linda Parker), the county's best pie (an apple, baked by Betty Datkuliak), the top Limousine breed steer (raised by Joey Milano) or the best all-around cucumber (produced by...emer).

Under the... man beings are... they stand... their booths. Every... from the municipal court candidates to the United States Congressman, has been smiling proudly all week handing out litter bags and pencils, calendars and nail files. Those results will not be in until November, although it appears from several dozen interviews here this week, that in the biggest competition, the Presidency, Bill Clinton continues to hold the early lead, attracting votes even in the fair's business exhibition hall and the Grange Hall, traditional Republican strongholds.

John Givens, owner of Givens Enterprise, a vacuum cleaner sales business with a display at the fair, voted for Republicans for President through the 1980's and for Ross Perot last time, but said the economy was

"pretty good right now" so he would vote for Mr. Clinton this time.

Joanna Davidson, 31, a vice president of Gulia Music, which had pianos and organs on exhibit, cast her first vote for President in 1984 for Ronald Reagan, but will vote for the Democrat this year. "Our business people having disposable income right now, people have more," she said.

Under..., Nancy Levengood, a Stark County fair board director who was overseeing the beef competition, said she voted for George Bush in 1992 but was undecided this time. "I'm just not real enthusiastic..." she said.

"Clinton... a lot since 1992. He... for another term."

"Right..." her assistant, Donna... voted for Mr. Clinton... that way again... Clinton, but... that welfare ref...

... easy to see with President C... and Vice President Al Gore get out of their way in their speeches this week to praise Bob Dole as a human being and have made much of taking the

Continued on Page 31, Column 1

In India, Attacks by Wolves Spark Old Fears and Hatreds

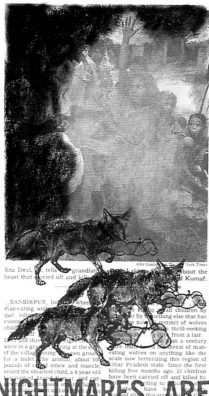

Sita Devi,... tells...grandfat... about the beast that carried off and kill... Kumar.

John Gianni... The New York Times

BANBIRPUR, India — When... man-eating wol... quit village... evening... children...

... and three... were in a gra... of the village... for a toilet... pounds of c... seized the smallest child, a 4-year-old... the boy three days later, half a mile away, all that remained was his head... had to... one of...

... tall children by... by nothing else that has... instinct of wolves... thrill-seeking... a... from a lair... in a century... threat of man-eating wolves on anything like the scale now terrorizing this region of ttar Pradesh state. Since the first killing five months ago, 33 children have been carried off and killed by...

Delhi. A hunt by thousands of villagers and police officers has killed only... hys... of the... interlaced with rivers and ravines that reaches about 60 miles north to south and about 40 miles across. More than nine million people live in the region in some of the harshest poverty found anywhere in India.

A frenzy of rumors has put the blame for the killings not on wolves but on werewolves, the half-man,

Continued on Page 14, Column 4

NIGHTMARES ARE MADE OF THIS

TODAY'S SECTIONS

*In New York City and the metropolitan region.
*(†Elsewhere, daily pages are in section 1.)
*§In most parts of New York City.
*In Long Island, Westchester, Connecticut and central and northern New Jersey.

NEWS SUMMARY

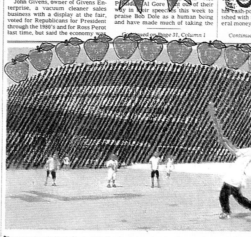

"To youngsters living in Yankee Stadium's shadow, the pinstripers are heroes, despite the team's recent slump."

Dith Pran/The New York Times

They Live to Be Yankees, but Lately It's Tough

By N. R. KLEINFIELD

Sure it's been excruciating for any Yankees fan, sitting and yelping helplessly at the grave reality of the Yankees... No wonder aggrieved people are kicking the dog...

radio call-in shows are full of vitriol. No wonder aggrieved people are kicking the dog.

But imagine the deepening angst of the kids over there in that asphalt parking lot, well-worn gloves tucked beneath their arms, dividing up sides

for their customary game. "Me, c'mon, take me, you meathead." Almost every day, at least a dozen of them congregate right here in a cherished regimen of summer, playing...13th... where... win.

They are 10 or 11 or 14 years old.

Most of them live in the brick apartment houses that form a silhouette to the lot, which in fact is used for fans' cars during Yankees home games. The boys enter the makeshift field by way of chicken-wire... through... board cover... from a videotape as bases. Ground... sometimes take a bad hop when they hit a crushed milk carton or a chunk of stale bagel, but hey, what said the game was easy. Any ball that carooms off the overhead subway

UNCONDITIONAL PRIDE

Continued on Page 44, Column 1

The New York Times

VOL.CXLV...No. 50,538 Copyright © 1996 The New York Times NEW YORK, MONDAY, SEPTEMBER 2, 1996 $1 beyond the greater New York metropolitan area 60 CENTS

Late Edition

New York: Today, very breezy, clearing skies. High 86. Tonight, clear, diminishing wind. Low 69. **Tomorrow,** partly cloudy. High 83. **Yesterday,** high 78, low 66. Details are on page 43.

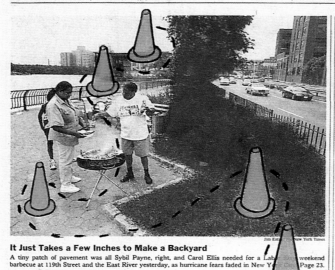

It Just Takes a Few Inches to Make a Backyard
A tiny patch of pavement was all Sybil Payne, right, and Carol Ellis needed for a Labor Day weekend barbecue at 119th Street and the East River yesterday, as hurricane fears faded in New York City. Page 23.

Jim Estrin/The New York Times

PALESTINIAN TALKS WITH ISRAEL NEAR

2 Sides Are Reported Close to Deal on New Negotiations

By SERGE SCHMEMANN

JERUSALEM, Sept. 1 — Despite all the dramatic gestures, public rancor and political wrangling on both sides, the new Israeli Government and the Palestinian leadership remained near accord on how to move forward with their alliance, Israeli officials said today.

Newspaper and television news programs reported that representatives of Prime Minister Benjamin Netanyahu and the Palestinian leader, Yasir Arafat, had met through the night.

They were said to be trying to conclude a deal that would include a joint announcement of renewed negotiations, a meeting between Mr. Netanyahu and Mr. Arafat and a Palestinian agreement to scale back all of its plan. The Israeli officials from Hebron.

"We will report that Israel was considering several "confidence building measures" — including increasing the number of Palestinians permitted to work to 50,000 at least 50,000, the opening of a Palestinian airport in Gaza and possibly the release or detention of the armed Yassin, the spiritual leader of the militant Islamic movement Hamas.

For his part, Mr. Arafat made a crucial concession last week when he quietly closed two Palestinian offices in Jerusalem that the Israelis had declared an obstacle to the withdrawal from Hebron, the only West

Continued on Page 6, Column 1

U.N. Halts Deal for Iraq As U.S. Pledges Action on Attack

By STEVEN LEE MYERS

WASHINGTON, Sept. 1 — The Clinton Administration vowed today to punish Saddam Hussein's military for its Kurdish enclave, and Secretary-General Boutros Boutros-Ghali, suspended the recent agreement to allow Iraq to sell oil to raise cash for medicine.

On a day full of diplomatic contacts in which the Administration kept all of its options open, there were indications tonight that the United States stepped up military activity even further in the region.

Among other things, one official said, the aircraft carrier Carl Vinson and accompanying ships moved north from the Persian Gulf. The ships were reportedly striking deep into Iraq without actual or in sales.

The suspension of the oil sales agreement in retaliation, an official said, in that one north against the Kurdish enclave has been approved by the United States and its allies since 1991. In a statement, Mr. Boutros-Ghali said he had decided to suspend the sale because of "the deterioration of the situation in northern Iraq."

Although the United States and others encouraged the suspension to punish Iraq, Mr. Boutros-Ghali's spokeswoman, Sylvanna Foa, said the decision arose primarily from concern about the security of the workers needed to monitor the sales.

At the same time, Administration officials stepped up the tenor of their criticism of Mr. Hussein and heightened their threats of retaliation.

Leon Panetta, the President's chief of staff, said the United States would "respond accordingly" to Iraq's incursion. "I don't want to say when or where or what, but we will respond," he said today on the NBC

news program "Meet the Press."

The suspension of the oil sale would likely hurt Iraq in Erbil, the ninth.

Iraq pledged to withdraw, officials in Washington said, expand its attack, at least one other itself with forces Democratic Party against its rival faction, the Patriotic Union of Kurdistan.

In Baghdad today, Iraq's Defense Minister, Lieut. Gen. Sultan Hashim Ahmed, emerged from a Cabinet meeting and announced that Mr. Hussein had ordered Iraqi forces to withdraw from Erbil, Reuters news service reported.

[Iraqi troops along with their heavy armor and artillery have withdrawn from Erbil, United Nations relief guards in the city said. Reuters reported

Erbil," one official in that city said. "We cannot see tanks or vehicles or artillery. officials said that Iraq will still face punishment.

Continued on Page 6, Column 1

Girl, 4, Is Dead in Manhattan And Her Mother Is Charged

By ROBERT D. McFADDEN

An emaciated 4-year-old girl who had apparently been starved to death in a Washington Heights apartment Saturday night, and her mother was charged with murder after confessing on video that she had not fed the child regularly for a year and had resisted medical help even after it was obvious that she was dying.

Prosecutors filed a criminal complaint that charged the mother, Nadine Lockwood, age 27, with treating the girl, Nadine Lockwood, because she did not want or love her, and had admitted that she knew she was mistreating her by withholding food and medical attention.

The case — in which child welfare authorities apparently had contact with the family, and the child was singled out for mistreatment while six other children were starkly remembered — was first reported by Elisa Izquierdo, the girl who was beaten to death by her mother

last year and who became a posthumous symbol for the need for reform in the child welfare system.

In her case, explanations remain elusive. But there were indications that it had unfolded in a family wracked by hardships. One neighbor said the mother had a drug problem, another said the family had been cut off welfare several months ago, and had borrowed food and money from neighbors.

And the city caseworkers who regularly visited about a month ago. If so, they apparently failed to detect the malnourished girl being kept in a locked back bedroom, and once may have been duped into believing that a neighbor's child was the

deteriorated in the last few weeks, her hair falling out, her ribs protruding, and her fingers swelling to skeletal frames, Carla Lockwood told the authorities, she kept the child in a crib in a locked bedroom and watched her weaken to a point where she could no longer stand or even sit up.

On Saturday night, the police said, the mother called her husband, who

Continued on Page 24, Column 4

The Times is printed today in two sections, SportsMonday begins on page 27, Business Day on page 37.

Dole to Press 'Broad Message' On Economy, Drugs and Crime

By KATHARINE Q. SEELYE

WASHINGTON, Sept. 1 — As he starts the final leg of what is likely to be his last campaign, Bob Dole, the notoriously undisciplined campaigner, says he has figured it out: "We just need to keep pounding the message and pounding the message."

"I know the media gets tired of it, but we have to stay on message every place we go," the Republican Presidential nominee said at one point in an interview on Sunday at his campaign headquarters here. [Excerpts, page 11.]

Mr. Dole, who developed a reputation for kicking over the traces and charging off toward disaster at the slightest provocation, has given up all that could be considered basing his strategy to win the Presidency on drilling the voters with his tax cut plan and on getting tough on crime.

There will be little evidence, he said, of the agenda of social conservatives that he allowed to dominate pre-convention news coverage and to control the party platform that he is trying hard to leave behind. "I want to stick to the broad message, an economic message, a drug message and crime message, appointment of judges," he said, adding only that he will have to make a special appeal to women.

To do so, Mr. Dole said, he will advocate a current ban on semi-automatic weapons, even though he voted for the 1994 bill that included such weapons. He would talk about assault weapons, "particularly in New England," where voters are generally more liberal

and more supportive of gun control measures.

His anti-drug message, which he now repeats everywhere, is also tailored for women. "In Ventura, I talked to a lot of people, particularly women," he said of a recent campaign stop in California. "It's a big issue with them."

As Mr. Dole mapped out his plans for the 66 days remaining before Election Day, he seemed relaxed, even introspective, speaking about his view of the office he seeks, about the difficulty of campaigning with one arm because of his war wound, about his awkward oratory and his rela-

Continued on Page 11, Column 1

Bob Dole at a campaign appearance yesterday.

Executive Tests Now Plumb New Depths of the Job Seeker

By JUDITH H. DOBRZYNSKI

Members of America's professional and managerial classes have always thought college and graduate school a prerequisite of at least one thing. Until they let their driver's licenses lapse, they had taken their last test. Chances of opening and a record of accomplishment would propel them up the corporate ladder.

It's not, rest assured, about math or grammar or any of the basic technical skills for which many professionals, sales and clerical workers have long been tested. Rather, employers want to grade upper-echelon candidates on intangible qualities: Is he creative and entrepreneurial? Can she lead and coach? Does she work in teams? Is he flexible in his style of learning? Does she have passion and a sense of urgency? How will he function under pressure? Most important, will the potential recruit fit the corporate culture?

These tests, which can take from an hour to two days, are all part of a broader trend. "Companies are getting much more careful about hiring," said Paul J. Jay Jr., chairman of the Association of Executive Search Consultants.

Express to North Mortgage and Supervalu are among the companies making a foray for many white-collar jobs top executives on down to giants of paper-and-pencil role-playing exercises, decision-making simulations and brain-teasers. Others put candidates through a long series of interviews by psychologists or trained interviewers, a bit like oral exams.

Ten years candidates could win a top job by simply the right look and with enthusiastic answers to questions of "how do you want this job?" you might expect to have the pleasure with questions designed to learn how they get things done. They may, for example, describe in great detail a career accomplishment of that patterns of behavior. They may also face questions like "who's the best manager you worked for and why?"

Continued on Page 38, Column

INSIDE

Rebels Face Mexican Wrath
With Mexico still stunned by rebel attacks, President Ernesto Zedillo pledged to fight the insurgents with the "full force of the state." Page 3.

Fallen Strategist Upbeat
Even though Dick Morris resigned as Clinton's campaign adviser, he says he will be an "active commentator on this election." Page 10.

THE NEW YORK TIMES is available for home or office delivery in most major U.S. cities. Call, toll free, 1-800-NYTIMES. Ask about Times marks TimesCard. 354613

A COMPUTER GAP IS LIKELY TO SLOW WELFARE CHANGES

ENFORCEMENT IS AT ISSUE

Lack of National Data Base to Track People Who Get Aid Poses Problem in States

By ROBERT PEAR

WASHINGTON, Sept. 1 — It sounds simple. The Federal Government will impose a five-year lifetime limit on cash payments to any family, starting no later than next July. But state and Federal officials say it will be months, probably years, before they have the computer capability to enforce such restrictions throughout.

That requirement is one of the immense provisions that officials here must carry out as they study the bill overhauling welfare that was signed by President Clinton on Aug. 22. To comply with the new rules, they must create a computer system to track each person from every state, of welfare recipients, on people who leave welfare and on all newly hired employees.

In Congressional debates, lawmakers almost never mentioned the practical problems of enforcing the five-year limit. But now that the aspects of the new law are becoming real to officials in the states, the need for uniform national standards and interstate cooperation on some issues.

Federal computer power to enforce such rules is also limited. At the same time, advocates for the poor are finding that the rights of welfare recipients have been drastically curtailed by the new law, which eliminates a 60-year-old Federal guarantee of cash assistance to the nation's poor children.

The states must also make changes in their computer systems to capture the necessary data. Many states say they have not kept track of how long people receive welfare because they had no need for such information.

Iowa's welfare director, Douglas E. Howard, said, "We don't track lifetime limits now. We'll need the capacity to track people for the rest of their lives."

The success of the effort will depend, in part, on development of a data base to keep track of people moving across the country from one welfare jurisdiction to another. A person who leaves welfare in one year, applies anew the next year in Chicago, and again against the lifetime limit must be enforced by officials in each state. The states now have no way of exchanging data.

James M. Hmurovich, the welfare director in Indiana, said, "There is no national public assistance com-

Continued on Page 12, Column 1

New Night of Horror In S. Carolina Lake As 7 Visitors Drown

By RICK BRAGG

UNION, S.C., Sept. 1 — The saddest that has befallen the town. Seven children, died swimming in a lake on Saturday night. They came to see the lake where Susan Smith drowned her two young sons in late 1994 in a murder that drew worldwide attention to this usually quiet town.

Continued on Page 9, Column 1

The New York Times

VOL.CXLV..No. 50,539 Copyright © 1996 The New York Times NEW YORK, TUESDAY, SEPTEMBER 3, 1996 $1 beyond the greater New York metropolitan area. 60 CENTS

Late Edition

New York: Today, sunny, warm, light breezes. High 87. Tonight, mainly clear. Low 70. Tomorrow, hazy, some clouds, humid. High 84. Yesterday, high 89, low 68. Details on page D13.

David Cone facing the Oakland A's in his dramatic return to the Yanks.

Peter DaSilva for The New York Times

Sensational Comeback for Cone: Seven Innings, No Runs, No Hits

By JACK CURRY

OAKLAND, Calif., Sept. 2 — David Cone's incredible comeback story evolved into unbelievable when the Yankees lost a no-hitter on his return to the mound. Cone, who had undergone surgery in May to remove an aneurysm from under his right armpit, pitched no-hit ball through seven innings.

Cone left the game after throwing 85 pitches because Manager Joe Torre did not want him to overtax his surgically repaired right shoulder. He was replaced by Mariano Rivera, who fell two outs short of completing the no-hitter when Jose Herrera managed an infield single off third baseman Charlie Hayes's glove with one out in the ninth inning. Rivera finished the Yankees' 5-0 victory.

IN THE NICK OF TIME

"I'll never wonder if this could have been an opportunity to throw a no-hitter, the delicate decision not to allow him to try to complicate it. I wouldn't think that way. I appreciate that they took me out of the game. It's more important to get to the playoffs and the series."

Before the game, Torre had said he would not allow Cone to throw more than 100 pitches. Torre insisted his decision to protect Cone for the sake of the pennant race was fairly simple.

"If I would have left him in to throw 105 or 106 pitches and his shoulder would have been achy tomorrow or down the road, I never would have been able to live with myself," Torre said. "I would have always regretted it."

It was a stunning and sweet afternoon for Cone, 33, a Cy Young award-winning pitcher who had wondered whether his 11-year career was over, and for the Yankees, who had not expected him to make it back to the mound this season but now hope he will be the boost the lethargic team needs to maintain first place in the American League East.

After undergoing surgery on May 10 to remove the aneurysm and replace the affected section of artery with a one-inch vein graft, Cone did not throw a baseball again until June 26. After a month of condition-

Continued on Page B9, Column 5

Bell Atlantic's Litany of Snags In Mexico Deal

By JULIA PRESTON

MEXICO CITY, Sept. 2 — In the first heady days of the free-trade pact between the United States and Mexico, the Bell Atlantic Corporation spent more than $1 billion to buy a piece of a new Mexican cellular telephone company with big plans to grow.

Bell Atlantic's stake in the company, Grupo Iusacell, remains one of the largest American investments in Mexico since the signing of the American Free Trade agreement, but it has become a morass that to jeopardize the accord well as Bell Atlantic's run into a dizzying obstacle course in this country that has blocked it from setting up a local telephone system is central to its growth.

CALL 911

In the view the North American Free Trade Agreement giant was envisioned Mexico as a stable of a former president, who is involved in a money-laundering scandal, among other problems. Bell Atlantic, which is currently involved in a $30.8 billion merger with the Nynex Corporation, became the first American company to suffer direct financial losses as a result of the scandal.

Only now, after two years of negotiations with the Government and lobbying by the American officials, is Bell Atlantic on the verge of breaking a regulatory logjam that cost it tens of millions in potential business.

Continued on Page D4, Column 1

Roughing It for Class

Colleges are encouraging students to backpack, canoe and camp together to get to know one another before starting their class work.

Article, A16.

Trailing, Dole Vows A Touch of Truman

By ADAM NAGOURNEY

ST. LOUIS, Sept. 2 — Invoking the come-from-behind victory of Harry S. Truman 48 years ago, Bob Dole opened his fall campaign today by describing this year's contest as a vivid choice between "old-style liberal vision" and a conservative vision that would roll back the Government. Mr. Dole devoted more than one-third of his speech to his promise of a tax cut.

At a hot and sweaty Labor Day kickoff rally here, with the 630-foot Gateway Arch before him and the graceful St. Louis skyline at his back, Mr. Dole framed the election as a debate over cutting taxes and reducing the size of Government. In so doing, he reminded his audience both of President Clinton's failure to implement a 1992 promise to cut taxes, and of his own campaign-signature pledge to slash taxes for businesses and individuals.

"This election is about two different visions of America's future," Mr. Dole said, squinting into the bright late-morning sun, his voice booming over the sound system and down to the Mississippi River.

"Our opponents offer an old-style liberal vision that puts government first," Mr. Dole continued. "And Jack Kemp and I offer an optimistic vision that puts the American people first. That's the difference. That's the key dividing line in this campaign. They believe in government, and we believe in you."

Continued on Page D10, Column 1

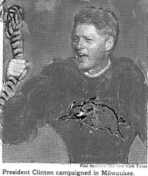

President Clinton campaigned in Milwaukee.

Paul Hosefros/The New York Times

In the Lead, Clinton Plays the Underdog

By TODD S. PURDUM

MILWAUKEE, Sept. 2 — President Clinton wound up nine days of intense campaigning with a brace of Labor Day celebrations in Wisconsin today, one at a picnic on traditionally Republican turf near Green Bay and the other in an old-fashioned evening rally with liberal leaders of big labor in Milwaukee.

The day amounted to a metaphor for Mr. Clinton's even as he portrayed himself a moderate to evenly divided between and liberal, all the while trying to spur turnout among women, labor and minorities to head off any challengers and spark turnout in November.

"God bless you!" the President exclaimed to one woman among the 25,000 people who packed Voyageur Park in De Pere, just outside Green Bay, and who was holding up a homemade black-and-white sign proclaiming "Republicans for Clinton." He added, "I appreciate Milwaukee, president of the American Federation of State, County and Municipal Employees, Mr. Clinton lit into Bob Dole's proposed 15 percent tax cut as impractically large and sure to "explode the deficit" and force cuts in domestic spending, while promoting his own small tax breaks for education as just right.

YOU'RE NO UNDERDOG

Continued on Page D11, Column 1

Bob Dole held a Labor Day rally in St. Louis.

Agence France-Presse

Seminarian Held on Bomb Charge at Airport

By ROBERT D. McFADDEN

Roman Regman, 21, who lives with the Orthodox profile of a terrorist bomber or hijacker. His manner at Tampa International Airport was polite, deferential, calm and cooperative.

In a strange encounter at a security checkpoint on Saturday — an incident whose circumstances are hotly disputed by the man's mother, who

CARRY ON ARSENAL

was there — officials said Mr. Regman, a Romanian immigrant who had spent the summer with his mother were summoned.

But, officials said, the luggage was too tightly packed for attendants to scan the contents. And when attendants said they would have to hand-search his luggage, Mr. Regman volunteered that he had a gun in one of his bags. They looked in and, sure enough, found an unloaded 9-millimeter Beretta pistol. Mr. Regman did not flee and offered no resistance as said they found other explosive devices, what were described as a variety of bomb-making materials, 100 rounds of ammunition for the 9-millimeter pistol, 100 rounds of ammunition for a .22 caliber knives.

Continued on Page D9, Column 1

INSIDE

A Battle Brews Over Jobs

A bill on Governor Pataki's desk would give some of Mayor Giuliani's power over economic development to the borough presidents. Page B1.

Future of Tennis Goes 1-1

Two 15-year-olds tried to advance to the United States Open round of 16 yesterday, and one — Martina Hingis — did. SportsTuesday, page B7.

U.S. Attacks Military Targets in Iraq

Pentagon Says Command Site Was Struck

By STEVEN LEE MYERS

WASHINGTON, Tuesday, Sept. 6 — The United States early today launched a second attack on Iraq.

The Pentagon, in a statement released at 1:55 this morning, announced the attack, saying the missiles were aimed at Iraq's anti-aircraft command and control centers. It gave no further details at the White House declined to specify the targets, the extent of the retaliation or the American forces involved.

"At the direction of the President," the Pentagon said President Clinton would discuss the attack at the White House at 8 A.M.

CRUSIN' FOR A BRUSIN'

The decision to use cruise missiles reflected concerns about putting American pilots at risk. There was no suggestion whether the first wave prolonged or a single strike.

In Baghdad, air raid sirens resounded at 9:25 to 11:25 A.M. (Eastern time), but there were no immediate reports on what areas were hit or what damage was caused.

Iraqis, hardened by two recent wars and stifling economic and social conditions, ignored the warning.

The Associated Press reported, there was no panic among motorists and pedestrians filling the streets during the morning rush hour.

On Monday, the Clinton Administration said it appeared to be missing a chance that Kurds as was not political.

Michael D. McCurry, the White House spokesman, said President Clinton had decided on a course of action against Hussein.

Iraq's forces, center of Erbil on Saturday, Mr. McCurry said the Administration officials joined around troops, backed by tanks and artillery, remained inside the region they seized of the United States and allies five years ago, protected Kurds.

"We have indications that they are preparing to withdraw back to their original forward positions," said Mr. McCurry. "However, with the President about making One on the the to capture troops in Wisconsin, he added that the pullout was terribly significant because they have a significant force remaining around Erbil.

Continued on Page A6, Column 1

Agency Had Noted Problems in Home Where Girl Starved

By MATTHEW PURDY

The head of New York City's Administration for Children's Services acknowledged yesterday that evidence of neglect was found "13 months ago at the home of Nadine Lockwood, the 4-year-old girl who investigators say was starved to death by her mother. But he said that after an initial review of records, he could not say what action, if any, was taken by city social workers.

There was a long history of contact between child welfare workers and the Lockwood family, which was investigated several times for child neglect — twice after Nadine and another child were born with drugs in their system and at other times, when friends or neighbors called child welfare officials.

SYSTEM OF SHAME

The agency found enough "credible evidence" of neglect to open an investigation at least once, but he said he was unable to say what conditions were found or what further action was taken. The case was

Continued on Page B4, Column 1

Calm Instead of the Storm

New Yorkers, including one enjoying the Hudson River from Wave Hill in Riverdale, basked in sunshine and a high just short of the 90-degree mark yesterday, a Labor Day that forecasters had said might be ruined by Hurricane Edouard. Instead, the storm moved to sea. Page A12.

Librado Romero/The New York Times

The New York Times

VOL.CXLV No. 50,540 Copyright © 1996 The New York Times NEW YORK, WEDNESDAY, SEPTEMBER 4, 1996 $1 beyond the greater New York metropolitan area. 60 CENTS

Late Edition
New York: Today, mostly cloudy, not as warm. High 82. Tonight, mostly cloudy. Low 71. Tomorrow, late showers possible. High 80. Yesterday, high 88, low 68. Details are on page B17.

Texas Immigrants Worry As Cuts in Welfare Loom

By SAM HOWE VERHOVEK

McALLEN, Tex., Aug. 29 — Here on the Texas-Mexico border, officials have... ... SCREWED ...

law is to prod more people into work. local officials and people...

All told, more than 32,000 legal immigrants will stop receiving food stamps by next summer...

Continued on Page A18, Column 1

Dole Is Facing a Tough Sell In a Suburb of Swing Voters

By RICHARD L. BERKE

MORENO VALLEY, Calif., Sept. 3 — If the 1996 Presidential election is to be fought out in bedroom communities like this one...

GOING OUT OF BUSINESS — EVERYTHING MUST GO — 15% OFF

Continued on Page B8, Column 1

Big Mall's Curfew Raises Questions Of Rights and Bias

By ROBYN MEREDITH

BLOOMINGTON, Minn., Aug. 29 — Marcus D. Wilson, 18, has been coming to the Mall of America here once or twice a week...

Continued on Page B9, Column 1

Choices Reshaping Schools Landscape

As American children return to school this fall...

VOUCHER'S NOT!

U.S. Launches Further Strike Against Iraq After Clinton Vows He Will Extract 'Price'

A Tomahawk missile taking off yesterday from the American destroyer Laboon in the first strike against Iraq.

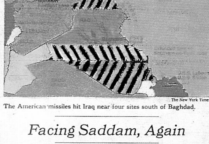

The American missiles hit Iraq near four sites south of Baghdad.

Facing Saddam, Again

U.S. Strikes Pick Up Where Bush Left Off, But It's Difficult to Discern Concrete G...

By ELAINE SCIOLINO

WASHINGTON, Sept. 3 — Three years and eight months into his presidency, Bill Clinton is fighting the war against Saddam Hussein that George Bush never finished.

ETERNAL RETURN

"Reckless acts have consequences," President Clinton said as he announced the strike on Iraq.

Muting His Criticism of Clinton, Dole Backs Troops in Iraq Raid

By ADAM NAGOURNEY

SALT LAKE CITY, Sept. 3 — teen hours after he assailed President Clinton for "weak leadership"...

BEHIND YOU 1000%

"All of us think not as Republicans or Democrats, but as Americans," Bob Dole said after the strike.

Continued on Page A19, Column 4

U.S. Continuing Bid to Smash Air Defense

By ALISON MITCHELL

WASHINGTON, Sept. 3 — The United States launched a second missile strike against Iraq's northern air defenses tonight...

IF AT FIRST YOU DON'T SUCCEED TRY TRY AGAIN

Continued on Page A8, Column 1

Edberg and Ivanisevic Win
Stefan Edberg, in his final Grand Slam event before retirement, reached the U.S. Open quarterfinals, and will next play Goran Ivanisevic. SportsWednesday, page B11.

China Season for Saying No
"The China That Can Say No," a new best seller in China written by a group of former pro-democracy rebels... Page A4.

Civilizing Kitchen Dictators
Overbearing, diva-esque chefs who drive away the help are the talk of restaurant owners... Living, page C1.

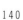

The New York Times

VOL.CXLV.... No. 50,541 Copyright © 1996 The New York Times NEW YORK, THURSDAY, SEPTEMBER 5, 1996 $1 beyond the greater New York metropolitan area 60 CENTS

Late Edition
New York: Today, partly sunny, warm. High 85. Tonight, mild, clouds. Fog possible late. Low 70. Tomorrow, turning cloudy. High 82. Yesterday, high 82, low 72. Details, page D20.

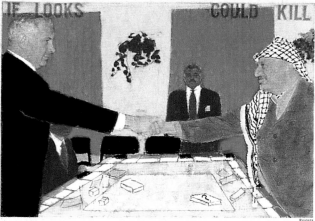

IF LOOKS COULD KILL

Prime Minister Benjamin Netanyahu and Yasir Arafat began their brief meeting with a handshake. Reuters

NETANYAHU MEETS WITH P.L.O. LEADER

He and Arafat Restate Support for Peace and Reopen Talks

By SERGE SCHMEMANN

EREZ, Israel, Sept. — weeks of mounting tensions, pressures and secret negotiations, Prime Minister Benjamin Netanyahu came face to face today with the Palestinian leader he disparaged during his election.

The meeting consisted largely of a cheery handshake across a formal negotiating table, and a news conference in which they reiterated their commitment to the Israeli-Palestinian peace. But the contact had critical ramifications for peace and for the political standing of the two leaders.

For Mr. Netanyahu, the handshake guaranteed a bitter struggle with the nationalist right, which backed him in the expectation that he would halt the reconciliation with the Palestinians.

[...] between the meeting was an Islamic militant camped the birth of the [...] marked the negotiations in which diplomats seem [...] after Mr. Netanyahu was elected. Their handshake represented a formal acceptance [...] and his Palestinian Authority [...] wing Government [...] the previous Labor Government for dealing with "terrorists" [...] referred to Mr. Arafat and his supporters.

Already at the news conference, a member of Parliament from the far-right Moledet party, Benny Elon, shouted out, "Excuse me, Mr. Prime Minister, but, what's happened to you?" Later, Likud members publicly assailed him on television, while the main council of Jewish settlers in the West Bank held an emergency meeting late into the night.

On Thursday, Mr. Netanyahu is to meet with the central council of his [...] re he is certain to [...] confrontation with [...] Ariel Sharon and Benny B[...] the two members of

Cont[...]d on Page A8, Column 1

Classes Open in New York City, In Closets, Hallways, Cafeterias

By PAM BELLUCK

With classrooms crammed into oversized closets, cordoned off in auditoriums and plunked into locker rooms, New York City schools opened yesterday to the worst overcrowding in decades.

Across the city, there were signs of strain and some confusion, not just from the overflow of students, 91,000 more than the school system can comfortably accommodate, but also from unfinished construction and the forced reorganization of some of the most severely troubled schools.

Lines of students trying to register stretched for blocks. Some schools had so many new students, many of them recent immigrants, they had to sign up that they had to turn away applicants for the day, saying they could not find time to evaluate and register everyone.

The overcrowding is a result of a combination of factors: immigrants flooding into the system, the effects of a miniature baby boom, fewer students dropping out and the failure to build new classrooms in time to accommodate the overflow.

Mayor Rudolph W. Giuliani pledged to try to alleviate the crowding by "producing more spaces, more buildings that are habitable." While he was not specific, he faulted state mandates that require spending on programs like special education instead of more pressing needs like finding new classroom space.

This year, 20,000 new students enrolled in the system at the same time the dropout rate declined, bringing the total of students to 1.06 million. That has left the system almost 10 percent over capacity, forcing the largest classes to grow to as many as 45. The maximum under the teachers' contract is 34.

Sandra Feldman, the president of the teachers' union, who on Wednesday threatened to pull her members out of schools where overcrowded conditions posed a danger to teachers or students, said yesterday that it was too early to tell if such a reaction was warranted.

"I couldn't say that at this point because not all of the children are in yet," Ms. Feldman said, noting that it would take days for all of the new students to be registered and start classes. "We hope we don't have to do that, but we're putting people on notice."

Yesterday, more than 500,000 students in the city's high schools and junior highs showed up, mostly to register and go to home room, and today, elementary school students begin classes.

At Intermediate School 61 in Corona, Queens, the teachers' cafeteria will become a classroom when teachers are not eating, as will a small projection room above the auditorium, and guidance counselors will meet with students in 8-foot-by-10 foot, windowless closets, which the principal said may also be used for small special education cl[...]

Continued on Page B6, Co[...]

Opening Pleasantries At All-Girls School

[...] York City opened its first [...] public school in a decade yes[...]ay, and it was a day for the 50 girls of the pioneering seventh-grade class to get to know their new surroundings: the top three floors of a commercial building on East 106th Street in East Harlem. The girls spent the day snipping on and nibbling croissants with the school's philanthropic founders, having their portraits snapped by a society photographer and fielding questions from a horde of reporters.

Article, page B6.

CLINTON, CLAIMING SUCCESS, ASSERTS MOST IRAQI TROOPS HAVE LEFT KURDS' ENCLAVE

A Failed Race Against Time: U.S. Tried to Head Off Iraqis

This article is based on reporting by Steven Lee Myers, Tim Weiner, Judith Miller and Elaine Sciolino and was written by Mr. Myers.

WASHINGTON, Sept. 4 — Last Friday, as Saddam Hussein sent tens of thousands of troops toward the protected Kurdish enclave in northern Iraq, American diplomats raced to the United States Embassy in London in a last-ditch attempt to save the fractured Kurdish alliance that has been a bulwark of United States policy in the region.

Ever since the chaotic end of the P[...] Gulf war in 1991, the United States had tried to hold the Kurds toge[...] to deny Iraq or Iran any pre[...]to move into the enclave. To that end, the United States defined and protected a safe haven of sorts for the Kurds. The Americans repeatedly brokered cease-fires when fighting erupted between Kurdish factions.

When the Americans [...] with the Kurds in [...] day, the long, bitter boiling over. It had [...] year that one side, the Pat[...] Union of Kurdistan, had accepted arms from Iran, while the leader of the other, the Kurdistan Democratic Party, had appealed to Baghdad to attack his rival. When the two sides reconvened on Saturday morning, Iraq's heavily armed troops had seized Erbil and begun to round up [...] r. Hussein's opponents.

A Friendly Ne[...]

[...]der of the Kurdish faction supported by Iraq insisted that the alliance was no more than a temporary, tactical partnership. Page A11.

While President Clinton today declared the military retaliation against Iraq a success, Mr. Hussein has nonetheless achieved a victory of his own. By the time Iraqi tanks had withdrawn under the pressure of United States cruise missile attacks, the Kurdish community that the United States spent the last five years trying to preserve had been torn apart.

Mr. Hussein had also regained substantial influence over an area he

Continued on Page A11, Column 1

President Saddam Hussein of Iraq, at a meeting yesterday with his military advisers. Agence France-Presse

AIR ZONE ENFORCED

Baghdad Leaves Enough Forces in North to Control the Region

By ERIC SCHMITT

WASHINGTON, Sept. 4 — After two American missile strikes [...] Iraq pulled [...] most of its troops from a contested Kurdish enclave [...] day, and United States-led air [...] met only token resistance enforcing a newly expanded prohibition on Iraqi military flights, President Clinton said.

Although Pentagon officials re[...] [...] Iraq kept enough tanks in [...] to retain control of it, the [...]nt declared the military mission a success.

The White House said the back-to-back cruise missile strikes against military targets in the southern [...] country had forced Presi[...] Mr. Hussein's troops into at [...] y retreat from the [...] and momentarily [...]

So[...] jet fighters fled the sou[...] urs before the United States expanded the [...] area in southern Iraq [...] they [...]tion of the zone's boun[...] from 60 [...] northward, brings American-led patrols north to within [...] miles of Baghdad.

"O[...] mission has been achieved," Mr. Clinton said. "There has been a withdrawal of the forces, a dispersal of the forces, but it's too soon to say that this is permanent or that further action will not be taken."

A senior Navy officer said, "This is for a while unless they do something really dumb."

Antiaircraft fire erupted over Baghdad early [...] but American officials deni[...] tacking the Iraqi capital, and blamed the shooting on skittish Iraqi gunners firing at phantom targets.

The expanded [...] area, which senior Pent[...] said is now permanent a[...] ch not shrink when the crisis subsides, provides a broader buffer zone between Iraqi forces and Washington's oil-producing allies to the so[...] and Saudi Arabia. It also [...] a corridor that American warplanes would fly through if ordered to bomb Baghdad.

"We have improved our strategic position," said a [...] official. "We've taken the opportunity to expand our security perimeter permanently."

Senior military officials were cheered by intelligence reports that many of the 40,000 Iraqi troops last week drove into the Kurdish enclave were now withdrawing, perhaps to barracks in Mosul and Kir-

Continued on Page A10, Column 3

Dole Gained Reputation in Senate As a Master of Special Tax Breaks

By DOUGLAS FRANTZ

In promoting his plan to cut taxes and balance [...] budget, Bob Dole [...] days creating a [...] system [...] closing the special [...] ty [...] that riddle the tax code and save wealthy businesses billions of dollars each year.

"If there ever was a time when some corporations needed special breaks or favors from Congress, that time is over," the Dole campaign proclaimed last week in its first detailed explanation of the tax overhaul, which is the centerpiece of Mr. Dole's Presidential campaign. "Least of all should Government be giving special breaks to corporations when working families and small businesses enjoy no such favors."

Mr. Dole repeated the message this week, saying he expected to pay for tax cuts and to balance the budg-

FROM DOLE CAMPAIGN, A 5-MINUTE AD

The usual 30-second political advertisement will give way to a biographical spot on CBS tonight. Page B9.

[...] art by [...] corporate tax loopholes.

"There's still some corporate welfare out there that we can tap into," he said in an interview published in The New York Times last week.

But, during his years in the Senate, Mr. Dole proved himself to be a master at engineering the very sorts of special tax breaks for constituents and corporations that he now decries. And recipients of those breaks, in turn, have been among Mr. Dole's most generous contributors, helping him over time to create one of the most successful campaign fund-raising machines ever.

As one of the most powerful members of the [...] Committee and the [...] Republicans, [...] tax breaks [...]lions of [...] corporations [...] Kansas [...]ut of state. [...] r Daniels [...]d's larg[...] [...]modity [...]ployers [...]ompany [...]r KI[...]

Clinton Ex-Partner Is Held in Contempt In Whitewater Case

By STEPHEN LABATON

WASHINGTON, Sept. 4 — A Federal [...] in conte[...]l fusing to answer questions [...] prosecutors about her former business partner, Bill Clinton, had testified [...]

Judge [...] ght of Federal [...]le Rock, Ark., gave [...]day morning to agree to respond to the questions before a grand jury or be immediately held in contempt. Mrs. McDougal, convicted in May of felony charges, was already scheduled to begin a two-year prison sentence on Sept. 30.

The questions described by Mrs. McDougal, all of which she would not answer, provided a clear-cut Whitewater prosecutors [...] their long-running investigation [...] a higher orbit, moving aggressively and directly in their investigation of President Clinton himself, rather than his associates or the First Lady.

Mrs. McDougal said she was called before the grand jury this morning and asked, "Did William Jefferson Clinton testify truthfully before your trial?" She said she was asked whether

Continued on Page A13, Column 1

New York City schools opened yesterday to the worst overcrowding in decades. On the Upper West Side, students and parents filled the sidewalk as they waited for the doors to open at Brandeis High School. Chester Higgins Jr./The New York Times

INSIDE

Limits for Business Districts
Mayor Giuliani may scale back the influence of the city's business improvement districts by limiting or ending their ability to sell bonds, out of concern that the city could be held responsible in a default. Page B1.

Tracing Mexico's Rebels
Officials identified the rebel army that staged attacks across Mexico last week as a fusion of leftist factions around a core group with a violent 20-year history. Page A3.

Merger in Office Supplies
Staples has agreed to acquire Office Depot for $3.4 billion in stock, creating the nation's largest retailer of office supplies. Page D1.

Clinton Has Cyst Removed
An apparently benign cyst was surgically removed from President Clinton's neck in a minor operation, the White House said. Page A17.

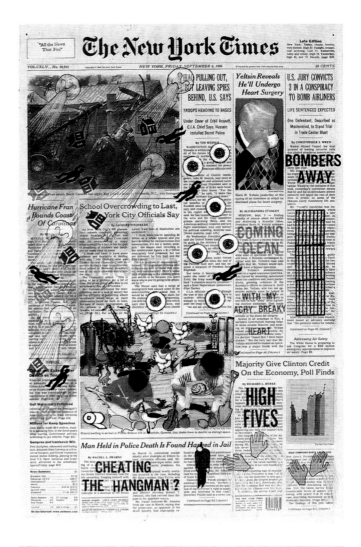

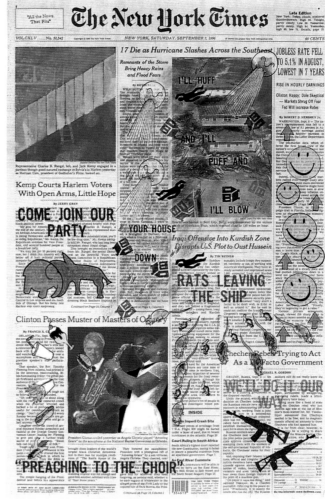

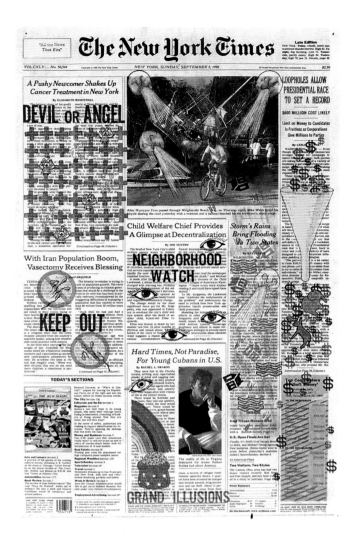

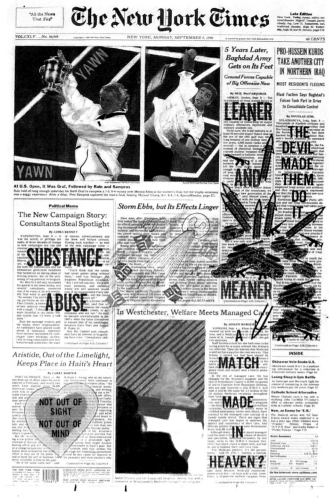

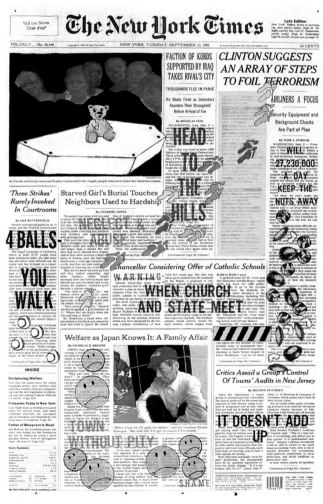

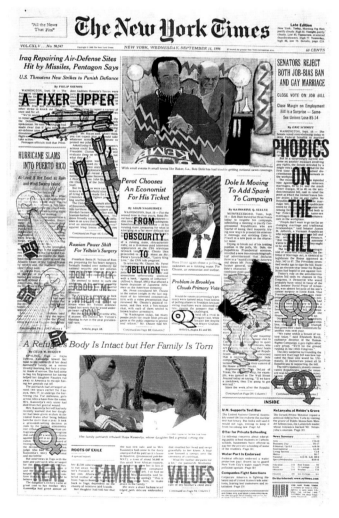

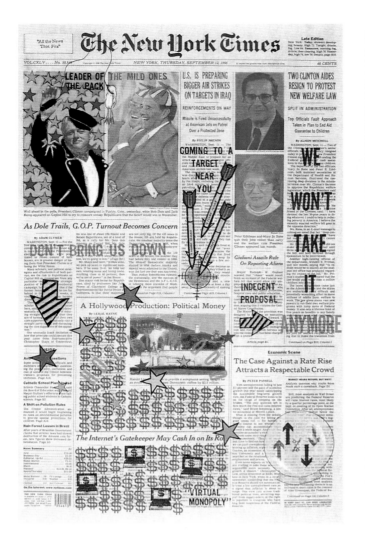

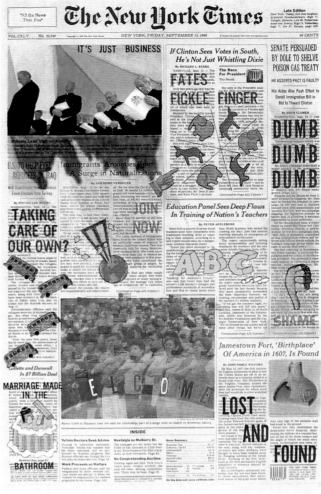

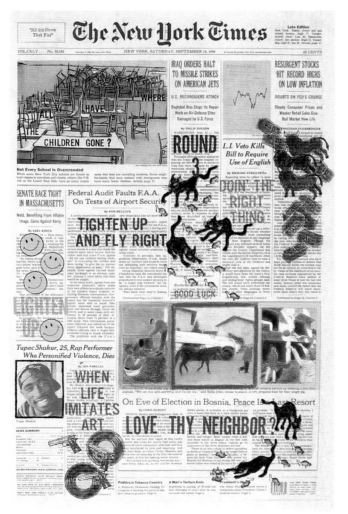

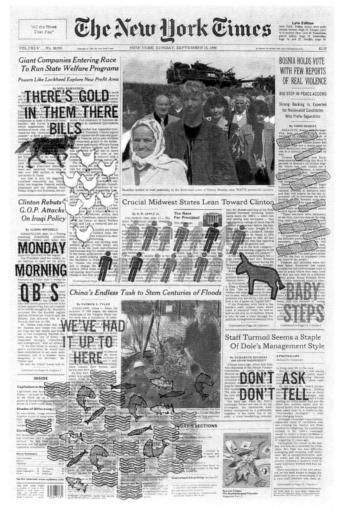

"All the News That Fits"

The New York Times

Late Edition
New York: Today, partly sunny, increasing afternoon clouds. High 73. Tonight, cloudy, Low 62. Tomorrow, rainy, breezy, cool. High 66. Yesterday, high 74, low 58. Details, page C16.

VOL.CXLV...No. 50,552 Copyright © 1996 The New York Times NEW YORK, MONDAY, SEPTEMBER 16, 1996 $1 beyond the greater New York metropolitan area 60 CENTS

Shots Silence Angry Voice Sharpened by the Streets

By MICHEL MARRIOTT

MARIN CITY, Calif., Sept. 15 — The news drifted into the Marin public housing project with a certain inevitability. The afternoon of Sept. 13, some 300 miles north of the Golden Gate Bridge, Tupac Amaru Shakur, rap music's bad-boy monarch, lay dead. Here, from the neighborhood he once called home, the news evoked less shock than a sense of weary expectation. Mr. Shakur discovered fame, fortune and infamy, he lived in this stairstep of barracks-like townhouses, a terrace apartment that residents call the "the jungle." Many here proudly referred to Mr. Shakur's style that lived more than $80

So in "the jungle," bedeviled by crime and drugs, word of the death of an adoptive native son spread quickly. Shortly before 5 P.M., on Friday the 13th, a woman slowed her car near Building 89, where Mr. Shakur lived in the late 1980's with his mother and sister. She rolled down the car window

RHYTHM AND BULLETS
A special report.

and screamed, "Tupac is dead."

Confirmation that Mr. Shakur, 25, had died from gunshot wounds he received in a drive-by ambush on Sept. 7 in Las Vegas was soon blaring from radios in nearby parked cars, stereos and boomboxes. All around, someone played "Life Goes On" by Tupac, the name under which he recorded, a prophetic eulogy for shellshocked survivors of those lost to urban gunplay.

Ken Jackson, 37, who was walking through the complex, reminisced about Mr. Shakur's career. "Everybody knew he was going to make it," he said. "He was always warning us."

Mr. Shakur came from a generation in Marin City to superstar at a time when inner cities were ripped by racial upheaval, gang violence, drug abuse and joblessness. Those conditions spawned the explosion of rap in the mid-1980's, cultivating a generation of raw, angry young voices.

But Mr. Shakur followed the

Continued on Page A12, Column 1

Presidents of Bosnia and Serbia To Meet Soon at Urging of U.S.

By CHRIS HEDGES

SARAJEVO, Bosnia and Herzegovina, Sept. 15 — The leaders of Bosnia and Serbia will meet to bring their war-torn nations' relations under a new agreement, after a meeting of Bosnian Presidents in Paris in about three weeks, the American mediator, Richard C. Holbrooke, said today.

Mr. Holbrooke, who led the American delegation monitoring the election, announced the agreement after meeting with the new civilian leaders chosen in Saturday's balloting.

Presiding over the creation of rail links that would connect the republics that once comprised Yugoslavia and with the ethnic Croatian and Serbian enclaves in Bosnia.

They will also begin to hammer out the relationship between the Bosnian Government institutions that were elected on Saturday and the Serbian Government in Belgrade.

But despite his persistent badger-

ing — a tactic that worked well in bringing about the peace agreement that ended the war — Mr. Holbrooke was unable to convince Mr. Izetbegovic to abandon a challenge by his Democratic rivals to the vote in the Serb-dominated half of Bosnia because of which some Serbs were voting irregularly.

Mr. Holbrooke did extract a promise that the Muslim-led Bosnian Government would turn in detailed accounting information requested by the monitors as the votes for a new Serb and a Muslim; a national Parliament; regional parliaments, and leaders of each of the three ethnic enclaves.

The turnout was between 60 and 70 percent of the 2.9 million eligible voters, said the Organization for Security and Cooperation in Europe, which organized the $100 million elections. The first preliminary re-

Continued on Page A8, Column 4

In New Jersey, Infants Languish in Hospitals

By JENNIFER PRESTON

TRENTON, Sept. 15 — Tiffany, the baby girl in crib No. 8, was ready for a bottle. She fussed until Rose Alston, a 72-year-old hospital volunteer, scooped her up into her arms. The infant looked into Mrs. Alston's eyes, holding her gaze as if fearing she might lose her attention.

Almost 8 months old, Tiffany has known no other home than the nursery at University Hospital in Newark. She has been ready to leave the hospital since early June, but like almost two dozen other healthy babies in the hospital on a recent morning, she is waiting to be placed with a relative or put in foster care.

It has been 16 years since the crack epidemic first flooded newborn nurseries in hospitals around the country with boarder babies, infants who lingered in hospitals, unable to go home with their mothers because they had been exposed to drugs or the virus that causes AIDS.

After a large public outcry, most states and major cities, including New York City, moved quickly to address the continuing problem, whether by recruiting more foster families and opening small group homes or creating special drug-treatment and housing programs for pregnant women and mothers.

But New Jersey remains the only state in the nation where boarder babies languish in hospitals for weeks, sometimes months at a time.

Over the years, the state has taken some steps. More than 700 babies are referred to state child welfare officials every year. But critics say that the measures have fallen short of the needs because the babies never became a top state priority.

"We are up against a very complex problem," said Denise Novye, a project manager at the Division of

Continued on Page B4, Column 1

Kurdish Refugees Find Temporary Haven in Turkey
Fearing for their safety after Iraqi-backed Kurds seized much of northern Iraq, Kurds employed by American Government agencies crossed into Turkey yesterday, headed for resettlement in the United States. Page A6.
Associated Press

Dole Gets Christian Coalition's Trust and Prodding

By GUSTAV NIEBUHR

Minutes after Jack Kemp, the Republican Vice-Presidential candidate, spoke to the Christian Coalition this past weekend in Washington, the organization's founder, Pat Robertson, took him backstage and asked that he emphasize a religious theme, not just economic ones. Bob Dole, the Presidential nominee, got much the same message: "Jack, you had a wonderful message today," Mr. Robertson said in an interview Saturday. "Please, balance the economic message with the family and

moral issues.'"

Mr. Dole has been campaigning largely on a promise to cut income taxes by 15 percent. But Mr. Robertson said that if Mr. Dole delivered a "clear-cut moral and social message," the Republican nominee could cut into President Clinton's considerable lead, winning religious conservatives, a core constituency of members in the Republican-majority party of the 1950's.

But those elections two years ago have left the Christian Coalition, once a fledgling political movement, in a quandary. Having matured from an aggressive insurgent, the organization is now playing a more defensive game, an unfamiliar role, as it works to rally voters' support for a members of Congress who are sympathetic to the coalition's agenda of opposing abortion, supporting school

vouchers and backing some form of school prayer.

The coalition, which reports a membership of 1.8 million, also approaches this task at a time when the national mood has shifted and the electorate voices less anger at Washington and even seems to have cooled to Mr. Clinton as it has warmed to Mr. Dole.

"We have to fight through and mobilize the people, because of the Congressional races," Mr. Robert-

Continued on Page B8, Column 1

A Religious Tilt Toward the Left

By FRANCIS X. CLINES

WASHINGTON, Sept. 15 — As members of the Christian Coalition strolled outside their convention hotel here this weekend, loud and challenging hymns drifted across their path from a different Christian group, where other Christians were following a different theology of "righteousness like a flowing stream."

Inside, praying and preaching, singing and strategizing, were hundreds of the vanguard leaders of a broad 18-month-old Christian movement. Their mission drawn as an alternative to the Christian Coalition and its political pressure groups of the religious right.

Frankly, leaders of Call to Renewal see their movement being organized as a way across a wide spectrum of Christianity — from storefronts to mainline

Protestant and Roman Catholic parishes — did not spend the weekend directing their "stream of righteousness" at the political machinations of Ralph Reed, whose Christian Coalition executive director has dictated important parts of the Republican Party platform.

Rather, they angrily and repeatedly targeted President Clinton for compromising with the Republican-controlled Congress and signing a law that will overhaul the Federal welfare program and end six decades of Government subsidies to the nation's poorest children.

"President Clinton's sin was to cooperate with this when he clearly knew better," said the Rev. Jim Wallis, editor of Sojourners magazine who is the chief organizer of the Call to Renewal movement.

"The welfare animal in him caused the President to make elections campaign bargains," said the preacher. He yielded the fundamentalist right as he acidly cited the biblical passage in Numbers 32, warning Mr. Clinton "and be sure your sins will find you out."

The Call to Renewal previewed the nation's capital with an intense weekend of Christian debate. Christian politics, the political battle speakers of Mr. Reed's more powerful movement were featured in the news and covered on C-Span news.

Continued on Page B8, Column 1

The Best Drama This Fall? Yanks' Pennant Race

By CLAIRE SMITH

TORONTO, Sept. 15 — In a sports era in which loyalties are strained, there never was so thin a line between the team and its fans — that at a time in a decade and the obstacles, who have been challenged to the better part of a season, if you try to do something about it. A messy showdown showing a blend of drama that begins Tuesday night and crowds will be big and raucous, with be intense, and in the end, in the standings that they've always notice the owner, George Steinbrenner yesterday, the Yankees lost, 3-1 to the Orioles bombard across the margin

Continued on Page C7, Column 1

U.S. WARNING IRAQ THAT NEW ATTACKS ARE STILL POSSIBLE

RIFT IS SEEN IN COALITION

Perry Arrives in Kuwait Trying to Secure Approval of Plan for Sending More G.I.'s

By NEIL MacFARQUHAR

KUWAIT, Sept. 15 — Secretary of Defense William Perry, who is seeking to repair rifts in the coalition arrayed against Saddam Hussein, said here today that further United States attacks on Iraq were "still a possibility."

But even as he spoke for the United States and its allies in the coalition, Mr. Perry played down the fact that Kuwait, on whose behalf that the United States had been able to do no wrong since Iraq invaded it at least temporarily disrupted Washington's plan to send more troops here.

With the Kuwaitis apparently annoyed because they felt they had not been consulted about the planned deployment, Mr. Perry was expected to have to wait here until the United States received permission from the Kuwaiti Government. American officials said they expected the permission.

In Washington, Clinton Administration officials said that Iraq had still not met all the terms of an American ultimatum and that there was still the possibility of a devastating American attack. [Page A6.]

The new warning followed the Administration's indication last week that a punishing American air strike on Iraq was all but certain, with Secretary Perry warning that the Iraqis would "very soon learn that we are not playing games" and that American retaliation would be "proportionate."

But even as some Administration officials were warning today of the possibility of another, perhaps far more damaging strike, other officials were sounding more conciliatory. The mixed signals were an indication that Washington had no consistent policy and that it began its actions more than a week ago by sending cruise missiles into areas of southern Iraq to punish it for violating the no-fly zone set limits by the United States and its allies.

[Madeleine K. Albright, the United States representative to the United Nations, said yesterday on the NBC News program "Meet the Press" that the Clinton Administration was "not going to be pressured into reacting."]

And Gen. John Shalikashvili, Chairman of the Joint Chiefs of Staff, said Iraq had apparently stopped repairing the air defenses hit by American cruise missiles — an Iraqi move that Washington had demanded.]

Stopping in Kuwait for four hours between consultations in Saudi Arabia and Bahrain, catalogued the continuing buildup of American forces in the Persian Gulf.

Aside from the previously announced second aircraft carrier battle group, the Nimitz, and the eight stealth F-117 fighter jets that arrived here yesterday, Mr. Perry said that Bahrain had agreed to the stationing of 26 American F-16 jet

Continued on Page A6, Column 1

INSIDE

Questions on Perot Partner
Now that Ross Perot is once again running for President, questions about his business and political dealings have returned. Page B6.

Secession in Italy
Italy's small but flamboyant secessionist movement raised its improbable challenge to Italian unity with pageantry and bombast. Page A3.

A Sea Change on the Ice
The U.S. victory in the World Cup of hockey was a devastating blow for Canada. SportsMonday, page C8.

On the Internet: www.nytimes.com

The New York Times

VOL.CXLV... No. 50,553 Copyright © 1996 The New York Times NEW YORK, TUESDAY, SEPTEMBER 17, 1996 $1 beyond the greater New York metropolitan area. 60 CENTS

Late Edition
New York: Today, periods of rain, cool, breezy. High 66. Tonight, some showers, fog. Low 56. Tomorrow, early showers. High 66. Yesterday, high 73, low 61. Details are on page A21.

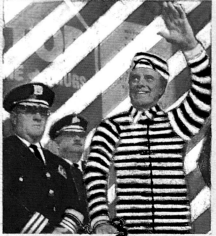
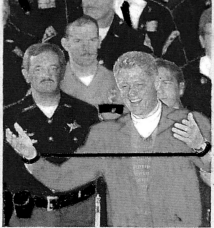

Bob Dole tried to shift the campaign's focus to law and order yesterday with a hard-hitting speech charging President Clinton with presiding over an epidemic of drugs and crime. Mr. Clinton countered with a sea of blue uniforms as he was endorsed by the nation's largest police union.

Photographs by Reuters

U.S. Command Faulted in Blast At Saudi Base

Warnings Not Heeded, Pentagon Report Says

By PHILIP SHENON

WASHINGTON, Sept. 16 — American military commanders ignored repeated warnings...

AGENCY TIGHTENS AIRPORT SECURITY IN NEW YORK AREA

ACTS TO PREVENT BOMBS

Procedures by Port Authority Include Employee Scrutiny and Dogs in Terminals

By JOHN SULLIVAN

Responding to repeated criticisms of the security at Kennedy International Airport since the crash of Trans World Airlines Flight 800, Port Authority officials announced yesterday they intended to plant a bomb...

Dole Attacks Crime, but Clinton Is Ready

By ADAM NAGOURNEY

WASHINGTON, Sept. 16 — The 1996 Presidential campaign abruptly shifted from the economy to law and order today...

WHO'S THE TOUGHEST OF THEM ALL?

Drugs Surge as Campaign Issue, But All the Talk Clarifies Little

By CHRISTOPHER S. WREN

Shortly after he took office in 1993, President Clinton gutted the drug office's director...

ISSUE DU JOUR

Giuliani's Flirtation With G.O.P. Ticket

Repeatedly over the last few weeks, Rudolph W. Giuliani has praised Bob Dole's selection of Jack Kemp as his running mate...

Article, page B3

WE'RE JUST FRIENDS

McGeorge Bundy Dies at 77; Top Adviser in Vietnam Era

By JOHN KIFNER

McGeorge Bundy

MASTER OF WAR

Movie History Emerges From a Basement

By BERNARD WEINRAUB

HOLLYWOOD, Sept. 16 — ... that archivists believe to be the oldest complete American feature, a 1912 version of Shakespeare's "Richard III," has been turned over to the American Film Institute in near-perfect condition...

Frederick Warde in a nearly perfect print of "Richard III," from 1912.

AS A

U.S. Knew in 1953 North Koreans Held American P.O.W.'s

By PHILIP SHENON

WASHINGTON, Sept. 16 — Newly declassified documents show that the United States almost certainly knew...

LEAVE AND LET DIE

WONDERFUL GIFT

INSIDE

Intense Efforts by Police Fail to Stop Brooklyn Killing

Skirting police patrols, a gunman obsessed with a teen-ager barricaded himself in her family's Brooklyn apartment with a dozen hostages. He shot three captives, then killed his pregnant former girlfriend and himself. B1.

Ford and Union Reach Pact

Ford Motor and the U.A.W. have reached agreement on a new national labor contract. The deal is intended to protect the jobs of current and future union workers, while providing modest wage increases. Page D1.

Simpson Redux

A second trial for O. J. Simpson in the killings of his former wife and a friend of hers is beginning in a California civil court with a different jury and different rules. Page A14.

Easing Tensions in Iraq

Kuwait yielded on the presence of troops, but President Clinton did not...

An Assassin...

A police official... career in South Africa... Page A3.

On the Internet: www.nytimes.com

The New York Times

Late Edition
New York: Today, morning showers
then cloudy, windy. High 86. Tonight,
brisk, cloudy. Low 55. Tomorrow, par-
tial clearing. High 69. Yesterday, high
63, low 58. Details are on page C20.

VOL.CXLVI...No.50,554 Copyright © 1996 The New York Times NEW YORK, WEDNESDAY, SEPTEMBER 18, 1996 ⅓ beyond the greater New York metropolitan area. 60 CENTS

New Approach For the U.A.W. In the Ford Pact

The Deal: No Job Cuts but Less Pay for Some

By KEITH BRADSHER

DETROIT, Sept. 17 — The Ford
CREATIVE
CONTRACT
labor for more than a decade: lay-
antee a minimum number of union
jobs, while adding incentives for the
company to produce more auto parts
itself.

All this runs counter to a trend in
which Detroit's auto makers have
halved their work forces over the
last years partly by closing or
selling parts factories, while buying
more from nonunion suppliers.

In exchange for the employment
guarantee, the U.A.W. decided to let
Ford permanently lower wages
in parts businesses that

It is unclear is whether
the deal will set a precedent for
other companies, both inside and out-
side the auto industry. Only a tenth of
the nation's private-sector work
force is unionized and there are few
other industries where unions hold
much power.

The first test for the union to
come quickly as it tries to impose
similar settlements on General
Motors Corporation and Chrysler
Corporation. Analysts say G.M. in
particular would be pressed to
accept such a deal because the com-
pany was trying force
manufacturing op parts

And beyond the auto makers, the
Ford contract might have much
weaker influence, even in those in-
dustries in which the U.A.W. repre-
sents workers. For example, Cater-
pillar Inc., a maker of heavy equip-
ment, was able to hire replacement
workers and continue doing business
last year despite a U.A.W. strike.

"I think that may be the model to
look at, rather than Ford," said
on F. Canner, the vice pre for
human resources policy Na-
tional Association of Ma ers
in Washington.

Under the new contract
guaranteed that for th five
years, the number of
sented workers in e

USUAL
SUSPECTS

Continued on Pa

EXISTING LEADERS OF ETHNIC GROUPS WIN BOSNIAN VOTE

3 OLD FOES SHARE POWER

Izetbegovic to Be First Head of Collective Presidency in Which Conflict Is Likely

By CHRIS HEDGES

SARAJEVO, Bosnia and Herzego-
na, Sept. — Bosnian voters hand-
ed power to the existing leaders of
the country's three major ethnic
groups, returns indicated to-
night, bringing the former enemies the
task of cooperating in a three-mem-
ber that will govern a restruc-
tu

official but incom-
plete the winner with the
most votes is the Bosnian President,
Alija Izetbegovic, a Muslim, who by
virtue of his plurality will be chair-
man of the presidency for its two-
year term.

Momcilo Krajisnik, a Bosnian Serb
separatist, will be the ethnic Serb
representative on the presidency,
and Kresimir Zubak, an ethnic Cr
who promised during the camp
to unite his group's enclave with
atia, will fill the Croatian seat.

One seat on a group
reserved for each group
was supported by the
nationalization for y and Co-
 operation drop Robert
the organiza-
tion's mission and final
results for the idential race
be announced Wednesday.
sults of the v national
and regional parties, which
were held Saturday g with the
presidential balloting, e to be an-
nounced in the next few days.

Based on the early y to-
night, with 80 percent of the votes
counted, Mr. Izetbegovic won
629,439 votes. Mr. Izetbegovic has
fought to preserve a unified multi-
ethnic Bosnia but has been criticized
for wanting the country to remain
under the of Muslim lead-
ership , former
Prime dzic, re-
ceived 110,845 votes.

Bosnian Serb politics leader
has been indicted on war-crime
charges, received 508,026 votes, offi-

Continued on Page A6, Column 1

Panel on Debates Bars Perot, Calling Him Unelectable

CAPTIVE AUDIENCE

Hard Time
Bob Dole continued to push his anti-crime message yesterday, visiting an Arizona prison camp known for unusual austerity. He met law-enforcement officials and crime victims and greeted some inmates. Page A19.

Texan's Camp Quickly Vows to File Suit

By NEIL A. LEWIS

WASHINGTON, Sept. 17 — The
Commission on Presidential Debates
announced today that it would bar
Ross Perot and his
wired the Presid and
that it would there d
to join President Clinton and Bob
Dole in this year's debates.

The Perot campaign immediately
protested the decision, calling it a
travesty and promising a lawsuit by
the en to overturn
it.

The welcomed the
panel aids to Mr.
Clinton, who have made no secret of
their hope that Mr. Perot's presence
in debates would dilute Mr. Dole's
chances of making gains, said they
would continue to insist that Mr. Pe-

IF YOU
CAN'T

rot
He received 19 percent of the vote
that year after a campaign largely
financed by his own money. Unlike in
1992, has in Federal
running
The commission said a survey of
political scientists and journalists
turned up no one who believed that
Perot could win the election or
even a single sta it would
please the names those sur-

JOIN 'EM

the last two national elections, invit-
ed Mr. Perot to participate in the
1992 debates.

BEAT 'EM

The commission et up
in 1987 by the tw litical
parties, can only tions
for the debates The
candidates are
its conditions,
to participate
though staying in

ch J. Fahrenkopf, a commis-
sio chairman and former chair-
man the Republican National
Committee that Mr. Perot had
met commission's cri-
teria being on the
ballot ations in all
50 sta commission
was de only those
with d
candid actually be-
come Pr those with mere-

Continued on Page A18, Column 5

Redefining Spending In Tight Senate Race

By not mentioning the Republican
candidate in the New Jersey Senate
race, ads assailing the Democratic
candidate, Robert G. Torricelli, do
not come under the spending limits
set by the Federal Election Commis-
sion. Such ads or by
the national come
committees races
through campaign
issues officially
back issues oriented
der Federal election laws not
supposed to advocate the election or
defeat of any candidate. But, in prac-
tice, the d up as attacks on the
candida es opposed by the or-
ganiza ying for the ads —
whether it is the Republican National
Committee or the A.F.L.-C.I.O.

These ads are not a new phenom-
enon, but a series of recent court
decisions have paved the way for a
significant expansion of their use.

LOOP
HOLES

Article, page

Dole's Tax Message Heard, Not Heeded, in Midwest City

By DAVID E. SANGER

SAGINAW, Mich., Sept. 15 — Only
a day after Bob Dole's "Citizen's
Ship" had whisked the Republican
Presidential candidate in and out of
this once-battered industrial corner
of Michigan, it seemed as if everyone
in Saginaw had seen the image the
Dole campaign wanted them to see:
Mr. Dole, in a gesture of Reagan-
esque simplicity, holding a nickel aloft
to symbolize how he would go about
cutting the Federal budget.

"Five cents!" he had shouted to
the airport crowd, a scene that local
television stations in Michigan ran
again and again over the weekend.
"All I have to do is take 5 cents out
a dollar to pay for this package,"
said, insisting that would be enough
to pay for a tax cut of 15 percent
while paying off the deficit Washing-
ton has run up over the last 15 years.
Mr. Dole's handlers were delighted
with the headline the next morning in
The Saginaw News: "Dole Clarifies
15 Percent Solution."

But when neighbors in the Herit-
age Square section of this ethnically
and politically mixed city gathered
for coffee and muffins one morning
this weekend, not one of them, even
Republicans who said they liked and
trusted Mr. Dole and would probably
vote for him, said they found his
central message credible.

"This isn't the 1980's, they com-
plained. Michigan's economy, fueled
by the automobile industry, has
roared back. In fact, the survivors of
the General Motors downsizing here

are now working too much overtime,
they assert. As a result, they say Mr.
Dole's economic message seems off
the point, focusing on taxes rather
than on what they want to hear: how
to hang onto their jobs in the next
recession, how to cope with competi-
tion from low-wage labor abroad and
how to make sure their children
know how to use computers.

"Forget the dinky tax cut," was
the advice offered by William E.
Fentress, a manager at Cincinnati
Milacron's purchasing department,
after Mr. Dole visited the company
last Thursday.

As his co-workers around the fac
machine nodded in agreement, Mr.
Fentress added, "We could use that
money to get rid of the deficit first."

Here in Saginaw, Mr. Dole's effort
to reduce his message to a camera-
ready scene — 15 percent — has
yielded more frustration than votes.
"It's not that people around here
wouldn't vote for a Republican,
cause there's not much loyalty to
party," said James W. Woolfolk 3d,
who has lived here since 1971 and

Continued on Page A18, Column 1

Spiro T. Agnew, Ex-Vice President, Dies at 77

Spiro T. Agnew, who was forced to
resign as the 38th Vice President of
the United States in 1973 when he
faced no contest to a charge of
income tax evasion, died yesterday
in Berkeley, Md. He was 77 years old.

John Moylan, the owner of Ullrich
Funeral Home in Berlin, Md.,
Mr. Agnew died at Atlantic General
Hospital in Berlin. A spokesman
for Atlantic General Hospital would
provide no details about his death.

Mr. Agnew, a Greek immigrant's
son whose rise to high office had
seemed to be a reassuring examina-
tion of the American dream, was
nearly unknown outside his native
state of Maryland when Richard M.
Nixon chose him as a running mate
in 1968. And Mr. Agnew might have
been as little remembered as most
Vice Presidents without the notori-
ety of his enforced departure.

Mr. Agnew's national experience,
before he won the Vice Presidency,
included three years as an appointed
member of the local zoning appeals
board in Baltimore County, two
years as the equivalent of county
mayor, of his suburban county, and
less than two years as Governor of
Maryland.

Mr. Nixon saw much of the sur-
prise had cornered so heartily
defended his choice at the time, say-
ing of Mr. Agnew, "He has really
impressed me with his tremendous
brain power, great courage and
unprejudiced legal mind. He has
or, imagination and above all, he

DYS
FUNC
TIONAL

Spiro T. Agnew

acts. He has the attributes of a
statesman of the first rank." Never-
theless, one widespread response to
Mr. Nixon's choice was "Spiro
who?"

The nine ial campaign
did little to Mr. Ag
age, marked as by ries of
gaffes. He spoke "Polacks," and of
a "fat Jap", ated Vice Presi-
Hubert H. Humphrey, the Dem-
candidate, of being "soft on
Communism," a comment that
even from fellow R
can though billed as the
camp han expert, Mr. Agn

ENOUGH TO
GIVE YOU
HEARTBURN

Continued on Page D21, Column 1

Safety of Catheter Into the Heart Is Questioned, Startling Doctors

By LAWRENCE K. ALTMAN

A standard procedure used more
than a million times a year on seri-
ously ill patients in this country of-
fers no benefit and may kill some
people, according to a new study that
is causing consternation among
many doctors.

For 25 years, doctors working in
high-technology world of inten-
sive care units have relied on the
procedure to diagnose, monitor and
treat very sick patients, like those
experiencing heart, lung or multi-
organ failure. The procedure in-
es data, and
hang and
body's use of the

But the authors of the study, led by
Dr tested the procedure in a large
randomized controlled trial, the
most scientifically rigorous type of
study.

This study was not that type of
trial, and some experts immediately
challenged the study's findings. Nev-
ertheless, the authors said it offered
compelling evidence but no proof of
the procedure's dangers. They also
said they could not determine pre-

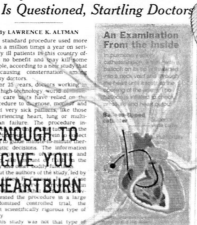

An Examination From the Inside

Continued on Page B2, Column 3

New York's Schools Are Planning a Test Of All-Year Classes

By VIVIAN S. TOY

Schools Chancellor Rudy Crew
said yesterday that to cut class size
at some schools, the Board of Educa-
tion will begin testing a year-round
school calendar in one of New York
City's overcrowded districts next
fall.

Testifying before a City Council
hearing on school crowding, the
said he would prefer not
to year-round classes be-
cause potential to disrupt fam-
ily schedules. But he said it appeared
to be an inevitable short-term solu-
to the problem.

There have been a couple of super-
intendents with whom I've spoken
who have expressed some interest in
the and who certainly as
pilots, and represent able
starting points for actually imple-
menting

He spoke of a school
districts could be taking the position
for the pilot program, but the
severely d districts in
Queens and the Bronx. Nor did he
say how many students the program
might include.

While previous have
announced similar s

Continued on Page B2, Column

INSIDE

Simpson Civil Tri ns
A civil trial for O. J. opens
with the judge issu that
show it will be difficult for him to
repeat the tactics that won him an ac-
quittal last year. Page A14

Examining a Woman's Killing
Police officials failed to inform pros-
ecutors that they were ending pro-
tection for a woman later slain by
her abusive boyfriend. Page B1

Shubert Splits a Top Role
The Broadway theater's legendary
owner and patron has divided the
role of its late president, reaffirm-
power of its chairman, Ger-
ald Schoenfeld. Page C13

Student Wins Appeal on Gun
The suspension of a Bronx high
school student who took a loaded
handgun to school was overturned by
a state appeals court. Page B2

Fish From the Farm
Salmon, catfish, trout and others are
increasingly farmed, not caught, and
questions are being raised about the
taste and purity of the cultivated
product. The Living Section, page C1

The New York Times

"All the News That Fits"

Late Edition
New York: Today, mostly sunny, breezy. High 74. Tonight, clear, diminishing winds. Low 54. Tomorrow, mostly sunny, nice. High 73. Yesterday, high 65, low 54. Details, page C18.

VOL. CXLVI.... No. 50,555 Copyright © 1996 The New York Times NEW YORK, THURSDAY, SEPTEMBER 19, 1996 $1 beyond the greater New York metropolitan area 60 CENTS

1991 BLAST IN IRAQ MAY HAVE EXPOSED 5,000 G.I.'S TO GAS

A SHARP RISE IN NUMBERS

Report by Pentagon Suggests Supply Dump's Destruction Loosed a Nerve Agent

By PHILIP SHENON

WASHINGTON, Sept. 18 — The Defense Department announced tonight that more than 5,000 American troops might have been exposed to deadly chemical weapons when a battalion of American soldiers blew up an ammunition depot days after the end of the Persian Gulf war.

The announcement by the Pentagon raises sharply the number of troops who may have been exposed to sarin, a deadly nerve agent, as a result of the demolition of the Kamisiyah ammunition depot in southern Iraq in March 1991.

It will also deepen the speculation about the Pentagon's role in a cover-up that is being disclosed only now, more than five years after the war.

Previously, the Pentagon had suggested that only about 300 to 400 troops may have been exposed to the toxic chemicals and that it knew of only one location within the vast Iraqi ammunition site that may have contained chemical agents at the time of the demolition. That site, a concrete bunker, was destroyed on March 4, 1991.

In a statement released here this evening, the Defense Department said its investigators had learned only recently of a second site in the ammunition depot that contained chemical weapons — a pit area where American troops destroyed rocket shells on March 10.

Thousands of veterans of the war have complained of health problems — especially gastrointestinal ailments, chronic fatigue, headaches and tumors — that they attribute to their service in the gulf. Some researchers have suggested that the health problems are the result of exposure to low levels of Iraqi chemical or biological weapons, although the Pentagon says it has no evidence of a link.

The announcement tonight suggests that two plumes of chemical agents — released into the atmosphere less than a week apart — may have wafted over American soldiers miles away.

"Low-level exposure may have taken place around the Kamisiyah site the statement area is about 16 miles.

The statement immediately about 5,000 serviceman who were in the possible dispersion area."

"As we learn more about Kamisiyah in the next few weeks," the troops might have been exposed.

Capt. Michael Doubleday, a Pentagon spokesman, said the information was released late in the day because

Continued on Page A9, Column 1

Hussein's Gamble

The Iraqi president seems to have over the could at home and Iraqis who say to his bet.

News analysis, page A18.

INSIDE

Spiro Agnew Dead at 77
Spiro T. Agnew, the tart-tongued political combatant who had to resign as Richard Nixon's Vice President in 1973 in the face of a kickback scandal, died of leukemia. Page B15.

Sharp Rise in U.S. Trade Gap
The United States trade deficit widened by 42.7 percent in July, surprising economists. The drop in exports suggested that the economy had begun to slow. Page D1.

Yanks Draw First Blood
In their biggest series of the season, the Yankees rallied to beat Baltimore in 10 innings, 3-2, and stretch their lead to four games. B17.

Transit Union Agrees to Allow Workfare Plan

Gets No-Layoffs Pledge in Deal With M.T.A.

By RICHARD PÉREZ-PEÑA

Leaders of New York City's transit workers agreed yesterday to would be laid off through 1999. The deal, officials said, would produce savings transit system general.

The agreement, part of a new contract that still must be ratified by rank-and-file members of the Transport Workers Union, was reached after talks prompted by a Metropolitan Transportation Authority to hire a private and to lay off employees.

Under the M.T.A. would cut up running jobs attrition, bringing der the city workforce.

When vacancies occur those 50% jobs, some welfare recipients would be hired full time, and union officials said.

"It's important to us that we are not pushing the welfare recipient... the Transit Authority we were giving them a opportunity, hope," said who grew up on welfare and who this year came president of Local 100, which represents transit workers.

eral welfare problems dates that many work, similar pro train to spring up around

M.T.A. program actually moving people from welfare real jobs, a departure workfare programs, and it is something to see more of around," said Mark Cohan, a professor Center on Social Law, a Manhattan organization that assists welfare recipients

Continued on Page B5, Column 1

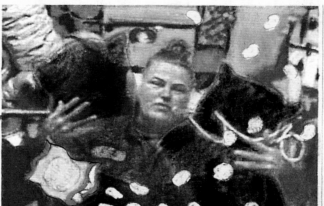

Weather and mechanical delays kept Shannon W. Lucid in space for her children's latest birthday parties.

NASA via Associated Press

A Hankering for Home
Shannon Wells Lucid

By WILLIAM J. BROAD

In the News

For the past half year she has been dealing with the exigencies of sponge baths, dehydrated food, 17,000 miles an.

She has been dealing with being in orbit pected, working tific projects operation in East tures.

But it is no secret that she is longing to get back to her family and a few creature comforts after living in a Russian space outpost seven weeks longer than planned, her return delayed by a hurricane and shuttle problems. ("I miss things like potato chips and junk food," she said in one of her broadcasts home.)

Her terrestrial hopes fulfillment as the shuttle docked with the Mir station up and drop off her John E. Blaha.

pears fit, relaxed and close to her normal weight of 150 pounds. NASA officials have paid special attention to her weight because experience of her only other American predecessor on the space station, Dr. Norman Thagard, a 52-year-old physician, was thin at the start of his four-month mission and came back to Earth more than 17 pounds lighter, causing some officials at the National Aeronautics and Space Administration to fear for his health. It took him several months to recover his weight.

In orbit, Dr. Lucid has been nourished

Continued on Page A24, Column 1

South Koreans Hunt Last of Infiltrators From Sub

By NICHOLAS D. KRISTOF

SEOUL, South Korea, Thursday, Sept. 19 — Thousands of South Korean troops tracker dogs a mountainous of a commandos who apparently sneaked into South Korea by submarine before dawn on Wednesday.

The authorities killed the infiltrators death this morning and captured after arresting one on Wednesday. The authorities also found the bodies of 11 others and the South Korean Government fears they may be planning sabotage.

The incident, which began when a suspicious taxi driver spotted the outline of a submarine just offshore, raised tensions in the already tense region. Amid the barbed wire and agree on is that the other could launch a war with little notice. Korea has periodically sent armed into the South, most recently and they are dropped submarine is rare.

The North Korean submarine, bay 100 near the east Kangnung. One American military expert said that the submarine had appeared to have damaged tower and to that it is the South to land today

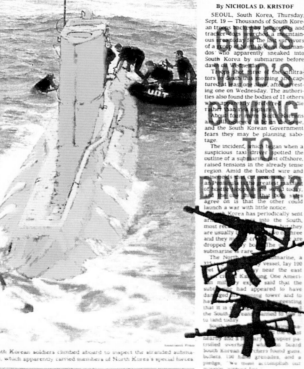

South Korean soldiers climbed aboard to inspect the stranded submarine, which apparently carried members of North Korea's special forces.

Government Photo

PEROT DENOUNCES SET-UP OF DEBATES

Pledges to Block Event Until He Is Allowed to Take Part

By JAMES BROOKE

SAN FRANCISCO, Sept. 18 — Ross Perot today denounced the decision by the Republicans and the large donors.

Visiting Reform Party President was to seek a restraining order to delay all television debates until public opinion forced the Presidential candidates to include him. The Democrats and Republicans have proposed that the first debate be held on Oct. 6.

"I don't think this is democracy as the framers of the Constitution intended it, do you?" Mr. Perot asked in his first public response to the commission's decision on Tuesday to limit the debates to President Clinton and Bob Dole. Aides said a lawsuit would be filed by Friday in Federal District Court in Washington.

Without contesting the legal basis for his case, Mr. Perot sought to make his case in the court of public opinion, citing a Harris Poll where 76 percent of respondents said they wanted Mr. Perot in the debates.

"The American voters don't have a voice — their views are ignored by the commission," he told 600 members of the Commonwealth Club of California. "As a result of the commission's ruling on Presidential debates I expect probably we should bring Bosnia and Haiti to observe our elections."

Continued on Page B12, Column 1

Abortion Lobbyists Battle

On the eve of a House vote on enforcing a ban on a form of late-term abortion, lobbyists are waging tough public campaigns. Page B12.

New Focus on Malfunctions In Inquiry on T.W.A. Crash

By MATTHEW L. WALD

PILL FOR ABORTION CLEARS BIG HURDLE TO ITS SALE IN U.S.

ACTION BY DRUG AGENCY

With Only a Modest Step Left, the Effort's Sponsor Aims for Mid-'97 Marketing

By GINA KOLATA

An abortion-inducing drug has cleared the last major obstacle to marketing in the United States by receiving conditional approval from the Food and Drug Administration, the drug's sponsor announced yesterday.

The sponsor, the Population Council, a family-planning group based in Manhattan, hoped to have the drug available abroad, on the American market by the middle of next

The Population Council said the F.D.A. had sent it a letter of conditional approval advising that it had met the agency's requirements for safety and effectiveness. The F.D.A. asked for more information, however, regarding the drug's labeling and manufacturing process.

With both the Population Council and the F.D.A. declining to specify the precise nature of further information required by the agency, the sponsor's plan to market the drug by mid-1997 meant that it sees no major remaining hurdles in its path.

The agency's latest step toward allowing the sale of mifepristone was not unexpected; a committee of advisers to the F.D.A. recommended two months ago that approval be granted.

But the move by the Population Council comes on the eve of a hotly contested debate in the House of Representatives, and so added to the swirling furor over the drug.

The drug, scheduled for today, comes a kind of late-term procedure that abortion opponents call a "partial birth abortion." Congress voted earlier this year to outlaw the procedure, but the legislation was vetoed by President Clinton. At stake in today's vote is whether to override that veto. [Page B12.]

The New York Times

"All the News That Fits"

Late Edition
New York: Today, mostly sunny, pleasant. High 74. Tonight, clear, mild. Low 62. Tomorrow, sunshine fading behind clouds. High 81. Yesterday, high 74, low 58. Details, page B15.

VOL.CXLVI.. No.50,556 Copyright © 1996 The New York Times NEW YORK, FRIDAY, SEPTEMBER 20, 1996 It beyond the greater New York metropolitan area 60 CENTS

A Union Chief Whose Life Led to His Workfare Deal

By RICHARD PÉREZ-PEÑA

Willie James, who heads the union of New York City's transit workers, put welfare recipients to work cleaning subways and buses for the first time even as eliminated 500 union jobs. But contract talks wound down this week, and wanted something in return.

So Mr. James, the president of the union, was a far more unlikely advocate than his members, insisted that as long as seniority was to use welfare workers, they should be given an advantage in the competition for permanent transit jobs, a feature of the workfare agreement that New York City's labor peace accords.

When Mr. James became the driver and then a salaried union official made to live down a lifetime trick of his fellow drivers in the union. And considering how as they could to skip stops to the union was trailing behind and would become overloaded with disgruntled riders, falling ever further behind schedule.

Today, Mr. James comes closer

Continued on Page B4, Column 2

G. Paul Burnett/The New York Times
Willie James

REPAYING AN I.O.U.

(handwritten overlay)

Guatemala and Guerrillas Sign Accord to End 35-Year Conflict

By JULIA PRESTON

MEXICO CITY, Sept. 19 — Moving decisively toward ending the longest guerrilla conflict in the Western Hemisphere, the Government of Guatemala and the leftist rebels there signed an ambitious peace accord here today.

It sharply reduces the size and power of the military, which for decades held political control and waged a 35-year counterinsurgency in which more than 100,000 people were killed.

The Government announced today, said the agreement, which closes the military's security role, was mediated by the United Nations.

The accord signed today, the fifth to emerge from the talks, the military agreed to reduce its 46,000

troops by one third next year and cut its budget by one third by 1999. The armed forces consented to a revised mandate that removes them from responsibility for security matters inside Guatemala, returning them to the traditional role of defending the nation's borders from outside threats.

Several difficult points remain to be negotiated. The sides must still agree on how the rebels, who have fought in hidden exile, will be reintegrated into civilian life in Guatemala.

Continued on Page A10, Column 4

LONG EARS OF THE LAW

(handwritten overlay)

TRUTH STINKS

(handwritten overlay)

INSIDE

7 North Korean Agents Slain
South Korean troops shot and killed seven infiltrators from a grounded submarine, but at least one commando remained at large on citizens. Page A3.

Microsoft Under Scrutiny
A new Government inquiry into Microsoft is examining the company's sales practices for its Internet browser software. Page D1.

Yankees and Orioles Split
A doubleheader split leaves the Yankees four games ahead of the Orioles in the American League East. Each team has 10 games left. Page B9.

News Summary	A2
Business Day	D1-16
Editorial, Op-Ed	A36-37
International	A3-16
Metro	B1-6
National	A18-28
SportsFriday	B6-15
Weekend	C1-31

On the Internet: www.nytimes.com

CELLULAR INDUSTRY REJECTS U.S. PLAN FOR SURVEILLANCE

COST AND PRIVACY ISSUES

Police Want Technology That Pinpoints Wireless Users Within a Half-Second

By JOHN MARKOFF

In a showdown with the Justice Department, the wireless communications industry voted today to reject Government-backed plans that would make it easier for law enforcement agencies to keep closer tabs on cellular phone users.

The Justice Department contends that the Government has the right to use powerful new surveillance technology under a 1994 law to bring law-enforcement techniques into the modern era. Among other abilities, the Justice Department wants to be able for the first time to determine the location of a cellular phone caller within a second and almost instantly know the status of cellular-phone voice mail, conference calls and other wireless communications features.

But many industry executives and privacy-rights advocates disagree with the Government's interpretation of the law. The industry says that the new cellular abilities would be burdensomely expensive to administer. Privacy groups argue that the measures the Government seeks will give the F.B.I. and other law-enforcement agencies worrisome new powers over citizens.

"This industry looks at the law and chooses more than is actually there," said Thomas E. Wheeler, president of the Cellular Telecommunications Industry Association, a trade organization based in Washington.

F.B.I. officials, however, say they are only trying to maintain their investigative skills in the face of rapidly changing technologies that offer criminals new powers for evading detection.

"In 1968 when the original wiretap law was written, we didn't move," said the Maelstrom, the deputy director in charge of the Federal Bureau of Investigation's New York office. "As privacy people say we shouldn't have this information, but the notion that we in law enforcement should not be able to use this new technology is very troubling to me."

Industry leaders said they had not yet seen the results of the technology committee decision, and so they would not comment on what the vote might be. But the 1994 act provides for a standards-setting process that permits the Federal Government and wireless disagreements to Communica-

Continued on Page D2, Column 1

Gulf War Veterans in Navy Unit Tell of an Iraqi Chemical Attack

Michael A. Schwarz for The New York Times
Jerry Jones of Leicester, N.C., says he had to retire early because of health problems he attributes to chemical exposure in the Persian Gulf.

Troops' Stories at Odds With Pentagon Account

By PHILIP SHENON

COLUMBUS, Ga., Sept. 18 — While the Pentagon continues to insist that it has no evidence that American troops were made sick from exposure to chemical weapons during the Persian Gulf war in 1991, more than 150 members of a Naval reserve battalion have come forward with details of what many of them describe as an Iraqi chemical attack that has left them seriously ill.

Members of the unit, the 24th Naval Mobile Construction Battalion, say something exploded in the air over their camps in northern Saudi Arabia early on the morning of Jan. 19, 1991, at the start of the air war. In minutes, they say, they began to burn over lips and eyes and their throats began to tighten. Several say chemical alarms began to sound and a cloud of gas floated over their camps.

"I put my gas mask on right away, but by the time I got to the bunker, my hands and face were burning, and I couldn't breathe," said Roy Butler, a 53-year-old ... officer from Columbus who served in the 24th ... now suffered from ... fatigue, joint aches, memory ... intestinal disorders, skin rashes — all symptoms considered typical of "Gulf War Syndrome."

"Right after I got into the bunker, my lips started turning numb, and the numbness lasted for several days" Mr. Butler said. "We washed down and that seemed to help, but

people started complaining with blisters."

Battalion commander ... later insisted that ... actually say, have lasted ...

... spring, the Defense Department had denied that it had any evidence suggesting that large numbers of American troops were exposed to chemical weapons in the gulf war. Then in June, it acknowledged that soldiers in an Army unit, the 37th Engineer Battalion, could

SOMETHING IN THE AIR
A special report.

have been exposed when they destroyed an ammunition depot in southern Iraq in March 1991 that was later determined to have contained sarin, a deadly nerve gas.

In disclosing that incident, the Pentagon originally suggested that 300 to 400 troops might have been exposed to chemical weapons at the depot. On Wednesday, the Defense Department said a second explosion at the same depot a week later raised the figure to more than 5,000 troops.

Pentagon officials continue to insist that they have no evidence of other large-scale exposures. They said they had reviewed the incident involving the 24th Battalion in Saudi Arabia and found no sign of unusual illnesses.

But several of the Navy reservists called a reporter after the Penta-

Continued on Page A24, Column 1

CONFEREES AGREE ON MORE COVERAGE FOR HEALTH CARE

PRESIDENT FAVORS MOVE

Bills Would Require Insurance on Mental Illness and 2-Day Hospital Stays for Birth

By ROBERT PEAR

WASHINGTON, Sept. 19 — House and Senate negotiators agreed today on health insurance coverage for mental and physical illnesses more comparable ... likely that they will become law. The changes would take effect by July 1998.

Consumer groups voiced their approval of today's agreement.

Senator Pete V. Domenici, the New Mexico Republican who wrote the mental health provision, said Congress is going to take one step to get rid of the terrible stigma and discrimination that is based on a mystique, mystery and dark ... It is common for employers, insurers and health plans to set annual and lifetime limits on what they will spend for a person's medical ... Often these limits ... illnesses like cancer, diabetes and heart disease.

The new measure prohibits such differences in lifetime or annual dollar limits for mental health ... health ... plans that have health insurance ... do not set a ... to offer mental health benefits at all. Paul ..., senior vice president of consumer ... employers

In practice, ... to Mr. ... said most employers will probably set ... over-all limit for coverage of ... and physical conditions ... both. Thus for example, a health ... with a lifetime limit of $1 million in ... of ...

Continued on Page A20, Column 4

SANITY PREVAILS

(handwritten overlay)

Vote for Abortion Ban

The House voted to override President Clinton's veto ... ban on a form of late-term abortion. But the Senate is expected to ... but the veto. Republicans ... the veto into an ... gleeful about their ... victory in the House, described ... as a turning point in the debate over abortion.

Article, page A22.

Dole Appears to Be More at Ease As Election Going Gets Tougher

By ADAM NAGOURNEY

LAS VEGAS, Nev., Sept. 19 — As Bob Dole's plane rumbled over California on Wednesday night, the Republican candidate sat back ... characteristically to the ... of ... craft in search of ... or ... phers on board.

Undaunted ... turned off in store at a rally in ... earlier — as he ... undaunted as ... that have ... centers ... picture of ...

He ... played out ...

... Presidential ... back in the ... shock, his body cringed ... pher who was ... "There ... murmured, as his aides shifted uncomfortably behind him.

"My hair stayed all right as I had enough hair spray on," Mr. Dole said, continuing the banter. He made only one request for the picture that was, at that moment, being transmitted around the world. "Don't show it to my wife," Mr. Dole said, raising

an eyebrow ... flashing a grin as the crowd of reporters ... around him.

By any ... Republican candidate has endured a

CALM BEFORE THE STORM

(handwritten overlay)

A Shift in the House?

With the battle for the House now considered to be extremely competitive, the Democrats are preparing for the possibility of power, assuring voters of a House very different from the one Democrats regain their majority.

Article, page A29.

BE PREPARED

(handwritten overlay)

Backlash of Intolerance Stirring Fear in Iran

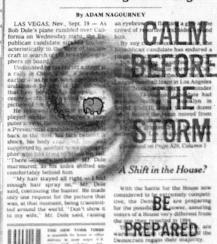

Kambiz Jahani for The New York Times
As fundamentalist authorities crack down in Iran, women's bicycle riding is confined to a fence-enclosed trail.

By NEIL MacFARQUHAR

TEHRAN, Iran — With ... raging around 50 percent ... fueled by ... politicians ... the ... Goldrums ... and the Government ... Col. Afshar, a satirical weekly, weighing in with a letter from ...

compromise — limiting his wife's riding to a stationary bicycle in the kitchen.

Some conservative religious scholars declared that, since bicycle seats resemble saddles and they believe that Muslim women should not ride horseback, then bicycling should be

cles by women in public places involves corruption and is to be forbidden.

This is a sign of widespread intolerance in Iran, a backlash against the incremental loosening of clerical control over the last few years in the arenas of politics, education, the arts and social activity. Today ... has a ... free ...

MEN BEHAVING MADLY

(handwritten overlay)

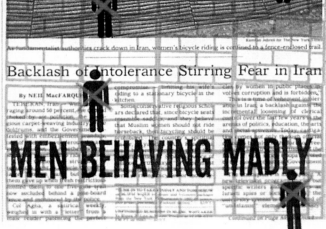

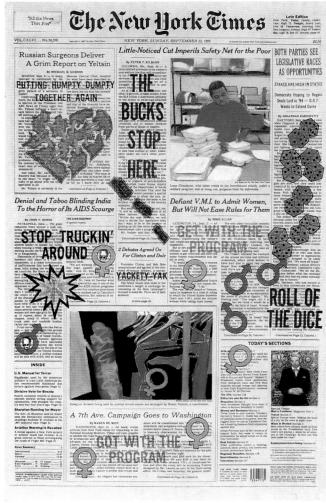

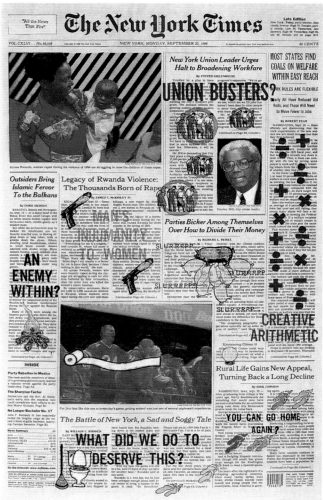

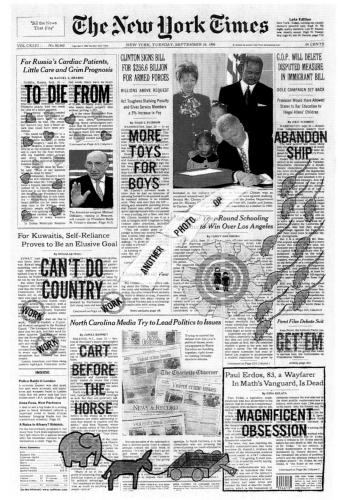

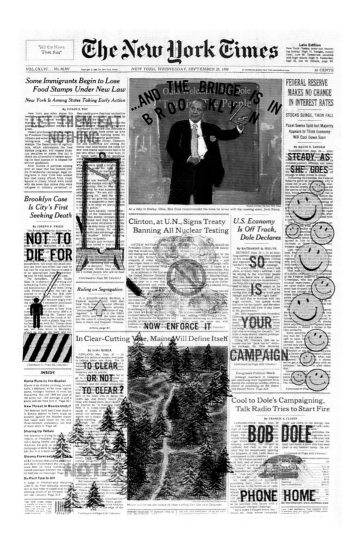

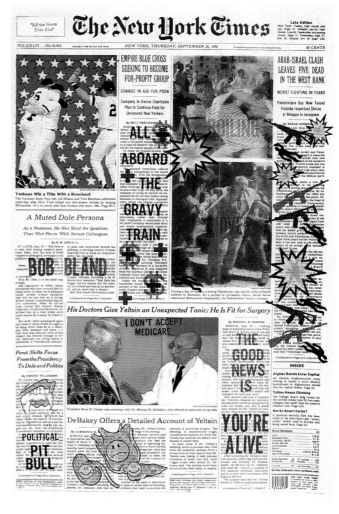

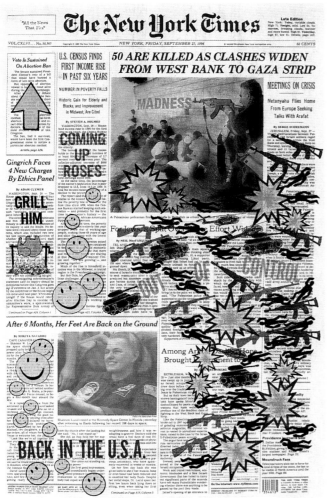

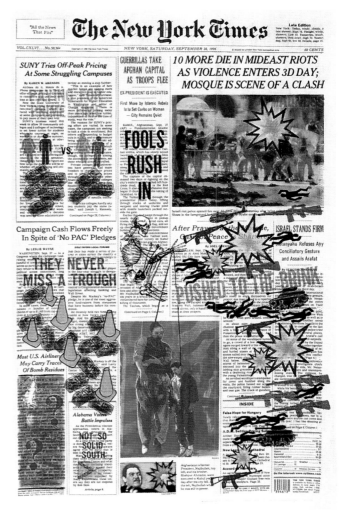

The New York Times

Late Edition
New York: Today, showers ending, brightening skies. High 76. Tonight, partly cloudy. Low 59. Tomorrow, sunny, pleasant, High 71. Yesterday, high 74, low 65. Details are on page 46.

VOL. CXLVI ... No. 50,565 Copyright © 1996 The New York Times NEW YORK, SUNDAY, SEPTEMBER 29, 1996 $3 beyond the greater New York metropolitan area. $2.50

Dole, in Choosing Kemp, Buried A Bitter Past Rooted in Doctrine

By ELIZABETH KOLBERT

A POLITICAL LIFE
Overcoming Differences

WASHINGTON — Even in an age of politics by autobiography, Bob

STRANGE BED-FELLOWS

II, his memories, as he said in his acceptance speech, of "an America only the unknowing call myth."

But when Mr. Dole embraced Kemp as his running mate last month, he put a long stretch of personal history aside.

As the two men have ... across the country together ... ing and bantering with each ... has not seemed to matter ... had spent nearly 15 years ... and exchanging insults. N... seem to matter that Mr. K... secretly helped engineer on ... Dole's most costly and hu... defeats as a legislative lead...

No ... to m... just ... to ... picked ... ma... Kemp ... mate political affront, endorsing his opponent in the Republican primaries, Steve Forbes, well after it was ... Mr. For...

of ...
paigns, the history of conflict between Mr. Dole and Mr. Kemp is, in fact, much more than that. A look at their shared past shows that the two men clashed not merely because they were rivals for political power — though this was doubtless part of it — but because they saw themselves

as representing alternative futures for the Republican Party.

Until last month, Mr. Dole could hav... ... ficit hawk ... ment ... in. ... tive, he ... he few ... sident

Kemp
Continued on Page 18, Column 1

Florida Victory No Sure Thing For the G.O.P.

By R. W. APPLE Jr.

MIAMI, Sept. 27 — It was one of the more spirited strategic arguments within Bob Dole's campaign: Should he spend serious time and money fighting for Florida, where Republican nominees have prevailed in every Presidential election since 1980 but where he has been running behind, or should the husband his resources for the big Midwestern swing states and hope for the best here?

"You g... ... Florida, and so maybe ... said one of those ... n's fourth-largest ... can't com... ... Illinois, ... and Michigan."

In the end, Mr. Dole decided that he could not afford to neglect F... ida, which is a microcosm of the ... finds himself in: states that ... constitute his have still not b... ... less than six weeks ... tion Day. In Flor... ... several polls, the Republican nominee trails President Clinton by 5 to 11 percentage points.

The most reliably Republican of the megastates, with 25 electoral votes, finds itself up for grabs.

Now the question is how large a commitment Mr. Clinton will make here. In 1988, the Democratic nominee, Michael S. Dukakis, closed his Florida headquarters in early Sep-

Continued on Page 22, Column 5

HOUSE BACKS DEAL ON BUDGET FOR '97 IN BIPARTISAN VOTE

A PACT ON IMMIGRATION

Republicans Yield to President on Benefits but Hold Fast to $30 Billion in Cuts

By JERRY GRAY

WASHINGTON, Sept. 28 — The House onight overw... ... ly approved a budget deal for 199... ... olds to President Clinton on iss... ... nd on some spending priorities but holds fast to Republican demands for $30 billion in overall cuts.

LET'S MAKE A DEAL

... ... vote of 370 to 3 part of 202 Republicans, 1... Democrats and the lone independent in the House. There were 24 Republicans and 13 Democrats ... the ...

... nate prove the on Mond... ident Clinton will sign the bill as soon as it reaches his desk, likely later that day.

... ... ouse came after Congressional ne... ... White House negotiators out on the budget orning.

The d... cene after a week of intense negotiations that · were capped by three sessions that stretched into the early-morning hours.

The toughest negotiations involved the immigration bill, which will also be folded into the larger measure. The White House had raised objections to provisions involving legal immigrants, particularly one that would have denied medical services for legal aliens suffering from AIDS. [Page 28.]

Early today, the Republicans backed away from that provision.

Continued on Page 28, Column 3

A Tougher Welfare Stance
Gov. George E. Pataki plans to renew his push for strict time limits on Home Relief, the state-financed cash assistance program for the poor. Page 39.

Violence Ebbs, Uneasily, in West Bank

An unidentified Palestinian comforted an Israeli border policeman injured yesterday in a jeep accident. Reuters

How Palestinian Policemen Were Drawn Into the Conflict

By NEIL MacFARQUHAR

RAFAH ... Strip, Sept. 28 — The fe... ... gypt and the Gaza Strip torn ... by hundreds of ... demonstrators by the time ... a Palestinian police... ... orders on Thursday to try to push all the Palestinian civili... away from the border.

He said he had been ... through the crowd ... hundreds of men, women and children for about 15 minutes when bullets from a near-by Israeli watchtower whizzed into the crowd, wounding two Palestinian men. At that point an elderly woman in a white head scarf grabbed his arm and asked why he was not fighting when ... ilians like herself were willing to ... for the cause.

At that ... he stood behind a wall and started ... ng toward the watchtower. ...

"I n... my life that I would in G... za where I would be ing at K... elis," said the 32-year-old policeman, who did not want his full name published

... out of f... ... ld ... e disci... po... fire. He ent ... morning trying to find 20 b... ... ts o... black market to replace ... clip he had expended against the watchtower.

"I had always been able to main... ... a barrier between my feelings as an ordinary citizen against the peace process, which has brought us nothing, and my military orders to preserve it," said Zahir, one of about 5,000 Palestinian fighters who returned from exile in May 1994 to form the foundation of a police force that has since grown to 40,000.

"But how am I supposed to follow orders when I see my cousin, my brother or my neighbor being wounded?" he continued. "At that moment the contradiction became too strong. My emotional reaction to take gun and respond overcame my military reaction ...

Palestinian ... ce commanders,
Continued on Page ... Column 5

Attention Turns to a U.S. Bid for Talks

By SERGE SCHMEMANN

JERUSALEM, Sept. 28 — A tense quiet settled over the West Bank and Gaza Strip today as the Palestinian police sought to prevent new fighting and American mediators pursued intensive efforts to arrange a meeting between the leaders of Israel and the Palestinians.

For the moment, both sides are reportedly locked over whether the meeting should be first between Prime Minister Benjamin Netanyahu and Yasir Arafat as Israel wants, or also with Egyptian and American participation, as the Palestinians insist.

Several clashes were reported to-day between Palestinian youths and Israeli soldiers, but they were not comparable in scope or bloodshed to the gun ... ts that flared over the last thre... ... ys, taking 54 Palestinian an... ... li lives.

I... the West Bank, and za Strip the scenes of some of the frontations, the Palestinian po... ... edge of men were shooting at Israeli soldiers this week, prevented ongs of youths from marc... ... on Israeli posts and ...

... Israeli Chief of Staff, Lieut. ... Amnon Shahak, declared that the situation remained "very unstable," and "liable to flare up at any moment." He warned that two militant Islamic organizations, Hamas ... Islamic Jihad, could stage terror ...

... announce... sures any ce... ting... ... full ba... ... move... Palestinians a... their town byes and the de... ... ment of ta... helicopters th... about the West Bank and alo... ... separating Israel from P... ian-run are... Israeli soldiers ... re ordered to hold back if ... from

Continued on Page ...

INSIDE

A Challenge to Yeltsin
In a challenge to Boris N. Yeltsin, his security adviser suggested that the ailing Russian President should temporarily step down. Page 9.

Redwood Reprieve
Negotiators reached a tentative agreement with a timber company to avert logging on thousands of acres of redwood forests. Page 38.

Gooden Will Watch
A slumping Dwight Gooden will not be included on the Yankees' roster for the first round of the playoffs. SportsSunday on 8.

News Summary
International	3-14
Metro	39-44
National	18-38

Obituaries	45	TV Update	34
Radio Highlights	34	Weather	46
Styles	47	Weddings	50

On the Internet: www.nytimes.com

SPECIAL TODAY

The Next Hundred Years

Reformers, writers and artists have long deployed visions of the future as parables, offering insight into their times. Today, in a third and final commemoration of its centennial, The New York Times Magazine responds to that same impulse, to use tomorrow as a prism through which to cast light on today.

Magazine, section 6

For Rural Japanese, Death Doesn't Break Family Ties

By NICHOLAS D. KRISTOF

MAIN STREET, JAPAN
Dead, but Not Gone

OMIYA, Japan, Sept. 25 — Bursting through the front door of hi... fri... ... ho... As... ... turned living room bypass family memb... ... chat with his buddy, offer him a drink, and ask for some help.

"Hi there Yaji... As... ha said casually to his friend ld day isn't it? How ke a ... look at you."

The friend, Isekichi T... jimoto, did not reply. He died last ... vember.

But it is just proto... ... Mr. Akita explained later, to s... first to the eldest person pres... if he is neither exactly a p... rt-ly present. "This is t... should greet people i... emphasized as he sat in room, looking warmly up dhist altar where his late fr... ... is said to reside.

Mr. Tsujimoto may be dead, but h... is certainly not gone. As is custom ... in Japan, he remains a res... ... ed presence in the house, regular... ... nsulted by family members tant matters. They giv... ... m a ... down on the local t... daily with te... even includ...

"Wher... dance him so... we're say... law, believe ities a... And as a Buddh... posed to an ... the

... SEE YOU ... TONI... ... CHECK ... of the Arts & Leisure section. The A... ... The New School offers world-class affordable Call 1-800-555-4251 Ext. F-10 for an events caler... ... Adv.

FREE EXPERT TIPS FOR THE INTERNET ...

Page 10, Col... mn 3

From Rap's Rhythms, a Retooling of Poetry

By MICHEL MARRIOTT

Even before the slaying of ... Shakur this month, the inspired by rap had started an intense self-appraisal. It soul-searching has led it, increasingly, to rap's precursor, street poetry, and has given rise to the "spoken word" move-

SPOKEN WORDZ

... young men and women have been re... use of the rhymes and rh... of magery, dru... -studio gimmickry. And when these new poets use musical backgrounds, they are only backgrounds; they do not dominate the words, as in rap.

A slew of poets, including some older veterans, are pounding out grit-ty-yet sophisticated meditations that ... ine issues of passion and pain and Their heroes are less likely the likes of Shakur and his Snoop Doggy Dogg. atures like Langston Amiri Baraka, Nikki Gio... ... Scott-Heron, and the Last e Harlem-based group of olutionaries who first career rap t a few eer poetry. people than ever are slowly ely turning their ears toward said Saul William, a 24-... ... old p... and a rising star of this world called ... poken w... ... d r... ... Wil-liams, of Brooklyn, has cars and on college campu... nantly black standing-r... -only crowds that cheer at the ... ere mention of his first name.

Mr. Willia... ... cently opened his "Untimely M... ... ations" with this:
The fiery sun of my passions evaporates the love lakes of my soul
closeth my thoug... and rains you int... ... istence.

... uch wordplay r. Willia... ...

Continued on Page ... Column ...

... Care Moore, who performed on Friday at ... au Commu College, ... ays: "We have gats and 40's in our poetry, but we also bout ways to get around them. We just don't celebrate it."

GONE BUT NOT REALLY GONE

TODAY'S SECTIONS

Arts and Leisure/Section 2
Contemporary art is flourishing across Asia, and Western audiences are finally getting a chance to see some of it.

Automobiles/Section 11†

Book Review/Section 7
Everyone agrees that American education needs reform. E. D. Hirsch Jr., in "The Schools We Need," offers a program. So does Theodore R. Sizer in "Horace's Hope." Naturally, they are not the same program at all. Sara Mosle reviews both books.

The City/Section 13§

Editorials and Op-Ed/Section 4

Magazine/Section 6

... and Business/Section 3
... New York ... azine's brash edi-... was let go the message ... no different an ... ing number of ot... on ne... ... papers, maga... grams and pu... houses hear-ing from the giant corpo... that have swallowed them up your numbers or else.

Real Estate/Section 9*
A ... market focus for housing devel-... the not-quite-retired.

... nal Weeklies/Section 13§

... portsSunday/Section 8

Television/Section 12†

Travel/Section 5
Three American Niagara Falls, Civil War site... ... the Universal Studios tour. Also, ... Robert Trent Jones golf trail in Alabama.

Week in Review/Section 4
After the Palestinian fury has been let loose, can the peace process in Israel still be considered irreversible?

Employment Advertising/Section 10*

* In New York City and the metropolitan region.
† pages are in section 1.)
§ In ... of New York City
... Westchester, Connecticut and northern New Jersey.

THE BRITTANY HAS BEEN LEARNED FROM ...

354713

THE NEW YORK TIMES is available for home or office delivery in most major US Call, toll-free 1-800- NYTIMES. Ask about Times media TimesCard. ADV'T.

The New York Times

Late Edition
New York: Today, mostly sunny and pleasant, light wind. High 71. Tonight, clear, calm. Low near 57. Tomorrow, sunny, warmer. High 73. Yesterday, high 67, low 59. Details, page C10.

VOL. CXLVI... No. 50,566 — Copyright © 1996 The New York Times — NEW YORK, MONDAY, SEPTEMBER 30, 1996 — $1 beyond the greater New York metropolitan area — 60 CENTS

In Ohio, the Campaign Is Just Now Gearing Up

By MICHAEL WINERIP

AN AMERICAN PLACE
Up Close and Political

GENTLEMEN START YOUR ENGINES

CANTON, Ohio, Sept. 29 — To read the major newspapers and watch television, the race for President is all but over, with the nominally being Even the Doonesbury comic strip's Presidential character, the White House, has started...

Congress's Leaders Debate Issues With a Seldomly Seen Decorum

By ADAM CLYMER

CIVIL WARRIORS

Behind the Scenes, D'Amato Wields Vast Power in Albany

By JAMES DAO and JANE FRITSCH

TIES THAT BIND
A special report.

ROTTEN TO THE CORE

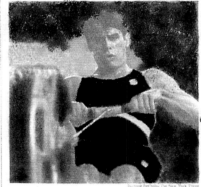

INSIDE

G.O.P.'s Budget Battle
Republicans in the 104th Congress fell short of their chief goal, a balanced budget. But they did achieve significant budget cuts. Page A14.

Unearthing a Mystery
The discovery of a skeleton in Washington State seemed to be a forensic puzzle at first, but it turned out to be an archeological one: Page A12.

U.S. USING SWAPS TO PROTECT LAND

Exchanges Broadening Federal Efforts on Sensitive Areas

By JOHN H. CUSHMAN Jr.

GIVE YOU BOARDWALK FOR PARK PLACE

TUNNEL OF BLOOD

WAVE OF HOPE

A tunnel in Jerusalem that touched off the Palestinian-Israeli clashes opened yesterday after being closed Friday and Saturday. A mixed crowd of hundreds rallied for peace at the other end of the tunnel.

LEADERS OF ISRAEL AND PALESTINIANS DUE IN WASHINGTON

TO TRY TO DEFUSE STRIFE

King Hussein to Attend Talks Over a Confrontation That Threatens Peace Pact

By SERGE SCHMEMANN

BE THERE OR ELSE

Clinton's Choice: Chaos or Diplomacy

With Olympic Glory Fading, Athletes Ponder: What Now?

1-900-PSYCHIC

Bill Carlucci, an Olympic rower, working out at his family's home.

NEWS SUMMARY

October

The *Times* hits the international note, but it's also a local rag, it's our paper. The Yankees were all over October—they were hot. At the same time, the peace conference was back on track (for the moment). The *Times* also did a big series on substandard housing in New York, beginning on October 6 and running for five days. Halloween caught up with me early, so everyone got into costume—I turned Yeltsin into a vampire on October 18, and Tiger Woods into a tiger on October 21, and then ghosts came in, with revolutionary costumes haunting the page on October 23. Even the orange cones were transformed into boomerangs. It culminated on the last day of the month, when all words and images referred to Halloween.

The New York Times

VOL. CXLVI .. No. 50,567 — Copyright © 1996 The New York Times — NEW YORK, TUESDAY, OCTOBER 1, 1996 — $1 beyond the greater New York metropolitan area. — 60 CENTS

Late Edition
New York: Today, mostly sunny, warmer. High 76. Tonight, partly cloudy. Low 60. Tomorrow, partly sunny, breezy. High 73. Yesterday, high 70, low 55. Details, page D21.

The Yankees Warm Up for Playoffs, but . . .
David Cone, right, at practice in the Stadium yesterday with Andy Pettitte, is scheduled to start Game 1 against Texas tonight. But umpires said they would not work unless Roberto Alomar of Baltimore was suspended for spitting in an umpire's face last week. Page B11.

Barton Silverman/The New York Times

New Hard Line by Big Companies Threatens German Work Benefits

By EDMUND L. ANDREWS

FRANKFURT, Sept. 30 — Shrugging off with scaling worker protests over the last few days, Germany's biggest manufacturers are starting to trim the most generous and onerous employee benefits.

In a move that could represent a major change in Germany's tradition of consensus between management and labor, companies like Daimler-Benz and the General Motors Corporation's Opel subsidiary plan to take advantage of a new law that goes into effect today and immediately cut sick pay by 20 percent — even though their workers are covered by labor contracts that do not expire until later next year.

The new willingness of the German corporations to take it upon themselves to clash with workers is being watched closely throughout Europe as a possible bellwether for changes in relations between employers and employees across the Continent. If German companies successfully extract concessions in their home country, it will almost certainly lower the bar for wages and benefits elsewhere.

The move has enraged unions and even startled the conservative Government of Chancellor Helmut Kohl, which did not expect business to apply the law to existing contracts. But it could be a harbinger of similar conflicts and changes in France, where teachers struck today to protest proposed budget cuts, and other parts of Europe.

As the Continent moves closer to economic unity in a single currency, political leaders in France are increasingly preoccupied with lowering costs. Unlike Europe generally and Germany, because they share a desire to lead Europe into the next century of economic austerity, has increasingly set the standard for economic aus-

Continued on Page D4, Column 3

New Afghan Rulers Impose Harsh Mores Of the Islamic Code

By JOHN F. BURNS

KABUL, Afghanistan, Sept. 30 — In the four days since the fall of the Taliban militia, the capital is one million people have been plunged into a labyrinth that Taliban already achieved a sweeping council of Islamic clerics has re-shaped the everyday lives of ordinary Afghans who, at least until they enjoyed one of the more liberal of the city's life. University and public sector have been closed. Kabul's television station has been closed. The playing of all music banned.

A decree on Sunday from the new Department for the Propagation of Virtue and the Prohibition of Vice ordered all men in government jobs to grow "proper beards" — untrimmed ones — within 45 days. Western-style suits are banned.

Women and girls have fared worse. Girls' schools have been closed while the clerics, known as mullahs, study the issue of education for females. Women with jobs

Continued on Page A10, Column 3

DIRECT TV HAS BEEN LIBERATED. 175 CHANnels exclusively from Liberty Cable for NYC Apt Bldgs. Call Liberty Cable 212/891-7777 — ADVT.

Arabs and Israelis Arriving for Emergency Meeting

U.S. Says 'No Miracles' Are Expected in Its Search for Peace

By STEVEN ERLANGER

WASHINGTON, Sept. 30 — Middle Eastern leaders will converge on Washington tomorrow for an emergency meeting with President Clinton that American officials said was prepared to negotiate a compromise issue of greatest concern to Palestinians, including control on the West Bank and the travel restrictions on the Palestinians...

Reuters

Yasir Arafat stopped in Cairo yesterday on his way to Washington. Prime Minister Benjamin Netanyahu of Israel left from Tel Aviv.

Associated Press

Netanyahu Seeks New Talks On 3 Major Palestinian Issues

By SERGE SCHMEMANN

WASHINGTON, Sept. 30 — Prime Minister and Palestinian delegations...

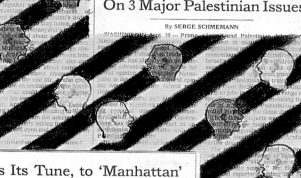

Kmart Changes Its Tune, to 'Manhattan'

By KIRK JOHNSON

From the Manhattan-centered view of the universe, Kmart has long been one of the big symbols of the world Out There, a caricature of shopping-center culture that is being laughed at both in sprinkling endlessly some fluorescent-lighted wonder of tackiness and glare.

Manhattan was the antithesis, everything that Kmart was not, lacking everything that Kmart made the Kmart formula work everywhere else: no large tracts of land to shop on, no parking lots and worst of all, high-price real estate and energy costs that would squeeze the company's already narrow profit margins into a thin shriek.

Then in the early 1990's, Kmart's formula stopped working. The company's aging suburban stores, facing take-no-prisoners competitors like Wal-Mart, stumbled. The stock price swooned and Wall Street watched for signs of decline, a Kmart was, seemingly the very model of placing the bottom-of-critical the company's spiral in each month.

In a major push, Kmart is opening two huge new stores, one at the Pennsylvania Station, while the other on Broadway between... which will open next... the company... the high operating costs, is going for volume. Each store will be expected to contribute more than $50 million in sales.

A kind of cultural exchange has begun as well. "People don't realize how normal New Yorkers are," said Myles Johns, who was appointed general manager of the 34th Street store two months ago.

Continued on Page B4, Column 1

Angel Franco/The New York Times

Kmart, which long shunned Manhattan, is opening two stores to help prop up the sag...

SENATE APPROVES A BIG BUDGET BILL, BEATING DEADLINE

CLINTON IS SET TO SIGN IT

Democrats Proclaim Victories Stemming From Reluctance to Force a Shutdown

By JERRY GRAY

WASHINGTON, Sept. 30 — The Senate passed a catchall, end-of-session bill tonight that includes nearly $400 billion in military and domestic budget appropriations for 1997, $30 billion in savings, major changes to immigration laws and a hodgepodge of other legislation.

The 84-to-15 Senate vote, only hours before the next budget year began at 12:01 A.M. on Tuesday, means Federal agencies will have the money they need to operate for the next year. The last two shutdowns that interrupted Federal services last year and worried Republicans enmity of...

Democrats crave the republican reluctance to force another impasse had led them to give way to many of their spending requests.

The House of Representatives had voted 370 to 37 on Saturday night to approve the package, known as an omnibus bill, and then adjourned.

The House had been expected to follow the Senate out to the Congressional trail with the budget package... waited down today over Medicare and public lands. A bill reauthorizing the Federal Aviation Administration.

But the Senate put those squabbles aside temporarily to approve the budget. While the Republican majority got its way on the overall size of the budget, the Clinton Administration was able to force Congressional leaders to retreat on some immigration issues, which were part of the bill, and on cuts to the President's favorite programs.

The White House said President Clinton will sign the bill. The Administration was the culmination on the legislation.

"It's clearly a victory for the President and the priorities that he has been fighting for four years," Leon E. Panetta, the White House chief of staff...

Mr. (and former Republican) chief to fire a resolution to chastise Clinton's chief rival in the presidency, Bob Dole, the Republican candidate and former Senate leader.

Asked if he thought Republicans and the White House would have come to an agreement as easily if Mr. Dole, who retired from the Senate earlier this year, were still majority leader of the Senate, he replied: "I just don't think that would have happened." He noted that while the Republican leadership were able to achieve some successful efforts... under leadership on the Senate side as well as the House in trying to get minimum wage done, get Kennedy-Kassebaum done, getting the welfare reform bill done, and now getting this large appropriations agreement enacted

Continued on Page A22, Column 5

Democratic Tide Is Eroding G.O.P.'s Stronghold in West

By B. DRUMMOND AYRES Jr.

LOS ANGELES, Sept. — George Bush carried all of the 1992 Presidential campaign and four years later, Mr. Dole is struggling to head off a similar debacle, especially in California.

With Election Day less than five weeks away, the Democrats are living in the great stretches... the surf of... seem reasonably satisfied... their lot at this point, particularly with the way the Western economy has recovered. Because of this, strategists and analysts say, voters could be poised, unless the obvious... changes, to give the... of the region's 124 electoral votes, 44 percent of the 270 needed to win a...

The Race For The President
The West

...side forces than many other Western states... account for just 15 electoral votes, with 5 electoral votes... out... report that Mr. Clinton leads... as well as in Montana... New Mexico, Washington, Oregon, Hawaii and most... all, Arizona, which has not a Democratic Presidential candidate many of those states, including California, the President's lead... a... comfortable range of a point or more points. Mr. Clinton carried 8 Western states in... early sign that the suburban region — 9 Californians now live in cities... to loose itself somewhere... traditional conservative... Mr. Clin-

Continued on Page A2

INSIDE

On the Internet: www.nytimes.com

A Plan for Coding Data
President Clinton is ready to compromise with the computer industry on coding software, provided police can get "keys." Page D1.

Chicago Schools Warned
In an effort to renew faith in Chicago's public education, the school board placed nearly a fifth of its schools on academic probation. Page A14.

New Attack on Welfare Law
Mayor Giuliani opened his attack on the Federal welfare law, saying some aspects were both inhumane and unconstitutional. Page B1.

New Jersey Couple Slain
A retired psychiatrist and his wife... social worker... stabbed... death in their... son who... questioned. Page B1.

HAPPY BIRTHDAY ELIE WIESEL FROM EARTH'S Biggest Bookstore, Amazon.com Books! http://www.amazon.com/ — ADVT.

CALL 1-800 BIRTHDAY THE EASIEST WAY to remember and send a great birthday present to anyone in the U.S. Call today! — ADVT.

354613

THE NEW YORK TIMES... delivery to most major U.S. cities. Call, toll-free: 1-800-NYTIMES. Ask about Transmedia TimesCard. ADVT.

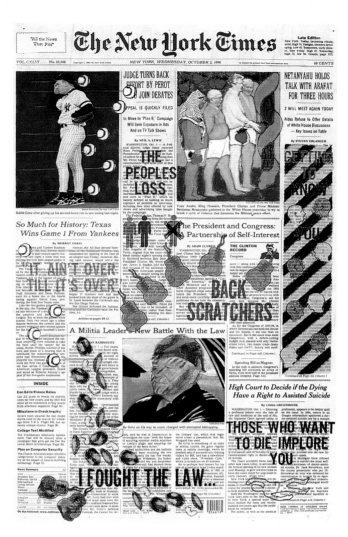
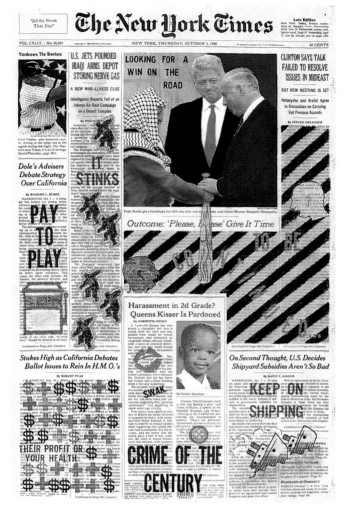
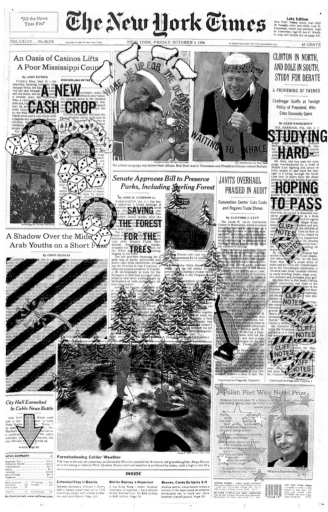
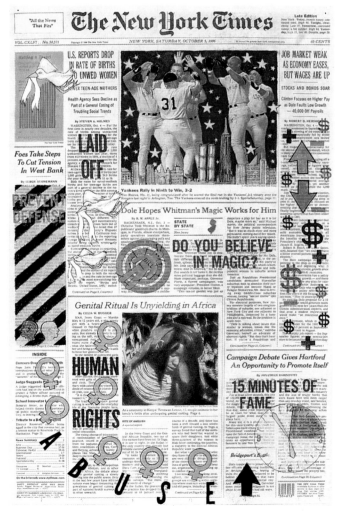

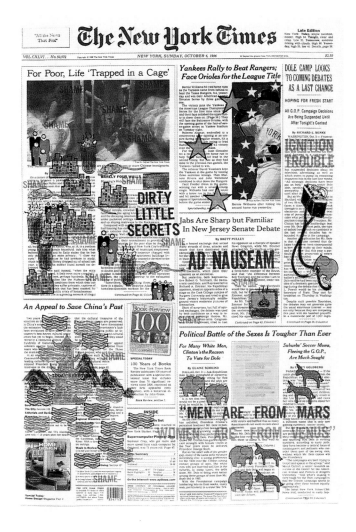

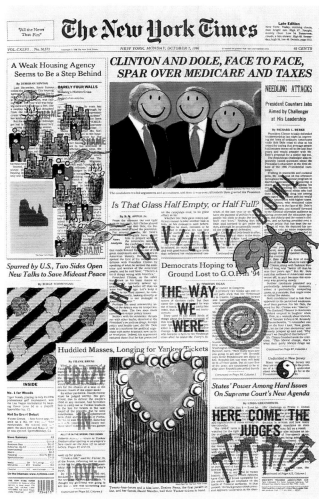

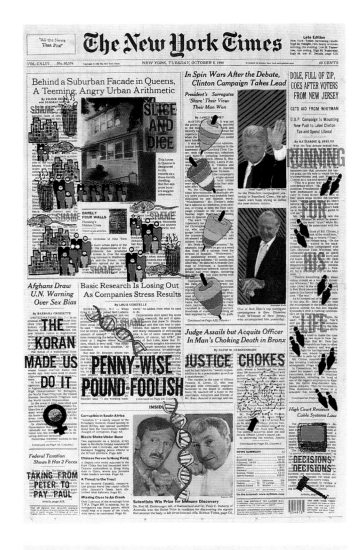

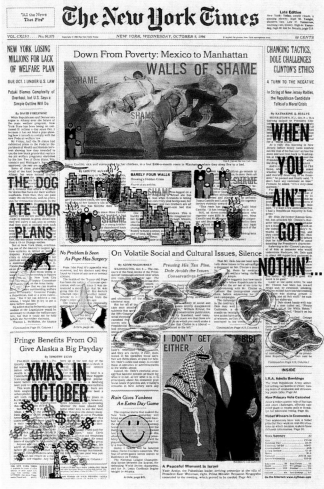

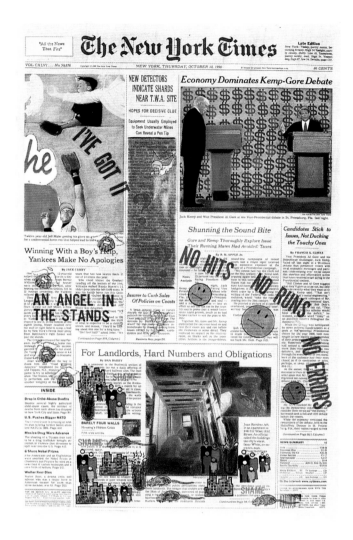

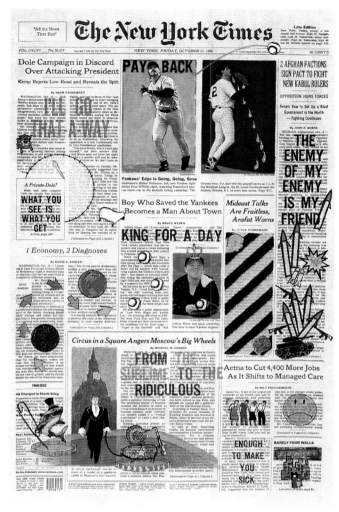

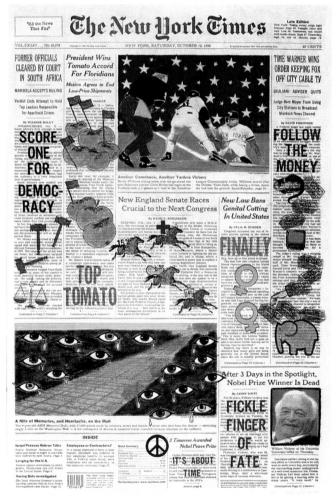

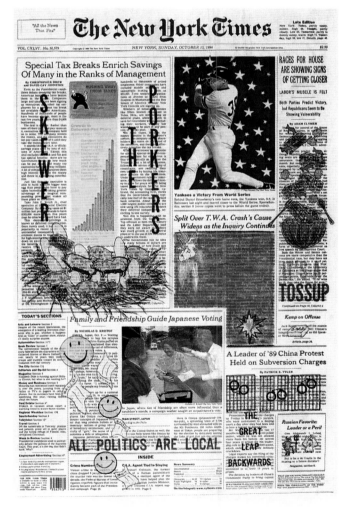

The New York Times

Late Edition
New York: Today, mostly sunny and breezy, quite mild. High 73. Tonight, mainly clear, cooler. Low 45. Tomorrow, sunny, cool. High 61. Yesterday, high 64, low 50. Details, page B5.

VOL. CXLVI No. 50,580 — Copyright © 1996 The New York Times — NEW YORK, MONDAY, OCTOBER 14, 1996 — $1 beyond the greater New York metropolitan area. — 60 CENTS

Managers Staying Dry As Corporations Sink

By DIANA B. HENRIQUES and DAVID CAY JOHNSTON

For 20 years, Ralph DeKlotz worked as an engineer for Morrison Knudsen, the fabled construction giant that fell on hard times

RUSHING AWAY FROM TAXES

The Great Retirement Divide

The second of two articles.

benefits for top executives were entirely or substantially preserved

cause the company stock he owned in his retirement savings plan became virt

Bad as he felt, he comforted by the company's and the company were in the same boat.

He was wrong. In fact, a separate retirement savings plan for about 100 top executives incurred no losses at all from the bankruptcy, even though that plan was supposedly riskier than his own.

Told of this, Mr. DeKlotz stared into space for a long moment and then asked himself softly, "Why am I not surprised?"

There were bitter surprises, too, for thousands of employees of Carter Hawley Hale, the West Coast retailer. Given no choice but to invest their 401(k) money in the company

most of executives

even supplemental benefits faced losses later, while their more powerful peers protected their own money.

In that case — in which the retailing chain Woodward & Lothrop filed for bankruptcy in early 1994 — dozens of retired executives waged a court fight but still lost a substantial chunk of their promised deferred benefits. But all the top executives still working at the company emerged from the bankruptcy with all their deferred benefits.

That case is a cautionary tale for the many middle-level managers who for the first time are feeling the chill

executives from Macy's to Dow Corning — the supplemental

WINNERS AND LOSERS

WILLIAM J. AGEE
Former chairman, Morrison Knudsen

His deferred compensation was paid despite the company's bankruptcy.

RALPH DEKLOTZ

Continued on Page B6, Column 1

Afghan Fights Islamic Tide: As a Savior or a Conqueror?

By JOHN F. BURNS

MAZAR-I-SHARIF, Afghanistan, Oct. 13 — If proof were needed that history makes curious turns, there is evidence in the heavy-set warlord with the shoe-brush mustache whose portraits loom over this old Central Asian city. Once a Communist general, he is now spoken of by people in northern Afghanistan, as Pasha, a title used by some of the region's ancient kings.

Earlier this year Abdul Rashid Dostum had been by turns a Communist-union boss on an Afghan gas field built by Soviet engineers and leader of an ethnic Uzbek militia that sided with the Soviet occupiers in their war with Muslim guerrillas. When the Soviet Union withdrew its troops from Afghanistan, he seemed washed up. But he came a major battlefield commander for Afghanistan's Communist dictatorship who won his campaigns against the Islamic

And now, long after the rebels drove the Russians out and then threw their pro-Soviet government than ever.

When he raced armored Cadillac to clandestine meeting in the Hindu Kush mountains year-old general emerged of a kind of ministate

Afghanistan. His alliance hopes to resist the Islamic purists of the Taliban movement, the guerrillas who defeated the Soviets and overrun much of Afghanistan south of the Hindu Kush.

Some who have watched General Dostum (pronounced doe-STUM) say his ambitions may run further than stopping the Taliban imposed what they say is Islamic structures in areas under their control, including ban on women's working and on girls' going to school. A diplomat here says may see himself emerging from Afghanistan's chaos as the country's new ruler, winning back years.

He thinks himself diplomat feature to the leaders of the hosemen who conquered Afghanistan in the 14th starting an t for years between Baghdad frontier of China is wide ty city and not many of martial state barrels and ling from other freedoms here. disappearance areas under Taliban control make him an icon.

Continued on Page A6, Column 1

THE NEW YORK TIMES is available for home or office delivery in most major U.S. cities. Call, toll-free 1-800-NYTIMES Ask about TimesCard. ADVT. 354613

Yankees in Series After 15 Years in Wilderness

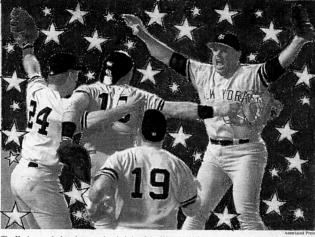

The Yankees rushed to the mound and pitcher John Wetteland, right, to celebrate winning the American League pennant in Baltimore yesterday. They open the World Series on Saturday at Yankee Stadium.

Associated Press

New York Tops Orioles by 6-4 in Clincher

By JACK CURRY

BALTIMORE, Oct. 13 — With awesome power and precise pitching, the Yankees continued their stunning superiority over Baltimore today to create a picturesque scene at Camden Yards: a 6-4 victory that secured the elusive American League Championship and the Yankees' first World Series appearance since 1981. The will be more meaningful baseball played in the Bronx in October. The season is alive.

The scenes keep getting prettier and prettier for the magical Yankees, a team that made first place its permanent spot during a regular season that was stylish comebacks its modus operandi in the post-season. The Yankees unveiled the basic nov off Scott Erickson during a six-run third inning fueled by second baseman Roberto errors able error and croz though once 5 while waiting to unlock countless bottles of Champagne.

Darryl Strawberry and Cecil Fielder, two sluggers who did not even join the assembled Yankees until July, and Jim Leyritz, who character otherwise his Andy

the 48,712 spectators to switch their focus to the Baltimore Ravens of the National Football League. The Orioles are officially finished after losing three straight games at home, going a stunning 6-9 against New York at Camden Yards this season and losing the league championship series four games to one.

"No question about it, this is the most exciting thing that has ever happened to me in this sport," said Manager Joe Torre, who will be involved in a World Series for the first time in his 32-year baseball career. "It's not close."

With music pumping in the clubhouse, the Yankees exchanged their gray uniforms for white T-shirts and white caps that declared them American League champions. The players instantly soaked the new additions to their wardrobe by reaching into a tub filled with bottles of Champagne and spraying anyone who moved in the cramped, humid

Continued on Page C7, Column 5

Clinton, in Detailed Interview, Calls His Health 'Very Good'

By LAWRENCE K. ALTMAN

DENVER, Oct. 13 — In his first interview about his health, President Clinton said that it was "very good," that he had never had a serious illness and that he had controlled his three most pesky problems: hoarseness, allergies and weight. Some, however, he misses comments in crowded areas because of hearing loss.

Mr. Clinton, who is 50 years old, pledged in the interview, on Saturday, to tell the public he developed any serious illness while in the White House. From the moment he took office, he has had a detailed written plan on how to activate the 25th Amendment if he is ever disabled and Vice President Al Gore needs to assume the duties of President. Mr. Clinton said he did not have a living will or other directive to guide his care if he developed an incapacitating illness, and details of the plan under the 25th Amendment

are classified for security reasons. Dr. E. Connie Mariano the White House physician covered a variety of potentially disabling medical conditions.

Mr. Clinton said that he had been open about his health and that he had missed only one day of work from a four-hour bout of intestinal early in his term the interview which Dr. Mariano was present, lasted about a half-hour aboard Air Force One en route to Denver. Mr. Clinton left from Denver today for Mexico to continue a campaign swing that will end with the second debate on Wednesday in San Clinton to re-enlist," said Dr. Mariano a Navy general internist, using standard military phrase to sum her belief that there are numerous reasons why Mr. Clinton serve a second

Continued on Page A12, Column 3

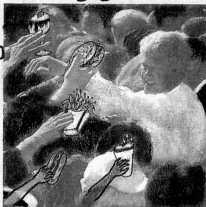

President Clinton was greeted by a large crowd that had gathered for a campaign rally at an intersection in Albuquerque, N.M., yesterday.

Monica Almeida/The New York Times

Political Ads Leap From the TV Landscape

By JAMES BENNET

PHILADELPHIA, Oct. 12 — The best turkey of the my from GMC best John Grish spend-and-tax lib Bob raised taxes by $900 billion.

The advertising between the two Presidential campaigns is nearing full strength, even in this hotly contested me paign commercial count for only a tiny fraction of slogan crossfire. On the three major commercial broadcasting networks in the past three days, only 65 out of 2,470 commercials logged during 22 hours of television-watching were

produced by the Presidential campaigns.

But that seems like plenty. The politics commercials the about truck head

"There is so much — and most of it, on both sides, is negative — that I think it's really abus" or Edward G. Rende phia, a Democrat. On

wrong for the future referring to a Clinton about Mr. Dole. "You could probably wake me up at 4 o'clock in the morn-

ing, and I could give for word."

In fact, the adverse overwhelm the ge tory repo on the on the lo televisi more ac ve, ta late-ni

When asked where voil learning about the President Rendell said, "It's it's not on the news. addition to the commercials, Pennsy tion viewers are recei reat — scorched-earth by candidates they cannot for (or against). Two Senate dates in New Jersey, Representative

Continued on Page A14, Column 2

MIDWOOD HS BK, 46-47 50TH REUNION October 27, 12 Noon. Call (718) 377-6433. — ADVT.

AIDES TO DOLE SAY HE PLANS BIG PUSH TO WIN CALIFORNIA

SEEKING ELECTORAL VOTES

Shift Is Seen as Risky and Will Mean Pulling Money From Other Important States

By RICHARD L. BERKE

WASHINGTON, Oct. fronting polls that show Clinton dominant in nearly every region of the country, senior aides to Bob Dole said today that they had tentatively decided to pour resources into California while pulling back in other important states like New Jersey and Ohio.

After Mr. Dole for about an hour with a handful of his closest advisers at his campaign's headquarters here Saturday, participants in the session unanimous agreement that they should make an about push for California.

The strategy is considered risky, and the decision comes quite late for a national campaign just three weeks before the election and at a time when Mr. Dole continues to trail the President in national polls by double-digit margins.

This particular state-by-state strategy has been the subject of an internal debate in the campaign for weeks and also comes as the campaign has been focusing, in recent days on another crucial strategy: whether Mr. Dole should attack the President on the issue of ethics in the final San

At least 11 states, with 22 electors, still appear too close to call, an are in addition to conte vigorously for votes needed for the cam pairs from dollars from grounds. But Do were buoyed Field Poll last that Mr. Dole lead there to

The aide had not to electoral always try opponen

But indicate California Jack Kem candidate rich tod can cha

o strate to t Call the pot of of it I to re

The decisions because three week be fore the election, an at the latest state polls and in ws with political profe show that

Continu

INSIDE

Gun Crime
Analyses of that crime dropped faster crime over all last year.

A Surplus of Salmon
Alaska's salmon catches are so big that fish are being thrown away, forcing down prices and prompting accusations of waste. Page A10.

Minding the Children
New York City spends millions of dollars a year paying for child care for welfare recipients without overseeing its quality or safety. Page B1.

Mexico Privatizing Ended
The Mexican Government canceled effort to sell the state-owned sector petrochemical industry to te investors. Page D2.

INTERNATIONAL OFFICE CENTERS HAS BEEN Liberated: For better business television, Call Edward Fay, Liberty Cable 212/891-7700 — ADVT.

The New York Times

VOL. CXLVI No. 50,581 Copyright © 1996 The New York Times NEW YORK, TUESDAY, OCTOBER 15, 1996 $1 beyond the greater New York metropolitan area. 60 CENTS

Late Edition
New York: Today, sun with some clouds late. High 61. Tonight, partly cloudy. Low 51. Tomorrow, variable clouds, milder. High 66. Yesterday, high 74, low 56. Details are on page B7.

Moscow Sends Homeless To Faraway Hometowns

By RACHEL L. SWARNS

MOSCOW, Oct. 14 — Behind the ica," Aleksandr V. Zolin, one of

SIBERIA HERE WE COME

He is not a criminal. He is homeless man.

In a measure condemn human rights advocates plauded by local citizen, has begun to deport thousands of homeless people, rousting them from railway stations and ble markets, detain up to 30 days with loading them on tant villages or w or w ght Boris N. Yeltsin and ari M. Luzhkov have de- the deportations as a po- on in the war on crime. of the 6,000 people de- so far have been charged any wrongdoing, the police acknowledge.

Rather, the measure seems in- tende to clear the streets of poor Russi and immigrants from the fo rep blics who have fl apital h h d perate, seae jobs and h

"We don't w ou like the streets of New York the shantytowns of Latin Amer-

debate over how to deal with reflects Russia's struggle to g with a social ill that has read since the collapse of the Soviet Union in 1991.

The new, post-Communist Rus- sian Constitution guarantees the right to freedom of movement and forbids detention without charge for more than 48 hours. And in the city's new policy, some rights advocates say they hear echoes of old Soviet decrees, which tried to close the capital to virtually all but the most politi- cally connected newcomers.

"As a whole this contradicts our Constitution and our law," Vladimir A. Kartashkin, chair- man of Mr. Yeltsin's Commission on Human Rights, said of the new policy. "This is a very serious issue."

Mr. Kartashkin said his com- mission would study the matter and present its findings to Mr. Yeltsin in a few months.

Undeterred by such criticism, officials re dily acknowledge

Continued on P

Powerful Bull Market Sends Dow To Its First Closing Above 6,000

By FLOYD NORRIS

UP UP AND AWAY

Continuing one of the most power- ful market advances in history, the Dow Jones industrial average rose past 6,000 yesterday, closing up 40.62 points at 6,010.

The Dow, by far the most widely watched gauge of the market, has risen 78 percent in the just over six years since the current run began after prices bottomed on Oct. 11, 1990, during the 1990-91 recession.

owes its strength easing p of stock and p funds concerned about having enough money for retirement.

And it reflects the prolonged eco- nomic cycle. The relatively slow growth of cized by B campaign well on W

"We call it the Silly Putty cycle," said Abby Joseph Cohen, co-chair- woman of the investment policy committee at Goldman, Sachs. "It is stretch out because things are de- veloping o result, she said d recession it g torm sig threat, and stock prices have contin- ued to advance. She noted that corpo- rate profits had risen substantially over the six years.

During that entire stretch, the Dow

has never suffered a 10 per cline. Not in the history which es back 100 aver su ever such

6 years than 16 years to make it to e double to 4,000 took just ove years. And the 6,000 mark wa reached only five and a half years after the index first hit 3,000.

The final lift above 6,000 came on Columbus Day, a holiday for many, including the bond market. Volume was light by current stock market standards, but trading on the New York Stock Exchange still exceeded 300 million shares, a figure that would have seemed very high only a

Continued on Page D23, Column 1

INSIDE

Crew Reviews His First Year
Acknowledging only modest gains in his first year, Schools Chancellor Rudy Crew said that just surviving in the job was a feat. Page B1.

An Afghan Fighter's Life
Afghan fighters rarely express fear, but rather a general sense that a life spent in the pursuit of battle is about all a man can expect. Page A3.

The Role of Microbes
Microbes have played a major role in shaping the earth's features. Hu- mans are no bar to their handiwork. Science Times, page C1.

On the Internet: www.nytimes.com

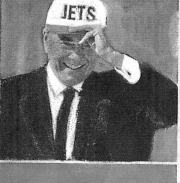

IT'S YOUR MONEY THAT WE'RE SPENDING, SUCKERS

e ential candidate es yesterday P esident Clinton, r ckin s e er's hat in Albuquerque, N.M., announced that surplus military planes w ight fires. In Kansas City, Mo., Mr. Dol he f the Administration.

Monica Almeida/The New York Times

Victory by Yankees Ignites New Battle: A Fight for Tickets

With the Yankees World Series for the first ti ears, the hottest commodit n this week is a ticket to the October Clas- sic. d strings, while others shell hundreds of dollars to scalp most determined wait- ed in lin at Yankee Stadium, in many cases missing work for the chance to pay s to $70 apiece for seats.

$

By the time box office opened yesterday, sands of fans were camped out, complaining about the lack of bathrooms and the tactics of ticket scalpers who were cutting in line. But for ll agony, many fans eft satisf ickets in hand. hose wh buy tickets by telephone, b ther hand, were mostly met with busy signals.

MY KINGDOM FOR A SEAT

Even the best connected were not guaranteed seats. The concierge at Hotel said chances of get- ket were virtually nil. Bro- were selling them for as

Meanwhile, the team was back in town savoring victory over the Baltimore and waiting to find out wha opponent will be. In the National League playoffs, Atlanta stayed alive by crushing St. Louis 14-0, he Bra won 3-2 in the se

Continued on Page D23, Column 1

Articles, pages B1 and

Shifting Tone of Campaign, Dole Presses the Ethics Issue

By ADAM NAGOURNEY

KANSAS CITY, Mo. Oct. 14 — Bob Dole mounted a pre on President Clinton e day, comparing potenti use scandals to Waterg man- manded, reversing an earlier state- that M ton the o a assoc which ons, war c istration," Mr. Dole shouted to a crowd gathered under a hot October sun for a holiday lunchtime rally here. "He does not have an ethical Administration. And we're going to go after that in that debate Wednes- day night."

Later, after some public prodding by his aides, the Republican Presi- dential candidate dened his as- sault and demag Mr. Clinton explain la dispu campaign contri g cates that ha ecent news accoun had not raised eech here, came a windy airpor d his re- marks talking is press sec- retary reading emorandum issued th camp ign manager ton about he contributions to the Democratic Party.

"We're going to raise the questions every day until the President prop- erly responds," Mr. Dole said, stand- ing in the shadow of his chartered Boeing 727 before flying off for San

AT CHURCH, POLITICS ASIDE

At a conservative Christian church in Stark County, Ohio, a political bell- politics are gen- the sanctuary. An ge A18.

THE MUD SLINGING BEGINS

Diego. Mr. Pr why they did it."

Mr inton's spokesman, Joe Lock aid this evening that Mr. Dol statemen lemaid that ing down the low road for the he added, "I've now this is suppo really ab

Mr. Dol his aides ve sent varied signals since the first Presi-

Continued on Page A23, Column 1

Clinton Steers Clear Of Tough Questions

President Clinton, flanked by fire- fighters at a speech in Albuquerque, N.M., announced that he had signed the ant Aircraft Transfer Act t b contro ver- si bill that would allow the Defense Depa ment to sell surplus aircraft to priva e contractors help them fight fores.

M Cli not usually make i such modest legislati b missing no chance to appear Presidential as the campaign swirls around him. His goal now is to make no mistakes and run out the clock.

Article, page A24.

Torricelli Accepts 'L' Word, But Also Says He's Moderate

By BRETT PULLEY

EDISON, N.J., Oct. 14 — New Jer- sey needs a senator who will work for a balanced budget who Government programs state the most, Repr ative Rob- ert G. Torricelli s extensive intervie case he has be voters in the rac seat in New Je Attacked as commercials ponent, Repre Zimmer, Mr. He supports lib issues, like a ment and gun c himself modera including immigra favor of continued for needy legal imm he favored excluding illegal immigrants schools. Referring to his view of the role of

I'M THE MOST MODERATE OF THEM ALL

NEW JERSEY'S SENATE RACE
Excerpts from the interview with Robert G. Torricelli, page B6.
crow: Richard A. Zimmer.

s "the real philosophi- erer between himself and opponent, Mr. Torri- th of them favored a d F ral budget, but that e for ich andidate they trust- as deficits were

"I believe i rong government positi but is a limited role," Torricelli who met for tw today with editors and reporter The New York Times.

n my i , the role of the United tates Government in this economy i to that the work force is and trained, that there's a

Continued on Page B6, Column 1

ARCHER DANIELS AGREES TO BIG FINE FOR PRICE FIXING

WILL PLEAD GUILTY TODAY

Grain Company's $100 Million Penalty to Set Record for a Criminal Antitrust Case

By KURT EICHENWALD

The Archer Daniels Midland Com- pany, long one of the country's most influential and politically powerful corporations, agreed to plead guilty to conspiring with competitors to fix the prices of two agricultural prod- ucts and pay $100 million in fines, the company announced yesterday.

The fine is by far the largest ever obtained by the Justice Department in a criminal price-fixing case, eclipsing the next highest by almost seven times.

For Archer Daniels, the plea deal will bring to an end almost four years of investigation that began when Mark E. Whitacre, then a sen- ior executive, agreed to act as a Government informer and secretly tape hundreds of conversations at the highest reaches of the company.

But it will also push Archer Dan- iels and its chairman, Dwayne O. Andreas, into an unusual new posi- tion. After decades of being run as a virtual family fief under Mr. An- dreas's iron-fisted control, Archer Daniels will be forced by the deal to provide evidence in the continuing investigation of Michael Andreas, the chairman's son and former eir apparent, and oth ople w

Law based today in Deca ourt in Chi- cago, C als and other people inv ion said. In t food proce sses it- self as to the World xed prices and used in various

Under Daniels will pay $70 mill for fixing lysine prices an millions for the citric acid case.

The settlement resolves all of the criminal investigations of Archer Daniels, including accus that com any fi fructose that th pay- ment to steal technology fro mpanies. Al- though t on of ssible bus tions to that involve a few people involved in the case said.

Justice De ment clined to C yes s executives and agr ment. S en Daniel s y or fo s for nor gover nor Mr. An as adviser to Mr. Andr as was a lawyer in priva ctice — Archer Daniels ha rong political force. that bred envy among

Continued on Page D7, Column 3

Zut! British Infiltrate French Fashion

By AMY M. SPINDLER

PARIS, Oct. 14 — In what some here are bemoaning as a blow to French cultural pride, it was announced today that cre- ative control of two of Paris's venerable couture houses, Christian Dior and Givenchy, will now be in the hands of Brit- ish designers.

And not just any British de- signers. Alexander McQueen, 27, stepping in at Givenchy, and John Galliano, 36, moving from a short stint at Givenchy to Dior, are famously working class, wild and drawn to such provocative impulses as but- tocks-baring trousers and spray-painted leather suits.

The change is one more risky maneuver by Bernard Arnault, 46, chairman of LVMH Moët Hennessy-Louis Vuitton, the biggest luxury-goods house in the world, which owns Givenchy and Dior and which had sales last year of $5.9 billion. At stake, far more than the fashion itself, is the image of the products that carry the Dior and Givenchy labels — perfumes, sunglasses, wallets, neckties, hosiery.

Since taking over Christian Dior in 1946, Mr. Arnault has assembled a group of famous if sometimes dusty names under LVMH. Thousands of American cl sers and dressers contain at least one product connected to M Arnault's empir otably because of his practice of charging manufacturers

Continued on Page B5, Column 1

New Look 1947

John Galliano's

354613

"All the News That Fits"

The New York Times

Late Edition
New York: Today, ample sun, southwest breezes. High 72. Tonight, some clouds. Low 59. Tomorrow, mostly sunny. High 66. Yesterday, high 58, low 43. Details are on page B17.

VOL. CXLVI... No. 50,582 Copyright © 1996 The New York Times NEW YORK, WEDNESDAY, OCTOBER 16, 1996 $1 beyond the greater New York metropolitan area. 60 CENTS

As Dole Weighs Tougher Image, Poll Finds He Already Has One

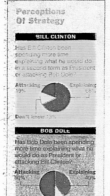

Perceptions Of Strategy

BILL CLINTON
Has Bill Clinton been spending more time explaining what he would do in a second term as President or attacking Bob Dole?

Attacking 19% Explaining 68%
Don't know 13%

BOB DOLE
Has Bob Dole been spending more time explaining what he would do as President or attacking Bill Clinton?

Attacking 50% Explaining 40%
Don't know 10%

Source: the New York Times/CBS News Poll

The New York Times

On Eve of Last Debate, Little Change Is Seen in Voter Attitudes

By RICHARD L. BERKE

Bob Dole and his advisers have **ATTACK** concluded that Mr. Dole is more combative than Mr. Clinton and is spending more time attacking than explaining what he would do as President, **GUYS** recent New York... Poll.

That is the latest complication for Mr. Dole as his advisers view the 90-minute encounter in San Diego as their candidate's last hope for a dramatic breakthrough in a campaign that has been remarkably static **FINISH** by the...

Perhaps most discouraging news for Dole... attitudes toward him and Mr. Clinton remain virtually unmoved since October 1995. Even after the first Presidential debate in Hartford, the Vice-Presidential debate in St. Petersburg, Fla. and tens of millions of **LAS** dollars of dueling television commercials, Mr. Clinton remains ahead by 17 points.

That may be even less likely to change because voters say they are paying less attention this year than they did in 1992 — and they find the campaign less compelling. Only 44 percent of registered voters described the 1996 contest as interesting, while 50 percent called it "dull." In early October 1992, 57 percent said that campaign was interesting, and that figure was 24 percent later in the month.

As Mr. Dole geared up yesterday in Albuquerque, N.M., to prepare for the debate, Mr. Dole pursued decidedly tough on the campaign trail in San Diego, in the words of Scott Reed, the Dole campaign manager, for a newly aggressive posture tonight.

Shedding, at least for now, concerns about reviving his lingering "hatchet man" image, Mr. Dole recited a catalogue of every scandal that has touched the Clinton White House as he accused the President of...

Continued on Page A14, Column 1

Presidential Debate
With the second campaign debate scheduled for 9 P.M. Eastern time tonight, President Clinton yesterday brushed aside Bob Dole's attacks on his ethics. Page A15.

Japan Seeking Way to Evolve 2-Party System

By NICHOLAS D. KRISTOF

TOKYO, Oct. 15 — Political candidates are doggedly bowing and pleading for votes ahead in **WE'LL SEND** as national elections... experiment aimed at producing a more responsive political system.

The election... landmark because it is the new electoral districts and methods of voting, conceived so as to lead Japan in the direction of a... system.

"This election will trigger drastic, far-reaching change in Japanese politics," said **SOME** Toshikawa, publisher of the... Line, a political newsletter. "but it will take time."

Many experts say that any change will be a very gradual process that will take several elections. Even then, some doubt that Japan will end up with anything looking much like a Western two-party system.

They say that in a consensus society, **CANDIDATES** issues are not much debated... voters want to be in the... dispense pork-barrel projects... party is likely to dominate for the indefinite future.

Issues are playing... role in this campaign. Few candidates **OVER** who decide at... where each of them...

There has been little discussion... foreign policy... or relations with the United States... the focus instead has been on... line and weaken the nation...

Continued on Page A10, Column 1

INSIDE

Court to Review Religion Act
The Supreme Court agreed to review a 1993 Federal law aimed at curbing governmental interference with Americans' religious lives. Page B8.

Sex Businesses Staying Put
Despite a new law to curtail the sex industry in New York City, most such establishments are not moving or changing their ways. Page B1.

Pierre Franey Dead at 75
Pierre Franey, the chef, New York Times columnist and author, died yesterday in Southampton, England, after suffering a stroke on Saturday on the Queen Elizabeth 2. Page D24.

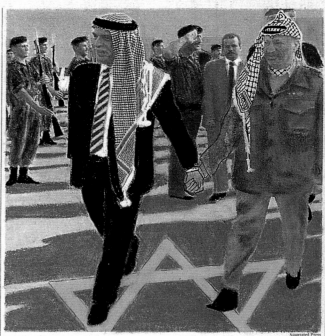

Three Decades Later, King Hussein Returns to West Bank
The King of Jordan, left, reviewing an honor guard in Jericho yesterday with Yasir Arafat, the Palestinian leader. The visit is King Hussein's first since Jordan lost the West Bank to Israel in the 1967 war. Page A6.
Associated Press

Dole's Plan: Bet the Ranch on One Shot

By R.W. APPLE Jr.

SAN DIEGO, Oct. 15 — A week... in the tight... little... politics were... **RAISING THE ANTE** California's 54 electoral vote... 27 Presidential trips to the state in less than four years, it seemed to be... Bob Dole... of money... like it away...

But then... new Field poll... only 10 percentage points ahead. That was followed by a decision by the Dole campaign to pour major resources, previously earmarked for swing states like New Jersey, Ohio, Pennsylvania...

Strategy Born of Blip in a California Poll Spurs Numerous Questions

Republican nominee "just a terribly long shot" in California, in the words of Gerald Warren, the former editor of The San Diego Union-Tribune, who worked in the Nixon White House. The man who took the poll that started the commotion, Mervin Field, said he thought the new tactics might constitute a feint of some kind, "because on our numbers it's hard to see..."

Field... has shown... more than Republican spending... In June, him... more than... percent in a four-way race (with Ross Perot and Ralph Nader, the Green Party candidate included). In July, he had 48 percent, in August 45 percent, and in the most recent poll, taken Oct. 7 to 9, he had 48. In September, after the Democratic convention, Mr. Clinton leapt to 55 percent, but that was transient "bounce..."

"The way we... it," said Field saying "there... more Clinton vote of close to... enough to win easily in a... race, to which he can... support from time to... reached... to 3, among... Steven... lawyer...

Continued on Page D8, Column 4

Ancient Scythian Bones Inspire New Perspective
Archeologists unearthed an untouched tomb in Ryzanokva, Ukraine, that could alter history's view of the nomadic Scythians. At left is the skeleton of a prince, and at right are his servant and horse. Page A7.
Jon Chechrowski

Pregnant Immigrants Wait Out Policy Storm

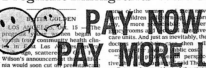

By B... GOLDEN

LOS ANGELES, Oct. 15 — pregnant... children... a more... rooms at... care units. And just as inevitably, the doctors... community health clinics. ...ago, scattered... Wilson's announcement... nia would soon cut off prenatal... to illegal immigrants under the new Federal welfare law.

Where the women have gone is uncertain. Most seem to have stayed home, assuming that their appointments had been canceled. But where... plan... in addition to the humanitarian... ethical considerations, it is simply prudent financial decision to let any woman go without adequate prenatal care."

The choice being posed has set off... public-health... racial ascent... state. Stripped of... tends to... said The... say... they will either have to carve... for illegal immigrants... own emaciated county health... ...or do nothing for...

Continued on Page B9, Column...

CONRAIL ACCEPTS $8.4 BILLION OFFER BY EASTERN RIVAL

BID BY CSX IS PROTESTED

Norfolk Southern Objects to Deal Creating a Huge Line in Midwest and East

By BARNABY J. FEDER

Conrail Inc., the largest railroad that dominates... said yesterday it... to merge with the... in a far larger railroad that flanked the Southeast, Middle Atlantic and eastern Midwest. **TYING THE KNOT**

The merger... $8.4 billion, would be the biggest yet in the cascade of deals... combining railroads since the deregulation of the... it would... east of the... two big railroad... freight.

Conrail and CSX have... with... Chicago... control... Se... and co... ia... and its...

It's only major rival was the Norfolk Southern Corporation, which had itself offered increased interest in merging with Conrail and might yet try to top... very least, Norfolk Southern demand and receive... its rival tracks in some areas that would... competitive freight... according to Wall Street analysts. CSX and Conrail said they expected to seek... of the merger... end of 1997.

"It's the merger at the right time between... executive and president... getting America's transportation infrastructure ready for the 21st century."

The merger... oldest company in... railroading — CSX is the descendant of the Baltimore & Ohio, which built the first common... Washington northwest to the Potomac River — with... Consolidated, formerly... Consolidated Rail Corp... created in a multibillion... government bailout of the... Central and other railroads two decades...

The company would have more than... employees and revenue... billion based on 1995's... making it the nation's... revenue. ...with the that the... would... competition, Conrail conceded that united... would offer only shippers a... modern trucking, especially... highways from the Northeast to Florida and other Southeast... Snow noted that trucking is probably a $300 billion industry... the size of the American railroads.

Trucks compete that the Conrail-

Continued on Page D8, Column 4

Zimmer Says He's a Centrist Who'd Shrink Government

By ALAN FINDER

NEW JERSEY'S SENATE RACE
Second of two articles. Excerpts from the interview with Richard A. Zimmer, page B7.

Differentiating himself from his Democratic opponent in the race for the open United States Senate seat from New Jersey, Representative Richard A. Zimmer says that if elected, he would emphasize... ernment spending and taxes and making government... less intrusive.

In a detailed interview with editors of The New York Times, Mr. Zimmer said he favors limiting the cost and size of the Federal Government...

sought to distance himself from Republican leaders... self as moderate on... ronmental protection... **I'M THE MOST MODERATE OF THEM ALL** counter political attacks from Mr. ...celli, who has characterized Mr. Zimmer as a conservative ally of... Gingrich, the House Republican leader...

Mr. Zimmer... republican... opponent, Representative Robert Torricelli, have fought over... themselves as centrists in a race known for its middle-of-the-road... ers. But in separate interviews, there were clear differences in emphasis between the candidates. Mr. Torricelli advocated a more active role of government, and Mr. Zimmer... a more limited one.

...pro-choice, pro-environment... reform Christie Whitman... Mr. Zimmer said, seek...

Continued on Page B7, Column 1

Spending in New Jersey
New Jersey's two Senate candidates said they each had more than $4.4 million for the final three weeks of what could be the most expensive Senate race in the country. Page B6.

PAY NOW OR PAY MORE LATER

The New York Times

Late Edition
New York: Today, partly cloudy and warm. High 75. Tonight, increasing clouds, drizzle. Low 58. Tomorrow, cloudy, some rain. High 66. Yesterday, high 73, low 50. Details, page A24.

VOL. CXLVI . . . No. 50,583 Copyright © 1996 The New York Times NEW YORK, THURSDAY, OCTOBER 17, 1996 $1 beyond the greater New York metropolitan area. 60 CENTS

Rising Star in the Kremlin: An Ardent Pro-Capitalist

Chubais Becomes a Moscow Mover and Shaker

By MICHAEL R. GORDON

MOSCOW, Oct. 16 — During the the Kremlin, Anatoly B_____ is plotting how to ca_____ ___xt sta___ _____ __ _____u-tion.

In a __, Mr. Chu____ the 41-ye_____ ___f, has ___ne from pol____ ___ become one of the _____ p_____ful behind-the-scenes _____s in the Russian Government.

Now the ardently pro-capitalist Mr. Chubais (pronounced choo-BY-iss) says he is striving to turn Russia's sometimes rudderless Government — which has become all the more fractious since President Boris N. Yeltsin became ill — into a disciplined state.

To advance economic reforms, Mr. Chubais asserts, the Kremlin needs to be sure that unpopular presidential decrees are actually carried out, that top officials do not attack their own Government's policies and that the Government's decisions are respected.

"The major question is no longer the alternative between the Communists and the non-Communists," Mr. Chubais said in an interview. "We are at the next stage of Russian history, where the question is the quality of the state. To achieve economic growth we need an efficient state."

Those are fighting words to Mr. Chubais's rivals, who worry that it means broader powers for the new chief of staff.

Mr. Chubais's uphill struggle to bring order to the Kremlin is taking place as an almost unseemly public scramble for power unfolds, with ambitious Kremlin aides trying to exploit the vacuum created by the 65-year-old President's illness.

No sooner ____ ____ull for discipline th___ ___dviser, Aleksand_ _____ ____nced an alliance _____ Chubais's mo_____ ___ the shadowy Alex____ _or zhakov, a former Ye____ s_____ __ho was dismissed by Mr. Yeltsin as head of the presidential bodyguards during the election campaign.

Turning the debate over the future of the Russian state into a national soap opera, Mr. _____rev as_____ Mr. Chub_____ ____ _____ threaten_____ _____ ____ ing materials.

The Kremlin ___ __ __ ___ twist today w_____ _____ Anatoly Kuliko____ _____ of planning ___ ____ __ nounced that he was ca___ _ security alert in major cit___ Mr. Lebed quickly denied ___ Kulikov's charges and said he would sue Mr. Kulikov. [Page A9.] The top Kremlin leadership under the President is a troika, with two horses pulling in different directions and one barely pulling at all.

Viktor S. Chernomyrdin, the stolid

Continued on Page A8, Column 1

Braves Win, 3-1; Force 7th Game

The Yankees' wait for a World Series opponent was prolonged again last night, this time by the man who has been the best pitcher in baseball over the past five seasons.

Greg Maddux _____ of the first 21 batters ____red to lead the Atlanta Braves to a 3-1 victory over the St. Louis Cardinals and force a decisive Game 7 tonight in Atlanta.

The Cardinals, who could have won a berth in the Series in each of the last two games, will pitch Donovan Osborne. The Braves will counter with Tom Glavine. The winner will face the Yankees in Game 1 of the World Series Saturday night.

The Yankees, already here, were working out and plotting strategy. ____ _____ strawberry guaranteed ___ yesterday that he would play in Game 1 despite a fracture in his big toe, but Manager Joe Torre hinted that pitcher Kenny Rogers might not be on the roster because of a shoulder injury.

Articles on page B15.

Britain May Forbid Private Ownership Of Most Handguns

By SARAH LYALL

LONDON, Oct. 16 — The British Government today proposed a ban on almost all privately owned handguns, a_ ___response _____ ____ ___ _____ after _____ __ ____ Scot___ ___an o___ with four handguns at a primary school, killing 16 children and their teacher.

Under the Government's proposal, all handguns of more than .22 caliber, including high-caliber semiautomatic pistols of the kind used in Dunblane, would be banned. Smaller caliber guns, including .22's, would ___ ___ ___ _____ __ petition ___ ___ _____ would ___ ___ _____ caliber ___ ___ _____ clubs.

If it passes, the Government said, the legislation would entail the destruction of some 160,000 of the estimated 200,000 handguns currently legally held in England, Scotland and Wales. ___ ___ the number of illegal __ ___ ___ ____ _____ountry vary from about ___ ___ ___tion.

Britain's gun ___ __ already among the toughest ___ world, far tougher than those ___ __ __ have been enacted in the United States in recent years. Machine guns, self-loading rifles and semiautomatic shotguns are

Continued on Page A4, Column 3

INSIDE

Drug War's New Legal Tactic
An experimental national program for drug offenders has gained enthusiastic acceptance among judges and prosecutors. Page A25.

A Rally for 'Atonement'
One year after a huge rally of black men in Washington, thousands gathered again to hear Louis Farrakhan, this time in New York. Page B1.

THE NEW YORK TIMES is available for home or office delivery in most major U.S. cities. Call, toll-free 1-800-NYTIMES. Ask about TimesCard. ADVT.
354613

DOLE ATTACKS CLINTON'S ETHICS; PRESIDENT PARRIES ON ECONOMY

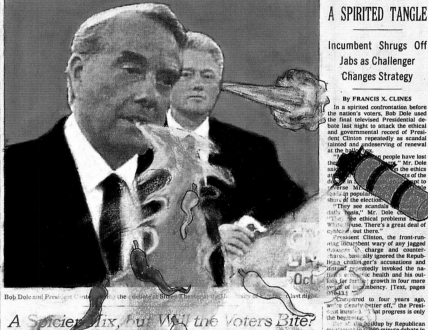

Bob Dole and President Clinton _____ the debate at Shiley Theater at the University _____ last night.

A SPIRITED TANGLE

Incumbent Shrugs Off Jabs as Challenger Changes Strategy

By FRANCIS X. CLINES

In a spirited confrontation before the nation's voters, Bob Dole used the final televised Presidential debate last night to attack the ethical and governmental record of President Clinton repeatedly as scandal tainted and undeserving of renewal at the ball____.

"_____ ___n people have lost the_____ _____," Mr. Dole said _____ on the ethics at____ __ ___orts of the de____ __ _____pt to deverse Mr. ____ _____ lead__ in popula_____ sho__ of the election.

"They see scandals _____aily basis," Mr. Dole con_____. "They see ethical problems in the White House. There's a great deal of cy____l __ out there."

President Clinton, the front-running incumbent wary of any jagged d_____ o_ charge and counter-charge, basically ignored the Republican challenger's accusations and instead repeatedly invoked the nation's economic health and his outlook for future growth in four more years of incumbency. [Text, pages B10-13.]

"Compared to four years ago, we're clearly better off," the President insisted. _hat progress is only the beginning.

Part of the buildup by Republican strategists to the 90-minute debate in the Shiley Theater at the University of San Diego, which Mr. Dole was advertised as seeking to relentless criticism of Mr. Clinton, the evening turned into a _____ victory of sorts for the _____er, who pressed the candidate with high-specific issues while generally kept the confrontation short of open insult.

Mr. Clinton, while avoiding an aggressive posture, did not hesitate to _____ some of the former Senate m_____ L_der's assertions on matter ___ public policy — particularly his conte____ the the current state of the econ____ the worst in this century.

"In February he said we had the best economy in 20 years," the President said in rebuttal, quickly turning an old Ronald Reagan line against Mr. Dole in a direct appeal to the audience: "If you believe that the California economy was better in 1992 than today, you should vote for Bob Dole."

Both politicians, standing on a red-carpeted debating stage with their two _____ lecterns on the line, tangled over an array of issues including Medicare and fighting nicotine addiction. The ____ of a town hall forum w_____ dif_____ the audience intera_____ ry one-on-one int_____

Continued on Pa__

A Spicier Mix, but Will the Voters Bite?

By R. W. APPLE Jr.

SAN DIEGO, Oct. 16 — What Bob Dole wants the American electorate to do on Nov. 5 is quite ___ing forward: he wants ____ Bill Clinton as the nation's C____ ___cutive, not ___ ___ _____ country ___ military.

"I keep m_____," Mr. Dole said again and again, by way of suggest___.

News ___ ___ ___nt, in the ___ Analysis __ _____te between the ___ here, was _____ng for the much to ___ _____ it stirred the invited au_____ with the city where the he re____ held their national convention i_ August. If that proves to be ca____ with the wider audience as well, ____ll be bad news for Mr. Dole, ___dly needed to ____ after ___ ___ ___

"_____ was ____ was," said Nelson Polsby, a political scientist at the University of California at Berkeley. "And remember, most of the people

Continued on Page B9, Column 5

Fumoyo Asada for The New York Times
Yoshitake Masuhara campaigns with a mandatory sash and a traditional bow (and an occasional handshake).

Japan Tries Aggressive Campaigning, Politely

By SHERYL WuDUNN

HIROSHIMA, Japan, Oct. 11 — It was 8 A.M. and Yoshitake Masu_____ weighty campaign message.

"I'm terribly sorry to disturb you so early this morning with a loud noise," said Kanoko Komura, her dainty voice booming incongruously through the neighborhood. "But this is Masuhara. This is Masuhara. This is Masuhara. This is Masuhara. This is Masuhara."

With national elections set for Oct. 20 candidates for the Japanese Parliament's ____ cam____ _____ ing _____ mix of _____ ____ ___ old and ___ newer_____.

The level of aggression this year is way up because of a new voting system and far stricter campaigning

rules. The new electoral system allows each district only one seat, whereas in the old system there were as many as five, and most major

candidates ____ went ___ _____tation _____ the old ___ 'l e__ demonstrations ___ _____ and Government this past _____ campaign workers used to distribute bags of cash to win votes or cut deals in smoky back rooms, both practices that the new system is intended to

Continued on Page A12, Column 1

Administration Moves to Defend Indonesia Policy After Criticism

By DAVID E. SANGER

WASHINGTON, Oct. 16 — The Clinton Administration today responded to Republican accusations that it had manipulated its trade and human rights decisions in return for campaign contributions from two wealthy Indonesian families.

Officials released copies of documents to support ____ ___gu___s that President Clinton had been tougher on Indonesia's treatment of workers' rights than had his Republican _____

The documents _____ fore tonight's d____ b____ Mr. Clinton and Bob Dole ___ Republican candidate, include a ____ commitment from the authoritarian Government of _____ Suharto to cease using _____ to break up union _____ and allow workers ___ ___ ___ pendent company ____ ___

In return for those conc_____ which have been p____ __ _____ and which did not ___ ___ ment of labor le____ Government this pa__ _____ ___ Administration renewed a special trade status for Indonesia in 1994.

That decision eliminated tariffs on

POLICING FOREIGN DONATIONS

Officials are struggling to distinguish legitimate political donations from illegal foreign money. Page B7.

industrial _____ electronics, machinery and other ____ris — exported _____ to the United States ____ ___ continued foreign _____ment in Indonesia.

_____ there were benefits for Mr. Clinton's Indonesian campaign con_____ ___ _____ With ___ _____e __ the Lippo erate — any quid pro quo appears to be _____ officials ___ ___ orm- _____ly a million dollars, which the ___ ___ ___ ___ say were legal were part ___ ___ __ ___ ___ win favor __ Wa_____gton.

But some ____ officials released detailed chronologies, offered interviews with major and minor players in the formation of policy toward Indonesia, and __ doc____

Continued on Page B7, Column 1

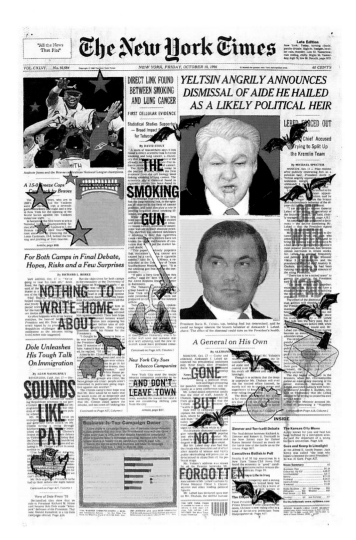
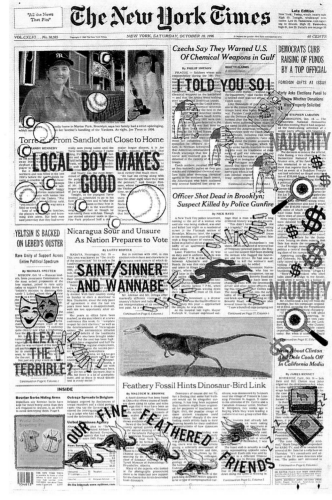
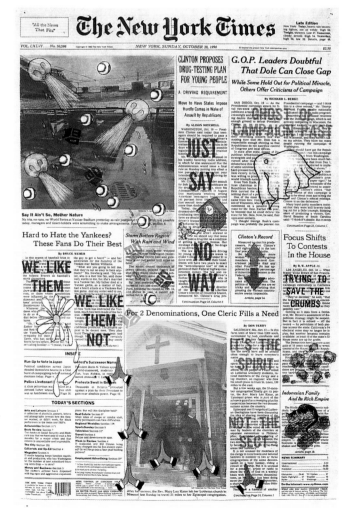
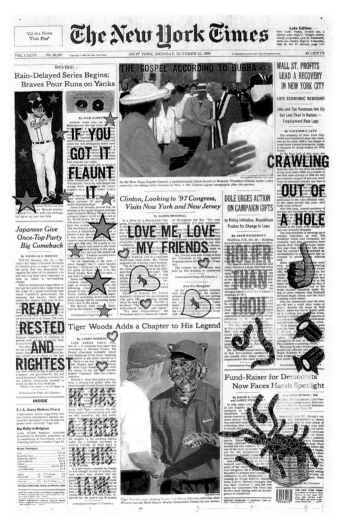

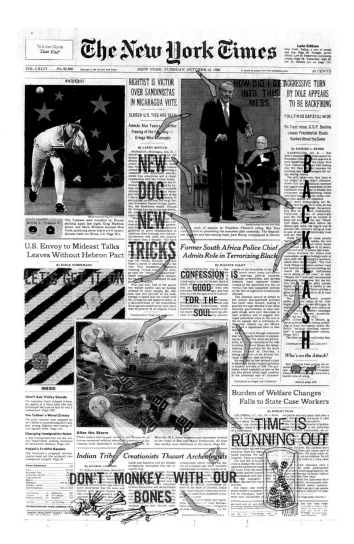
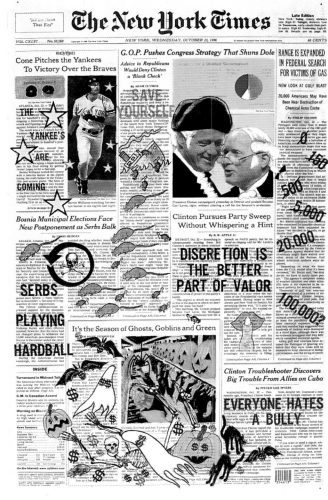
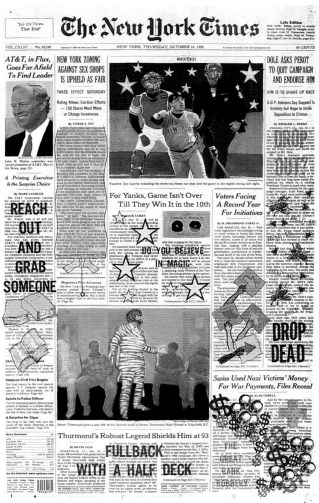
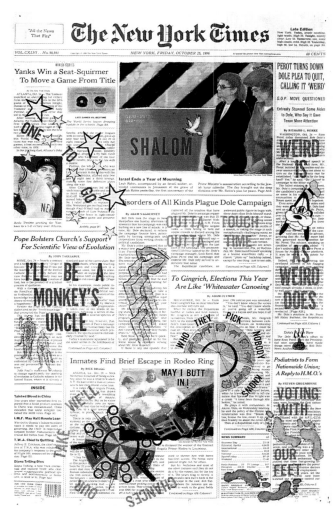

"All the News That Fits"

The New York Times

VOL. CXLVI... No. 50,593 Copyright © 1996 The New York Times NEW YORK, SATURDAY, OCTOBER 26, 1996 $1 beyond the greater New York metropolitan area. 60 CENTS

Late Edition
New York: Today, sunshine dimmed by clouds. High 68. Tonight, partly cloudy, mild. Low 55. Tomorrow, partly cloudy, breezy. High 70. Yesterday, high 67, low 52. Details are on page 12.

Judge Orders 2 Separate Trials For Oklahoma Bomb Suspects

Risk of Prejudice to Both of the Accused Is Cited

By JO THOMAS

A Federal judge yesterday ordered separate trials for the two men charged with bombing the Oklahoma City Federal Building in 1995, ruling that a joint trial would present an unacceptable threat of prejudice to both of the accused, Timothy McVeigh and Terry L. Nichols.

No date was set, but Judge Richard P. Matsch, who is presiding in Denver, ordered that Mr. McVeigh be tried first. Mr. McVeigh's lawyer, Stephen Jones, said afterward that the defense could be prepared for trial by March or April 1997, if pretrial discovery issues are resolved.

Joseph Hartzler, the special prosecutor handling the case, said he was ready to try the case now. Although the Federal Government opposed the defense request for separate trials, Mr. Hartzler agreed with the judge that two trials would not cost significantly more time than one.

At the heart of Judge Matsch's decision was a nine-hour interview that Mr. Nichols gave the Federal Bureau of Investigation at the police station near his home in Herington, Kan., on April 21, 1995, days after a bomb that killed 168 people.

In that interview, Mr. Nichols talked about his actions and those of Mr. McVeigh in the days before and after the bombing. Among other things, he asserted that he went to Oklahoma City on April 16, three days before the bombing, to pick up Mr. McVeigh, that he lent Mr. McVeigh his pickup truck on April 18, the day prosecutors say the bomb was built, and that Mr. McVeigh took some of his belongings from his locker in Herington on the day that he did.

During the trial, prosecutors intend to limit the evidence they will glean from his interview to statements he made. But Judge Matsch ruled that Mr. McVeigh could not be admitted at a joint trial even by admitting just these three statements because he would have no opportunity to cross-examine Mr. Nichols, who is protected by the Fifth Amendment from having to testify. Earlier, the judge ruled that the statements could be admitted

Continued on Page 12, Column 5

U.S. AND NATO PLAN NEW BOSNIA FORCE

Move After the Election Could Deploy Around 5,000 G.I.'s

By STEVEN LEE MYERS

WASHINGTON, Oct. 25 — Although the White House has maintained a deliberate silence for fear of provoking a pre-election controversy, American and NATO military planners are preparing for what is, in effect, the extension of the peacekeeping force in Bosnia that could include at least 5,000 American troops.

Continued on Page 7, Column 1

WORDS CAN HARM YOU

INSIDE

Mass Protest in Canada
Thousands of Canadians paralyzed parts of Toronto to protest provincial government spending cuts that could reach nearly $6 billion. Page 3.

Pace of Layoffs Was Steady
New figures show that the rate of layoffs in the middle of the decade remained roughly constant compared with the early 1990's. Page 37.

Disturbance in Florida
A state of emergency was declared in St. Petersburg, Fla., after a fatal shooting by a police officer touched off a night of violence. Page 8.

HAPPY BIRTHDAY PAT CONROY FROM Earth's Biggest Bookstore, Amazon.com Books! http://www.amazon.com/ —ADVT.

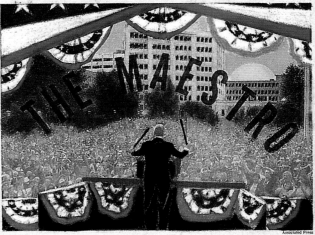

THE MAESTRO

President Clinton, addressing a rally in Atlanta yesterday, did not hesitate to take a dig at Bob Dole.

Associated Press

Milestones and Missteps on Immigration

By ERIC SCHMITT

WASHINGTON, Oct. 25 — By all measures, the Clinton Administration has poured more money and political capital into addressing immigration problems than any other administration in recent times.

From its budget for the Immigration and Naturalization Service to other Government agencies that have suffered substantial cuts. It has increased the number of Border Patrol agents by about 45 percent, and increased about 25,000 more illegal immigrants in the 1996 fiscal year compared with three years ago. It has weeded out abuse in the political asylum process, and President Clinton signed a bill last month that imposes some of the toughest measures in decades against illegal immigration.

But looking at the numbers may not tell the whole story. Some immigration experts outside the Administration warn that those numbers may be misleading. And critics call Mr. Clinton's policies inconsistent and largely reactive.

In contrast with the welfare issue,

THE CLINTON RECORD: Immigration

Mr. Clinton did not bring a wide range of experience with immigration to the Presidency; as a Governor, he understood his state's riot of Cuban refugees that he believed cost him his re-election in 1980.

But as a 1992 Presidential candidate, Mr. Clinton sharply defined by Mr. Clinton's opponents on the right; his role has been reduced to softening provisions of bills drawn up by Republicans that make sweeping breaks with the past. The new immigration and welfare measures, as a group, are the most punitive toward immigrants in years, stripping them of some of their most important legal protections and denying them a broad range of social benefits — changes that immigration advocates denounce, while immigration opponents hail them as a belated attempt to crack down on freeloaders.

The Administration's record illustrates the tensions between humanitarian goals, the need to enforce immigration laws and political pressures — including political implications in the states with large immigrant populations.

"I'd consider the Clinton record to be one of hypocrisy, incompetence and progress," said Lamar Smith, a Texas Republican who was a main author of the recently enacted immigration law.

Continued on Page 9, Column 1

Stronghold in 1992 Mostly Ignores Perot

On the morning after the 1992 Presidential election, Waldo County, Me., could easily have been Perot County. With 36.2 percent of the county's vote, Ross Perot edged Bill Clinton and George Bush.

But Perot, in the county's support for Perot's campaign offices and signs in yards and store windows. Interviews with more than a dozen county voters found that many did not vote Mr. Perot because of his timing in entering the Presidential race, his fight with Richard D. Lamm for the Reform Party's nomination and his choice of his running mate.

Still, one Maine resident said: "I'm going to vote for Perot. I know I'm going to waste my vote."

Article, page 11.

DOLE IS IMPLORING VOTERS TO 'RISE UP' AGAINST THE PRESS

CRITICIZES 'LIBERAL BIAS'

Visiting Houston and Dallas, He Asserts That Clinton Is Violating Public Trust

By KATHARINE Q. SEELYE

DALLAS, Oct. 25 — Sounding like a crusader, Bob Dole implored audiences today to "rise up" against the nation's news organizations, which he said were biased and helped the public.

He said the liberal bias that news organizations declared to more than he picked on the coverage at Southern California.

"Don't read that stuff. Don't watch television! You make up your mind! Don't let them make up your mind for you!"

The appreciative crowds greeting Mr. Dole in Texas, where he is in a virtual dead heat with President Clinton, have given him thunderous and sustained applause, shouting along with him that they do care about members of the news media pass by.

In a string of questionable actions of the Administration, including accepting what he called donations from foreigners and influential Presidential friends in Indonesia.

Appearing at an engineering arts center, where before a giant mural, Mr. Dole continued his attacks. "No! Just imagine Bob Dole doing this, do you think? Where. So where's the outrage? Where's the outrage that voters start to focus?"

"My other point he asked: "When do the American people rise up and say, we get the media in America! We're going to make up our minds! We're not going to make up our minds! This is about saving our country!

Lashing out the New York Times for the second straight day, Mr. Dole said: "We are not going to let the media steal this election. We're going to win this election. The country belongs to the people, not The New York Times."

On his third day out, President Clinton continued his tour of the South today, visiting Georgia, where he floated a proposal for teaching third graders and where he managed to direct an insult or two at Mr. Dole. [Page 10.]

In the litany of complaints detailed by Mr. Dole today, there was a new charge: that the Democrats were "rushing" immigrants with criminal backgrounds into the country so they could vote for President Clinton.

"We have all these new people

Continued on Page 10, Column 1

In China's Outlands, Poorest Grow Poorer

By PATRICK E. TYLER

NIUJUAN, China — Life is unimaginably hard in the burnt umber hills of this part of northwestern China. In four of the last five years there has been no harvest and millions of poor farmers are living in a state of hunger, poor health and illiteracy that in some areas approaches the deprivation levels of China's great famine in the late 1950's.

Muslim villagers here in southern Ningxia, known as the Hui Autonomous Region, say that no official from the Xiji County government, 20 miles away, has ever hiked into this desperately poor hamlet to offer assistance to the peasants, most of whom cannot afford to send their children to school, and for the few who are

[continued in photo caption area]

Patrick E. Tyler/The New York Times
[In a village, Ma Xinggui and his wife, Ma Chunhua, harvest potatoes, the only crop that can keep hunger at bay this winter.]

since 1979, from 60 million to 100 million, Chinese still live on the edge of starvation and on the lowest rung of the economic ladder.

And, according to new World Bank estimates, more than one quarter of all Chinese — about 350 million — are in substantial deprivation, subsisting on less than $1 a day. In addition, for the first time a significant number of urban dwellers

THE GOOD EARTH

Although China has made prodigious efforts under Communist rule to eradicate poverty, lifting tens if not hundreds of millions to a higher standard of living through the economic reforms led by the paramount leader, Deng Xiaoping,

about 15 million below the subsistence level are still found in cities with no social security or welfare nets to catch them.

The significance of the new estimates is that they show a larger

Continued on Page 6, Column 1

Biggest Victory for Torre Family: Heart Transplant Arrives on Time

By RANDY KENNEDY

For a family and a tiny Brooklyn neighborhood whose life is baseball, it was the timing that convinced them that Someone up there must be a fan.

Only four hours after watching his baby brother take the World Series, Frank Torre, 64, yesterday morning at Columbia-Presbyterian Medical Center with the news he had been waiting for four months: he was getting a new heart.

And after a flawless transplant, which he had obtained from a heart where else? — the Bronx — more good news. "I'm pretty safely that he would watch the game tomorrow night," said Dr. Robert Michler, the director of the heart transplant program at the hospital, "but he didn't play it my way, believe me."

The four-hour operation drew of a drama that could have come right out of a movie around the city.

Continued on Page 28, Column 1

GOD IS A YANKEE

Transit Agency Plans Its First Volume Discounts

By RICHARD PÉREZ-PEÑA

For the first time, the New York City Transit Authority will offer riders volume discounts, selling 11 fares for the price of 10 starting late next year or early in 1998, in what amounts to a partial rollback of last year's recent fare increase, transit officials said yesterday.

Fare discounts, combined with the start next summer of free transfers between subways and buses, are likely to give a much-needed lift to the popularity of the Metrocard, which

after two years and an investment of hundreds of millions of dollars has won over only 10 percent of riders. Both benefits will be available only to users of the electronic fare card.

Metrocard users will be able to pay $15 for a card worth $16.50, lowering to $1.36 a ride from the current $1.50, the Metropolitan Transportation Authority officials who insisted on anonymity, they said the plan would be announced either at the M.T.A. finance committee's meeting Monday or at its board meeting Thursday.

"This is going to attract millions of riders, and it's finally going to make a winner out of Metrocard," one official said.

Fare discounts and free bus transfers are a turnabout for the Transit Authority and its parent agency, the M.T.A., after two years of cuts, reduced service and city, state and Federal aid. Two years ago, M.T.A. officials said the 25-cent fare increase would offset those cuts and subsidies.

Continued on Page 28, Column 1

A FARE SHAKE

220 EAST 52ND ST. HAS BEEN LIBERATED from the cable monopoly! Better building, wide service. Better prices. Call Liberty Cable 212/801-7777 —Advt.

354613

THE NEW YORK TIMES is available for home or office delivery in most major U.S. cities. Call toll-free 1-800-NYTIMES. Ask about TransMedia TimesCard. ADVT.

THIS LAND IS OUR LAND NOT YOUR LAND

The New York Times

Late Edition
New York: Today, variable clouds, very mild. High 70. Tonight, scattered showers. Low 57. Tomorrow, becoming sunny, windy. High 64. Yesterday, high 65, low 49. Details, page 43.

VOL. CXLVI .. No. 50,593 Copyright © 1996 The New York Times **NEW YORK, SUNDAY, OCTOBER 27, 1996** $3 beyond the greater New York metropolitan area. **$2.50**

DOLE IS CONTINUING ATTACKS ON PRESS AND THE PRESIDENT

EFFORT TO STIR 'OUTRAGE'

Republican Turning Attention to First Lady and Clinton's Lack of Military Service

By KATHARINE Q. SEELYE

FRESNO, Calif., Oct. 26 — On a bus trip through the verdant Central Valley of California, 10 percent ... Bob Dole ...

... appeared ... cut plan ... for soccer ... for day care." President Clinton's policies, Mr. Dole asserted, amounted to a "war on families."

"Wake up, America! Wake up, America! Wake up, America!" the Republican Presidential nominee thundered ... "Give America back ..."

As Mr. Clinton cracked down on his campaign, he focused on crime more than his Republican opponent. In his weekly radio address today, the President called for more Federal assistance to crime victims. [Page 28.]

Mr. Dole, suggesting a media bias against Republicans, said today that members of his party "were punished in the 1970's because of Watergate — we probably deserved it." He added, "Now it's taken all this time to get back on our feet."

But if a Republican did only a fraction of the things the Clinton Administration had done, he said, "there would be outrage."

"They'd be putting out special editions of The New York Times," he went on. "They would be so outraged. And now it appears in Section D or later, if they got a later section."

While Mr. Dole's criticism of the news media ebbed today from its intense level of the previous two days, it was the third day in a row that he singled out The New York Times. Earlier, in the city of Visalia, he said: "I know that with a crowd this size, The New York Times will write not many people showed up, but the other papers will get it right."

The Secret Service estimated the crowd at 3,000 in Visalia, which has a population of about 75,000.

At the rally here in Fresno, 40 miles up the highway from Visalia, Mr. Dole also ridiculed the President

Continued on Page 26, Column 1

TODAY'S SECTIONS

Arts and Leisure/Section 2
Once a basket case, the Lincoln Center Theater today is anything but. A string of critical hits, a big budget, a huge membership and a just-finished major renovation have made it the preeminent nonprofit theatrical institution in the country. And yet many wonder, is all that it can be?

Automobiles/Section 11*†

Book Review/Section 7
Alice Munro's "Selected Stories," from the last 20 years, is reviewed with Canadian weather and Canadian austerity, testing the gap between the real world and the pursuit of happiness.

The City/Section 13¶

Editorials and Op-Ed/Section 4

Magazine/Section 6
The school reform that really matters is not vouchers or charter schools or breaking the unions or wiring the classrooms. It's a curriculum set in Washington, monitored in every town and city.

Money and Business/Section 3
The House of Rothschild, a banking family divided and in decline for decades, took a historic step toward restitution.

Real Estate/Section 9*
Group buying Helmsley's holdings at Parkchester plans a restoration.

Regional Weeklies/Section 13¶

SportsSunday/Section 8

Television/Section 12*

Travel/Section 5
In the Caribbean this winter, you can loll on a private terrace (in Petit St. Vincent), dive off St. Thomas, visit gardens in Barbados or eat (and drink) royally in Anguilla.

Week in Review/Section 4
In South Africa, is truth enough balm for the wounds of injustice?

Employment Advertising/Sec...

WORLD SERIES

Comeback Is Complete: Yanks Win the Series

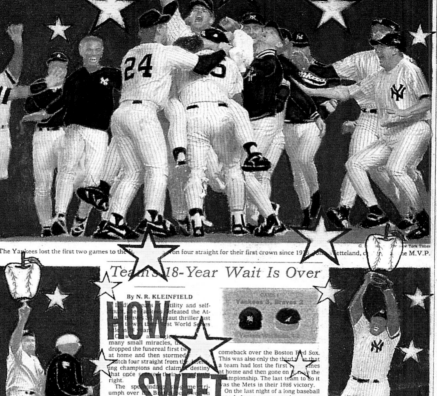

The Yankees lost the first two games to the ... won four straight for their first crown since 19... ...ettleland, ... the M.V.P.

Team's 18-Year Wait Is Over

By N. R. KLEINFIELD

... utility and self-... defeated the Atlanta ... taut thriller last ... st World Series ...

many small miracles, ... dropped the funereal first two at home and then stormed to match four straight from the reigning champions and claim a destiny that once seemed theirs by right.

The spectacular accomplishment triumph over the Braves gave the Yankees their 23d World Series championship, the ... team, and perhaps their sweetest. Never since the Yankees began winning World Series titles in 1923 with a perfunctoriness that became an autumn habit has a storied franchise waited so long before its victories. ... fore now, the team's lengthiest streak stretched between 1962 and 1977. Before the 1970's, world championships arrived in the South Bronx ... years, if not every year. ... last time either of New York's ... ball franchises had captured the ... title was a decade ago, when ... Mets mounted their improbable

comeback over the Boston Red Sox. This was also only the third ... that a team had lost the first two games at home and then gone on to win the championship. The last team to do it was the Mets in their 1986 victory.

On the last night of a long baseball year, before a raucous and expectant crowd a team that has illuminated the imagination and touched the hearts of New Yorkers scored all of its runs in the third inning. Greg Maddux, the four-time Cy Young winner who shut down ... with captivating artistry. The Yankee lead-off ... Paul O'Neill, a triple by ... and singled by ... Derek Jeter and Bernie Williams ... drawing on their dominance ... then, they made the three-run lead stand up.

Maddux went seven and two-thirds

Continued on Page ... Column 1

Charlie Hayes snags Mark Lemke's foul to end the game.
Associated Press

By the Way, Giuliani Backs Kemp (and Dole)

By DAVID FIRESTONE

With a little more than 200 hours left before the Presidential election, Mayor Rudolph W. Giuliani ended months of hand-wringing yesterday and endorsed the Republican Presidential ticket of Jack Kemp and Bob Dole, virtually in that order.

In fact, the Mayor's long-awaited announcement, made after he met Mr. Kemp at La Guardia Airport, contained not one word of praise for Mr. Dole, except to say that his choice of Mr. Kemp as running mate had opened up the party to Mr. Kemp's themes of inclusiveness and tolerance. By contrast, the Mayor effusively complimented his old friend, Mr. Kemp.

"For a long time, the issue was, 'Should the Republican Party broaden itself, should there be a broad tent, an inclusive party?' " Mr. Giuliani said, standing in front of a huge bust of his favorite former Mayor, Fiorello La Guardia, in the rotunda of the Marine Air Terminal. "Jack Kemp was at the core of fighting for that, and Senator Dole in reaching out to him, bringing in others, has been in a way changing the direction of the party."

He went on to commend Mr. Kemp's performance in the recent debate — saying nothing about Mr. Dole's — and even credited Mr. Kemp's ideas for what he said was his own economic success as Mayor. As he and Mr. Kemp left for their box seats at the World Series, Mr. Giuliani did not rule out campaigning for the ticket, if asked.

However tepid, the endorsement may appease concerned Republicans as the Mayor heads into a re-election campaign, but its timing — just before the end of the race, and on a critical night for the Yankees — seemed designed to produce as little publicity as possible. That reticence underscores Mr. Giuliani's difficulty in supporting a Republican candidate so far behind in the polls, particularly in a city in which Democrats outnumber Republicans by 5 to 1.

"He's intentionally doing it in the dead of night," said

Continued on Page 39, Column 1

Jack Kemp, right, received a baseball and an endorsement last night from Mayor Rudolph W. Giuliani.
Michelle V. Agins/The New York Times

INSIDE

Paving Paradise
Several states and environmental groups are challenging the quick permit program the Army Corps of Engineers uses for development of wetlands. Page...

Death of an Afghan Village
Another village in Afghanistan was destroyed last week, one of the thousands razed this time, the destroyers were troops who had vowed to bring peace. Page 12.

A Monday... international ... it will reset ... next year.

International	3-15		
Metro	35-40		
National	16-34		
Obituaries	41-42	TV Update	53
Radio Highlights	53	Weather	43
Styles	47	Weddings	50

On the Internet: www.nytimes.com

PARTIES PRESSING TO RAISE TURNOUT AS ELECTION NEARS

BOTH SIDES FEAR APATHY

If Voters Are Not Drawn by the Presidential Contest, Other Races Could Be Swayed

By ROBIN TONER

The final 10 days of the 1996 campaign are shaping up as a furious struggle between the parties and their allies to get their supporters to the polls, in the face of widespread indications that flagging voter interest may well depress the turnout.

Strategists in both sides are legitimate after a lopsided and largely static Presidential campaign. There is a worry, they concede, that many of the would-be supporters ... no longer need ... and fear that this year's campaign will so dispirit many of the party faithful that they will simply stay home. Either way, it is the struggle for control of the House of Representatives that could be most affected, many analysts say.

Mary ..., ... press secretary for the Republican National Committee, said, "It's totally fair to say that the party, on a national and state level, will be donating unprecedented resources to turning out our voters this year."

Democrats make similar vows. "We've seen in the states of low turnout, particularly this year, the Democratic National Committee's ... communications. "We lost some ... races by very close margins ... resulted in a Republican Congress that tried to gut a lot of important priorities."

The final drives by the parties and their allied interest groups are well under way, supported by extensive research ... to locate likely ... to the polls. This weekend ... labor allies ... rallies and volunteers directed at ... in the fields of suburban Georgia and the Wal-Marts of ... the A.F.L.-C.I.O. has sent 1,000 field troops into the field to help unions coordinate the endgame of their effort to oust the Republican House ... volunteers distributed ... literature ... on a single day last ... State.

On the other side, the Christian Coalition is distributing 45 million ... including 120,000 churches ... running get-out-the-vote, commercials on Christian radio outlets and getting in touch with more than three million voters

Continued on Page 28, Column 2

Prosecutors Declare Guard Isn't Suspect In Atlanta Bombing

By KEVIN SACK

ATLANTA, Oct. 26 — Clearing away the suspicions that had turned a security guard into a pariah, the Justice Department today declared that Richard Jewell was no longer a suspect in the July 27 bombing at Centennial Olympic Park.

"Barring any newly discovered evidence, this status will not change," said the anticipated letter, which was written by ... Alexander ... to the United States ney here, to be released on ... of Mr. Jewell's lawyers.

Mr. Jewell became the subject of almost frenzied media attention after The Atlanta Journal reported on July ... that he was widely praised for evacuating ... no noticed an ... containing the bomb ... because ... the intensive Federal investigation into the attack. The newspaper did not cite its sources for the information.

Mr. ... proclaimed his innocence and ... took a polygraph test commissioned by ...

The pipe bomb filled with metal detonated at 1:20 ... Olympic revelers watched ... One woman was killed in a blast, a Turkish cameraman died of a heart attack ... the bombing, and ...

The letter written by Mr. Alexander does not ... apology to Mr.

Continued on Page 32, Column 1

The New York Times

VOL. CXLVI ... No. 50,594 Copyright © 1996 The New York Times NEW YORK, MONDAY, OCTOBER 28, 1996 $1 beyond the metropolitan area. 60 CENTS

Late Edition
New York: Today, clouds, showers, then clearing. High 67. Tonight, clearing, cooler. Lows 44. Tomorrow, mostly sunny. High 59. Yesterday, high 70, low 54. Details are on page B8.

A Man's Life Turned Inside Out By Government and the Media

By KEVIN SACK

ATLANTA, Oct. 27 — Two days after Richard A. Jewell found the bomb that later exploded during the Olympic Games here, he received a telephone call from a Georgia Bureau of Investigation agent whom he considered a longtime friend.

The agent, Tim Attaway, who was assigned to work in Centennial Olympic Park during the Olympics, told Mr. Jewell that he had been off duty when the bomb detonated in the park and was having trouble finding out what had happened. Mr. Jewell, a security guard hired by AT&T sound and light park, promptly invited him to come to his apartment for a casual dinner.

For nearly two hours, Mr. Jewell poured out his story, laced liberally with police talk and profanity, about how he had been the target when he had noticed a suspicious green knapsack that was later found to contain the bomb. But it was only weeks later, after Mr. Jewell became a suspect in the July 27 bombing, that he realized that his friend had called on him purely to satisfy personal curiosity.

Mr. Attaway was wired with a concealed recording device that captured the conversation with Mr. Jewell. A transcript of the meeting, which Mr. Jewell's lawyers say, depicts the naïveté and the earnestness of a man who had no reason to believe he was under suspicion.

THE RICHARD A. JEWELL INQUIRY
A special report.

In the transcript, said one of his lawyers, "Richard Jewell had diarrhea of the mouth like you can't even imagine. Attaway, all he gets a chance to say is 'Uh-huh,' now and then."

Investigators redoubled their efforts to prove that Mr. Jewell was the person who planted a pipe bomb in a crowded park, an act that killed one woman, hurt 111 people, and transformed the 1996 Summer Olympics into a symbol of America's vulnerability to terrorism. For a while, at least, the F.B.I. firmly believed it had its man.

But after three months, none of the bureau's investigation had turned up enough evidence and the decision was made that Mr. Jewell was no longer a target, barring the discovery of new evidence.

Mr. Jewell's saga provides a fresh object lesson about the immense power of the Federal Government.

Continued on Page A10, Column 1

It's Autumn in New York, and Triumph Is in the Air

By ROBERT D. McFADDEN

They called it historic, majestic, sublime. They compared it to Christmas morning as a kid or the best birthday ever or winning the lottery. New Yorkers were finally lost among the reality yesterday, but any way you looked at it, the New York Yankees were the toast of the town — and it was strong stuff, like the fumes of that first whisky.

After 18 years without a championship, the Yanks had dethroned the defending champions and captured the World Series. It was a day and night. The Yankees of old — and Mantle had been gone — were back.

On the morning after the victory and a night of raucous celebration, Joe Cammarata, 42, an Emergency Medical Services worker, took his son out to play ball at Marine Park, Brooklyn, where the Yankees' manager, Joe Torre, grew up. It was a sumptuous autumn of delft skies, and New York seemed...

...less magical, more small-townish. "The fans brought back so much that the city," Mr. Cammarata said. "It's as if the Yankee triumph confirmed that persistence, that character made a difference and that ideals were important. "It gives us that old-time feeling of New York," he said.

Everyone's city embraced each other. People in the streets are hugging and congratulating each other."

Yesterday, despite Sunday calm and the litter-strewn stale-beer spirit, people spilled into the streets in the parks and soccer playing fields and Paris. It was a from Belfast and Paris. It was abo celebration went on, though hourly lower key.

"It was incredibly awesome," Matt Hall, of Melbourne, Fla., said over lunch at Mantle's restaurant on Central Park South.

Continued on Page C3, Column 1

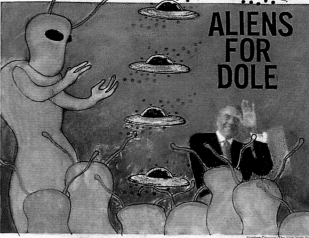

ALIENS FOR DOLE

Stephen Crowley/The New York Times

As the campaign verged on its final week, President Clinton visited Virginia and Tennessee, where he appeared with Vice President Al Gore yesterday at Vanderbilt University in Nashville. Bob Dole, in California, attacked the Clinton White House staff as "elitists" and appeared at a rally in Sacramento.

"BOB'S GOT SOME NEW SUPPORTERS"

James Estrin/The New York Times

In Battleground State, Weapons Are Falling Silent

By R. W. APPLE Jr.

HARRISBURG, Pa., Oct. 27 — What happens when a Presidential campaign all but disappears?

Pennsylvania, historically one of the most hotly contested of the big political battlegrounds in this election. For those reasons, both Bill Clinton and Bob Dole visited here and pulled television advertising off the air — one because he was behind, one because he was ahead, both because they thought they could use scarce resources to better effect elsewhere.

Mr. Dole staged a big rally at Point State Park in Pittsburgh just after the Republican convention in San Diego. Mr. Clinton spent $400,000 on one Philadelphia television station in the first week, as the same as in other cities. In Pittsburgh and Harrisburg. The Clinton campaign followed suit last week.

With little coverage on local television news, Pennsylvanians have been left with mere glimpses of the campaign on network broadcasts and in newspaper accounts. Only an occasional radio commercial pierces the silence in the media markets around Philadelphia, Pittsburgh, Allentown and Wilkes-Barre.

"THE SOUNDS OF SILENCE"

...tising space just below the windshields on 33 Red Rose Transit Authority buses, and there President Clinton, looked visit the area.

Continued on Page A17, Column 1

CLINTON CAMPAIGN PUTS AN EMPHASIS ON FEMALE VOTERS

SEEKS TO INSURE SUPPORT

President Focuses on Health, Family and Other Subjects of Interest to Women

By ALISON MITCHELL

SPRINGFIELD, Va., Oct. 27 — Seeking to insure a strong turnout from a crucial voting bloc, President Clinton made a special appeal to women today by highlighting Government efforts to fight breast cancer and telling a rally audience in Virginia that the election "is not about party, it's about you."

The President's appearances at the White House and in this Washington suburb today capped a weekend of rallies and organizing by his campaign in 35 states to insure that women — the voters who have consistently shown central to Mr. Clinton's majority — turn out to vote.

Standing on a high school field in Springfield this afternoon, a blue banner behind him proclaiming "Strengthening America's Families," Mr. Clinton stressed the health care, education and child-based themes that have been central to his campaign and that have a particular resonance with women.

Drawing a contrast between his proposals and those of the Republicans, he said, "Do we really believe that we would be better off if their vision had prevailed over the past four years?

"Would we be better off if there were no Family and Medical Leave law?" Mr. Clinton said, referring to a law that guarantees many workers 12 weeks of unpaid leave for family emergencies.

"Would we be better off if we cut student loans instead of increasing them? Would we be better off if we cut Head Start instead of increasing it? Would we be better off if we had not made those 100 million women and children healthier?" On cue, his several thousand listeners chanted and shrieked back, "No."

Bob Dole, campaigning today in California, increased the sharpness of his attacks on the Administration's ethics and called its members a "group of people who have never done anything." [Page A15.]

The President's rally appearance in Virginia came hard on the heels of one at the White House where he emphasized breast cancer as a health care issue of particular interest to women.

Across the country, many Clinton

Continued on Page A16, Column 1

Drawing Away From Dole

Representative Richard A. Zimmer, the Republican candidate for the United States Senate in New Jersey, distanced himself from the flagging candidacy of Bob Dole, and said it would not be unusual if New Jersey voters picked Bill Clinton. Article, page B4.

Clinton as a Military Leader: Tough On-the-Job Training

By TIM WEINER

WASHINGTON, Oct. 27 — In his first term as President, Bill Clinton, who came to power having commanded nothing more martial than a from took command, soon found the should have learned as a hardened cold warrior.

His spy service discovered that it had been betrayed by a traitor for the was at first reluctant to wage small battles in faraway places for political goals. And President George Bush had sown political land mines in Somalia, Bosnia, Haiti, Iraq, North Korea, Somalia.

Mr. Clinton groped for clear-cut paths through the wrenching foreign policy decisions that faced him. As a commander who had less experience than his predecessor.

Today he can rightly claim to have used American military force, without losing a life in battle, to save lives in Bosnia and Haiti. He proudly points to the fact that Moscow's nuclear missiles are no longer aimed at the United States and his name as a lot to learn when he took office, as interviews with present and past Clinton Administration officials suggest. In 1993 and 1994, they learned by making mistakes.

"The whole national security apparatus of the President was in terrible disarray," said Philip Zelikow, a National Security Council staff member under both who came from the White House staff now — the work that Reagan Administration and not now what they did.

Clearly, Mr. Clinton did not inspire

"STUDYING HARD AND HOPING TO PASS"

THE CLINTON RECORD

Continued on Page A16, Column 1

NEWS SUMMARY A2

Arts	C15-19
Business Day	D1-10
Editorial, Op-Ed	A18-19
International	A3-9
Metro	B1-6
National	A10-17, B7
SportsMonday	C1-14
Media	D9
TV Listings	D11
Obituaries	D11
Weather	B8
Classified	B8
Auto Exchange	C11

On the Internet: www.nytimes.com

354613

Joie R. Lopez/The New York Times

Joe Torre, whose 32-year wait to win a World Series ended Saturday, carrying the coveted trophy yesterday at Yankee Stadium.

After Torre Pinches Himself, the Yanks Are Still Champions

By JACK CURRY

Joe Torre was so emotionally drained Saturday night after his Yankee Stadium win the he was so busy with all the first telephone calls to answer up late into the

He was so appreciative that he had finally won an elusive World Series title the day after his older brother had undergone heart transplant surgery, that he wondered if his body was going to nudge him to sleep that seemed to prolong slumber.

This must be a dream, he thought. This has to be a dream, he thought. But every time the Yankee manager opened his eyes and looked at the smiling faces, it was no dream. The Yankees were the world champions.

They are the perfect New York team and they own New York, as and as Torre told the principal owner, George Steinbrenner, they would before the end of the series.

"This is like some out-of-body experience," Torre said from his office at Yankee Stadium.

"It really is dreamlike. You wish everybody could experience this sometime in their life. It's very emotional. It's not only emotional, it's exhausting and exhilarating. You want everybody to cherish everything in life. Everybody in New York certainly does and many will continue to do so when the team is honored

Continued on Page C3, Column 1

The New York Times

VOL. CXLVI... No. 50,595 — Copyright © 1996 The New York Times — NEW YORK, TUESDAY, OCTOBER 29, 1996 — $1 beyond the greater New York metropolitan area. — 60 CENTS

Late Edition
New York: Today, sunny, not as windy. High 61. Tonight, increasing clouds. Low 46. Tomorrow, cloudy, spotty showers. High 63. Yesterday, high 64, low 51. Details, page C10.

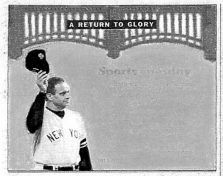

A RETURN TO GLORY

Missed Mideast Chance

Talks Appeared Close to a Turning Point, But Israelis and Arabs Would Not Turn

By SERGE SCHMEMANN

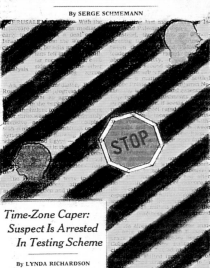

Time-Zone Caper: Suspect Is Arrested In Testing Scheme

By LYNDA RICHARDSON

A California man has been arrested...

Broken Water Mains Sow Familiar Chaos

Article, page B9.

Richard A. Jewell

On the Internet: www.nytimes.com

INSIDE

Ex-Suspect Tells of Ordeal
Richard A. Jewell held an emotional news conference... Page A12.

A Bigger Stock Exchange
...Page B11.

A Worrisome Oil Price Rise
...Page D1.

Russian Rockets Get Lift
...Science Times, page C1.

Cast of 'Les Miz' to Go
...Page C...

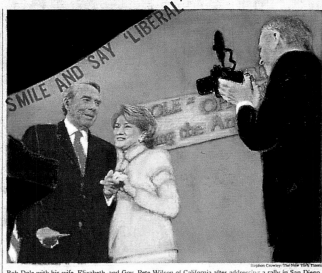

Bob Dole with his wife, Elizabeth, and Gov. Pete Wilson of California after addressing a rally in San Diego.

SMILE AND SAY 'LIBERAL'

For Big Labor, And New Chief, A Time to Smile

By FRANCIS X. CLINES

AUGUSTA, Me., Oct. 28 — John J. Sweeney...

FLEXING THEIR MUSCLES

Clinton Hails Drop in Deficit, Declaring 'America's Awake'

By ALISON MITCHELL

CHICAGO, Oct. — ...

MUST BE THE COFFEE

Continued on Page A20, Column I

DOLE SEES FAILURE OF THREE DECADES IN ANTI-BIAS FIGHT

OPPOSED TO PREFERENCES

Backing California Initiative, Candidate Calls Laws He Once Backed Misguided

By ADAM NAGOURNEY

ANAHEIM, Calif., Oct. 28 — Bob Dole today declared...

President Clinton, with Mayor Freeman R. Bosley Jr. of St. Louis, left, and Gov. Mel Carnahan of Missouri, waited to address a rally yesterday in University City, a suburb of St. Louis, during a trip through three states.

Documents Rebut White House, Ex-Trade Aide

By STEPHEN LABATON

WASHINGTON, Oct. 28 — ...

WHERE IN THE WORLD IS MR HUANG

The New York Times

VOL. CXLVI . . . No. 50,596 Copyright © 1996 The New York Times NEW YORK, WEDNESDAY, OCTOBER 30, 1996 $1 beyond the greater New York metropolitan area. 60 CENTS

Late Edition

New York: Today, cloudy, a brief shower. High 62. Tonight, clearing, breezy at times. Low 49. Tomorrow, mostly sunny. High 57. Yesterday, high 59, low 46. Details, page C20.

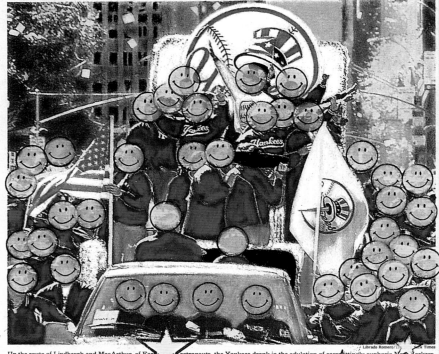

Up the route of Lindbergh and MacArthur, of Earl... astronauts, the Yankees drank in the adulation of ears fittingly euphoric New Yorkers.

Dole Says Vow To Trim Taxes Means Victory

Calls News Coverage of Plan Mostly Negative

By ADAM NAGOURNEY

IRVINE, Calif., Oct. 29 — Relaxed, warm and witty before a Republican audience in the conservative heart of Southern California, Bob Dole today returned to what had once been the foundation of his campaign — a 15 percent tax cut — to predict that that promise alone would elect him to the Presidency next week.

"Don't worry about it," Mr. Dole said, offering words of comfort that seemed intended as much for himself as for his partisan audience. "In the last few days, the American people will understand that voting for Bob Dole is voting for a tax cut."

Mr. Dole's speech this morning was before the World Affairs Council of Orange County, and the principal subject was intended to be a final in-depth explanation of his economic plan. Mr. Dole asserted that the reason his proposal had yet to catch on was because news coverage of it had been overwhelmingly negative.

But Mr. Dole's attempt to deliver what would have been his second serious policy speech in as many days did not quite come off. For a variety of reasons — the embrace and laughter of an unusually affectionate crowd, a failed teleprompter, but most of all the prospect that he was heading home — combined to put a reinvigorated and entertaining Mr. Dole on display a week before Election Day.

Gone, at least for the moment, was the combative, dark and studious Mr. Dole who has barreled his way through California these last days attacking White House corruption, elite newspapers and voter apathy. Instead, Mr. Dole mixed patches of policy — which he read from a text — with humorous asides. ("The teleprompter doesn't work, by the way," Mr. Dole commented, remarking on

Continued on Page A16, Column 3

Aircraft Deal With Chinese Is Questioned

By JEFF GERTH and DAVID E. SANGER

WASHINGTON, Oct. 29 — Nearly two years ago the McDonnell Douglas Corporation announced a deal with China that seemed like a victory for both American commercial diplomacy and the aircraft makers, work force to $1.5 billion order for 40 airplanes, half to be built in California, half in Shanghai.

The deal had been years in the making, and President Clinton touted it as an example of the Administration's deft handling of a huge project that could have easily been derailed by Washington's rocky relationship with Beijing. And for Mc-Donnell Douglas, it was a chance to make some profits in China.

But now a Federal grand jury is investigating whether McDonnell Douglas or its Chinese partner, the procurement arm of the Chinese Aviation Ministry knowingly violated American export-control laws. And this criminal inquiry has prompted a round of finger-pointing in the Administration, as well as a growing debate over whether the United States should provide demands for technology, some with potential military value, in return for billions in contracts.

At issue is an unnoticed, multimillion-dollar agreement that for

Continued on Page A16, Column 1

Walkouts at 2 G.M. Plants

Workers walked out at two G.M. plants, moves that may lead to a ripple of factory closings. Page D1.

CLINTON PUTS STING INTO RARE ATTACK ON DOLE'S RECORD

A RESPONSE TO HECKLERS

In Detour From the High Road, President Pounds His Rival for Votes on Education

By ALISON MITCHELL

PHILADELPHIA, Oct. 29 — President Clinton momentarily abandoned his air of sailing above the partisan fray today and, goaded by hecklers supporting the Republican ticket, lashed out repeatedly at Bob Dole's voting record in the Senate.

Mr. Clinton had just begun speaking this morning at Ohio State University in Columbus — after two days of campaigning past midnight — when a group of demonstrators carrying "Dole/Kemp" signs began drowning out his words by chanting, "Tell the truth!"

But while waving off the cheering thousands of Clinton supporters in the sports arena who were shouting their indignation at the interruption. "This is a university and we have respected their free speech," the President said. "They won't respect ours because they hate the truth."

Mr. Clinton usually refers to Mr. Dole in only the vaguest of terms, like "our opponent," and his campaign speeches, often delivered on college campuses, can sound like community college addresses looking toward a commencement ceremony.

But today, at one of his last appearances in Ohio, a state in the swing states that Pennsylvania had become important to his strategists to sum up his agenda.

But uncharacteristically, Mr. Clinton offered one of the most direct assaults of the campaign on Mr. Dole, using the protesters as a foil to lambaste his Republican opponent's voting record.

"They must not have the student loans," Mr. Clinton said of the demonstrators. "Senator Dole voted against creating the student loan program." Moving on to the direct loan program, in which the Government replaces banks as the lender, he said the students have not received those either "because Senator Dole still believes we should start the 21st century as the only great nation in the world with no one in the President's Cabinet to represent education," he added, "because

Continued on Page A17, Column 1

Democrats Release Records

After criticism, the Democratic Party made public an accounting of its contributions for the first two weeks of October. Page A18.

The Clinton Factor Fuels Final Tactics In New Jersey Race

By JENNIFER PRESTON

TRENTON, Oct. 29 — With polls showing Republicans enjoying a strong lead in New Jersey, Democrats and the United States Senate is counting on the Clinton-Gore ticket to help sweep him into office to help his Republican opponent that a Clinton landslide could sweep their candidate along.

Over the years representative Dick Zimmer, Republican, has acknowledged that he is depending on New Jersey's "inveterate ticket splitters," to help propel him into office, noting that voters here "more often than not have voted differently for President than Senator."

Representative Robert G. Torricelli, a Democrat, on the other hand, is campaigning in the next week with a mix of top Administration officials.

Continued on Page B8, Column 6

EX-C.I.A. ANALYSTS ASSERT COVER-UP

Contend Agency Knew of Risk From Chemicals in Gulf War

By PHILIP SHENON

WASHINGTON, Oct. 29 — Two intelligence analysts who resigned earlier this year from the Central Intelligence Agency say the agency possesses dozens of classified documents showing that tens of thousands of American troops may have been exposed to chemical weapons during the Gulf war in 1991.

The husband-and-wife intelligence team, Patrick and Robin Eddington, who are being investigating the issue, said, they turned up evidence of as many as 60 incidents in which gas and other chemicals were released in the vicinity of American troops.

The Eddingtons say that the C.I.A. and the Pentagon have tried to hinder a standardized investigation and that when they sought to raise the inquiry over the objections of officials, their efforts were effectively blocked at the highest levels of the agency, including John M. Deutch, a former Pentagon official who is now the Director of Central Intelligence.

"The levels of chemical exposures immediate troops in overwhelm the government won't deal with," Mr. Eddington, who resigned this month after more

Continued on Page A14, Column 1

A Parade of Pride in Yankee Triumph

By N. R. KLEINFIELD

Ticker Tape Celebration Draws Throngs Paying Tribute to Champs

With its lungs and its City at its effulgent spirit, the triumphant Yankees roared in a rousing ticker tape parade up lower Broadway's canyon of Heroes.

For several hours in the middle of a splendiferous autumn work stopped, play stopped, and time had to wait. Nothing else mattered, nothing else.

Three days after the last pitch, a ball plunked into the open glove of third baseman Charlie Hayes and the World Series finally belonged to the Yankees again, New Yorkers made it clear that they were not yet ready to let go of perhaps the most emotional October baseball the city has ever seen.

His was the supreme expression of civic unity ushered with pure and unreasoned sports joy — what many interpreted as one more chapter in a rebounding metropolis, euphoric fans who had exhausted their lungs during the heart-squirming World Series melodrama that they had still relished in their soul, waiting for more.

"I've been a Yankee fan since I was born, and I had to be part of history," said 11-year-old Eddie Padilla, who with a guilt-troubled conscience skipped school to watch the parade. "These guys made this my best year, and I wanted to tell them that by screaming as loud as I can."

On a brisk and windy day, under azure skies with unlimited blue, the city showed itself in all its extroversion. Screeching, passionate rooters dangled out of windows, scrambled into tree branches, settled on roof-

tops and choked the broad sidewalks into human gridlock, as after Manhattan groaned under the weight of a crowd that Mayor Rudolph Giuliani put at 3.5 million. The parade probably bore more enthusiasm than precise measure.

Joe Torre, the Yankee manager, who had endured the most profound emotional tribulations during the postseason, told the crowd at a rally at City Hall after the parade that he seemed moved — obviously never even close to being involved in anything like this parade today and this sea of humanity we see out here this afternoon," he said. "This is absolutely spectacular.

"What else? You could have lit up the whole city today with the energy of the people today out here. Electricity. That's what it was all about."

Up the route of Lindbergh and MacArthur, of Ruth, Cliburn and Nehru, of Earhart and the Apollo astronauts, the men in pinstripes, wearing

Continued on Page B6, Column 1

Insurers Returning To Poor City Areas

Insurance companies, which virtually wrote off the inner city in favor of the suburbs and wealthy pockets of cities, are now rediscovering poor and working-class urban neighborhoods.

Insurers like State Farm and Allstate have opened offices in the urban marketplace, and many are doing a brisk business.

The new-found industry follows years of prodding, lawsuits and political pressure from residents and advocacy groups.

Still, insurance coverage is often much more expensive in urban neighborhoods than in the suburbs.

Business Day, page D1

Kohl Is an Iron Man, but the Price Is High

By ALAN COWELL

LEIPZIG, Germany — Helmut Kohl, who triumphantly proclaimed about 10 days ago his commitment to serve a full term as Chancellor, fused a comparison with Mr. Konrad Adenauer's leadership in 1949 to 1963, when Germany was rebuilt from the ruins of war into a European powerhouse. But even at this moment of tribute, his longevity is beginning to exact a price.

A certain grumble of Mr. Kohl's 14 years in office — his exhaustion to cushion the pain of reunification with unparalleled financial largess — has produced at best mixed results from his staggering $600 billion in subsidies, incentives and aid that has oiled into the former East Germany in the last six years.

His spending proved politically expedient for Mr. Kohl's electoral fortunes, but many economic analysts now say it half-bought Germany's taxes and did not based on facts and figures," said Christian Jackstein the Leipzig's Director.

Mr. Kohl himself acknowledged at his Christian Democratic party congress in Hanover this month that adding up the sums is not his strongest suit. But in a speech earlier to mark the sixth anniversary of reunification, even he finally admitted that righting the two Germanys would take much longer than the five years in

Otto von Bismarck united Germany 125 years ago; Helmut Kohl is about to become the longest-serving Chancellor since Bismarck.

Culver Pictures Agence France-Presse

which, he once predicted, eastern Germany would become as prosperous as western Germany.

In 1990 set the picture, and was not based on facts and figures.

"The East was cut off," said Christian Jackstein the Leipzig's Director. "The firms have gone, and people are satisfied are the beautiful landscape."

The approach of the 66-year-old Mr. Kohl's record-setting anniversary has inspired much musing about precisely how a provincial politician beloved of solid food, labored jollity and postponed decisions took his place among Germany's titans.

Mr. Kohl has not publicly discussed his political longevity in great detail, though he decided to be interviewed on this anniversary. To chart his success, including even his adversaries in eastern Germany point to his political record, the weak opposition and general satisfaction with stability that has followed the fall of Communism.

"There's a conservative way of thinking," said Lothar Tippach, the leader in Leipzig of the Democratic Socialist Party, the successor to the East German Communists. "So the people say: We want

Continued on Page A6, Column 1

News Summary

Arts	C13-19
Business Day	D1-21
Editorial, Op-Ed	A20-21
International	A3-11
Living Section	C1-12
Metro	B1-8
National	A12-19
Sports Wednesday	B11-17
Education	B9
Health	C12
Obituaries	D22
Real Estate	D20
TV Listings	C21
Weather	C20
Classified	B17
Auto Exchange	B17

On the Internet: www.nytimes.com

354613

"All the News That Fits"

The New York Times

Late Edition

New York: Today, brisk, sunny. High 56. Tonight, breezy, cloudy. Low 40. Tomorrow, morning clouds, a shower, then clearing, brisk. High 53. Yesterday, high 65, low 51. Details, page C13.

VOL. CXLVI ... No. 50,597 Copyright © 1996 The New York Times NEW YORK, THURSDAY, OCTOBER 31, 1996 $1 beyond the greater New York metropolitan area. 60 CENTS

Wang Dan's sentence is among the harshest given to leaders of the Tiananmen Square movement.

Chinese Verdict Points to an Era Of Harsh Rule

By PATRICK E. TYLER

BEIJING, Oct. 30 — With a harsh court verdict today that will send the former student leader Wang Dan to prison for 11 years, China's Communist Party leadership may have silenced the last of its prominent critics at home and ushered in an era of authoritarianism that leaves only commerce to occupy the Chinese.

Despite the international protests that greeted the announcement this month that China had charged Mr. Wang, the 27-year-old icon of the Tiananmen Square democracy movement, with capital offense, a Beijing court convicted and sentenced him today after a four-hour show trial in a sealed courthouse.

In Washington, the Clinton Administration condemned the Chinese court's verdict and said Secretary of State Warren Christopher's visit to China in November would go ahead as planned. An American official said that though the verdict was "harsh," it would not interfere with the coming visit.

Mr. Wang's conviction and sentencing follow by two weeks the handing down of a similar sentence to the No. 1 counterpart in the Peoples Court, who was convicted of "putting up banners and writings in foreign lands" in 1995 and 1995 and among his association with other prominent dissidents like Wei Jingsheng.

Continued on Page A12, Col. 1

HIGH COURT ASKED TO REVERSE RULING IN A RELIGION CASE

AN UNUSUAL PROCEDURE

White House Would End Ban on Public School Teachers in Some Remedial Classes

By LINDA GREENHOUSE

WASHINGTON, Oct. 30 — Invoking a rarely used procedure to reopen a decided case, the Clinton Administration has asked the Court to overturn a 1985 decision barring public school teachers from traveling to parochial schools to offer federally financed remedial and other counseling.

Supporters in New York City, which made a similar request to the Court earlier this month, filed the brief, filed late yesterday by Solicitor General Walter Dellinger, said the 1985 decision should be burdensome and expensive to administer and had a "significant, adverse impact" on the ability of public school systems to serve low-income students with special needs.

The brief said public school systems have hundreds of millions of dollars to comply with the 1985 ruling, banning religious school students from attending school for the special services and teaching by mobile vans and off-site locations. New York City spends $5,000 for parochial school teachers a year in more than a dozen leased at an annual cost of $15 million each.

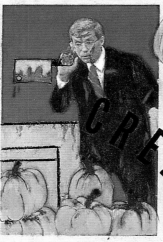 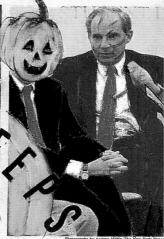

Photographs by Andrea Mohin/The New York Times

An Attack of Calm in New Jersey

The New Jersey Senate campaign, one of the country's most bitter, turned positive yesterday, as Richard A. Zimmer (left) and Robert G. Torricelli (right, with George Stephanopoulos, the Clinton adviser), focused on education, not each other. Page B8. A profile of Representative Torricelli is on page B1.

Party Aide Now in Eye of Storm Frequently Visited White House

By STEPHEN LABATON

WASHINGTON, Oct. 30 — John Huang, the senior Democratic finance official at the center of questions about the party's fund-raising activities, was a frequent guest at the Clinton White House even as he was raising millions of dollars for the 1996 election effort, according to Government records.

The records show that Mr. Huang, a vice chairman of the Democratic National Committee's financing operation, was often at the White House three hours at a stretch, more than once on the same day.

On one day, Feb. 9, he was there four times. His most frequent visits occurred in February, when he made 8 and in August, when he made 10. His last recorded visit was on Oct. 3.

Continued on Page B13, Column 1

ECONOMIC GROWTH RETREATS TO 2.2%

Experts Differ on How Long Slowdown Is Likely to Last

By DAVID E. SANGER

WASHINGTON, Oct. 30 — In one of the last major indicators of the country's economic performance before the Presidential election, the Commerce Department today reported a sharp slowdown in economic growth in the third quarter of the year, but no sign of a slide into even modest inflation.

Today's report said the growth rate fell to 2.2 percent in the third quarter, from 4.7 in the second, did not come as a surprise. Most economists had predicted that the economy would cool considerably. But they differ on whether this is the beginning of a slower economy or a brief expansion that can be sustained into next year.

Continued on Page D4, Column 3

DOLE ASSERTS DATA ON ECONOMY SHOW RECESSION IS NEAR

FRESH ATTACK ON CLINTON

White House Rebuts Charge, Calling G.O.P.'s Predictive Abilities 'Questionable'

By ADAM NAGOURNEY

NEW ORLEANS, Oct. 30 — After a midmorning visit for prayer and reflection at the Lincoln Memorial in New Orleans waiting over the Election Day horizon.

"If this is a recovery, I can hardly wait for the recession — if this is the recovery," Mr. Dole declared, his voice booming off the hard walls of a stuffy state gym this afternoon in central Tennessee before Louisiana.

GHOULS AND GULAGS

GHOSTS OF GLOOM AND DOOM

INSIDE

A South African has sentenced the former apartheid security police assassin to 200 years in jail. Page A3.

Tiny Glitch, Huge Ripple

A dip in electrical power after a fire at a Con Edison substation in Yonkers hampered trains and computers in the New York region. Page B1.

NBA 1996-97

New Look in the N.B.A.

After a summer of transition, the N.B.A. season opens tomorrow with everyone chasing Michael Jordan and the champion Bulls. Page B.

On the Internet: www.nytimes.com

Did Somebody Say Treat?

A Halloween story at Jamaica Market in Queens yesterday prepared little creatures more scared than scary (in reality, children from Tree House Nursery and the New Busy Bee Learning Center) for today's festivities.

Rebecca Cooney for The New York Times

WITCH WAY TO GO

CREEPS

Refugees Are Caught in Central African Crossfire

...C. Mo... Burundi...old son, Eric, who had succumbed after 10 days of fighting and refugees died in the border from Zaire this morning. He was not yet 2, a tiny victim of an intensifying battering this part of Central Africa.

"He was suffering from ... and we couldn't get medicine," the mother, Lachel Ngengesere, as her friends dug a shallow grave and wrapped the baby, Patrick, in a soiled yellow cloth. "I blame the war, the war and the disorder."

A few feet away, Tito Nankimbesha stood over the body of his 2-year-

being caught in the crossfire as refugees surge toward a bridge toward a "first," he said.

for water to drink, and all day there was no water, and today there was water. Some 10 minutes ago he died. The babies were buried side by side here on a wide plain along the north shore of Lake Tanganyika, just a few miles from Uvira, Zaire, where Tutsi rebels have reportedly defeated the Zairian military. They were among the hundreds of thousands of ethnic Hutu dislodged from refugee camps by the growing conflict, and who are now in serious danger of...

Continued on Page A10, Column 1

Home for Teen-Age Mothers Tries to Break Welfare Cycle

By PETER T. KILBORN

SOMERVILLE, Mass. — an updated version of the Victorian Cameron, a mother at 18, and homes for unwed mothers, ride 24-toddler son, Shaun, sleep under a herd on their charges, providing glow of the stars that she pasted on care while teaching the mothers the ceiling of their tiny bed. Homemaking and child-rearing From the wall over the bed and seeing that they finish high bed, she took a frame high school diploma.

"This is my second home," the State Secretary and Human Services, Jo- said, "we say we've got after Shaun," she said. All of these kids who are...

THE DEVIL MADE THEM DO

354613

November

Disaster was in the stars. The winners of the U.S. election

went to Disney World, the losers went home,

and I went wild filling up the entire surface of the front page

with text, stamps, and drawings. The color of the month was

a vibrant acid green. The Rwandans began leaving Zaire on

October 31 and marched through the 17th of November

trying to get back home. A Russian satellite fell to earth,

Amtrak derailed, and the hijacked plane from Ethiopia crashed.

After that we celebrated Thanksgiving.

The New York Times

Late Edition
New York: Today, becoming cloudy, spotty rain. High 48. Tonight, spotty light rain or snow. Low 40. Tomorrow, partly sunny. High 48. Yesterday, High 59. Low 50. Details, page B22.

VOL. CXLVI . . . No. 50,598 Copyright © 1996 The New York Times NEW YORK, FRIDAY, NOVEMBER 1, 1996 $1 beyond the greater New York metropolitan area. **60 CENTS**

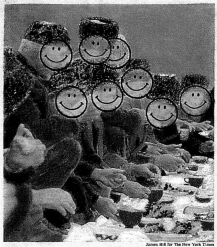

Chechens gathered this week to celebrate the rout of Russian troops. — *James Hill for The New York Times*

In War-Ravaged Chechnya, Russia's Presence Is Fading

By MICHAEL SPECTER

ZUMTSOI, Russia — Draped in mists and surrounded by the unspoiled snow covered weeks of the Caucasus, the elders gathered on a hilltop here to thank Allah for bringing them victory in their war against Russia.

They prayed, then slaughtered cows in vast black cauldrons. It was a celebration without joy though, because, as the separatists' President, Zelimkhan Yandarbiyev, told a assembled villagers, "War is very hard for our bodies but what is to come will be much harder for our souls.

"Allah demands that we be free to live as a holy land, as a Islamic land," he said, as the men dressed in sheepskin-lined burkas against the young winter, nodded

their agreement. "We will get nothing from Russia, and we must be glad. The spring death won't sure be we war. Now the real struggle for Allah."

Two months after Chechen separatists defeated the Russian Army, this region remains a desert. In Moscow and here they talk of the future of the region with great intensity, always saying that Chechnya must never be independent.

But for the Chechens, that kind of talk means nothing any more: The traditional green Chechen flag of the lone wolf flies over every battle-scarred town hall in the shattered republic.

The puppet government installed by Moscow has vanished. Its leader, Doku Zavgayev, lives in Moscow. Pakistan, Jordan and an — Muslim countries that have supported Chechnya's war — have each sent emissaries and cash to help guide the republic. The mayor of Grozny is the nephew of Dzhokhar Dudayev, the rebel leader killed this year in a bombing raid. One man in charge of distributing credentials to journalists in the Republic of Ichkeria, as the rebels call their land, helped lead the infamous 1995 raid on the city of Budyonnovsk.

Russian soldiers assigned to

Continued on Page A16, Column

Panel Sees No Proof Of Health Hazards From Power Lines

By WARREN E. LEARY

WASHINGTON, Oct. 31 — There is no convincing evidence that exposure to electric and magnetic fields from power lines and appliances in the home is a health hazard, a committee of scientists said today.

A 16-member committee of the National Research Council an arm of the National Academy of Sciences, said after reviewing more than 500 studies over 3 years that it produced no proof that electromagnetic fields common in households caused leukemia or other cancers, or harmed humans in other ways.

After a 3-year study that involved reviewing research papers and interviewing scores of experts, the committee concluded, no conclusive scientific evidence shows that the residential electric and magnetic fields produce cancer, adverse neurobehavioral effects or reproductive and developmental effects.

The report was commissioned by Congress to address wide ranging concern that low-level electromagnetic fields caused by power lines and appliances or the power lines near homes, schools and public buildings might harm people's health. The concerns had set off a fierce debate over whether expensive steps should be

Continued on Page A29, Column 1

INSIDE

Another Hint of Martian Life

Scientists in Britain say they have found that another meteorite from Mars displays some indications of rudimentary life. Page A12.

News Summary A2

Business Day	D1-18
Editorial, Op-Ed	A14-15
International	A3-17
Metro	B1-7
National	A20-32, B8
SportsFriday	B9-16
Weekend	C1-35
Media Business	D2
Obituaries	B14-15
Real Estate	B14
Classified	D18
TV Listings	D18
Weather	B22
Auto Exchange	B22

On the Internet: www.nytimes.com

354613

BOOM IN PROFITS FOR CORPORATIONS NOW APPEARS OVER

WEAK GAIN IN 3D QUARTER

Surge Helped Buoy Economy and the Stock Market for More Than Four Years

By JONATHAN FUERBRINGER

The great boom in corporate earnings, which helped propel a market and buoy the economy for more than four years, seems to be over. What analysts say for now is how much more slowly earnings will grow.

While companies have reported healthy results, the revised results for the second quarter and first quarter should have the weakest gains in operating earnings in about four and a half years. And third quarter results are expected to be the smallest since profits actually fell in 1991.

Worker earnings are certainly a worry. That is be cause something that investors may object to is apparently happened. Companies can support stocks in the face of growth slackening if year's gains in the stock they make that abundantly clear. Jones industrial average has reach 15 percent through yesterday and the broad Standard & Poor's 500 index is up

But with the broader market in record level at the stocks are relatively high. So earnings which next year may worry investors and undermine the stock market's performance with earnings forecasts all over the lot — from flat to up 10 percent. The debate continues on whether the market can continue to expand or yet another year.

The reasons for the profits slowdown from the 15 percent average rate from 1992 the 1995 run the gamut. They range from an increase in prices and the slowing velocity of workers to the modest pace of growth in the economy. That a lot of the corporate cost-cut operating year's slow down and the efficiency of the economy.

In the third quarter earnings for industrial companies Motorola, and a number of industries, including International Paper, Phelps Dodge and Tenneco Inland, all served as anchors that put a drag on earnings growth.

The positive push came from energy

Continued on Page D4, Column 3

Abductions Rock Mexico, Scaring Not Just the Rich

By SAM DILLON

CUERNAVACA,

Francisco Resendiz has paid two ransoms for his teen-age son, who is still a captive. — *Keith Dannemiller for The New York Times*

Stephen Crowley/The New York Times

While Bob Dole appeared in Florida with George Bush, President Clinton shook hands with supporters at Arizona State University. — *Paul Hosefros/The New York Times*

Dole Plans Campaign Marathon As Candidates Wind Up Appeals

Clinton Goes One-on-One

By TODD S. PURDUM

OAKLAND, Calif., Oct. 31 — As President Clinton worked the crowd on the steps of a theater in Tempe, Ariz., this morning, a single excited teen-ager pierced the tumultuous din of the crowd that struggled to pet him. under the palms.

"I touched the President five times!" Teresa Apodaca, a 16-year-old student from Tempe exulted to her girlfriends as she bubbled back from the barrier she had hurdled with history.

As Mr. Clinton swings across the country — the latest legs carried him today from Phoenix to Las Vegas and then on here to Oakland — Ms. Apodaca never too late reaching out to the crowds and letting them reach back for him — personifies the kind of organizer supporters. In a new days of the campaign, the President has singled out for conversation, attention and heavy doses of the considerable Clinton empathy a girl with a rare disease, a towheaded toddler with asthma, a teen-age woman distraught at the idea of late-term abortions and a young father leaning toward voting for Bob Dole.

Mr. Clinton listens, and tries to help. But these encounters also perform a vital function for his own psyche: They inspire, energize and

Continued on Page B12, Column 1

A Nonstop G.O.P. Tour

By ADAM NAGOURNEY

ATLANTA, Oct. 31 — Looking for a last-minute flourish with which to conclude his bid for the White House, Bob Dole announced today that he would embark on a 96-hour nonstop campaign marathon of airplanes and buses that would take him from Ohio to California and back to Russell, Kan. to vote at his local schoolhouse.

In a round-the-clock campaign-ending burst of rallies and bus trips — "We're going to be busy. And probably sleepy," Mr. Dole observed laconically — seemed an inevitable and appropriate last act for Mr. Dole's candidacy, coming in a notably chaotic week in which Mr. Dole and his staff have cobbled together his schedule from news cycle to news cycle.

Mr. Dole's announcement nearly overshadowed a speech in Tampa, Fla., during which he assailed President Clinton for easing Republican measures to curb the growth in Medicare spending. Mr. Dole asserted there that Mr. Clinton's television advertisements had frightened elderly voters in Florida, complicating both Mr. Dole's electoral hopes in the normally Republican state and congressional efforts to restore confidence in the government social among the elderly.

"We need to finally up in four years or five years unless something is done," Mr. Dole said. "This is a problem that cries out for leadership — but we don't have any leadership in the

Continued on Page B11, Column 1

RENO MAKES MOVE TOWARD AN INQUIRY INTO FUND RAISING

RULING DUE AFTER NOV. 5

Need for Special Prosecutor Is to Be Weighed in Review of Democrats' Finances

By STEPHEN LABATON

WASHINGTON, Oct. 31 — Attorney General Janet Reno said today the first official step toward investigating possible wrongdoing by Democratic fund-raisers.

Although it does not guarantee such an appointment, the action provided the first official suggestion that complaints of possible crimes in the raising of millions of dollars by Democrats might rise high to warrant outside prosecution.

Ms. Reno's comments also seemed to suggest that the issue of possible criminal activity in the swirl of events around the Democrats' fund-raising activities would remain a prominent political issue for at least another month as Justice Department prosecutors weigh whether to push the review to the next stage of inquiry. But a final decision on whether to seek an independent counsel will be reached until weeks after Tuesday's elections.

White House officials did not express much concern about it today.

"They have to review the matter if they've received a formal request from a member of Congress," said the White House press secretary, Michael D. McCurry. "We would assume that she would do whatever she considers appropriate in the circumstances." Mr. McCurry then added, referring to questionable fund-raising practices by the Republicans, "She also may she'd review all that other stuff about them."

Continued on Page B10, Column 1

In New Jersey, Meeting the Voters Is a Luxury

By NEIL MacFARQUHAR

NEWARK, Oct. 31 — If the New Jersey Senate race is any guide, mingling with the public is no longer a prerequisite for office.

Time spent spontaneously shaking hands or kissing babies, long out-moded in large states like California, has been given to extreme this year this geographically compressed the real campaign, consists of a barrage of

Each candidate — Representative Robert G. Torricelli, the Democrat, and State Assemblyman Dick Zimmer, the Republican — is spending at least half the day, most days a week, on the phone dialing for money. Representative Torricelli, the Democratic candidate, actually left the state this week

to fly to California to hobnob with Hollywood donors, while Representative Richard A. Zimmer said facetiously that he would probably not hold a fund-raiser on Election Day.

Stumping in New Jersey circa 1996 consists of showing up every day somewhere for an hour or two — an elementary school, a factory floor, a police station, a newspaper editorial board — swinging along your crew to create footage at the expense of the market, divided mainly between New York and Philadelphia.

Continued on Page B6, Column 5

unscripted stops hold the fearsome potential for embarrassment.

Both Mr. Zimmer and Mr. Torricelli say that they don't really have time to spend with voters. There are too many donors' calls to make, too many breakfast shows to appear on, too many editorial boards to meet to fuse an electorate.

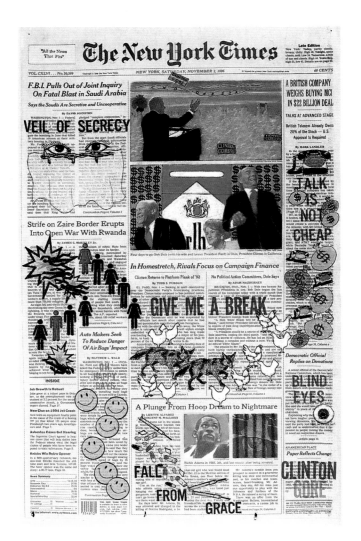
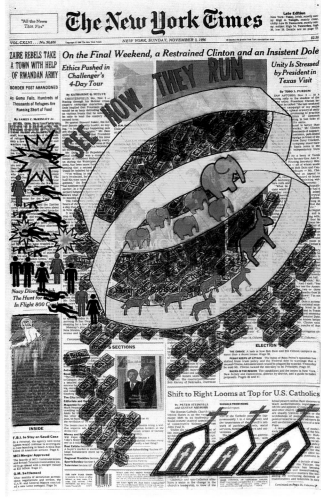
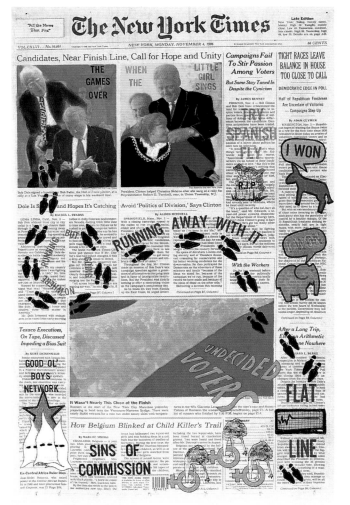
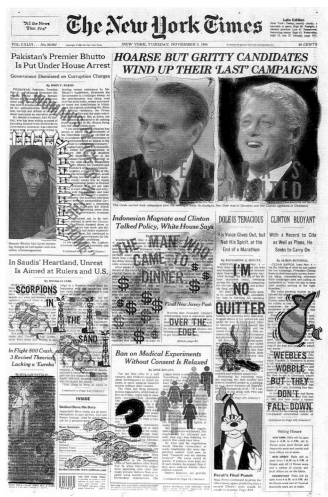

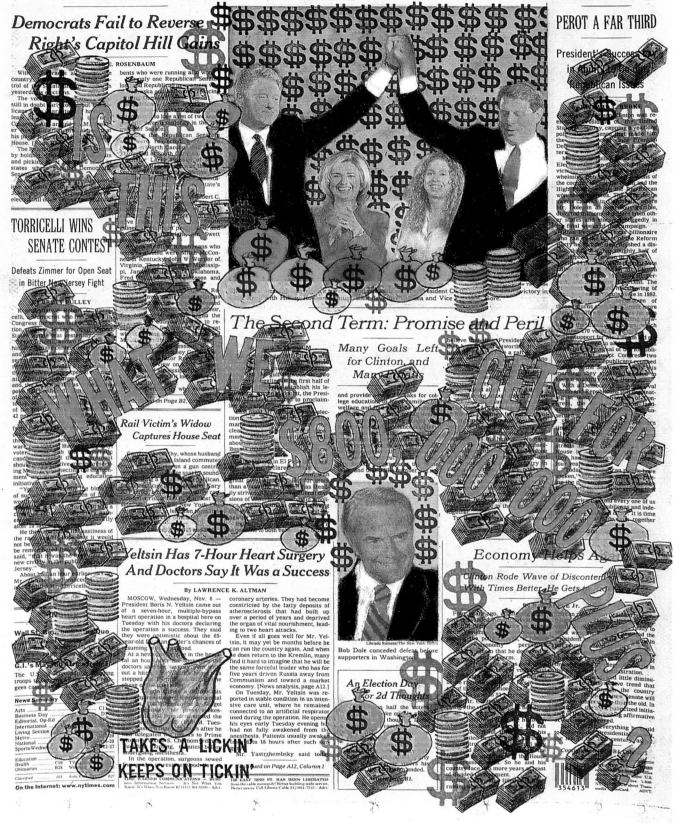

"All the News
That Fits"
The New York Times
Late Edition
New York: Today, mostly cloudy, a sprinkle. High 64. Tonight, breezy, mild, patchy drizzle. Low 56. Tomorrow, windy, showers. High 63. Yesterday, high 59, low 53. Details, page B24.

VOL. CXLVI... No. 50,604 Copyright © 1996 The New York Times NEW YORK, THURSDAY, NOVEMBER 7, 1996 $1 beyond the greater New York metropolitan area. 60 CENTS

Dredgers Recover a Lode Of T.W.A. Crash Debris

By ANDREW C. REVKIN

Aided by increasingly sophisticated sonar and metal detectors as well as by the discoveries of divers, investigators of the crash of T.W.A. Flight 800 have in the last few days found the largest concentrations of wreckage yet.

But investigators said this was just the beginning of a raking process that has already covered an area of nearly four pounds of the ocean floor and could provide the physical data to explain what ignited a blast that destroyed the jet and the 230 people aboard.

Among the pieces located yesterday were some that probably froze the heart of the fuel tank, investigators said, that section of the plane holds the key to the crash, they believe.

Since dredging began early Monday morning, more than 60 bags — each 4 feet by 6 feet by 8 feet — with wreckage have been brought up, providing the first substantial new haul of potential clues in more than a month.

A boatload of aircraft debris sent ashore yesterday afternoon included some pieces too large for bags, including almost a dozen recovered metal beams or frames some four to six feet long — and one of the jet's tires, four feet in diameter.

Federal crash investigators were heartened by the new finds, hopeful that answers might finally be produced for one of the most confounding disasters in the middle of the Atlantic.

Although investigators have just begun to analyze the new finds, they are already "pretty excited," said Shelly Hazle, an official of the National Transportation Safety Board.

"I don't think anyone anticipated we'd be this successful so soon," she said.

"Calm weather has allowed two separate scallop-fishing boats to work around the clock, said Greg Bagley, the manager of search and recovery operations for Oceaneering International, a private company running the operation under contract with the Navy.

A couple of hundred pounds of newly dredged wreckage was being examined yesterday for any indications that an explosive device or mechanical failure had destroyed the jet.

So far, investigators know only that something instantly cut power, caused a loud noise or surge in temperature and broke off the front of the jet, ahead of the wings.

They also know that the center fuel tank exploded, but have not yet concluded what set it off, or whether that blast alone led to the plane's destruction.

The pieces appearing to be from the center fuel tank were tentatively identified by a safety board investigator aboard the boats, Ms. Hazle said. "But further analysis by specialists on shore will be needed to confirm that," she said.

Continued on Page B12, Column 1

Serbs Said to Ship Arms to Libya In Effort to Evade U.N. Sanctions

By CHRIS HEDGES

BROTHER CAN YOU SPARE A BAZOOKA

BELGRADE, Serbia — For three hours last Wednesday, Russian transport planes and instrument panels shut down in a power failure that circled low over the Belgrade crash, as it made an unscheduled landing at Surcin International Airport.

Shortly after the doomed IL-76 lowered its landing gear, a secondary explosion lit up the night sky, eyewitnesses said. Serbian police officials scattered around the site, whereupon the Russians who had arrived at the entry were ordered dead in the nearby embassy, but carefully collected intelligence sources here concluded that the

INSIDE

China Paroles Key Dissident
The Chinese authorities released a leading dissident from jail, a man whose fate has been a weather vane of American-Chinese relations over the last two years. Page A6.

Texaco Punishes Executives
Texaco suspended two executives and cut off some benefits to two retirees. They were tape-recorded planning to destroy documents in a discrimination suit. Page D1.

Earlier Origin of Life
Scientists have found that life on earth may have begun 3.8 billion years ago, 350 million years earlier than previously thought. Page A30.

Players Suspended
Boston College suspended 13 football players for gambling, including two who are accused of betting against their own team. Page B27.

A Setback for Baseball
The agreement forged with the players union was rejected, 18-12, by the owners, guaranteeing a new impasse over a contract that expired nearly three years ago. Page B27.

On the Internet: www.nytimes.com

111 FOURTH AVENUE HAS BEEN LIBERATED from the eville monopoly! Better building wide service. Better prices. Call Liberty Cable 212/891-7721—Advt.

TWIN PEAKS GOURMET TRADING POST IN-dulge your desire. http://tpeak.com—ADVT.

L.I. Widow's Story: Next Stop, Washington

By DAN BARRY

MINEOLA, L.I., Nov. 6 — The trains pulled into the Mineola station this evening with clockwork regularity, pausing for a few moments before moving on to the sigh of released brakes. It was fitting, in more ways than one, that Carolyn McCarthy was there on the platform, waiting.

Mineola is her home. On this line, at the Merillon Avenue station west of here, her husband was shot and her only child critically wounded. And commuters stepping off the 4:50, the 4:55 and the 5:08 were among those who, just yesterday, had overwhelmingly elected her representative of the Fourth Congressional District, and the first Congresswoman in Long Island history.

Long Islander, mother, candidate — Mrs. McCarthy was all of these tonight as commuters stepped onto the platform and photographers jostled for just the right shot. She recognized a gaggle of teen-age boys as students at Chaminade High School. She confided in an adviser that the photo opportunity, so close to the tracks, was dangerous. And she drank in the adulation of her peers.

"Carolyn! Carolyn! Carolyn!" one young woman shouted from the other side of the tracks. When Mrs. McCarthy turned to look, the woman gave a thumbs-up sign, and another. "Really?" — she said.

Mrs. McCarthy, 52, was one of several Democrats to unseat Republican incumbents in Congress on Tuesday. But the power of her particular story distinguished it from all others in the 1996 campaign. She was the Long Island Everywoman, forced into the limelight by a flash of violence, who reluctantly

Continued on Page B14, Column 1

Vic DeLucia/The New York Times
Carolyn McCarthy

CLINTON PREPARING FOR 2D TERM WITH SHUFFLE OF TOP OFFICIALS

CABINET CHANGES

Christopher Resigning; Kantor and Panetta Expected to Leave

By RICHARD L. BERKE

President Clinton followed his 31-state electoral sweep yesterday by beginning to build a new Government, accepting the resignations of some of his top Cabinet officials, including Secretary of State Warren Christopher.

The moves indicated that Mr. Clinton intended to act swiftly to inject some freshness into a second term in which he is facing a much-reduced agenda and a Congress still controlled by the Republicans.

White House officials said Mr. Clinton might hold a news conference later today, at which he would discuss his plans and name some replacements.

Others who have said or indicated that they would include Defense Secretary William J. Perry, Leon E. Panetta, the chief of staff, and Commerce Secretary Mickey Kantor. The leading candidate to replace Mr. Christopher is Richard C. Holbrooke, who is negotiating in the Balkans.

With the shake-up confirmed the only one officially announced was that of Mr. Christopher, whose top aides said his departure was Mr. Clinton's Christopher and who revealed the resignation were either vague or...

"WE'RE OFF TO DISNEY WORLD"

As the shake-up of the Cabinet began yesterday, the Clintons accepted congratulations at the White House.
Reuters

Top Republicans Say They Seek 'Common Ground' With Clinton

By ADAM CLYMER

With control of Congress secure after slight House losses and slimmer Senate gains, Republican leaders proudly sought to define their role yesterday as seeking "common ground" with a re-elected President Clinton — while keeping their guard up.

They said that before laying out any details of agenda, they wanted to see what Mr. Clinton, the first Democratic President to win a second term without giving Congress to his own party, would propose. "The President is sort of entitled to the first at-bat," said Senator Trent Lott of Mississippi, the majority leader.

The Republicans' fragile majority in the Senate grew to 55, depending on the outcome of a race in Oregon. [Page B2.]

But their majority in the House, which had been 234 seats, shrank to at least 225 seats, with 4 seats undecided and 1 awaiting a Dec. 10 runoff in Texas.

A Conciliatory Gingrich

After ending a campaign of pointed denunciations of President Clinton, Speaker Newt Gingrich sounded more conciliatory than he had in 1994, when he began honing his reputation as a revolutionary. Page B3.

House Democrats went from 198 seats to at least 203. But they also led in 3 of the undecided races and had more votes in one of the Texas races to be decided next month. They can also count on the support of the House's lone independent, Representative Bernard Sanders of Vermont.

In the Senate, the key to Republican victory lay in winning three seats vacated by popular Democratic Senators who almost surely would have been re-elected had they not retired: Howell Heflin of Alabama, David Pryor of Arkansas and Jim Exon of Nebraska.

In South Dakota, Senator Larry Pressler was the sole Republican incumbent of either party who was defeated. The unsettled Oregon seat is the only previously Republican open seat that may go Democratic with Mark O. Hatfield's retirement.

The Democrats came closer to taking the House. They defeated 17 Republican incumbents, including 12 of the 70 Republican freshmen who sought re-election.

Incumbency was neither the handicap it proved to many Democrats in 1994 nor the sure ticket to re-

Continued on Page B2, Column 4

More Election News

THE STRATEGY The contours of the 1996 campaign were largely set in 1995, when Mr. Clinton rediscovered his voice and forged a campaign from a budget battle. Page B1.

AIR WARS A yearlong drumbeat of advertisements attacking Republicans as extremists proved more dangerous than Republican attacks on Democrats as liberals. Page B1.

LABOR'S ROLE Republicans and labor disagreed on the worth of labor's $35 million gamble for a Democratic-controlled Congress. Page B3.

THE OUTLOOK Despite murmurs of bipartisanship in Washington, infighting is still likely. News analysis, page B6.

Nineteen pages of election coverage begin on page B1. The Metro Report begins on page B21.

OUT TO GREENER PASTURES

Continued on Page B1, Column 1

Fear of G.O.P. Cuts Emerges In Clinton's Northeast Sweep

By DAVID FIRESTONE

New York State barely saw Bill Clinton during the campaign, and its economy benefited greatly from the President's re-election, the state's popular political leaders rejoiced in large part. Its support spread from New York and surrounding states, support that both Democrats and Republicans said illustrated clear regional support for the government programs that Clinton vowed to preserve.

New York, New Jersey and Connecticut combined to produce one-third of President Clinton's million-vote margin of victory, and Massachusetts and Rhode Island added to the mix and the percentage of his margin in the region.

In New York State, Mr. Clinton appeared to carry most counties, compared with only eight won by George Bush in 1992. Counties were still too close to call. Areas around New York City where Mr. Bush did well four years ago, like Orange and Suffolk counties, moved solidly into the Democratic column. Mr. Clinton took 57 percent of the state vote — 59 percent in New York, 53 percent in New Jersey and 52 percent in Connecticut. The regional sweep was galling to local Republican leaders, who watched

STICK A FORK IN THEM

helplessly as the Dole-Kemp campaign wrote off the area in favor of the South.

"We're disappointed in our results," said Bill Powers, the chairman of the New York State Republican Party and the city chairman of the Dole campaign. "Our party is in bad shape throughout the country, and we have a lot to deal with it. I think what happened here, the more campaigning people calling and asking for bumper stickers, and there were none to be found.

The party's greed with his Democratic counterparts that the Northeast has become much more reliant on the Federal government programs that Republicans had tried to cut, and the uncover-of-Congress this year.

In New York City, Mr. Clinton did well, winning a strong coalition that elected Mayor

Continued on Page B12, Column 1

"All the News That Fits"

The New York Times

Late Edition
New York: Today, windy with showers. High 68. Tonight, stormy, mild. Low 58. Tomorrow, colder, rain ending. High 58 early then falling. Yesterday, high 69, low 54. Details, page C33.

VOL. CXLVI.. No. 50,605 Copyright © 1996 The New York Times NEW YORK, FRIDAY, NOVEMBER 8, 1996 $1 beyond the greater New York metropolitan area. 60 CENTS

BOSNIA REPORTED TO BE SMUGGLING HEAVY ARTILLERY

ARMS ENTER VIA CROATIA

Turkey and Malaysia Linked to Effort to Build Up Muslim Force, Europeans Say

By CHRIS HEDGES

ZAGREB, Croatia, Nov. 7 — European intelligence agencies have uncovered a massive Bosnian Government effort in a covert operation to bring heavy artillery weapons through the drab port of Ploce, Croatia, according to a senior

into Bosnia through the southern Croatian coast, along the Dalmatian coast, according to a report stating that the Bosnian Government intended to build up a badly equipped army outside the control of the Bosnian Croat forces.

Continued on Page A4, Column 1

New York Official Seeks to Overhaul Special Education

By RAYMOND HERNANDEZ

ALBANY, Nov. 7 — The New York State Education Commissioner, Richard P. Mills, proposed an overhaul of special education today that would eliminate the financial incentives that encourage schools to transfer children with mild learning or behavioral problems into segregated classrooms.

But thousands more children are referred each year, largely because schools get about $4,000 a year from the state for each additional child. The money had been intended to give extra care to the more severely handicapped, but in recent years, the number of children separated for emotional problems or learning disabilities has risen sharply.

Continued on Page B2, Column 4

Lessons for the Schools

When researchers looked into how schools try to meet math standards.

Article, page B2.

Liquor Industry Ends Its Ad Ban In Broadcasting

By STUART ELLIOTT

The American liquor industry decided yesterday to end a decades-long voluntary ban on advertising of liquor products like vodka, Scotch whisky, gin and tequila on television and radio.

The decision by the Distilled Spirits Council of the United States, the liquor trade association also known as Discus, came six months after the Seagram Company, the nation's second-largest maker of distilled spirits, began to break the ban — in effect since 1936 for radio and 1948 for television — by running commercials for several brands in scattered markets around the country.

Those tentative steps set off a furor among anti-alcohol groups and some Federal legislators and regulators, who urged that if the voluntary ban was abandoned, it be enacted into law. Even President Clinton urged Seagram to reconsider.

Continued on Page D5, Column 1

How Bob Dole's Dream Was Dashed

By ADAM NAGOURNEY and ELIZABETH KOLBERT

On a gusty evening and a half weeks before Election Day, Bob Dole was standing at center stage in an airport hangar in Wichita, Kan., smiling at the audience. The scene before him was not instant and the hangar was just over half full.

Mr. Dole was closing out the final weekend of the election season. For this portion of those who had shown up were Clinton supporters, there to disrupt the event.

Mr. Dole's older brother, Nelson, with a dozen or so miles from their home in Russell, Kan., to join Bob and make his way across the tarmac to stand beside

A POLITICAL LIFE
A Special Report.

him. "How's it going?" she whispered.

Mr. Dole's smile never left his face, and his eyes never left the crowd.

"Pretty rough." he said.

On Tuesday, Mr. Dole's political career, one of the most enduring in American political history, effectively came to an end. To run for President, he had resigned his seat in the United States Senate and given up the position he was, by many accounts, best suited for, majority leader.

Mr. Dole sacrificed these things not merely to lose the Presidency, but to run one of the most ineffectual Presidential campaigns in recent memory. Always the legislative tactician, Mr. Dole, according to his close associates, approached the Presidential race much as he did a Congressional negotiating session, believing that the key to victory was a clever endgame strategy. But so bleak were the polls, and for so long, that Mr. Dole was forced to realize, far earlier

Continued on Page A28, Column 1

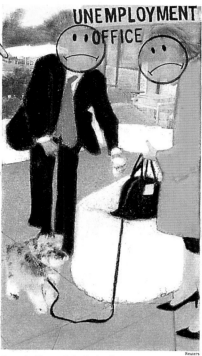

A cup of coffee, a walk for the dog: Bob and Elizabeth Dole settle into a new private life two days after he lost the race for President.

Clinton Seeks 'Vital Center' in His Cabinet

As he accepted the resignation of Secretary of State Warren Christopher, President Clinton began today to set selections for a second term that would reflect his view that the election results were a call for him to govern from the "vital center."

Aides described Mr. Clinton's remark as a signal that he would try to reach out to Republicans by preserving a member of their party to a substantial Government post.

Mr. Clinton made the comment at a White House ceremony for Mr. Christopher, who gave notice he would resign was just the beginning of a shake-up of the White House staff and Cabinet. Some aides have chosen to leave and others have quietly been asked to do so.

As Mr. Christopher saluted, Labor Secretary Robert B. Reich also announced he was leaving.

As political Washington turned to a second Clinton term, the party received some good news today. Alfonse M. D'Amato reiterated he would not seek to reopen Senate hearings into the Whitewater real-estate venture.

But for the party, in recent weeks, Senate and national committees decided to return a large contribution solicited by John Huang, the party finance official who was suspended last month.

Articles, page A29.

A Star Turn for a Retired Vermont Farmer

By SARA RIMER

Of 807 registered voters who turned out on Election Day in the tiny town of Tunbridge, President Clinton scored 276 votes, Bob Dole 158, Ross Perot 88, and

also got 5 write-in votes for United States representative, 6 for Governor, 1 for lieutenant governor, 3 for state treasurer, 2 for secretary of state, 1 for attorney general, 2 for state senator, 2 for state representative and a whopping 997 for high bailiff.

"I'm not sure exactly what high bailiff does," said Kay O'Donnell, the town clerk. But Mrs. O'Donnell knows who Fred Tuttle is. Everyone in Vermont, it now seems, knows of Fred Tuttle.

"Fred is Fred," Mrs. O'Donnell said with the sort of cheerful respect that in Vermont qualifies as extravagant praise. "There is nothing to him. He's just the way he is."

This year's protest vote, the man whose endearingly political cians across Vermont scrambled to lock up, is a 77-year-old, flat broke, retired dairy farmer from Tunbridge who has survived three heart attacks and prostate cancer, is nearly blind in one eye, is borderline diabetic, has two ruined knees from decades of milking cows, and is not a candidate for anything.

But people have been writing him in for various political offices ever since his hilarious performance as a retired dairy farmer who runs for Congress in "Man With A Plan," a movie made by his neighbor, John O'Brien, that opened in Vermont last January to rave reviews, and opened in New York

For local celebrities, Vermonters used to have to settle for Ben and Jerry, the ice cream kings. Now they have Fred Tuttle, too.
Paul O. Boisvert for The New York Times

Washington on Nov. 1. In the film, Mr. Tuttle's character is a striking resemblance wins election with campaign money, as they say in Vermont. He stole the show.

It used to be that Vermont had Ben and Jerry, Now, O'Brien, a 33-year-old filmmaker and sheepherder who also is the town jester of the peace. Mr. Tuttle said he like acting lessons if he were younger.

In his trademark overalls and hat with Fred written across it in big letters, he was a guest on Conan O'Brien's late-night television show in October. Fred was Fred.

Fair, autograph seekers in the Vermont Republican Presidential primary against Senator Jim Jeffords. Mr. Tuttle received more than 1,000 votes all over the state. Senator Patrick J. Leahy, the Democrat, ended up with Fred.

Continued on Page A18, Column 1

PANEL CONDEMNS PENTAGON REVIEW OF GULF AILMENTS

CITES LACK OF CREDIBILITY

Independent Inquiry Is Needed on Exposures to Chemicals, Presidential Group Says

By PHILIP SHENON

WASHINGTON, Nov. 7 — A special White House panel has condemned the investigation for its investigation into whether American troops were exposed to Iraqi chemical weapons in the Persian Gulf war and called for an independent inquiry into more than 15 incidents in which nerve gas and other chemical agents may have been released.

"The Department of Defense has conducted a superficial investigation of possible chemical warfare agent exposures," the report said, "which is not necessarily to provide credible answers to veterans' questions."

Continued on Page B6, Column 1

CRAFT IS LAUNCHED TO EXPLORE MARS

Search for Life Is Ultimate Aim as Mapping Mission Begins

By JOHN NOBLE WILFORD

CAPE CANAVERAL, Fla., Nov. 7 — Intrigued by fresh evidence of possible life on Mars, scientists launched an unmanned spacecraft today as the first step in a planned 10-year campaign to explore the arid plains, valleys and polar ice caps of the red planet.

The ultimate goal of this new generation of robotic explorers is to solve a mystery that has long first the human imagination: have there ever been Martians, no matter however rudimentary, and do they still exist?

Toward that end, the one-ton Mars Global Surveyor blasted off into a brilliant noon sky here, scheduled to arrive at its destination, an orbit of Mars, next September. Mission officials gave glowing reports on the success of the launching and the flight so far.

"It's clear we got a really good ride today," said Glenn Cunningham, the mission director for the Jet Propulsion Laboratory in Pasadena, Calif. "All in all, the spacecraft looks to be in really good condition."

The global surveyor's cameras and other mapping instruments will produce quick answers to the many questions. Its mission is to photograph the planet's atmosphere and surface and map its entire surface, perhaps identifying promising areas for the life search.

Two other spacecraft are ready.

Continued on Page B6, Column 3

INSIDE

Army Accuses 2 of Rape
The Army has charged an officer and a drill instructor with raping enlisted women at a Maryland training center, and is considering other harassment accusations. Page A16.

Hospital Lease Advances
In a milestone for efforts to put public hospitals in private hands, New York City's hospitals agency is expected to approve the leasing of Coney Island Hospital today. Page B1.

Refund for Shoreham Taxes
Suffolk County and two local governments have been ordered to pay the Long Island Lighting Company up to $1.16 billion for overtaxing the Shoreham nuclear plant. Page B5.

Scandal Over a Caravaggio
Testimony that a mafia turncoat damaged a Caravaggio caused the biggest stir so far at the trial of former Italian premier. Page A12.

Smoke and Teen-Age Deaths
More than five million Americans now under the age of 18 will die prematurely from smoking, according to new projections. Page A16.

The New York Times

Late Edition
New York: Today, rain, then brighter, cooler. High 61. Tonight, clearing. Low 41. Tomorrow, sun then clouds, late rain or flurries. High 49. Yesterday, high 67, low 62. Details, page 14.

VOL. CXLVI ... No. 50,606 Copyright © 1996 The New York Times NEW YORK, SATURDAY, NOVEMBER 9, 1996 $1 beyond the greater New York metropolitan area. 60 CENTS

Corruption and Money Woes Divide and Anger Miamians

By MIREYA NAVARRO

MIAMI, Nov. 8 — Just last summer this city turned 100 years old, a cause for celebration and congratulation. But the good feeling by this time had turned to some... petition...

"You would think that for the taxes we're paying, we'd get better services," said Louis Wechsler, a homeowner association president who supports the movement to cede Miami's rule to the Dade County government. "But there is so much graft and corruption we're not getting services."

fiscal problems pose a formidable challenge for the city, which has about 350,000 residents, but that they can be fixed with tightening...but the budget scandal...posed...divisions...may...ake...

Some critics of Federal investigators have used charged terms like "lynching" to characterize the investigation of the officials, many of whom are black or Hispanic...their own communities.

...those behind the drive to disband Miami's city government portray it as an effort to lower taxes, skeptics say it reflects doubts among whites about the competence of a city government increasingly run by members of ethnic, foreign-born minorities...

Along with Federal...tions of fraud and corruption, the highest levels of mismanagement of the city's finances has left residents disgusted and seething.

MIAMI VICE

Financial analysts...

Russian Traders Go Abroad For Some Serious Shopping

By ALESSANDRA STANLEY

ISTANBUL, Turkey, Nov. 6 — Galina Glazova walked purposefully down a narrow, crowded street in black ankle boots, a white leather jacket and matching skirt, trailed by her friend Tatyana Savkina and the beckoning glances of several hundred Turkish merchants. She icily ignored the warm cries of "Natasha! Natasha!" (the generic Turkish word for Russian woman) and entered a narrow basement shop.

In Russia they are known somewhat derisively as cheinoki, a Russian word for the rapid-flying shuttle in a weaving loom. They prefer to call themselves "shop tourists."

Their harried way of life is a testimony to the murky contradictions in Russian life: the traders exemplify the country's new entrepreneurial spirit — people going out by the millions and hustling to put food on...But they also vividly illustrate Russia's byzantine tax...on the verge of...with socialism.

INSIDE

Serb Army Chief Ousted
The Bosnian Serb President, Biljana Plavsic, dismissed Gen. Ratko Mladic, the commander indicted for directing war atrocities. Page 3.

Coney Island Hospital Deal
In a historic vote for New York City, a profit-making company has been approved to operate Coney Island Hospital. Page 25.

Uproar Over T.W.A. Rumor
A revived rumor that T.W.A. Flight 800 was brought down by a Navy missile caused a stir for a curious media and a furious F.B.I. Page 26.

Haircuts Fall Short
When three female cadets at the Citadel shaved each other's heads they were punished: their cuts did not meet military standards. Page 9.

News Summary
Arts
Business Day
Editorial, Op-Ed
International
Metro
National
SportsSaturday 30-34
Obituaries 52 Weather 14
TV Listings 51
Classified 44 Religious Services 29

On the Internet: www.nytimes.com

U.N. SAYS MILITARY MUST ACT TO SAVE REFUGEES IN ZAIRE

FEARS 'A NEW GENOCIDE'

Action Is Backed by Bonn and Paris but U.S. is Insisting on a Cease-fire

By BARBARA CROSSETTE

...central Af...called today...force...many...dying...

...foreign intervention...resistance from...which stalled Security Council...on a military mission...French and German troops...support the council, the...said they...held out a cease-fire that would allow...to resume without consideration...protection.

"We...cide," Mr....ers today...starving...

...ely" to the...gees...tutu, who two years...for Zaire...again.

...Americans...could agree...fighting...suffering on...

"The cowboys' just...town is not going to solve the problem," Nicholas...department spokesman...Mr. Burns...tration's...French p...tablishing...Zaire, wh...me the...ing grounds...e current conflict.

President...on's senior foreign policy aides...for 90 minutes today to discuss the crisis, but the meeting was adjourned for the weekend with no decision on what kind of force the United States would support.

The Administration has...considered sending troops to...distributing food...communicat...

After the m...the Administration...vention would not be n...official added that...and cargo companies...

Page 6, Column 1

Continued on...

Clinton Calls on G.O.P. for Cooperation

Seeks Talks on Financing of Campaigns

By ALISON MITCHELL

WASHINGTON, Nov. 8 — Moving swiftly to start his second term, President Clinton said today that he had asked Republican leaders of Congress to meet with him next week to begin negotiations on a plan to balance the budget and on campaign finance restrictions. He also named Erskine B. Bowles, a soft-spoken and politically moderate North Carolina businessman, to fill the critical position of White House chief of staff.

In a wide-ranging news conference — his first since he won re-election — Mr. Clinton said the voters' choice of a Democratic President and a Republican majority in Congress showed "that the American people want us to...responsibilities as Democrats...Republicans first...and...join...this...

...administration had start...arms to Indonesia...takeover of East Timor...the United States...sponsored a United Nations...calling for improvement...rights in East Timor.

The issue...this month after reports that the Riady family of Indonesia, which runs a $12 billion business empire that is largely in Asia, and its former senior executive in the United States, John Huang, had raised millions of dollars for the Democrats in recent years. Mr. Huang was suspended from his role as a fund-raiser amid questions about some of the contributions he solicited.

The session in the East Room of the White House was Mr. Clinton's first formal White House news conference since...Jan. 11, although...questions in appearances with foreign leaders and several reporters after a summit in France, June. In the last two campaigns, as his opponents made the issue of foreign money in American politics...Mr. Clinton made himself completely inaccessible to reporters.

At his news conference today, he sought both to dispense with the questions about money and to signal that this start to his second term...out to the Republicans...swiftly to put his agenda...Bowles, at the head of his White House staff to succeed Leon Panetta, who will return to California. The President answered questions for more than an hour.

Mr. Clinton said that no issue was "more fundamental than balancing the budget," and he called on the Republicans to discuss "how we can develop a plan together."

In another olive branch to the Republicans Mr. Clinton said he would like to have Republicans in his Cabinet in order to "have a Government that can unify the country." But one

Paul Hosefros/The New York Times

President Clinton named Erskine B. Bowles, a soft-spoken moderate from North Carolina, to be chief of the White House staff.

A Grin, but Nary a Gloat

The President, Taking Pride in His Victory, Offers Only Kind Words for His Opponents

By R. W. APPLE Jr.

News Analysis

WASHINGTON, Nov. 8 — Fresh from one of the great triumphs of his life, Bill Clinton avoided any suggestion of triumphalism at his post-election news conference today. At times, he sounded almost...low...

An...victory...Clinton said...dent must agree with...He was clearly...by the size of his victory...grin that 379 el...votes...having fall...the majority...of its limitation...made a big effort...zers of campaign...

have fallen silent, to encourage stirrings of bipartisanship.

Many in the Democratic Party think there is little chance of passing meaningful changes in campaign finance laws. One of them, Senator Christopher J. Dodd of Connecticut, the national Democratic chairman...committee said at...reporters that "nothing has increased my sense of optimism that this new Congress will be any better on this issue than the last one."

But the President, upbeat, would hear none of that. He said the nation had "a unique moment of opportunity now" to reform the way American politics is financed, and he said he would...with the Congressional leadership...talk about that and about the budget. He said he had been encouraged by what the Republican leaders have been saying in the last few days.

He said he hoped to get a top Republican into the Administration. And he said only kind words about his vanquished foe, Bob Dole, who concluded their campaign with daily denunciations of White House ethics...Mr. Dole still had confidence in the President to govern...

...asked Mr. Clinton whether he had properly handled the question of contributions from...which dominated the last few days of the contest, and he volunteered no opinion. Mr. Clinton made essentially stonewalled until today,

Continued on Page 12, Column 4

Continued on Page 11, Column 4

Toll in Indian Cyclone Rises to at Least 1,000

More than 10,000 homes were leveled in the storm that ravaged India's southeast coast. Reuters

HYDERABAD, India, Nov. 8 — The cyclone that rampaged across India's southeast coast this week killed at least 1,000 people, officials said today, as they began an emergency airlift of food and medicine to half a million victims left stranded by floods.

The death toll from the storm, which struck on Wednesday night, was expected to rise to perhaps as high as 2,000, said Chandrababu Naidu, the chief executive of Andhra Pradesh state, the worst-hit region. More than 1,000 bodies had already

been recovered, officials said, and they expected many more to be found once roads were cleared and communications were restored to some of the most devastated areas.

More than 10,000 homes, mostly simple mud-and-thatch dwellings, were leveled in the cyclone, which hammered the fertile agricultural region with winds...hour.

...storm flooded acres...and hundreds of villages, leaving the police, army troops and relief officials to battle swirling waters, seven to ten feet deep in some places. It ripped power poles from the

ground and washed out roads and rail lines, halting traffic and stranding thousands of people.

Tons of the stored rice, gathered...and bean...and sugar...plantations...turned into swamps.

"The most...rice-growing region...of East Godavari has turned into...ground," Mr. Naidu said on Thursday after his aerial survey of the area.

"Except for houses made of brick and cement, nothing is standing."

Continued on Page 8, Column 1

A Southern Point Man

Erskine Boyce Bowles

By TODD S. PURDUM

Man in the News

WASHINGTON, Nov. 8 — When President Clinton summoned his Vice President, his chief of staff and his chief of staff-to-be to join him on a small platform in the East Room to announce his new appointment...no particular order."

Erskine B. Bowles, a 51-year-old North Carolina businessman, whom Mr. Clinton asked to serve to lead the White House staff in a second term, moved instinctively to the background. That is the spot Mr. Bowles grew used to as a deputy chief of staff for 15 months until he left last December to return to the private sector.

"We're two Southern guys," Bowles said in an interview last spring, summing up his bond with his boss. "I didn't want anything. I

talk to reporters. I came from a world where your relationship with your clients was confidential and he was my only client. I think he felt comfortable that I could listen."

Now he will be front and center in the East Room's high-pressure...Mr. Bowles, an investment banker who went on to become head of the Small Business...then the President...time manager...will not only have to deal with dozens of demanding constituents, from senators to Cabinet secretaries to anchormen.

Yet if most of those who saw the East Room ceremony on television today were hearing Mr. Bowles's voice for the first time, few who know him seem to think he will have

Continued on Page 12, Column 1

HOT AIR

SOUTHERN COMFORT

354613

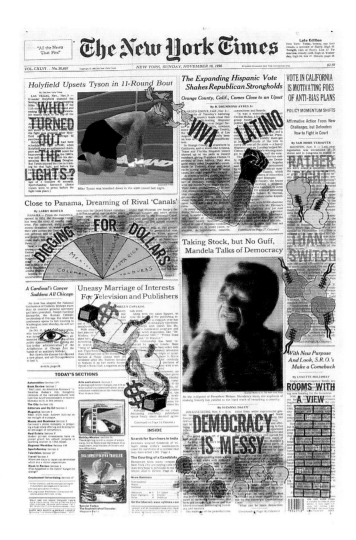
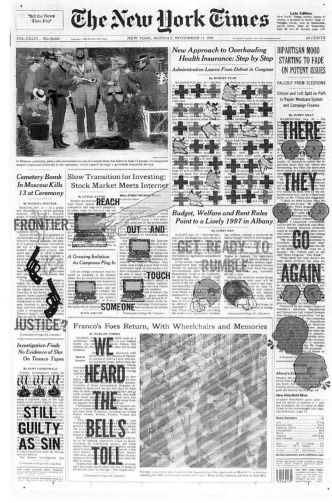
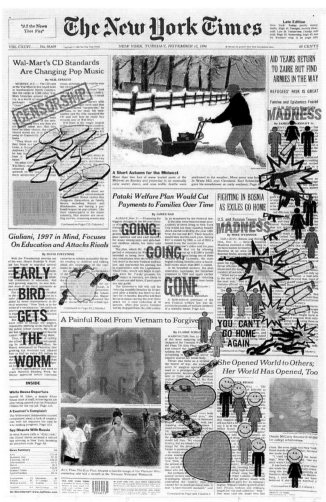
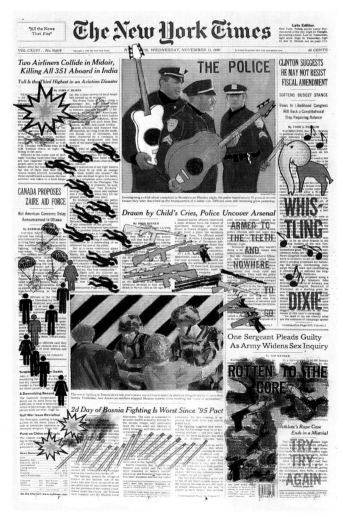

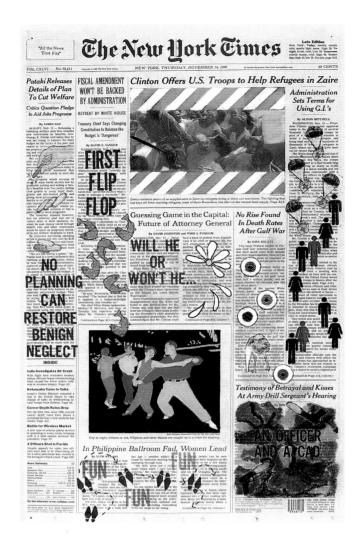

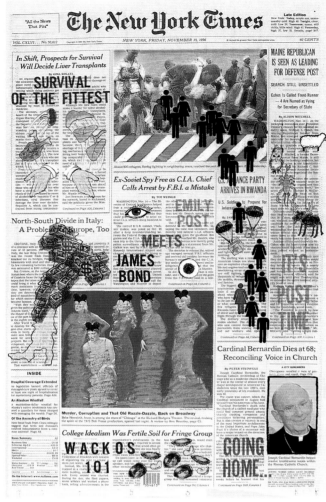

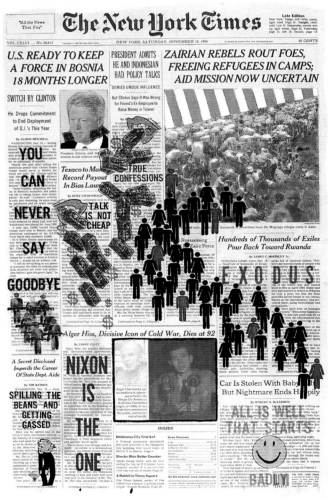

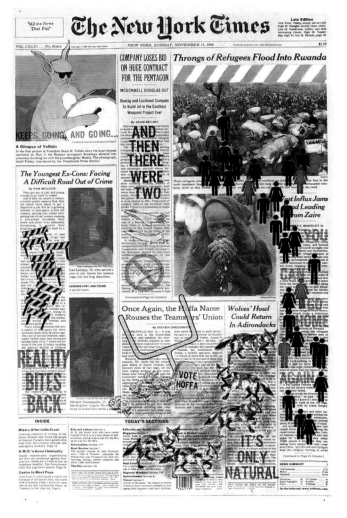

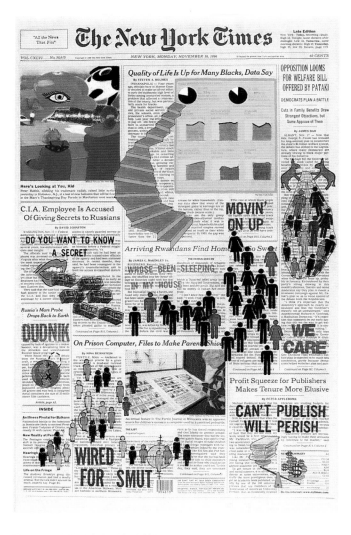

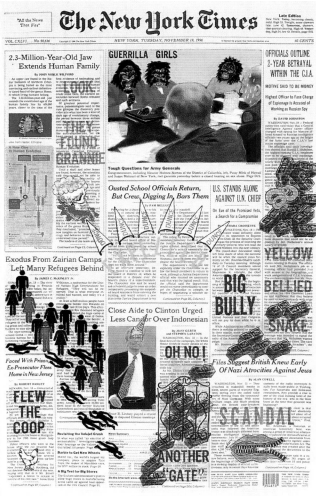

"All the News That Fits"

The New York Times

Late Edition
New York: Today, becoming partly sunny, brisk. High 46. Tonight, partly cloudy, cold. Low 33. Tomorrow, partly cloudy, a flurry. High 44. Yesterday, high 50, low 41. Details, page C14.

VOL. CXLVI .. No. 50,617 Copyright © 1996 The New York Times NEW YORK, WEDNESDAY, NOVEMBER 20, 1996 $1 beyond the greater New York metropolitan area. 60 CENTS

New Yorkers Allowed to Pursue Money Awards in Rights Cases

Court Expands Protections of State Constitution

By JAMES DAO

ALBANY, Nov. 19 — Sweeping damages from the state, the university and the state college, reversing a lower court that dismissed the action. The court ordered the case to be returned to the lower courts for trial.

For years, lower courts had ruled that the State Constitution was immune from civil suits, and opened the door to a breach of constitutional protections complaints alleging misconduct took that in New York State, individuals whose fundamental rights have been violated will have legal recourse.

The ruling by the Court of Appeals significantly expands protections against the State.

The decision stems from a higher incident at the State University of New York, when campus security officials systematically interrogated black students and towed residences after a woman was attacked at knifepoint near the campus, about 13 miles northwest of New York City.

state courts to issue injunctions requiring the state to stop its unconstitutional activities. But they could not demand monetary damages, as they can, for example, in personal injury cases.

Such suits could be brought against the state in federal court, but plaintiffs say civil liberties cases are much harder to bring in federal court. Federal judges are more reluctant to intervene in state affairs, and the United States Constitution...

The Onondaga case illustrates that issue. The plaintiffs brought suit in both Federal and state courts charging that among other things, their right to be free of unreasonable searches and their rights to equal protection under the law were violated. Almost all counts in the Federal case were dismissed. But today the...

Continued on Page B7, Column 1

U.S. to Settle for $4.8 Million In Suits on Radiation Testing

By PHILIP J. HILTS

The Federal Government has agreed to pay $4.8 million as compensation for injecting 12 people with radioactive materials in secret war experiments.

Energy Secretary Hazel R. O'Leary, who announced the settlement yesterday, said the Government was ending "this dark chapter" in the nation's post-war history. The experiments were carried out by Government doctors, scientists and military officials from 1945 to 1947 in many places across the nation.

Before the end of the year, President Clinton will face further pressure to apologize to the many thousands of other subjects who were exposed to radiation, so that such experiments could be conducted, interview.

Yesterday's announcement follows an 18-month investigation and hearing by the President's Committee on Human Radiation Experiments, which found last year that many medical experiments, some of them done without the consent of subjects, had been conducted during the postwar years. The committee announced yesterday that a settlement had been...

INSIDE

Cocaine Is Cocaine
A panel found there is little difference between crack and powdered cocaine, undercutting a rationale for sentencing differences. Page A12.

Plan for Environmental Test
For agreeing to exceed environmental standards a major computer-chip factory was granted greater flexibility in its operations. Page A18.

Belle Hits a Home Run
The Chicago White Sox made Albert Belle baseball's highest paid player ever, signing the slugger for $55 million. Sports Wednesday, page B13.

News Summary A2
Arts C17
Business Day
Editorial, Op-Ed
International
Living Section
Metro
National
Sports Wednesday
Education B11 Real Estate
Health C15 TV Listings
Obituaries D21 Weather
Classified B17 Auto Exchange ..

On the Internet: www.nytimes.com

THE NEW YORK TIMES is available for home or office delivery in most major U.S. cities. Call toll-free 1-800-NYTIMES. Ask about Times media TimesCard. — ADVT.

354613

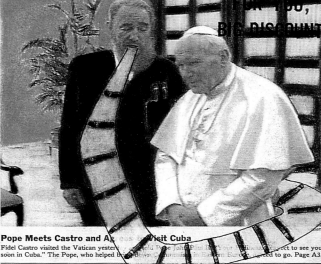

Pope Meets Castro and Accepts a Visit Cuba

Fidel Castro visited the Vatican yesterday and told Pope John Paul II, "I expect to see you soon in Cuba." The Pope, who helped bring down Communism in Europe, agreed to go. Page A3.

Careers Are Among the Casualties Of C.I.A.'s Latest Security Breach

By TIM WEINER

WASHINGTON, Nov. 19 — The career bright new graduates of the Central Intelligence Agency's school for spies are blighted; the F.B.I. has their class lists and curriculum, courtesy of a Russian safe.

The identities of American businessmen in Moscow who volunteer occasional services to the C.I.A. have probably been exposed. The agency's operations in Mexico, Tokyo, Manila and Malaysia have been compromised. And the reputation of the nation's clandestine service has suffered another crippling blow.

The C.I.A. counterintelligence officials dealt with yesterday's settlement were only a few among thousands of different kinds of experiments that were part of a long campaign to find out how the use of nuclear weapons might affect soldiers and civilians in a nuclear...

to Moscow must assume the worst. And the worst is very, very bad.

Officials suspect that Mr. Nicholson sold his Russian contacts the names of every student who prepared for undercover assignments overseas at the C.I.A.'s training school in 1994, 1995 and the first half of 1996.

The school, Camp Peary, is a secret 9,275-acre base near Williamsburg, Va., known informally as "The Farm." It provides a yearlong graduate education in espionage.

Officials said he might a 16-week course to learn the trade like stealing mail, using disguises, evading pursuers and handling agents. He is suspected of telling the Russians everything about Camp Peary's core curriculum.

Mr. Nicholson read the biographies and the future assignments for every officer trained at Camp Peary.

Continued on Page A20, Column 1

Continued on Page D20, Column 1

Boutros-Ghali vs. 'Goliath': His Account

By BARBARA CROSSETTE

UNITED NATIONS, Nov. 19 — When Boutros Boutros-Ghali visits Japan he inevitably makes a quiet pilgrimage to an obscure shrine in what an aide calls "some godawful far-reaching corner of Tokyo."

There, with intense writing around him, the Secretary General pauses alone for a moment of respect and bows.

The shrine is a monument to Adm. Heihachiro Togo, the Japanese naval commander who defeated Russian fleets at Port Arthur and the Tsushima Strait in 1904 and 1905 — the first great victories of an emerging nation over an imperial European power.

Today, as Mr. Boutros-Ghali stood his ground against an American veto, the first if as many as it will take to deny him a second term as Secretary General, this proud descendant of Egyptian aristocracy could draw from a complex personal history: part radical anti-colonialist, part French-educated intellectual and scholar, part diplomat sharpened and deromanticized by the politics of the Middle East and Africa.

Today's vote in the Security Council was 14 to 1 in his favor, but no American no...

...in foreign affairs but a good political instinct for distancing himself from a man viewed with suspicion by many American conservatives.

President Clinton's aides say they never considered the United Nations Secretary General important enough to warrant a private meeting with the chief.

"Friends come to me and say, 'Don't be passive,'" Mr. Boutros-Ghali said. "You are in America; they like fighters. You look like a lame duck. You have to act. But how...

can I fight Goliath? Come on! Who am I to fight a superpower? I cannot."

He said that when he asked Secretary of State Warren Christopher to make his case with Mr. Clinton, Mr. Christopher told him, "I'm the lawyer of the President. I'm not your lawyer."

In Boutros-Ghali style, he said, is tete-a-tete, and it helped him build "good chemistry" with Presidents Carter and Bush. Now he finds himself frozen out of the White House.

"Do I represent a danger to the...

Continued on Page A8, Column 4

The Secretary General says his fight with the United States, almost certainly a futile one, is not just for himself but for the entire third world.

SWACKHAMMER THREATENS NATIONAL Treasury. www.spaceworm.com — ADVT.

SIZE OF U.S. FORCE BOUND FOR AFRICA IS CUT BELOW 1,000

EMPHASIS NOW ON RELIEF

With Military Tension Easing, Main Aim of Mission Shifts to Feeding Rwandans

By JAMES BENNET

WASHINGTON, Nov. 19 — Faced with the relatively peaceful homecoming of more than half a million refugees in recent days, the Administration has drastically scaled back its dispatch of up to 4,000 troops to Central Africa and now intends to send most 800 to help oversee the relief aid, Administration officials said today.

The United States will still take part in a Canadian-led multinational operation authorized by the United Nations Security Council to help return refugees to Rwanda from neighboring Zaire, where hundreds of thousands of ethnic refugees remain.

But the immediate crisis of a longer plan to send refugees to Zaire, one mission involving one of feeding people awaiting food rather than protection, officials said.

One White House official said the total number of troops required by all countries taking part in the mission might be fewer than 1,000, reducing the number of troops from the United States even further.

The long-delayed accord follows pressure from a group of relatives of the victims of major air disasters abroad.

Continued on Page A11, Column 1

AIRLINES IN ACCORD ON DISASTER PLANS

7 U.S. Carriers to Speed Lists Of Those in Crashes Abroad

By BARRY MEIER

The State Department and the seven leading American airlines have reached an accord intended to notify American families in the event of air disasters abroad.

The accord, announced on Monday, will put to rest a decades-old problem that long weighed on the minds of airline officials and government officials — how to notify quickly the families of Americans aboard doomed jetliners.

"This will finally expedite the sharing of important information," said Hans Ephraimson-Abt, chairman of a group that represents families of crash victims who were aboard Korean Air Lines Flight 007, shot down by Soviet fighters 13 years ago.

The accord will be a significant step in a process that should provide basic information about victims and their families.

In fact, the accord could soon be superseded by a more demanding Federal rule that was recently proposed by the Transportation Department.

Continued on Page A22, Column 1

Charge of Impeding Justice Filed Against Former Texaco Executive

By KURT EICHENWALD

The former Texaco executive who recorded secret conversations belittling minorities and planning the destruction of documents that had been demanded in a discrimination lawsuit was charged yesterday with obstruction of justice.

The charge is a sharp turnaround yet in the fortunes of the executive, Richard A. Lundwall, who until August was an executive in Texaco Inc.'s finance department.

It was Mr. Lundwall who, after he was forced out in August, turned the recordings over to plaintiffs' lawyers in the lawsuit. The tapes set off a national furor about the company's attitude toward minorities, and led to a record settlement last week.

"It's truly the only person to be charged is the person who blew the whistle," said Christopher and Lundwall's lawyer, in a negative way...

But as someone charged was singled out from the Government to strike a deal with the Federal investigation. Mr. Lundwall, who has not yet agreed to testify in the case, is the first Texaco executive to be charged in the matter...

RENEWED PUSH ON EQUAL OPPORTUNITY

Texaco's case has revived a debate over how to promote diversity in the business world. Business Day, page D1.

...ter and the lowest-level executive to participate significantly in the conversations to make the dispute less conflict-ridden. "Mr. Lundwall is the very grand jury investigating the Texaco matter — the typical move in such a white-collar case. Instead, an agent of the Federal Bureau of Investigation took an oath, which was used against Lundwall.

That was the signal sign that prosecutors were moving rapidly to bring the charge for strategic purposes, rather than carefully drafting a criminal indictment for the purpose," said Harvey Pitt, a prominent Washington lawyer who has handled a number of prominent...

Continued on Page D3, Column 3

The New York Times

Late Edition
New York: Today, morning sun mixing with clouds. High 45. Tonight, becoming clear. Low 33. Tomorrow, ample sunshine. High 48. Yesterday, high 44, low 36. Details are on page C13.

VOL. CXLVI . . . No. 50,618 Copyright © 1996 The New York Times **NEW YORK, THURSDAY, NOVEMBER 21, 1996** $1 beyond the greater New York metropolitan area. **60 CENTS**

42% of School Budget Is Shown Reaching New York City Classes

For First Time, Details of Spending Are Released

By JACQUES STEINBERG

After decades of clamoring by parents and officials ... the budget ... Crew ... direct classroom instruction ... as slightly more than 42 percent ... Education, giving an unusually detailed accounting of how the nation's biggest school system ... ey. The bottom line ... percent of the ... billion budget finds its way ... the classroom.

The Chancellor, using ... last year's budget, reported ... the system spent an average of ... on each student in a regular classroom. Of that, it paid $2,554 for the teachers' salaries, $61 for aides and $... textbooks. Of the remaining ... went for janitors and maintenance, $285 for the cafeteria, $78 for ... lights and power, $102 for transportation and nearly $250 for administration in board headquarters and ... trict offices.

A large portion of the budget, ... percent ... billion ... goes to the 130,000 students ... education.

The cost of administration ... a target for Mayor ... about bloat in the bur ... was one figure that the Chancellor's report said it could not ... Still, the estimate — no more than ... percent of the board's overall budget — was half what a report commissioned by Mayor Rudolph W. Giuliani found two years ago as part of his successful campaign to cut the bureaucracy.

On the other hand, a figure ... parents' groups and politicians ... they always want to be higher — the

Continued on Page B8, Column 3

It was not clear how the classroom ... compared with other districts because every district ... categories in a slightly ... Some, unlike New ... heat and lights as classroom ... funding. Some include teachers' ... sions.

... el Casserly, the executive director of the Washington-based Council of Great City Schools, which ... nation's largest ... yesterday that ... cent was roughly in line with ... large urban school districts.

The 41 volumes of data that the ... ard released yesterday — with detailed school-by-school spending — was a first for New York City, where fiscal accountability ... between the centr ... cal school boards.

In part, the information has been stymied by a lack of technical capability: the board has no fewer than five computerized accounting systems, none of which comp ... ely with each other. But there ... also been a lack of political ... th the ambi ... e Board of Edu ... make their own claims of how ...

A Tutorial for Young Saudis On Ways to Toil for Money

By DOUGLAS JEHL

RIYADH, Saudi Arabia — Twice a day, six days a week, Saudis in their 20's file into ... classrooms here ... master something new ... work.

These are the children of the oil boom, born in the 1970's and reared in a world of nearly unrivaled wealth, whose Government doled out jobs and loans ... abandon.

But that ... longer exists, as Saudi Arabia ... vulnerable apprehension ... ning to discover. Put plainly, the country is running out of jobs, or at least the kind of undemanding jobs in Government ministries that Saudis have been willing to accept.

And to their bewilderment and that of others, young Saudis are finding themselves steering beyond the familiar horizon of public employment and steeling themselves for riskier pursuits with courses like "The Salesman."

"Ev ... " ... not even to ... -Baz, 24, who ... salesmanship ... his future employer, the Riyadh agent for Mercedes-Benz. "But this is the new Saudi Arabia, and it's going to be more complex."

For the Saudi monarchy and its Western allies ... pressing concern is that ... mplexity — and the dashed expectations it will inevitably engender — may breed resentment like that already being expressed by the country's religious militants.

Combating ... is in part the self-appointed ... of the Sau-

Bomb on Flight 800 Called 'Less Likely'

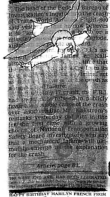

The head of the Federal Bureau of Investigation's inquiry into the crash of Trans World ... Flight 800 ... last ... yesterday ... believes ... that the ... plane ... explode, ... up ... as ... Kall ... last ... that ... ir ... in its ... that ... the crash, the F.B.I. has ... released to publicly favor ... cause of the crash over another ... the ... remarks yesterday ... hint in the ... on the first time ... growing choice ... National Transportation Safety Board investigators who say that a mechanical failure will ultimately emerge as the explanation for the crash.

Article, page B1.

THE IN CROWD

Amy Toensing for The New York Times

House Republicans renominated their leadership yesterday. Speaker Newt Gingrich was joined by Dick Armey, majority leader, left; Jennifer Dunn, secretary of the party conference, and Tom DeLay, whip.

On the Trail of a C.I.A. Man: Trips and Big Cash Transfers

By DAVID JOHNSTON and TIM WEINER

WASHINGTON, Nov. 20 — At 10:11 A.M. on June 27, Harold Nicholson, a veteran C.I.A. officer, slung a camera bag over his shoulder and locked ... Garden ... tel, then strolled ... past the luxury cars in the driveway and into the elegant streets of Singapore.

For four hours, according to the F.B.I. ... a scene ... the pace ... palm ... blossoms. He stopped to linger at shop windows, using their reflection to watch ... and backtrack ... part-ed. He was ... himself, using every trick in the book to make sure he was not being followed, the F.B.I. says.

But he ... self ... F.B.I. was tailing him ... oblivious that ... and his winding route ... A white man with Slavic features met him in the concourse. They walked together

... nand. A car pulled up. Mr. ... threw his camera bag into ... and got into the back seat, ... car pulled away. The F.B.I. ... hardly follow Mr. Nicholson could ... that the car bore diplom ... to the ...

The ... luck, ... received their reports in ... gation. Was this ... they wondered, really the man who for two years had taught the C.I.A.'s trainees to be spies? The blunder ... F.B.I., helped bu ... circumstantial case ... son, the highest ... officer ever charged with espionage.

The evidence against Mr. Nicholson ... 31-page F.B.I. affidavit ... law enforcement and intelligence officials who charge ... the identities of scores ... undercover C.I.A. officers he had trained, for at least $120,000 before a ...

Continued on Page B15, Column 1

G.O.P. Leader Tries to Replace Ethics Panelists

By ADAM CLYMER

WASHINGTON, Nov. 20 — Representative Dick Armey, the House Republican leader, is trying to replace most of the members of the ethics committee, which is considering charges against Speaker Newt Gingrich.

Representative ... Michigan ... has left ... and co ... change ... against ... fix the ca ... merely part ...

The ethics committee has ... as House Republicans, without ... sent these Mr. Gingrich and ... Armey as the House's new 105th Congress, the first time ... when Republicans have been able to choose the leaders ... tive Congresses. The 58-year-old stepfather, a retired soldier died yesterday, urged House Republicans to adopt Robert Gingrich's creed ... "duty, honor, country" were more than words; they were a way of life.

"We are more than just politicians," Mr. Gingrich said. "We're more than just the cynical, venal, narrow, corrupt ... small too often is a ... current culture. We are ... the lifeblood ...

Today's Republican conference, while enthusiastic, lacked the wild exuberance of the one two years ago which was punctuated by shouts of "Newt! Newt! Newt!" Despite the continuing ethics investigation, which has led several members to tell reporters that they think Mr. Gingrich should step aside as Speaker until the charges are resolved.

Because it would be inappropriate for Mr. Gingrich to choose members of the committee investigating him, Mr. Gingrich asked Mr. Armey to take on this task for him, said Michele Davis, a spokeswoman for Mr.

Continued on Page B15, Column 1

U.S. TRADE DEFICIT WORSENS, AND GAP WITH CHINA GROWS

CLINTON TO PRESS BEIJING

A Wider Opening for American Goods Is Sought as Critics Fault President's Effort

By RICHARD W. STEVENSON

WASHINGTON, Nov. 20 — As President Clinton prepares to press top Chinese leaders to open their markets ... American goods ... today ... China rose ... ord. It ... over ... ed by the ... States ... said the nation's over ... for September unexpected ... to $11.3 billion, $1 billion ... than a month earlier and ... ghest gap, after July's ... since the Government ... rent measurement ... economists had predicted ... of $1 billion or more.

For the second ... month and the third ... largest deficit with China ... with any nation ... ence of how China is ... pan as the primary ... tension for the United ...

Mr. Clinton ... to meet President Jiang ... China in the Philippines ... a gathering ... Pacific ... Clinton is expected ... China ... break a long p ... erence and lower tr ... if it wants to join the ... body, the World Trade O ... ber ... ary of State ... ber ... day with China's leaders in ... to prepare the ground for Mr. ... meeting. [Page A10.]

The U ... tes as China ... ute to each other di ... we will continue to discuss them ... didly," Mr. Clinton said in Australia, where he was visiting before attending the meeting of Asian leaders.

"But by working together where ... our ...

... two nations also at odds ... es including human rights ... lear arms, Mr. Clinton spoke ...

... fractionally from its August level but nearly $1 billion higher than the September deficit with Japan, which was down marginally from a month earlier.

While the cumulative deficit with Japan for the first nine months of the years remained larger than the deficit with China ... the gap with Japan was ... period while ... China.

Today ... policies to ... Ad ... team has ... re ... been ... for ... market ... the ...

Continued on Page D8, Column 5

INSIDE

Dispute on Veterans' Health
The head of a panel on the health of gulf war veterans said she believed they had more health problems than other veterans, showing the sharp disagreement of scientists and doctors about the situation. Page B11.

Students in U.S. 'Average'
An international assessment of the achievement of students in 41 countries placed United States students slightly below average in mathematics, while ... slightly above average in science. Page B14.

On the Internet: www.nytimes.com
TOP-FLIGHT FINANCIAL JOURNALISM HAS A new address — and a whole attitude. The Street.com. http://www.thestreet.com — ADVT.

THE NEXT MAYTAG MAN?

$299

Bob Dole's Next Campaign
Fresh from defeat in the race for the White House, Bob Dole is appearing in an new ad campaign for Air France. Advertising, page D10.

THE NEW YORK TIMES is available for home or office delivery in most major U.S. cities. Call, toll free 1-800-NYTIMES. Ask about TimesCard. media TimesCard. ADVT.

354613

Chicago Bids Solemn Farewell to Its Archbishop
Joseph Cardinal Bernardin was laid to rest yesterday after a funeral Mass where he was praised for bringing people together. After the Mass, his coffin was carried from Holy Name Cathedral. Page D25.

Agence France-Presse

Rwandan Road Is Lined With Lost Children

By SUZANNE DALEY

NEW TENSIONS RISING IN RWANDA

KIGALI, Rwanda, Nov. 20 — By early afternoon, there were already 15 c ... on the side ...

... ng each ... thers, in ... ere were ... be found ... offered ... othe them. how they were quietly waiting.

Occasionally mothers came to the tent, their tired, bloodshot eyes scanning ... the youngest victims of the ...

Hutu refugees returning from Zaire are being confronted by Tutsi people living in their old homes. Page A18.

But the ... end ... away ... returning ... today ... half a million Rwandan refugees ... as began their trek home from ... re last week, more than 2,000 ... en have been found alone, abandoned or lost at the side of the road ... m ... re children to be lost in the next

... ing turmoil this country. Sundered families ... familiar symbols of refugee crisis ... preve had ... of workers sorted ... addled dislocat ...

Already ... ncles in ... clogging ... ergency set up to care for them. ... he huddle in corners unspeak. Others cling to any will smile at them. ... d workers expect hundreds m ...

Continued on Page A18, Column 5

"All the News That Fits"

The New York Times

Late Edition
New York: Today, partly sunny, continued cool. High 46. Tonight, a few clouds and chilly. Low 35. Tomorrow, sun with high clouds. High 53. Yesterday, high 43, low 33. Details, page D17.

VOL. CXLVI ... No. 50,619 Copyright © 1996 The New York Times NEW YORK, FRIDAY, NOVEMBER 22, 1996 $1 beyond the greater New York metropolitan area. 60 CENTS

From Suspect in Murders To a New Life in America

U.S. Aided Salvadoran Linked to Marines' Death

By TIM GOLDEN

In the last days of spring in 1985, Pedro Antonio Andrade was a leftist guerrilla commander so committed to overthrowing the United States-backed Government of El Salvador, officials say, that he helped plan the most violent attack on Americans of El Salvador's civil war: the shooting of four off-duty marines and nine other people as they dined at sidewalk restaurants in the Zona Rosa section of San Salvador.

Five years later, Mr. Andrade and his family were living quietly in the United States, their visas approved by American diplomats and their new life financed with thousands of dollars from the Central Intelligence Agency for his services as an informer against the cause he once championed.

The facts of Mr. Andrade's admission were confirmed by United States officials this month after nearly a year's investigation by officials of the State, Justice, and Defense Departments and the C.I.A. That long inquiry broke into public view after the family of one of the marines killed in the attack led a United States Senator to battle to have Mr. Andrade been staying in the U.S.A.

"And it's illegal, the murder of Americans, and it must not be muffled in bureaucracy," said Senator Richard C. Shelby, an Alabama Republican, who wrote to President Clinton and made the public this day.

Mr. Andrade has consistently denied any direct involvement in the killings and has said he agreed to become an informer under duress. He also took two lie-detector tests that were declared by several American officials as inconclusive. Some U.S. officials — including one who came to know Mr. Andrade well — said they believed that the evidence of Mr. Andrade's role in the Zona Rosa massacre was far from certain.

Others told of their account of other former rebels and of a dozen American officials familiar with his case, the story of how one of the reputed masterminds of the Zona Rosa massacre became a highly paid informer for the Salvadoran armed forces reveals the contradictory impulses that guided the United States involvement in the Salvadoran civil war. It is perhaps the most remarkable in a series of recent cases that have illuminated questionable ways in which intelligence

FORGIVEN ENEMY
A special report.

Librado Romero/The New York Times
Pedro Antonio Andrade is now jailed on immigration charges.

Continued on Page D18, Column 1

On Eve of African Relief Talks, Aid Donors Argue Over Numbers

By BARNET

WASHINGTON, Nov. 21 — before a major meeting to plan international military missions Central Africa, United Nations government and humanitarian agreed today on the proportion of how to handle the crisis are still trying to answer a number of questions about Zaire.

The Rwandan Government continued to insist today that about 100,000 refugees had gone home in recent days and that it was therefore back on track. Officials of the United Nations High Commissioner for Refugees said hundreds of thousands of refugees were spread out in groups in the vast eastern Zaire. But many of the guerrillas and people are from Rwanda and Burundi, or even from other countries. It remains very much an open question. "It's unclear at this juncture," said Anita Parlow, a spokeswoman for the refugee commission.

Further complicating the mission, the United States Ambassador to Rwanda, Robert Gribbin, said in an interview that the opinion of many experts and relief workers are uncertain. Relief officials want to return the refugee populations is a notoriously tricky endeavor, a mix of compassion and bluffing like plumes in the

Continued on Page A3, Column 1

Canadians' Failure: Indians and Eskimos

Canada's policies toward the Indians and Eskimos have been a "WASTED MONEY, WASTED LIVES" failure, a report said. The only way to make things better is if these policies are not changed, a commission that spent $3.5 million studying the condition of the country's Indians said.

One notable failure is the Indian community at Davis Inlet in Newfoundland, now the focus of efforts that stresses self-government and economic development.

Articles, page A6.

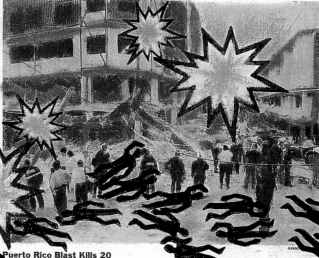

Puerto Rico Blast Kills 20
At least 20 people were killed and 80 were injured when an explosion ripped through a five-story building in the heart of a shopping district in San Juan, P.R. The blast followed reports of a gas leak. Page A14.

29 Arrested in Tax Fraud Scheme Described as New York's Largest

By LYNDA RICHARDSON

In what was described as the largest tax fraud case in the history of New York City government, Federal prosecutors announced the arrests of 29 people yesterday. Three of the 29 included former head of tax collection in Brooklyn.

As many as 200 more are expected in the scheme, which eliminated or reduced taxes on 1,500 properties.

In exchange for bribes from property owners, city workers who took part in the scheme made it appear as if the unpaid taxes had been paid, officials said. In other cases, legitimate taxpayers' payments were misapplied to the accounts of those who paid bribes. One instance, a property owner owed applied to the account of a corrupt property owner without Mr. Trump's knowledge, officials said. The scheme defrauded the city of $20 million, including $13 million in real estate tax bills that were erased from the Finance computer and $7 million in interest on that sum, investigators said.

Although only a few people have been arrested relative to the size of the scheme, officials said they expected to track down and arrest as many as 200 more who paid bribes. Property owners who had their taxes reduced through the scheme can be tracked down through computer records, city officials said, urging those people to turn themselves in.

Officials said the average homeowners would not be affected by the losses because the city expected to recoup the money from the people involved in the fraud.

Prosecutors said that some buildings owners received huge tax breaks. In one instance, with just a half million dollars or more in taxes owed on their property. The city officials said, depending on the property owner or in bribing the

In most cases accepted bribes

furs, a refrigerator, investigator said in one instance, a bottle of aftershave lotion into the role of the bribe in another.

Continued on Page B6, Column 2

RUSSIAN MILITARY LOSES SATELLITES

Land of Sputnik Finds Itself Without Spies in the Sky

By MICHAEL R. GORDON

MOSCOW, Nov. 21 — In a vivid demonstration of the problems afflicting this country's once-proud space program, Russia has been without photo-reconnaissance satellites for nearly two months, Russian and Western scientists say.

It is the first time since the early 1960's that the Russian military has been without the satellite pictures modern armies deem essential for detecting threats and conducting combat for more than a brief period.

Russia's last operable photo satellite burned up in the early atmosphere on Sept. 28, and since then, Russian and Western experts say, the Russian military has lacked up-to-date imagery of such potential hotspots as Afghanistan and the Russia-China border.

"This is the consequence of continued underfinancing of the space program, particularly in the military sector," said Maxim Tarasenko, a space analyst at Moscow's Institute for Physics and Technology.

Russia's military and intelligence services are not completely without surveillance, the experts said, since other types of satellites that could detect ballistic missile attacks and track electronic emissions from military warships are still working.

"In the heyday of the cold war, it would have been unthinkable for them to go for an extended period

Continued on Page A7, Column 1

TRADE-OFF IN PROTECTION

Drivers Can Deactivate Devices and Auto Makers Can Slow Speed of Deployment

By ROBYN MEREDITH

DETROIT, Nov. 21 — Faced with mounting public anxiety over the danger that air bags pose to small adults and children, the Transportation Department has decided to allow drivers to have the air bags disconnected and manufacturers to make bags that inflate more slowly, Government and private safety experts said today.

The National Highway Traffic Safety Administration, an agency of the Transportation Department, is to outline the proposed rule changes in Washington on Friday, experts said.

Since 1991, 51 people — most of them not wearing seat belts, and 30 of them children under 10 — have been killed as their air bags inflated with great force and as victims were thrust forward in crashes. The Transportation Department calculated in late summer that air bags — which deploy at speeds up to 200 miles an hour — were killing children at the rate of one a month. But by the year 2000, when air bags are expected to be far more prevalent, the child death rate could increase to one a week if no action is taken.

Government estimates to allow manufacturers to make slower-inflating air bags is a victory, offering less protection to small adults in high-speed crashes while the bags less harmful to small and frail or small children and accidents.

Currently, over than 15 percent seat belts, compared with 68 percent now, and federal regulators began requiring air bags quickly in the 1980's while auto executives publicly complained that the cost to consumers that air bags were worth their many lives. Air bags have saved more than the number expected to grow so no-one knows how many will need air bags.

In recent years more people have strapped on seat belts. But public opinion on the danger of air bags has brought a change has led auto makers to propose air bags that deploy more slowly, but that would still hurt passenger and slant that can pose a risk to very small children.

Just as the many years ago when air bags were causing public concern over safety groups, auto makers and air bags. Government and safety over how air bags can protect passengers, consumer groups are urging slower air bags that deploy more slowly in fender-benders, and the agency has been weighing various proposals.

"We think we've proposed a way of

Continued on Page A17, Column 1

U.S. Set to Allow Reactors to Use Plutonium From Disarmed Bombs

By PETER PASSELL

In spite of protests from its own arms control specialists, the Clinton Administration is on the verge of relaxing a two-decade-old policy intended to keep nuclear weapons out of the hands of terrorists and rogue states.

The Energy Department will allow a recommendation that plutonium from dismantled atomic bombs be used as fuel in civilian nuclear power plants, to be discarded.

The recommendation, to be released next month, would breach a wall between the nation's commercial nuclear actors and its nuclear establishment that has kept commercial plutonium out of the country. To reduce the risk of loss of theft, and with the cold war over, the United States and Russia have large stockpiles of plutonium on hand.

Administration officials say using the plutonium as reactor fuel would not be an easy measure and would help cooperation for weapons disposal from Russia.

Continued on Page A22, Column 1

Fugitive Surrenders in Infant's Death
Brian C. Peterson Jr., the New Jersey teen-ager accused with his girlfriend of killing their newborn child and leaving the body in a hotel Dumpster, surrendered to the F.B.I. yesterday in Wilmington, Del. In hiding since Saturday, the young man was accompanied by his parents. Page B1.

INSIDE

Cisneros to Step Down
Housing Secretary Henry Cisneros became the latest Cabinet member to announce his resignation since the election. Mr. Cisneros said his decision was based on financial considerations. Page A22.

U.S. Ignored China Warning
An inquiry indicates that the Commerce Department approved the sale of American machine equipment to China in 1994 despite advance warning that it might be used for military purposes. Page A9.

Simpson to Testify
As the civil trial of O. J. Simpson moved toward its dramatic high point, Mr. Simpson's testimony, observers and legal experts warned against expecting any "Perry Mason moments." Page A14.

On the Internet: www.nytimes.com

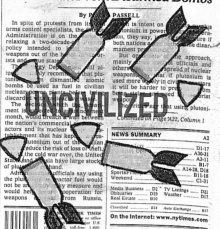

The New York Times

VOL. CXLVI . . . No. 50,620 Copyright © 1996 The New York Times NEW YORK, SATURDAY, NOVEMBER 23, 1996 ...beyond the greater New York metropolitan area. 60 CENTS

Late Edition
New York: Today, partly to mostly sunny, mild. High 48. Tonight, dim moonshine. Low 40. Tomorrow, dim sunshine, mild. High 52. Yesterday, high 45, low 37. Details, page 25.

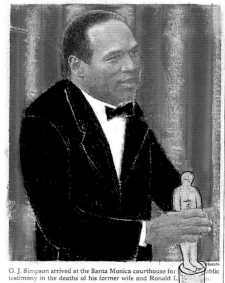

O. J. Simpson arrived at the Santa Monica courthouse for ... public testimony in the deaths of his former wife and Ronald L. ...

Testifying at His Civil Trial, Simpson Says He Is Innocent

By CAREY GOLDBERG

SANTA MONICA, Calif., Nov. 22 — The accu... ...dden rapid-fire... ...'s d: You had glov... ...ou had sweats,u confronted Nicole Brown Simpson, and you killed her. And you killed Ronald Goldman, didn't you?

Uncowed and unprovo... d... ..., Simpson turned to look d... the stone-faced jury as h... ... under oath, every dark act a... ... to him.

"That is absolutely not true," Mr. Simpson said, emphatically denying again and ag... ... sinister port... ... er.

Testifying first time about the double killing that made him the most famous murder defendant of the decade, Mr. Simpson said he had never done any thing worse than "rass... his ex-wife and denounced an... ... to the contrary, including her diary, as lies.

"This was a woman I love today," he told a predominantly white jury of seven women and five men. "I always loved her."

Sighing frequently into the witness stand microphone and looking tense but poised in a quiet gray suit, Mr. Simpson delivered more than four hours of baritone testimony in a performance considered... dramatic high point of his civil tr... ...t will

likely be the deciding factor in wh... ... wrong-ful... ..., held, assassi... ... the un-sp... ... about 70 ... that ... s... ...

Mr. Simpson was acquitted last fall of murdering his ex-wife, Nicole Brown Simpson, and her friend Ronald Goldman. It is their relatives who h... ne now brought suit.

B... se he chose not to testify at his ... nal trial, Mr. Simpson's testimony today gave his accusers their first chance to grill him publicly about allegations that he had abused in... ... after thevil trial.

Throughout much of his morning testimony, an enlarged photograph of Mrs. Simpson's battered face was projected on a screen at the front of Petrocelli, the lead law...

Continued on Page 10, Column 1

U.S. AGENCY PLANS TO REDUCE DANGER POSED BY AIR BAGS

1998 CARS TO BE AFFECTED

Policy Changes Are Intended to Protect Children Without Sacrificing Safety Gains

By ROBYN MEREDITH

WASHINGTON, Nov. 22 — The Department of Transportation said it ... that it would try to require auto makers to install new, more advanced air bags within two years as part of a package of steps to reduce the danger the safety devices posed to children and small adults.

The actions today by the National Highway Traffic Safety Administration, a Transportation Department agency, reflect an acceptance by Government officials that air bags, which were widely viewed in the 1980's as a panacea for automobile safety problems, carry some dangers of their own.

As expected, the agency said today that it would try to require slower-inflating air bags and to allow mechanics and automobile dealers to deactivate the devices of customers demanded it. It will also extend, probably until late in the year 2000, its policy permitting auto makers to install switches that allow drivers to deactivate ... devices temporarily in vehicles And it will requ...bels.

But fa... ... ese short... ... teps to a... ... wrong-ma... ... to de-ve... ... install th... ... old in rely would mine... er to inflate on... ... circumstances and... ... the passengers.

"This is... ... quantum leap in frontal... Ri-card... ... at or —auto ide a... ... rid-... ... people w... of them ch... ... old. They ha... 1,600 lives. Fe... s were eager to emphasize that over all, cars and trucks

Continued on Page 9, Column 1

Clinton Campaigns for Coral Reefs

President Clinton greets the crowd in Port Douglas, Australia, yesterday after giving a speech about protecting coral reefs. And he snorkeled in the sparkling blue-green waters of the Great Barrier Reef. Page 3.

Associated Press

Zairian Crisis Part of Broad Web Of African Subversion and Revol...

By HOWARD W. FRENCH

ABIDJAN, Ivory Coast, Nov. 22 — From the moment that fighting broke out in eastern Zaire last month, and a crisis involving more than a million refugees, the question many asked was: Where could the potent rebel force that ignited this conflagration have suddenly sprung from?

Forced to explain his country's loss of control over its eastern Zairian Prime Minister, wa Dondo, has repeatedly ... that the rebels have been "trained on Rwandan soil by mercenaries of several nationalities."

Many diplomats agree tle doubt that ... Rw... Government played ... role in

Continued on Page 7, Column 1

LITTLE PROGRESS IN AID TALKS

No conclusions were reached at a meeting in Germany on plans to aid the Rwandan refugees. Page 7.

supporting the rebel... in eastern Zaire by an ethnic...

But more broadly, military and... ... of the current... ... vast web... sion and... winning that... th... ... y time si... heigh of the... war.

The afflicted countries — Angola to the Red Sea, and Z... Sudan, Ethiopia, Bur... di and Rwanda itself. A... ... can experts say the outcome of ... struggles could result in the reshaping of African borders that remained almost unchanged since the powers c...

...ning of agglefrican lines to break ... of the colonial anda ...

Continued on Page 7, Column 1

STATE TELLS CREW TO SEIZE CONTROL OF 42 BAD SCHOOLS

THREATENS TO SHUT SOME

Move Is Albany's Strongest Yet — Gives Chancellor Power He Hasn't Had Before

By PAM BELLUCK

The State Education Commission ... ordered the New York City School Chancellor, Rudy Crew, ... direct control ... schools and ... them. If they do not get better, the Commissioner said, the state could far-reaching and aggressive effort yet to force the city's poorly performing schools to improve their students' achievement. The schools he singled out represent nearly 4 percent of all of the city's public schools.

"I intend to keep ... pressure on these schools," Mr. Mills said in a statement arly, the c... s to act ...

... ru...veral er sch...

"I'm fact that we have low-performing schools," Dr. Crew said. "When you establish a standard and someone is below the standard, there needs to be obviously some corrective action taken. Now, system stands e that effective public-ed... ... consist... ... r... ... for greater cont... l over ... schools, the state's move gives him a degree of authority he has not previously had over these schools.

Eighteen of the schools have been on the state's list of troubled schools for at least three years — some as long as seven years — and they still have not improved enough, Mr. Mills ... id. Schools are placed on the watch list based ... the percentage of students who do poorly on ... in competency tests on mathematics, reading...

They remain til state investigators,teacher qualifications ms, as well as how do not have enough

Mr. M... ... he 18 schools, in Brooklyn and ... Manhattan and ... them. For these schools, the state issued detailed reports yesterday

Continued on Page 22, Column 1

Mayor Drops School Demand

Mayor Giuliani effectively withdrew his demand for ... control over the school sy... ... would give the Chancellor more ... er. Page 21.

How a Killing Roused Irish Conscience

By WARREN HOGE

DUBLIN — Shots from a .45-caliber handgun were fired at her through the window of her cottage as ... put her 9-year-old son to bed. The country's most notorious criminal ... and ... reatened to sodo... ... and kill her entire An her a crash helmet home, held a phony drinking ses... o her thigh and

... ... eveal he or she eronica Guerin, February as she her wound. She ot be deterred from inuing, on about Dublin's ban, confided that getting shot had been "the most frightening moment of my life," one "I hope I shall never have to face again."

Like ever... ... this society, she un... and ruth... she sa... ... fabulously liberal by... ... reporting spective wom... hom... her min... the murder... en an unusual thing... or a land as practiced as this one is in the rites of martyrdom and the ance of episodic death flict.

Acting in her name, ment passed a series of laws giving Ireland's outmaneuvered and underfunded law enforcement agencies the ability to deal with the newly ticated enemy that Ms. Guerin been writing about organized crime.

"It's terrible to think that it took the murder of a journalist in broad daylight to embarrass the Government into taking action," said Tony Gregory, a member of Parliament

Veronica Guerin, a Dublin reporter who was shot to death on June was surreptitiously photographed meeting with John Traynor, who later sued to prevent her from identifying him in print as a drug dealer.

The Sunday Independent

FATAL SHOTS, LOUD ECHOES
A special report.

from a drug-ridden and long-neglected working-class Dublin district.

... ategy to co ... battle have been more evident in the past months than in the previous 15 years."

... Gu... ... court on... ith...'re a modern European state with an economy that is doing very well, but crime has modernized also, and we haven't escaped it here anymore than anywhere else has," said

Liz McManus, the Minister for Housing and Urban Renewal.

Of the new laws, the most immediately effective was one creating a Criminal Assets Bureau that has been aggressively confiscating money and property of coming from criminal activities. Another measure stitutional change empowers judges to deny bail to suspects thought likely to commit new crimes while free, is the subject of a national referendum Nov. 28.

Judges in land have almost no power to refuse bail, and the numbers of crime are ... able to people awaiting trial have reached alarming proportions. "The bail proposal seeks to bring Irish criminal law into line

Continued on Page 6, Column 1

Victory of 5 Redistricted Blacks Recasts Gerrymandering Dispute

By KEVIN SACK

ATLANTA, Nov. 22 — The re-election of five black members of Congress, in districts recently redrawn to eliminate black voting majorities, has sharpened the debate on a crucial legal and political question: Is it still necessary to gerrymander legislative districts along racial lines to insure minority representation?

Those who have successfully petitioned the Supreme Court to reject districts drawn along racial lines see the results of the five races in Florida, Georgia and Texas as a vindication of their efforts. The success of black candidates in majority-white districts, they say, demonstrates that legislators need not ... con-solidate black ... oddly shaped ... tricts in er... ... ure that a seat is elected...

"The have a ers to v... history o... ... the law... ... iffs who black-majo... ...

But civil r... ... that the key to the ction Day was less the design of the districts than the incumbency of the black candidates. Early analysis of the results suggested that whites and blacks continued to vote largely in racially polarized lines. And most of

the winners said that they succeeded only because their previous representation of black-majority districts gave them the name recognition, fund-raising capacity and legislative records they needed to attract the necessary share of the white vote in their new districts.

"The real test of these majority-minority districts are still necessary will come from the minority candidates who vie for this seat after me," said Representative Cynthia A. McKinney, a feisty and flamboyant black Democrat who won 58 percent of the vote in Georgia's newly designed Fourth District.

"It may very well be the case that attitudes in the South have changed for the better," Ms. McKinney said. "But one thing is for certain: representing the old 11th District allowed me to run and win in the new 4th District without having to change my views, my gold tennis shoes, my braids, or having to auction off my principles to the highest bidder."

It is clear that the direst predic-

Continued on Page 10, Column 1

INSIDE

Success at Subic Bay
Subic Bay, the former United States base in the Philippines where President Clinton and 17 other leaders to meet next week, has become a symbol of economic success. Page...

Democrats to Return Gift
The Democratic Party said it would return $450,000 solicited from an Indonesian couple by John Huang, who is at the center of inquiries into party fund-raising. Page 9.

Couple Guilty in Assault
In a case that stirred ugly memories in a Southern town, a white couple were convicted in an attack on a 10-year-old black boy, but were acquitted of a more serious charge. Page 8.

Physics Trailblazer Dies
Abdus Salam, a Pakistani who shared the 1979 Nobel Prize in Physics for his research on two of the fundamental forces of nature, died at 70 in Oxford, England. Page 11.

On the Internet: www.nytimes.com

Artwork overlaid text: BEST ACTOR IN A COURTROOM SERIES WITHOUT ARMIES BORDERS. RIDE 'EM COWBOY. STOP. ENOUGH TO GET YOUR IRISH UP.

"All the News That Fits"

The New York Times

VOL. CXLVI No. 50,621 Copyright © 1996 The New York Times NEW YORK, SUNDAY, NOVEMBER 24, 1996 $3 beyond the greater New York metropolitan area. + $2.50

New York: Today, Increasing clouds, milder. High 50. Tonight, cloudy, ashower: Low near 40. Tomorrow, damp then brighter. High 50. Yesterday, high 47, low 36. Details, page 54.

Washington Talk

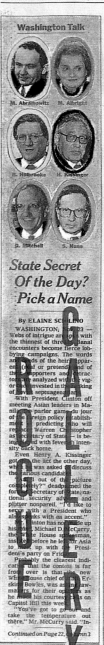

M. Abramowitz M. Albright
R. Holbrooke H. Kissinger
D. Mitchell S. Nunn

State Secret Of the Day? Pick a Name

By ELAINE SCIOLINO

WASHINGTON, Nov. 23 — Webs of intrigue around the thinnest of three or four banal encounters become fierce lobbying campaigns. The words and deeds of the heir apparent (real or pretended) of the supporters and detractors are analyzed with a vigor reserved in the making of a septuagenarian.

With President Clinton off meeting Asian leaders in Manila, a parlor game du jour of foreign policy establishment — predicting who will succeed Warren Christopher as Secretary of State — is being played with feverish intensity back home.

Even Henry A. Kissinger got into the act the other day, when he was asked to discuss the various candidates.

"...out of this picture completely?" deadpanned the former Secretary of State, national security adviser and plotter nonpareil. "I'd like to serve with a President who also speaks with an accent."

Clinton has not made up his mind, Michael D. McCurry, the White House spokesman, insisted before he left for Asia to team up with President Clinton's party on Friday.

Probably the clearest indication that the contest is far from over is that the new White House chief of staff, Erskine Bowles, was asked lawmakers for their opinions as he made his courtesy rounds on Capitol Hill this week.

"You've got to go out and take the temperature out there," Mr. McCurry said.

Continued on Page 22, Column 3

INSIDE

Yeltsin Orders Withdrawal
Leaving Russia without even a face-saving presence, President Boris N. Yeltsin ordered the withdrawal of nearly all of the remaining Russian forces from Chechnya. Page 4.

The Fight Against Ebola
Eighteen months after an Ebola outbreak in Zaire killed at least 244 people, scientists have chosen a remote national park there as the front line in fighting the disease. Page 3.

Scrutiny for Army Teachers
Scandals involving sexual and other misconduct at several military bases have left the drill sergeants, and those who train them, under scrutiny. Page

Marijuana Comes Indoors
Several recent raids in Florida underscore the increasing tendency of marijuana growers to bring their crops indoors, where they can raise higher-potency plants. Page 18.

On the Internet: www.nytimes.com

CONCERN IS VOICED OVER THE QUALITY OF ECONOMIC DATA

MAJOR REVAMPING URGED

Commerce Dept. Official Says Statistical System Fails to Keep Up With Changes

By ROBERT D. HERSHEY Jr.

WASHINGTON, Nov. 23 — Almost nobody questions whether the statistical information used in making decisions related to monetary policy and the Federal budget.

But a senior Administration official warns that the quality of those statistics has been eroding steadily, which could undermine the confidence of investors.

Others warn that remedies could involve reducing the growth of Government benefits, including Social Security, and raising taxes.

The official, Everett M. Ehrlich, Under Secretary of Commerce for Economic Affairs, said in an interview that the economic statistics where the data are the marines can bar reliance on "misrepresentation as utterly productivity growth and the economy's changing composition."

A panel appointed by the Senate is expected to report in December that the Consumer Price Index overstates inflation by as much as 2 percentage points, which would cost the Government as much as $634 billion over the next 10 years, primarily because of inflation-linked payments for Social Security and other Federal benefits.

Government officials admit their methods have not kept pace in the face of the rapid commercialization of business and the growing economic role of services that are generally harder to measure.

There are more dollars, in real terms, too. The price index, for instance.

Continued on Page 24, Column 5

A Surprising Finding On School Spending

The superintendents who oversee New York City's elementary and middle schools have long complained that the city's sprawling high schools soak up a disproportionate share of precious education dollars.

So it was a surprise when Schools Chancellor Rudy Crew, in the system's first-ever exhaustive accounting, found that the high schools actually spend less — an average of $634 less per student than the elementary schools and $760 less for high schools.

"...and always we got short shrift," said one former superintendent. "...I had the sense that high schools got very high ..." we did...eve me."

Continued...article, page 37.

In Manila, Asians Pore Over Washington's Inner Truths

By DAVID E.

MANILA, Nov. 23 — Anyone wondering why Asian business leaders showed renewed interest in the inner workings of American political system this fall — and such

In the days leading to President Clinton's arrival and meetings with the leaders of Pacific Rim nations, the region's billionaires and its industrial planners and its real estate investors poured into this city to assess what a second term for the Clinton Administration will affect billions of ...

...segments from ...ta, Indo... ...Los Angeles... ...was, of c... ...usual head... dose of cli... ...ight doing business in the ...but it ...was quickly evident that many of the ...gas were more nervous than ever about Washington's increasingly ...al or... ...hions... — or vetoing — ...al deal. After years ofthat Some Asia is a diminishing ...ng power, Asia's ...executives have concluded that ...tions made in Washington carry more important to their prosperity than ever.

So while Mr. Clinton was scuba diving off the Great Barrier Reef, the acting United States trade representative ...arshefsky, was holding ...sions about the conditions under which America would let China join the World Trade Organization — an issue little discussed in America but one on which fortunes could turn. When Commerce ...Kantor spoke today about the emergence of a "Clinton Doctrine" — "not mutually assured destruction and a policy of containment but ...market ...ured prosperity" — ...

Continued on Page 12, Column 1

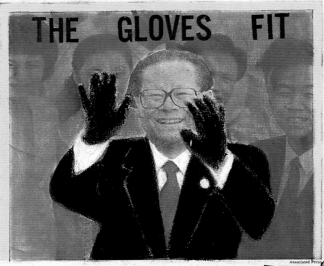

THE GLOVES FIT

President Jiang Zemin of China arrived in Manila yesterday for the Asia Pacific Economic summit meeting. He is to meet with President Clinton to discuss arms sales, Taiwan and trade.

Associated Press

A HIJACKED PLANE CRASHES IN OCEAN OFF MOZAMBIQUE

SURVIVORS ARE RESCUED

An Ethiopian Jet Carrying 175 on a Flight From India to Africa Ran Out of Fuel

MORONI, Comoro Islands, Nov. 23 (Reuters) — A hijacked Ethiopian Airlines Boeing 767 with 175 passengers and crew aboard crashed into the Indian Ocean near the Comoro Islands today after running out of fuel.

"There are 45 survivors and they have found 50 bodies," Ahmed Chanfe, deputy manager at the Comoros' main airport, said.

"Most of the survivors have been taken to hospitals but some are in local hotels."

Airline officials said the pilot and one crew member were among those who survived when the plane, hijacked by men from ...a, Ethiopia, ...ashed into ...and on the ...que and ...

Thirty ... victims, mostly ... ions, were laid out under blankets in the conference room of a beach hotel near where the plane came down about 25 miles north of Moroni, capital of the Indian Ocean archipelago.

The state radio appealed to all doctors at the island's two main hospitals on Grande Comore. Tourists at the hotel said they include a group of 20 French doctors on vacation, rushed to the rescue effort.

Airline officials said the hijackers were from Bombay, India. The flight originated in Bombay, and after the stop in the Ethiopian capital was scheduled to continue to Kenya, Congo, Nigeria and the Ivory Coast.

The officials said the number and nationality of the hijackers was not confirmed.

Speaking earlier to the BBC World Service, Frederick O'Neill, manager of a hotel in Grande Comore, said one survivor spoke of seeing two hijackers on board. Earlier reports from officials spoke of a group of up to ... hijackers.

...said there was little informa... about the motives or demands of the hijackers. Earlier reports said the hijackers had wanted to be flown to ...

But Mr... survivors he had spoken ... said the men were panicky.

"He said ... was quite panicky and trying to ... contact with the Ethiopian ... but they couldn't get through and ... why ...

...age 8, Column 3

Amtrak Derailment in Secaucus Marsh Injures 35

By ROBERT D. McFADDEN

An Amtrak fast-mail train approaching New York with 108 passengers and crew members derailed as it sped across a Hackensack River swing bridge on a desolate New Jersey meadow land early yesterday, ...sideswiping an oncoming ...er train, part of the mail ...lunged down a 30-foot embankment.

...one was killed but Amtrak said ...5 people ... ill, two critically, and do...s shaken and terrified as a ...dozen passenger ...behind twin locomo... ...was wrecked at 6:33 A.M. at th...rtal Bridge in the marshes of Secaucus. The site is a mile from the junction where two New Jersey Tran...uter trains collided ...killing 3 people and ...

...e crash was still under ...tion, United States Senator ...ank R. Lautenberg, who went to the scene and talked to railroad officials, indicated that mitered rails on the br...ight not have been closed ...after a boat passed ...hours earlier, causing th...

"It appear...closure of the ...it may ... been fully ...ectively closed ...nd Senator ...nberg, who is on the Transportation Appropriations subcommittee. Yesterday ...ctacular crash, which ...comotives nose ...baggage car and three ...cars derailed and a...zigzagged on torn-up ... five miles southwest of

A derailment ...way at ...rtal Bridge in the marshes of Secaucus, N.J., sent tw... trak ... and several cars down an embankment.

Associated Press

Continued on Page 40, Column 1

Piles of Storied Jewish Books Are Languishing in Lithuania

By MICHAEL SPECTER

VILNIUS, Lithuania, Nov. 21 — Tens of thousands of rare Hebrew and Yiddish texts lie in dusty heaps innius University, and who along with a Holocaust survivor, Fira Bramson, has been sorting the books in an ...and unit...remains ...ished here."

The books, for...regard as one of ...collections in the w... first from the Nazis and then concealed for years from the Soviets under stacks of farm statistics. They are the property of the Lithuanian National Library, whose ...says he considers ... beyond value." But... been given reg... church and ... struggling to ... they have re... are left to A... "This...Lam...brew and ...

...in New York City, ...wars, "hunting season" nears. ...Beijing.

...ntrol ...that the Clin... ...en would take away ...doctors. The plan died. Manage...

...a way — and a place... ...en nearly impossi... ...00 Jews are left in ...elderly, and community leaders say that these books are their last powerful link to a heritage that the Nazis and then the Soviets tried hard to obliterate.

Jewish scholars say the books, collected from the most important and renowned yeshivas and libraries in Eastern Europe, no longer belong in Lithuania.

They consider their presence here ... where the Nazis killed 240,000 ...ws and ca... ...many ...er count...

TODAY'S SECTIONS

Arts .../Section 2
As b... ...ook at the schedule for a n... ...they frequently notice th... ...rite work has disappeared ...as returned. What they do... ...see is the complex decision making... goes into the programming.
Automobiles/Section 11††

Book Revie...
"Damned to P... ...fe of Samuel ...ten... by Ja...son, the ...chosen by Beck... ...rite his ...phy, reveals a new sid... of Beck... ...knowledge and use of music and ...er; reviewed by James Knowlson. James Ellroy's latest book, "My Dark Places: An L.A. Crime Memoir," is a true-crime story with a big difference: it's about the murder of his own mother. The review is by Bruce Jay Friedman.
The City/Section 13§

Editorials and Op-Ed/Section 4

Magazine/Section 6
They're everywhere now — in politics, in music, in sports, but most especially in our imaginations: female icons. A special issue today of The New York Times Magazine, "Heroine Worship," considers some of the women in this overflowing pantheon.

Money and Business/Section 3
That rosy glow emanating from Washington as it prepares to tackle the budget deficit and Medicare is a byproduct of a lengthy economic expansion. But a small slip could spell trouble.
Regional Weeklies/Section 13§

Real Esta...
SportsSunday/Section 8
The 1996-97 college basketball season
Television/Section 12*
Travel/Section 5
Pacific hideaways that inspired Gauguin and caused Melville to jump ship.
Employme...

186

VOL. CXLVI No. 50,622 Copyright © 1996 The New York Times NEW YORK, MONDAY, NOVEMBER 25, 1996 $1 beyond the greater New York metropolitan area. 60 CENTS

Late Edition
New York: Today, cloudy, possible shower. High 50. Tonight, late rain. Low 47. Tomorrow, rain ending near evening. High 52. Yesterday, high 44, low 41. Details are on page D9.

Clinton and Chinese President Agree to Exchange State Visits

But They Fail to Narrow Differences in Manila

By TODD S. PURDUM

MANILA, Nov. 24 — Despite deep and unresolved differences, President Clinton and President Jiang Zemin of China agreed today to exchange state visits over the next two years. They would be the first such extended meetings between their nations since the massacre of pro-democracy demonstrators at Tiananmen Square in 1989.

The White House hopes the reciprocal visits — to be preceded by a trip to Beijing by Vice President Al Gore in the first half of next year — will cement the first steps toward improving a relationship that has floundered badly in the last four years over human rights, trade, nuclear proliferation and Taiwan.

But after an 85-minute meeting at an economic summit meeting of 18 Asian-Pacific leaders here, it was clear Mr. Clinton and Mr. Jiang had made little substantive progress on those issues.

The one possible exception, Administration officials said, was Mr. Jiang's apparent willingness to move ahead on opening markets to pave the way for China to join the World Trade Organization and thus diminish a source of longstanding tension between Washington and Beijing. The organization, which includes more than 100 countries, aims to promote trade and remove barriers that inhibit it.

In a separate meeting with President Kim Young Sam of South Korea, Mr. Clinton apparently succeeded in persuading him to maintain his country's minimal links with North Korea, despite Seoul's outrage over the incursion of a North Korean submarine and its crew into South Korean territory in September.

After that incident, the South demanded an apology from the North, which threatened to break the few remaining lines of communication across the Demilitarized Zone. But today Mr. Kim and Mr. Clinton issued a statement simply calling on the North to take "acceptable steps" to resolve the matter.

American officials said the precise timing of the Chinese-American state visits remained to be set, depending in part on the smoothness of the transfer of Hong Kong to the Chinese next July. But the assumption has been that Mr. Jiang will travel to Washington next year, perhaps in April, for scheduled APEC talks, in Vancouver in November, and Mr. Clinton may go to Beijing in July.

As he posed with Mr. Jiang in front

Continued on Page A6, Column 3

Reduced H.M.O. Fees Cause Concern About Patient Care

By ELISABETH ROSENTHAL

After signing up large numbers of New York doctors and establishing a seemingly unshakeable position here, health maintenance organizations are radically changing the way they pay physicians and have begun to reduce reimbursements.

Patients who see the same doctor in the same office are generally not aware that a change has occurred. But while the health maintenance organizations assert that new types of payments help control medical costs, the nation's doctors, and medical experts, are warning that the quality of care will suffer and, in some cases, it already has.

Managed care plans that have continued to pay old-style fees for office visits have been cutting rates, sometimes on a monthly basis. Beyond that, however, a growing trend among many large health maintenance organizations like Aetna, Oxford and U.S. Healthcare has doctors off fixed monthly fees instead of per-visit charges.

ALTERED MEDICINE
A special report.

New Jersey and Pennsylvania.

Although doctors admit that traditional insurance, which paid handsomely for every office visit, rewarded doctors for doing too much, they say that the new reimbursement methods are troubling.

Continued on Page B4, Column 1

Broken Rail Joints Are Cited in Wreck On Secaucus Bridge

By ROBERT D. McFADDEN

Continued on Page B2, Column 1

E.P.A. ADVOCATING HIGHER STANDARDS TO CLEAN THE AIR

INDUSTRY WARNS OF COSTS

In Areas Struggling to Reduce Pollution, New U.S. Goals Could Be Hard to Meet

By JOHN H. CUSHMAN Jr.

WASHINGTON, Nov. 24 — The Environmental Protection Agency is recommending tighter national standards for two types of air chemicals and particles that harm smog and soot, saying that most pervasive and unhealthy forms of air pollution.

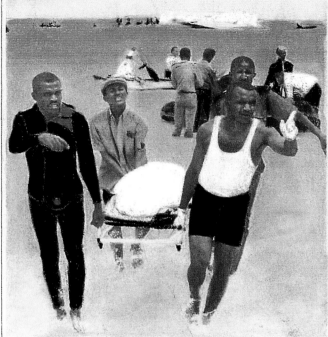

Rescuers removed a passenger's body yesterday from the hijacked jet that crashed off the Comoros; 123 died.

Associated Press

Terror in the Air, and Frantic Rescue From the Sea

MITSAMIOULI, Comoros Islands, Nov. 24 — When two passengers burst out of their seats and ran up the gangway to the cockpit, Hit Addesse, a flight attendant, at first followed them, holding something in his gloved hands, she knew the plane was being hijacked.

"I pushed back my trolley and told the other girl to stop serving drinks," she said today. "The terrorists said for everyone to be seated. They said they had to a... they were going to... the

That moment of... the start of a terrifying four-hour ride... ended in the death of most passengers... in any other previous

The Boeing 767 struck the water once, bounced and then smashed nose first, breaking into three pieces. The airplane carried only 500 yards

Continued on Page A8, Column 3

32 Works of Art by Masters Left to Met and the Modern

By CAROL VOGEL

Florene May Schoenborn, a partment store heiress who became a passionate collector of modern art, bequeathed works by masters like Picasso, Braque, Bonnard, Braque, Matisse, Jean Arp, the Museum of Modern Art. Mrs. Schoenborn died in August 1995 at the age of 9...

*
Picasso's "Woman With Pears" and Brancusi marble "Bird in Space" are among the 32 20th-century works bequeathed to the Metropolitan Museum and the Museum of Modern Art by Florene May Schoenborn.

Metropolitan Museum of Art

Continued on Page A13, Column 1

INSIDE

Refugees Emerge from Zaire
Ten days after the Rwandan refugees who have hid for nearly two years inside Zaire have begun to emerge, telling vivid tales of suffering. Page A8.

Referendum Held in Belarus
Defying the West, East European nations and his Parliament, President Aleksandr Lukashenko of Belarus went ahead with a referendum on expanding his power. Page A3.

Return to Populism
Hundreds of people from 32 states met in Texas for the founding convention of what they pledged would be a populist alliance for the 21st Century. Page A10.

Endless, Unattainable Love
A legion of young Japanese men have lost their hearts to virtual girls in "love simulation" games, a hot new category in Japan's home videogame industry. Page D5.

On the Internet: www.nytimes.com

Oner Mohamed, The New York Times

10 Sets, 2 Champions
Steffi Graf defeated Martina Hingis in five sets yesterday to win tennis's Chase Championships. In Germany, Pete Sampras was a five-set winner over Boris Becker in the men's year-end final. SportsMonday, page C1.

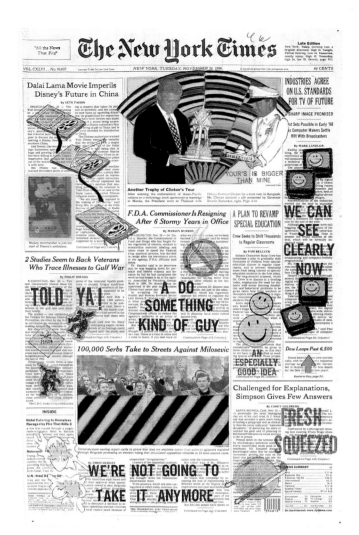

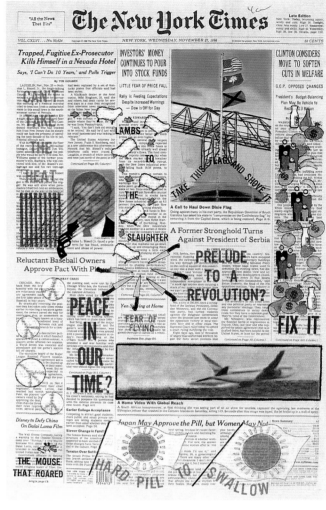

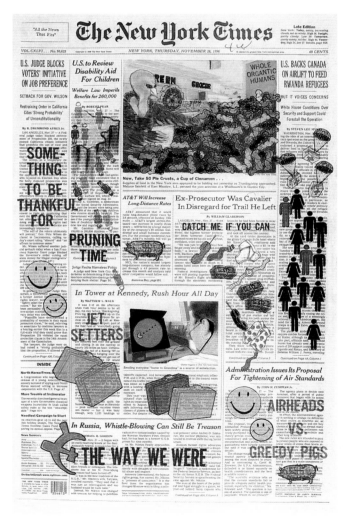

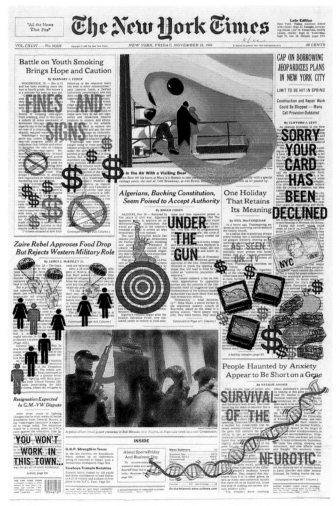

The New York Times

VOL. CXLVI . . . No. 50,627 Copyright © 1996 The New York Times NEW YORK, SATURDAY, NOVEMBER 30, 1996 $1 beyond the greater New York metropolitan area. 60 CENTS

Late Edition
New York: Today, thickening clouds. High 47. Tonight, rain arriving, breezy. Low 46. Tomorrow, rainy, windy, warm. High 59. Yesterday, high 41, low 27. Details are on page 24.

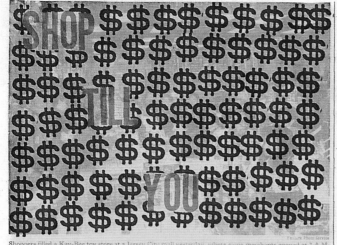

SHOP TILL YOU DROP

Shoppers filled a Kay-Bee toy store at a Jersey City mall yesterday, where some merchants opened at 7 A.M.

WAR CRIMES PANEL IN FIRST VERDICT

Croat in Army of Bosnia Serbs Is Sentenced to 10 Years

By MARLISE SIMONS

ONE DOWN HUNDREDS TO GO

THE HAGUE, Nov. 29 — The international tribunal on war crimes in the former Yugoslavia handed down its first verdict today, sentencing a Croat in the army of the Bosnian Serbs to 10 years in prison for his role in the massacre of Muslim...

Continued on Page 8, Column 1

INSIDE

A Killer Kills Himself
John Salvi 3d, who fatally shot two people and wounded five others at two Boston area abortion clinics in 1994, has killed himself, prison officials said. Page 9.

A Bullish Month for Stocks
The Dow Jones industrial average rose 22.36 points, ending November with the best monthly gain since December 1991 and the best election-year November since 1928. Page 43.

Death on Road to Rwanda
Some Hutu refugees returning to Rwanda say Tutsi rebels in Zaire are taking young men off trucks and killing them.

Tea and Speculation
Like sightings that may have swirled with new energy. Room will newly ... says Warner ... new owner. P.

On the Internet: www.nytimes.com

Day 1 Arouses Retailers' Hopes That Christmas Is on the Rebound

By JENNIFER STEINHAUER

$$$ DROP

HOW MANY FINGERS?

China Comes to India
In the first visit to India by a Chinese head of state, President Jiang Zemin of China and Prime Minister H. D. Deve Gowda of India met in New Delhi yesterday. The two leaders pledged to settle a border dispute. Page 4.

Kabul's Museum: The Past Ruined by the Present

By JOHN F. BURNS

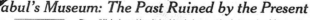

ART TAKES A BEATING

KABUL, Afghanistan — One recent visit to the ruins of the National Museum of Afghanistan...

Shrinking Safety Net Cradles Hearts and Hopes of Children

By PETER T. KILBORN

THE WELFARE OVERHAUL
A special report.

LOUISVILLE, Ky. — Nothing conspicuous in Christopher and Jennifer Cundiff's appearance says they are poor, not the navy blue soccer shirt and blue jeans Christopher wears, or Jennifer's white May jacket with a white rose button...

Continued on Page 9, Column 1

88%

76%

The New York Times

Planning to Close Its Landfill, New York Will Export Trash

By VIVIAN S. TOY

TAKE THIS TRASH AND DUMP

Hoping to close its Fresh Kills landfill by 2001, New York City is planning to end the flow of residential garbage next year...

Continued on Page

In a Quirky Market for Milk, Consumers and Farms Lose

By BARNABY J. FEDER

SOMEONE'S GETTING MILKED

Consumers are paying record prices for cheese and many dairy products...

Continued on Page 4, Column 3

REPUBLICANS' CALL FOR A PROSECUTOR IS REJECTED BY U.S.

DISPUTE ON FUND RAISING

Justice Dept. Says It Found No Evidence of Crime by Top White House Officials

By DAVID JOHNSTON

NO FOULS BY BIG BIRDS

WASHINGTON, Nov. 29 — The Justice Department today rejected a request by Republican lawmakers to seek an independent prosecutor to investigate whether Democrats illegally raised millions of dollars for their party's treasury this year.

Continued on Page 15, Column 1

354613

December

Finally December, AIDS day, the Peruvian hostages,

and Clinton's historic new cabinet, with Madeleine Albright, the first

woman Secretary of State. One of the most unusual pages was

on December 18, when every photograph featured men of color or from

Africa—Boutros-Boutros Ghali handing over the flame,

Rudy Crew, Chancellor of the New York City Schools, Mobutu

going home to Zaire from France. You can see the representation

of certain stories appear and disappear, regardless of what's happening,

particularly the Peruvian hostages, who disappeared from the

front page on the 22nd although they were still being held.

On the last day of the year, Michael Kimmelman wrote a piece

about art that nearly took over the page.

I took advantage of it and ended the year with a bang.

"All the News
That Fits"

The New York Times

Late Edition

New York: Today, periods of rain, some heavy, windy. High 53. Tonight, rain, windy. Low 43. Tomorrow, drier, breaking clouds. High 50. Yesterday, high 45, low 34. Details, page 65.

VOL. CXLVI No. 50,628 Copyright © 1996 The New York Times NEW YORK, SUNDAY, DECEMBER 1, 1996 $3 beyond the greater New York metropolitan area. $2.50

Wealthy, Helped by Wall St., Find New Ways to Escape Tax on Pr...

By DIANA B. HENRIQUES
with FLOYD NORRIS

Last spring, Wall Street bankers made an irresistible sales pitch to Eli Broad, the billionaire home builder and co-founder of the booming SunAmerica insurance empire.

For a fee, they would help him lock in $194 million in profits on some of his SunAmerica stock and free up cash to pay family debts — best of all, without having to sell the stock and give up all future profits on his shares. He would therefore not owe a penny of the estimated $54 million in taxes he would face if he sold the shares.

Mr. Broad accepted. "We have our cake," he said recently with a chuckle, "and are eating it too."

The thousands of less affluent investors who also own SunAmerica stock, either individually or through mutual funds, get no such deals. To cash in on their stock, they almost invariably have to sell it and face a Federal tax of up to 28 percent on their profits.

Seventy-five years after it was enacted, the Federal tax on profits from the sale of stock, land or other assets — known as the capital gains tax — is becoming largely academic to the nation's wealthiest taxpayers. Even as a growing number of Americans with more modest incomes are paying capital gains taxes because of their growing mutual-fund profits, wealthy taxpayers like Mr. Broad can take advantage of a growing arsenal of Wall Street techniques to delay or entirely avoid taxes on their investment gains.

These strategies, some granted by Congress and others using the tax code in legal but wholly unanticipated ways, give taxpayers these breaks:

¶Owners of a private business can sell it to their employees without paying capital gains taxes as long as they put the proceeds in certain investments — investments that Wall Street is eager to provide.

¶Real estate owners can swap properties without the capital gains tax required when a sale is made, allowing them to diversify their holdings and raise cash for

RUSHING AWAY FROM TAXES

The Capital Gains Bypass

A special report.

No Longer Just A Bill for the Rich

For many middle-income taxpayers, the only source of capital gains is profits funds. Lately, those ta... gains have shot up, w... ... reported by the typic... wealthier taxpayers ... profited from all kind ... of assets stagnated ...

Percentage change since 1988 in reported capital gains.

other purposes.

¶Large shareholders can use any of several exotic Wall Street strategies to raise cash and lock in their stock market profits without actually selling their shares, which would create a tax bill.

Some of these techniques have been around for a dozen years or more but are now being used in new and aggressive ways. Others are new — the technique Mr. Broad used is only three years old. It allowed him to use his SunAmer-

ica stock collateral urity issued M ... Lynch, which used ... of the mo... ... ed from ... sale back t...

... ng a deca... ... Congress changes ed to ma... ... able, the ation an x-avoidance niques ... among the wealthie ises questions mes ... some minds.

"The si that anyone sitting on oney today probably capital gains taxes," sa Bradford, an economist ceton University and a cri current income tax syste will the Government can adop fter rule after rule — but the p who will get stuck paying capi ains taxes will be the ordinar estors who own mutual fund ...

William economist at the Brookings tution, agreed: "How fair is at the wealthy can apparentl but the middle class get ith? I don't see any fairness at."

The consequen ... of Wall Street's ingenuity ... ry eve ... some of those who p m it am torn on the issue Rob ... Willens, a managing tax analyst at Lehm ... "As someone who make catering to these clien these products useful an ful. But as a citizen, y ... after about $750 eve ng. I ... worry that there is to the per ception that these hniques are available only wealthy few, that the av tizen doesn access to our tax than that."

... Wall these tech are ... rofitable. Rath sts throughout the U ment ... study Saudi Arabia un the m ... rigorous process user ... American national security, intelligence officials said.

Continued on Page 44, Column 1

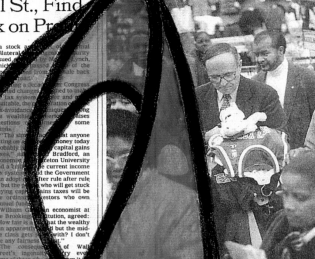

Edward Keating/The New York Times

Don't Show This to ... Giuliani Children

Mayor Rudolph W. Giuliani ... Christmas presents for his children, Andrew and Caroline, ye ... n Harlem, where he also met reporters to discuss plans to expe York's trash. Page 47.

U.S. Take... ...ard Look at Saudis With B... ...bing and Shah in Mind

ByFF GERTH and ELAINE SCIOLINO

WASHINGTON, ... ov. 30 — The bombing in ... rabia last June that killed ... cans not only confirmed ed States had intelligence ... sition with underlined audi royal ashington the in ...

... the bombing, al In Agency organiz the n a special of sts throughout the U ment ... study Saudi Arabia un the m ... rigorous process user American national security, ... intelligence officials said.

One reason for subjecting Saudi rabia to the C.I.A.'s "hard target" rategy," which it uses for countries Russia, China, Iran, Iraq and Korea, was concern that the States could lose its closest Persian Gulf the way it 1979 when a religious tion overthrew the mon officials said.

... concluded that Sau ... di Arabia world's largest oil-producer, re olitically stable and is unlike come another

Iran, despite King Fahd's poor health and uncertainties about the succession.

But it warned that the information void about the threats facing the Saudis requires the United States to find creative new ways and resources to penetrate one of the most closed societies in the world.

The threats confront both countries: There are 6,000 United States soldiers and 50,000 American civilians in Saudi Arabia. And the intelligence shortcomings come at a crucial time. The Saudis have suggested Iranian and Syrian involvement in a conspiracy behind the June bombing, which occurred at a military housing complex. American officials are skeptical of this theory, but have few independent insights into the tors.

... importance of improving joint ance efforts was underlined by Defense Secretary Wil ry, who said the two coun that they had recently her terrorist attacks by sharing intelli Mr. Perry met in Riyadh. rican intelli ...

Continued on Pa...mn 1

Road for the Senate's Leader... Is Expected to Be Tortu...

By ADAM CLYMER

WASHINGTON, Nov. 30 — Trent Lott is all the things that most Republican senators want in a leader. He is a strong partisan. But his manner is smooth, almost unctuous, not occasionally scary like Speaker Newt Gingrich's rhetoric.

He consults, but not endlessly. "I like to get other senators involved," he said in an interview, but "I like some order in the way things are done."

By any rational standard, the 55-year-old Mississippian is very conservative. But the dwindling band of Republican moderates gives him high marks for attentiveness. "I've always found him considerate o... those in the party who weren't ... total lock step with him," said Se... tor John Chafee of Rhode Island, has not always found other cons... tives so tolerant.

And Mr. Lott seems prepared, b... neath a pleasantly civil tone, to battle President Clinton, whom most Sen-

ate Republicans disda...

But even if he cont... ... satisfy his Republican cons on these matters — and he f opposition to re-election as y leader on Tuesday — it is whether Mr. Lott will succ a leader of the Senate. For Congress poses special pr that may not be easily ma by someone with his experie ...

The um has as much to do with anging nature of the Sen bers with Mr. Lott, who was leader and an ally of Mr. before coming to the Senate ...

... er retirements and the 1996 ctions, the Senate is a distinctly conservative body, changed more than the increase from 53 to 55 Republicans would suggest. Behind se numbers is a larger shift with ral Republican moderates re ...

... ued on Page 38, Colum...

TODAY'S SECT... ...

Arts and Leisure/Section 2
As China tries to reach an international audience with an officially approved film, "The Opium War," many of the country's most innovative directors are out of work, going abroad or struggling to work under the most tenacious censorship campaign of the 1990's.

Automobiles/Section 11†

Book Review/Section 7
"Duchamp," by Calvin Tomkins, is the first full-dress biography of Marcel Duchamp, the man who drew the mustache on the Mona Lisa and more or less invented conceptual art.

The City/Section 13§

Editorials and Op-Ed/Section 4

Magazine/Section 6
A man who runs one of the most successful mutual funds in America says that things can only get better. But Sept. 11 was the kind of day that tested even his faith.

Money and Business/Section 3
Harlan Crow saved his father's company, Trammell Crow, from the real es-

tate debac re-saw that made just building them, prof-its in the 1990's.

Real Estate/Section ...
Chinese home buyers ... the latest immigrant group to put their mark on Sunset Park's streets.

Regional Weeklies/Section 13§

SportsSunday/Section 8

Television/Section 12†

Travel/Section 5
Journeying through South Africa to see penguins, whales and exotic birds.

Week in Review/Section 4
Many economists say the Government's inflation numbers are wrong. Which means Americans may be better off than they think.

Employment Advertising/Section 10*

* In New York City and the metropolitan region.
(† Elsewhere, auto pages are in section 2.)
§ In most parts of New York City.
¶ In Long Island, Westchester, Connecticut and central and northern New Jersey.

Life in the Spotlight, Death in Disgrace

An unexceptional child of New ... sey's modest suburbs, Nich ... Bisnell Jr. quickly learned th ... tance of appearances. An ... baseball catch, people ... would be turned into a ... performance. He rose ... feared prosecutor in S... ... Coun... ... known for his swag ssault on drug dealers. He lized on the attention and more.

Then he fell. Bu control of his fate. He chose ld prison on Federal fraud s by killing himself in a room in an end-of-the-road M town.

... page 52.

S... ...ved! Prof. Plum andhorts in the Clear

By ROBERT McG. THOMAS Jr.

A B clerk who whiled away his time on World W ... patrol in England dreaming up a board vers ... popular parlor game that is such obscurity tw it was learned last week, that not even C ustard or Miss Scarlet had a clue.

They, of course, B th Professor Plum, Mrs. Peacock, Mrs. White Green, owe their very existence to the clerk, A E. Pratt, who linked them together in a nine-ro rian mansion as the perennial murder suspec classic game, Clue.

Mr. Pratt, who was 90 and ed out of sight a decade ago, died in 1994 ne ngham, England. But this did not become ge edge until after Waddington's, the co first published the game in 1948, issued appeal to find its creator. Ceremonies wer planned to commemorate the impending 150 llionth worldwide sale of the game, known in Britain as Cluedo ...

What the British press termed Clue's mystery was solved when the company, which had set up a hot line, received a call from Gillian Lewis, the superintendent of the Bromsgrove Municipal Cemetery, 12 miles from Birmingham. He said Mr. Pratt had been buried there in April 1994.

The company, which knew that several men named Anthony Pratt had died in recent years but hoped that the inventor was still alive, accepted that it had traced the right one when Mr. Lewis reported

Continued on Page 4, Column 1

Law clerk, fire warden, inventor of confounding parlor game. The face behind the mystery: Page 4.

COLONEL MUSTARD

COLONEL MUSTARD

Clue

STRICTER AIR RULES COULD PLACE FOCUS ON THE MIDWEST

LEVERAGE FOR NORTHEAST

Political Opposition Emerging From Areas That See Added Burden in E.P.A. Plan

By JOHN H. CUSHMAN Jr.

The Clinton Administration's new proposal to tighten national air quality standards for smog and soot may offer an opportunity for some regions of the country that have struggled for years to bring their cities into compliance with the existing clean-air goals.

The hotly debated new standards, proposed on Wednesday by the Environmental Protection Agency, would establish a new definition of healthful air and reduce the allowable levels of pollution from ozone and fine chemical particles, two main ingredients of smog.

The strict new rules might seem to spell more regulatory trouble for many states, including New York, Connecticut and New Jersey, whose urban air fails to meet even the current health standards.

But not every city's smog is all homegrown. In New York and other big cities from the Great Lakes to New England, much of it wafts in on the winds from other states.

For that reason, some air quality experts say the new rules may help clean up the downwind areas by controlling pollution from the smokestacks of distant factories and power plants. Those plants now escape strict controls because the air in their areas is clean enough to meet existing standards.

"Certainly, the new standards will end up giving the Northeast some leverage to get at the problems coming in from the Midwest," said Nancy H. Sutley, a senior aide to the E.P.A. Administrator, Carol M. Browner.

Ohio, for example, where all but a few towns already comply with the current ozone standard, would suddenly find much of the state out of compliance with the new standard. The new pollution controls that Ohio and similar states might have to adopt would be a big help in making the air more breathable in the Northeast, including the New York metropolitan area.

Controls on power plants in the nation's cleaner areas are likely to play a big role in any new strategy aimed at curtailing the ozone that drifts across the eastern half of the nation, damaging people's lungs along the way. Other steps might include the wider use of cleaner-burning gasoline and less-polluting cars.

The idea that upwind states ought to do more to help protect the environment in cities hundreds of miles away is not new. Northeastern states banded together a few years ago and agreed to require the use of reformulated gasoline throughout their area as one way to address the problem of regional ozone movement.

For similar reasons, the E.P.A. has also controlled power plant emissions that cause acid rain at great distances.

... until now, it has proved much ... fficult to expand the geo of the Clean Air Act nger-range ozone transport problem of wind ...

Contin Page 34, Column 1

INSIDE

...ative Action Jumble
... passage of a California ballot ... ative on Election Day left oppo ts of affirmative action jubilant, ... ut a judge's ruling has replaced that glow with confusion. Page 34.

Serbia's New Power Broker
An opposition leader is emerging as the power broker in Yugoslavia, playing Kennedy to President Slobodan Milosevic's Nixon. Page 18.

Florida State Wins
Florida State defeated Florida, 24-21, in a battle for state bragging rights and the No. 1 spot in college football's national rankings. SportsSunday, section 8.

News Summary		2	
International		3-20	
Metro		47-56	
National		22-45	
Obituaries	58	TV Update	37
Radio Highlights	37	Weather	65
Styles	59	Weddings	62

On the Internet: www.nytimes.com

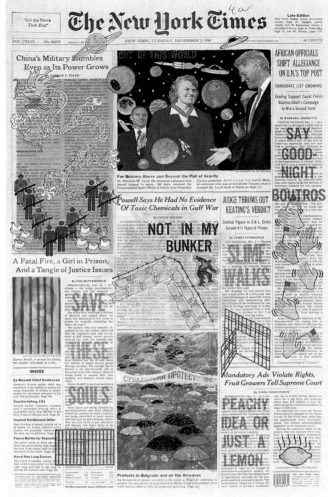
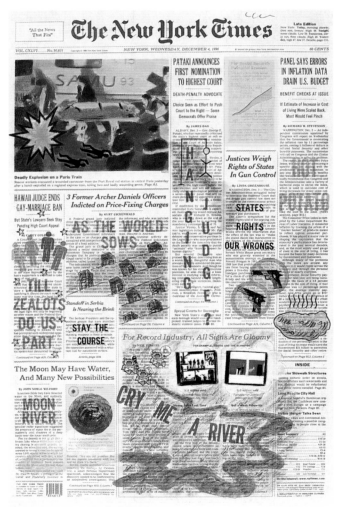
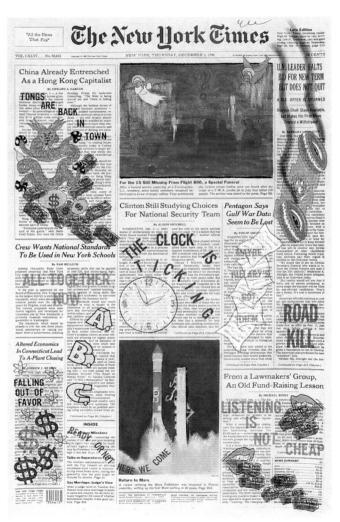

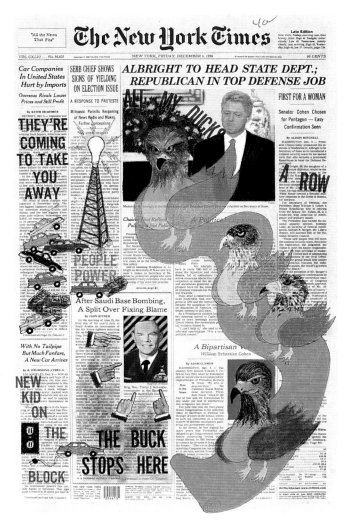

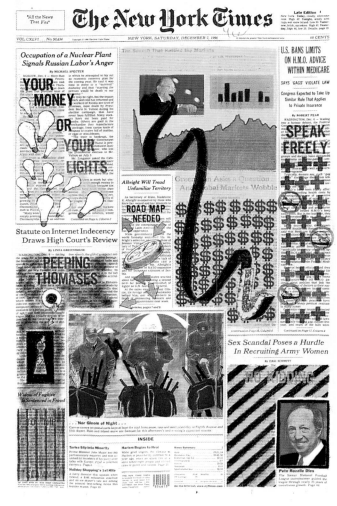

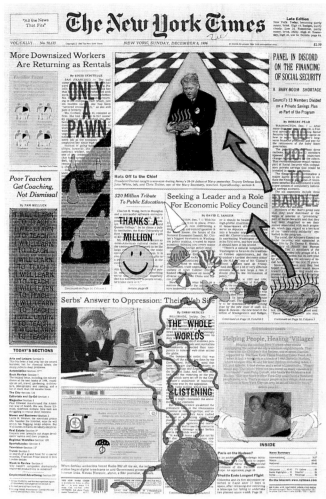

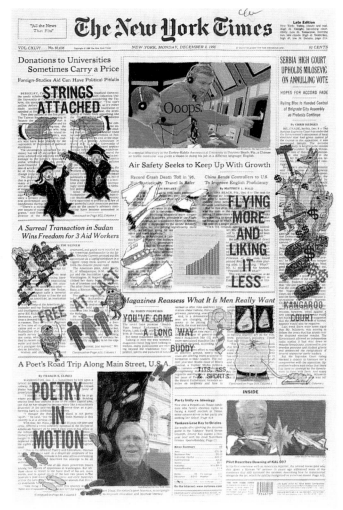

The New York Times

VOL. CXLVI . . . No. 50,637 Copyright © 1996 The New York Times NEW YORK, TUESDAY, DECEMBER 10, 1996 $1 beyond the greater New York metropolitan area. 60 CENTS

Late Edition
New York: Today, increasing clouds, a shower or flurry. High 42. Tonight, light rain or snow. Low 35. Tomorrow, early showers. High 46. Yesterday, high 41, low 35. Details, page B11.

Hospitals Looking Abroad To Keep Their Beds Filled

BY MILT FREUDENHEIM

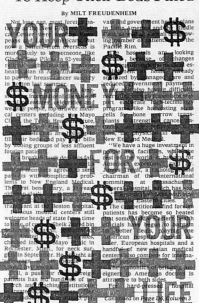

Not long ago, most foreign patients could come into America's hospitals. But now a patient from overseas is more likely to be someone like Gloria Sauer, a 62-year-old...

[text partially obscured by graffiti] YOUR MONEY OR YOUR LIFE

We have a huge investment in people and facilities, which the rest of the world wants...

"We have a huge investment in people and facilities, which the rest of the world wants," said the chairman of the international committee at a Massachusetts general hospital, which has...

Continued on Page D6, Column 3

Scandal Links Turkish Aides To Deaths, Drugs and Terror

BY STEPHEN KINZER

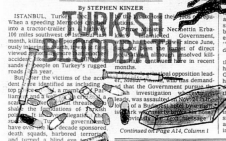

ISTANBUL, Turkey — [obscured by graffiti "TURKISH BLOODBATH"] When a speeding Mercedes crashed into a tractor-trailer 100 miles southwest of Istanbul last month, killing three people...

Continued on Page A14, Column 1

Mary Leakey, 83, Dies; Traced Human Dawn

BY JOHN NOBLE WILFORD

Mary Leakey, matriarch of the famous fossil-hunting family in Africa whose own reputation in paleoanthropology soared with discoveries of bones, stone tools and the footprints of early human ancestors, died yesterday in Nairobi, Kenya. She was 83.

Her family announced her death but did not give the cause, saying only that she died peacefully.

Over half a century, Mary Leakey labored under the East African sun, scratching in the dirt for clues to early human physical and cultural evolution. Scientists in her field said she set the standard for documentation and excavation in paleolithic archeology. They spoke of hers as a life of enviable achievement.

"She was one of the world's great originals," said Dr. Alan Walker, an anatomist at Pennsylvania State University who has long excavated fossils with the Leakey family. "Untrained except in art, she developed techniques of excavation and descriptive archeology and did it all on her own in the middle of Africa. It was an extraordinary life."

In a biography of the Leakey family, "Ancestral Passions," published last year, the author, Virginia Morell, characterized Mary...

Continued on Page B11, Column 5

Protesters gathered in front of a statue of a Serb nationalist poet at Belgrade University yesterday. They blame President Slobodan Milosevic for failing to create a greater Serbia, as well as for annulling elections last month.

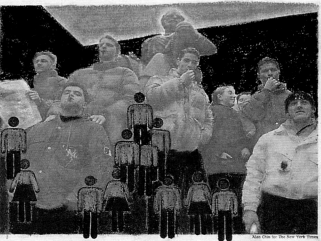

Alan Chin for The New York Times

Student Foes of Belgrade Leader Embrace Fierce Serb Nationalism

By CHRIS HEDGES

BELGRADE, Serbia, Dec. 9 — The front door of the Philosophy Department at Belgrade University is guarded by students [obscured by graffiti "STORM TROOPERS"]...

Sunday night, Jack Lang, former...

Mr. Lang stumbled unwittingly on the virulent Serbian nationalism that has increasingly colored the anti-Government protests by students here. The incident, intellectual dissidents in Belgrade say, illustrates the challenges for those who want to change Serbia do not lie in overturning the rule of one man, but in transforming a society that considers racist remarks to be acceptable and has learned to express itself in the language of hate.

Continued on Page A8, Column 1

NEW LOOK URGED ON GULF SYNDROME

Important Evidence Withheld by Pentagon, Scientist Says

By PHILIP SHENON

WASHINGTON, Dec. — A scientist who led a 1994 study that discounted links between chemical weapons and the illnesses suffered by veterans of the Gulf war said today that the findings might be wrong in light of newly disclosed evidence from the Pentagon.

Joshua Lederberg, a Nobel-winning geneticist and the president of Rockefeller University, said the Pentagon had never told his study group about an incident in the war in which American engineers blew up an Iraqi ammunition depot that contained chemical weapons, potentially exposing thousands of troops to nerve gas.

He said in an interview that as a result of the newly disclosed evidence, there should be an intensified effort to determine whether low doses of nerve gas can cause long-term illnesses.

The comments by Dr. Lederberg throw into question conclusions that the Pentagon has cited for more than two years in insisting that there was no evidence that Americans had been exposed to Iraqi nerve gas or other chemical weapons during the war.

Continued on Page A24, Column 1

AGENCY TO PURSUE 2 PLANS TO SHRINK PLUTONIUM SUPPLY

BOTH WILL NEED TESTING

52 Tons of Weapons Material Could Become Reactor Fuel or Be Sealed in Glass

By MATTHEW L. WALD

WASHINGTON, Dec. — Confronting one of the more intractable problems of the old-war era, the Energy Department said today that it would try to dispose of plutonium from old nuclear weapons both by using it as fuel in utilities' reactors and by mixing it with nuclear waste created when the plutonium was made and solidifying the mixture in glass.

Officials said in choosing both methods, the department would keep its options open even while it hoped to...

The department would dispose of 52.5 tons of plutonium, more than half the nation's stockpile. Its goals are to ensure that the reactions are used to reduce the amount of plutonium and to prevent the unauthorized reuse of the material that would make weapons available...

But some experts complained immediately that using the plutonium in civilian reactors could, because of the security problems, increase the amount of potential weapons fuel in circulation around the world. And department officials conceded that there were technical questions about the feasibility of the plan to solidify the plutonium for storage.

Department officials said it would take at least two years for them to determine whether either, both or neither method would work. The initial cost estimate was $2.3 billion no matter how the processing is divided between the two methods.

In remarks at a news conference today at which she announced the effort, Hazel R. O'Leary, the Energy Secretary, acknowledged the extent of the problem.

"The arms race is over," she said. "Our struggle now is to get rid of this sea of plutonium."

Mrs. O'Leary, who is leaving office next month after four years, said that she considered today's announcement the capstone of her tenure and that it was a big step toward reducing the risk of nuclear war.

The department and the White House had previously declared the plutonium surplus.

Originally, dozens of options for plutonium disposal were being considered, including some that involved disposal in space. "We started out with more than 35 options for plutonium disposition," Mrs. O'Leary said. "I think I was a child when we started."

The plutonium was created over four decades in military reactors atom by atom by extracting neutrons...

Continued on Page B8, Column 1

New York's Top Democrat Takes Tougher Stance on Juvenile Crime

By JAMES DAO

The Assembly Speaker, Sheldon Silver, who has often been accused by Republicans of being the chief obstacle to anticrime legislation, said yesterday that he wanted to...

[obscured by graffiti "ANOTHER CLINTON DEMOCRAT"]

In a speech before prosecutors, police officials and judges, Mr. Silver, a Manhattan Democrat, endorsed several ideas advanced by Gov. George E. Pataki that the Assembly had rejected as too harsh...

But with get-tough oratory that surprised many Republicans, Mr. Silver told a breakfast meeting of the Citizens Crime Commission of New York City, a private group that monitors criminal justice policy, that he would introduce new legislation next...

"Crime committed by hardened juvenile thugs whose lack of remorse is all too commonplace," Mr. Silver said. "Because it's not only the volume of crime we must address, but the coldness and callousness of the acts."

As the single most powerful member of the Assembly, Mr. Silver is in a position to push all his ideas through the House. And because Mr. Pataki and the Republicans who control the State Senate have supported such get-tough measures in the past, Mr. Silver's support could make it almost inevitable that tougher juvenile-crime legislation is passed next year...

Continued on Page B6, Column 2

Hey, Santa, Don't Wait

Catalogue companies like L.L. Lands' End and Victoria's Secret, which do the bulk of their business during the holidays, are running short of goods. Page C1.

New York's Welfare Problem

Federal officials said they have a problem with New York State's welfare program, that the state stands in danger of losing money under the new welfare law. Page B1.

No Mayoral Bid for Bratton

After 20 days of mulling a race for mayor of New York, former Police Commissioner William J. Bratton has bowed out. Page B3.

Giuliani-D'Amato Alliance

Mayor Giuliani said he would attend a fund-raiser for Senator D'Amato, apparently signaling an end to their long and bitter feud. Page B3.

Computer's Flash of Insight

A computer program has come up with a math proof in work that would have been called creative if done by a human. Science Times, page C1.

INSIDE

NEWS SUMMARY A2

On the Internet: www.nytimes.com

354613
THE NEW YORK TIMES
is available for home or office delivery in most major U.S. cities. Call toll-free 1-800-NYTIMES. Ask about TimesmediaTimesCard. ADVT.

The New York Times

Late Edition
New York: Today, cloudy, some rain. Highs lower to mid 40's. Tonight, light rain and fog. Lows in the 30's. Tomorrow, cloudy. Highs upper 30's. Yesterday, high 42, low 33. Details, page B14.

VOL. CXLVI No. 50,638 Copyright © 1996 The New York Times NEW YORK, WEDNESDAY, DECEMBER 11, 1996 $1 beyond the greater New York metropolitan area. 60 CENTS

New York City Hears of Surplus, But Big Budget Gaps Lie Ahead

Wall Street Boom Brightens the Current Picture

By CLIFFORD J. LEVY

Heady profits on Wall Street are generating so much extra revenue from businesses taxes that New York may end its fiscal year with a surplus of nearly $350 million, city officials said yesterday. But even with this unanticipated boom, the city still faces budgets gaps in several later years because its revenues continue to lag behind its revenues.

The surprising surplus revelation presents Mayor Rudolph W. Giuliani with several city series of choices as he begins his re-election campaign, forcing him to weigh his political needs and fiscal ones.

Should he spend the surplus to try to bolster his standing with voters who may be weary from years of steep budget cuts? Or should he save it to close future shortfalls?

The projected surplus of nearly $350 million comes on top of another $450 million in unexpected revenue that Mayor Giuliani last month said the city would reap because its economy, which had been anemic, has been rebounding.

Yet even as the Mayor was mulling over how to use these windfalls, his aides disclosed yesterday that he had ordered $400 million in new spending reductions for the next fiscal year, which begins on July 1.

The contrast underscores a sobering truth about the city's finances: its current good fortune has done little to cure its long-term ills. So if and when the stock market boom wanes, the city will be facing the same longstanding financial difficulties.

"We have not solved the problem," said the City Comptroller. "I mean, we are getting a benefit from the tremendous Wall Street growth, but I don't know how long that can be sustained."

Next year, in fact, the city must cope with a projected $1.1 billion deficit in its $33 billion budget, all but insuring that Mr. Giuliani will have to find money for a range of services, anything from street cleaning to day care to community centers for the elderly.

The projected shortfall for the year 2000 would be about $5 billion, the largest in the city's history.

Randy M. Mastro, the Deputy Mayor for operations, acknowledged that the projected shortfalls for the next few years were large, but he said the Mayor would address them. "We cannot address the structural budget deficit problem that occurred over many, many years overnight," Mr. Mastro said. "You have to do it in a responsible, phased-in way over time."

Mr. Mastro and Mr. Giuliani would not take specifics into consideration when projecting the extra revenue. "You can't make decisions on that basis," Mr. Mastro said. "This Mayor makes decisions based on what is the city's best interests."

The Mayor's aides said it was too early to discuss what the administration would do with the extra revenue, but said that with the surplus of $350 million that Mr. Hood, of the city would have in its 1997 fiscal year ends on the next two years, the administration was recommending a plan to make the next year's budget easier to balance. Primarily because of accounting changes, dealing a better picture to his aides essentially getting the city into the next fiscal year. But this year, Mr. Giuliani is under more pressure to spend.

In his plan, some $400 million in

Continued on Page B6, Column 1

2 MAJOR HOSPITALS FORM CORPORATION

Savings Seen for Beth Israel and St. Luke's-Roosevelt

By ESTHER B. FEIN

Beth Israel Medical Center and St. Luke's-Roosevelt Hospital announced yesterday that they were forming a single parent corporation to oversee both hospitals, a major shift in the realignment of the health care industry in New York City.

The partners agreed that the two hospitals would remain separate — each will maintain its own board of trustees and clinical departments and will be responsible for their own assets and debts. But it is the intent of each of the institutions to join in the extensive reorganization to enhance their bargaining positions with health maintenance organizations, which increasingly control whether Americans get their care.

Slow to join a wave of mergers, partnerships and consolidations that have been going on across the country, it has suddenly this summer, the region is looking at a number of institutions investigating medical institutions — Mount Sinai Medical Center and New York University Medical Center — announcing yesterday that they would merge without hospitals and medical schools. In the New York Hospital and Presbyterian Hospital announced that they would unite.

Beth Israel and St. Luke's-Roosevelt had each previously tried to break up relationships with

Continued on Page B5, Column 1

Corps Is Tightening Rules on Wetlands To Curb Developers

By JOHN H. CUSHMAN Jr.

WASHINGTON, Dec. 10 — The Clinton Administration significantly tightened wetlands regulations today, reigning in a streamlined kind of expedited approval procedure that has allowed developers to drain tens of thousands of acres of wetlands, 10 acres at a time.

The Army Corps of Engineers, which regulates development on wetlands, said the procedure will be abolished altogether in two years. Until then, the corps said, projects qualifying for the permit may involve no more than three acres of wetland.

Environmentalists and other Federal agencies had complained that the quick procedure was letting the corps' permission to cutting the wetlands, known as Nationwide Permit 26, allowed for the destruction of wetlands, which can filter floodwaters and provide habitat for wildlife.

The permit, originally planned to expire in 1994, but Permit 26 along with other nationwide permits authorized under the Clean Water Act.

Federal officials said overall program, the Pending Permit 26, to be published in the Federal Register on Friday.

Expedited permits, in effect

Continued on Page B10, Column

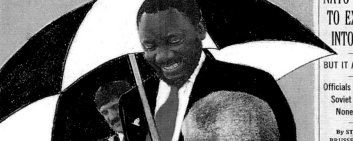
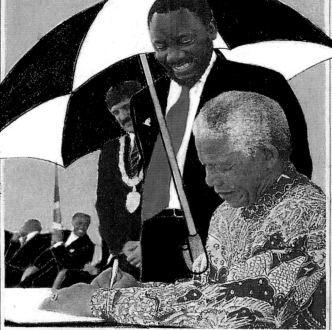

A New Constitutional Order in South Africa
President Nelson Mandela of South Africa signed the country's new Constitution yesterday as Cyril Ramaphosa, secretary general of the governing African National Congress, watched smiling. The signing ceremony was held in Sharpeville, site of the massacre of anti-apartheid demonstrators in 1960.

Pool Photo by Adil Bradlow

Council Vows Defeat of Giuliani's Superstore Plan

By VIVIAN S. TOY

City Council members declared yesterday that they would defeat Mayor Rudolph W. Giuliani's plan to make it easier to build superstores in the city, dealing a bitter defeat to his most ambitious effort to eliminate regulations that he said discouraged investment in New York.

On the eve of the Council's vote on the plan, the Mayor, who has repeatedly said that his proposed zoning changes were vital for the city's continued economic revitalization, harshly criticized the Council's action, saying it was tantamount to a vote against the poor. The poor, he said, stand to benefit this from the broader selection and lower prices that superstores offer.

The superstore plan, which would have allowed estimated 57 of the big warehouse-style stores to open in various areas, has been an extremely contentious issue in many neighborhoods where local merchants feared that the stores would put them out of business.

But the biggest issue in the failed negotiations with the City Council was a provision in the plan that would have eliminated neighborhood review of the store proposals and removed the Council from the approval process.

The defeat does not mean that superstores will be banned in New York; in fact, several have opened in Brooklyn and Queens in the last few years. But without the Mayor's proposed zoning changes, the stores could not open nearly so fast nor in the numbers that the Mayor had wanted.

"The vote against it would be a vote for maintaining the high prices that exist in the city of New York," Mr. Giuliani said. "The City Council is seeking to preserve the status quo, which is harm and injury to people of moderate and low incomes."

Despite the Council's expected vote, Peter F. Vallone, its Speaker, said it was prepared to discuss another plan for attracting more superstores to the city.

"The only thing dead on the issue of megastores is the Mayor's pro-

Continued on Page B6, Column 1

NATO TAKES STEPS TO EXPAND RANKS INTO EAST EUROPE

BUT IT ASSURES RUSSIANS

Officials Adopt Plan to Invite Soviet Ex-Allies to Join — None Are Identified Yet

By STEVEN LEE MYERS

BRUSSELS, Dec. 10 — Taking the first formal steps toward enlarging its alliance to include former Soviet bloc members of Eastern Europe, NATO today issued a plan that should help smooth the way to negotiations on actual changes, but said it would not increase members on NATO's eastern flank.

The ministerial meeting of NATO's 16 foreign ministers came as the alliance opened discussions here, at its headquarters, with the first effort to move toward bringing in new members by the end of the century.

The new minister of foreign affairs, Yevgeny M. Primakov, arrived this evening for talks with his counterparts in NATO, but made clear in statements before leaving Moscow that with NATO's Secretary General Javier Solana and Secretary of State Warren Christopher that Russia is to appear before extending membership to other Eastern European nations on Thursday morning, and officials said that he will address the remaining concerns, top issues at the conference.

Russia's concern has been expressed in Moscow today, as President Boris N. Yastrzhembsky, said that the resistance remained "fairly tough," adding that the issue "would only lead to negative consequences."

Although the issue of expanding the alliance has been discussed for nearly three years, today's action represented the formal approval for inviting new members to join. The foreign ministers said leaders of

Continued on Page A9, Column 1

Oil Flows From Iraq

Iraq began pumping oil abroad for the first time in six years, opening a 616-mile pipeline to ports on the Turkish coast and a deal with the United Nations that it said that it could be weeks before oil reached delivery points. Article, page A8.

Groups Gearing Up to Fight For More Precise TV Ratings

As a television industry panel finishing work on a new TV ratings system amid a growing chorus of parents organizations protesting the proposal as too broad, several are finishing letters to Mr.

The new plan, to be announced next week, and the longterm Picture Association it. But draft of the proposal will be inappropriate to the way it tell parents the program's content, as ample, it includes for children.

Those organizations plan to release a joint letter to

Continued on Page B1, Column 1

Freud in Russia: Return of the Repressed

By ALESSANDRA STANLEY

MOSCOW, Dec. 10 — The young Russian psychoanalyst was confused, hesitant, analyzing, intelligent but deeply unhappy young woman, seemed affronted when he interpreted her flood of sexual reminiscences as her fantasy of their future relationship.

"I think maybe I gave an interpretation too early, but I couldn't help it," he said.

therapy — that have taken root since Communism collapsed. Freudian psychoanalysis is by far the most challenging and the most controversial.

The rediscovery of Freud and psychoanalytic therapy puts Russia squarely in a collision course with trends in the West.

In part, the reversal is caused as a shaking increased Soviet-era many of their Western parts — spurred by advances in biochemistry and managed care — are turning away from such long-term talk therapy in favor of drugs like

had hopes that the rise of psychoanalysis in some ways mirror the great expectations of their American and European counterparts 30 years ago. "For 70 years the Russian people were robbed of self-knowledge," said Sergei G. Agrachev, 45, president of the new Moscow Psychoanalytic Society. "Psychoanalysis is one weapon with which we can some order to our society."

In July, President Boris

Continued on Page A10, Column

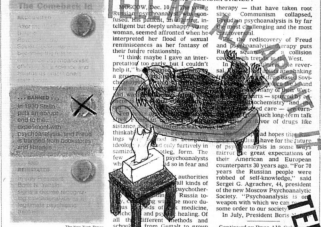

The New York Times

INSIDE

Hope for Cerebral Palsy

Researchers are uncovering data suggesting that cerebral palsy and some mental retardation might be largely preventable in very premature infants with a well-known drug. Page C13.

Sex Offender Law in Court

The Supreme Court heard argument on whether a state can legally confine a sexual offender who is dangerous but not mentally ill confined in a mental hospital after a criminal sentence ends. Page A24.

Not-Guilty Plea in Bombing

In an unusual hearing linking a Federal court in Newark to a law office in California via television, the Unabom suspect, Theodore J. Kaczynski, pleaded not guilty in the 1994 killing of an advertising executive. Page B1.

Picking on St. Nick

St. Nicholas has been a fixture of Dutch culture since the Middle Ages, but a recent attack and mocking cartoons are making some wonder if he will make it into the next millennium. Amsterdam Journal, page A4.

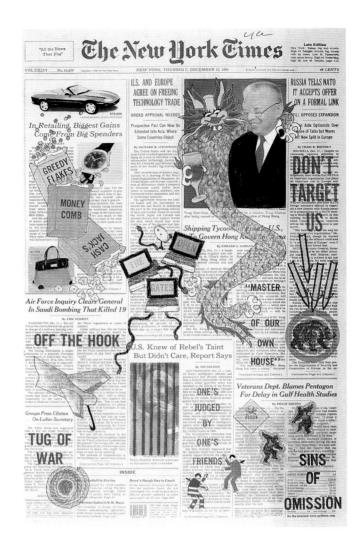

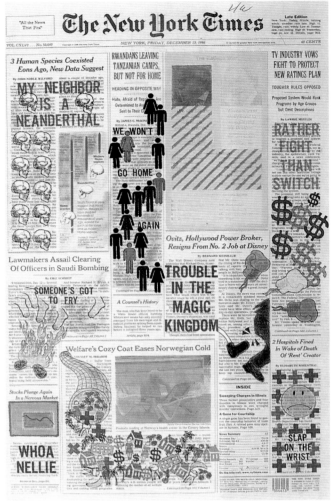

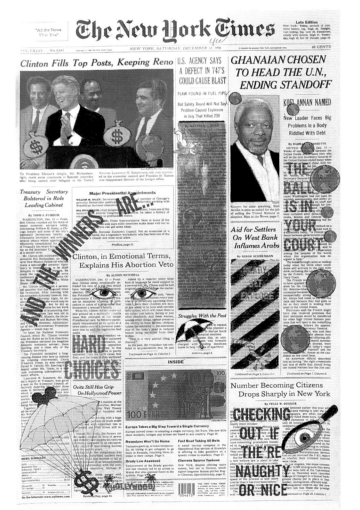

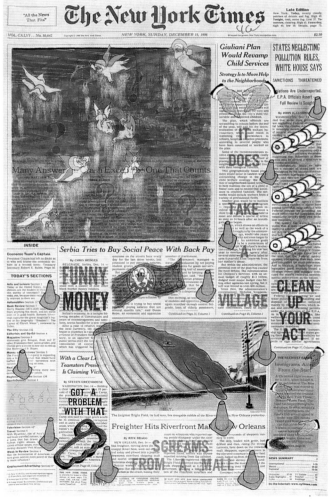

"All the News That Fits"

The New York Times

Late Edition
New York: Today, mostly cloudy, patchy drizzle. High 45. Tonight, drizzle, some fog. Low 42. Tomorrow, milder, showers. High 50. Yesterday, high 45, low 39. Details, page B14.

VOL. CXLVI .. No. 50,643 Copyright © 1996 The New York Times NEW YORK, MONDAY, DECEMBER 16, 1996 $1 beyond the greater New York metropolitan area. 60 CENTS

Iraqis Look Ahead to Fattening Of Rations as Part of U.N. Deal

By DOUGLAS JEHL

BAGHDAD, Iraq, Dec. 15 — From the storefront today, the measured out for each of 130 Iam in charge, scooping out ... sugar and rice according to ... prescription. But for the first time in six years,

PIPE DREAMS

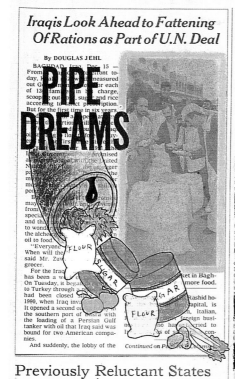

Iraqi government promised ... at with the United Na... ger pa... he m... per... may ... from ... speci... and tha... to wonde... the alcho... oil to food.

"Everyone ... When will they ... said Mr. Zuv... grocer.

For the Iraq... has been a w... On Tuesday, it began ... to Turkey through a ... had been closed ... 1990, when Iraq inva... It opened a second ou... the southern port of Basra with the loading of a Persian Gulf tanker with oil that Iraq said was bound for two American companies.

And suddenly, the lobby of the

Continued on Pa...

Previously Reluctant States Moving on Welfare Changes

By PETER T. KILBORN

PHOENIX, Dec. 12 — Banking on ...

GETTING ON THE BANDWAGON

Even state with ... traditions, li ... and Minnesota ... long lagged ... fare policy, like ... Carolina, are charging ahead out of concern that if they do not act now to shift people into the w ... force, it will be much more difficult later, when the economy t ... rish ...

The plans being ... de ... fering employers ... es and relocating ... ment ... w ... they can ... d jo ...

But criti ... say ... their habit ... ir ... dead-end jobs. They ... drops in the welfare rolls result ... from a good economy will be precar... ous and that a downturn will make it even more difficult to find work for people now on welfare, who are often unskilled, uneducated and inexperienced.

And the critics still contend that the ... wed ... ty ... sta ... ate ... to en ... abilitis w ... he m ... ntaining c ...

Many state officials continue to ... n about the ... toughest ... ing off the ... ng of people ... within two year, and those recipients will be ... total of five years on welfare. As it is not clear ... ow many of the ... programs be ... devised will be certi... tied by the ... Federal Government, a ... necessary ... get financing, or another ... work ... that ... ems of state ... welfare offic ...

Silver's Push Right Has Liberal Troops Pushing Right Back

By JAMES DAO

ALBANY, Dec. 15 — Despite the gains Democrats made in this year's ele ... the ... s ... tu ... as ... iss ... from ... ulat ... welfare to abort ... ights. Though Republicans are leading the charge on many of those fronts, there are growing signs that conservative and even moderate Democrats push to assert themselves more vigorously against the assembly's still sizable liberal wing in a continuing struggle for control over the party's direction.

WE'RE LIBERAL AND PROUD

Mo ... re... cent ... legislative ... d in the As... sembl ... wi ... ed a double setback to his party's left wou ... e ... Republi ... s ... nal ... ban certain late-term abortions.

The Legis ... duled to reconvene ... consider other bills ... change the governing structure of New York City ... ucture of New York City ... extend ... ice and th ... The move ... ve ...

Continued on Page B5, Column 1

MOVING TO DEFUSE SPLIT, NETANYAHU AND ARAFAT TALK

BUT FIRST A WAR OF WORDS

At Close of Tense Day, Leaders Approach West Bank Issue With an 'Amiable' Chat

By SERGE SCHMEMANN

JERUSALEM, Dec. 15 — After a ... long w ... Prime Mi... ter Ben ... etanyahu and Yasir Arafat ... late ... night by ... tom ... going to defuse the ... ort ... Mr. Net ... first ... vertures to ... e ... with ... n telephone ... with ... hat an Isra ... described as "amiable" ...

The official ... d also talked ... the two ... had a so ... re... sum ... negotiation on ... hdraw from H ... he W ... s ... es ... Mr. Arafat ... at ... Call ... the ... ssion on Friday ... cread ... s ... ed te ... med ... tem ... he charged Mr. ... were con ... d wave of ...

... grew mo... heated, a ... with top security ... and M ... and two senior c ... Mr. Arafat said, t ... to explain to Mr. ... hu't's decision on ... special economic sit ... settlem ... ts was released only ... they benefits to the levels ... hou... p areas. They ... the need to stop ... continue the ...

... at Safety Board

... investigator for the National ... ation Safety Board said he ... her investigators were sur... ed by the assertion of ... s agency ... at it had identified as a possible cause ... the crash of Flight 800 ...

... article, page B1...

Swift Transfo...

By JAMES STER...

LOS ANGELES, Dec. 15 — With the Boeing Company's startling announcement today of its ... merger with the McDonnell Doug... orporation, it signified the ... completion of ...

News Analysis — swiftest and most com... plete transformations ever of an industry — as a matter of an explicit Government policy.

The lesson is that the Clinton Administration has largely succeeded in transforming the country's military contractors, during a span of

... G. Stonecipher, left, chief executive of the McDonnell Douglas ... and Phil M. Condit, president and chief executive of Boeing, at a ... conf ... ounci... announcing the proposed merger.

BOEING OFFERING $13 BILLION TO BUY McDONNELL DOUGLAS, LAST U.S. COMMERCIAL RIVAL

FEW JOB CUTS SEEN

Aerospace Giant Moves to Expand Its Status Into Military Field

By ADAM BRYANT

The Boeing Company announced yesterday that it planned ... the McDonnell Douglas Corp ... in a $13.3 billion deal, th ... largest merger in American history and ... largest ever in the aerospace indus... try.

The acquisition would make Boeing the only manufacturer of commercial jets in the United States, while catapulting ... of the Lockheed Martin Corp ... the world's largest a ... and ... and bolstering ... as a na... tion's leading ...

Boeing's ... er ... with the producer of ... the MD-11 civilian airliner and the Navy F-18...

... to undersco... the Army bu ... of size in the air ... had ... busi... nesses, which ... le ... e be ... and deca ... of McDonnell ...

Yesterday's an ... t sig... nals that aircraft ... during will increasingly be a ... tion among nations. Airbus ... le, the European consortium ... ld its first jet, in 1974, has gro ... e a formidable competitor before being.

So far this ... by some meas... ures, Boeing ... n roughly 60 per... cent of ... mercial aircraft or... der ... ds has won 35 percent ... Donnell Douglas with ... cent of the new orders.

E ... ves at Boeing and McDon... glas, as well as industry ex... said the deal made sense.

... predominantly a comme ... il aircraft builder that hope... ... tinue expanding its ... es contracting ... nnell Dougl ... ilit ... world... ... chief execu... d the merger it in aviation ... ell Washing... companies ... tions to the balance ... vilian busi... ne ... ill lend to th ... which will ... cu ... be Boeing Co... pany. Th ... s clearly represented so ... sales... manship by Washing... ton, wh lizing the m ... t and the Fe ... Commission, which re ... mergers, had no com... me... yesterday on the proposal. But company officials and analysts do

Continued on Page D14, Column 2 Continued on Page D14, Column 1

INSIDE

1

Founded, 1870; First National Crown, 1996

St. John's soccer team, celebrating with Coach Dave Masur, won the Queens school's first National Collegiate Athletic Association title with a 4-1 victory over Florida International yesterday in Richmond. SportsMonday, page C1.

A River's Danger

The crash of a freighter into a river-front shopping mall in New Orleans seemed to manifest the fears of many people who work, live and play along the Mississippi. Page B10.

Insuring the Japanese

American and Japanese negotiators reached agreement on opening Japan's insurance market, ending a protracted trade dispute. Page A8.

Coke Plans New Drink

Coca-Cola plans to challenge Mountain Dew, a major money maker for Pepsico, by introducing a drink called Surge, people with knowledge of the plans said. Page D2.

Another Series Hero Leaves

Yankee pitcher John Wetteland, most valuable player in the World Series, agreed to a $23 million deal with Texas. SportsMonday, page C1.

On the Internet: www.nytimes.com

Tourists Flock to New York To Catch Its Holiday Glitter

By RACHEL L.

The lights were twinkling, the car... olers were warbl... erupting a ... dio of ... Rockefell ... and bod ... tourists ... battled fo ... I g ... Sh ... Blo ... got g ... told th ... entir ... And ... trudged ... gloom a ... ly long ... pure Stre ... Music Ha ... vidson C ... tried to b ...

"What is this?" grumbled Mr. Ed... uidso ... -year-old flight attend... from Jacksonville, Fla. "Is this ... World?" ... es the jin... sidewalks, ... mas sales, ... rs, there ... tourists. ... iamonds ... blue ... oak ... rs ... s ... sitors ar ... shops ... lks, ... than ... tourist ct and centers ... natives ... misery than usual ... rymaking this year. Hotel

Continued on Page B3, Column 1

IF YOU CAN'T BEAT 'EM JOIN 'EM

JUST MARRIED

354613

The New York Times

"All the News That Fits"

Late Edition
New York: Today, cloudy, patchy drizzle, increasing winds. High 52. Tonight, fog, drizzle. Low 48. Tomorrow, a few showers. High 55. Yesterday, high 45, low 41. Details, page C16.

VOL. CXLVI...No. 50,644 Copyright © 1996 The New York Times NEW YORK, TUESDAY, DECEMBER 17, 1996 $1 beyond the greater New York metropolitan area. 60 CENTS

Boeing's Deal Quickens Pace For Arms Industry Takeovers

By JAMES STERNGOLD

LOS ANGELES, Dec. 16 —

COUPLE

MANIA

A Giant Gets Bigger

Business Day, page D1.

An 'All You Can Eat' Price Is Clogging Internet Access

By PETER H. LEWIS

The most popular number for computer users in 1996 has become $19.95, which is emerging as the standard monthly price for unlimited access to the Internet.

A NEW ON-LINE LINK ON LONG ISLAND

Cable television subscribers on Long Island will be offered a new link to the Internet. *Business Day, page D1.*

$19.95 BUFFET

Union to Start H.M.O.

Article, page B1.

NEEDY WHO LOSE PARENTAL RIGHTS GAIN IN TOP COURT

JUSTICES DEEPLY DIVIDED

Appeals Made Easier for Poor by 6-to-3 Decision on Two Constitutional Issues

By LINDA GREENHOUSE

WASHINGTON, Dec. 16 —

EQUAL PROTECTION

Chester Higgins Jr./The New York Times

On a Clear Day, You Can See 1997
Robert Vasiluth cleaned and adjusted the pole atop One Times Square yesterday, in preparation for the traditional ball drop on New Year's Eve. The official ball, by the way, is much larger than the one here.

Legal Fund for Clintons Rejects $639,000 Raised by Businessman

By STEPHEN LABATON

WASHINGTON, Dec. 16 —

RETURN TO SENDER

Continued on Page A22, Column 2

Netanyahu at Bay: Bloom Is Off His Promise

By SERGE SCHMEMANN

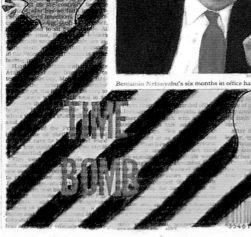

Benjamin Netanyahu's six months in office have been plagued by crises.

TIME BOMB

U.S. SEEKS TO LIMIT INSPECTIONS' SCOPE AT NURSING HOMES

FOCUS ON PROBLEM AREAS

Administration Wants to Cut the Number of Documents and Residents Checked

By ROBERT PEAR

WASHINGTON, Dec. 16 —

Continued on Page B8, Column 1

With Big Money and Brash Ideas, A Billionaire Redefines Charity

By JUDITH MILLER

A GIVER'S AGENDA
A special report.

PUT YOUR MONEY WHERE YOUR BELIEFS ARE

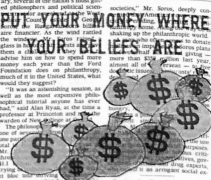

Continued on Page B19, Column 1

INSIDE

Tax Surcharge Talks Fail
Talks over extending an income-tax surcharge that paid for hundreds of new police officers in New York City have collapsed. Page B1.

Rift Over Police Job
Willie L. Williams's plans to seek a second term as Chief of the Los Angeles police threaten to unleash a racially charged battle. Page A16.

Alas, Poor Hamlet!
Serbia has a novel production of "Hamlet," one meant to convey the message that usurping power brings ruin. Belgrade Journal, page A4.

News Summary ... A2

Arts ... C17-22
Business Day ... D1-25
Editorial, Op-Ed ... A24-25
International ... A3-15
Metro ... B1-7
National ... A16-22, B8-10
Science Times ... C1-16
SportsTuesday ... B14-20

Environment ... C4
Fashion ... B13
Medical Science ... C3
Obituaries ... B11
TV Listings ... C22
Weather ... C16
Classified ... B2b Auto Exchange ... B19

On the Internet: www.nytimes.com

The New York Times

VOL. CXLVI . No. 50,645 Copyright © 1996 The New York Times NEW YORK, WEDNESDAY, DECEMBER 18, 1996 $1 beyond the greater New York metropolitan area. 60 CENTS

Late Edition
New York: Today, cloudy, drizzle, some fog. High 56. Tonight, more showers. Low 43. Tomorrow, colder, rain ending as snow. High 44. Yesterday, high 58, low 43. Details, page B21.

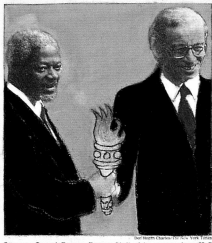
Secretary General Boutros Boutros-Ghali, right, congratulates Kofi Annan before the Ghanaian's swearing in at the United Nations.

AS TORCH PASSES, U.N. CHIEF SCOLDS U.S. FOR ARREARS

ANNAN FORMALLY NAMED

In His Farewell, Boutros-Ghali Says Debts Are Thwarting Organization's Mission

By BARBARA CROSSETTE

UNITED NATIONS, Dec. 17 — Minutes before the General Assembly appointed his successor, Secretary General Boutros Boutros-Ghali used a valedictory farewell speech today to scold the United States for failing in its obligations to the United Nations.

In an oblique but unmistakable swipe at the country that vetoed his reappointment, faulting him for failing to reform the United Nations bureaucracy, Mr. Boutros-Ghali said the United Nations lacked the resources to do its job.

"It is not the result of mismanagement," he said. "It is the refusal to fulfill a treaty obligation." He was referring to the arrears of the United States, by far the largest unpaid liability to the United States.

The General Assembly hailed the outgoing leader with a standing ovation, then formally appointed Kofi Annan of the West African country of Ghana as his successor.

Mr. Annan, who will become the seventh Secretary General on Jan. 1, is the first person from sub-Saharan Africa to hold the job and the first career United Nations official to rise through the ranks to the highest office.

In his characteristic speech after his swearing in, Mr. Annan, 58, dwelt on human themes, referring to economic development issues as affecting "real people with basic needs: food, clothing, shelter and medical care." [Excerpts and profiles, page A8.]

In contrast to the intellectual and lytical remarks of Mr. Boutros-Ghali, Mr. Annan said:

"I intend to serve you and our

Continued on Page A8, Column 3

Amnesty in Guatemala

As Guatemala ends a 36-year civil war in which at least 100,000 people were killed, its Congress is poised to approve a sweeping amnesty. Law exempting both soldiers and guerrillas from prosecution for abuses. Human rights groups and relatives of victims have expressed outrage.

Article, page A9.

ALBANY IN SCHOOLS ACCORD TO GIVE CHANCELLOR POWER AND WEAKEN LOCAL BOARDS

Consolidation Of Authority

The measure to overhaul New York City school system gives the chancellor more control over hiring and increases his authority over failing schools.

The bill would remove hiring power from the city's community school boards.

DISTRICT SUPERINTENDENTS
The schools chancellor will hire them, choosing from candidates nominated by community school boards. The chancellor can reject all nominees and ask the local boards for more names.

PRINCIPALS
District superintendents will hire them. While the principals project gives them tenure after five years, the chancellor will have new rights to remove the m because of "persistent educational failure," a term the measure does not define.

BUDGETS
Principals will write the spending proposals, using input supplied by the chancellor, with advice from school management groups made up of parents, teachers and administrators. Superintendents will review these proposals.

Nancy Siesel/The New York Times
Schools Chancellor Rudy Crew.

OVERHAUL IS VOTED

Measure Curbs Control by Elected Officials in New York City

By JAMES DAO

ALBANY, Dec. 17 — The State Legislature tonight enacted the most significant overhaul of New York City's school system in a generation, sharply curtailing school decentralization and vesting broad new authority in the schools chancellor and the people who run the city's schools.

After years of partisan and ideological fighting that often seemed beyond resolution, the Legislature approved a bill that would strip all hiring power from the city's 32 community school boards, many of which had become synonymous with patronage and machines.

Under the new system, the local elected school boards will lose significant power over their schools. They alone picked the school superintendents and the principals who ran the city's elementary and junior high schools.

But under the new measure, the schools chancellor would hire superintendents from lists offered by the school boards. If the chancellor did not like their recommendations, he could demand new names. The superintendents, in turn, would hire principals and would hire administrators for each.

City education officials consider this change particularly important because principals set many of the policies that determine whether a school succeeds or fails. They say it will insure that principals as well as superintendents are accountable to the chancellor, not to local political leaders.

"This will transfer control to the professionals serving the children. It doesn't have to be about doing it as a political reward," said William Thompson Jr., president of the New York City Board of Education. "Now they have to focus on doing the best job to educate our children."

But Jack M. Friedman, president of Community School Board 26 in Queens, said he would consider resigning once the bill became law because he said he believes it will sap local boards' powers.

"If there's no reason to be there, if there's no authority to act on curriculum, no authority to act on budget,

Continued on Page B9, Column 3

Scandals at the School Boards Led to Loss of Their Power

By JOSEPH BERGER

For much of its history, the New York City school system has struggled with the question of where decision-making should lie — at the center, with the Chancellor and the Manhattan bureaucracy along Livingston Street, or out on the far-flung locally elected school boards that would be more responsive to their communities.

For the last 25 years, much of the power has laid in the city's neighborhoods. Community school boards existed before decentralization, they were essentially toothless until 1970, when they gained hiring power.

But the community school boards have indeed been eviscerated — all the details were not well aired by educational experts in city, critics contended that the change was overdue, given the long record of scandal and incompetence on many boards. Under the local boards, a school system that was once a national urban model was plagued with schools that year after year could not teach students to read or calculate effectively. Moreover, many board members engaged in petty thievery and flagrant patronage.

Some school board members stole

High schools (high school principals have always been chosen centrally). With that, the role of the neighborhood school board members had been rendered more advisory.

Continued on Page B9, Column 1

Peru Rebels Raid Envoy's Home And Seize Hundreds of Hostages

LIMA, Peru, Dec. 17 (AP) — Leftist guerrillas champagne about a diplomatic party at the Japanese ambassador's house Tuesday night, then set off explosions and took hostages hundreds of diplomats and government officials.

Police officers with assault rifles surrounded the guerrilla compound in the exclusive Isidro district of Lima, and crouched behind their cars as gunfire was heard coming from inside. Witnesses saw smoke and tracer bullets.

From inside the compound, the Japanese Ambassador Morihisa Aoki, called a radio station. "There are people here, nothing, and we are safe," he said as he added, "For the moment, we cannot speak freely."

The Japanese Foreign Ministry in Tokyo estimated that at least 500 people were attending the party to celebrate the birthday of Emperor Akihito of Japan. A local television station, citing the Japanese Ambassador, reported that 600 people were inside.

The attack came while the compound was dressed for a party and unloaded the guests with most set off at intervals in the explosion and two minutes as they took control of the embassy compound after 8 P.M.

The rebels, who according to the police numbered about 30, identified themselves as members of the Tupac Amaru guerrilla movement and

demanded the release of imprisoned comrades.

"We want all of our fellow prisoners, who are being mistreated and tortured in the dungeons of the various prisons," said a guerrilla who identified himself as Comandante Mejia Huerta.

Many leaders of the Tupac Amaru, including its chief, Victor Polay, was captured in 1992 and is serving a life sentence. Its former lieutenant, Peter Cardenas Ortega, the top commander, conceded defeat and surrendered in July 1993.

Government and Red Cross officials reportedly were negotiating with the rebels, and President Alberto Fujimori convened an emergency meeting of his Cabinet.

In a telephone call to a Japanese station, NHK, the Ambassador said the rebels were "completely armed" and wanted to talk with President Fujimori.

It seems that after releasing the women and elderly, they are going to negotiate with President Fujimori. "The conditions for release us," Aoki said. "He was allowed to speak only in Spanish, and said he was not allowed to say how many rebels were in the compound.

In the hours after the attack, the

Continued on Page A6, Column 3

6 Red Cross Aides Slain in Chechnya, Imperiling the Peace

By ALESSANDRA STANLEY

MOSCOW, Dec. 17 — In the worst premeditated attack in the 133-year history of the International Committee of the Red Cross, six Western aid workers were shot and killed in their sleep early this morning in the separatist republic of Chechnya.

Five women — one nurse and one man — were shot with automatic bullets by masked gunmen who broke into their hospital compound near Geneva.

Red Cross workers, which put the fragile peace efforts and the future of international aid in jeopardy. They had time for the peace.

It is not clear whether today's attack was politically motivated or part of other factions from a Western organization. At least one organization has paid ransom in recent weeks to free kidnapped workers.

The killings in the village of Novye Atagi were among the most brutal sights of the lawlessness and violence

Continued on Page A10, Column 3

A Weary Zaire Welcomes Mobutu Home
After cancer treatment in Europe, Zaire's dictator, Mobutu Sese Seko, made a triumphal return to his tormented land yesterday, greeting the crowd in Kinshasa, the capital, with his wife, Bobi Ladaw. Page A3.

Brooke Astor Has a Year's Worth of Giving Left

By GERALDINE FABRIKANT

At 94, Mrs. Brooke Astor is giving up giving.

After 38 years of seeing to it that $175 million in New York went to world-renowned cultural institutions and tiny neighborhood self-help programs, Mrs. Astor says she wants more time to travel and write poetry. She has decided to close the Vincent Astor Foundation, and will give away its remaining $25 million by the end of next year.

While there are many larger philanthropic foundations, few have be-

come so entwined in the fabric of a city's life, because of Mrs. Astor's role as a social arbiter and her determination to focus her philanthropy on York.

She also set a standard for personal involvement in philanthropy. Determined to know every group that received money, Mrs. Astor personally visited hundreds of institutions, from the New York Public Library to a modest project that gives furniture to formerly homeless families.

Everywhere she went, the city's lead-

Continued on Page C22, Column 1

Fund-Raiser Visited White House Even After Concerns Were Raised

By STEPHEN LABATON

WASHINGTON, Dec. 17 — Charles Yah Lin Trie, the Arkansas businessman whose fund-raising efforts were rejected by President Clinton's legal defense fund earlier this year, continued to be a visitor to the White House long after Presidential aides began raising questions about money he had given to the fund for the Democratic Party.

Mr. Trie attended a Democratic dinner last Friday and spoke with Mr. Clinton about issues "of concern to Michael D. McCurry, the White House press secretary.

The White House was unable to explain exactly why Mr. Trie had been invited to dinner in December, when Mr. Clinton has repeatedly declared his intention to make campaign finance reform a centerpiece of his second term, and at a time when Washington is buzzing with a series of Congressional and Justice Department investigations into fund-raising practices.

Mr. McCurry sought to distance the White House from Mr. Trie, saying that he did not know and could not say whether Mr. Clinton

attended the dinner celebration for fund-raisers and other supporters of Mr. Clinton's re-election campaign. Nor would they say how many times Mr. Trie had been at the White House or who he had been seen, saying they were still checking records.

The legal defense fund was set up by the President and the First Lady from

(Handwritten/graffiti overlays across the page:)
4a

BANG UP A
DAY
BRING
OUT ARMY
PARTY
CREW'S CONTROL

ALL GOOD THINGS COME TO AN END

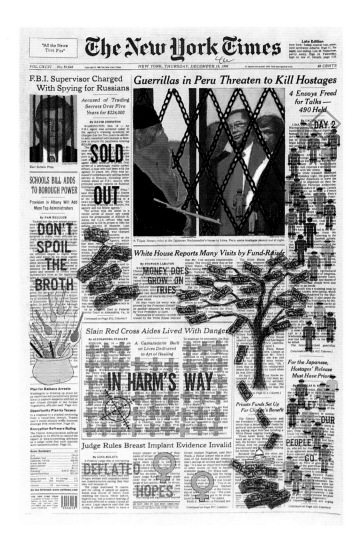

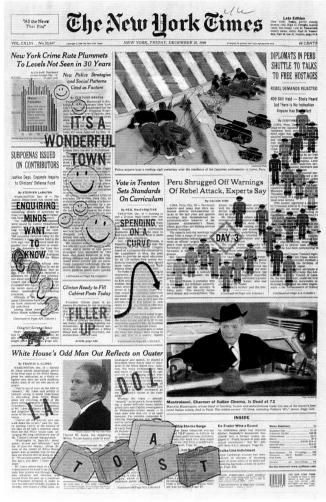

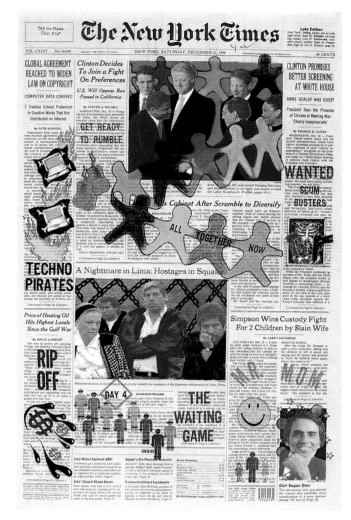

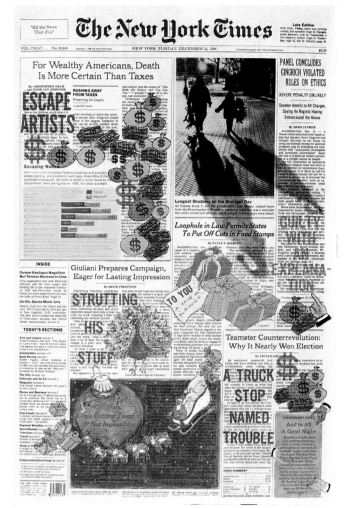

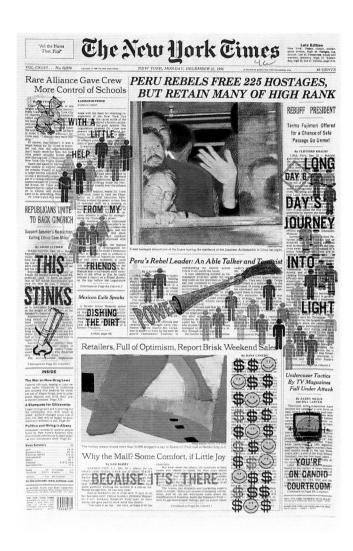

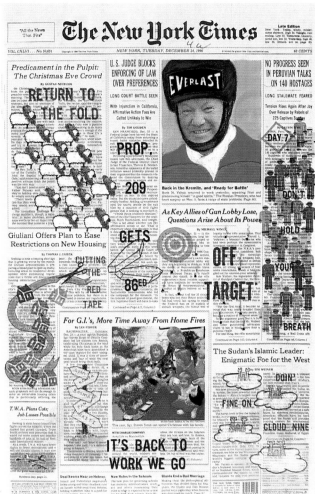

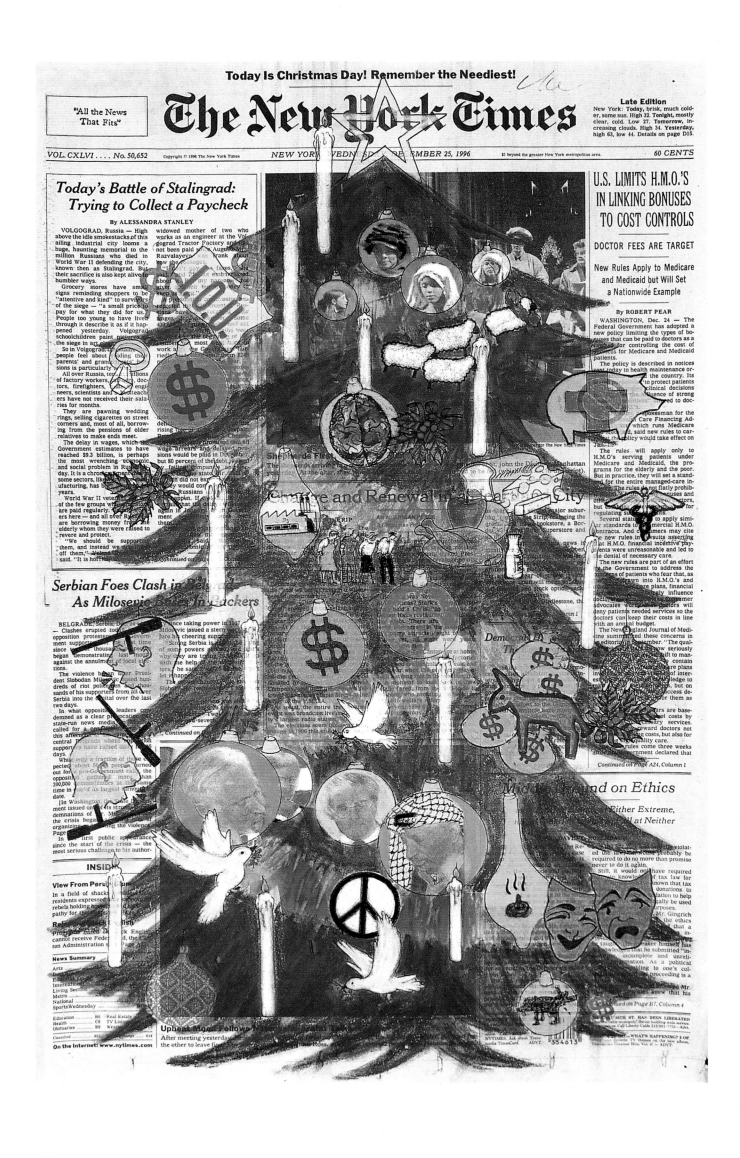

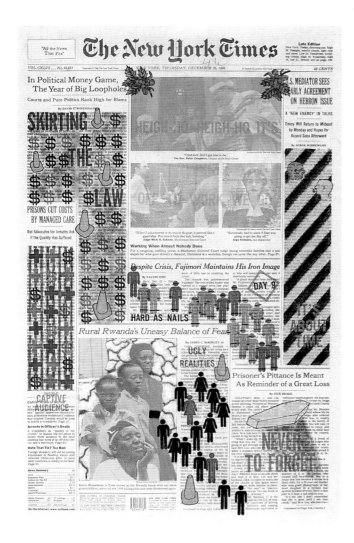

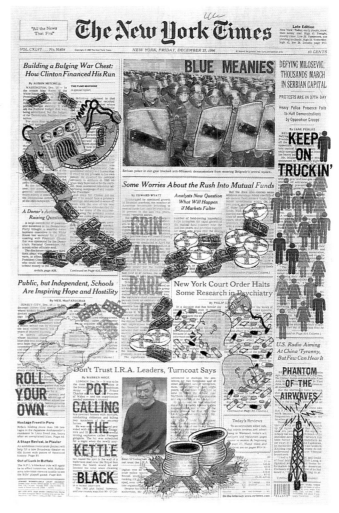

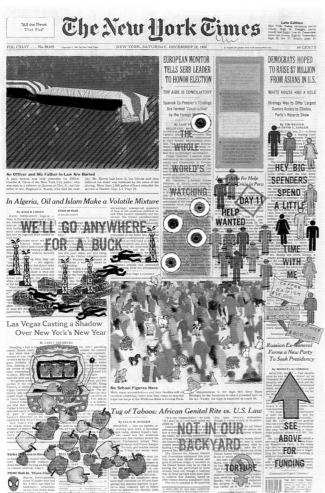

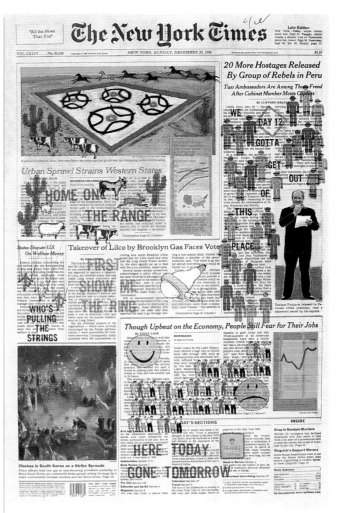

The New York Times

VOL. CXLVI .. No. 50,657 Copyright © 1996 The New York Times NEW YORK, MONDAY, DECEMBER 30, 1996 $1 beyond the greater New York metropolitan area. 60 CENTS

Late Edition
New York: Today, partly sunny. High 46 early afternoon, then turning cooler. Tonight, cloudy. Low 29. Tomorrow, mostly cloudy. High 38. Yesterday, high 55, low 48. Details, page D7.

Michael Shavel for The New York Times
"He'll be a Speaker who's weighed down," said Representative Michael P. Forbes of Long Island.

L.I. Republican Urges Gingrich To Step Down

By MELINDA HENNEBERGER

WASHINGTON, Dec. 29 — One of Speaker Newt Gingrich's most enthusiastic supporters today became the first House Republican to call for him to step aside. Representative Michael P. Forbes of Long Island, a freshman, admitted ethical lapses did not ring true.

"We need a Speaker who's weighed down," said Representative Michael P. Forbes of Long Island.

To Democrats it signaled serious trouble for Mr. Gingrich because at least a half-dozen other Republicans had said they were all embattled. Mr. Forbes said that technically as of 39 Republicans in Congress might well follow suit if the Republicans voted to reelect Mr. Forbes said he planned to do. Mr. Gingrich would not be reelected as Speaker.

"I'm physically sick to do it, but he'll be a Speaker who's weighed down," said Mr. Forbes, who represents the eastern part of Suffolk County, adding that Mr. Gingrich had gone off track in the last year.

Continued on Page B8, Column 1

A Spreading Furor Over 'Black English'

When the school board in Oakland, Calif., wanted to do something about the poor performance of black students, it decided that a language barrier might be part of the problem. It endorsed the idea of using "black English," the distinct language of many low-income blacks, in the classroom to reach such students.

The decision caused a furor that has spread nationally. Part of the debate is over whether the strategy is intended to help black students eventually learn standard English, or to promote a black nationalist ideology. And part of the debate is over what gave rise to black English in the first place.

Article, page A9.

NEWS SUMMARY

Arts
Business Day
Editorial, Op-Ed
International
Metro
National
SportsMonday
Media
Obituaries
Classified

On the Internet: www.nytimes.com

BOARDS AUTHORIZE A MERGER OF LILCO AND BROOKLYN GAS

NEW UTILITY TO BE FORMED

Electric Rates on Long Island Are Expected to Drop, but Debt Problems Remain

BY ROBERT D. McFADDEN

In a deal with far-reaching political and financial implications, Brooklyn Union Gas and the Long Island Lighting Company agreed yesterday to a merger that would create a new utility and perhaps lead eventually to deep cuts in electric rates — now the highest in the continental United States — for 1.1 million customers on Long Island.

The merger, approved at board meetings at both companies' headquarters in Brooklyn and Hicksville, L.I., would involve a tax-free exchange of stock for securities in a new holding company and would take effect in 12 to 18 months if endorsed by the stockholders of both companies and by state and Federal regulatory agencies.

Concluded in months of negotiation, Dr. William J. Catacosinos, chairman of Lilco, and Robert B. Catell, the chairmen and chief executives of Brooklyn Union, with George E. Pataki and Senator Alfonse M. D'Amato in behind-the-scenes roles, the merger would create a utility with revenues of $4.5 billion, 8,400 employees and 2.2 million gas and electric customers on Long Island and in Brooklyn, Queens and Staten Island.

"We have a very good deal here," Joseph McDonneIl, Lilco's senior vice president for marketing and external affairs, said at a late afternoon press conference in Hicksville. He said the company would save money over the next decade or so on fuel costs, and through consolidations, layoffs, and other steps.

Government officials encouraged the merger as an important step in the state's goal of doing away with the high taxpayer rates.

Consumer groups in neighboring territories and in the industry were cautious, saying any rate reductions for Long Island and Queens customers would have to be approved by the Public Service Commission. The next round of hearings is expected to take place in the spring.

For Lilco, which has 1.1 million electric customers and 453,000 gas users, the deal could lead to modest electric rate reductions at first and

Continued on Page B6, Column 1

Administration Proposes Paying U.N. Debt, but Congress Resists

BY STEVEN LEE MYERS

WASHINGTON, Dec. 29 — Having orchestrated the ouster of Boutros Boutros-Ghali as Secretary General of the United Nations, the Clinton Administration is facing increased diplomatic pressure to pay America's outstanding United Nations dues. But the Republican-controlled Congress are resisting.

Republicans insist that the way to block Mr. Annan's re-election this most pressing problem — not only presence of a new secretary general could persuade Congress to pay the hundreds of millions of dollars that United States has owed for years.

Republicans insist the way to block Mr. Annan's re-election this most pressing problem — not only the United States debt until they are convinced that the newly elected Secretary General, Kofi Annan, will make a difference. Mr. Annan, they say, must persuade them in a way he is determined to streamline the organization's budget and bureaucracy.

As Marc A. Thiessen, the spokesman for Jesse Helms, chairman of the Senate Foreign Relations Committee, put it: "They thought if they just brought us Boutros-Ghali's head on a platter, that it would satiate us and we'd pay up. Our concern is not Boutros-Ghali, but whether the United Nations reforms itself."

For the United States, the back dues have become a nagging diplomatic embarrassment. Even Administration officials acknowledge the issue has damaged American credibility within the United Nations even as they are pushing the organization to overhaul itself.

Continued on Page A4, Column 3

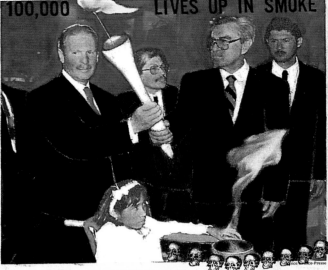

100,000 LIVES UP IN SMOKE

Guatemalans Formally End 36-Year Civil War

President Alvaro Arzú Irigoyen, left, and Rolando Morán, a guerrilla leader, held a peace torch in front of the Presidential Palace in Guatemala City yesterday after the signing of an agreement ending Central America's deadliest civil war. The girl in the wheelchair is a victim of the war. Page A8.

'DEEP REGRET' SENT BY NORTH KOREANS

Statement on Spy Submarine Halts Standoff With South

BY NICHOLAS D. KRISTOF

SEOUL, South Korea, Dec. 29 — In an unprecedented sign of its yearning to improve relations with the rest of the world, North Korea expressed "deep regret" today for sending a submarine full of armed commandos into South Korean waters and for "the tragic loss of human life," and promised not to do it again.

By North Korea's own truculent standards the statement was an astonishing sign of contrition. It opens the way to resume a dialogue that America had provided bitter an earlier pledge to put the delivered an assembly floor. And North Korea States in a way that over-sees North Korean spy submarine landed on a South Korean beach in September, and the commandos on board broke up into small groups and headed for their homeland.

The question in the 1994 agreement under which North Korea agreed to scrap its nuclear program that other countries suspected could lead to the production of nuclear weapons, as well as American plans to engage the North and bring it out of its isolation. "This is a major breakthrough in inter-Korean relations," a South Korean official said today.

The North Korean statement was worked out in negotiations in New York between a senior North Korean Foreign Ministry official, Li Hyong Chol, and a State Department offi-

Continued on Page A6, Column 1

GROWING OPTIMISM FOR PEACEFUL END TO CRISIS IN PERU

MORE FLEXIBILITY SHOWN

After Meeting at the Embassy, Government and Guerrillas Seem to Soften Stance

BY CALVIN SIMS

LIMA, Peru, Dec. 29 — Optimism is growing here that the hostage crisis at the Japanese Ambassador's residence will be resolved without bloodshed, as Government officials and leftist rebels met face to face on Saturday for the first time. Both sides appeared to soften their positions.

Foreign diplomats and international officials said today that while they anticipate a quick resolution to the crisis, the latest statements by the Túpac Amaru rebels and the Government's chief representative show that both sides have tempered the hard-nosed language that characterized their initial positions.

Neither side, however, which demanded the release of imprisoned comrades by the Government, which has offered only that it will give the rebels holding the hostages safe passage if they lay down their arms, has officially softened any positions, and both sides seem somewhat more flexible.

Michel Minnig, the Red Cross representative who has served as the main intermediary between the Government and the rebels, said today in a brief commentary on the talks that the outcome was uncertain.

"We don't like to predict the outcome of these situations, especially since there are still 100 people inside," Mr. Minnig said in an interview, referring to the hostages and the estimated 15 guerrillas that the rebels have released, that the face and the face of the situation. It's opposed, it's inconceivable one can foresee an obvious conclusion."

Many diplomats have been particularly encouraged that the Túpac Amaru guerrillas have stopped setting deadlines for beginning the execution of their captives.

In their most recent communiqué, the rebels demanded only that the Government provide better prison conditions for their jailed comrades rather than insist it free them, which President Alberto K. Fujimori is said to strongly oppose.

After the rebels released 20 hostages on Saturday night, the Government's chief negotiator, Domingo Palermo, had a four-hour meeting with a moderate rebel, Néstor Cerpa Cartolini, to produce what he called "advances toward the solution of this grave problem."

Mr. Minnig of the Red Cross, who since the start of the crisis has urged the Government to speak directly with the guerrillas, helped arrange the way to the breakthrough meeting between Mr. Palermo and Mr. Cerpa.

But Juan Luis Cipriani, the Roman Catholic Bishop of Ayacucho, who is a close friend of President Fujimori, also played a key role in setting the two sides down to talk. Since the start of the crisis, Bishop Ci-

Continued on Page A5, Column 1

INSIDE

Social Security Strategies
There is broad agreement that Social Security needs an overhaul, and groups representing labor, business and numerous other constituencies want a voice in the debate. Page A11.

Army Said to Back Protests
A letter expressing solidarity with the anti-Government protesters and said to be on behalf of an elite Yugoslav Army unit was read out as an opposition rally in Serbia. Page A3.

No Deal on Hebron
Israeli and Palestinian negotiators failed to seal an agreement on Hebron in another round of intensive bargaining, leaving only two days till a self-imposed deadline. Page A3.

Surprise: It's School Choice
A reference in a school finance bill could soon allow New Jersey parents to send their children to the public schools they choose. Page B1.

TV That Crosses Borders
Satellite television signals, which carry "The Simpsons" and other American shows to neighboring countries, are creating new kinds of border disputes. Page D1.

Drawing a Hard Line Against Urban Sprawl

By TIMOTHY EGAN

PORTLAND, Ore. — One of the great challenges of the West, the writers and thinkers...

David Falconer for The New York Times
Portland's light rail system, Max, was crucial in its planning with an aim that would be ringed by farms and forests.

BECOMING LOS ANGELES
Second of two articles.

Continued on Page A12, Column 1

The New York Times

Late Edition
New York: Today, a period of light snow then partial clearing. High 35. Tonight, mainly clear. Low 23. Tomorrow, plenty of sun. High 34. Yesterday, high 53, low 40. Details, page D20.

VOL. CXLVI ... No. 50,658 Copyright © 1996 The New York Times **NEW YORK, TUESDAY, DECEMBER 31, 1996** $1 beyond the greater New York metropolitan area. 60 CENTS

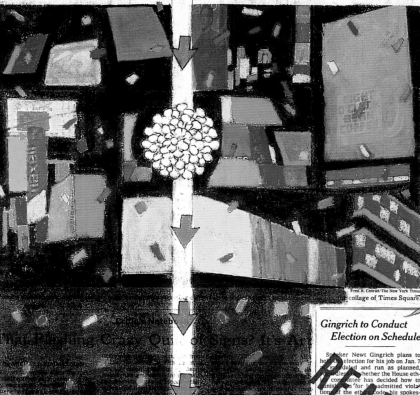

Fred R. Conrad/The New York Times
A collage of Times Square.

Doctors Given Federal Threat On Marijuana

U.S. Acts to Overcome States' Easing of Law

WASHINGTON, Dec. 30 (AP) — The Clinton Administration said today that doctors in California and Arizona who prescribe drugs like marijuana that are illegal under Federal law could lose their prescription-writing privileges and even face criminal charges.

Voters in those two states approved propositions in November that relax restrictions on the medical use of some illegal drugs. But the Federal Government, uneasy with the measures, has been developing a strategy to counter them.

"These propositions are not about compassion, they are about legalizing dangerous drugs," Gen. Barry McCaffrey, Retired, director of the Administration's Office of Drug Control Policy, said at a conference today after announcing the administration's position to deal with the new California law.

Supporters of the new California measure also pointed to some research that indicated marijuana may be useful in relieving internal eye pressure in glaucoma patients and lessening cancer patients' nausea associated with chemotherapy. But some immunologists worry that smoking marijuana weakens the immune system.

Yet several medical experts say marijuana is not proved medical use for marijuana and that in any case better drugs exist to treat nausea, the effects of glaucoma and H.I.V. called "wasting."

"It makes a point underscored at the news conference today by General McCaffrey, Attorney General Janet Reno and Donna E. Shalala, the Secretary of Health and Human Services.

"All available research," Secretary Shalala said, "has concluded that marijuana is dangerous to our health. Marijuana harms the brain, heart, lungs and immune system."

Under the administration plan of counterattack outlined today, doctors who counsel patients to use marijuana could be excluded from the Medicare and Medicaid programs, since their right to prescribe drugs depends on their being registered.

Articles, page D17.

U.S. REPORTS FOES IN KOREA WILLING TO DISCUSS PEACE

A MOVE TO EASE TENSIONS

North Agrees to Hold Talks on Formal End to State of War, Washington Says

By STEVEN LEE MYERS

WASHINGTON, Dec. 30 — A day after North Korea expressed regret for sending a submarine into the South, the Clinton Administration announced today that North Korea had agreed for the first time to talk with South Korea and the United States about the possibility of a negotiated formal end to the Korean war.

The agreement represented a significant breakthrough in efforts to ease tensions on the Korean peninsula, Administration officials said.

The United States had proposed such a meeting — or briefing, as officials call it — nine months ago, only to see it lost in the tensions that arose after a North Korean submarine full of commandos ran aground on a South Korean beach in September. The four North Koreans and 13 South Koreans were killed in the ensuing hunt. South Korea had considered the incursion into its waters a virtual act of war.

The point of the briefing would be to persuade the North Koreans to join broader talks with South Korea, as well as with China and the United States, in an effort to devise a formal end to the Korean War. The fighting ended with an armistice in 1953, but no peace agreement was ever concluded. Administration officials said today that the details of the meeting might be announced within a few days or weeks.

The expression of "deep regret," issued Sunday by North Korea's official news service, also cleared the way for progress on other volatile issues dividing the two Koreas and the United States.

"The negative atmosphere that has hung so heavily nearly two months has drifted away so that there is a possibility now for moving ahead on the issues that we have, that the South has, that the North has," Stanley Roth, senior director for Asia at the National Security Council, said at a news conference.

After the three weeks of intense negotiations in New York that led to the expression of regret, North Korea seems to be, in effect, committed to store more actively raised.

Continued on Page A10, Column 1

Gingrich to Conduct Election on Schedule

Speaker Newt Gingrich plans to hold an election for his job on Jan. 7 as scheduled and run as planned, regardless of whether the House ethics committee has decided how to punish him for his admitted violations of the ethics code, his spokesman said yesterday.

House Republicans have also sought to rally support for Mr. Gingrich among the lawmakers in his party with a 45-minute pep talk by coast-to-coast conference call.

In Mr. Gingrich's home district, in Georgia, many loyal supporters say the offenses were minor and unintentional, but some say they would not have voted for him if they had known of the lapses.

Continued on Page D18, Column 6

China Rushes Cases Against Dissidents Before Shifts in Law

By PATRICK E. TYLER

BEIJING, Dec. 30 — China is preparing this week to carry out a series of legal reforms hailed by some as a step toward the rule of law and protection of individual rights. But the impending changes seem to have provoked officials around the country trying to speed up the prosecution and sentencing of long lists of political dissidents, and several Chinese scholars and Western human rights advocates say they do not expect the changes to end the abuse of police power or curb excessive punishment.

On Jan. 1, China's police prosecution and judiciary are to put in effect reforms of criminal procedures approved by China's legislature, the People's Congress, in March. The reforms give defendants greater access to lawyers and put a 30-day limit on detention and interrogation, which under China's police powers officials can extend.

China recently announced on Dec. 24 that it had drafted legislation to erase the political crime of "counterrevolution," a demand of human-rights and civil-liberties advocates to establish a more specific standard against acts that jeopardize state security. Human-rights organizations in the West see Beijing's attempt to establish "counterrevolution" crimes from the criminal code as a kind of reform being debated as a fundamental reform leading toward a body of law providing greater protection of individual rights.

Continued on Page A7, Column 1

U.S. Mediator Meets Netanyahu And Then Arafat in Hebron Push

By SERGE SCHMEMANN

JERUSALEM, Dec. 30 — The special envoy on ways to protect the Jewish settlers in the Middle East.

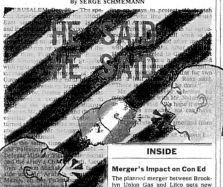

INSIDE

Merger's Impact on Con Ed
The planned merger between Brooklyn Union Gas and Lilco puts new pressure on Con Edison to get ready for a deregulated market. Page B1.

Peaceful End Seen in Peru
Peru's Prime Minister said he expected a peaceful end to the hostage standoff at the Japanese Ambassadors' residence in Lima. Page A3.

Train Bombed in India
A bomb ripped through a train packed with holiday travelers in eastern India, killing at least 26, local officials said. Page A5.

NEWS SUMMARY	A2
Arts	C9-20
Business Day	D1-16
Editorial, Op-Ed	A12-13
International	A3-10
Metro	B1-6
National	A11, A14, D17-18
Science Times	C1-7
SportsTuesday	B8-14

Environment	C4	Obituaries	D19
Fashion	B7	TV Listings	C21
Medical Science	C3	Weather	D20

Classified D21 Auto Exchange B12

On the Internet: www.nytimes.com

THE NEW YORK TIMES is available for home or office delivery in most major U.S. cities. Call, toll-free: 1-800-NYTimes. Ask about TimesCard. ADVT.

How Afghans' Stern Rulers Took Hold

By JOHN F. BURNS
with STEVE LeVINE

KANDAHAR, Afghanistan — When neighbors came to Mullah Mohammed Omar in the spring of 1994, they had a story that was shocking even by the grim standards of Afghanistan's 16-year-old civil war.

Two teen-age girls from the mullah's village of Singesar had been abducted by one of the gangs of mujahedeen, or "holy warriors," who controlled much of the Afghan countryside. The girls' heads had been shaved, they had been taken to a checkpoint outside the village and they had been repeatedly raped.

At the time, Mullah Omar was an obscure figure, a former guerrilla commander against occupying Soviet forces who had returned home in disgust at the terror mujahedeen groups were inflicting on Afghanistan.

He was living as a teacher, or talib, in a mud-walled religious school that centered on teaching of the Koran.

But the girls' plight moved him to act. Gathering 30 former guerrillas who had also returned between them, they had 16 rifles, he led an attack on the checkpoint, freed the girls and, said the checkpoint commander from a noose to the barrel of an old Soviet tank. As shots shared out with a cry of "God is Great!," Mullah Omar raised the tank barrel and raised and left the dead man hanging as a grisly warning.

The Singesar episode is now part of Taliban lore, with barely 30 months ago, with his rifle, Mullah Omar, became the ruler of most of Afghanistan. The mullah, a heavyset 38-year-old who lost his right eye in the fight against the Russians, is now the unchallenged leader of the Taliban, that has conquered 20 of Afghanistan's 32 provinces.

Much of what has happened in Singesar, and what has happened since, emerged from weeks of travel across Afghanistan and from scores of interviews with Afghans.

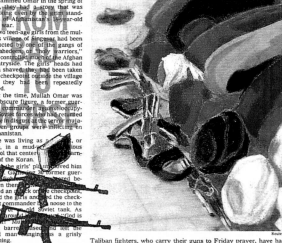

Reuters
Taliban fighters, who carry their guns to Friday prayer, have help from Pakistan in their rise to power in Afghanistan.

ROOTS OF REPRESSION
A special report.

their successes alone. Taliban leaders saw domestic political gains in supporting the movement, which draws most of its support from the ethnic Pashtun who predominate along the Pakistan-Afghanistan border.

Perhaps as important, Pakistan's leaders found new supplies of ammunition, money and food to the Taliban, hoping to advance an old Pakistani dream of linking their country, through Afghanistan, to an economic and political sphere.

Continued on Page A6, Column 1

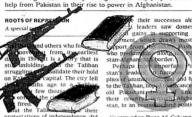

List of Collectors

Elaine Berger, Roslyn, New York: August 1; November 9

Dorothy Berenson Blau, Bal Harbour, Florida: June 13

Effie and Larry Coyle, Brooklyn: August 16

Sandy Deak and Rob Simon: April 30

Helen and Fred Dunbar, Bronxville, New York: April 26

Rosa and Aaron Esman, New York: September 27

Ellen Feldman, New York: November 3

Frayda and Ronald Feldman, New York: August (entire month)

Irene and Barry Fisher, Morristown, New Jersey: April 21

Mr. and Mrs. Thomas L. Friedman, Bethesda, Maryland: September 26

Jeanie and Richard Hersh, Sebastapol, California: November 11

Hort Family Collection, New York: November (entire month)

Gary Indiana, New York: March 21

Kennell Jackson, Stanford, California: May 13; September 17

Nancy Lee, New York: July 20; November 6; December 25

Colleen J. May, Brooklyn: May 8; August 30; November 5

Mrs. and Dr. Al Miller, San Antonio, Texas: June 17

Ms. Foundation for Women, New York: April 25

The New York Times, New York: October (entire month)

Marc Nochella, New York: July 23

Nancy and Steven Oliver, San Francisco, California: September 18 – 24

Park Slope Framing and Gallery, Brooklyn: March 24; May 3, 23; June 9;
July 11, 14; August 26; October 14, 18; November 26; December 3

The Progressive Corporation, Cleveland, Ohio: December (entire month)

Gene Roberts, New York: July 18, 19

Dee and Tom Stegman, Cincinnati, Ohio: May (entire month)

Jeff Stegman, Cincinnati, Ohio: October 29

Todd Stegman, Cincinnati, Ohio: August 10

Elaine Sterling and Lyle Starr, New York: September 5

Sandra Thomson, New York: May 22

In addition, the following are in private collections: April 15, 25; May 5;
June 8, 14, 26, 27; July 22; August 18, 19, 31; September 11, 12; December 31

Details

page 4
October 30

page 6
November 16, April 19

page 7
April 15, June 14

page 8
March 28, August 2, March 29

page 9
May 26, October 18,
May 13, July 19

page 10
July 19, October 30, January 15

page 11
November 3, October 29,
November 6, October 28

Nancy Chunn has exhibited internationally and has been represented by

Ronald Feldman Fine Arts in New York for more than ten years.

She grew up in California, attending the California Institute of the Arts,

and moved to New York in the late seventies. Her work's focus has consistently

been the documentation of the political arena, including a series of

interpretive maplike paintings of countries in turmoil.

She has twice been a recipient of a National Endowment of the Arts fellowship.